THE MIEGUNYAH PRESS

This is number forty-eight in
the second numbered series of the
Miegunyah Volumes
made possible by the
Miegunyah Fund
established by bequests
under the wills of
Sir Russell and Lady Grimwade

'Miegunyah' was the home of
Mab and Russell Grimwade
from 1911 to 1955

MR FELTON'S BEQUESTS

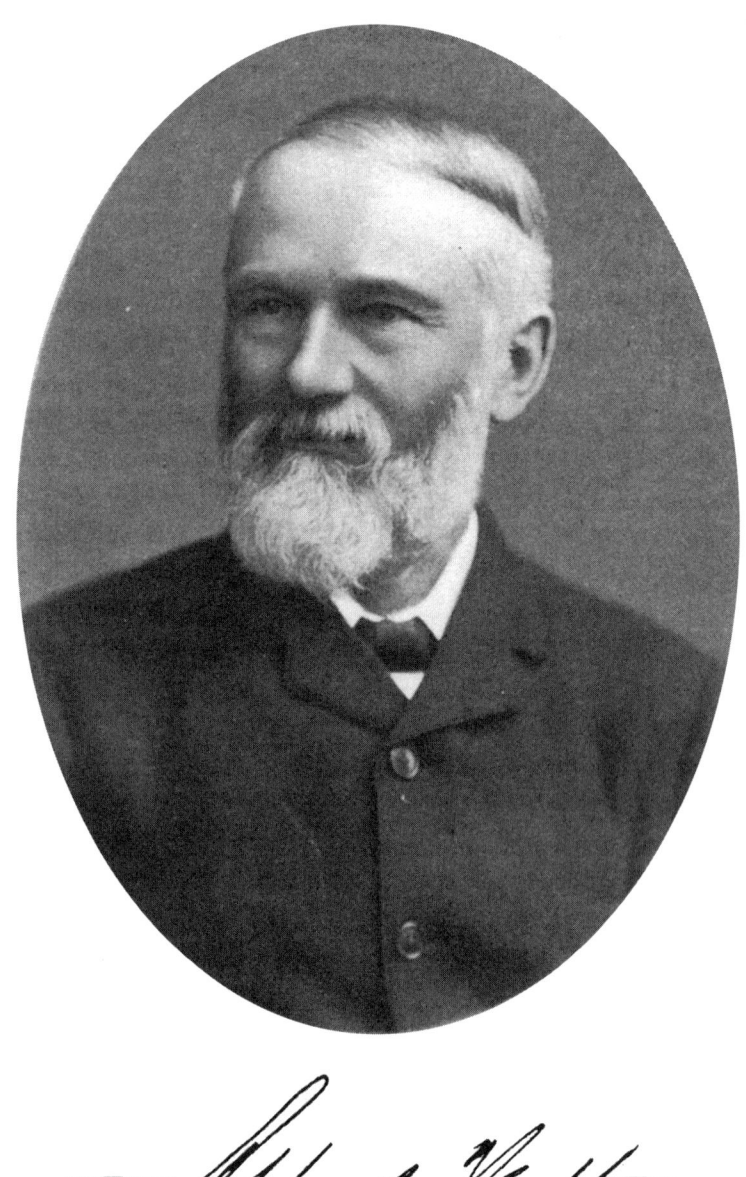

Alfred Felton, photograph and signature
(from Bage, *Historical Record of the Felton Bequest*, 1923)

MR FELTON'S BEQUESTS

JOHN POYNTER

THE MIEGUNYAH PRESS

THE MIEGUNYAH PRESS
An imprint of Melbourne University Publishing Ltd
PO Box 1167, Carlton, Victoria 3053, Australia
mup-info@unimelb.edu.au
www.mup.com.au

First published 2003
Text © John Poynter 2003

Design and typography © Melbourne University Publishing Ltd 2003

This book is copyright. Apart from any use permitted under the *Copyright Act 1968* and subsequent amendments, no part may be reproduced, stored in a retrieval system or transmitted by any means or process whatsoever without the prior written permission of the publishers.

Production management: Melbourne Publishing Group

National Library of Australia Cataloguing-in-Publication entry

Poynter, J. R. (John Riddoch), 1929– .
 Mr Felton's bequests.
 Bibliography.
 Includes index.
 ISBN 0 522 85079 0.

 1. Felton, Alfred, 1831–1904. 2. National Gallery of Victoria. 3. Art—Collectors and collecting—Victoria—Melbourne—Biography. 4. Philanthropists—Victoria—Melbourne—Biography 5. Businessmen—Victoria—Melbourne—Biography. I. Title.

708.0092

FOREWORD

THE FELTON BEQUEST is a name unto itself. Whether or not it is the most valuable gift ever made to the fine arts in Australia matters little: it has certainly been the most beneficial. The Felton Bequest made the National Gallery of Victoria the first encyclopedic collection of art in Australia. It brought the art of both the western and eastern hemispheres to the doorstep of Melbourne, spanning the ages from classical antiquity to twentieth-century art. From that first, and still startling, acquisition of Camille Pissarro's *Boulevard Montmartre* in 1905, the Felton Bequest has placed the hallmark of excellence upon its major acquisitions. It has aimed for high artistic quality and historical significance from Memlinc to Magritte. Without the Felton Bequest, Australia would have no complete account of Dürer's or Goya's graphic work. There would be no Rembrandt, no Poussin, no Boucher, no Canaletto, no Reynolds nor Gainsborough of substance, no groups of Turner and Constable, no Manet, to cite only the most obvious examples. Although the last quarter of the twentieth century saw a dramatic and exciting expansion of Australian art museums from the creation of the National Gallery of Australia to the renovation of the State galleries and the revival of many regional ones, no institution could hope to replicate the collection of the National Gallery of Victoria assembled under the aegis of the Felton Bequest.

How strange that it should have taken the centenary of the Bequest to have its history fully told but how fortunate that it has found Professor John Poynter as its historian. Among many fresh insights and scintillating details, Professor Poynter has three remarkable achievements in this comprehensive account of a man and his bequest.

First: Alfred Felton has emerged from the shadows of the past. *Primus inter pares* among Victorian philanthropists, he has hitherto remained an elusive if benign presence. In Professor Poynter's pages he comes across as a remarkable

figure of his age. If the reasons why Felton should have bestowed his munificence upon the National Gallery of Victoria, as well as upon indigent women and children, remain enigmatic, Professor Poynter has gone further than others in resolving the enigma.

Second: The Felton Bequest has been the subject of speculation and mystification over the years. What Melbourne could have had as much as what was acquired was a constant source of myth and rumour. Professor Poynter now supplies the authoritative narrative. His clear-eyed view of the successes of the Felton Bequest has not diminished his keen sense of miscues and lost opportunities. But what art museum does not have a similar tale to tell? Nonetheless it jolts the mind that a peerless Vermeer might have joined Melbourne's mighty Rembrandts.

Third: Professor Poynter's narrative records vividly and unblinkingly the controversy and rancour that attended the deliberations and decisions of the Felton Bequest almost from its inception. Maybe the arrangement of a Felton Bequests' Committee with its own London adviser and the trustees of the National Gallery of Victoria with a director and staff eager to shape the collection were a combustible mix. The tensions between them make for gripping if uneasy reading. The members of the Felton Bequests' Committee and the trustees of the National Gallery of Victoria were drawn from the same business, legal and intellectual elite—the Melbourne Establishment—and, except for rare periods of peace, they fought and mistrusted each other. At times it seems a miracle that so much good was done for the National Gallery of Victoria and the attendant charities.

In short, Professor Poynter has written a masterly narrative equal in every way to its subject. It is a complex story of the fitful triumph of good, even noble, intentions translated into works of art of abiding significance and value. That these good intentions had to struggle to make themselves manifest over provincial pettiness only adds to the fascination of the Felton Bequest.

Patrick McCaughey

CONTENTS

Foreword	vii
Preface	xi
Acknowledgements	xix
Abbreviations	xxiii

PART ONE
A MERCHANT OF MELBOURNE

Prologue: East Anglia		3
1	The Colonist	11
2	Colonial Partnerships	28
3	Friends and Causes	44
4	Merchants Adventuring	74
5	Home News	92
6	Pests and Poisons	110
7	Where the Heart is	119
8	Church, Charity and Art	134
9	The Swaggering Things are Bust	158
10	On the Esplanade	177
11	Desirable Things	193
12	Towards a Solitude	206

PART TWO
ART AND CHARITY

13	The Bequests	223
14	Beginnings	245
15	Discordance	268

16	Moby Dick and the London Whale	287
17	Art and Anthropology	309
18	Rinder's List	327
19	The Rending of Rinder	350
20	Famine	368
21	Feast	387
22	Old Men Disputing	403
23	Tribes and Diatribes	415
24	Reconstruction	442
25	Peace	457
26	Apogee	474
27	Valhalla	503
28	From Charity to Philanthropy	533
29	Coming to Terms	558
30	Towards a Centenary	583

Members of the Felton Bequests' Committee	609
Illustrations	611
Bibliography	617
Index	628

PREFACE

Alfred Felton was an unusual man. Born in East Anglia in 1831, he arrived in the Colony of Victoria in 1853 and made a fortune as a merchant and manufacturer. When he died in Melbourne in 1904, his will unexpectedly established two major bequests, one for the relief of less fortunate fellow citizens, the other for the cultural edification of the community in which he had chosen to live. The income from his bequests has since been devoted, in equal shares, to charities 'in the legal sense' and to the purchase, for the National Gallery of Victoria, of works of art calculated 'to raise and improve public taste'. The Gallery suddenly gained access to acquisition funds greater than those of London's National and Tate galleries combined, and between 1904 and 2001 more than 15 000 items purchased by the Felton Bequest were entered in its Accession Register. Their estimated value in 2002 was approximately one and a half billion dollars.

Felton was a man of the nineteenth century. His bequests have now entered the twenty-first. Approaching the centenary of his death, it is timely to take stock of the man, and of the use which has been made of his fortune. Felton was an interesting person, if in many respects also elusive. He did not hide himself away, but neither did he seek public office or attention. We know a good deal about the last twenty of his seventy-two years, including his opinions and values, in business and in social life. We even know what he spent, in his last decade, on drink and cigars, what else he bought and how much he gave away. But his earlier life is meagrely recorded, and (above all) we do not know why his will took the form it did, or who or what moved him to make art and charity the causes he chose to support in perpetuity. His biographer is teased by the thought that somewhere, in the detritus of the nineteenth century preserved in our archives and libraries, lies a piece of paper on which Felton, or one of his friends, recorded the origins of the impulses which led him to make the testament he did. The best we

have is an agenda he prepared, at the age of sixty, for the last years of his life, in which 'expenditures on the sick and poor' and on 'art works' figure alongside 'desirable things—personal or other'.

Felton gave the responsibility of investing and managing his bequest to a trustee company, and the task of spending both halves of its income to a committee of his friends. The charitable part was at first relatively straightforward, distributing grants mainly to the causes Felton had favoured in his lifetime; although a lifelong bachelor, he wished in particular to aid charities for children and women. The bequest to art, however, had a dilemma built into it. Who was to decide what 'works of art, ancient and modern, and antiquities or other works or objects' should be bought, to raise public taste? Since there was seldom public consensus on what constituted artistic value—as there was agreement, more or less, concerning charity—for half a century public debate raged over the art works bought or not bought by the Felton Bequests' Committee for Melbourne's Gallery. The critics greeted the annual exhibition displaying new Felton acquisitions as they might the opening of the Victorian duck season, but with no license required to shoot and no limit on the bag.

THIS BOOK FALLS naturally into two parts. The first is a biography of Felton himself, set in the context of the colony of Victoria in which he settled in 1853. While emphasis is given to his interests in art and his charitable activities, his life as a Melbourne merchant and manufacturer and his general views of the world necessarily loom larger.

Felton the man is much less well known than his Bequests. The image which continues to dominate public perceptions—such as they are—of 'the greatest benefactor to art in Australian history' was constructed by Russell Grimwade, who could write with the authority of one who had known Felton in real life, though he was nearly half a century younger.[1] Grimwade sketched Felton succinctly in 'Some memories of Alfred Felton', an address given, as Chairman of the Felton Bequests' Committee, in 1954, shortly before his own death. 'Despite the dimming of memories by the passing years', he began, 'I have a very lively recollection of the kindly and rather finicky old bachelor', whose business partnership with Russell's father, FS Grimwade, had 'lasted for nearly 40 years and digressed over a wide field in the developing colony', in enterprises ranging from the wholesale drug trade to a glass bottle works.

[1] The words are Ursula Hoff's (*The Felton Bequest*, p. 7); his will (she continued) endowed the National Gallery of Victoria with 'the only encyclopaedic art collection in Australia'.

Through all these years Felton lived as a bachelor either in boarding houses or occasionally with his own establishment, but always frugally and modestly in comparison with the means in his possession... His way of life was always seasoned by a moderation that amounted to frugality and a simplicity that was akin to humility. His character was essentially one of kindly benignity and dignity, coupled with a rare whimsicality. He made many acquaintances but few close friends, and seemed to enjoy the propinquity of the ordinary men, women and children he would meet on holiday excursions.

Russell Grimwade's longest account of Felton had appeared in 1947 in *Flinders Lane, Recollections of Alfred Felton*, a book based on long research but in which, unaware of the existence of some surviving sources, he happily reconstructed conversations and correspondence as he imagined Felton, FS Grimwade and others would have conducted them. Much in Russell's account has to be corrected: Felton was less frugal and more sociable than he depicts him, enjoying the pleasures of food, drink, gossip, literature and art; and as a partner Felton did much more than merely provide 'the means that enabled the hard work and good sense of my father to establish a good business'.[2] The charm of this early example of fictionalised biography has faded a little, while the mood it creates—autumnal, drawn with much affection, but depicting an amiable and withdrawn eccentric—is essentially misleading. Felton's surviving letters are much more pungent than Grimwade's constructions; in biography—it is a truth which ought to be universally acknowledged—the actual (when and in so far as it can be uncovered) is usually more surprising than the imagined. 'One chemical is related to another chemical', Felton himself wrote to a friend, 'and so the human composite thing (body, soul and spirit) called man has a relation to other men and a different one to each'.[3] Neither Felton, nor his life, was as simple as in old age they seemed to the young; but no life is.

There is no doubt that Alfred Felton was a little eccentric, or that he was generally benign towards his fellow human beings—in itself perhaps an eccentricity—but he was also shrewder and sharper than the man Russell Grimwade depicted.[4] He was always kindly towards young Grimwades; to others he could be tough and unyielding, especially if he thought himself deceived. He belonged to a remarkable group, the merchants who flourished in Melbourne in the

[2] Grimwade, *Flinders Lane*, p. 6.

[3] AF to TWK, 19 July 1895.

[4] Grimwade conceded that 'whilst today we are inclined to think of him as a whimsical and perhaps rather eccentric old man', Felton 'was not always old, and... must have been a young man of vigour and enterprise'. Even in benign old age he 'could become testy upon occasions when his determination was countered'; nevertheless 'he never let the sun go down upon his wrath', and his will ultimately 'revealed his kindly character'.

Colony of Victoria after the gold rushes, and he did not become one of the most successful among them by being merely whimsical and kind.

THE SECOND PART of the book deals with Felton's testamentary bequests, and is in consequence more narrowly focused, on the tasks the Felton Bequests' Committee was given, the manner in which it set about achieving them, and the difficulties and opportunities encountered along the way. The financial management of the trust rested with the trustee companies, and not with the Bequests' Committee, and its history is no more than sketched here.

One peculiarity of writing of a man and his bequests is that one subject perforce begins only when the other ends. Felton's life and the story of his bequests cover the better part of two centuries and nudge into a third, setting the author a marathon to be run with patience (which he must hope his readers share). Attempts to find continuity in the story are aided at least by a geographical unity: after Felton arrived in Australia, the focus of his life and his bequests was Victoria, and especially Melbourne, and the characteristics of that city have in consequence, in this book, become not merely the place of action, but a part of it.

Within Melbourne, certain institutions had a continuity of their own, especially the conglomerate of Public Library, Museums and National Gallery of Victoria, a great Victorian educational enterprise established after 1854 under one roof and single body of Trustees. The Felton Bequests' Committee could not purchase what the Trustees would not accept, but neither was it obliged to buy what the Trustees recommended. Tension was inevitable, and for some forty years the relationship between the Bequests' Committee and the Gallery's Trustees was distressingly turbulent, resembling an unhappy marriage with no prospect of legal dissolution, exacerbated, as is often the case, by the involvement of a third party, the Director of the Gallery, with passions of his own. Even death, the usual liberator from domestic strife in earlier centuries, was delayed by the longevity of some of the participants; the Director, and one leading member of the Committee, each held office for more than forty years, a long time to nurture grudges.

Inevitably, these relationships ran their course in committees and conferences. Committees, as organisations for arranging human affairs, are ubiquitous in Western democratic life, though too often overlooked in history, perhaps because they usually meet in small rooms in which tedium is only occasionally relieved by drama. It is indeed paradoxical that Felton, a man who succeeded in never sitting on a committee in his lifetime, should have set up, by his will, an almost unworkable conjunction of two.

For the first five decades Felton's Art Bequest was the National Gallery's only significant source of funds for acquisitions. After 1955, for another three decades,

the Bequest remained the major source of acquisitions, though the Gallery gained access to some other funds, and the extraordinary inflation in prices for works of art reduced the volume of purchases flowing into the collection from Felton sources. Those trends were accelerated in the last three decades of the century: Felton Bequest funds became less important over the whole range of the Gallery's acquisitions, while remaining capable of acquiring occasional major works of strategic importance.

The history of the Felton Art Bequest as a whole has its moments of drama—tragedy sometimes, farce occasionally—and is often merely depressing, but even its simplest processes were rarely routine. Every collection tells a story (even a meta-narrative) and the tale of triumphs and blunders can be told, and retold as perspectives alter; but despite the controversies which frequently interrupted the process of acquisition, the outcome of Felton's bequest to art has been a massive achievement, the fruits of which are demonstrable. When, in 2000-01, an exhibition of *European Masterpieces from the National Gallery of Victoria* went on tour in the United States, some three-quarters of the eighty-eight paintings shown had been acquired through the Felton Bequest, while other treasure troves—for example the Print Room and the Chinese collection within the field of Decorative Arts—are less transportable but equally impressive.[5]

But what, it could be asked, of the masterpieces that are not in the Gallery, though they might have been, of the opportunities missed? One Felton Adviser, touring North America in the 1950s, reported observing in major galleries many masterpieces each of which he knew to have been rejected in Melbourne at one time or another. The history of the Art Bequest—like the history, indeed, of any great gallery—could certainly be told as a succession of fumbles and blunders, of misunderstandings and malice; in art, this year's coup is next decade's folly, and the work dismissed as unworthy yesterday tops tomorrow's auction. The historian, as well as the buyer, must beware; and beware also of the vicissitudes of changing attributions. The small number of Vermeers in the world accepted as genuine goes up and down, like the tide; and the Ince Hall *Madonna and Child*, enthroned as the queen of Melbourne's collection in 1923 and deposed after 1959 as a mere copy or even pastiche, has had those judgements questioned in 2001. There is no certainty in scholarship, though some bets are better than others.

It is not well known that fully half of Felton's Bequest supports charity, not art. Victoria had and has a vast network of charities, and a very large number of organisations received support from the Committee, year after year from 1904; but

[5] Vaughan, Introduction to *European Masterpieces*, p. 8.

the world of charity was less volatile than that of art, and the annual grants, though published, caused little stir. For decades the Bequests' Committee did not recognise that it faced the same strategic issues in charity as in art: whether to concentrate its funds in selected fields, and a few expensive projects, or to continue to spread support widely (as, on the whole, Felton himself had done). Most of the early grants were so small that it is fair to ask what they achieved. Later in the century, when state provision for welfare expanded over most of the fields previously supported by the Bequests, the Committee needed new strategies, and gradually developed them. Later still the Bequests' Committee, like other charitable trusts, was much influenced by new notions of philanthropy, selective and co-ordinated, stemming mainly from North American theory and practice, much as the concept of 'scientific' charity had been imported from Britain a century earlier by Felton's friend Edward Morris. The importance of this progression from charity to philanthropy, and the association of both with government, emerges clearly from the history of Felton's Bequests.

By the end of its first century the Felton Bequests, though by no means the largest of the philanthropic trusts operating in Australia, were distributing, in the causes of charity and art, more than a million dollars a year. In charity there remained plenty to do, but in some respects responsibility for the Art Bequest had become the more problematic as the century closed. The stock of major art works in the market is permanently depleted, and because those remaining are bought as commodities and resold for profit as well as collected and cherished, many prices are far beyond the reach of any endowed fund. The scale of earlier achievements cannot be maintained, though useful opportunities to add significant works to the Gallery's collections are still to be found. Language and its changing meanings, especially evident in the arts, may however pose other, unusual problems in the twenty-first century, as the concept of art so expands its boundaries that they cease to exist, having nothing beyond them. Felton's simple terms—'works of art' judged 'to have an educational value and to be calculated to raise and improve public taste'—will require translation; but into what new vocabulary, born in New York, Paris or London, slouching towards Melbourne?

WHEN ALFRED FELTON died, aged seventy-two, in January 1904, the Trustees Executors and Agency Company Limited sealed his rooms in the Esplanade Hotel, St Kilda, where he had spent his last twelve years, and arranged for the National Gallery of Victoria to choose which of his pictures and works of art it wanted. The rest of his pictures, his books and photographs, and his curios, carvings, bronzes, statuary and silverware, were auctioned in three separate sales. The company kept, and stored among its own records, a couple of private ledgers,

two bundles of letters (one from members of Felton's family, the other from his partner in property ventures, Charles Campbell) and two 'private' letterbooks, ghostly pressed copies, tissue-thin, bound in large volumes. Few documents by or about Felton survive from the first fifty years of his life, although he must have written thousands, since he seems to have dictated to an amanuensis virtually all the five hundred pages preserved in the letterbook, 'AF', commenced in 1875; most deal with the 1880s, and a sequence sent fortnightly, between March 1884 and June 1885 to his partner Grimwade, then in Europe, range widely over business, personal matters and the Melbourne social scene. (The other letterbook, 'AF No 1 General', covering the years 1895-96, deals mainly with business.) We thus possess documentation for about two years of Felton's personal life more or less equal to the total for the other seventy years, a mixed blessing for a biographer. Felton was a lively observer, and a connoisseur of gossip; we must regret the diary he did not keep, and regret also that a man who wrote so much, and so well, seems to have published nothing, not even a letter to the newspapers, against whose inaccuracies he habitually fumed.

Felton's papers remained with the Trustees Executors and Agency Company Limited until passed to its successor, the ANZ Executors and Trustee Company Limited, when they came close to being thrown out, as the bank had to cope with inheriting a mass of other people's history. Russell Grimwade was unaware of their existence when he collected material for *Flinders Lane* in the 1920s and 1930s, his main sources being his own recollections of Felton and those of surviving associates, including other members of the Grimwade family. The 'AF No1 General' letterbook (for 1895–96), and 'FG&Co Private Letters' (the Partners letterbook for 1884–95) were discovered in the Trustee company's files in time for Daryl Lindsay to add some biographical details to his *Felton Bequest*, published in 1963. More material was discovered, and used for a brief biography published in 1974, though the third letterbook ('AF') still escaped attention, and errors which Grimwade unwittingly imported from misleading sources in England were amplified.[6] By then the business papers of Felton Grimwade and Company, and related enterprises, had passed to the University of Melbourne Archives, which now also holds Russell Grimwade's papers, including the material on Felton which he, and others, collected.

If the surviving personal records of Felton the man are meagre, materials concerning the conduct of Felton's Bequests form an ore body so massive that even this large book is based on little more than a geological survey and a few exploratory shafts, of varying depth. The main documents generated by the

[6] Poynter, *Alfred Felton*, 1974, based mainly on *Russell Grimwade*, 1967; the entry on Felton in the *ADB* is in vol. 4.

Felton Bequests' Committee were held by the Trustee company until 1996, when some—including nine bulky Minute Books covering the period 1904–90, handwritten until mid-century and then typed—were transferred to the La Trobe Library, together with useful books of press cuttings and material concerning the Felton estate. Most of the correspondence concerning the Bequests, and in particular the important series from the Committee's London Advisers, stayed with the Company; but because the Bequests' Committee was in constant communication with the Gallery Trustees, much—at least from the 1920s on—can also be found elsewhere, in copies produced on the inky but then ubiquitous Roneo machines. The Gallery's own records concerning the Bequest, once piled in a dusty room in the old Swanston Street building occupied also by the young Education Officer and future Director, James Mollison—who read them and gained thereby an education in art and committee politics—were later divided between the Gallery's own Library, the La Trobe Library and the Public Record Office, Victoria. Material concerning the charity half of Felton's Bequests was not so widely distributed, though some survives only in the private papers of individual Committee members. Very little has been written concerning the Committee's charitable work, perhaps surprisingly, since the literature on charity in Victoria, and more recently on modern philanthropy, is now considerable. Writings about the Art Bequest are numerous: in the earlier decades the Bequests' Committee itself published *Historical Records*; Daryl Lindsay surveyed developments up to the 1960s; and in 1983 Dr Ursula Hoff, then recently retired as Felton Adviser after a distinguished career within the National Gallery, added new insights in her essay *The Felton Bequest*.[7] Ann Galbally's *The Collections of the National Gallery of Victoria* (1987) contains much historical information and perceptive comment; and the Gallery has produced many relevant publications, including Ursula Hoff's *European Painting and Sculpture Before 1800* and Sonia Dean's *European Paintings of the 19th and Early 20th Centuries in the National Gallery of Victoria*. The large volume produced in 1970 by Dr Leonard Cox, *The National Gallery of Victoria 1861 to 1968*, is both a history of the Gallery and a primary source, since his long involvement with the institution included periods as Honorary Curator of Oriental Art, Chairman of the Gallery Trustees and membership of the Felton Bequests' Committee. Later writers remain in his debt.

[7] Bage (compiler), *Historical Record of the Felton Bequests* (1923), *Historical Record of the Felton Bequests, Supplement No. 1* (1927) and *The Felton Bequests: an Historical Record, 1904–1933*, compiled by Burdett (1934). The Trustees of the Public Library, Museums and National Gallery published *Alfred Felton and his Art Benefactions* in 1936.

ACKNOWLEDGEMENTS

I FIRST WROTE ABOUT ALFRED FELTON in the 1960s, in a biography of Russell Grimwade, and returned to him in the 1970s, to write his entry in the *Australian Dictionary of Biography* and a small booklet *Alfred Felton* (1974). This latest volume has therefore benefited from the advice of friends and scholars and helpful informants over some forty years. Sir Clive Fitts, Professor Sir Joseph Burke, Sir Daryl Lindsay, Sir John Medley, Dr Geoffrey Serle, the Felton Bequests' Committee's long-time Secretary, JH Stephens, and its distinguished Adviser, AeJL McDonnell, all now dead, were especially helpful in earlier years. Paul de Serville, Dr John Lack, Professors Miles Lewis and Boris Schedvin, Vida Horn, Mal Harrop, Jane Clark, Marion Poynter, Judith Pugh and Keith Edkins (Felton's great-great-nephew) are among those who have aided my recent researches. Professor FB Smith, who has done almost as much for the discipline of history by his tireless reading of other people's drafts as by his own writings, has helped me from the beginning, as has Sir Andrew Grimwade, a knowledgeable guide to the complexities of his family and of Felton's Bequests alike.

I am not an art historian, and did not realise my temerity in tackling a history of the art half of Felton's Bequests until embarked beyond turning back. My misunderstandings must be legion, but I hope I have been saved from too many errors by the patience of several scholars who have read all or part of my drafts, including Professor Jaynie Anderson, Dr Ann Galbally, Professor Bernard Smith, Dr Paul Paffen, Sheridan Palmer, Hugh Hudson and Peter Tzamouranis. Exploring the charitable side of Felton's Bequest revived an earlier interest in nineteenth-century attitudes to poverty and its relief, on which I worked for much of the 1950s. Current doctrines on philanthropy are very different; Elizabeth Cham, Executive Director of Philanthropy Australia, who formerly worked with the Felton Bequests' Committee, has been especially helpful in exploring them. I should declare a further interest: I was, for nineteen years,

involved with the Citizens Welfare Service, formerly the Charity Organisation Society, recipient for more than a century of donations from Alfred Felton and of grants from his Bequest.

My dependence on that national treasure, the *Australian Dictionary of Biography*, is evident. I thank my colleagues in that enterprise.

This new publication, and my researches, have been supported by the Felton Bequests' Committee, which instigated the project nearly four years ago, after I had suggested revising and reprinting the small booklet on Alfred Felton. Present and past members of the Committee, Sir Gustav Nossal, Sir Andrew Grimwade, Mrs Caroline Searby, Dr Alison Inglis and Professors Margaret Manion and Jenny Zimmer, have been sources of helpful comment and patient readers of drafts, though the judgements and errors are mine, not theirs.

The work could scarcely have been undertaken without the co-operation of the National Gallery of Victoria, the institution to which the Felton Bequests' Committee is bound inexorably by the terms of Felton's will, and I am especially grateful to the Director, Dr Gerard Vaughan, for his support. Present and past members of staff who have been generous with assistance include three former Directors (Drs Eric Westbrook, Patrick McCaughey and James Mollison), Dr Ursula Hoff, Sonia Dean, Terence Lane, Geoffrey Smith, Ken Gott, Michael Watson, Frances Lindsay, Jennie Moloney, Janine Bofill, David Belzycki, Kirsty Grant and Veronica Angelatos (but not, to my great regret, Kenneth Hood, who died before I could tap his deep knowledge of the institution he served so well).

In an earlier incarnation the National Gallery and the State Library of Victoria were parts of a single institution, and the Library also benefited from Felton's Bequest. I am grateful for assistance from members of its staff, especially Dianne Reilly (La Trobe Librarian), Jock Murphy (Manuscripts Librarian) and Des Cowley (Manager, Rare Printed Collections). Other repositories of material related to Felton and his bequests which have provided ready assistance include the ANZ Executors and Trustee Company (especially Teresa Zolnierkiewicz, Peter Bearsley and Hugh Hodges); the University of Melbourne Archives (especially Frank Strahan, Dr Cecily Close, Dr Mark Richmond and Michael Piggott); the National Library of Australia (especially Graeme Powell); and the Ian Potter Museum of Art, the University of Melbourne (especially Belinda Nemec).

Most of the illustrations of works of art in this volume have been generously provided by the National Gallery of Victoria. The La Trobe Library was the main source of the black and white illustrations, and I am especially grateful to Madeleine Say (Manager), Olga Tsara and Fiona Jeffery of the Picture Collection for their help. Other illustrations were provided by the Ian Potter Museum of

Art, University of Melbourne, the University of Melbourne Archives, the Museum of Victoria, the ANZ Trustees, Trinity College, The National Trust of Australia (Victoria), The Old Colonists' Homes, Young and Jackson's Hotel, Philip Bacon, Tom Hazell, Jane Poynter and John Monahan. I am grateful for the assistance of Rhoda Lord and of Pamela Luhrs, Curator, Foster's Group.

My thanks are due to Andrew Watson and the Board and staff of Melbourne University Publishing, to the designer, Lauren Statham, and especially to my self-effacing editor, to whom I also offer an apology: each of my last three books has been longer than the one before. I am naturally pleased that this book has been accepted into the Miegunyah series, in which *Russell Grimwade* was the first, in 1967, and supported by the Miegunyah Fund.

I am grateful for the academic hospitality the Australian Centre in the University of Melbourne has given me over nine years of retirement.

If this book had a dedication, I would like it to be to my grandfather, Robert Poynter (1833–1905), born two years after Felton and a few miles from his birthplace, who briefly worked alongside him behind the counter of Hickinbotham's Emporium in Bourke Street in the 1850s; and to my father Robert Samuel Poynter (1875–1948), a country client of Felton Grimwade's all his working life, who lived just long enough to read Russell Grimwade's *Flinders Lane*, and to assure a sceptical eighteen-year-old History student that Alfred Felton was a subject worth writing about. As usual, it was many years before I realised he was right.

ABBREVIATIONS

IN THE TEXT

Conferences	Meetings of the Bequests' Committee and the Purchase Committee, at first informal but later formally minuted
The [Felton] Bequests' Committee	The committee established under Felton's will to authorise expenditure for the purposes specified
The [Felton] Purchase Committee	The Committee established by the Trustees to act with the Felton Bequests' Committee
The [Gallery] Trustees	Before 1944 The Trustees of the Public Library, Museums and National Gallery of Victoria, and after 1944 The Trustees of the National Gallery of Victoria
The NACF	The National Art Collections Fund
The Trustee Company	Before 1983 the Trustees, Executors and Agency Company Limited, and after 1983 the ANZ Executors and Trustee Company Limited

IN THE NOTES

ADB	*Australian Dictionary of Biography*
AF	Alfred Felton
FBC	The Felton Bequests' Committee Minutes
FG&Co	Felton Grimwade and Company

FSG	FS Grimwade
NGV	The National Gallery of Victoria
NLA	The National Library of Australia
SLV	The State Library of Victoria
TWK	TW Kempthorne
UMA	The University of Melbourne Archives
VPD	*Victorian Parliamentary Debates*
WRG	(Wilfrid) Russell Grimwade

Letters of Felton preserved in the two letterbooks in the Felton Bequest Papers (Box 4) in the La Trobe Library, covering the periods June 1875–July 1885 and January 1895–August 1896, are identified not by archival location but only by date. The location of other letters and documents is identified; accession details can be found in the Bibliography.

PART ONE

A MERCHANT OF MELBOURNE

Who can set a limit to a man's powers?
Alfred Felton to FS Grimwade, 15 June 1885

PROLOGUE: EAST ANGLIA

> Far Essex,—fifty miles away
> The level wastes of sucking mud
> Where distant barges high with hay
> Come sailing in upon the flood.
> John Betjeman, *Essex*

FELTON LEFT NO ACCOUNT of his early life, and there are but few traces of him in East Anglia, the region of his birth and upbringing. Some of the records first found there have since proved to be in error, and although the evidence remains meagre, accounts depicting Felton as an impoverished orphan are inaccurate. He died wealthy, but was born neither to riches nor to poverty, as commonly understood.

Alfred Felton was born on 8 November 1831 in the small town of Maldon, where the river Chelmer flows into the broader estuary of the Blackwater River, and the fertile fields of Essex meet the mudflats and marshes which fringe the coasts of East Anglia. The town, built by Saxon invaders on a low rise above an abandoned Roman settlement, was the site of a chronicled battle between Saxons and Vikings in 991, but had a usually peaceful development thereafter as a port trading with London and the Continent. The great Thames sailing barges, bulbous and efficient, moved vast quantities of goods around these coasts, feeding Londoners with corn and their horses with Essex hay. Maldon's long High Street, its neat façades interrupted by the portico of a handsome Moot Hall, retains the signs of the town's eighteenth-century prosperity, though the port had competition after 1796, when 'the Navigation', the great system of canalised rivers which opened the internal trade of Essex to the sea, bypassed Maldon in

favour of the neighbouring village of Heybridge. According to an 1839 directory, Maldon retained a good local trade, especially in corn, and could be commended for oysters 'of superior quality', abundant in the Blackwater River. The town, long a corporate and Parliamentary Borough, had 3831 inhabitants in 1831, when Alfred Felton was born. They were a hard-working lot; Pigot's *Directory* listed no 'Nobility' in Maldon, and far fewer 'Gentry and Clergy' than in Chelmsford, the county town ten miles inland, which was 'distinguished for the number of genteel and opulent residents'. Felton's parents were neither opulent nor especially genteel, but neither were they poor—unless we accept Jeremy Bentham's demanding definitions of 1795, that poverty was the condition of one who had to work for a living, and indigence that of one who could not get a living even by working.[1]

Alfred Felton was baptised on 31 January 1832 by Robert Burls, Minister of the Maldon Independent Chapel, in his handsome and recently enlarged Meeting House at the top of Market Hill, a street winding steeply from the river. Like most of East Anglia, this was Puritan country; Maldon had two established parish churches, at either end of High Street—thirteenth-century All Saints', with its unusual triangular tower, at the top, and at the bottom, by Hythe Quay, St Mary's, its tower surmounted by an octagonal spire as a beacon for mariners—but the Dissenting population was large and very influential. The Reverend Burls' Chapel had been founded in the seventeenth century by Joseph Billio, a divine whose name remains in the language as a synonym for fervent hard work; and Burls himself, Minister at Maldon from 1820 to 1856, retained a congregation of some nine hundred, despite competition from other Dissenting chapels. Discipline was strict: one Mrs Hewitt was 'separated' for improper language and other sins, and Eliza Jones 'prayerfully admonished' for being pregnant upon her marriage, but Burls was also a charitable man, disbursing considerable sums to the poor in the hard times which came with the Peace. Young Alfred would have seen the large Union Workhouse built, across Market Hill, as a bastion against pauperism after the Poor Law was amended in 1834, but the congregation of the Meeting House would have remained on the Independent side of the road.

Mr Burls was conscientious, and when the Act introducing the central registration of births, marriages and deaths in 1837 required that all current parish registers of such events be deposited with the new authority, he complied, and sent them to London. But not before the information was copied—not by

[1] In Bentham's terms only those with independent means (like Bentham himself) escaped being poor or indigent (Poynter, *Society and Pauperism*, p. 119).

Burls—into new volumes, to be kept in the Meeting House. Unfortunately, in the case of the Felton family, the copyist made a mistake, repeated seven times. It was the custom in the Chapel to baptise in batches—Burls christened thirty-one infants in one marathon—and the baptism of two Felton infants together was listed in 1827, another two in 1831, and three more in 1837. (Only Alfred was baptised alone, in 1832; perhaps he was poorly, and thought to be in danger of death.) In every case the parents were listed as Thomas and Hannah Felton; but in the original Register, now in the Public Records Office, the entries signed by Burls himself give the father's name as William Felton, not Thomas.[2]

Error breeds errors. Russell Grimwade, in Britain in 1932 seeking (among other things) information concerning the birth and early life of Alfred Felton, invited the vicar of Maldon (of which parish is unclear) to lunch at the Burlington Hotel, and with his help obtained a photograph of the pages in the Meeting House copy of the Register of Baptisms. The record gave him no reason to doubt that Alfred's father was named Thomas, and he so stated in *Flinders Lane*, printing a photograph of the entry and adding a report that Thomas was a tanner by trade.[3]

A later search of East Anglian records, in 1970, established that one Thomas Felton had a vote in Maldon in 1832, though he appears thereafter in no central or local records other than the Register of Baptisms, and could be presumed dead after the birth of the youngest Felton child. This, with a report (also erroneous) of Hannah Felton's death, seemed to justify the assertions in 1974 that Alfred Felton was 'the fifth among nine children of Hannah and Thomas Felton, a man said to have been a tanner by trade, and poor but not indigent', and that since there was 'no trace of Thomas Felton after 1836', it was 'likely that when Hannah died in 1847 Alfred Felton became, at the age of fifteen, an orphan'.[4]

Likely, it might have seemed, but it was not true. The Reverend Burls had buried Thomas Felton beside the Meeting House, in a brick grave eight feet deep, on 22 April 1833, while William and Hannah lived on, neither indigent nor even poor by local standards, and had more children, including a tenth born in

[2] The full entry reads: 'Felton, Alfred: Alfred Felton, the son of William Felton and of Hannah his wife, of the Parish of St Mary's, Maldon, in the County of Essex, born on the eighth day of November 1831 was baptized on the thirty-first day of January 1832 by me [sgd] Robert Burls' (PRO film RG4/1767 Essex 41).

[3] Grimwade did note—inaccurately—on the back of the photograph that 'in the Congregational Church the original records are not kept carefully but transcribed into a register in alphabetical order'.

[4] Poynter, *Alfred Felton*, p. 1. 'Poor but not indigent' was based on the absence of Thomas' name from the lists of Freemen and of paupers. By coincidence one Hannah Bell, Hannah Felton's maiden name, also lived in Maldon, dying in 1851.

1838.[5] By trade a currier—one who dresses and colours leather after it is tanned—and later described as a leather factor, William was no doubt associated with the tannery which had long stood among the thriving businesses by the river. He had been born in 1800 at Sheerness, Kent, his wife Hannah Bell in 1797 in Spitalfields, Middlesex, and there is no record of their presence in Maldon before his listing among *Curriers and Leather Cutters* in Pigot's *Directory of Essex* for 1823-24. Thomas Felton might have been a relative; the couple, having named their first son William, called their second Thomas (perhaps prompting the copyist's error). In the 1830s the family lived in the High Street, at the lower end; William owned the house, paying Church Rates of 6 shillings (on a valuation of £8) in 1835, qualifying among the Freemen and Electors in Maldon in 1836 and 1837 as a freeholder, while owning also a cottage in Kelvedere Road. He was literate; in April 1836 he attended a Vestry meeting and wrote his name with fluent penmanship, one of three lay persons signing as 'inhabitants'.[6]

In later life Alfred Felton also wrote fluently, and pungently, and had academic and intellectual friends. He no doubt received some years of formal education, in one of Maldon's three schools: a Grammar School, founded in the seventeenth century on the site of St Peter's (a third parish church, closed when its tower collapsed), and two new schools, a National School and a rival British School, both products of the movement for popular education which emerged from the great charitable debates of the 1790s.[7]

National Schools were the creation of Andrew Bell, advocate from 1797 of educational principles developed in an Orphan Asylum in Madras, which he applied after 1811 as Superintendent of the National Society for Promoting the Education of the Poor in the Principles of the Established Church. British Schools were 'Lancasterian', established by Nonconformists according to the

[5] *Register of Interments in the Ground belonging to the Maldon Meeting House*, held in the Plume Library. Burial in a brick grave was expensive, costing £2 2s to the Trustees, 10s to the Minister, and 5s to the Sexton; for an earth grave the Sexton received 4s 6d, the Trustees 4s and the Minister 5s.

Two of William and Hannah's children, William, the oldest, born in 1825, and Edmund, the youngest, born in 1838, do not appear in the Meeting House Register, which records the births of Thomas Felton (26 August 1826), James (8 October 1827), Mary Ann (22 November 1828), Eliza (5 May 1830), Alfred (8 November 1831), Ellen (10 June 1833), Arthur (18 March 1834) and George (8 October 1836). The entries were listed alphabetically until 1837, continuing chronologically thereafter. The volumes are now in the Plume Library in Maldon.

The history of the Meeting House (now the United Reformed Church) is told by Earnshaw in *The Church on Market Hill*, 'published to mark the 300th anniversary of Dissenting worship in Maldon Essex'.

[6] I am indebted for this information to the late Patsy Hardy, who searched Essex records in 1970, and to a descendant of William Felton, Mr Keith Edkins, of Cambridge, who has gathered much family material on his website, http://www.gwydir.denon.co.uk.

[7] Poynter, *Society and Pauperism*, pp. 95, 195–9.

precepts of Joseph Lancaster, a Quaker who had published his *Improvements in Education* in 1803, after establishing a free school for a thousand poor boys at the turn of the century. Both systems were 'monitorial', based on the economical assumption that the older children, as monitors under adult supervision, could teach the younger children. Maldon's British School was built in the grounds of the Meeting House, and it was presumably in its simple brick classroom that Alfred and his siblings both learned and taught (under the discipline, according to Pigot's 1839 *Directory*, of 'Poole, Master—Poole, Mistress'). One of the young Feltons, Eliza, became a teacher herself; Alfred learned, at the least, to learn for himself, becoming in later life the classic Victorian autodidact, product and advocate of intellectual self help, the enlightened doctrine of the age. 'Who can put a limit', he later wrote, 'to the development of a man's powers?'[8]

The notoriously imperfect Census of 1841 listed, as resident in High Street, Maldon, William Felton, Currier, aged 41, his wife Hannah (42) and their sons Thomas (14, described as 'Assistant'), James (13), Alfred (10), and Arthur (7). Neither George (5), nor the infant Edmund (3) was listed, and the census taker ignored the daughters. The eldest son, William, then 16, was no doubt away, learning his trade.[9] We know little of the family's life later in the 1840s, except that William senior acquired more property, including a new residence among the comfortable houses in Wantz Road, Maldon. In the 1851 Census he was listed as a 'Proprietor of Houses', apparently having escaped from Bentham's definition of poverty into independent means. Not so his children; living with William and Hannah in Wantz Road, and working for their living, were daughters Eliza (20, a teacher), and Ellen (17, a dressmaker) and son George (14, a grocer's assistant). Edmund (12) was a 'scholar'. The older sons, William, Thomas and James were not listed, and neither was Mary Ann. Nor was Alfred, who no longer lived in Maldon, but further north, in the handsome old Suffolk town of Woodbridge, a few miles east of Ipswich, on the edge of the country John Constable painted into universal familiarity.

On the river Deben, some miles upstream from its sea-mouth near Felixstowe (then a resort but now dominating the skyline with container cranes), Woodbridge was another Saxon settlement, and its inhabitants still half-remembered that the Wuffing King Rewald was buried across the river, in his great ship laden with golden treasure, though they had forgotten the tomb's location, in the field of

[8] AF to FSG, 15 June 1885.

[9] Grimwade recounts (*Flinders Lane*, p. 10) that he learned the business of a hay and corn merchant in Brighton, but the 1881 Census lists him as a 'Retired Confectioner'.

Sutton Hoo. Medieval Woodbridge had a famous market on St Audrey's Day, unhappily the source of the word 'tawdry'; and also an abbey, replaced after the Reformation with a manor house, built by a prominent Elizabethan lawyer who also provided Woodbridge with a row of almshouses. (Their endowment, the rents of his village of Clerkenwell, became immensely valuable when rebuilt as a London suburb in the nineteenth century.) Like Maldon, the town had been firmly Parliamentarian in the Civil War (and was later, for a time, the resting place of Cromwell's skull). During the Napoleonic wars, barracks for five thousand soldiers were built nearby, and houses in town for the officers; and the Prince Regent would change horses at The Crown Inn on his way to enjoy the hospitality of the Marquess of Hertford at Sudbourne Hall, and more intimate favours from Lady Hertford. Woodbridge had more resident gentry than Maldon, the grounds of their fine houses flanking the meandering Thoroughfare, the main street running parallel with the river; it was also a port, with quays beside a large tide mill, in a stretch of river once notorious for smugglers. Alfred Felton later remarked that Woodbridge was 'dull', though he qualified the statement. Less dour than his birthplace, it also had literary associations: Felton would surely have noticed his eccentric fellow townsman, Edward Fitzgerald, late of Cambridge, contemplating translating the *Rubaiyat of Omar Kayyam*. (Fitzgerald had a boat called *Scandal*, from which he once fell overboard while reading and climbed back on board without losing his place.) We also know, from a later reminiscence, that at Woodbridge—and presumably as a boy at Maldon—Felton himself indulged in the East Anglian habit of scudding about the local rivers in boats, and enjoyed it. Water, like mud, was part of the regional habitat.[10]

What took Felton to Woodbridge? *Flinders Lane* records a report—plausible, in view of his later career as a wholesale druggist—that young Alfred had an uncle who kept a chemist's shop in London and that he himself was apprenticed to a chemist, sleeping under the counter, at Woodbridge.[11] But the Census of 1851 indicates that Felton had learned a different trade; it lists, in the household of Robert Drake Gant, watchmaker of the Thoroughfare, Woodbridge, a wife, two daughters, one servant, and Alfred Felton, assistant, aged nineteen.[12] Robert

[10] AF to FSG 19 May 1884.

[11] 'F[rederick] W[illiam] G[rimwade] says AF apprenticed to chemist at Woodbridge and slept under the counter' (pencil note by WRG, 9 July 1932, University of Melbourne Archives).

[12] Parish of Woodbridge, Ecclesiastical district of St John's, town of Woodbridge: 'No. 11 Thoroughfare St: Robert D Gant—Head—married, 47, Watchmaker, (b. Devon); E Gant—wife—50 (b. Devon, Nth Lawton): E Gant, daughter, 17, (b. Devon, Exeter); MH Gant daughter, 9, (b. Suffolk, Woodbridge): Alfred Felton, Assistant, unmarried, 19 yrs, Watchmaker (b. Essex, Mauldon [*sic*]); residing in home E Price, servant, unmarried, 30 yrs (b. Suffolk,

Gant seems to have arrived in Woodbridge from Devon in 1834 or 1835; it is not known whether he was related to Felton, or indeed whether Felton had served an apprenticeship with him. It seems likely that Felton had been living away from the family home for some years; nothing is known of his dealings with other family members during this time, though a report that he regarded his eldest brother William as his mentor is supported by their warm relationship in the last decades of their lives. Alfred's parents moved away from Maldon in 1852, William senior still qualifying as an elector there with 'houses in succession' in High Street and Wantz Road, but his place of abode was given as Brighton.[13]

Another record of Felton's English years suggests some youthful idealism. The name 'Alfred Felton, jeweller' was listed among delegates to a large 'British Peace Conference' held in Exeter Hall, London, in July 1851. Born on the eve of the Great Reform Act of 1832, Alfred was an adolescent in the years of the People's Charter, a cause widely supported among Dissenters. After the 1848 revolutions in Europe, a succession of 'Peace' Congresses were organised by Elihu Burritt and other zealots for foreign policies based on morality rather than dynastic interest and military power, and when in London in 1851 the radical journalist and lay preacher Henry Vincent moved a motion against intervention in the affairs of post-revolution Hungary and Italy, his auditors were almost entirely Dissenters. 'Peace' was a cause likely to attract a serious young man born a Congregationalist, and Felton's attendance suggests that he had liberal opinions, as well as the skills of an artisan.[14]

In 1853 Felton emigrated. We do not know precisely why, though it was common enough at the time for the younger sons of large families to seek their fortunes in the colonies or the United States, and two of Felton's brothers also emigrated.[15] In 1852 Earl Grey, the Secretary of State for the Colonies, told

Clapton)'. Gant appears in directories for 1844 and 1846 at the same address, but not in 1853; and appears also in the poll book of 1841 (East Division of Suffolk; he voted for the sitting member), but not in the only other poll book of the period (1853). He paid church rates of 8s 8d on £13 in 1837. E[dward] H[all] G[rimwade], asked by WRG if Felton had knowledge of any trade, replied, 'Yes I believe he was a watchmaker'.

[13] In 1859 he was still an elector, but in 1861 'Wm Felton' of Brighton, qualification a house in High Street, was struck off on the overseer's objection.

[14] 'British Peace Conference 1851', Report, bound with of the 'Third General Peace Congress in Frankfort, August 1850' in the British Library (I am indebted to Professor FB Smith for this reference). 'The true policy of the nations', Vincent told the 1849 congress, 'is to mingle their sympathies, to mingle their interests, to mingle their affections, until a fusion shall take place, that shall end in promoting the fusion of all races and all towns'.

[15] James became a leather merchant in Grahamstown, South Africa, and Arthur later joined Alfred in Australia. A report that another brother reached New Zealand has not been substantiated.

Charles Dickens that 'it is not the steady and well conducted that are the most disposed to emigration', though emigrants might have more 'energy and intelligence' than the stay-at-homes; Felton was steady enough, but was not the type to marry and settle down as a tradesman, his obvious prospect in East Anglia.[16] A woman who knew Felton well later in life surmised, intriguingly, that his youthful ambition was to be among 'interesting people', and to have an opportunity 'not to make money but to be able to satisfy his tastes'. Robert Gant seems to have moved away from 'dull' Woodbridge by 1853, perhaps prompting his assistant, who was no doubt happy to escape 'that terrible East Wind, which has gathered so many to their fathers', to leave also.[17] News of the Victorian gold discoveries made that colony a popular destination, and in 1853 Felton set sail for it.

[16] Quoted in Clarke, *The Land of Contrarities*, p. 97.

[17] Alice Creswick's memories of Felton, WRG's notes; AF to FSG 16 June 1884.

1

THE COLONIST

Melbourne in 1853 was a small colonial town in sudden travail to become a city. Founded in 1835, it was four years younger than Felton himself, and its streets covered no layered strata of Roman and Saxon settlement but the engulfed encampments of the Wurundjerri clan of the Woiworung people. In 1803 a government expedition to settle convicts in Port Phillip had failed, and retreated to Van Diemen's Land (renamed Tasmania in 1853), leaving Bass Strait and its northern shore to whalers and sealers; and it was not until 1834–35 that bands of free settlers, drawn by reports of a hinterland especially favourable for sheep, crossed the Strait to Portland and Port Phillip. They had ambitions, but no legal authority, despite John Batman's bizarre treaty purporting to 'buy' land from Aboriginal 'chieftains' with no European concept of ownership let alone its transfer; and the barque which first warped up the Yarra to land men and stock on the site they first called Bearbrass was appropriately named *Enterprize*. 'Overlanders' from New South Wales, following Major Mitchell's trail to 'Australia Felix', soon joined the Vandemonians in 'a gold rush without gold', and the Sydney government was forced to recognise the Port Phillip District, naming the town on the Yarra Melbourne after Britain's Prime Minister. Squatters and their flocks spread rapidly across the plains, renaming every feature of the land and thrusting aside, subduing and in an unknowable number of cases slaughtering an Aboriginal population already reduced by smallpox and other diseases introduced into New South Wales.[1] The new settlements soon suffered

[1] Shaw (*A History of the Port Phillip District*, pp. 18-20) concludes that 'we can only guess how many [Aboriginal people] were occupying the lands of the present state of Victoria' before European settlement, and notes that the early impact of European diseases has been disputed. On one estimate the Aboriginal population of the District fell from 30 000 in 1834 to about 2700 in 1851, with no more than a few hundred remaining in or near Melbourne. He discusses the extent of slaughter in Ch. 7. On the impact of gold discoveries on the Aboriginal population, see Goodman, *Gold Seeking*, pp. 17-20. See also Cannon, *Old Melbourne Town before the Gold Rush*.

Princes Bridge (Albert Charles Cooke, in *The Picturesque Atlas of Australasia*, vol. 1, 1886)

the first of the periodic booms and busts which have characterised Victoria's economic history, but in the 1840s the flocks of the Port Phillip District rose to more than six million, and with them the prosperity of Melbourne, though the District's centre was not yet as dominant over its hinterland as it was to become. The settler population—some 77 000 for Victoria as a whole by 1851—was almost entirely British in origin, but the high proportions of Irish and Scots were reflected in the population's religious affiliations: half Anglican, a quarter Catholic, and most of the rest Presbyterian.[2]

The young and ambitious Hugh Childers, arriving in Melbourne in 1851, was immediately optimistic: 'Here we have a limited population, with immense

[2] *Victorian Yearbook 1984*, p. 6. A general account of the settling of Victoria is given in Broome, *The Victorians: Arriving*.

production ... As you may imagine, there is a great deal of profit to be divided among a very few persons'.[3] By 1851 the town's population, of some 29 000, included a significant group of merchants, and not a few adventurers. An independent lot, the settlers of Port Phillip resented government from Sydney, and most were determined in particular never to accept convict transports to 'Australia Felix'. After some enterprising campaigning—including electing an unknowing Earl Grey as their nominal representative on Sydney's Legislative Council—they won both causes. On 1 July 1851 they celebrated independence as a separate colony of the British Empire, named, with the Queen's permission, after Victoria herself.[4]

Sixteen days later, finds of gold were announced, and before the year was over a large proportion of the crowds cheering 'Separation' had fled from Melbourne to the goldfields, discovered first at Clunes and Warrandyte, and then in rapid and immensely rich succession at Ballarat, Mount Alexander, Sandhurst (later Bendigo) and elsewhere in central Victoria. More than filling the vacuum caused by this stampede came the immigrants: some 570 000 arrived by sea between 1851 and 1861, and although many did not stay permanently the population grew from 77 345 to 540 322 in the decade. In the 1850s, when Victoria produced more than a third of the world's output of gold, Melbourne's population increased fivefold, and the leaders of this vigorous community rebuilt their city, confidently providing it with streets of substantial warehouses and shops and with ambitious public buildings: a university, a public library, a magnificently crafted Parliament House, a new Treasury (with secure gold vaults underground), and (a little later) a Government House which the Queen herself thought improperly grandiose. For a time the Governor of Victoria—for whom the colonists had sought, with characteristic effrontery, the title Governor-General—was paid a salary equal to that of the President of the United States. Melbourne had set out

[3] 'Emigration in fact does not keep pace with the increase of the wool and tallow exported. While the exports of the United Kingdom are about £4 to £5 a head, Port Phillip has an export of £1 200 000 and a population of 60 000. The regular profits on sheep-farming average from twenty to twenty-five per cent and on mercantile business far more' (quoted in Oldham and Stirling, *Victorian: A Visitors Book*, pp. 29-30). On Childers' role in the new colony, including his part in founding the Public Library and the University, see HL Hall's entry in *ADB*, vol. 3.

[4] There had been an earlier celebration, on 11 November 1850, when the news arrived of the passing in August of the Australian Colonies Bill: 'The long oppressed and buffeted Port Phillip is at length an Independent Colony ... endowed with a flourishing revenue and inexhaustible resources ... God bless the Queen!!!' Childers reported that 'Four days were appointed as a holiday, during which the shops were shut, newspapers did not appear, and everybody went mad. Fortunately there was little or no intoxication, but bonfires and fireworks were everywhere, and, as many houses are of wood, there was some danger ... Of course there was a great procession; about fifteen thousand grown-up people are supposed to have been on the ground' (quoted in Oldham and Stirling, *Victorian: A Visitors Book*, pp. 28-9).

Victoria's 'Declaration of Independence', 11 November 1850 (La Trobe Picture Collection, State Library of Victoria)

on a progress which was to make it a city of half a million people before it was sixty years old, the commercial and financial capital of Australia, 'the metropolis of the Southern Hemisphere', and a marvel for that whole British Empire of which it remained self-consciously a part.[5]

All this was well publicised, even in East Anglia: the *Ipswich Journal* reported in 1853 the large number of people emigrating to the Australian colonies and the ships they left in (though once again Felton's name is not to be found). Sources of

[5] The claim to be a metropolis was made in 1883 by REN Twopeny, in *Town Life in Australia*, p. 2, later qualified (p. 73) to read: 'Melbourne is quasi-metropolitan' ('while Sydney and Adelaide are alike provincial'). Asa Briggs included Melbourne in his classic study *Victorian Cities* (1963). On the 1850s generally, see Serle, *The Golden Age*, and Cannon, *Melbourne after the Gold Rush*. Bate, *Victorian Gold Rushes*, gives a succinct analysis of their nature and impact.

information and of graphic representation available to prospective emigrants included the *Illustrated London News*, and journals such as *Murray's Australian Circular: a Monthly Record of Intelligence from the Gold Colonies* (Price 2d), which first appeared in May 1853 with a special number on Melbourne.[6] Its pages were packed with advice and a medley of advertisements: for shipping lines, for Borden's Patent Meat Biscuit, Moore and Buckley's Patent Concentrated Milk ('none should go to sea without it'), Keating's Cough Lozenges, and for waterproof clothes, portable folding baths and much else. Rates of wages and prices of provisions and clothing were published for the several colonies, New Zealand being included among the 'Australian'. 'Hints to Emigrants' told them—'especially those of weak constitutions'—what clothing to take, and what food for the voyage, and warned them not to trust the promises of ships' brokers. The journey was indeed perilous: months of sailing without sight of land, relying on the captain's dead reckoning to find, half the world away, the narrow passage between the rocky shores of Cape Otway and King Island, graveyards of ships and men alike.

In July 1853 *Murray's Australian Circular* carried an advertisement for one of the 'Temperance' Line of Packets:

> For Adelaide, Geelong and Melbourne, with guarantee to land Passengers and Freight, the splendid new Clipper-built Ship *California*, A1, 824 tons register. Lying in the East India Docks. This vessel has a full poop and lofty 'tween decks, and carries an experienced Surgeon. A well selected Library will be put on board for the gratuitous use of the passengers.

This was the ship on which, by all accounts except the passenger list, Felton embarked on 23 July 1853. The list is incomplete, providing names for only twelve of the nineteen cabin passengers, and none for the 104 who sailed steerage; 'I was in the saloon', Felton later told one of Russell Grimwade's informants. He arrived in Melbourne on 1 November; according to the *Argus*, the *California*'s passengers, many no doubt impatient to reach the goldfields, were so pleased with the ship's fast passage of ninety-eight days that they presented her captain with a silver speaking-trumpet.[7]

When Felton arrived, Melbourne was still a city of transients. 'All Persons Emigrating', *Murray's Australian Circular* had warned, 'should be provided with a

[6] See also Dowling, 'Gold in Australia', pp. 24-38. The development of cheap illustrated papers and journals in these years enhanced the attractions of the goldfields.

[7] 'AF said that Henry Francis came out as a steerage passenger on same ship; "I was in the saloon"' (E[dward] H[all] G[rimwade] to WRG, 11 November 1932). *Argus*, 9 November 1853, quoted in notes prepared for Russell Grimwade by Arnold Johnson. The *Argus* described the *California* as the first Dutch iron-built ship to visit Australia. Other sources give the sailing date as 1 August.

Canvas Town, South Melbourne (A Sutherland, *Victoria and its Metropolis*, vol. I, 1888)

PORTABLE HOUSE, as it is well known that on their arrival in the colonies, scarcely any accommodation for shelter can be obtained, and that enormous charges are made for the most indifferent and comfortless lodging'. Most brought tents instead; and one correspondent reported that the corporation of Melbourne had 'set aside an unhealthy piece of ground ... close to a swamp', charging 5 shillings a week ground rent for an immigrant's tent. 'Within the last few months this chapel of ease, or as it is now called "Canvas Town" has grown quite a large place, with an increasing population of 5,000 or 6,000 inhabitants.'[8]

[8] *Murray's Australian Circular*, p. 26.

THE GOLD RUSHES OF THE nineteenth century were extraordinary episodes. The big Californian rush of 1849 had been followed by discoveries near Bathurst in New South Wales; the Victorian rushes were on a larger scale, and differed also in the unusual amount of alluvial gold spread over large areas, especially around Castlemaine and Bendigo, with Mount Alexander probably the biggest alluvial goldfield in history. Until this surface gold was exhausted, and deeper pits and more complex machinery were needed to reach the deep leads below, Victoria offered extraordinary opportunities to the individual able-bodied digger with a mate or two, picks, shovels and a washing pan or primitive 'cradle'. The process was inherently egalitarian, requiring luck and labour but little capital.[9]

The nature of the Victorian goldfields also stimulated the extraordinary influx of immigrants which made each field 'a mosaic of nationalities', as an estimated 250 000 arrived from other Australian colonies and New Zealand, 300 000 from the United Kingdom, some 45 000 from foreign ports and an uncounted number from China.[10] Those who stayed at home, in Melbourne and elsewhere in Victoria, feared for the preservation of established moral and political order as men quit their normal occupations to seek a precious metal, which might be easily dug—by some—but could be as readily stolen. 'At the time of the gold discoveries', a historian of St Kilda wrote, 'convicts, ticket-of-leave men, bond-breakers, and others of the convict classes' swarmed into Victoria, 'in pirated boats' or 'on stolen horses', their descent on the Port Phillip District likened to 'a horde of hungry rats stealing by night into a barge filled with a cargo of rich cheeses'.[11] 'The moral condition of the colony is still sufficiently gloomy', a correspondent in *Murray's Australian Circular* reported in 1853, 'the principal crime is robbery, generally with violence . . . [though] the diggers are almost of necessity a peaceably disposed body, if they are not provoked to violence'. Correspondence home from the diggings told of tedium and discomfort more often than of criminal or riotous behaviour. Those accustomed to middle-class comforts and upper-class privileges had the unusual experience of roughing it, and of democratic equality. 'You live in tents, or huts, made by yourself, you have no rent to pay', a young digger on the Forest Creek field wrote; 'being your own servant you have no wages to pay, and washing your own shirt you have no washing-bill to pay'. A digger's life was very virtuous, he assured his father: 'there being no theatres, public houses, concerts, or gambling houses, concerts, or any public entertainment, he has no chance of

[9] 'This gold rush was therefore like no other, before or since' (Bate, 'Gold: Social Energiser and Definer', p. 7).

[10] Bate, *Victorian Gold Rushes*, pp. 27–8.

[11] Cooper, *The History of St Kilda*, vol. I, p. 45.

spending money in such places, save he be a frequenter of the "sly grog shop", which of course no respectable man is'. (Instead he spent his evenings killing fleas, 'a great source of annoyance'.)[12]

Not everyone went to the diggings to dig. Another young man told *Murray's Australian Circular* that he had found a job in the 'detective police force' in plain clothes, with the Gold Commissioner at Fryer's Creek, and many went to trade. In the long run men built surer fortunes meeting the newcomers' needs for goods and services of all kinds, for mutton to boil, houses to live in, and banks for their wealth; Victoria in these decades proved the place and time to make a fortune, and the ordinary courses of trade and commerce were more likely to provide it than was a hole in the ground, or even acres of grassland. Moreover Melbourne's merchants were well placed to meet the needs of the other colonies, for capital and goods: its port was the main destination for shipping from Britain—in 1853 it received an astonishing 15 per cent of Britain's exports—and they had ready access by sea to Sydney, New Zealand, and Adelaide, and (later) inland to western New South Wales, and north into Queensland.

That Victoria was a good place to lose a fortune was also propounded, especially by those who, richer or poorer, returned to Britain. Henry Moor, three times Mayor of Melbourne, took his fortune 'home' in 1854, warning that Victoria would 'always be liable to heavy fluctuations', and 'no one, however clever and reflecting he may be, can ever safely calculate from one year to another'. Hugh Childers was another who went back, but in his view, 'any poor man who is industrious, tolerably sober, and sharp must get on here. So will a man of capital who will exercise caution and keep above a certain class of speculation, so will a thorough man of business, or a man of strong activity or intelligence. Almost all the men who have made money ... are either shrewd active young fellows who came out with a very little; or else men of considerable capital combined with intelligence; nothing else will do here'.[13] Alfred Felton was certainly shrewd, active and young; he did reach the diggings, but he went there to trade rather than to dig. He must have had some capital: the poor did not travel in the Saloon, and according to one of his later partners he brought with him 'enough money to buy a team of horses with which he carted goods to the gold-

[12] *Murray's Australian Circular*, p. 27.

[13] Melbourne merchants suffered recurrent gluts in imported consumer goods, one as early as 1854 (Bate, *Victorian Gold Rushes*, p. 15). Moor is quoted in de Serville, *Pounds and Pedigrees*, p. 235, Childers in Oldham and Stirling, *Victorian: A Visitors Book*, p. 31.

fields and thereby made much more'.[14] We do not know which fields he visited, though Mount Alexander, Sandhurst and Castlemaine (where his brother later died) were probably among them; and also Maldon, the town (on the rich Tarrangower field) so named in 1854 because a young member of the survey team was corresponding with a girl in Felton's birthplace.[15] Felton later had business interests in Kyneton, the town supplying these fields, and in Sandhurst, but none (that are known) in Ballarat.

Felton arrived when life on the goldfields was well established, but troubled with discontents, provoked by too rigid an enforcement of the licensing system successfully improvised at Ophir in 1849. For particular reasons Ballarat was the most disturbed, culminating in the building of the stockade at Eureka and its storming by troopers on the orders of a government fearful of losing control. 'There has been a sad to do at the Ballarat diggins', a newly arrived immigrant noted in December 1854, 'between the diggers and the soldiers, with a great many killed on both sides. All is now quiet'.[16]

Quiet it remained, to a surprising degree. That the violence of Eureka was an aberration, on both sides, was confirmed when juries acquitted all the rebels of treason. Their leader, Peter Lalor, was elected in 1856 to the new Legislative Assembly, established after Britain granted Victoria self-government in 1855; it was soon to be the most democratic house of parliament in the Empire, though fettered to a conservative upper house dominated by landed interests, prompting recurrent constitutional crises in the following decades.[17] Eureka did dampen the radical fire of Edward Wilson, refounder of the *Argus* in 1848 and editorial thorn in the Government's side ever since, allowing the *Age* and the Syme family to

[14] Note by WRG 1932 of conversation with Edward Norton Grimwade; and E[dward] H[all] G[rimwade] to WRG, 11 November 1932: 'I always understood that AF for some time travelled the gold mines with a waggon selling to the miners and introduced Felton's Chlorodyne which had a regular sale when I was in Melbourne and I think this was how he made enough money to take over Youngman's business with FSG. I cannot vouch for the truth of this but I recollect FSG[rimwade] telling me something about it in one of the many talks I used to have with him in the evenings at Harleston'.

[15] Williams, *A Concise History of Maldon*, p. 3. Maldon produced more than 2 million ounces of gold before the mines failed in the 1920s.

[16] Diary of Robert Poynter, MS in author's possession. 'Diggins' was a common colloquial usage. On Eureka, see especially Serle, *The Golden Age*; Blainey, *The Rush that never Ended*, ch. 4 (a notable revision of previously accepted views); and Bate, *Lucky City*, ch. 4 and *Victorian Gold Rushes*, pp. 41–6.

[17] On the old and new constitutions, see Wright, *A Blended House*. By 1859 the Assembly had manhood suffrage, the secret ballot, no property qualification for members and triennial elections; the Legislative Council, with a high property qualification and power to reject legislation, was soon seen as the squatters' bastion against change, though it could not prevent the introduction of payment of members—the first such provision in the world—in 1873.

come through on the left. The two papers dominated the Victorian press for many decades; Felton, though often scornful of both, was to be influenced by Edward Wilson, at least in matters of charity.[18]

The brilliant Archibald Michie, one of the barristers who defended the Eureka rebels and was for many years the Victorian correspondent for the London *Times*, later reflected on the sources of Victoria's democratic temper:

> All men—gentle or simple, educated or ignorant—came to work at something or other ... Until the better classes began to emigrate, to work with the hands was thought degrading to a gentleman. The revolution set in when gentlemen began to dress sheep for scab. The revolution surely is complete when a French marquis is driving a dray in Collingwood, the son of an English peer is in the police, and ex-Fellows of colleges are in the deep-sinkings of Ballarat.[19]

As Geoffrey Serle observed, the extraordinary political and commercial history of Victoria in the nineteenth century, while fuelled by gold, owed much to the fact that so many of its people were neither assisted immigrants nor former convicts, but free settlers—like Alfred Felton—who had the means to pay their way to the colony and the determination to prosper there. As the never tactful Richard Twopeny put it: 'the first population of Sydney was of the wrong sort, while that which flooded Melbourne from 1851 to 1861 was eminently adventurous and enterprising'.[20] Nevertheless Victoria's 'democratic temper' should not be exaggerated. Its society retained class divisions less rigid only in degree than those of Britain, and although touted as 'a workingman's paradise', only the successful entrepreneurs and the skilled workers—and, of course, the lucky digger while the alluvial gold lasted—demonstrably improved their lot by emigrating. The largest of Melbourne's early buildings was its Benevolent Asylum, built on Hotham Hill in 1850 to house the settlers whose fortunes had failed. The building was opened with a very grand ball celebrating Separation; after the rich departed, the indigent moved in.[21]

We do not know where Felton was during the troubled days of Eureka, or where his political sympathies lay; the fuss could scarcely have improved his already critical view of governments. We do know that he did not remain long on the goldfields, and soon ceased to be an entirely itinerant trader. Another East

[18] On the remarkable Wilson, radical and (eventually) rich, see Geoffrey Serle's entry in *ADB*, vol. 6.

[19] Sir Archibald Michie, Readings in Melbourne, pp. 3–4 (quoted in Serle, *The Golden Age*, p. 375.)

[20] Twopeny, *Town Life in Australia*, p. 3. For Serle's conclusions concerning the legacies of the 1850s, see *The Golden Age*, pp. 369–81. How many ex-convicts entered Victoria from other colonies cannot, however, be determined.

[21] Kehoe, *The Melbourne Benevolent Asylum*, describes the institution, p. 10. On contradictions between the changing reputation of the Australian colonies and the reality, see White, *Inventing Australia*, especially chs 2 and 3.

Anglian, William Hickinbotham, had a furnishing and drapery 'emporium' at the corner of Swanston and Bourke streets; there, Hickinbotham's nephew Robert Poynter later recalled, Alfred Felton 'rented a portion of the drapery counter for his stock of watches, knives and sundries for the diggers'.[22] In 1857 the first contemporary record of Felton's existence in Australia appeared in Sands & Kenny's *Melbourne Directory,* where he was listed as a 'commission agent and dealer in general merchandise' at 5 Collins Street West, north side; he must have been there in 1856, when the entries were compiled. (Until 1888, when they were renumbered from Spring Street in the east, Melbourne's east–west streets were designated East or West and given numbers beginning at Elizabeth Street, then a natural boundary, with a creek running down it. 5 Collins Street West was thus a few doors from Elizabeth Street, towards Queen Street.) The 1858 *Directory* described Felton as a 'wholesale dealer in fancy goods'; a year later he had set up, across Elizabeth Street, at 4 Little Collins Street East, as an 'importer'; 'and dealer' was added in 1860. By 1861 Felton had at last entered the trade which was to remain his principal concern, being listed as a 'wholesale druggist' at 41A Swanston Street. Whether trained for the business or not, he is reputed to have been successful from the beginning, making 'a fine income' from the sale of (among other things) Chlorodyne and Felton's Quinine Champagne.[23] He had joined Melbourne's remarkably enterprising band of merchants, who were to be his companions, and sometimes his competitors, for the rest of his life.

FELTON'S PRIVATE LIFE after his return to Melbourne from the diggings was that of the stock Victorian figure, the bachelor in a boarding house. An 1859 *Directory* gives his residential address as Gertrude Street, Collingwood, but thereafter the boarding houses seem to have been almost always in or near St Kilda, originally 'a pretty little straggling village' on the Bay, 'with an unpretending inn or two and a number of equally unpretending cottages ... accessible by devious tracks which had been formed through the dense and all-prevailing ti-tree scrub'.[24] Sea breezes and the absence of Melbourne's notorious dust made it 'a place of

[22] RS Poynter, 'The Poynter Family', p. 2 (typescript in the author's possession). Robert Poynter, RS Poynter's father, born a few miles from Maldon in 1833, arrived in Melbourne with his parents in 1854, and went to work in his uncle William Hickinbotham's business.

[23] *Flinders Lane*, p. 35. There were 'Commercial Chambers' at 41 Swanston Street, with some eighteen tenants listed.

[24] *Our First Fifty Years*, pp. 54–5. Mrs Childers, settled there in 1851, described to her mother the difficulties of travel to and from St Kilda: 'I think you would have been amused to see the fashion in which we went out to dinner yesterday evening: part of the way in an omnibus, then half a mile to walk, and for our return we considered ourselves very fortunate in finding a good-natured neighbour, who took me in his gig, Hugh and himself walking and driving by turns, as we dared not go beyond a foot's pace on account of the stumps. Was it not decidedly Australian?' (Oldham and Stirling, *Victorian: A Visitors Book*, p. 29).

residence favoured by the professional and mercantile classes of the city', and by 1853 it was both seaside resort and suburb. The first stone bridge linking the five-kilometre St Kilda Road to Melbourne was built just before Felton's arrival, though bushrangers—all assumed by virtuous Victorians to be former convicts from Van Diemen's land—could still waylay travellers near St Kilda in 1852 and escape unscathed.[25] Soon a toll-road and a railway, and later a cable tram, gave rapid access between the city and the bayside suburb, and by the 1880s mansions built along St Kilda Road made it a grand boulevard indeed. St Kilda still contained (Victoria's chronicler noted) 'many stately houses encircled with ample pleasure grounds', but terraces had replaced the 'spacious gardens' of others, as large hotels had supplanted the earlier simple hostelries; 'the salubrity of the air' had also 'promoted the establishment of private schools of a superior character'. Felton was more succinct: 'There is a look of prosperity about the neighbourhood', he remarked in 1884.[26]

In 1863 Felton was living on the Esplanade at St Kilda, in a boarding house kept by a Mrs O'Reilly—'a good kind-hearted and common Irish widow'—when he was joined there by a new lodger, Frederick Sheppard Grimwade, who was to become his chief business associate. Grimwade was the son of Edward Grimwade, Manager of Grimwade, Ridley and Company, prosperous wholesale druggists, of Ipswich and London. One of the firm's apprentices, a 'bright little man' called Edward Youngman, had emigrated with his brother Henry to Sydney in 1841, setting up as Youngman & Co, wholesale druggists. In 1855 they established a Melbourne branch, with premises at 125 William Street and in Flinders Lane; and when Edward Youngman visited England in 1862 he invited Edward Grimwade to send one of his sons to manage the Melbourne business. Frederick Sheppard, the second son, newly come of age, accepted the invitation, and was appointed 'to superintend our drug business in Melbourne' on a salary of £300, 'to be hereafter increased in proportion to your talent and industry'.[27] On 29 November his father sent him off from Plymouth in the *Lincolnshire,* one of 'the sturdy old Money Wigram ships that did the voyage around the Cape in seventy-two days', his parting gift a copy of a small book published by the Religious Tract Society,

[25] The incident, sketched the next day by William Strutt, was reconstructed in his painting exhibited in London in 1887, and later purchased by Russell Grimwade and bequeathed to the University of Melbourne. The 'St Kilda Road' referred to was not the road between St Kilda and Melbourne but that between St Kilda and 'Little Brighton', later Elsternwick.

[26] AF to FSG, 14 July 1884.

[27] Quoted in John FT Grimwade, *A Short History of Drug Houses of Australia Ltd to 1968*, p. 21. The Youngmans had already sold their Sydney business to Elliott Brothers, long the dominant firm in New South Wales and Queensland.

CHV Bogatzky's *A Golden Treasury For the Children of God, Whose Treasure is in Heaven: Consisting of Devotional and Practical Observations on Select Passages Of Scripture for Every Day of the Year*, 'with the best wishes and earnest prayers of a Loving Father, that the truth herein may ever be found a Treasury of "Life unto Life" in the land of his adoption'. Already inscribed in its margins were some family birthdays and anniversaries, a practice the son and his descendants have continued ever since (though leaving no evidence that they read the uplifting material thus so thickly annotated). Beside the meditation on 'Godly Sorrow' for 10 February, Frederick Sheppard cheerfully recorded his arrival in Melbourne in 1863, and three days later (under an especially pious verse) 'came to live at Mrs O'Reillys'. He was already at work in the offices of Youngman and Co.

Family tradition suggests that it was mere coincidence that brought Grimwade and Felton together at Mrs O'Reilly's; if so, it repeated a coincidence of twelve years earlier, when among Felton's fellow delegates from East Anglia at the British Peace Conference had been the pious Dissenter Edward Grimwade, Frederick Sheppard's father.[28]

Felton, then thirty-one, was nine years older than the newcomer, and of humbler social origin; other emigrants were driven, but Grimwade had been invited. The two men nevertheless had much in common. Both were East Anglians, both had arrived (by different routes) in the same profession, and both were by instinct businessmen of enterprise and acumen, though wary of merely speculative ventures. Theirs was never a demonstrative friendship—for forty years they addressed each other as 'Felton' and 'Grimwade' with the formality then customary—but there is no record of serious disagreement between them at any time, and each seems to have taken for granted an absolute trust in the ability and probity of the other.

[28] *Bogatzky*, and *Flinders Lane*, pp. 33–4. Bogatzky (20 August) records that Edward Grimwade had attended a Peace Conference in Paris in August 1849. *Felton Grimwade & Co. Forty Years' Retrospect* states (p. 1) that Grimwade arrived in February 1863 and that he and Felton became 'intimate' friends in June; four months delay in becoming friends while living in the same boarding house suggests a reserve unusual even in Englishmen. One passage in a later letter by Felton implies that Grimwade 'visited' him in 1863, as if they were not then living in the same house. Directories, often incomplete and always out of date, list Felton living in Carpenter Street, Brighton, in 1863, list no residential address for 1864, and from 1865 until 1871 list the Esplanade, St Kilda; perhaps he moved there after his brother's death in 1865. (Another *Directory* for 1868 has him at 'Beach House, St Kilda', probably the same address.) A 'Mrs O'Reilly, Esplanade, St Kilda' is listed in the 1860 *Directory*, and again in 1866 on 'Esplanade and Beach', between Victoria Street and Rose Street. It seems reasonable to assume that Felton lived at Mrs O'Reilly's from 1863 until 1871, when he moved to Westbourne Terrace, in Grey Street, St Kilda. In *Flinders Lane* (p. 33) Russell tells of FS Grimwade pointing to a site in Fitzroy Street as that of Mrs O'Reilly's boarding house, but it seems certain that Mrs O'Reilly's was on the Esplanade, and that Felton and Grimwade were there together from some date in 1863 until Grimwade left in 1865.

TWO YEARS AFTER Grimwade's arrival Felton suffered a family tragedy, the only event in his life at this time of which we have details. His younger brother Arthur had followed him to Australia, though why and when is not known; he might have worked with Alfred, though his name does not appear in any directory. Certainly by 1865 he was employed as a commercial traveller by William Watson and Son, warehousemen of Little Collins Street East; they were general importers, and although Arthur was described in the press as 'a chemist and druggist', the wares he hawked around the colony seem not to have been pharmaceutical. On Saturday 6 May he was in Castlemaine, staying at the Imperial Hotel, where he was well known; feeling unwell, he bought some medicine at French's drug store, and more the next day. On Sunday evening he asked the publican to give him a vapour bath, and while being rubbed dry asked for the medicine from his coat pocket. He was given by mistake a glass of liquid ammonia, which he drank. 'Mr Felton's agony was, of course, excruciating', the *Castlemaine Daily News* reported, 'and the fright of the person who had administered the ammonia, proportionate'. The chemist was called, and then a doctor, and another in the middle of the night, since a tracheotomy might be necessary; but by the time Alfred Felton arrived on the morning train, with yet another doctor, recovery seemed certain. Alfred returned to Melbourne next morning 'to send up an old servant so that his brother might receive every attention'; but Tuesday brought 'delirium, not wholly attributable to the dose of ammonia', and in the evening Arthur died.[29]

The inquest next day unfolded a sorry story. Arthur, like others of his profession, had taken to alcohol to soften the discomforts of the commercial traveller's life in country hotels. He had been drinking up to three bottles of pale brandy a day, though several witnesses described him as 'a man on whom drink did not show', one even asserting he was not intemperate 'but only drank for company's sake'. The chemist told the coroner that on Saturday night, after returning from a trip to Maldon, Arthur complained of feeling 'very queer', and admitted he had been drinking. He was given a purgative; next morning he appeared again, feeling 'very nervous' as well as queer, and was given bicarbonate of soda and gentian. That evening he felt better but still nervous, and prescribed for himself a draught of henbane; the chemist gave him also a small unlabelled bottle of ammonia, to clean his soiled trousers, warning him to be careful not to confuse the bottles. Dougall, the publican, gave evidence that when Arthur instructed him 'Jim, put your hand into my pocket and take out the bottle', he found only one bottle

[29] *Castlemaine Daily News*, 9, 10 and 11 May 1865.

there, unlabelled. The doctor who performed the autopsy found indications of delirium tremens; his colleague agreed, and the jury accordingly found death due to 'delirium tremens, accelerated by taking liquid ammonia', adding a rider that 'all bottles of medicine should be distinctly labelled'. That alcohol was not the only health hazard for commercial travellers was revealed when the chemist testified that Arthur had also asked for a solution of bicarbonate of mercury to treat an infestation of crabs.[30]

Arthur's remains were placed in the first lead coffin made in Castlemaine, but he was not buried there. John Sleight, Undertaker, of Collins Street East, announced in the *Argus* of 12 May 1865, that 'Friends of the late Mr Arthur Felton are invited to follow his remains to the Melbourne General Cemetery. Funeral to leave Spencer Street terminus on the arrival of the Sandhurst train at half-past ten o'clock, this day . . .' His brother Alfred erected a handsome memorial over his grave, 'in affectionate remembrance of Arthur Felton, who died May 9 1865 aged 30 years'. (Since Arthur was born on 18 March 1834, and was therefore thirty-one, it seems that Alfred had his birth dates muddled.) Russell Grimwade noted blandly in *Flinders Lane* merely that Arthur's untimely end was caused by 'the tragic carelessness of taking the wrong medicine'.[31]

There were, of course, failed black sheep in many a successful colonist's family. Felton's future friend Alexander Leeper first came to Australia in search of an errant elder brother, who died of apoplexy while being extradited from Sydney to Melbourne to face a charge of bigamy; and even the very respectable FS Grimwade soon acquired a skeleton for the family closet. He had taken a liking to the colony, and also to a colonial girl, Jessie Taylor Sprunt, whom he married two months after Arthur Felton's death. Her father, John Sprunt, had arrived in Hobart from Scotland in 1824 as a free settler, but her mother—it has only recently emerged—was the daughter of an entirely involuntary emigrant, one Edward French, a sheep farmer transported with his brother in 1812 for stealing two sheep from a neighbour. Edward French was given a ticket-of-leave in Hobart in 1819, and later a conditional pardon; he remained in Van Diemen's Land and prospered in a carting business in Launceston. He also married a local girl, a former maid at Government House, and had five more children, matters which raised some delicate issues in 1831, when the wife and daughter he had left behind in Cornwall nearly twenty years before arrived in Launceston. A year later the newly-arrived daughter, Grace French, married John Sprunt, and their

[30] *Castlemaine Daily News*, 12 May 1865; *Bendigo Evening News*, 12 May 1865.

[31] *Flinders Lane*, p. 10.

Arthur Felton's grave, Melbourne General Cemetery: Italian headstone imported by Alfred Felton; gentlemen unidentified (photograph by JW Lindt, ANZ Trustees)

daughter Jessie was born in Launceston in 1842. John Sprunt died, Grace remarried, and her new husband took the family across Bass Strait to Portland and later to Kyneton. There Jessie Sprunt grew up, and taught in a school before she and Frederick Grimwade were married in the local Anglican church on 29 July 1865. Grandfather Edward French was not present; he had met his nemesis in 1835, unexpectedly crushed while sleeping under a cart he had overloaded with

stones. The family embarrassment could thus be put aside; convict ancestry, a badge of honourable antiquity worn with pride in the twenty-first century, was a 'stain' to be concealed in the nineteenth, successfully in the case of the able and respected Mrs FS Grimwade, who became a formidable figure in Victorian society. Felton was a good friend—Jessie Grimwade was the only adult he was known to call by her Christian name—and if he knew the secret of her grandfather he would never divulge it.[32]

Even the virtuous and successful remained prone to the perils of the sea. In 1866, Edward Youngman, returning from another visit to England, was drowned with 277 others when the steamer *London* was wrecked in a gale in the Bay of Biscay. His brother, heart-broken, had no further interest in the business. Alfred Felton put up £12 000—a handsome sum for a thirty-six-year old to have accumulated—while FS Grimwade borrowed £8000 from his father in Ipswich, and together they made Youngman an offer. On 1 July 1867 the new firm of Felton Grimwade and Company took over Youngman's business. The first of their joint enterprises had begun.

[32] Sir Andrew Grimwade, 'The Story of Edward French 1786–1835'. FS Grimwade later donated a stained-glass window to the church, in memory of the headmistress of the school. Jessie Sprunt's mother, Grace French Sprunt Robinson, lived until 1883, and her stepfather William Robinson until 1886. Jessie's background was unknown to present members of the Grimwade family until recently; if Russell Grimwade uncovered any of it during his researches, he left no record, citing only the details of her birth and marriage, his source presumably *Bogatzky*.

2

COLONIAL PARTNERSHIPS

Pharmacy, in the nineteenth century, was an ancient craft newly emerged as a profession, and its Bible, *The British Pharmacopoeia,* included many a remedy hallowed by traditional practice rather than science. The individual retail chemist still produced pills, powders and mixtures, from natural substances by relatively simple processes, and promoted his own brands and labels as well as a few proprietary lines. In country communities in colonial Victoria he was also often called on for dental, veterinary and medical work. A wholesale druggist supplied the outback pharmacist not only with raw materials and prepared medicines, but with a wide range of business and professional advice, and also, as like as not, a substantial loan to start his business. Banker as well as supplier, the wholesaler had a peculiar responsibility, the retail chemist an unusual dependence.

Felton and Grimwade were very enterprising partners. Within a year they had built new premises, described as 'the handsomest drug house in Australia', at 34 Flinders Lane West, one of the narrow streets originally intended to serve the rear entrances of houses on Melbourne's broad thoroughfares; instead each teemed with business, in Flinders Lane merchants' warehouses, utilitarian strongholds blocking the light.[1] Built for them by Henry ('Money') Miller, and described as 'the handsomest drug house in Australia', the building had four storeys, and frontages on both 'the Lane' and Bond Steet; wrought iron girders

[1] In 1886 they were compared to 'the severely simple and solid palaces' of old and noble families, to be met with in many cities of central Italy. 'In massiveness and magnitude they bear a striking resemblance to the dwelling-places of the turbulent patricians of the middle ages . . .' (Garran (ed.), *Picturesque Atlas,* vol. 1, p. 215). Later the rag trade dominated Flinders Lane, and more recently, at the upper end, commercial art galleries. Other specialised concentrations developing in early Melbourne's narrower streets included Chinatown in Little Bourke Street and the brothels of 'Little Lon'.

gave a clear span to one whole floor, and innovations included a new-fangled hydraulic lift, an 'American hoist' and speaking tubes between the office and the various departments.[2] Felton and Grimwade also built a factory in Flinders Street, at first producing only popular proprietary lines such as Kruse's Insecticide and Kruse's Magnesia—their originator, John Kruse, was engaged to manufacture them—but soon extending production in whatever directions demand and the means permitted.

Although there were other wholesale druggists in Melbourne in 1867, most of the competitors were driven out of business within a decade, a phenomenon Grimwade explained by the fact that he himself was the only man in the trade with a proper training for it. Felton noted more wryly that it was 'difficult to limit trade to put aside competition'; they had bought out one rival 'at a fearful cost only to make room for a severer competitor'.[3] By 1878 the growth of the firm justified commissioning the leading architects Reed and Barnes to build—again in Flinders Lane, between Queen and Elizabeth streets—a new and larger warehouse, with on the ground floor a special 'vault', with walls two feet thick, and a ceiling of concrete six feet thick, for storing dangerous substances; and a new factory in Spencer and Jeffcott streets. Both buildings were further enlarged in the 1880s. The factory grew to cover an acre by the end of the century.

Trade in the new colony was not always easy. The Hobson's Bay Railway, the first in Australia, linked Melbourne and Sandridge (Port Melbourne) in 1854, and by the 1860s the Government had built lines—all the broad 'Irish' gauge, deemed too expensive by the other colonies—to Williamstown and Sunbury, to Ballarat (via Geelong) and to Bendigo; a line to Echuca in 1864 made Melbourne the seaport for the fast-growing riverboat trade along the Murray and the Darling, and Echuca itself Victoria's second busiest port.[4] But customers away from rail or river could order only by slow mail, and expect delivery by carrier 'when the

[2] The architect was George Wharton. On Miller, see entry by Suzanne G Mellor in *ADB*, vol. 5, and Ursula Hoff, 'The Everard Studley Miller Bequest', pp. 150–5. His political career had just concluded in defeat; for the rest of his life he concentrated on making money, in which he was famously adept.

[3] AF to TWK 14 April 1885. Felton was referring to the acquisition in 1877-8 of the wholesale druggist business of Edmund (and Michael) Keogh in La Trobe St, and the almost immediate appearance of Rocke, Tompsitt & Co, a smaller but aggressive competitor. The acquisition of Keogh's was indeed expensive: the accounts show that £24 942 of Felton Grimwade's profit of £33 630 in 1876-9 went to pay for Keogh's, and the rest into a suspense account; neither Felton nor Grimwade received any dividend over those three years. Other early wholesale druggists are referred to in *Felton Grimwade & Co. Forty Years' Retrospect*, p. 12.

[4] Weston Bate ('Gold: Social Energiser and Definer', p. 9) described Echuca during the gold rushes, when it was the point of transit for food from New South Wales to the diggings, as 'the oesophagus of Victoria'. For a time New South Wales judges going on circuit to western areas of the state would come by sea to Melbourne, rail to Echuca, and thence by river to their destinations.

roads were good'. Travellers were unknown in the trade until the partners imported 'an experienced man', though Grimwade would occasionally visit Bendigo and Ballarat to take orders for as long as three months ahead. Difficulties of supply and delivery sometimes gave opportunities for monopoly profits which a later chronicler of Felton Grimwade's described as 'making the mouth water'; in 1873 the firm succeeded in buying up all available supplies of mercury, then much used by the mining industry, and raising the price to give a profit of 2s 6d, a pound, 'which, seeing that each bottle contained almost 75 pounds, was something handsome'. But the firm sometimes tolerated a loss to provide new services which customers sought, producing (for example) the sedative chloral hydrate at a loss when a Melbourne hospital had urgent need of it. Special premises were hired in South Yarra to produce sulphide of arsenic, sought by the holder of a patent for using it to remove wool from sheepskins; this also proved unprofitable. Most Victorians sought only a steady supply of popular medicines, such as Holloway's Pills, Steedman's Powders, Cockle's Pills and Chlorodyne. The colonists would have found life harsh indeed without the £30 000 worth of Pain Killer sold them each year.[5] When the firm produced the first whole-sale price list in the Australian drug trade in 1882, its ninety pages included the stocks of a new dental department, as well as that array of familiar medicaments which reconciled Victorian colonists to their adopted country.

Although Australia seemed to its recent settlers to be the only continent with little of its own to contribute to the medicine chest of the world, the partners succeeded in developing a small export trade to Europe and the United States. Grimwade visited Echuca in 1870, and signed a contract to purchase a million leeches at 10 shillings a thousand; 'these were caught by the aborigines, who waded into swamps and allowed the leeches to fasten to them'. The crop was sent to the firm's specially-constructed leech aquarium in South Melbourne, and thence by passenger ship to Britain, France and the United States, to be sold at 20 shillings to 30 shillings a thousand. There were occasional complaints that leeches escaped to attack passengers in their bunks at night, but it was a decline in profit which led to the abandonment of the trade after a few years.[6]

The partners' enterprise was otherwise well rewarded. Youngman's business proved a bargain, for within three years they had recouped, in salary, profit and interest, more than the purchase price. Profit in the first year was nearly £6000;

[5] When *Podophyllum* was first imported it fetched four guineas an ounce, though 'the retailer grumbled when he paid it'. Pain Killer must have been about the largest sale, 'probably about £30,000 worth being imported every year' (*Felton Grimwade & Co. Forty Years' Retrospect*, pp. 12–13).

[6] *Felton Grimwade & Co. Forty Years' Retrospect*, p. 13.

in the tenth year nearly £14 000. Felton held a three-fifths share of the partnership until 1871, when the two men became equal partners. They were the only members of the firm until 1881, when Edward Bage, who had entered their employ as a boy and had shown outstanding ability, was admitted to a share; unfortunately his health failed in 1886, and he died prematurely in 1891. Thereafter the only new partners admitted were three of Grimwade's four sons, Norton joining the firm in 1887, Harold in 1893 and Russell in 1907, three years after Felton's death.[7]

Why form a partnership, and not a company? The Australasian colonies had adopted, with little modification, the English Limited Liability Act of 1862, but few registrations were made under it. Most businesses were too small, but incorporation was foreign to the business culture even of the larger. Adam Smith had thought limited liability suitable only for companies involved in banking, insurance, canal development and waterworks; the nineteenth century added railways, mining, gasworks and road construction, but in the colonies most such enterprises relied on public funds, and only mining companies sought registration. Limited liability was as yet ill regulated, and business morality still dictated that undertakings outside Smith's list be conducted as partnerships, constrained by the penalties of bankruptcy and commercial discredit—drastic sanctions indeed in an isolated business community—which 'hung over the heads of anyone who strayed from the norms of behaviour in their financial dealings with others'.[8] When these conventions loosened in the 1880s, the outcome was dire indeed.

In the daily conduct of business Felton and Grimwade were, again, shrewd but upright adherents to the manners of their age, standards which were demanding but not over-scrupulous.[9] Competition could be sharp, but collusion to protect a market from interlopers was acceptable, and indeed admired. As employers, Felton and Grimwade were generally considerate towards their staff, but did not hesitate to judge, rebuke and instruct them; writing to London in 1885 in search

[7] The 1877 and 1878 Directories included J Longstaff, formerly of Keogh's, as a member of Felton Grimwade's, but he seems not to have been a partner, and disappears in 1879. Bage had a tenth share in the partnership, with Felton and Grimwade sharing the remainder equally, between 1881 and 1889, when Norton replaced Bage, with a one-twentieth share. In 1893 Harold was admitted to a one-twentieth share, and Norton's increased to one-tenth. In 1897 Harold and Norton Grimwade were given a one-sixth share each, their father and Felton retaining one-third each.

[8] As Rob McQueen has observed, the community thus depended on 'self regulation through the device of unlimited liability and the threat of commercial disgrace' ('Limited Liability Company Legislation', p. 63).

[9] It is a pity that Anthony Trollope's biting dissection of London's business morals in *The Way We Live Now* (1875) was not replicated for Melbourne in his two novels with Australian settings, *Harry Heathcote of Gangoil* (1874) and *John Caldicote* (1879), Trollope was in Australia in 1871–72 and again in 1875, visiting his son, a squatter in western New South Wales until drought forced him off the land and into the Public Service.

of a new laboratory manager, they offered £5 per week but stipulated that 'if he gets drunk he will be dismissed'. On another occasion they apologised to competitor Rocke Tompsitt's for having given an unblemished reference a man they later found guilty of 'several acts of such abominable carelessness on his part as to amount almost to culpable indifference to our interests'.[10] They also felt obliged to provide pensions for employees they deemed loyal, and their widows, and although Grimwade was later to support in Parliament the introduction of the Old Age Pension, both partners were apt to think government intervention in management matters an affront. Trade unionism, and especially the strikes of the 1890s, seemed to men of their class and generation to threaten the collapse of the moral and social order.

The expansion of Felton Grimwade's was largely financed from within, in a manner also then customary, apart from an occasional mortgage on one property or another and the acceptance of sums on deposit from friends or associates. The partners habitually left much of the profits uncollected, paying themselves interest as a charge on the business and sometimes also depositing further sums. Among the several varieties of capitalist then existing they were of the creative, not the speculative, kind; profit was capital to be employed in further enterprise, not siphoned off into personal indulgence. Private wealth could be enjoyed, as the fruit of hard work and good fortune, but idleness had no attraction, and it is difficult to conceive that either partner would simply give up work, take the money and run.

WHILE FELTON AND GRIMWADE were building up their business in Victoria they were also forming links with other colonies. They had no ambition to establish their firm in every capital city; in 1890, when dispatching a traveller to the northern colonies, they specifically warned him that 'we do not wish, in any way, to interfere with the wholesale druggists in N.S.W. or Queensland, and you will offer our Pills and Specialties through them'. In particular, Felton Grimwade's in Melbourne, the long-established Elliott Bros in Sydney and Bickford and Sons in Adelaide usually respected each other's territorial interests.[11]

New Zealand, then firmly within Melbourne's sphere of economic influence, was another matter. After the Otago gold rushes of the 1860s, Felton and Grimwade rapidly developed a considerable trade across the Tasman, working in co-operation with TW Kempthorne and Evan Prosser, 'wholesale druggists, importers and general merchants' of Dunedin and Auckland; Kempthorne they

[10] FG&Co to Rocke Tompsitt, April 1890.

[11] John Grimwade, *A Short History of Drug Houses of Australia Ltd to 1968*, gives a short account of the principal firms in each of the Australian colonies.

knew from his earlier days as a druggist in Melbourne. In 1876, when Felton Grimwade's began to set up a branch of their own firm in Wellington, Kempthorne and Prosser proposed instead a partnership to amalgamate their interests. A new firm was established with a capital of £40 000; Felton and Grimwade provided one half, but were specifically exempted from devoting any time to the business.[12] They allowed their investment to grow by leaving dividends on deposit, and kept themselves very well informed of progress across the Tasman, visiting New Zealand occasionally. Both corresponded regularly with Kempthorne, the active director, on both personal and business matters; Prosser left to establish a business in Queensland, later moving to Sydney.

By the end of the 1870s Melbourne's financial and commercial dominance of the Australasian colonies was a commonplace. 'It is Melbourne money chiefly that opens up new tracts of land for settlement in the interior of the continent, and Melbourne brains that find the outlets for fresh commerce in every direction', wrote Twopeny in 1883.

> Is there a company to be got up to stock the wilds of Western Australia, or to form a railway on the land-grant system in Queensland, to introduce the electric light, or to spread education amongst the black fellows, the promoters either belong to Melbourne, or go there for their capital. The headquarters of nearly all the large commercial institutions which extend their operations beyond the limits of any one colony are to be found there.[13]

Within the busy Melbourne community Felton and Grimwade were drawn into a number of new activities. Financially conservative, despite their enterprise, they avoided diversifying too far the activities of their original firm, preferring to form a network of new partnerships in one likely venture or another.

One of their earliest collaborations was with Joseph Bosisto, the able and public-spirited founder of the eucalyptus oil industry (and, coincidentally, one-time researcher into the Australian leech). Bosisto had arrived in Adelaide in 1848, aged twenty-one, to set up a branch of the British pharmaceutical firm FH Faulding; he moved to Victoria in 1851, opened a pharmacy in Richmond, and built a laboratory in which he investigated the chemical properties of Australian plants. Europeans had been aware of the 'gum' tree since the seventeenth century; Bosisto was encouraged to study the medicinal properties of the strongly perfumed

[12] The firm was later incorporated as the New Zealand Drug Company, the two Australian partners receiving £25 000 in shares.

[13] Twopeny, *Town Life in Australia*, p. 2. 'The actual production does not take place in Victoria, but it is in Melbourne that the money resulting from the productions of other colonies as well as Victoria is turned over'.

oil in eucalyptus leaves by his friend Ferdinand von Mueller, the Victorian government botanist, the man who played the largest individual part in the extraordinary migration of the genus around the world. The trees themselves were thought therapeutic, and were cultivated in Italy and Spain to eliminate from the atmosphere 'the noxious exhalations of the soil'; 'fever trees' were even thought capable of banishing malaria from the Campagna. Europe accepted the oil as a new medicament, perhaps on the principle that anything with so pungent a smell must be good for you, and *'l'eucalyptus étonnant'* even entered avant-garde literature in an early poem by Arthur Rimbaud.[14]

Bosisto began distillation on a commercial scale at Emerald, refining and bottling the oil at his Richmond laboratory, and producing such novelties as 'asthma cigarettes', made of eucalyptus globules, and 'Syrup of Red Gum', said to be very soothing to the bowels. Early sales were slow, but demand grew sufficiently for Bosisto to begin exports to England in 1865, Felton Grimwade's becoming the chief distributors. Eucalyptus oil became the only distinctively Australian substance in the *British Pharmacopoeia*, and Felton and Grimwade, impressed by the possibilities of the trade, in 1880 joined Bosisto and three others in forming the Eucalyptus Mallee Company, setting up a new distillery on Antwerp Station in the Wimmera. The area was remote, but the distillery produced some 8600 pounds of oil by the middle of 1883. Sales were brisk, thanks to what was for the time lively promotion: elaborate new labels—an Emu Brand for the Mallee product and the (still-surviving) Parrot Brand for the original Emerald oil—and a thousand circulars, distributed throughout the colonies and in Europe, attesting the powerful properties of the eucalypt for 'Arts, Manufactures, Medicine and Sanitary Purposes'. Although European producers proliferated as eucalypt plantations flourished, in 1884 Grimwade, Ridley and Company disposed of two-thirds of the Mallee production in London, and the company made a modest profit of £324 on an investment of £4500.[15]

IN THEIR INVOLVEMENT with Bosisto, Felton and Grimwade began as merchants and became manufacturers, a progress common in Victoria as it moved to become, by 1891, the most industrialised of the Australian colonies. Melbourne merchants found it profitable to invest in local manufacturing, shielded

[14] The poem, *'Ce qu'on dit au poète à propos des fleurs'*, written in 1871 when Rimbaud was sixteen, is quoted in Stirling, *Joseph Bosisto*, pp. 16–17. Like Bosisto, Ferdinand Mueller had earlier worked with a pharmaceutical firm in Adelaide. Zacharin, *Emigrant Eucalypts*, tells the story of the spread of the genus, and of the oil, overseas. On Bosisto, see also [Russell Grimwade?], *The Story of J. Bosisto & Co. Pty. Ltd.*; Feehan, 'Joseph Bosisto'; and James Griffin's entry in *ADB*, vol. 3.

[15] Russell Grimwade described a visit to the Antwerp plant in the 1890s in *Flinders Lane*, ch. 11.

(frequently but not always) by protective duties. Felton and Grimwade, being from the beginning manufacturers as well as importers, had interests on both sides of the free-trade debate, hotly argued as Victoria's expanding web of protective tariffs came to require customs inspections at border posts on the roads and railways from Sydney and Adelaide, as well as on the wharves. In 1881 Grimwade was appointed a member of a Royal Commission on the Tariff, which spent two years in a careful survey of trade and industry and presented a moderate report, recommending the abolition of a few former duties, the introduction of some new ones and amendments to others. The one outspoken protectionist on the Commission refused to sign the report; Grimwade, though stating that 'he did not think that any protective policy is a saving to the colony', did not withhold his signature.[16]

High freight-rates and long delays in delivery made local manufacture of some goods profitable, with or without protection. The production of sulphuric acid—proclaimed in mid-century (by Benjamin Disraeli, among others) to be a primary indicator of a country's industrial development—became an urgent necessity in Victoria, because imported mineral acids were carried only as deck cargo, and thrown overboard at the first sign of bad weather. That is the reason, according to *Felton Grimwade & Co. Forty Years' Retrospect,* why the partners established an acid works at Port Melbourne in 1872, but the truth seems more complex, involving new relationships with two Scotsmen which were to be important to both partners, but especially to Felton.

There was already a local acid works, across the river in Yarraville, owned by one Robert Smith and managed by George Smith (not a relative), an Aberdonian who had come to Melbourne in 1862 with his brother-in-law James Cuming. Born a farm boy in Banffshire and trained as a farrier in Aberdeen, Cuming was a man of extraordinary physical and mental strength, who with great effort set up in Melbourne a good farrier's business, the service station of the horse-drawn era. While his brother-in-law learned the acid-making trade, so did he: 'I spent my evenings at the public library [just as its founder intended] reading up till I got the end of the ropes and a fair idea of process, all of which led to the conclusion that there was money in the business, if properly managed'.[17] He ran his forge instead, until the aged proprietor of the acid works married for the third time; when the new wife moved to have her brother become manager, George Smith resigned, and with Cuming set about starting an acid

[16] The report is in *Victorian Parliamentary Papers,* Second Series, 1883, 4. Bosisto was one of six parliamentarians on the Commission.

[17] On James Cuming senior, see John Lack's entry on James junior in *ADB,* vol. 8; and Lack, *A History of Footscray.*

Felton Grimwade and Co's Stores, Flinders Lane and Bond Street, 1868 (G Wharton, architect, WH Harrison, engraver, *Illustrated Australian News*, 20 June 1868, La Trobe Picture Collection, State Library of Victoria)

works of their own. The aged proprietor, facing competition, sold them his, for £4000; Cuming had only £700 saved, so he approached another Aberdonian friend, Charles Campbell, who put up the rest and became senior partner in the new firm of Cuming, Smith and Company.[18]

[18] The £3300 represented his own share of £1600, all £1200 of Smith's share, and £500 towards Cuming's £1200 (Lack, Introduction to James Cuming's *Autobiography*, p. 14).

Aberdeen was a long way from East Anglia, in more than miles. When Campbell was born there, in January 1840, its elders were still quarrying its granitic heart to build a modern city, grey and clean (and clean-smelling too, except near the market where trawlers unloaded mountains of herring to be kippered for the breakfasts of the nation). Duncan Campbell was a cattle driver, probably not long arrived from the Highlands when his baby Charles was baptised in Aberdeen's Gaelic-speaking church.[19] In 1858, aged eighteen, Charles quit Scotland for Victoria, and after a short time on the goldfields settled in Woodend, as forwarding agent for a firm of carriers during construction of the Mount Alexander railway. He then moved to New Zealand, again working as a carrier before becoming a very successful flour miller. Returning to Melbourne late in the 1860s, he formed the firm of Mixner and Campbell, in the lime business, and joined the community of Melbourne merchants. He was, as Cuming wrote later, 'a first class man of business', as he demonstrated when Felton Grimwade and Co ceased to be customers for acid and became competitors, later in 1872. They were moved to do so, Cuming later alleged, by that troublesome third wife:

> When we started everything looked bright. The affair was small for a business of that kind, but the plant was of the best, and although output was not great it was growing, and the prices were good. But the late owner, though he could not start himself, as we had bought his good-will, goaded by his young wife, who was determined to find employment for her brother, persuaded a large chemist and druggist firm, our best customers, to start opposition, which they did. This cut things pretty fine, but Campbell saved the situation. He was a first-class diplomat. He pointed out to these people that there was no sense in murdering the business. Sulphuric acid is not a product that can be forced upon the market by the mere cutting of price, so we came to a gentlemanly understanding which lasted twenty years and the trade was satisfactory to both . . . we kept the price of acid just under what it could be imported for, which left us a good profit.[20]

IT SEEMS UNLIKELY that Felton and Grimwade would start a new venture without stronger motives of their own, but they certainly accepted that co-operation was better than competition. They did not follow Cuming Smith's into the fertiliser

[19] Charles, son of Duncan Campbell of Printfield and Catherine McLean, was baptised in the Spring Garden Church, in the Parish of Old Machar, on 29 February 1840.

[20] Cuming, *An Autobiography*, pp. 79–80. In the Catalogue of the 1875 Intercolonial Exhibition Felton Grimwade & Co advertised four strengths of sulphuric acid, two each of hydrochloric and nitric acids, and also nitros, sulphuros, sulphate soda, sulphate iron, soda ash, nitrate soda, nitre cake and potashes.

The New Premises of Messrs Felton Grimwade and Co, 1878 (Reed & Barnes, architects, Samuel Calvert, engraver, *Illustrated Australian News*, 13 May 1878, La Trobe Picture Collection, State Library of Victoria)

business—entered in 1875, when an adjoining bone mill was acquired and rebuilt—but in 1881, when Kempthorne Prosser moved to establish an acid works in New Zealand, Felton Grimwade's brokered a licensing agreement, under which Cuming Smith's provided technical assistance and the services as manager of George Smith, who then left the Melbourne business. In 1882 Felton and Grimwade joined Campbell and Cuming in forming the Adelaide Chemical Works Company, producing acid and fertiliser, with Campbell as chairman and with Cuming's second son Robert Burns Cuming as manager.[21] By now their

[21] Campbell put up a third of the capital of the Adelaide Works Company, Felton, Grimwade, James Cuming senior and Robert Burns Cuming a sixth share each.

interlocking businesses had effectively established a cartel in the acid trade, excepting Sydney.

James Cuming remained a leader of the Footscray community (while sending his sons to Melbourne Grammar School), but Campbell and his wife Mary brought up four sons and six daughters in 'Wollahra', a mansion in Albert Street, East Melbourne (later a boarding house for the Presbyterian Ladies College). Campbell became involved—as his obituary put it in 1905—in many 'mercantile firms and financial institutions in the city', several of them in association with Felton, or Grimwade, or both.

As the joint ventures of Felton and Grimwade grew, and their interests diversified far beyond their original trade as wholesale druggists, the division of labour in the partnerships increased. Grimwade took charge of acid production, and Felton took primary responsibility for another field of manufacture Felton and Grimwade entered in 1872. Their business as druggists was inconvenienced by the high price and uncertain supply of bottles—glass being a fragile and expensive cargo—so the two men formed yet another partnership, the Melbourne Glass Bottle Works Company, investing in land, buildings and plant at Emerald Hill (South Melbourne), on the shores of a lagoon which at that time stretched inland from the bay.

Mechanisation came late to bottle-making, and the first methods of production at Emerald Hill differed little from those practised in ancient Alexandria. The workers would be roused from their homes at whatever time of day or night the 'metal' was hot. The 'gatherer' in each 'shop' took a warmed blow-pipe from the furnace, collected sufficient hot glass on its end, turning the pipe continually to keep it under control. The 'blower' then took the pipe, and having made the suspended glass the approximate shape of a bottle by rolling it on an iron or sandstone marver, placed it in the mould. The bottle then went to the 'maker', sitting in his two-armed chair by the furnace, for the ring to be formed with hand tools and fresh metal. The boy called the 'taker-in' then took the bottle to be annealed, and inspected by a sorter. It was hard and hot work, and fists were the usual means of settling disputes in the industry. The partners were necessarily dependent on the abilities of the managers they appointed, though Felton made himself fully conversant with the trade.[22]

[22] The managers were LL Mount, a Canadian engineer (whose other claim to distinction was the introduction of lacrosse to Victoria), who remained manager until 1898; William McNeilage, former glass blower, manager until 1922; and W. J. ('Gunboat') Smith, who after 1922 dominated the firm, the industry, and much else in Australia. Felton and his partner chose Mount and McNeilage; Smith he knew, if at all, only as an apprentice of 1897 whom the company sued when he broke his indenture and ran away to Sydney. McNeilage later had the sense to employ Smith again in a more responsible job.

The history of the glass bottle industry in Australia is strewn with the wrecks of foundered enterprises. The Melbourne Glass Bottle Works Company was to have an illustrious future, but its infancy was sickly. When, in 1875, James Service, the Colony's Treasurer (and a fellow merchant) set out to rationalise tariffs, and a deputation of bottle importers and soda-water manufacturers sought an end to protection for local bottle-making, Felton wrote the Company's counter-submission: 'I wish to inform you that the company have now <u>4000 gross of good serviceable bottles</u> packed and ready', and could turn out more than enough to cover the imports of earlier years. Success in manufacturing had been achieved 'only by persistent efforts and a great sacrifice of Capital', involving 'the weeding out of much worthless labor'. Skilled workmen had been imported, but 'were found to be mutinous and intemperate to a fearful degree. In consequence only one third of the proper quantity of Bottles was made for the supply of the first season and those of extremely bad workmanship'. Dealers 'took the alarm' and imported bottles, and a glut followed. 'The conduct of the workmen imported at such heavy cost first defrauded the Company of the just quota of labor and secondly spoiled the market.' Nevertheless, despite 'great cost to the Proprietors', the industry was 'securely established'.[23]

Five days later, realising that his conclusion played into the hands of free-traders who would concede protection only to 'infant' industries, Felton wrote again to Service, claiming that the 'manufacture' was established, but not yet the 'industry'. The Company had wasted £12 000 on the works already, and had not yet benefited from the 20 per cent duty because of poor labour, oversupply of imports and the 'prejudice that has always to be lived down against Colonial-made articles'. The duty, he wrote 'unhesitatingly', was 'a <u>necessity to the existence</u> of the Glass Bottle Works'.

> When prejudice has been removed and the supply brought evenly to meet the demand, and that demand a much larger one, and labour trained in the Colony to be had freely at rates that compare with other occupations, then I think that the Glass Bottle Works can stand alone without a single prop, but not till then.[24]

The Government fell, and the Bottle Works struggled on. In 1876 it was reported that 'partially through the aid of the local police magistrate' the unruly glassblowers had become 'amenable to control'; indeed 'a more orderly set of workmen could scarcely be found'.[25] Nevertheless, and despite protection, Felton and

[23] 'The supply . . . is equal to the present demand and can be raised' (AF to Service, 24 June 1875). 'The education of a number of youths in various departments of the art' had been necessary.

[24] AF to Service, 29 June 1875.

[25] *Illustrated Australian News*, 12 June 1876.

The Melbourne Glass Bottle Works Company, The Beach, Emerald Hill, 1876, soda water bottles in production: 'The amount turned out on melting days should gladden the heart of the staunchest Good Templar' (*Illustrated Australian News*, 12 June 1876, La Trobe Picture Collection, State Library of Victoria)

Grimwade were forced to write down their investment to less than £1000 each in 1882, though they retained sufficient faith in the venture to plan a major expansion, buying a new site and sending Mount, the manager, to England to choose and purchase new plant and to recruit more skilled labour. Felton, a music-lover, perhaps devised the elaborate code Mount used for telegraphic correspondence: some thirty-six words ranging from *Violin* ('have adopted the Siemens system. Construct house as per plan Violin. Estimate can start making

bottles by 1st September') to *Discord* ('Doubt ability to ship men to reach Melbourne before 20th October'). The partners were to report on the rate of bottle orders by wiring *presto, allegro, andante* or *largo*. Unfortunately the tempo of putting the new plant into effective operation proved no more than *moderato*.

Felton was the leading partner in the last and least successful of the major ventures he shared with Grimwade, the Australian Salt Manufacturing Company, founded with fair hopes of profit in 1882. Richard Cheetham had come to Victoria from England in 1861. Interested in the extraction of salt from the sea, he set up in the 1870s a small salt works on French Island in Western Port, in salt marshes not unlike those of distant Maldon. In 1882 Felton, Grimwade and other Melbourne businessmen were persuaded to become partners in a new Company, buying Cheetham's works for £3000, half being paid in cash and the other half representing his capital in the firm.[26] A call of £100 was immediately made for expansion of the plant, but a frustrating alternation of hope and disappointment followed. In 1883 fire and a gale severely damaged the large timber evaporator. Cheetham returned from an inspection of European salt works a few months later full of enthusiasm for a new plant relying on solar evaporation only, and considerable sums were invested by the partners. An estimate prepared in 1884 was optimistic, but the venture had as yet no savour of success.

ALFRED FELTON CONDUCTED all these business affairs from his office in the bluestone warehouse of Felton Grimwade and Company in Flinders Lane. In 1889 Grimwade described the contents of the building in detail: in the Cellar, bulk stocks of Sulphate of Iron, Chloride of Ammonia, Mineral Waters, sea salt, Carbolic Acid, Alum, Lime Juice, Whiting, Epsom Salts, Caustic Soda, Arsenic, Manganese and other substances; on the ground floor, the offices, and behind them 'case goods', mainly Patent Medicines, Infant Foods, and the firm's own proprietary articles; on the first floor, show rooms, displaying 'surgical instruments, Brushware, Patent Medicines, Perfumery, Show Bottles, Shop Jars, etc'; on the second floor, the Sponge Room, Assay and Chemical Apparatus, and a large packing room; three-fourths of the third floor held 'open drug stock' the remainder cases of 'Essential Oils, Confectionery etc.'; the top floor was the bulk stock room, with empty glass bottles packed in casks, cut cork in bales, and medicinal roots and herbs, also in bales. Below there was the fireproof store 'erected at great cost', for 'dangerous articles such as Acids, Ethers, Chloroforms, Naphtha,

[26] The other partners were the firms Hughes & Harvey and Shaw & Co (metal-merchants; their warehouse still stands in Franklin Street).

Bisulphide of Carbon etc.'; Melbourne had as yet no regulations for the storing of such substances.[27]

That description was prepared for the firm's fire insurers. Some years later Russell Grimwade recalled the handsome bluestone warehouse in more human terms. Beyond the partners' rooms and general office, where clerks on hard stools wrote copperplate at high desks—and no female 'typewriter' was seen until 1901—stocks of imported patent medicines stood beside bulk stores of herbs and chemicals, jars of Rochelle salts, bales of Spanish liquorice, sacks of English chalk, and bins of Turkish sponges, still gritty with Levantine sand. The smell, in recollection, was a compound of iodine, vanilla, ether, alcohol, benzoin and a score of other ingredients; the atmosphere one of busy and successful enterprise. There is every indication that Alfred Felton found life congenial in the orderly clutter of Flinders Lane.

[27] FG&Co to Messrs Berthau and Inglis, 31 July 1889.

3

FRIENDS AND CAUSES

Despite the closeness of their friendship, and of their business association, the lives of Alfred Felton and FS Grimwade were otherwise very different. Grimwade pursued a public career, and founded a dynasty—three of his four sons carried on the businesses he and Felton created—and in 1875 he built 'Harleston', a mansion at Caulfield. In 1895 he also acquired 'Coolart', a handsome property on Westernport; its amenities included a race-horse training track, though he claimed never to have bet on a horse in his life.[1]

Felton took pleasure in the family life of others, though he never married. A photograph of 1867 shows him as a handsome man, dark and bearded, with lively intelligent eyes and a smartly striped tie; but in all his life only one rumour—and that no more than office gossip, passed on second-hand, which is why Russell Grimwade did not repeat it—associated him in any sexual or romantic relationship. It is possible that in youth he was 'a broth of a boy'—a phrase he himself later applied to a philandering chemist—but it seems most unlikely. The Victorians were as adept at concealing irregular sexual liaisons as they were at punishing breaches of discretion, but echoes can often be found in the record, and their absence in Felton's case suggests that a later observation, that he admired women, but without passion, may have been as true of his youth as of his age. Russell Grimwade asked his informants directly whether they had ever heard of any relationship between Felton and a woman; the response was negative, apart from the office rumour and a speculation that he had once been jilted. Felton's friendships with men—with one in particular—were close, but seem to have been

[1] In 1866, the year after his marriage, Grimwade was listed as living at 63 Fitzroy Street, St Kilda, and from 1867 in Westbury Street, before moving by 1873 to 'Ardleigh', a large house in Chapel Street, St Kilda, and in 1875 to 'Harleston'. On FS Grimwade's public career see Poynter, *Russell Grimwade*, pp. 41–5.

convivial rather than passionate. Nevertheless Grimwade's staid conclusion, that 'Mr Felton's regard for his fellow men and women was entirely intellectual and mental … physical charm evoked in him mental and aesthetic approbation untinged by carnal colourings', depicts too cold a fish: the only woman whose opinion Grimwade sought had 'never heard of any relationship with any woman. He didn't care for them, but his kindness flowed over to them'. Despite current assumptions to the contrary, some people find celibacy congenial.[2]

Felton's homes were usually more modest than Grimwade's, though he did once buy, renovate and briefly occupy one of St Kilda's notable houses. For the rest he moved, quite frequently, between boarding houses or rented terraces, directories listing some eight addresses for him from 1859—the first two in Collingwood and Brighton, the rest in St Kilda—until 1891, when he settled for the last twelve years of his life in rooms in the Esplanade Hotel, still standing, sadly changed, on the St Kilda foreshore.[3] In earlier years he usually had one or more friends living with him, and some of his house companions were notable men. When, in 1874, Judge Brice Bunny's beautiful German wife took their young children—including eight-year-old Rupert, not yet an artist—on a long trip to Europe, the judge lived with Felton, in Westbourne Terrace, St Kilda, for two and a half years, cementing a friendship which might have gone back to the goldfields. Bunny has been described as a well-read linguist, a music lover, and a 'torrential' talker.[4] Also living there at the time was Professor Herbert Augustus Strong, since 1872 Professor of Classical and Comparative Philology and Logic at the University of Melbourne. Strong married in 1875, and set up house elsewhere. How far he and Felton had tastes in common is uncertain; in 1879

[2] 'No woman's name has ever been coupled with his other than in terms of sexless companionship, intellectual regard, or protection against the hardships of life' (Grimwade, *Flinders Lane*, p. 90); and compare 'Some memories of Alfred Felton': 'He remained a bachelor all his life and his name was never associated in fact or rumour with that of any woman. He displayed a chivalry and gallantry towards all women that was typical of the Nineteenth Century'. In response to Russell's question, Sheppard Grimwade replied that 'While he was always nice to women I don't think he had any feelings towards them', and Edward Hall Grimwade, who had known Felton since 1880, 'No, but I think he liked women's society'. The note, probably from EH Grimwade, reported the rumour that Felton was the father of one of the young men employed at Flinders Lane; the only source given was a man who 'liked a bit of scandal', and the author suggested that Grimwade discount the story unless his brothers provided corroboration. Grimwade also ignored the speculation that Felton had once been jilted. Alice Creswick, the woman consulted, knew Felton well and was very perceptive in her comments.

[3] Directories give his early addresses as: 1859: Gertrude St, Collingwood; 1863: Carpenter St, Brighton; 1865: Esplanade, St Kilda; 1867: Beach House, St Kilda (Sands and McDougall; the Official PO Directory still gives the Esplanade, which continues as Felton's address in 1869–71); 1872–76: Westbourne Terrace , St Kilda; 1877–79: 7 Dalgety St, St Kilda, where Felton remained until 1885.

[4] Judith A Samuel, in *ADB*, vol. 3; Hilda Mackinnon (née Bunny), 'Before the Nineties: Pt 2: A Trip to Europe Under Sail', *Table Talk*, 1 March 1934, p. 6; and Kane, Rupert Bunny's Symbolist Decade, p. 57. Mrs Bunny was overseas between April 1874 and October 1876.

Alfred Felton and FS Grimwade, 1867 (from *Forty Years Retrospect*, 1907)

Alexander Leeper, the young Warden of Trinity College collaborating with Strong on an edition of Juvenal, complained to his fiancée in Sydney that the professor was mean with money, and especially food; fortunately, he reported, his new friend Alfred Felton had restored his good humour with meat and a cigar.[5] A cryptic later entry in Leeper's account book does not explain the circumstances in which he 'lent Felton and lost' threepence.

Among Felton's other friends from his early days in the colony were the merchants William Couche (1830?–90) and Edward Keep (1828–1901), a man of sly wit, founder of Edward Keep and Co and Chairman of the Victorian Hardware Association. His closest companion over many years was a Yorkshireman ten years his senior, Bryan Champney Burstall, described as 'a genial man of large stature, earning a moderate livelihood by importing wine and cigars'. Burstall

[5] Alexander Leeper to Adeline Allen, 13 and 15 August 1879, quoted in Poynter, *Doubts and Certainties*, p. 95.

appeared in the 1856 *Directory*; he had a partner from 1860 to 1863, but both names then disappear for some time—Burstall's business career was chequered—his reappearing in 1869 as a commission merchant, and in 1870 as a 'wine merchant and general importer' at 8 Elizabeth Street. Burstall, like Grimwade, met Felton while sharing the same boarding house, and later joined Felton's household when he moved to Dalgety Street, St Kilda, in 1876.

It was Burstall who introduced Felton to another Yorkshireman, Henry Creswick, of 'The Hawthorns', Hawthorn, where Burstall dined every week. Creswick, born in 1824, had arrived in 1842, one of three brothers who had settled a run on Creswick Creek (after which the town was named); he married the granddaughter of Alexander Thomson, first Mayor of Geelong, and in 1851 formed a partnership with a wine and spirit merchant which made a fortune selling grog to the diggers. At least three times Creswick, like other rich squatters, made 'the run home', hunting, shooting and attending the Derby; back in Victoria he became a member of parliament before his retirement. Felton was a frequent visitor to The Hawthorns, and Creswick became perhaps his closest friend. 'Last Sunday I dined at the Creswicks', Felton wrote in 1885. 'A nice place and nice people: there are three generations there, and the first and the last generations are alike gracefully pleasing, and happy.' He once gave Alice Creswick, of the middle generation, a diamond brooch, 'a present for being a good daughter'; he also gave her improving books, including *The Joy of Living*, which she described as 'semi-religious'.

Also mentioned as a friend of Felton was FW Haddon, a journalist recruited by Edward Wilson in 1863 and from 1867 editor of the *Argus*, making it (in Twopeny's judgement) 'the best daily paper published out of England'.[6] Edward Morris was another friend, influential if less close than Burstall or Creswick. Morris came to Victoria in 1875 to be Headmaster of Melbourne Grammar School (bringing Alexander Leeper with him, as his Second Master) but resigned from the school, disillusioned, in 1882, and prepared to return to Britain. He had married the daughter of the brilliant George Higinbotham, whose eloquence, delivered in a soft Irish brogue but fiery enough to infuriate conservative opponents, had dominated Parliament in the 1860s.[7] One evening in November 1882, after Morris and his father-in-law had dined in the company of the schoolmaster-politician Charles Pearson and of Felton, Strong and Leeper, he was driven home by Felton 'behind two very dashing somewhat frisky horses', to find a

[6] Quoted in Carole Wood's entry on Haddon in *ADB*, vol. 4.

[7] Gwyneth M Dow gives a succinct account of Higinbotham's career in *ADB*, vol. 4.

telegram appointing him Professor of English in Adelaide. The University of Melbourne promptly created a Chair of English, French and German Languages and Literatures to keep him in Victoria. Imposing, eloquent and influential, with views on society which earned him the title of 'the philanthropic professor', Morris had brought to Melbourne the latest principles of 'scientific' charity, but it was some time before he could put them into effect.[8]

IN THE AUSTRALIAN COLONIES, as in Britain, the 'respectable' classes were apt to despise the mass of the emigrants—convict and free alike—as a poor lot.[9] Nevertheless the early British settlers in Victoria were proud of their achievements. In 1869 George Coppin, theatrical entrepreneur and prolific creator of community organisations, moved to found a society of 'old colonists'—defined as those who had arrived before 1851—inviting twenty to a dinner which became an annual event, with occasional smoke nights or picnics in the intervening months. (In 1853 an earlier 'Old Colonists' Festival Dinner', for those who had 'founded' the colony then newly independent, broke up in a riot, thanks to the excessive ebullience, habitual with him, of WJ ('Big') Clarke.)[10] In 1869 Henry Creswick qualified for membership of the new Association, but Felton himself did not until 1872, when arrival before 1855 became the test.

Membership of the Old Colonists' Association included many successful men, such as JB Were and Henry Henty, but Coppin ensured it was egalitarian in spirit. Its formal aims were to assist necessitous old Colonists 'by loan or otherwise', to promulgate facts relative to the early history of the colony, to promote the advancement of native-born Victorians, and 'to promote a friendly recognition of the founders of the colony'. Support for the native born became the role of the Australian Natives Association, founded in 1871, with which the Old Colonists', a less political organisation, co-existed happily enough. The Old Colonists' purposes

[8] EE Morris to Edith, 5 November [1882], quoted in Kennedy, *Charity Warfare*, p. 84. Kennedy, who discusses Morris at length, assumes that 'Strong' was Charles Strong (on whom more below), but it could have been Herbert Augustus, in Melbourne until 1884; these Morris papers can no longer be found. Alice Creswick said that Felton 'kept a fine carriage', but by his own accounts usually drove ponies rather than 'frisky horses' in the 1880s; perhaps Morris was a nervous passenger.

[9] On 'The Emigrant as Failure', see White, *Inventing Australia*, pp. 37–40.

[10] Coppin was also active in the Victorian Humane Society, St John's Ambulance, the Australasian Dramatic and Musical Association, and was the first Grand Master of the Freemasons in Victoria; he also established free dispensaries in Richmond. The Coppin Papers are in the La Trobe Library; and see the entry by Sally O'Neill in *ADB*, vol. 3. The 1853 dinner had been a riot: 'If bedlam could be imagined to have suddenly imported its inmates into the colony: if Donnybrook Fair and a thousand drunken Irishmen had dropped down amongst us: if a well-stocked bear-garden had discharged its inmates upon the dining room—in short, all that is brutal, noisy and ill-behaved in civilized nature had all at once concentrated itself in the Criterion ballroom—such another scene may again occur' (*Argus*, 15 September 1853, quoted in O'Neill, *Picturesque Charity*, pp. 3–4).

St Kilda Pier, Sunday Afternoon, 1879 (*Illustrated Australian News*, 12 April 1879, La Trobe Picture Collection, State Library of Victoria)

were primarily philanthropic and convivial, and within six months of founding they had decided to build 'almshouses' for worthy aged and distressed settlers down on their luck. In a society composed of emigrants, there would be many who entered old age with few or no family members to support them; the poorest entered the Benevolent Asylum in North Melbourne, but the number of those once moderately affluent who sank into genteel poverty was considerable.

Voluntary charity was stronger in Victoria than in New South Wales. The Benevolent Society of New South Wales, founded in 1817 by seven earnest

Evangelical gentlemen of Sydney to relieve the distressed and to enforce 'the sacred duties of Religion and Virtue in NSW'—a hopeless cause, in the Reverend Samuel Marsden's opinion—raised some money from the public, but became so heavily dependent on government funds that their Benevolent Asylum became 'part of the convict establishment'.[11] But when settlers of Port Phillip first asked the Governor for a hospital in Melbourne, Gipps minuted in 1840 that he did not 'consider it the business of Government to provide a general Hospital for the District.... Such institutions are the objects of private charity'. 'His Excellency is persuaded that establishments of this nature are best conducted by persons chosen out of their own body, by those who contribute to their support.' Convinced, eventually, that 'the public of Port Phillip' seemed disposed 'to undertake the business' themselves, he agreed to provide a capital contribution and a subsidy to running costs, pound for pound.[12] And thus it was that the Benevolent Asylum, and virtually all the subsequent institutions built for health and welfare in colonial Victoria (other than lunatic asylums and gaols) were founded and run by boards of management nominally elected by all subscribers to the charity, but in practice by self-perpetuating cliques, of varying ability and benevolence, all too inclined to patronise the poor they succoured. Charities deemed to be 'public' received annual subsidies, substantial in total, from the colonial government, which could not, however, prevent their extraordinary proliferation. As Stanley Greig-Smith, the formidable Secretary of the Charity Organisation Society, later observed, the new population drawn by the gold rushes prompted the creation in the 1850s of a network of benevolent societies, hospitals, orphanages and other charitable services throughout the colony, including the Immigrant Aid Society's sprawling establishment next to Canvas Town. 'How splendidly', he added, 'this voluntary spirit' met a series of crises, including caring for the dependants of breadwinners rushing to the new goldfields of New Zealand in 1863 and Western Australia in 1887. The headlong pursuit of wealth has always left a trail of indigence for others to deal with.[13]

[11] Dickey, *No Charity There*, pp. 21, 26; and Conley, 'The "Undeserving" Poor'. The Benevolent Society attempted to establish the model of community-based poor relief developed by the Reverend Thomas Chalmers in Glasgow (see Poynter, *Society and Pauperism*, pp. 234–7).

[12] Quoted in Dickey, *No Charity There*, p. 35. As late as 1877 the Chief Secretary told the ladies seeking Government funds to found an Infant Asylum (to reduce the incidence of infanticide) that 'In his opinion an appeal to the wealthy portion of the public who in this Colony are not burdened with a poor rate, would, or ought to, put the promoters readily in receipt of the necessary funds to establish an Asylum such as they contemplate and keep it in operation' (Beryl Penwill, *Looking back, Looking forward*, p. 10).

[13] Greig-Smith, 'The Development of Philanthropic and Social Work in Victoria', pp. 46–8. For a much more critical account of what Kennedy calls 'the Victorian Charity Web', see his 'Charity and Ideology in Colonial Victoria'.

The Old Colonists' Association received a grant of land in Fitzroy from the government, but thereafter relied solely on donations. Coppin sought subscriptions to the charity, in the way then customary, but also solicited donors to build cottages in a new village. Eight cottages were originally planned, attached to a hall—a secular chapel—at a cost of £8000; since the first pair cost £677, when a worker's cottage could be built for £100, the respectable poor were to live in some comfort. The village grew, and began to show (it has been plausibly suggested) the architectural influence of the much publicised and picturesque Blaise Hamlet almshouse village, created near Bristol by John Nash and Humphrey Repton in 1810.[14] Felton approved the concept and the practice; he saw in the Old Colonists' Almshouses (later called 'Homes') men and women whose careers resembled his own in all but success. He was not, however, much involved in the Association's early years.

GRIMWADE, ABANDONING THE nonconformity of his upbringing, became a leading Anglican layman, prominent—indeed outspoken—in the debates which periodically rent the Church Assembly.[15] Felton did not follow his partner into Anglicanism; nor it seems did he join the local Congregationalists, the church of his baptism, in building their handsome Independent Church in Collins Street. He probably always attended a church, but the first evidence of his allegiance comes after the arrival from Scotland in 1875 of the remarkable Charles Strong to be Minister of the even grander Scots Church, built on the opposite corner. Strong's character won him the approval of the Anglican Bishop Moorhouse, and his modernist theological views, advocacy of freedom of conscience and condemnation of social abuses attracted the admiration of Pearson, Higinbotham, and later of Alfred Deakin and HB Higgins, all leaders of Victoria's liberal intelligentsia. Felton was one of the many hundreds of liberal-minded Melburnians drawn into the orbit of the charismatic preacher, whose views and actions nevertheless outraged many conservatives, especially within his own Presbyterian Church of Victoria, a recent and none-too-solid federation of the varieties of Presbyterianism previously existing in the colony.[16] In one of his first ventures in social reform, Strong worked with Coppin, the scheme's begetter, for the

[14] In *Flinders Lane* (p. 70) Russell Grimwade confused the Old Colonists' Homes with the Immigrant Aid Society's Homes by Princes Bridge, demolished at the turn of the century.

[15] Later the Diocesan Council. On Grimwade's involvements in Church affairs see Poynter, *Doubts and Certainties*. He was said to be 'largely instrumental' in building Holy Trinity Balaclava (*Argus*, 5 August 1910).

[16] On Strong see Badger, *The Revd Charles Strong and the Australian Church*, and his entry in *ADB*, vol. 6. On this and related religious controversies, see Serle, *The Rush to be Rich*, ch. 4.

Almshouses of the Old Colonists' Association, 1870 (Albert Charles Cooke, *Illustrated Australian News*, 10 October 1870, La Trobe Picture Collection, State Library of Victoria)

Improved Dwellings and Lodginghouse Co Ltd, a project with powerful supporters, including the Governor; in July 1883 Sir Henry Loch laid the foundation stone of the apartment block built for workingmen's families in Little Bourke Street (still standing, though gentrified, as Gordon House).[17]

Intellectual life in Melbourne in those years was lively enough to support two substantial journals, the *Melbourne Review: A Quarterly Publication Devoted to Philosophy, Theology, Science, Art, Politics and Belle-lettres* (1876–1885) founded by journalist-banker Henry Gyles Turner and friends, novelist Marcus Clarke among them; and the *Victorian Review* (1880–1886), edited by H Mortimer Franklyn. Intending his journal to be 'distinctively Australian in tone, while eclectic in char-

[17] The *Argus*, 23 July 1883, reported the ceremony, at which Loch cited the Peabody Legacy in London as a precedent. Coppin, writing to Strong on 27 July 1884, does not mention Felton in a list of shareholders (Strong papers, ANL 2882/1/3).

acter, patriotic in aim and progressive in policy', Franklyn was ready to publish articles on any subject, from German Philosophy to the newly refrigerated ships ('A new Phase in the Dead Meat Question') and even gave space to Anon's interesting prediction that the Anglo-Australian Race was bound to degenerate because racial characteristics were determined by the qualities of soils, which were here too poor. A sceptical article by Marcus Clarke, 'Civilisation and Delusion', sold 10 000 copies of the *Victorian Review* in 1879. In neither of these journals, nor anywhere else, does Felton himself seem to have committed a word to print, but contributions by his friends abounded.[18] Charles Strong wrote for both journals, and an article on the Atonement, published in the *Victorian Review* in 1880—work which later earned him a DD from Glasgow University—prompted the Presbytery to appoint a committee to examine their minister's orthodoxy, later called further into question by his sponsoring a public lecture on Science and Religion by Higinbotham. The row was reported in great detail in the press, where the balance of opinion was in Strong's favour; not only the stricter Presbyterians but all Scotland came in for criticism ('Land of tyranny and tyrants/ Sneaking tyrants, deep and sly/ Land of Bibles and of bastards . . .').[19] In March 1881 Strong was impeached for heresy; in August, before proceedings were completed, he shocked his supporters by announcing that he would resign, leaving in two years time. His resignation was not accepted; Presbytery proceedings dragged on, and Strong was eventually summoned before it on 13 November 1883. He did not attend, sending a belated letter declining the invitation; he was in fact near by, at the Melbourne Town Hall, packed with supporters for a formal farewell, described by the *Herald* as 'one of the most memorable meetings ever held in the colony'. The Mayor was in the Chair, Higinbotham among the speakers, and 420 Anglicans signed one of the many addresses in his honour. He left for Scotland the next day, farewelled by a 'huge crowd' and comforted by a public subscription of £3000. As the ship sailed his adamantine opponents assembled again to expel him from membership of the Presbyterian Church of Victoria.[20]

[18] Grant and Serle (*The Melbourne Scene*, p. 142) mention Felton among the contributors, but nothing by him has been found in either journal. The long list of those contributing who were either Felton's friends or were later involved with his Bequests includes HG Turner, CH Pearson, EE Morris, R Murray Smith, John Winthrop Hackett, Edward Langton, James Smith, Joshua Lake, JS Elkington, RJL Ellery, WH Fitchett, both Strongs (Charles and HA) Alexander Sutherland and PD Phillips, who drafted Felton's will. Turner's sister Martha and Catherine Spence were among the few women contributors.

[19] The Strong Papers (ANL 2882/1/2) include a flyer with these verses, which continue:
'Land of dreary psalms and sermons/Land of lasses—fearful, frail/Land of prayer and strong raw whisky/Churches, shebeens, carl and kail/Land where some declare they worship/Every Scottish hill and rock/But, of all the lads that leave thee/Deil a ane gaes ever back'.

[20] *Herald*, 15 November 1883. Numerous press cuttings on the whole controversy are collected in the Strong Papers (ANL 2882/6/1, 2 and 3).

Felton's name does not appear in the accounts of these events. It is known that he greatly admired Strong's teachings, and had formed a close friendship with him. He corresponded with the Minister in his exile, and hoped for his return.

FELTON WAS A CONVIVIAL MAN, within the bounds of dignity. He was one of those who responded to the call of James McBain and his small Provisional Committee to found a 'New' club at the western end of Town, to cater especially for gentlemen to whom the Melbourne Club at the 'top end' of Collins Street was either inconvenient or—for one reason or another—inaccessible. (The reason commonly given was that they were cut off from their lunch when the creek running down Elizabeth Street flooded; but at least one of the gentlemen concerned had been 'pilled', the current slang for blackballed.) In May 1878 Felton attended the meeting of thirty-eight merchants and pastoralists which formally established and named the Australian Club, and approved the purchase of a site in William Street for a new, and very grand, clubhouse. He was member number five. His partner Grimwade, though absent from the May meeting, was also a founding member, and on occasion an outspoken participant in annual meetings, objecting in 1881 to the Club having shares in and dealing with a co-operative company (the Mutual Store) and again to 'the very arbitrary rule' against serving 'tea' during dinner hours. Grimwade nevertheless became President of the Club in 1901 and again in 1906–7, the first of four members of his family to hold that office. Charles Campbell was also a member; and with these and other partners and friends Felton enjoyed himself, lunching, dining and talking, but he had no appetite for office, not even in a club.[21]

Felton was also a member of the Athenaeum Club, founded in 1867 as a proprietary club, its 'proprietor', rather than the members, owning and managing its conveniently central quarters in Collins Street.[22] He also made use of another institution often confused with the Club, the still-existing Melbourne Athenaeum, formerly the Mechanics Institute, a lending library and meeting place—one for both sexes, unlike the clubs—popular in late nineteenth-century Melbourne. Felton reported that the Athenaeum had 'a capital tea room', with especially good chops.[23] Closer, in Collins Street near Queen Street, was the

[21] de Serville, *The Australian Club, Melbourne 1878–1998*, pp. 9–10, 22, and 27.

[22] Felton's name is not mentioned in Pacini, *Windows on Collins Street*, but Paul de Serville has found it in an 1884 membership list, and Felton's subscription appears annually in his surviving ledger, which begins in 1892. Burstall was also a member.

[23] AF to FSG, 22 September 1884. Felton also joined the St Kilda Bay Club in 1897; he was not (despite Poynter, *Alfred Felton*, p. 19) a member of the Melbourne Club, though small unexplained payments to it appear in his ledger.

The Melbourne Exchange Hall, 1879 (Lloyd Tayler, architect, *Illustrated Australian News*, 31 October 1879, La Trobe Picture Collection, State Library of Victoria)

'Mercantile Exchange', established in 1880 by the remarkable Henry Byron Moore, after he was sacked without notice as Assistant Surveyor-General — despite his enterprising creativity in decorating the city with 10 000 Chinese lanterns to welcome Prince Albert—when Graham Berry's radical government purged the public service on 'Black Wednesday' in 1878. Moore took over and expanded the old Hall of Commerce building, where the still-primitive

Melbourne Stock Exchange, forerunner to the Stock Exchange of Melbourne, conducted its business (much of it in the street outside, as was the custom also in Ballarat). Moore—whose many talents included writing fairy stories and playing the violin—added a spacious Exchange Hall, and made the place a combination of stock exchange, telegraph and reading room (with five hundred newspapers) and club (with barber and billiards room), offering every facility, from Melbourne's first telephone exchange to three pairs of carrier pigeons, acquired by Moore through application to Prince von Bismarck. Felton lunched there when too busy to go elsewhere, 'so the Exchange has had a few of my eighteen pence'; he also had a 'mailbox' there, a locked drawer (with his name on it, in gold letters) in a desk which still exists in the Mercantile Exchange, now diminished to an advertising agency in Bank Place.[24]

Felton enjoyed membership of the Melbourne Cricket Club, even when 'the Britishers' were 'whipping the Australians'. He paid his subscription to the Victoria Racing Club, occasionally attending race meetings at Flemington, and favourably compared the Melbourne Cup to the Derby, which (he recalled to Grimwade) 'you leave with a depression, the status of man and men seems sadly lowered ... but the [Melbourne] Cup, on a fine day has a different effect, it exalts man and men, they are seen at their best, social amenities are observed, and I am sure a sense of delight and happiness seems to pervade the whole crowd'.[25] Felton also attended concerts, subscribing to the remarkably active and expert Melbourne Liedertafel, one manifestation, among many, of the strong German cultural influence in Melbourne in the nineteenth century.[26]

He was also fond of travel, making frequent trips to other colonies, especially New South Wales and New Zealand, and he revisited Britain in 1870; no details of this, or of possible (though unlikely) earlier visits, survive. His family was, by then, well scattered, but he would certainly have visited his brother William, and possibly his father.[27] Felton later suffered one serious mishap while travelling: on

[24] On Moore, see Suzanne G Mellor's entry in *ADB*, vol. 5, Cannon, *The Land Boomers*, esp. pp. 102–3, and Adamson, *A century of change: the first hundred years of the Stock Exchange of Melbourne*, esp. pp. 191–2. I am indebted to Mrs Eunice McMurray of the Mercantile Exchange for additional information. Felton's name disappeared from the drawer when the desk was repolished a few years ago.

[25] AF to FSG, 14 July 1884.

[26] Grimwade was at one stage President of the Melbourne Liedertafel. On German influences, see Struve, 'Nineteenth Century German Melbourne on Display', and other articles in Mitchell (ed.), *Baron von Mueller's Melbourne*.

[27] By 1881 (but probably much earlier) his mother was dead; his father was living in Deptford, Kent, with his youngest son Edmund, daughter Eliza and Edmund's wife Mary; Thomas, a traveller in the leather trade, was established at 21 Townshend Road, Marylebone, with his wife Mary, daughters Annie (12), Maud (8) and Lucy (1), and son William (6); brother William was in Haywards Heath, Sussex; and James in South Africa. There remains no trace of George.

10 December 1881, on board a train to Sydney, he allowed his leg to project from the observation platform and had it so violently broken by a passing train that his boot bruised his thigh. He was taken to Goulburn, and thence to Sydney, where Grimwade visited him on Christmas Eve. Felton was incapacitated for some months, and walked thereafter with a pronounced limp.

WHY AND WHEN FELTON started collecting works of art is not known. Since it was an interest not easily indulged in a boarding house, and a large collection is a strong disincentive to frequent change of residence, it seems unlikely that he became a heavy purchaser of pictures and other art objects in his first years in the colony. There was, in any case, little opportunity to do so. Some wealthy settlers brought their pictures with them, but a market in Melbourne for other than local art was limited before the 1870s, though the great Victorian boom in prints, which made so many British artists rich, spilled over into the colony in the 1850s.[28] Books Felton probably always bought.

It is easy to recognise among Felton's friends those who would encourage and influence his philanthropic impulses—Edward Morris and Charles Strong in particular—but who among them shared his growing interest in acquiring works of art, for which his Bequest is best known? Perhaps he did not need such stimulus: art for the education of the people and the elevation of public taste, part of an urgent agenda to civilise and tame democracy, was high on the moral agenda in Britain, North America and the Australian colonies in the nineteenth century. In Victoria the foundation stones of the University of Melbourne and of the Free Public Library, a mile apart, were laid on the same day in July 1854; Felton might well have been away at the goldfields when Redmond Barry, the dominating figure in both institutions, made two two-hour speeches—presumably similar but not identical—one at each ceremony. In Sydney the notion that government funds should be spent on public museums had been opposed by some self-appointed colonial gentry arguing that such learning was the preserve of their class, but in cultural matters Victoria, thanks to Barry, Childers, La Trobe and others, had a more liberal temper.[29] The Library, with Barry as 'Senior Trustee',

[28] Vaughan, Art Collectors in Colonial Victoria 1854–1892, notes (p. 9) that it is 'impossible to exaggerate' the importance of the new market for prints among the middle classes; that the products of the Arundel Society, founded in 1849 with Ruskin a Council member, were always available in Australia, and (p. 19) that the Art Union of Victoria published its own prints from 1872, until hit by cheap imports in the 1880s. Vaughan is a main source on Felton and other collectors of the period; see also his 'The Armytage Collection'.

[29] Galbally, '"For the Instruction and Amusement of the Inhabitants": The Development of Public Museums, Libraries and Art Galleries in Colonial Australia', in Galbally and Inglis, *The First Collections* (the catalogue of an exhibition reconstructing part of the original collection, with introductory essays), p. 15.

Sir Redmond Barry (courtesy Thomas Hazell)

was hailed in the press as marking 'an epoch in our social advancement', and a 'stride forward in civilisation'.[30]

It is unlikely that Felton knew Sir Redmond Barry, who was emphatically not a member of Melbourne's merchant class but an Anglo-Irish patrician, one of the group which dominated official circles and especially the law in early Victoria.[31] Born near Cork in 1813, he read classics at Trinity College, Dublin, and law in London before emigrating to New South Wales in search of a livelihood. In personal life a son of the Regency, taking his pleasures (especially sexual) as he could find them, his prospects in Sydney were blighted by arriving with an ill-concealed shipboard affair with a married woman to his discredit. Melbourne,

[30] White, *Inventing Australia*, p. 61, quoting the *Age*.

[31] On Barry, 'the most remarkable personage in the annals of Port Phillip' ('Garryowen'), see the entry by Peter Ryan in *ADB*, vol. 3, and his *Redmond Barry: A Colonial Life 1813–1880*; and Galbally, *Redmond Barry: An Anglo-Irish Australian*.

short of both gentry and lawyers in 1839, accepted him readily, and even tolerated the lifelong relationship he established in 1846 with another married woman, Louisa Barrow, who bore him four children, whom he publicly recognised and loved.[32] When Felton arrived in Victoria, Barry had recently quit the post of Solicitor-General in the newly separate Colony to become a Supreme Court Judge, remembered for his harsh sentences and above all as the man who tried Ned Kelly, while his more liberal attitudes—such as his sympathy for and interest in the position of Aborigines—are overlooked. Barry's tastes and opinions, like his dress and his behaviour, tended to remain pre-Victorian; he was conservative in politics, and despised modern literature, snubbing Trollope when Melbourne lauded him in 1871. He retained, and fought for, the classical values instilled in him at Trinity College, Dublin; what set him apart from other members of his profession and class was his passionate commitment to founding and (unlike Alfred Felton) running cultural and philanthropic institutions. No Victorian outdid him in service to the ideal of universal betterment through self-education; institutions in which he involved himself ranged from the Victorian Horticultural Society through the Mechanics Institute (where he was prone to give lectures, as he did at the Philosophical Institute and its successor the Royal Society), successive International Exhibitions, the Melbourne Hospital, the Philharmonic Society (where he sang) and especially to the University of Melbourne and the Public Library, two roosts he ruled with extraordinary vigour and determination. London visitors were astonished to find that Barry's Library did not require readers' tickets, but admitted all comers; indeed he once appeared to encourage visitors to steal any modern novels which had infiltrated the collection.

Large public museums and galleries were relatively new developments in the 1850s, even in Europe. There had long been public access to some private collections (as there was to Barry's library at home); and the British Museum, the model of the comprehensive institution housing both books and objects of art, had its origins (like the earlier Ashmolean in Oxford) in a gentleman's 'cabinet of curiosities', while the heirs of successive Marquises of Hertford, complaisant husbands and ardent collectors, were to provide London with the Wallace Collection. But unlike

[32] It is argued that he did not marry her after her husband's death because of her social inferiority, but perhaps she had no liking for two-hour speeches; more likely he simply wanted to combine part-time family life with the independence of bacherlorhood, manifestly enjoying both.

In 1841 Barry fought a duel, then not uncommon in the Port Phillip District. The touchy Peter Snodgrass, who had thought himself insulted, was so unnerved by the appearance on Sandridge beach of Barry, formally dressed as a Regency dandy, that he accidentally discharged his pistol; 'Barry at once magnanimously fired in the air' (Galbally, *Redmond Barry*, pp. 58–9).

continental Europe, where the great royal collections were made open to the public—in France by revolution and elsewhere by decree—Britain's main public collections had to be created.[33] Proposals for a National Gallery for London emerged from the Royal Academy, founded in 1768 to be an art school as well as a place of exhibition; as late as the 1840s the Louvre was reserved for students copying for five days a week, and open to the public only on Sundays. Some Academicians wanted a collection of 'old' pictures for the public to admire, but not all, Smirke complaining that 'the bringing forward the works of the great artists of former periods' would encourage those with money to buy old works rather than 'the British artists of this period'.[34]

One of the champions of a public gallery was the philanthropist Sir Thomas Bernard, already a founder of the Royal Institution, devoted to public education in all the arts, including science; in 1805, with a Gallery in mind, he helped found the British Institution for the Promotion of the Fine Arts—both organisations later echoed in Barry's Victoria—but in the end the British Government approved a separate National Gallery, prompted by the purchase of the Angerstein Collection in 1824. The premises built in the new Trafalgar Square in 1838 were at first shared with the Royal Academy; the first Director was appointed only in 1854, the year the Melbourne Library's foundation stone was laid. Four years earlier, in 1850, in Edinburgh, after a long row between the Royal Scottish Academy and the Board of Manufactures, the Prince Consort had laid the foundation stone of William Henry Playfair's great new National Gallery of Scotland, built on the Mound of earth dug to form the New Town's cellars and to link it with the Old.[35] In Dublin the inclusion of art in the 1853 Exhibition (Ireland's response to the Crystal Palace) led to a movement to found a National Gallery, eventually opened in 1864.[36]

The social role of such cultural institutions in various parts of the world has been much analysed in recent years, in the light (not uniformly illuminating) of current cultural theories.[37] The nineteenth-century creators of Melbourne's library, museums, and art gallery were undoubtedly exercising the hegemonic authority of their class and generation, and if their conscious intention was to

[33] The Medici had given the collections in the Uffizi to the Tuscan State in 1737, and public galleries were opened in Vienna in 1781, Paris in 1793, Amsterdam in 1808, Madrid in 1809 and Berlin in 1823 (Hendy, *The National Gallery London*, p. 15).

[34] Hendy, *The National Gallery London*, pp. 14–15.

[35] Gow and Clifford, *The National Gallery of Scotland*, p. 11.

[36] De Courcy, *The Foundation of the National Gallery of Ireland*.

[37] See, for example, Duncan, *Civilizing Rituals*, and Hudson, Frank Rinder and the Felton Bequest 1918–1928, ch. 3.

The Sculpture Gallery at the Public Library, 1866 (Charles Nettleton, photographer, Samuel Calvert, engraver, *Illustrated Melbourne Post*, 27 July 1866, La Trobe Picture Collection, State Library of Victoria)

elevate the knowledge and taste of the masses within a general programme of moral education, the political quiescence of the lower classes was indeed one looked-for outcome. But only one; others were increased prosperity, for society and for each individual, and freedom from inherited servility, which only a generation earlier the opponents of education had sought to preserve by keeping the poor illiterate, lest they read Tom Paine. One generation's liberator seems an oppressor in the next.

Among the great institutions championed by the Victorians as vehicles for public education, libraries had the longest public history, and what was required of them was a new accessibility. Museums had further to develop, from cabinets

of curiosities into systematic displays illustrating the classificatory systems of the new sciences. So too galleries became more than collections of objects chosen for enjoyment and display, or even for their edifying aesthetic qualities alone. They were expected to teach about art (and, more utilitarian, design). Throughout Britain and her colonies of settlement, and to an extent in North America, art and industry came together to forge these instruments of public education; they believed prosperity lay in becoming a clever country, with taste. Earlier, in 1835, a Select Committee of the House of Commons on Arts and Manufactures had advocated 'the opening of public galleries' as a 'means of extending a knowledge of the Arts and of the Principles of Design among the people'; and the Museum of Manufactures (renamed the Victoria and Albert in 1899) had 'the improvement of public taste in Design' among its purposes when opened in 1852, celebrating the practical Arts triumphantly displayed in the Great Exhibition in 1851.[38] In the Australian colonies the humbler Mechanics Institutes, by providing small libraries and lecture halls, also contributed to the cause of self-education.

Barry set a bold course at the helm of Melbourne's Public Library (as he did for the University), disdaining narrowness of purpose. 'At the time of the foundation of the Institution', a later Annual Report of the Public Library asserted, 'the projected plan included, with the Library, a Museum of Fine Arts and a Picture Gallery, to which would be eventually added a Drawing School and School of Design'.

> The intention was to trace the outline of a scheme of general instruction by which the chief epochs of mental pre-eminence might be strongly defined . . . and a new stimulus be given to the cultivation of the intellect, and the elevation of the public taste. The proximity of the various objects would . . . attract to them an observation more prolonged and instructive than that bestowed during visits to isolated buildings in which they might be dispersed, and would create and promote a sympathy between the different branches of Literature, Science, and Art . . . while the repeated and associated impressions thus produced would assist in furthering the design, and effectually advancing the general interests of learning.[39]

It was easier to achieve these grand designs in Melbourne than in Edinburgh or Dublin (where the Museum, built across Leinster Lawn from the new Gallery, remained a separate institution, and the attempt to include a public library in the Gallery failed). The newly independent colonies of Victoria and South Australia had no established cultural institutions to quarrel over status and territory, and each was able to construct combined institutions, the Melbourne Public Library

[38] *The History of the Victoria and Albert Museum*, p. 5.

[39] Report of the Trustees of the Public Library, Museum, and National Gallery of Victoria for the year 1870–71, quoted in Galbally and Inglis, *The First Collections*, p. 7.

spawning an Art Museum in 1861, a Picture Gallery by 1864 and Schools of Design (Drawing) and Painting. In 1870 it and they came under a new Board of eighteen Trustees, who were also given responsibility for the National Museum (created in 1854 but hijacked by Professor McCoy to the University of Melbourne, whence it returned to Swanston Street only in 1899), and for a newly created Industrial and Technological Museum (which also undertook teaching functions, absorbed after 1887 by the nearby Working Men's College, now RMIT University). The Trustees of this conglomerate of institutions did indeed preside over a power-house of knowledge.[40]

In fact there had been more evolution in Barry's aims and ambitions than the retrospective view from 1870 implied. He had set his own pace with the Library, buying, begging and exchanging books (but never modern literature) around the world. He soon supported, but did not initiate, the agitation of the journalist and art critic James Smith and others to add a gallery of painting and statuary to the Library, and with Childers he persuaded the Victorian Government to grant, in 1859, £2000 to the Public Library Trustees to buy works of art.[41] The decision provoked debate on the purpose of a collection—education, recreation, civic instruction and the cultivation of taste were all championed—and on the types of objects to be sought. Barry's own immediate model was the classicist's collection of casts of ancient sculptuary, such as he had seen in Cork and Dublin in his youth, and was insistent that Childers, charged with spending the money in London, buy only 'busts, casts of statues and similar objects—to which with coins and photographs, we propose at present to limit ourselves. Pictures are out of the question with so small a sum at our command and I have not much faith in copies when photographs are to be had'.[42] His grand purpose was 'to bring together a comprehensive and well-balanced series of groups to illustrate national characteristics, and exhibit the history of the growth of refinement and intellectual excellence represented in the arts', with a secondary intention 'to form not merely a Museum for amusement but the rudimentary basis for a School of Design'.[43] Unfortunately many casts were broken in transit, but after repairs by the leading local sculptor Charles Summers, the Governor opened the new Museum of Art in

[40] For the early history of the Schools, founded in 1870, see Jane Clark, 'The Art Schools', in Clark and Whitelaw (eds), *Golden Summers*, pp. 31–4. On the museums, see Rasmussen, *A Museum for the People*.

[41] On Smith (1820–1910), see entry by Ann-Mari Jordens in *ADB*, vol. 6.

[42] Barry to Childers, 16 January 1860, quoted in Galbally, *The Collections of the National Gallery of Victoria*, p. 15.

[43] Barry to Childers, 20 August 1860, quoted in Galbally, *The Collections of the National Gallery of Victoria*, p. 14. Barry might also have wished to avoid a repeat of the mediocre loan show, mainly of landscapes and dubious old masters, which had been largely ignored by the public in 1854 (Vaughan, Art Collectors in Colonial Victoria, p. 1). See also Cox, *The National Gallery of Victoria*, pp. 9–10.

May 1861, and some 62 000 Victorians admired the acquisitions in the first couple of months. (Summers was soon to be busy on the first large bronze cast in Australia, his statue of Burke and Wills, leaders of the grandiose Victorian Exploring Expedition, who were starving to death at Cooper's Creek as the new Museum was opened. Victoria's ambitions were broad indeed.)

The success of the Museum renewed agitation for a Picture Gallery, and Barry, true to his own principles, systematically taught himself about paintings while in Europe in 1862. In 1863 a Commission of Fine Arts was set up, with Barry in the Chair and Augustus Tulk (the learned Chief Librarian chosen by him), Smith, Summers and seven other members, to plan further acquisitions. Late in the year the Government gave it £1000 to spend on paintings, immediately posing the question, what to buy? The debate which ensued rehearsed arguments which were to echo in the history of Felton's Bequest. One member sought to buy only original paintings by modern artists, selected in London, the colony's cultural capital. Another, the first lonely champion of a legion to follow, wanted to include artists working in Australia. A third believed the new Gallery should display pictures representing all the chief schools of art, ancient and modern, in European collections; it should therefore buy only copies of great works, a conclusion much ridiculed in the twentieth century, but a widely prevailing view in an age before the mass reproduction of coloured images, and before 'the modernist belief in the primacy of originality'.[44] A compromise was reached: the Trustees did acquire Arundel Society prints—colour reproductions of Italian frescoes—and also photographs, mainly of antiquities, an innovation of the period for which Felton also became an enthusiast, but in general the advocates of art then thought modern—with Barry their leader—won the day.[45]

These decades were, as Gerald Reitlinger put it, the Golden Age of the Living Painter, when works by fashionable contemporary artists were bought 'not because the great masters of the past were unprocurable' but 'because they were much preferred to the old masters'; and their incomes were inflated by selling both the pictures and the rights to print steel-engravings.[46] The distinguished Sir Charles Eastlake, the first Director of London's National Gallery, who had been sought out by Barry as adviser, was told to buy only works by living artists, and not old mas-

[44] Inglis, 'A Mania for Copies: Replicas, Reproductions and Copies in Colonial Victoria', in Galbally and Inglis, *The First Collections*, p. 36.

[45] In consequence, as Ursula Hoff has observed, the Melbourne Gallery in the following years largely 'confined itself to acquiring contemporary decorative art and "original paintings by modern artists"', especially landscapes and the history and genre paintings fashionable in London (Hoff, *The Felton Bequest*, p. 7).

[46] Reitlinger, *The Economics of Taste*, volume 1, p. 99 and ch. 6.

Opening of the New Fine Arts Gallery, Public Library, 1875 (the McArthur Gallery) (Samuel Calvert, engraver, *Illustrated Australian News*, 14 June 1875, La Trobe Picture Collection, State Library of Victoria)

ters (on which he was a great authority, and which were cheaper); he not only obeyed, but agreed that Melbourne's policy was appropriate, though he broadened it to include foreign as well as British works, as yet outside the prevalent taste of most of the handful of Melbourne collectors. (In 1870 James Smith was to attack von Guérard, an immigrant from Austria, as 'foreign'.)[47] Nevertheless the popular taste was served; crowds thronged to a new Picture Gallery opened in 1864, and

[47] Vaughan, Art Collectors in Colonial Victoria, p. 53; Vaughan calls Eastlake's recommendation of contemporary foreign works for Melbourne 'revolutionary'.

Eastlake's acquisitions were much admired. The age when modernity was unpopular had not yet arrived.

Whether Felton was among the crowds viewing the Melbourne Gallery's first acquisitions is not known. Nor is it known whether he attended the series of 'Exhibitions' which Melbourne began, again with Barry's leadership, in 1854. Before the discovery of gold, Victoria had sent only one modest bag of flour to Britain's Great Exhibition of 1851; three years later, ambition inflamed by riches, it rushed to join the cities emulating London in presenting the products of progressive industrial society as a spectacle. The first Melbourne Exhibitions were housed in a special building in William Street, later the site of the Royal Mint; those of 1866 (an Intercolonial Exhibition), 1872 (of exhibits to be shown at Exhibitions in London and Vienna) and 1875 (for the Philadelphia Exhibition) in an annexe built beside the Library.[48] The high educational purpose was 'learning by looking', and Barry was involved in all the Exhibitions up to 1875, which he celebrated with a big dinner at the Athenaeum. The Exhibitions excited new support for his Library complex, that of 1866 prompting the establishment of the Technological Museum, while a Loan Exhibition mounted by the Trustees in 1869—Barry proudly extolling such a profusion of art as an 'aid to social refinement and material prosperity'—was so great a success that the Schools of Painting and Design, under von Guérard and Thomas Clark, were set up the following year.[49] By 1870 the Trustees had bought thirty-five pictures and been given seventeen, justifying construction in Little Lonsdale Street of the Macarthur Gallery, specifically designed for paintings, for £7000 by 1875. Barry seems however to have been more directly involved in acquiring books than pictures in these years, when the collection grew steadily, though with some controversy—a pre-echo of the Felton Bequests' difficulties—concerning purchases in London by a succession of advisers, ranging in expertise from Ruskin to a well-meaning retired squatter.[50]

The Exhibitions gained political significance when championed after 1874 by the protectionist United Manufacturers Association (from 1881 the Victorian Chamber of

[48] Dunstan, *Victorian Icon*; Dugan, 'Victoria's Largest Exhibition'. Robert Poynter's diary notes that his uncle Hickinbotham had the 'furnishing' of the 1854 Exhibition. The *Official Record of the Intercolonial Exhibition of Australasia, Melbourne 1866–7* does not suggest that many significant works of art were then on display.

[49] Barry's speech at the loan show is quoted in Vaughan, Art Collectors in Colonial Victoria, p. 4. Ann Galbally, *Redmond Barry*, traces his involvement in successive Exhibitions; see especially pp. 148–56 on his curious withdrawal from the 1866 Intercolonial Exhibition, of which he had been appointed Chairman of Commissioners. Galbally surmises that he might have objected to the withdrawal of Summers' sympathetic 'Casts of Aborigines from the life'.

[50] Galbally, *Redmond Barry*, pp. 168–9, and her *The Collections of the National Gallery of Victoria*, pp. 19–29.

Manufactures), which supported the radical government of Graham Berry. In 1877, spurred on by Sydney's plans for an International Exhibition in 1879, Berry appointed a Commission to organise a yet greater Exhibition, including among its members Felton's business associate Joseph Bosisto (but not Sir Redmond Barry). The triumphant outcome was the Melbourne International Exhibition of 1880–81.

Providing the community with 'the rudiments of modern art' was a major purpose of the Exhibition, and many hundreds of paintings were hung in the upstairs galleries of the great new building, built for the occasion and still standing. There Victorians could see the art which other countries thought their best, including over eight hundred pictures from Britain alone. Richard Twopeny (who thought the standard of pictures hung in Melbourne homes 'abominable') remarked that people 'like pictures somewhat as a savage does, because they appeal readily to the imagination, and tell a story which can be read with very little trouble'.[51] The extensive Australian exhibit was dismissed by the visiting critic from *Le Figaro* as 'very feeble': 'the Australian artists have the defects of the English painters without any of their good qualities'; but it included Buvelot's *Between Tallarook and Yea*, which won a Gold Medal and was later acquired by the National Gallery, and works by the young Tom Roberts and Charles Douglas Richardson, both recently suspended from the National Gallery School for being rebellious.[52] The picture most noticed was one from the large French Exhibition, the Academician Jules Lefebvre's elegant nude of 1875, *Chloe*, which was bought by Thomas Fitzgerald, a Melbourne surgeon. Exhibited on a year's loan at the National Gallery in 1883, *Chloe* aroused such protest when allowed to appear naked on the Sabbath that she had to be taken down.[53] She had already been attacked in 1880 as 'repugnant to British taste'; Melbourne collectors, like many in Britain, had virtually no interest in French art. Only German artists were admitted, by some, to rank with British; the German Gallery was the largest in 1880, and made a great impact, though not much was bought from it.[54] Indeed not many of the hundreds of works shown in 1880 were retained in Australia,

[51] Twopeny, *Town Life in Australia*, p. 42. Twopeny thought taste in prints a little better than in paintings.

[52] See Sheridan Palmer, 'Fine Art for Purchase and Contemplation', in Dunstan, *Victorian Icon*, pp. 131–6.

[53] The question of opening the Exhibition on Sundays had been debated in 1880. In 1883 the Town Hall was crowded for a meeting in favour of opening the Public Library on Sundays, with Higinbotham in the Chair and Charles Strong in support; a counter meeting called by the Sunday Observance League was not filled, and the cause was won (*Argus*, 4 and 8 May 1883). *Chloe* was, however, a casualty.

[54] Vaughan, Art Collectors in Colonial Victoria, pp. 56, 59; 'in a broad sense cultural life in Melbourne was increasingly dominated by Germans. Carl Kahler was the most publicized painter in Melbourne'.

International Exhibition of 1880 Building (*The Picturesque Atlas of Australasia*, vol. 1, 1886)

although Chief Secretary Berry aroused Opposition ire by buying some fourteen sculptures, mostly Italian, with public money.[55]

Purely local taste was revealed in the Victorian Loan Collection, where wealthy Melburnians exhibited their private acquisitions. A passion for collecting had certainly developed since the first loan exhibition of 1854, mainly among a handful of wealthy merchants; squatters were noticeably immune. In 1870, the

[55] LL Smith, soon to be a major figure among the Exhibition Trustees, defended Berry's purchases in the House, as did Bosisto. Daryl Lindsay de-accessioned the works in 1941–42.

Chloe—A Question of Propriety, 1883 (*Illustrated Australian News*, 13 June 1883, La Trobe Picture Collection, State Library of Victoria)

year the National Gallery School was founded, the Victorian Academy of Art opened 'for establishing schools for study of the various departments of the fine arts, and for exhibitions', with much optimism but uncertain success. Exhibitions of imported works for sale became more frequent; some were foreign, but English landscape remained the predominant interest of collectors, the 1875 loan exhibition including works by Turner and Morland, and several by Scottish

artists.[56] Although the Loan Exhibition of 1880–81 included works by (allegedly) Rembrandt, Sir Benjamin West, Salvator Rosa and Claude Lorrain, the local preference for British art persisted.[57]

It is to be presumed that Felton saw both the imported and the local pictures, though his only recorded comment on the 1880–81 Exhibition was a merchant's. 'We have had a great many visitors here during the Exhibition', he wrote to a colleague, 'and General trade has much revived . . .'[58]

IN 1881 FELTON became a member of the new Chamber of Manufactures, but characteristically did not seek to become a Council member; unlike Grimwade, who had joined the Council of the Melbourne Chamber of Commerce in 1875, at the age of thirty-five, and became its Chairman in 1882. Similarly, in 1891, Grimwade, though scarcely a zealous political partisan, became a Member of Victoria's upper house, the Legislative Council—over which his namesake and great-grandson was later to preside—while Felton merely observed the world of politics, with no ambition to enter it.

In 1884 Felton sent Grimwade, then overseas, a sharp account of the opening of the Victorian Parliament. After a period in opposition, Berry, his radicalism diminished, had returned to office in 1883 in a coalition of conservatives and liberals, sharing leadership with Felton's fellow-merchant, James Service, in a government which promised, and largely delivered, political stability. When Parliament opened in 1884 Sir William Stawell deputised for the Governor, and Lalor, the Eureka rebel, was Speaker of the Assembly; Berry had sat on one of the juries which acquitted the rebels in 1854, while Service had spent his first weeks in the colony in 'Canvas Town', and had learned his first politics at nearby Emerald Hill. Felton had many friends and acquaintances among those present.

> Parliament was opened last week, and for the first time I witnessed it, the largest crowd on record at an opening—such a collection in the Gallery of the sisters, and the cousins, and the aunts.
>
> I stood on the Steps a few minutes and enjoyed the play. I met Morris and his wife both looking palish. Dobson the jovial came up smoking his after lunch cigar, till I reprimanded him for pulling at a Stump in such a scene. Thompson Moore was

[56] Vaughan, *Art Collectors in Colonial Victoria*, pp. 8, 12, 5.

[57] The *Official Record of the Melbourne International Exhibition 1880–81* (Melbourne, 1882) listed all the works exhibited (pp. 506–31) and commented on some of them. Vaughan concluded that the exhibitions 'provoked in all fields a new enthusiasm to be up with the latest' (*Art Collectors in Colonial Victoria*, p. 48).

[58] AF to MF Mann, 26 November 1880.

shepherding the pretty women—various—he had asked to see the sight. When the grim Stawell had advanced to the Chair, I went into the tail of the crowd, till room was called for the Speaker, and the rubicund face of Lalor appeared followed by Service, Berry and the bevy of Ministers. At the door of the Council retiring room stood Sargood, twisting his [oiled?] moustache . . .[59]

Clearly the scene did not greatly impress Felton, but he knew that it was not all show. 'It is noticeable how quiet was the air of the <u>real</u> workers and real powers, and what airs the Jenkinses and the other small fry put on, but no more of this.' 'It is said Service and Co have a certainty for the present, and it is hoped that a fruitful session is inaugurate', Felton concluded, his attitude perhaps a little influenced by the number of Ministers who were fellow-members of the Australian Club; 'for a brief period the Club could be said to be at the centre of political as well as financial power', its historian has noted.[60] Felton had disagreed with Service over protection, but seems to have shared many other views with the man described as 'a merchant of large views and fine culture—at once a scholar and a man of business'.[61] Berry's earlier radicalism does not seem to have upset Felton, who was happy to gossip equally about both men when honours were rumoured, his report to Grimwade revealing also the importance of consorts in the determination of such matters:

Birthday honours—In our cablegrams from London came the news that Service and Berry were Knighted. I was up with Alcock that day and we both agreed it would not come off. First—the truly great man likes to be a great commoner . . . —Then the Lady would be in the way . . .[62]

[59] AF to FSG, 16 June 1884. Frank S Dobson (1835–95), a barrister, was a member of the Legislative Council from 1870 until 1895 but refused to accept a portfolio. When he was appointed University lecturer in Law in 1863 it was objected that 'being a good flute player is not a qualification for a law lectureship' (Elizabeth Barrow, *ADB*, vol. 4). (Sir) Frederick Sargood (1834–1903), Minister for Defence—Victoria's first—in the Service–Berry ministry, was a leading Melbourne merchant. Arrived in Victoria in 1850, he joined his father's softgoods firm after time on the goldfields. Sargood built the mansion 'Ripponlea' in 1868–69. A Congregationalist, he was also President of the Metropolitan Liedertafel. (John Rickard, *ADB*, vol. 6.) Jenkins was presumably (Sir) George Jenkins (1843–1911), Clerk of the Legislative Assembly.

[60] 'By 1883 half the upper chamber belonged to the Club', de Serville, *The Australian Club*, p. 30. Felton soon reported, however, that 'Service and co have made a great blunder in shelving the Tariff report' (AF to FSG, 28 July 1884).

[61] BR Wise, quoted in Geoffrey Serle's entry on Service in *ADB*, vol. 6; on Berry, see Geoffrey Bartlett's entry in *ADB*, vol. 3.

[62] AF to FSG, 2 June and 31 June 1884. 'Alcock' was probably Randal James Alcock (1853-1927), who had joined James Service and Co as a boy, rose to be managing partner by 1888 (when aged thirty-three) and bought the company when Service died in 1899 (entry in *ADB*, vol. 7, by Roger C Thompson); but was possibly Henry Upton Alcock (1823–1912), who arrived in Melbourne in 1853, tried the diggings, and became a very successful billiard table manufacturer (see entry on his son AU Alcock by GB Lincolne in *ADB*, vol. 7).

Opening of Parliament—Interior of Legislative Council Chamber, 1864 (Samuel Calvert, *Ilustrated Melbourne Post*, 25 February 1864, La Trobe Picture Collection, State Library of Victoria)

Service's marriage had broken up in the 1850s, and he lived with and had several daughters by a woman he never married. His public position muted gossip, but not to the extent that he was ever knighted. Berry's knighthood was shelved also, which Felton thought 'hard on' him—'for his missus would wear his budding

honours and distinction well'. Berry was eventually appointed KCMG when Agent General in London in 1886.

The Queen's Birthday was not the only event celebrated on 31 June 1884. Economic involvement in other colonies had given many Victorians a broader than local perspective, prompting some to urge federation of the Australian (or indeed of the Australasian) colonies. In 1883 Victoria abolished the Separation Day holiday it had celebrated since 1851, and began to champion the adoption of 26 January, date of the landing in Sydney Cove, as a national day. Victoria made 26 January a holiday (as Australian Natives Association day) in 1888; in the interim a composite holiday was held on 1 July, as Felton described in 1884: 'today is Separation Day and made to represent Queen's Birthday all in one, so holiday reigns more or less through the town'.[63]

By this time Felton easily identified himself as an Australian, distinguishing himself from the English of England. He was not concerned to define that identity precisely, in the manner which became 'a national obsession', increasing in intensity in the late twentieth century.[64] In Felton's time loyalty to Victoria and to the Empire could be distinguished while both were maintained. George Higinbotham's outspoken (and legally questionable) insistence on full self-government within Victoria in the 1870s had forced the colony into constitutional crises severe enough for the Colonial Office to assume he was a dangerous separatist—of whom there were but few in Victoria—but London seemed not to notice that Higinbotham was equally insistent on elevating Imperial powers in all matters external to the colony, to the point of later opposing proposals for Federation. To other, less rigorous, Victorians, loyalty to Victoria, to Australia and to the Empire were seldom seen to conflict: Australian nationalism and Imperial loyalty, to Britain and its Crown, more often reinforced each other, and one of the early motives for Federation was to create a single, and therefore stronger, Australian voice in the councils of the Empire. That Felton shared these views is shown by his subscribing to both the Federation League and the Imperial Federation League, which aimed to reorganise the Empire itself on federal lines; but it was not in his nature to take a public lead in such matters. He wished to mind no business but his own.

[63] AF to FSG, 1 July 1884.

[64] The phrase is White's, in his *Inventing Australia*, pp. viii, 72–3.

4

MERCHANTS ADVENTURING

When Grimwade delivered his presidential address to the Melbourne Chamber of Commerce in 1883, he deplored the bitter political conflicts of the 1870s, and looked forward to 'practical' government, sound administration, railway building, support for irrigation and improved public health.[1] Victoria did receive some of those things in the 1880s. Its railway network—the 'octopus' which enforced Melbourne's dominance over the provinces—more than doubled in length between 1881 and 1891, new Melbourne suburbs were built to house an influx of people from the goldfields towns and to meet a rising marriage rate, and new mineral discoveries, mostly in other colonies, brought opportunities to invest Melbourne's money.[2] There were thus good reasons for Victoria's economy to expand, but unfortunately growth was overlaid by a succession of speculative booms, especially in urban and suburban land. At long last incorporation began to be preferred to partnership, and with little regulation companies were floated recklessly: the Great Centennial Land Distribution Company even proposed to distribute land by public lottery. Drought and an Australia-wide recession in 1886 caused a brief interruption, but London financiers, facing German and American competition in other markets, were all too willing to pour cheap money into Victoria, eventually to reach the clients of banks and land companies diligent to lend but not to check credit worth. Land prices went ever higher, and the boom was boosted by speculation in mining shares. The Victorian Boom of the 1880s,

[1] The address was printed in full in the *Argus* and *Age*, 14 April 1883.

[2] Graeme Davison (*The Rise and Fall of Marvellous Melbourne*, p. 153) rightly argues that the building boom of the 1880s was more soundly based than was commonly supposed. On the boom and bust see Serle, *The Rush to be Rich*, and Michael Cannon, *The Land Boomers*. Kilometres of railway in Victoria grew from 444 in 1871 to 4448 in 1891 (*Victorian Year Book 1984*, p. 720).

simplified from its complex reality, became archetypal in Australian economic history, and 'land boomer' a pejorative term for an unscrupulous pattern of business behaviour common in a sector of Victoria's business community but assumed to be universal, bringing disgrace upon 'marvellous Melbourne'.

Geoffrey Serle has noted that many of the most prominent boomers were 'new men': 'the old squatting-mercantile-financier group of leading businessmen' largely steered clear of land and building speculation, as did 'rising manufacturers', like Felton and Grimwade, 'determined to finance their own growth'.[3] Manufacturers did begin to convert their partnerships into companies in the mid-1880s, though many still eschewed them, for reasons stated by biscuit-manufacturer TB Guest to his son:

> there are plenty of lunatics not locked up yet ... Byron Moore and JH Were have waited on me and promised to float this business in one hour for anything I like to ask but I am not yet persuaded that it will be the correct thing to do ... you know how companies are run not so much to do a legitimate business as to do plenty of it and ... chances are there would be no profits to anyone ... The fact is almost everything goes off now and I think before long there will be a big crash.[4]

That the term 'land boomer' retained overtones of disapproval in Melbourne even a century later arose in part from genuine moral disapproval of financial chicanery, if also from the residual snobbery of old money towards new. Felton and Grimwade were not particularly snobbish about their success, though certainly proud of it; five water-colours commissioned about this time formed the basis for a triumphantly elaborate wood engraving of *Felton Grimwade and Co's Factories* which appeared in the *Australasian Sketcher* in March 1884.[5]

In 1883, after busy years as President of the Chamber of Commerce and as a member of the Royal Commission on the Tariff, Grimwade became ill, apparently with kidney trouble, and a long visit to Europe was prescribed. He left in March 1884, taking his wife and most of their children with him, and remained overseas until October 1885, longer than originally planned.[6] Edward Bage, a partner since 1881, was given effective control in Flinders Lane—'my young

[3] Serle, *The Rush to be Rich*, p. 267.

[4] TB Guest to son, 29 March 1888, quoted in Rob McQueen, 'Limited Liability Company Legislation', p. 62. McQueen points out (p. 63) that the rate of incorporation fell with the end of the land boom, but manufacturers' incorporation continued at about the same rate in the 1890s.

[5] The water-colour of the Glass Bottle Works was last noted sold through Sothebys in 1994. The other four, and another of the Flinders Lane Warehouse, are in the University of Melbourne Art Collection.

[6] Bogatzky's *Golden Treasury* records that FSG had 'returned home ill' from a visit to Sydney with his eldest son.

H Byron Moore (Julian Rossi Ashton, *The Australasian Sketcher*, 16 January 1881, La Trobe Picture Collection, State Library of Victoria)

partner has got all things very well in hand and so in this department of life "all goes merry as a marriage bell'", Felton noted—but as senior partner he took overall responsibility for the several businesses, as usual consulting Grimwade on major decisions.[7] At fifty-three, Felton was at the peak of his skills, as merchant, manufacturer and investor, and his frequent letters to Grimwade gave an unusually frank account of his activities over these months.

[7] AF to TWK, 30 September 1884: 'Business is going along briskly'.

LATE IN THE evening of 5 May 1884, two months after Grimwade's departure, Felton sent him a long letter, ominously headed 'Do not alarm yourself <u>all being well</u>'. He had begun the letter that morning—'little thinking that the most eventful thing affecting us would remain to be chronicled in the history of the day'—and had lunched late at the Club; returning, he noticed a crowd at the end of Flinders Lane, 'and on reaching the group was told our place was on fire. I rushed down as soon as my game leg would carry me ... There was considerable alarm abroad owing to the loud reports which came every few minutes from the scene'.[8]

He found a better state of things than he feared; the back of the Store and the Drug Room were filled with fumes and smoke, but 'there was not a spark of fire there'.

> The Vault has been our preserve: it was in a desperate state of incandescence. The fireman with two powerful hoses were flooding it with water, but the terrible combustibles burned on from 2.30 to 5 o'clock
>
> Poor Cowley—who has borne much of the heat and burthen of the hour—reported matters to me on my coming in. Whilst he was speaking loud reports from the Vault told that the Brigade had not altogether mastered the fire. (Indeed for an hour afterwards the flames broke out at intervals.)

From the Vault a huge flame had rushed up the wall to the roof, cracking the Essential Oil Room windows; 'the reports below sent the glass flying'.

> Here Mr Pritchard with his aides was most useful; with buckets of water they kept this assailable point clear of fire. Louis Court did this same good office through the broken window of the [Lab?] floor. There was much more done by our men that I cannot describe, but I hear that Brodie faced the Vault with our Hose till the Brigade arrived, [illegible] manfully at work on the burning mass ...

The firemen, having smothered the fire, began to remove the contents of the Vault, an extraordinary conglomeration of hazardous substances. 'Strange to say from out of that Vault came nearly all the Naphtha, and Benzine, nearly all the cases of Turps, Ether, Chloroform, Sodium, Potassium, and the metal packages of Bisulphide.' Felton could 'only regard the escape of our Buildings, and immensely valuable stock, as a providential mercy'. 'The first element of the mercy was the Vault, which as you remember was an idea and design of mine when the building went up.' The loss was 'wonderfully small for the alarming nature of the fire ... when with this volcano at work for two hours, I now walk

[8] The account is given in AF to FSG, 5 May 1884.

through our long piles of merchandise, I feel a sense of thankfulness that the damage has been providentially overcome'.[9]

The fire had however been spectacular enough to alarm the public. The loud explosions had 'sent some people into fits, and many friends rushed up from all parts to learn the tidings'.

> Poor little Mrs Bage came up with pale white face. Charley Bage [Edward's younger brother, later Felton's doctor, and later still Chairman of his Bequest] came up and as he came along the Lane looked for the first signs of the charred ruins. He as well as scores of others left us with congratulations at our escape from a terrible catastrophe.

The fire out, Edward Bage went home 'to make the little wife composed'. 'Bage will write you when he returns from Tea', Felton concluded, 'and in his quiet way will give you details I may have left out.'

> I have conferred with him and Cowley as to the origin of the fire—the item that combusted—but we cannot solve it. Cowley can only suppose that one of the four tins of phosphorous put up at the Factory leaked, and having destroyed the tin burst into flame ... The odour of phosphorous reigns supreme.
>
> The debris of the fire has been put into casks and topped up with water. Now that darkness has come on the yard and gangways in the store are smeared with phosphoric light, showing how intimately the substance is bound with the Catastrophe.

Cowley's surmise proved incorrect, as Felton later reported. 'The demon phosphorous' had indeed been the agent, but made dangerous by 'disobedience of orders'. Felton had instructed that phosphorus be kept in a tank under water, but the tank was too small to take a whole case, and some of the phosphorus was put on the shelves. 'Hence the accident. This I am afraid will cost us dear.'[10] Felton claimed that he had been 'always grumbling' about unnecessary stocks of dangerous goods kept on the premises; 'now we will work a change. I will build a large shed with floor room to keep all these goods in separate groups down in the Chemical Works'. The matter was not for him alone to decide: the fire 'caused quite a Commotion among the Companies and in the City', and a deputation went to the city authorities about storage of explosives.

[9] Other 'elements in the providential condition of the day' were 'the hour—when all our people were about at their best—Bage, Cowley, Edridge and Isaac, and all others being there' and the 'grand force of the water today and our energetic firemen, everyone doing their utmost with admirable good will and composure ... As you know I had a lot of Nitric Acid removed; this was good, as from the wall a posse of firemen could play on the burning side of the Vault'. The letter concluded, 'I know you join me in thankfulness to providence and secondarily to, our employees for the energy in quelling this danger and averting what might have proved a very great calamity indeed. I am, My dear Grimwade, Yours faithfully, Alfred Felton'.

[10] AF to FSG, 19 May 1884.

> Meeting Parsons [Secretary of the Adelaide Insurance Company] in the Street I told him the amount of damage done, about £500, and he said, looking at the pile of buildings that surround us, it might have been half a million.[11]

The insurance claim was settled for only £550 for goods and £10 for damage to the building. 'With a blazing volcano at work underneath for two mortal hours, this fact must speak volumes in favour of our Vault in its construction.'[12] But the firm's insurers returned next year's premiums, refusing to accept the risk; Felton asked Grimwade to try to get insurance cover in London. 'Now that the steed is stolen we are going to shut the stable door': 120 drums of Naphtha were to be sold. 'Such materials must not again be stored in quantity' on the premises; and in rebuilding the Vault 'we shall put our Strong room on the telephone, so that at certain degree of warmth they will ring up the Brigade'. (The telephone was presumably linked to the Melbourne Telephone Company, a rudimentary exchange set up by Henry Byron Moore two years before London had one.)[13] Apparently these arrangements proved acceptable to the authorities, and eventually to the local insurers.

THIS NARROWLY AVERTED catastrophe did not interrupt the steady growth of Felton Grimwade's business in the 1880s. A month after the fire Felton told Grimwade that Flinders Lane was very busy, though 'I do not go much upstairs'. The staff were stocktaking, and 'Bage in a mood to get the pricing done'. The Jeffcott Street factory was also producing well.[14] The partners had earlier decided to expand the capacity of Flinders Lane, and had plans ready to add two new storeys, but now decided to build storage at Jeffcott Street first. The Flinders Lane additions were not completed until 1888.[15]

Felton had advanced views on advertising, reporting proudly that it had increased sales of Nestlés from 30 to 50 cases in the previous month. His enthusiasm grew:

> Some day we must initiate an advertising department. We spend £2000 per annum, more or less—skill and knowledge are required to make this really worthwhile

[11] AF to FSG, 19 May 1884. Charles Robert Parsons was also a committee member of the Australian Club.

[12] AF to FSG, 19 May 1884.

[13] AF to FSG, 2 June 1884. The exchange had 1100 subscribers when he eventually sold it to the government in 1887 for £40 000, a price many thought exorbitant. Moore also founded the Melbourne Electric Light Co, lighting up the Eastern Market in 1880, to general astonishment (Suzanne G Mellor in *ADB*, vol. 5).

[14] AF to FSG, 2 and 31 June 1884.

[15] The partners still owned Youngman's warehouse in Russell Street in 1884 (AF to FSG, 14 July and 11 August 1884).

The Telephone Room, Melbourne Exchange, 1881. Note that the operators are young women; the one on the left is recording calls with a quill pen. (Julian Rossi Ashton, *The Australasian Sketcher*, 29 July 1881, La Trobe Picture Collection, State Library of Victoria)

—first invention; second astuteness in the purchase of spaces. I take it a very special knowledge is required in this—keep your eyes open—much may be learned by the study of what others do.[16]

He also suggested that Grimwade buy up quinine if cheap enough; 'this article should be well watched'. Six months later Grimwade, embarrassed, thought he had bungled the matter; Felton assured him he had done well, though missing a 'coup'.[17]

Felton's generally favourable view of the business did not prevent him sending Grimwade a depressing account of some of their pharmacist customers. Rose 'was as big a fool as ever'; he made bad business decisions, and 'had again entered matrimony with rather a disreputable party'. 'Whittle is still a blister and shows no signs of improvement either in his common sense or in his cash account. We have to pound into him now and then, and then there come complaints from a very ill used man.' 'Bastrick's is a forlorn case, he has growled and grumbled every customer out of his shop …' 'I hear that Noakes of Dandenong has taken to drinking and is so far gone as to require asylum at Harcourt's or McCarthy's asylum.'

> Your Hibernian friend [illegible] of Echuca is a broth of a boy—vide sundry legal reports in the *Argus*, Laing v somebody or other. The ladies seem to move him much, although these events may have been before his elopement with the widow Affleck—if you will remember this last named event caused a sensation. I daresay he sometimes wishes he was Robinson Crusoe and beyond trouble.

Age took its own toll: 'Poor old Rastrick and the poor old woman are both I think a little off their heads. They both go into a cottage'. Rastrick had wanted to sell, but had 'let the business down to nothing'. Bage sold the stock for him.[18]

Fortunately there remained some good prospects in the profession. Felton reported lending a man £2570 to buy a business: 'Bage thinks a few years will see him clear'.[19] Hard work, especially by Bage, enabled Felton to send Grimwade the 1884–85 accounts as early as 10 July, with a covering letter proudly drawing attention to the results achieved in Grimwade's absence.[20] Business was good, and improving; the partners' income in profit and interest rose steadily, though

[16] AF to FSG, 15 June 1885.

[17] AF to FSG, 16 June and 17 December 1884.

[18] AF to FSG, 14 and 24 July and 22 September 1884.

[19] AF to FSG, 22 September 1884. Nevertheless he described their vigorous competitors Rocke Tompsitt's and Co as 'our brave young friends' for lending money to another chemist (AF to FSG, 24 July 1885).

[20] AF to FSG, 10 July 1885.

Flinders Lane, c.1883 (showing new telephone wires) (Nicholas Caire, photographer, La Trobe Picture Collection, State Library of Victoria)

not without fluctuation, until 1890 when total profit reached a peak of £26 642. In that happy year the firm's wage-book reveals that fifty-seven men and boys were employed at Flinders Lane at wages ranging from £5 10s to 8 shillings per week, with an average of a little under £2.

BOSISTO'S WAS ALSO doing well with eucalyptus oil, though Joseph Bosisto was increasingly committed to his public career. He had become a prominent figure in the colony, as Mayor of Richmond and a member of the Legislative Assembly.

'I still wait the opportunity of a Conference with this gentleman', Felton told Grimwade in June 1884, 'Parliament detains him now, but I must see him soon'.[21] Bosisto was also a founder of the Pharmacy College, and in July Felton went to a lunch given by the Pharmacy Board to open the new Hall of Pharmacy. Bosisto responded to the toast to the Board 'with a plain unvarnished tale—the history of pharmacy in Victoria'. Felton thought the Hall, in the old County Court, looked 'good', with a classroom and 'a bevy of fresh faced young students'. He promised a substantial present from Felton Grimwade & Co; in the end they gave £100.

In 1884 Bosisto was appointed Victorian Commissioner at the Indian and Colonial Exhibition, to be held in London in 1886. 'Bosisto was in today', Felton wrote in December:

> The good old fellow was a little down, his wife is very ill; quite confined to her room now. Yet he has a great spring of juvenescence about him and he looks forward to the Exhibition in London in 1886 which is to be under his charge, and a fine position in the great European world—may his hopes be realised.[22]

Bosisto's temporary withdrawal from the business prompted Felton to foreshadow, in July 1885, 'a great change in the Bosisto Oil concerns'. The Mallee company was merged with Bosisto's original firm in a new partnership called J. Bosisto and Company, with Felton and Grimwade each putting in five-eighteenths of its capital. The new company was solely a manufacturer, Felton Grimwade's undertaking not only distribution but all the necessary book-keeping and correspondence.[23]

Felton's mood in the 1880s was seldom bullish. Writing to a friend in 1880, he had reported that 'general trade has much revived, but competition in the manufacturing branch has brought profits on this class of good down to a very low ebb'.[24] In his reports to Grimwade, Felton was nevertheless optimistic concerning the Glass Works, long his especial responsibility. In the winter of 1884 'guerrilla warfare' by some British manufacturers sneaking in discounted soda water bottles upset importers; 'we must make it the last occasion for these gentlemen', he wrote determinedly. With the new 'house' recently added, 'the Glass

[21] AF to FSG, 16 June 1884.

[22] AF to FSG, 17 December 1884. Bosisto received a CMG while in London.

[23] AF to FSG, 10 July 1885. Bosisto, Felton and FS Grimwade bought out C Smith, G Graham and the estate of JG Francis in 1885 and formed a new partnership with Bage to run the whole business.

[24] AF to MF Mann, 26 November 1880.

Messrs Felton and Grimwade Factories, 1884: 'The aspect of the place is altogether one of busy and thriving industry' (*The Australasian Sketcher*, 12 March 1884, La Trobe Picture Collection, State Library of Victoria)

Works looks hopeful and well, and I hope one or two good seasons will clear the works'.[25] But a few months later, when part of the new house broke down, he had to concede that 'this ever troublesome business puts in its phases of disaster pretty continuously'.[26]

Matters improved in the Spring: 'I went down to the Glass Works about a week ago. Both Houses were in full work, there was a great show of Bottles about, in fact a large stock; there was a very prosperous look about the place, every department seems very effective'.[27] Analysing the Balance Sheet in June 1885 he concluded 'you may consider the Melbourne Glass Bottle Works an accomplished fact' (unlike Elliott's works in Sydney, closed with a loss of £13 000). Moreover, wages had been 'liberal': 'Mount estimates that concessions to the men that they were not really entitled to have cost £1000 during last year'. Though pleased with success, Felton remained restless to do better still: 'I regret I did not press upon you the desirability of seeing Glass Bottle making in the States ... If I _ever_ do get to Europe I shall look all these things up for myself'.[28]

In May 1884, having reported progress at the Glass Works to Grimwade, Felton added with obvious frustration, 'I wish I could say the same of Salt!!' The Salt Company and its plant at French Island drifted on, 'a most discordant piece of work'; 'as usual no plan, no estimate, no figures are before us'. In March 1884 he warned Cheetham that 'it is not wise to proceed in any undertaking without counting the cost, and in all the plan of the salt marsh, this plan must be rigorously carried out'; by December he told Grimwade that 'with you I have lost confidence in Cheetham's management'.[29] In May 1885 Felton complained again that he lacked an 'estimate of our opportunities'. 'It seems strange to me, at the price of

[25] AF to FSG, 19 May 1884. The firm planned to make soda water, patent soda water, pickle, bitter, whisky, and other bottles sufficient to 'place us in a position to fill every order and fight importations completely'. A failed competitor had been bought out and the assets realised: 'Buckhurst [a leading estate agent] has sold for us the land from which we moved the old Thwaites glass house ... and so closes the last chapter of an affair that has been a trouble and loss to us, and a trouble and loss to the stupid originators'. 'Poor old Thwaites, he is muddling along at St Kilda.' The Works had just sold Montgomery and Co 1000 gross soda water bottles, and banked £975 (AF to FSG, 2 June 1884).

[26] AF to FSG, 17 December 1884.

[27] AF to FSG, 2 and 16 June 1884 and 20 April 1885. After careful enquiry into which was the best patent bottle to manufacture, Felton asked Grimwade to find a supply of stoppers for the 'Lamont Stoppering Bottle' (AF to FSG, 11 August 1884).

[28] AF to FSG, 2 June 1885.

[29] 'Cheetham cannot be left with the full management of affairs.—A man suitable for the business must be got either here or from home', AF to FSG, 19 May 1884; AF to Richard Cheetham Esq, French Island, 27 March 1884; AF to FSG, 17 December 1884.

salt here, that we cannot carry this thing successfully through. There is about £10 000 already spent—is this to be lost, or is it to be utilised?' Could Grimwade 'get practical acquaintance with the subject . . . from some working place'?

> Will a few days suffice to get you a private and interior view of this business, and can you mount the breach and save this company . . . What we want to know is, can salt be made here economically. The marsh holds the brine well—that difficulty is solved—then comes the question of economically working. How is it to be done?[30]

Later Felton had a twinge of guilt: was he pressing his allegedly ailing partner too hard? 'Just act as you feel inclined, and whatever you do in this I shall be content.' But he worried on in successive letters: 'it appears to me the thing ought to pay . . . the muddle first and last is—Cheetham . . .' In June, on the eve of a meeting on salt, he confessed that he did not 'know what to do in it. The industry is right—but the Cheetham is all wrong. He is deaf, irascible and was so insulting the other day, as well as ungrateful for what we have done for him, that I told him not to come in again'.[31] Another meeting resolved (against Cheetham's vote) to wind up the company; he was instructed to dismiss all men not needed for finishing off salt in preparation for sale. Apparently he disobeyed, for later in 1885 Grimwade, returned, gave him peremptory notice that the other partners would not undertake further liabilities. In 1886 they bought out Cheetham's interest in the company, and reversed the decision to wind up operations. The remaining partners had faith in the works, but not in Cheetham, a mistake which proved costly; two years later Cheetham established new Salt Works on Corio Bay, and prospered, while the Australian Salt Manufacturing Company struggled on in search of profitable production.

EVEN AS THE boom of the 1880s gathered strength, Felton found much to justify the native caution which led him to avoid entanglements he could not control. Cycles of boom and bust seem simple only in retrospect; at the time, the surges and eddies of daily business life make it easy to get wrecked, even when others are riding the crests. In 1884 Felton told Grimwade of one such castaway, William John Greig, who had fled the Colony and his debts:

> Since I wrote you last, Greig's House, Lands Pictures, Books, Plate, Equipages and furniture have been brought to the hammer in seven days' sales . . . The pictures and

[30] 'We have already put into this £1950 and are responsible for £500 more. Is it worth while to make pertinent enquiries on the head?' (AF to FSG, 5 May 1885).

[31] AF to FSG, 15 June and 24 July 1885. 'Are salt works managers to be got, and for what sum?' (AF to FSG, 29 May 1885).

books were sold at Frazer's Rooms. It is a sad picture this—the man flying from such surroundings … Anyhow there is a complete break-up there, to the last stick, all spread to the winds.[32]

Hubris has its own cycle. Felton was told that the fall of Greig 'may be dated from his joining the Melbourne Club. He essayed to imitate Standish and that ilk—imitation does not do—the fable informs us—one man's meat is another man's poison'.[33] The mansion—in Toorak, the newish suburb south of the river, where (the *Argus* reported) 'the crème de la crème of the upper classes' had their 'splendid chateaux'—failed to sell at auction, and Felton later suggested that Grimwade might buy it.[34] 'If on your return you desire to pitch your tent among the Toorak quality it may suit you to work an exchange, to sell Harleston and buy Orrong House.'[35] Grimwade, who had leased Harleston to John Riddoch of Penola while he was away, did not sell; instead the 'Toorak quality'—or rather their sons—came to Harleston: after Jessie Grimwade's death her sons gave it to Melbourne Grammar School, and as Grimwade House it still stands as a preparatory school.

A host of miscellaneous projects crossed Felton's desk. He made a personal loan to a Kyneton chemist, perhaps the occupant of a property on which Felton and his friend Henry Francis held a mortgage. In 1875 he lent money to HC Armstrong, a chemist in Wilcannia, on the distant Darling, and to another in newly-established Broken Hill in 1883.[36] Mr Koch, of Sandridge, had a 'plan for extracting fine Gold

[32] AF to FSG, 2 June 1884. 'WJ Greig and Co, merchants and agents', are prominent in the directories up to 1883, then disappear. Greig was elected to the Melbourne Club in 1872, and was also a member of Union Club (de Serville, *Pounds and Pedigrees*, p. 301).

[33] FC Standish, described in detail by Paul de Serville in *Pounds and Pedigrees*, ch. 2 ('A Clubman's Life'), was not at all a good bourgeois model. Son of a one-time companion of the Prince Regent, he came to Victoria under an assumed name to escape his debts, became assistant gold commissioner at Sandhurst and Protector of the Chinese, and from 1858 Victoria's Chief Commissioner of Police. His diary records his elegant, indolent life. From about 1872 until his death (from cirrhosis of the liver) in 1883, he lived at the Melbourne Club; in 1882 he was nearly thrown out of one of its windows by a stout fellow-member insulted by the greeting 'What ho! Jumbo!' (McNicoll, *Number 36 Collins Street*, pp. 102–4).

[34] *Argus*, 6 September 1884, quoted in Davison, *The Rise and Fall of Marvellous Melbourne*, p. 150. Another failure in the 1880s was the drapery shop Robert Poynter had established in fashionable Smith Street, Fitzroy, in the 1850s. After the formidable Mark Foy opened in competition, Poynter quit in 1885 and moved to Avoca, where his stepson established a short-lived 'Avoca Music Academy'.

[35] AF to FSG, 25 August 1884. Later still Greig was said to have dined in London with Robert Murray Smith, then Agent-General, and appealed to return to Melbourne, but was threatened with prosecution. Felton reported that Greig's family had returned to Melbourne: 'they could not do with Sydney'. Miss Greig played Lady Macbeth in the 'Olde English Christmas Show' (AF to FSG, 17 December 1884).

[36] AF to Land Mortgage Bank, 2 September 1880; FSG to HC Armstrong in Wilcannia, 30 October 1875, and AF to Armstrong, 27 November 1883.

from the matrix', and a syndicate—facilitated by and possibly including Felton—supported him.[37] In 1884 Felton's advice was sought by the remarkable Dr S Mannington Caffyn, medical practitioner, charity reformer and author of two bad novels and of *Quacks and Quackery, being a short exposition of homeopathy, bone-setting and other anomalies found in these colonies and elsewhere*. His wife was later a much more prolific novelist (under the pseudonym Iota), and their home in Brighton—then, unlike now, more bohemian than St Kilda—was soon to attract and influence the young painter Charles Conder. ('It was here, for the first time, that I saw the coastline of Bohemia, twinkling, and dangerously beautiful', Hugh McCrae wrote of the Caffyn house.) Caffyn had invented an 'Improved Liquid Extract of Meat Compound', but Felton advised him that it was definitely not possible to form a company to develop the idea. 'Your present method of introducing it, and developing it gradually, is the best and surest method of securing a lasting success for it. Nestlé first made his 'Milk Food' in a saucepan and fed the children of a Swiss Village, and it is now all over the world ... I will if you like try introducing it in sundry places for you.' Although Felton warned Caffyn that the 'invention might not be patentable', being merely an unusual application of 'known preservatives', the doctor's patent application was successful, and he later did form a company in London (with Lady Loch's brother a director, and other aristocratic patronage) but sales of 'Liquor Carnis'—a title pitched to attract the vulgar and the learned alike—were meagre. Felton's advice had been sound.[38]

Despite a brief recession, Melbourne's mood remained optimistic. Henry Byron Moore, who was by nature so, branched out into all sorts of activities:

> I saw Byron Moore the other day in his office. He had a lot of Noah's Arks, Churches, schools etc. He was making the Bishop a map of his diocese, and planting a Church here and a schoolhouse there. The Bishop feels fagged with his wide-ranging territory. What a useful man B M is! He is getting out his Lynch Park Scheme. I intended to send you the pretty Books he has got up by this mail, they shall follow next. 'Art applied to Land Sales'. With these you may be able to teach the old folks something.[39]

The scheme (actually called Grace Park) was based on William Lynch's large estate in Hawthorn, which Byron Moore had bought and tried to sell, subdivided, on

[37] Felton nevertheless chided Koch for giving his address only as 'Sandridge': Sandridge was 'a straggling place, and Koch is a good mining name there' (AF to Koch, 12 March 1884).

[38] AF to Caffyn, 3 June 1884. On Caffyn and his wife, see Ann Galbally, *Charles Conder*, pp. 38–41, and (on McCrae) pp. 29 and 39; and Geulah Solomon in *ADB*, vol. 3. Weston Bate describes the Caffyn home in *A History of Brighton*, p. 289.

[39] AF to FSG, 16 June 1884.

fifty-year leaseholds. The scheme did not go off well; 'our people do not understand leases', Felton concluded.[40]

People certainly understood the import of a bank failing. One swallow anticipating the end of the 1880s summer was the Oriental Bank Corporation, forced to close its doors without warning in May 1884. The crowd gathering on the pavement in Queen Street saw the wealthy TB Payne in the adjoining lane, hauling off in a dray his own safe of strong boxes.[41] The trouble was not local—the bank, based in London but with branches spread from India to Japan and twenty-two offices in Australia, had lost money on coffee in Ceylon and sugar in Mauritius—but the scare in Melbourne was real enough. It was followed by another, fortunately unfounded, about the London Chartered Bank; Campbell, who had £12 000 deposited there, 'said it gave him a turn'; 'he has since placed his cash among friends at easy call'.[42] Felton had another friend with an account with the Oriental 'on the right side—nothing like a good overdraft when your Bank stops'. Charles James Hepburn, chairman of the OBC in Melbourne, was 'much troubled' with the stopping of his bank; the 'old fellow stayed away from the Australian Club 'till his friends wouldn't have it' and insisted he come to lunch. The Oriental was the Club's banker; it renewed itself, as the New Oriental, repaying its Australian depositors, but in the meantime lost many customers (including the Club) to its rivals.[43]

In April 1885 Felton reported an invitation refused:

> Parsons is getting up a Company to be called the 'Australian Property and Investment Co'. He has a grand provisional Directory including Couche, Bruce, Langdon, and thirty other great names. They want me to go in for it, but I think not—my ventures are enough. I suppose our good friend Parsons wants a vent for some of his unemployed time and energy.[44]

[40] AF to FSG, 14 July 1884. Moore went bankrupt when the boom burst, though largely by coincidence (Cannon, *The Land Boomers*, p. 396), and continued more modestly.

[41] AF to FSG, 2 June 1884. On the crash, see Blainey, *Gold and Paper*, pp. 127–8.

[42] AF to FSG, 14 July 1884.

[43] AF to FSG, 19 May 1884; de Serville, *The Australian Club*, p. 30. One of the reasons Felton was late discovering the Flinders Lane fire was talk over lunch about the closure, which had happened the day before. CJ Hepburn had been elected to the Club in 1879; he resigned in 1890. The Bank's manager, JL Ogilvie (also a member of the Australian Club), went to Sydney to manage the Melbourne Commercial Bank there; before he left he became engaged to Payne's daughter, prompting Felton to remark that 'Ogilvie has not spent his time here in vain"(AF to FSG, 2 June 1884).

[44] AF to FSG, 20 April 1885. Henry Joseph Langdon (1822–98) was a merchant, founder of the firm of HJ Langdon and Co (which still exists) and Parson's father-in-law. William Wilmot Couche (1830?–90), merchant, was a partner in Stuart Couche and Co and an old friend of Felton; Felton included his son, Reginald S Couche, in his will. John Munro Bruce, merchant, was a founder of Paterson Laing and Bruce, and father of SM Bruce, later Prime Minister.

Aware that businessmen are an emotional and nervous breed, Felton noted in May 1884 that 'there is much grumbling abroad, but I do not think that we have cause to complain'. 'If City lands are any criterion things are not going down in Melbourne', with £820 a foot paid for a small site in Collins Street.[45] Within weeks of the OBC closure Melbourne's business community was excited by the beginnings of the Broken Hill silver boom which was to spark the mining speculation of the next decade, but Felton—like the more conservative among Melbourne's bankers and businessmen—remained calm:

> The town has been all agog with the 'Barrier Ranges' silver mines ... I have kept entirely out of the fever, don't want the profit or the loss, but some of the venturers have made large sums by selling out ... Anyhow silver is talked every where—the mountains of precious ore—the richness of some of it—nearly all silver—and so on. This restores to Melbourne for a time its old character as the centre of the Australian El Dorado. In regard to it I trust it may be a bountiful success, but I don't want to have anything to do with it.[46]

His ledgers show, however, that he had the Melbourne habit of making occasional small purchases of mining shares. He continued to be an active investor, placing varying amounts in a range of ventures, from the Ararat Gas Company to the Riverina Frozen Meat Company Limited, the Australian New Hebrides Company and later the All Nations Mining Venture in distant Coolgardie; but the money was his own, and not borrowed.

IN FACT FELTON was sceptical of Melbourne's future. In 1884 he discouraged a young man from seeking a position there, advising that for four or five years trade had been advancing more briskly in New South Wales and Queensland.[47] In March 1885, after an extended visit to New Zealand and a 'disagreeable passage' thence to Sydney, he found there 'matters of great interest', beginning with difficulty in getting a decent breakfast. 'Such has been the development of things in Sydney—Trade, Commerce, Pleasure—that the Hotel accommodation is altogether inadequate'. He had not been in Sydney for three years, and was 'much interested in noting the great signs of progress there'. Sydney itself seemed 'like a grand city in process of being built'.[48]

[45] AF to FSG, 19 May and 16 June 1884.

[46] AF to FSG, 14 July 1884.

[47] AF to Edward Cousins, 1 August 1884.

[48] Although 'the week I spent in Sydney was not calculated to give one Tone; even Sydney folks complaining of the muggy weather, the mosquitoes and lack of sleep' (AF to FSG, 25 March 1885). He had seen the Elliotts, trying to

Melbourne, by contrast, disappointed. 'I have just alighted from the Sydney Express', he wrote, 'hot and out of sorts' after 500 miles in the train. 'Now that I return Melbourne appears like a quiet village, after Sydney. Collins St is humdrum, for aught I know it may be as profitable, but the . . . throng of vehicles and pedestrians is not there. I have to doubt now as to Melbourne becoming the metropolis of Australia.' Nevertheless Melbourne was growing fast: 'When you return', he told Grimwade, 'you will see great changes. Collins St is getting tall. The Stone Bank ES&A Chartered is getting up—so is the [City?] Bank and many buildings going on—nevertheless Sydney is distancing us'.[49]

Felton reported to Grimwade—who had sent him a book on cable propulsion—the construction of the Hawthorn Bridge cable tramway, the beginning of the remarkable network Melbourne built in conscious competition with San Francisco; 'other lines I suppose will soon be pushed on'.

> I like to dwell on the Melbourne of the early future—these lines of trams completed, the Cathedral which now only partly built towers over Swanston St—open with its crowds of worshippers pouring in. New Princes Bridge stretching in noble length to the opposite bank of the River, while on either side a Railway Station of grand proportions. In the principal Streets now there is much building—the erections are tall, 6 or 7 stories some of them—the old buildings are quite dwarfed by the new. These old buildings will all be gone in the future . . .[50]

Grimwade would find that 'a new era' had set in. Indeed it had; in 1888 Melbourne's twelve-storey Australia Building was, briefly, one of the tallest structures in the world.

Felton enjoyed Sydney, and visited it frequently in his later years, but never sought to live there.

persuade them to withdraw their travellers from New Zealand. The visit to New Zealand may have been partly holiday, with his friend William Wilmot Couche: 'I do not consider Couche himself very robust just now. He talks of running down to New Zealand, perhaps with me if I can get away' (AF to FSG, 17 December 1884).

[49] AF to FSG, 20 April 1885.

[50] AF to FSG, 15 June 1885. Felton later bought shares in the Melbourne Tram and Omnibus Company.

5

HOME NEWS

Felton did not revisit 'home' as frequently as many of his friends. Grimwade had been in Britain between December 1873 and November 1874, but Felton not since 1870; then, or possibly earlier, he had spent time on the Continent, and in the United States, but New Zealand had been his only overseas destination since. His partner's letters from abroad in 1884–85—neither they nor a diary Grimwade kept have survived—prompted in Felton memories of his own youth in East Anglia.

> You were just about to start for Felixstowe. Many a time have I boated down the picturesque Deben and with jubilant heart scudded along the cliffs to the sands of Felixstowe. Beautiful days I remember these, with an ocean all glittering with light. I trust you had these bright days while you were there; these would be your best medicine.[1]

'We Australians'—the term flowed naturally from the immigrant's pen—'feel so much the chilling influences of those North and East winds that blow on that coast'. Unfortunately the winds had blown cold that year; 'I mentioned the horrible North Easters but little did I think, at that moment, that your Easter at Felixstowe would be almost entirely marred by those cruel winds'. Fortunately Grimwade had been comfortable in Felixstowe House, which his father had recently bought; 'a great bargain', in Felton's opinion.[2] Grimwade also went to Woodbridge, prompting a mixed reminiscence from Felton:

> Woodbridge is <u>dull</u>. How dull these places strike one after the glare of an Australian city. The life is hid; until you penetrate beneath the surface, and find the existence of much interesting life ebbing onwards among the tranquil shade of blinded windows,

[1] AF to FSG, 19 May 1884.

[2] AF to FSG, 2 June 1884: 'I had not long posted you a letter giving you my recollections of Hollesley, Bawdsey, Felixstowe, the Deben and the Orwell in the leafy summer months'.

and tree-embowered houses, you think the place is dead. It is not so, from these quiet places emerge much of the beauty and intellect of the country, nurtured as it should be, first in quiet seclusion, ripening afterwards in the sunlight of social successes.[3]

Grimwade also met Felton's eldest brother and confidant, William. 'I am glad you have seen my brother" Felton wrote. 'I hope you will be able to see him at home at Haywards Heath and become real chums.' William had recently married a woman twenty-two years his junior, and had a young daughter and son.[4] Felton did not mention other family members: his mother was dead, and presumably also his father, though the 1881 Census had shown him, aged eighty, living in Deptford with his daughter Eliza (unmarried and an 'annuitant'), son Edmund (a traveller in the boot trade), and daughter-in-law Mary. Brother Thomas had long been living in Marylebone, with his wife and five children, though in 1881 his son William was apprenticed to a chemist and druggist in Maidstone; Thomas was listed as a 'traveller in the leather trade', though identified simply as a 'gentleman' on the marriage certificate of his daughter Ellen in 1882.[5] Alfred remained in close touch with his eldest brother, clearly regarding William as the head of the family.

Letters from Grimwade in Switzerland reminded Felton of his own time there.

> I have been at all the places you describe, but you beat me hollow at Chamonix, where I was doubled up with rheumatism ... I hope the success of this venture will give Mrs Grimwade courage to make other detours, to see the admirable and the wonderful here and there in Europe ...

Nevertheless he feared Grimwade was over-exerting himself. 'Had I been standing by you, I think I should have observed—Young man [Grimwade was forty-four]; don't you think you are overdoing it—Eight hours on the mountain side and Glacier—wet through. No man can think himself either pumped or screwed (a la cheval) who can do this'.[6] If Grimwade was so fit he could do some work, in Paris:

> You know the States of each item of our trade; these are principally of British, though partly of American origin. How far France can surpass in finish and in price would be most valuable to learn ... You may see fit to add new lines that are not

[3] AF to FSG, 22 September 1884.

[4] AF to FSG, 16 June 1884. The 1881 Census had listed William (55, a 'retired confectioner') living in Chestnut Grove, Cuckfield, Sussex, with his wife Fanny (33) and daughter Winifred (later called Freda); son William Henry was born later.

[5] Ellen married James George Edkins, 'chemist, 12 Wigmore St' (though later an accountant); her sister Annie was a witness. The 1871 Census had listed Thomas (44), Mary (40), Annie (12), William (6) and Lucy (1) at 47 Townshend Road, St Marylebone; by 1881 Ellen (22) was a Governess, Lucy (11) a scholar; son William lived in Maidstone, and Maud (18) was an assistant milliner in Exeter.

[6] AF to FSG, 14 July 1884. Grimwade's travels were published in the *Telegraph* of 15 July. In correspondence Felton referred formally to 'Mrs Grimwade', not Jessie.

altogether foreign to our trade. To do this will help general trade—just in the way that our advertising of special items helps our general trade.[7]

Like many returned emigrants, Grimwade found some things distasteful in the land of his birth. Felton agreed: 'I note what you say about London holiday crowds, they are not so pleasing as our little crowds—not so well dressed, and not so joyous. It is in the sun—the light is sad, the people are sad with you; with us the light is bright, the people are bright'.[8] Felton spared a thought for Grimwade's third son, aged ten, in a 'foreign' school: 'I can imagine Shep feels his isolation. One little Australian boy among a lot of strangers . . .' (Russell, at five, was too young for school.) Grimwade gave news of his eldest son, working with the London firm Umneys before returning to Flinders Lane and (in 1887) a partnership; 'you give a good account of Umney's place. When Norton comes back we shall expect to find him learned in all the learning of the Egyptians . . .'[9]

Felton, envying Grimwade's Christmas in East Anglia with his 'bright-eyed youngsters', asked him to toast absent friends. He was perhaps lonely; Campbell was taking his family to the country. 'I do not think I shall go with him. I shall try for the mountains, weather permitting.' It had been unseasonably stormy and unsettled in Melbourne.[10]

Felton assured Grimwade that he need not return in March 1885, as planned. 'Do not be in a hurry'; if he felt Grimwade was really needed he would cable. In July 1885 he agreed that 'of course' the family should not leave England 'until you get a comfortable ship', and the possibility of good weather in the Red Sea.[11]

In June 1885 Grimwade went to the United States, alone; 'I can appreciate your feelings as to the void one feels in solitary travel. It is all very well for the young, open-eyed . . .' Felton had not altogether enjoyed his own time in the United States—presumably in 1870—recalling with distaste 'the long railway journeys, the cookery, the infinity of dishes, the grease therewith, the hard practical nature of the American crowd at these hotels, all these things grate on the sensitive nature, and leave an impression on the mind of stupendous materiality'. Nevertheless he knew

[7] AF to FSG, 14 July 1884.

[8] 'I have only seen the Derby once to your thrice . . . As far as I know it, I quite agree with you, it is beastly as you say', AF to FSG, 22 September 1884.

[9] AF to FSG, 14 July and 19 May 1884. In August 1884 the Grimwades went to Scotland, where it rained. 'I have been a fellow sufferer in the matter of the Scotch climate', Felton wrote (AF to FSG, 25 August 1884).

[10] AF to FSG, 17 December 1884.

[11] AF to FSG, 16 June 1884 and 24 July 1885. A following wind in the Red Sea, prevailing in some seasons, made for uncomfortably overheated ships in the days before air conditioning.

there was more beneath the surface: 'are there not streaks of gold and of azure—the lines of beauty one has felt in other things, and other places, and the memory of which is a gracious pleasure?' On developments in the New World, 'my summation was that it was commonplace—but there was a great deal of it'.[12]

EXCURSIONS, WHETHER ON sea or land, remained a source of great pleasure to Felton. One frequent recreation was running around and about Melbourne in his pony trap, behind Polly or her stable-mate Ruby; he was clearly very fond of both ponies. Each morning the trap was brought around for him to drive to work. 'Ruby is still a good pony and in first class fettle', he reported to Grimwade in June 1884. 'She looks for her apple every morning on coming to the door, as a regular time-honoured institution. Now that evenings are dark, and sometimes wet and slushy, I tend to take her back at mid-day. This morning having no whip with me she had her own way.'[13] When visitors, such as the Chairman of the New Zealand Drug Company, were in town, Ruby was called into duty. 'Mr Sievwright spent last Sunday with me and drove from 11 am to 6 pm through Toorak, Malvern, Kew and Heidelberg and back through Alphington by the old road', he wrote, and when Sievwright returned a fortnight later, 'I drove him to Doncaster and we had a most pleasant day, the Pony taking us there and back in good Style'.[14]

Sunday was the customary day for such excursions, usually after attending Scots Church (if Mr Dods, formerly Strong's assistant and now himself under assault from the Church Assembly, was preaching):

> Last Sunday, our Mr Dods gave a grand sermon at Scots Church . . . The day was fine, so after this grand intellectual treat, I basked in the sun and gently drove Polly over to Studley Park. There I made a study of the green lanes of hill-sides from Judge Stawell's to the Asylum Grounds. This land has lately been cut up for building lots; as you near the Asylum the site gets undesirable from the noise of the lunatics. But the landscapes are charming. Polly wondered what the dickens I was at in wandering about these lanes, so when we reached St Kilda at 3 o'clock we both were in good form to enjoy our lunch, she of oats, I of cold lamb.[15]

[12] AF to FSG, 15 and 2 June 1885.

[13] AF to FSG, 16 June 1884.

[14] AF to TWK, 29 April 1884; AF to FSG, 19 May 1884.

[15] Proceedings against the Rev. Dods were reported in the *Age* 10 March 1884 .
 Some expeditions were closer to home: 'Yesterday (Sunday) was a pink of a day. I drove Polly round Brighton— I had Smith the architect with me, and we took devious ways through that interesting suburb. We went to see architectural beauties and we had a feast of landscapes as well. The pony was in grand form and did not turn a hair' (AF to FSG, 2 June 1884).

Sunday Morning—Collins Street (George Rossi Ashton, in Sutherland, *Victoria and its Metropolis*, vol. I, 1888)

He reported fondly on Polly's state of health:

> Polly is in wonderful condition. She has been clipped, and is strong as a tower, though a little lazy. She never turns a hair. I do not like to take more out of her, for you know she stumbles a little, although much better in this respect now, but as the horsey men put it, she stands over on the left foreleg—saddle work has done this, side saddle nearly always does it, but it was not the fragile forms of B or A that worked this, but the bulky Duncan. He must have laid the foundation of this.[16]

[16] AF to FSG, 19 May 1884. Duncan's stables seem to have been the source of the ponies; Polly might once have been Grimwade's and B and A Grimwade's daughters Elizabeth and Alice. Felton wrote often about horses: 'Charles on Sailor and Regie on Black Bess I met in the Alma Rd as I was driving to poor Charley's funeral. The contrast was so great: Sailor so tall, Bess so short, and the walking pace was stately' (AF to FSG, 10 July 1885). He was angry if a horse suffered injury. 'I asked Begg about his pony the other day. He (the pony) is getting better of his wounds and abrasements and when recovered Begg is to recover the £30 he cost. May he do so!, say I' (AF to FSG, 16 June 1884).

Sometimes he took longer excursions:

> Yesterday as Mr Dods did not preach at Scots Church I took the opportunity to drive with Lorimer (of Bright's) over to Mordialloc. Little Ruby enjoyed it very much. I have not been across the Common for years, but I steered a very good course. The heath and the wattle are already out in splendid bloom, showing that spring is upon us.[17]

In May 1885 the health of one of his ponies caused concern; he thought he would send her to the country, but kept her in town, having to go to the chemical works in Sandridge 'at least three times a week', and 'so I save 30/- weekly in cab hire. So she has the gentle exercise of running to the Yarra three times a week and on other days has half an hour in the salt water for her legs. She has her winter coat on now ... she will look sleek and fine ...'.[18] She, and her owner, were to find that not all excursions to Sandridge were so pleasant.

WHEN GRIMWADE LEFT for Europe in 1884, Felton was living at 7 Dalgety Street, St Kilda, with BC Burstall and sometimes others. 'Our friend Burstall enjoys having portions of your letters read', Grimwade was told, 'and esteems your friendly messages, he is in good form and desires me to send you his kind regards'.[19] An account of Felton's establishment was later given to Russell Grimwade by his English cousin Edward Hall Grimwade, who had lived there for about six weeks in 1880, when 'you had scarlet fever at Harleston'.

> AF was then living in quite a small bungalow house in a street about 5 minutes from St Kilda Station with old Burstall. I slept in a sort of box-room as there were only two bedrooms, a drawing or living room and a small billiard room; we generally spent the evening playing and both AF and Burstall got cross when they lost. We had a [famous ?] old housekeeper who gave her notice to leave about twice a week but stayed on ...[20]

The 'small bungalow'—actually a two-storeyed Victorian terrace house, still standing—had room enough for another servant, one Ashfold, described as a butler by Edward Grimwade, who reported that one evening Burstall arrived home late to find Ashfold enjoying his employer's port in the hall.

[17] AF to FSG, 25 August 1884. 'Lorimer' was probably (Sir) James Lorimer (a friend of Charles Strong but not a member of the Australian Church, according to Badger, *ADB*, vol. 5), though James Lorimer was a principal of Lorimer, Rome and Co, merchants and shipping agents, and not of Gibbs, Bright and Co.

[18] AF to FSG, 24 July.

[19] AF to FSG, 14 July 1884; and again: 'Now my dear fellow I hope you are getting along finely, and that you will soon be able to send me good news of yourself. Numerous friends asked to be kindly remembered to you—especially amongst whom Burstall' (AF to FSG, 2 June 1884).

[20] Notes by EH Grimwade for Russell Grimwade, 7 October 1931.

In 1884 the gregarious Felton was for various reasons finding his establishment lonely,

> At Dalgety Street we are suffering from absenteeism. We cannot spare our old friends and companions, and so <u>very</u> many are away. Yourself, Bunny, Strong, Withers, Hackett, Leeper, Parfitt, Price, and about half a dozen of occasional visitors. I need not say this makes the Cottage more dull than of old … New ones to fill the vacant places are not readily to be found …[21]

Some of their friends, for example Leeper and Hackett, were simply out of Melbourne, but other news was sad. In August 1884 Felton wrote that 'our old friend Bunny is still a great worry though he goes up to his office regularly. He has got very thin and has not yet cornered his enemy, but we have yet hope that he will'.[22] In April 1885 Felton reported that 'whilst I was away in New Zealand, I arranged for Ashfold to drive Judge Bunny from his office in the afternoon. I thought the drive might do the Judge good, and so it did', though Felton was distressed on his return to find the pony 'not very well'.[23] He was even more distressed to write in June that 'Judge Bunny I fear will not rise from his bed again. I called on Saturday … He bade me goodbye; I think he cannot rally now and I expect to hear of his death hourly'. A fortnight later he wrote that 'poor Bunny has sunk to his rest. I sent a wreath to place on his coffin—there was a large gathering of his friends and acquaintances at his funeral. Service by Gregory, cemetery St Kilda'.

Mrs Bunny would now have 'a more limited income'. She proposed to sell the house and visit her relations in Europe. 'It is well', Felton added, 'that she has the

[21] AF to FSG, 25 August 1884. George Withers (1845?–1900), was superintendent of the P & O SN Co (de Serville, *Pounds and Pedigrees*, p. 349); Felton gave him financial assistance in 1895. Leeper and Winthrop Hackett, friends at Trinity College, Dublin, had arrived in Australia together; when Leeper became Principal of Trinity College in 1876 Hackett was his Vice Principal until he left for Western Australia in 1882. Leeper was on leave in Europe in 1884. Parfitt was possibly Peter Thomas James Parfitt, an accountant with the Bank of New Zealand, a member of the Bohemian Club (de Serville, *Pounds and Pedigrees*, p. 246). Price has not been identified.

Towards Christmas 1884 Captain [Renslie?] 'brought in his good old ship the *Sobraon*, with his usual complement of 100 passengers. The old boy looks as jolly as ever. We hope to have him to cheer us up a bit at St Kilda' (AF to FSG, 17 December 1884). The *Sobraon*, a popular ship on the Australian run, had an after-life in Sydney Harbour as a reformatory for delinquent children and (renamed the *Tingira*) as the Royal Australian Navy's first training ship).

[22] AF to FSG, 17 December 1884. 'He is going to try [Koumiss? a yoghurt-like substance taken to counter tuberculosis]—have you ever tried this? It seems to me a very nourishing thing …'

[23] 'From the first of your going away, she showed signs of weakness in the hind feet. I got a 'Vet' to look at her, and he said that she has a hardening in the feet, which she is not likely to recover from. I have had her bandaged with vinegar and water compresses, also I send her to the sea daily. I only drive her to Town perhaps twice or thrice a week. I think I must soon send her to Duncan's to see what complete rest will do for her. I think the work she had done had begun to tell on her when I took her. I know you will be sorry to hear this' (AF to FSG, 20 April 1885).

larger portion of her family floated off and settled'.[24] Son Rupert, by then in London, had certainly 'floated off' but had hardly settled; Felton was to include both mother and son in his will.

Felton's friend Burstall had further bereavements. When 'Charley'—not otherwise identified—died in July, Felton wrote that 'Burstall feels much the losing of his friends—one by one they go—and it makes things lonely—the journey is nearing its end, and of those who started so few remain'. A fortnight later Burstall was 'away to Kyneton today to attend the funeral of Goodman Teale. This is the third of his old friends that he has followed to the grave within about a month. This is very sad for him I assure you'. 'Perhaps', Felton added, with some prescience of his own end, 'the last stages will be a solitude'.[25]

ILLNESS AND EARLY death have loomed large over all human generations except a lucky minority in the twentieth century; and Felton's rheumatism in his thirties, serious accident in 1880, and perhaps a tinge of Victorian hypochondria concerning his liver, led him to be much concerned—indeed almost obsessed—about health. His letters were full of pronouncements on how Grimwade should overcome his illness. He needed 'extra good conditions of health around you so that you may thrive—good air, sunlight—cheerful society—plain food attractively presented, and I trust you will look for and get all of them'. He also needed exercise and massage: 'It is true', Felton pontificated, 'that from the exterior of the body, help from healthy organisms accompanied with exercises that act on the internal organs, will work an amendment in their functions'. He recommended a visit to Carlsbad or one of the other Great Baths.[26]

Like any Victorian in his fifties, Felton was becoming accustomed to losing friends and acquaintances. 'Smellbourne', not yet properly sewered, was an unhealthy place. In June 1884 Felton encountered a medico friend, literally in the middle of the street. 'I saw Rankin yesterday . . . We stopped our traps in Alma Rd and so conversed.' The Doctor, who 'looked handsome and well', suggested a London doctor, but Felton said Grimwade was tired of doctors.

> I passed his and Robertson's trap standing before a house in Westbury St, it was an omen for the house—Typhoid has been very prevalent in St Kilda—Dalgety St has a

[24] AF to FSG, 2 and 15 June 1885.

[25] AF to FSG, 24 and 10 July 1885.

[26] AF to FSG, 2 June 1884. Grimwade had been having Dr Kylgren's treatment; he sent details to Felton, who responded that he himself had found 'good old Johnson' best for 'his troubles'. Grimwade saw Johnson, who prescribed a regimen and also the visit to Switzerland (AF to FSG, 19 May 1884).

bad name for it—other streets also share the bad name ... I intended to ask Rankin of this Typhoid Scourge but omitted doing so.[27]

Felton was always pleasantly surprised when he was well. 'I am a marvel to myself', he told Kempthorne, who had himself been ill. Felton proffered a remedy: 'I am sure you must have begun to despond after such a long and confining illness. With many of us it is all liver—the Sea is the thing—the Sea has set you up—the Sea has set Grimwade up—I may have to try it myself soon'.[28]

He was not always well. In August 1884 he asked Grimwade to apologise to Edward Grimwade for his tardy reply to a letter; he had not yet got his liver into order, and 'the writing mood is not on me'. In the winter of 1884 everyone had colds, including Felton. In April 1885 he told Grimwade he had intended to write a pleasant letter but 'my head has appeared as though it is not my property, and so would not work. I am the third man today that I have heard complain of his head, and so I suppose it is epidemic, or in the air'. In May 1885 Edward Bage was away for a while with a 'cold in his eyes'; in August Felton reported that 'everyone says it has been the coldest—the wettest—the muddiest—the most disagreeable winter known'. 'Even the hardy Campbell ... says he does not ever before remember being so miserably ill.' Public business was suspended: the bishop, the premier, the mayor and a procession of other worthies were 'all laid up'.[29]

Some of his friends were worse off: 'At lunch today poor old Daly told us he had been ordered home to have an operation for Hydatids ... I must say Daly appears pretty jolly for a man with Hydatids'.[30] Great wealth was no protection: 'Our friend Ormond is returned. I do not consider him in the very pink of health'; Francis Ormond, one-time stable-boy become great philanthropist, died in 1889, leaving an estate of two million pounds.[31]

Death was all around. Eight members of the Australian Club died within a few months (including one 'whose means had dwindled to a small thing'). DP Keogh ('not the wily Edmund', one of the former competitors taken over by Felton Grimwade's) 'joined the great majority'. 'Hearing of his death gave me a shock.

[27] AF to FSG, 16 June 1884. Dr William B Rankin had rooms in High Street, and a Dr Robert Robertson in Alma Street, St Kilda.

[28] AF to TWK, 1 January and 18 March 1884.

[29] AF to FSG, 11 August and 28 July 1884, 20 April, 5 May and 7 August (pasted in) 1885.

[30] AF to FSG, 20 April 1885. Possibly William John Daly (1847–1902), a member of the Club.

[31] AF to FSG, 20 April 1885. The Ormonds stayed at the Grand Hotel but the ladies didn't like the food or the service so moved to the Esplanade. Mrs Ormond placed some money on deposit with Felton Grimwade's.

The Australian Club (A Sutherland, *Victoria and its Metropolis*, vol. I, 1888)

We think the ground under us too firm, don't you think? The cracks and fissures surprise us.'[32]

Some died young.

> I was shocked one morning to hear that Davies opposite the Railway terminus St Kilda was dead. A young man and a cheery one. I used to see him nearly daily as I passed in the Buggy, and he had always a friendly salute. I hear liquor had something to do with it ... The widow I hear is to carry on the business.

[32] AF to FSG, 20 April 1885 and 14 July 1884. DP Keogh, MLC (1827?–84), was a wine and spirit merchant with pastoral interests.

Some were middle aged: 'at Benalla another death—poor McBurney in the tide of his prosperity and not very old'. Some were old, and less lamented, like William Lynch's 'ancient mate'.[33]

It was common in late Victorian times to link drunkenness, failure and death, including suicide. In June 1884 Felton, obviously shocked, told of the son of James McEwan, founder of the hardware firm, 'destroying himself at Hay's Esplanade Hotel'.

> I happened that evening to be dining with Koch at the Esplanade ... As the waiter removed the cloth he told Mr Koch that Mr McEwan was dead. As Mr Koch had bade him (McEwan) goodbye only a few hours before on the belief that he was about to take the special to Sydney, the consternation was great. The Crystal of Strychnine in the glass soon disclosed the agent of death, the cause lay deeper, we cannot say what, drink, debt and the rest.

There had been other suicides lately; 'the three D's appear to be the proximate causes, drink, debt, disease; but drink appears to put in an appearance first'. 'At times', Felton mused, 'I feel that one might really take the Blue Ribbon [emblem of Temperance] to wear as a sign'. The feeling wore off; and a year later Felton reported his own health 'better than I have been for six months past ...' But 'what everlasting trouble is this sublunary sphere, aye?'[34]

DESPITE HIS CONCERN about health, most of Felton's long letters to Grimwade in 1884–85 were cheerful, even jaunty, and included much shrewd comment on affairs in the Colony. Sometimes he grumbled that he was too busy—'I have a lot of things on hand at the present time, as well as Flinders Lane and the various works'—and unable even to go to the Australian Club for lunch. But he made time for visitors, and in consequence attracted them. 'Fred Elliott stepped in this afternoon, on way from Europe to Sydney.' 'About ten days ago at luncheon time the ancient Gabriel [not otherwise identified] put in an appearance. We adjourned to the Athenaeum [probably the Club] to lunch to see if the quality of the beef steaks was as good as of old.' After much gossip, mostly about cattle stations in Queensland, 'the old gentleman left me to spend an afternoon with the National pictures and I have seen him no more'.[35]

[33] AF to FSG, 14 July and 25 August 1884. William Lynch was a solicitor, one time Mayor of Brighton. His first wife, Caroline, was twenty-one years his senior. Their large art collection is discussed below.

[34] AF to FSG, 'Tues AM' 31 June 1884, 5 May 1885.

[35] AF to FSG, 19 May and 24 July 1884.

Art, as well as business, brought visitors:

> Duerdin looked in to see one or two of my pictures this afternoon. I asked him if he had anything to send you, and with his customary twinkle of the eye he said 'I have nothing particularly malicious to say just now—this is what is expected from friends, is it not' and so he left me. I think we can read it backwards and say he sends kind regards.[36]

Grimwade had himself been acquiring some art in London. In December 1884 three paintings by R Dowling—one of which, *Ruth and Boaz*, had been 'very well placed in the Academy'—arrived in Melbourne in the *Sobraon*, and Felton Grimwade's offered them to the Trustees of 'The Public Library and Picture Gallery' for exhibition on loan until Grimwade returned. No response is recorded.[37]

Felton enjoyed gathering gossip to pass on. 'We had the great election at the Australian club' he told Grimwade in May 1884. 'Twelve men went in, but one was badly pilled, Fulton [later corrected to Fallon, 'the man who married one of the Dawson heiresses']. He is an unpopular man. He was told he should go down, but he persisted in standing'.[38] The Club was rebuilding, and despite the disruption 'the Luncheon Room presented an animated scene'. The Athenaeum Club was also being rebuilt, and Felton reported, 'they want you back again'. 'The Athenaeum does not intend to be stranded by the larger craft. It is showing signs of vitality ... It is still the most centrally situated club in Melbourne. Last night I spent a half hour in the Reading Room on my way to Scots Church ...'[39]

Felton's social life outside his clubs was mostly among men of business. 'I dined with Bruce Smith last week', he told Grimwade, 'where I met Mr and Mrs Parkes, Mr and Mrs Rolfe, Mr and Mrs Smith Senior. They all enquired much about you. Parkes is as jubilant as ever. Smith Senior is not great at whist'. ES Parkes was Superintendent of the Bank of Australia, and Mrs Rolfe the eldest of his three daughters.[40] Felton was invited to 'a great party at Parke's on the occasion of the marriage of his [third] daughter to Sargood's son', but could not go as he was

[36] AF to FSG, 2 June 1884. James Duerdin (1839-92?), solicitor, had arrived in Melbourne in 1840 and bought enough property in St Kilda to make him later a wealthy man. He was also Secretary of the Yorick Club.

[37] FG&Co to Trustees, 19 December 1884. The other paintings were *Rachel* and *The Moorish Fruit Sellers*.

[38] AF to FSG, 19 May 1884; correction AF to FSG, 2 June 1884.

[39] AF to FSG, 22 September, 2 June and 14 July 1884.

[40] AF to FSG, 5 May 1885. One daughter of Edmund Samuel Parkes married Morton Rolfe, son of George Rolfe (1808–71), founder of Rolfe and Co. (Born in 1834, Parkes died after a train collision at Balaclava station in 1887.) The dinner host was possibly Arthur Bruce Smith and 'Mr Smith senior' William Howard Smith (1814–90).

likely to be out of town, 'and I cannot indulge in the sparkling' (champagne had begun to upset Felton's liver). 'Again, may the young people be happy.'[41]

The visit to Melbourne of Hanlan, 'the great Canadian rower', caused a stir, which Felton at first observed wryly. His reception at the Exhibition was 'the greatest fiasco on record—places 10/-, 5/-, 2/6. Stawell, Service and lots of others on the Bell. I am told not 50 paid entrances were there. The whole crowd was but a handful under the spacious dome'.[42] But having seen Hanlan in action on the lagoon in St Kilda Park, Felton showed himself by no means immune from the worship of the sportsman, already seen as an 'Australian' characteristic, though his admiration was primarily aesthetic. 'Hanlan is the perfection of form, and gives one the same pleasure as gazing on the Greek statues in the Vatican, or the fine pictures of the great masters. He is undoubtedly one of nature's finest pieces of mechanism'.[43] It was still possible then for men to write or speak admiringly of male bodies without inferences being drawn. Hanlan went on to Sydney where he lost 'the sculling championship of the world' to an Australian a few months later.

The arrival of a new Governor was always an occasion for great celebration in Colonial society, and Felton described the welcome given to the elegant and rich Sir Henry Loch in June 1884. The Lochs and 'a squad of young and aristocratic looking attaches' went to the Flemington races, where 'I caught sight of the party as I passed on the Terrace'. He also saw them at an 'overflowing Liedertafel Concert', and remarked that they attracted crowds, being 'quite a card of late for all the shows'. The Australian Club banquet for Loch was booked out. 'As usual the Colonists are a little overdoing it'. Felton also went to the Mayor's Ball; 'I had a walk around with Mrs Young who is very good fun. I left the interesting scene about 12.45 for St Kilda'.[44]

The Australian colonies had two of their periodic Russian scares in 1882 and 1885, the latter causing Felton Grimwade's to seek cover from Lloyds for war risk on

[41] Some months later Felton recorded that he was not going to another wedding, at Christ Church South Yarra, called for the then unusual time of 7 p.m. on a Saturday; 'Is this not a new fashion?', he asked (AF to FSG, 20 April and 2 June 1885).

[42] AF to FSG, 2 June 1884. (Sir) William Stawell, formerly Attorney-General, had been Chief Justice since 1857.

[43] Felton was amused by his 'good old friend Professor Johnson'—not identified; a reference to Professor Irving, the founder of Victorian amateur rowing, would have been more readily explicable—who did not think much of Hanlan, although he had not seen him. Believing his own countrymen [Northmen?] to be 'the only people who know how to row', he wanted 'to race him for a wager to Schnapper Point. The professor burns at the thought of the prowess of his countrymen' (AF to FSG, 16 June 1884). At that time rowing could be a dangerous sport. In December 1884 Felton reported two members of the St Kilda Rowing Club 'drowned in Corio Bay taking their boat to the Geelong Regatta' and two others missing (AF to FSG, 17 December 1884). On Australians' early admiration for sportsmen, see White, *Inventing Australia*, pp. 76–7.

[44] AF to FSG, 28 July and 11 August 1884.

The Race between Beach and Hanlan for the Sculling Championship of the World (FA Sleap, engraver, *Illustrated Australian News*, 3 September 1884, La Trobe Picture Collection, State Library of Victoria)

'all goods that may be afloat at this date'.[45] Victoria strengthened its defences with a Royal Naval presence and some British Military officers, welcomed into the higher reaches of Melbourne society. Felton recounts one incident illustrating the First Law of Snobbery, that all snobs have greater snobs upon their backs to snub them.

> Some of [the military men's] ladies have awakened a little indignation in the breasts of some of our leading citizenesses. A committee of Ladies with Mrs Holroyd as Chairwoman got up a Cinderella Ball, for the benefit of that Needlework Association in Collins St. Mrs Brownrigg, wife of the Colonel, was on the

[45] AF to Archibald Currie, Australian Lloyds, 28 April 1885.

Committee, and having two tickets for the Ball gave them to her own and Mrs Ind's maid. These demoiselles were dressed up and sent to the Ball.—Great was the indignation of the Lady Patronesses of the Ball. In explanation, Mrs B excused herself by saying that most of the ladies at the Ball had probably been servants and that in a few years the girls would probably be occupying similar positions in Colonial Society as the Lady Patronesses, so what harm? Anyhow this has been a hot and amusing topic ... the outline as I have received it in after dinner chat.[46]

In 1884 Felton and Charles Campbell went by train to Queenscliff for the weekend, and 'had a pleasant time' investigating the defences strengthened against Russian invasion.[47]

One of Melbourne's most interesting clubs was the Bohemian, whose members were allegedly obliged to play cricket in the summer and to sing in the winter. 'The Bohemians', Felton reported, 'are getting up one of their Dramatic entertainments'. Mrs Ind, 'the young and attractive wife of one of the Defence Officers', was billed to perform, 'but on Saturday I note that a bolting horse ran into Captain Ind's trap, capsizing them and dislocating Mrs Ind's arm'. The event went on nevertheless. Felton, attending, saw his friend Couche 'surrounded by a bevy of maids and matrons ... I daresay the weight was not too much for him'. A great success—'rarely a better body of amateurs to be seen or heard'—the event raised £350 for a hospital.[48]

Felton apologised to the Grimwades when he was 'too busy to store up any social news for you', but there was always a little to tell, and sometimes a lot. An organ recital by 'your little Dr Torrance' for 'friends of the organ' was postponed because of 'a rasping night of cold windy rain'.[49] Friends were sharply observed, and reported:

> I saw Miss Lavender [Henry Francis's sister-in-law] this morning. She was out servant hunting ... Francis himself looks well, a little more robust than of old. I think he gets to resemble his father. It must not go too far, for it will not be a good change. You remember the old gentleman, he was not inspiriting; like Atlas, he always seemed to bear a heavy weight.[50]

[46] AF to FSG, 16 June 1884. If 'Mrs Holroyd' was the wife of (Sir) Edward Holroyd, a judge known for his dislike of frivolity (RGDeB Griffith, *ADB*, vol. 4) she would not have been amused.

[47] 'We walked over to the Swan Island fortifications in the morning, then in the afternoon drove to Point Lonsdale and Lake Victoria, and on our return going over the Queenscliff fortifications' (AF to FSG, 22 September 1884).

[48] AF to FSG, 28 July and 25 August 1884. Couche was presumably William Wilmot, but could have been his son Reginald.

[49] AF to FSG, 19 May 1884. On GW Torrance, Irishman, clergyman, organist, composer and first acting Principal of Trinity College, see Robin S Stevens in *ADB*, vol 6. In 1884 Torrance was at Holy Trinity Balaclava; his oratorio *The Revelation* had been performed in the Melbourne Town Hall in 1882.

[50] AF to FSG, 15 June 1885. Felton was to leave 'Miss Lavender' an annuity.

In July 1884 Felton passed on 'another phase in the Macdowell tragedy', clearly a notorious Melbourne saga. Katharine, one of the five daughters of William Thomas Napier Champ—a Sandhurst graduate who had been Commandant at Port Arthur, Premier of Tasmania, Victoria's Inspector General of Penal Establishments and Colonel in the Victorian Military Forces—had married one Swanson MacDowell, in a match soon shown not to have been made in heaven:

> Colonel Champ insisting on his daughter getting a protection order, Mac went in a drunken fit to take vengeance, broke into the wrong house, assaulting the owner, and got into the Melbourne Gaol for a fortnight, there to come to his senses and repentance.
>
> By great good fortune his wife got a passage for him to West Australia, in a steamer taking 3,500 sheep, sundry cattle, and men, to one of the new ventures there—Macdowall to be employed on the station. He knows station work and was pleased with his prospect, so he wrote me in acknowledging a parcel I sent him, and he seems to have good hopes of coming back a wiser, better and richer man. When Mrs Mac called on me and told me the story of the imprisonment, I thought here comes the beginning of a tragedy; between her fears and her duty the poor woman has had a hard time of it.[51]

When Grimwade asked about MacDowell some months later, Felton reported him still in Western Australia. The marriage—or perhaps the husband—did not survive, and Katharine married again.

In September 1884 Felton had, he said, little to recount. The son of a late neighbour of Grimwade had called upon him; 'the lad seemed as bright as his late father seemed gloomy. How pleasant to be young'. The colourful politician and boomer 'Tommy' Bent—having successfully passed his 'octopus' bill promising railway lines to all state electorates in a bid for universal support—had bought a house in Brighton with 37 acres for £12 000, and 'Little Sim, the lawyer who has married some lady in Sydney, has taken the house for £500 a year'. 'This is a poor compendium of a fortnight's social events, but I cannot help it, there is a dearth in the land.' (He did, however, enclose a circular from the Australian Club about a 'member named Angus Robertson, squatter, who gets drunk and makes a beast of himself', and caused great scandal by doing both at the special dinner for Admiral Tryon, the handsome and robust British officer attempting to create an Australian squadron.)[52] Ending another letter, containing a glut rather than a dearth, he added (after quoting the Duke in *Patience*) 'you will be tired of all

[51] AF to FSG, 14 July 1884 and 20 April 1885. On Colonel Champ, see entry by John V Barry in *ADB*, vol. 3.

[52] AF to FSG, 22 September and 25 August 1884. The episode, involving a special meeting called but forestalled by Robertson's resignation, is recounted in de Serville, *The Australian Club Melbourne*, pp. 32–4. On Tryon, later to go down with his flagship after a notorious collision, see BN Primrose in *ADB*, vol. 6.

Cup Day, a Sketch on the Road, 1876 (*The Australasian Sketcher*, 25 November 1876, La Trobe Picture Collection, State Library of Victoria)

this—I find my thumb is of holding the pencil ... as for myself, these lines will indicate that numerous engagements have not yet killed me—and now for another fortnight I again say farewell ...'[53]

THERE IS NOTHING about Felton's charitable activities in these letters to Grimwade, though there is evidence of his generosity. When told of the imminent marriage of a young friend in England, Felton enlisted Grimwade's help.

[53] AF to FSG, 2 June 1884.

I want to make him a nice present, see to it for me—say about £50—a piano—a silver tea set—a little plate chest—knives forks and spoons—one or other of these useful things ... I have known him from a little fellow and have always felt a great regard for him.[54]

He was extremely helpful to some individuals, for example seeking out James Service to recommend GM Reid, an old colonist and an Edinburgh MD, for a position at Castlemaine Hospital; he called at Service's office in Collins Street but found he was at the Treasury, and sent in an eloquent note: 'I am in a sort of way a beggar', he wrote to the Minister, 'yet as the sequel of this will disclose, I bring as good as I ask'; he was recommending a 'first class man'.[55]

If he felt his trust was betrayed, Felton was relentless. He had lent £120 to Mrs A Taylor (a relative of a friend, Joe Taylor, then in England), but she concealed further debts from him. 'She has deceived me', he declared; when asked again to help her, he offered £5 to start a subscription, but insisted she protect herself, especially from one insistent creditor, by bankruptcy. To Grimwade he complained that he had not heard from Joe Taylor for some time; perhaps Mrs Taylor's affairs had 'lost me my correspondent'.[56]

There was little in the letters about art, though one piece of gossip involved a painting. In 1885 Simon Fraser (Prime Minister Malcolm Fraser's grandfather) gained notoriety by sitting for a portrait by Millais for a very high fee. A little later Felton reported that 'Simon Fraser of the 1000 guinea portrait has recently married again. There is a changed expression on his face—youthful hope—he should have [completed] this episode before presenting himself to Millais'.[57]

[54] AF to FSG, 20 April 1885.

[55] AF to James Service, 26 March 1884.

[56] AF to FSG, 2 June 1884; AF to R Sandford, 3 June 1884; AF to FSG, 16 June 1884.

[57] AF to FSG, 7 August 1885 (pasted in). Elizabeth M Redmond's entry on Fraser in the *ADB*, vol. 4, records his marriage to Anne Bertha Collins in 1885. The date of the Millais portrait is given as 1897 (the year in which it was exhibited in Melbourne) but corrected to 1885 in the *ADB* corrigenda.

6

PESTS AND POISONS

Putting aside the case of the European human, the rabbit was the most harmful immigrant ever to enter the Australian environment. Domestic rabbits, arriving with the First Fleet, did little damage, but wild rabbits, introduced for sport from the 1850s, found the Western District plains of Victoria as congenial as had the Scottish squatters, and bred even more prolifically, especially where grazing had already degraded native vegetation. Assisted by misguided sportsmen, and by wily rabbiters expanding their professional boundaries, rabbits spread with astonishing rapidity across the grasslands of Victoria, South Australia and New South Wales, and eventually into Queensland and Western Australia, despite 'rabbit-proof' fences (usually built after the rabbits had already moved past them). Rabbiting became a major new rural occupation, the poor man's best opportunity for an independent livelihood since the gold rushes, and rabbit meat a significant export—sharing the newly refrigerated ships with mutton and beef—but squatters walked off worthless runs, as vast areas of land were ruined. The plague became, and remained, a major threat to Australia's prosperity and a great challenge to Australian science and technology.[1]

By the 1880s the gravity of the problem had long been recognised. In 1887 the New South Wales government, prompted by other colonies, offered an enormous reward for a solution: £25 000, enough to attract the attention of Louis Pasteur, who proposed infecting rabbits with chicken cholera. The project, tested on Rodd Island in Sydney Harbour, failed, as did other suggested biological ingenuities—including the introduction of the polecat, skunk, mink, sable, civet

[1] Eric C Rolls vividly describes the rabbits' spread, in fits and starts but inexorable, in his classic, *They All Ran Wild*, pp. 28–90. 'The rabbit has not just successfully invaded the Australian landscape', Brian Coman has remarked, 'it has burrowed into our social history as well' (*Tooth and Nail*, p. xii).

cat, lynx, jackal, coyote, meer cat, ferret, stoat, weasel, mongoose or South African carnivorous ant as predators—until the release of myxomatosis in the 1950s.[2] The chief weapons against the pest long remained traps, dogs, fences and especially poisons. 'Men swapped poison recipes as women the ingredients for cakes and scones', and spread their favourite mixtures about regardless of the coincident slaughter of birds and small animals. Strychnine, which killed too quickly and frightened the living away, and slower-acting arsenic, mainly used to poison water, became less popular than phosphorus, whose treacherous instability had caused such havoc at Flinders Lane. Mallee settlers experimented with wheat soaked in phosphorus dissolved in boiling water, a hazardous process since a grain with even a pinhead left undissolved could start a bushfire as the sun warmed the bait. When it was found that phosphorus dissolved more easily in carbon disulphide, demand grew for that nasty colourless liquid, though it was so volatile that even a spark from a horse's hoof could explode it, and a whiff of its foul-smelling fumes produced headache and vomiting.[3]

By 1884 Alfred Felton had become a passionate purveyor of poison. The firm had taken out a patent for phosphorising wheat, presumably with carbon disulphide, but the project initially failed, Felton reporting (prematurely) that it 'must be written off; who is wise at all times?'[4] Carbon disulphide began to be used alone, at first it seems in South Australia, as a poison to fumigate burrows, in a process which, like the chemical, was nasty and dangerous. Eric Rolls describes its use:

> Special containers with self measuring taps to dispense about a dessertspoonful at a time were made. A fumigating team carried the chemical in heavy drums with an inch of water on top. If the weather was hot the drums were wrapped in cloth and kept wet. Siphons and funnels were used for drawing-off into the dispensing cans. This job was akin to handling rusty grenades ... Apple sized balls of cotton waste were also carried and long canes with needles on the end like park-cleaners' sticks. A ball was speared and the measured dose served on to it. Then it was poked as far down the hole as possible so that when the cane was withdrawn and the hole filled in immediately, dirt did not cover it. Each hole in a warren was treated.[5]

'James Tyson of Tupra', he adds, 'insisted that his men set fire to the carbon disulphide in the warrens. This surely caused some singed eyebrows if not worse ...'

[2] For Lord Casey's favourable view of Pasteur's bacillus, and later experiments with it, see his *Australian Father and Son*, pp. 113–14.

[3] Rolls, *They All Ran Wild*, pp. 149, 169, and 172–3.

[4] AF to FSG, 17 December 1884.

[5] Rolls, *They All Ran Wild*, p. 179.

The success of carbon disulphide as a fumigant gave Felton Grimwade's a new opportunity. The Acid Works were normally Grimwade's responsibility, but in his absence it was the production of this substance—always misnamed 'Bisulphide' of carbon in these years—which gave Felton more 'excitement' than any other of their businesses.[6] Early in 1884 he arranged the preparation of a document he believed to be the ablest account yet printed of the 'Rabbit Extermination Issue'. His purpose was to sell poison, and his strategy bold.

> I am going to send this publication to all the Colonies, commencing with the Governors and going on to the Judges, MLCs, MLAs, Heads of Departments, Bishops and the Country Clergymen, reading rooms—Clubs—Post Offices—Stock and Station Agents—and to all the landed proprietors and squatters in the Rabbit infested districts; and trust we shall find it a good advertisement, not only for Rabbit Poison, but for our other goods.[7]

In two months he sent out seven thousand Rabbit circulars, and had applications for extra copies from Sir William Clarke and other prominent men.[8] 'Where you are the Rabbit is a boon not a bane', he wrote—quite inaccurately—to Grimwade in England; in Australia victory over the rabbit would be 'a long job'.[9] So it proved; and the achievement of efficient production in Felton Grimwade's never-well-run Acid Works proved a long job also.

Bisulphide of carbon was produced by heating molten sulphur, passing the vapour through a retort containing charcoal at a high temperature, and condensing and distilling the disulphide produced. The firm's two existing retorts were not working well. Grimwade visited producers in Britain, and sent plans of their works, but manager Begg could not understand them. Felton read scientific books on the subject—presumably, like James Cuming, in the Public Library—and urged Grimwade to find out more: 'as we have started this Manufacture, it will be well for you to get to the bottom of it'.[10]

In June 1884 Felton made 'anxious enquiries' about rivals' intentions to produce bisulphide; supply was running out, though the Victorian Government had not yet formulated the new Rabbit Law, expected to increase demand. Felton sent his Rabbit circular to all New Zealand legislators; could Kempthorne sell

[6] Rolls notes (*They All Ran Wild*, p. 191) that 'the term *bisulphide* was used instead of *disulphide* in all contemporary accounts'.

[7] AF to FSG, 19 May 1884.

[8] AF to FSG, 2 June 1884.

[9] AF to FSG, 19 May 1884. Coman (pp. 8–10) shows how the damage done by rabbits in Britain became obvious when myxomatosis reduced their numbers.

[10] I am indebted to Professor Emeritus Tom O'Donnell for information on this process.

more bisulphide of carbon if Felton Grimwade's could make it?[11] He bought a shipment of sulphur from Italy, and in September 1884 the firm made 17 146 pounds of bisulphide and sold 10 677 pounds, but at too high a cost: 'we must arm ourselves with the cheapest and best mode of manufacture for next season'. A German, planning to make bisulphide of carbon in South Australia, wanted Felton Grimwade's 'to subsidise him to keep out of Victoria', but Felton was thinking how he could 'carry the war into his own country'. It was not easy. 'This man Blaubaum is a nuisance'; he had been dismissed from an Adelaide company as 'untruthful and unreliable, yet I daresay by his pertinacity he will get some one to go into this manufacture, and so ruin it as a source of income ...' Meanwhile Begg was asking some disconcertingly simple questions about the new plans, such as 'How is the door made tight?'[12]

Grimwade sent even newer plans, and in April 1885 Felton replied that it was a pity that they had not had this information when they 'went into the Bisulphide matter some years ago'. Begg had built one new retort, but it burned through; and meanwhile more competition loomed. 'One can see danger ahead ...' A Government order for another 1000 drums of Bisulphide was cheering; 'we should be happy in this business if we could only conquer the method of manufacture'. In May Felton was 'very vexed' because Begg had still not finished Grimwade's latest plan; delay was likely to bring in opposition, 'but we must push on, and at all hazards fill the market. We want to make for all the Colonies and we must'. They were getting close: 'The first plant put up after receiving your plans was an abortion', the second 'moderately successful'.[13] In July a letter in an execrable hand informed Grimwade that 'Edridge my amanuensis' had been working so hard Felton had sent him on a country tour, not as a holiday but 'to visit the shire secretaries, vermin boards and private buyers in the rabbit infested areas'.[14]

FELTON WAS MEANWHILE trying to ensure that acid producers in each colony kept out of each other's way. 'The only method by which a reasonable price can be maintained for acid is by leaving each Works to treat with its own market', he argued to Fred Elliott in Sydney, asking him to stop Sydney acid going into

[11] AF to FSG, 2 and 16 June, 14 July 1884; AF to TWK, 4 June 1884.

[12] AF to FSG, 22 September and 17 December 1884.

[13] '"Hope deferred maketh the heart sick"', he wrote in June 1885, under the heading 'Bisulphide', 'the force of this proverb I have felt in grizzling over the above important chemical ... I cannot rest until we fill all the field' (AF to FSG, 20 April and 5 May 1885). 'It will therefore be a most valuable labour on behalf of the business, if you will make your knowledge as complete as possible on this general subject of chemical manufactures' (AF to FSG, 2 June 1885).

[14] AF to FSG, date illegible but July 1885.

Adelaide, and claiming he had tried to protect Sydney's market in the past.[15] In New Zealand Kempthorne, who was still receiving help from Melbourne on his own acid works, was asked by his former partner Prosser to join in another acid works in Sydney. Felton was aghast: 'In the matter of starting acid works in Sydney, Prosser may wish this for his <u>own</u> purposes; but the result can only be disastrous to all concerned . . . It is only by not interfering with each other's market that the industry can be carried on without loss'.[16] His friend Campbell had instructed him well in the usefulness of cartels.

Kempthorne was suffering from new competition from Elliott's of Sydney in his pharmaceutical trade, and in response was tempted by Prosser's offer to sell him his Sydney pharmaceutical business. Felton told Grimwade he believed that Kempthorne wanted to buy it for the 'glamour'. 'That Sydney is a good field for two houses I admit, but as far as we are concerned it would not suit us to be interested in any business there.'[17] He warned Kempthorne that 'I do not think you have a trusty ally in Prosser', and wheeled in London opposition to the move, obliging Kempthorne to drop it. Felton also persuaded Elliott's to withdraw their traveller from New Zealand, and sent Kempthorne to Sydney to make friends with the Elliotts. As a merchant, Felton was adroit indeed; but it is evident also that even his competitors trusted his integrity.[18]

Felton often gave quite peremptory advice, even concerning Kempthorne's own career and his son's. 'My wish is that Orlando should go into the service of the Company', he wrote. 'As soon as the Board thinks he is up to the post, give him the management of one of the branches. Now what say you to this?' Moreover Kempthorne himself should not again manage a branch, but only the whole concern: 'Now what say you to this?', he repeated.[19] We have no reply.

In July 1885 Grimwade received a long, passionate letter from Felton, about 'wars and rumours of wars', and acts of treachery, in 'the little world of chemistry':

> The average man seems to think what a lot Felton Grimwade and Co and Cuming Smith & Co are making out of their unknown Chemicals, so when a workman leaves he is pounced upon as the depository of valuable secrets. The man Creighton for instance, who according to his letter was poisoned with noxious gasses, left after

[15] AF to F Elliott, Sydney, 6 January 1885.

[16] AF to TWK, 13 May and 13 July 1881, 11 September 1883, 1 January 1884 and 13 May 1884.

[17] AF to FSG, 2 June 1885.

[18] AF to FSG, 20 April 1885 ('Fred Elliott has written me a nice letter about their NS Wales trade. I think Kempthorne will run up to see the Sydney people, to put matters on a more comfortable footing').

[19] AF to TWK, 27 May and 24 June 1884.

beholding the working of the new Bisulphide Retort, and was so struck with its value that poisoning at once came on, and now he has carried away with him the form and the particulars of the new plant.[20]

A syndicate including HJ Langdon put up £200 each 'to test this manufacture', intending to set up a £30 000 company if it worked. 'The Pirates, as I call them', erected an iron shed on some land at Footscray for trial production, causing a fuss in the two local newspapers, concerned—not for the last time in that area— about environmental pollution.

> These two papers are not friends to each other. How fine is the passage when the *Independent* is called the 'Bone Mill Gazette', and that the Bisulphide of Carbon works should be erected in the backyard of the paper; and then comes the enquiry— how many of the subscribers to this precious journal would be left alive in a fortnight?, and so on. I am glad the Bisulphide works are objected to in Footscray. I hope they will have to be moved out of that. If Langdon and Co succeed in making Bisulphide at all, the price will have to go down to a starvation rate.[21]

Felton was happy to stir the pot. 'I am seeing dozens of people', he wrote, including 'Citizens of Footscray who have yet to smell the Bisulphide'. He even took his problem to lunch, and 'ventilated the subject at the Club Table', with disappointing results. 'The piracy excited a little feeling of disgust, although the general subject was amusing, as you may suppose' to his table companions.[22] In response to the challenge, Felton feverishly stepped up production, installing more retorts. 'The number of retorts no doubt staggers you', he wrote to Grimwade, 'I think it desirable you [visit some works and] get all the Secrets of the art, and to see the process <u>at any cost</u>. The last three words were twice underscored. 'It is a little too exciting this conflict. I call it the Bisulphide of Carbon War. See how it rages at Footscray. You should see how it works in my head . . .'

[20] AF to FSG, 13 July 1885. Felton had earlier noted that Begg had put on 'a whole family of Creighton's, now trying on their own'; but had optimistically claimed that 'we shall fill the market before they start anything' (AF to FSG, 15 June 1885).

[21] AF to FSG, 13 July 1885. In April Felton had refused to join the property company Langdon's father-in-law Parsons was proposing.

[22] AF to FSG, 13 July 1884. He listed Hepburn (Charles Jameson, of the Oriental Bank); Riggall (William, solicitor, of Blake and Riggall); Duffy (probably John Gavan, solicitor, son of Sir Charles Gavan); Hurley (Alfred William, merchant, of Wilshin and Hurley); McComas (John Wesley, auctioneer, merchant and inventor); and Scarr (Frank, stock and station agent). 'Blake [Arthur Palmer, solicitor, of Blake and Riggall] was at another table or he would have freely damned the pirates.' HJ Langdon was also a member of the Club, but presumably not at lunch that day.

Felton was using all expedients; 'when war is on you know ... "damn the expense"'. The state of roads in a wet winter was the greatest impediment to extending the works: 'horses have been killed in Ingles St', which was full of 'impassable quagmires'. He himself was almost a casualty.

> I have narrowly escaped having my one sound leg broken. It occurred in this wise—the road to the chemical works being nearly impassable ... I hurried up the fence to gain the road; here the damage had made a perfect quicksand, and in a moment the pony was down in it to her belly and floundering wildly. I jumped out and holding her by the head the pony threw up her forelegs striking me and inflicting a deeply bruised wound. Had the bone been struck it must have gone as my foot was embedded in the sand ... A squad of sand casters helped me and we soon got the pony out of her harness and out of the quicksand but she remembers her immersion to this day.[23]

Felton kept the pressure on his partner to study the business abroad because he was dissatisfied with the local management (especially when compared with Cuming Smith's, who had made great changes at Yarraville, establishing works which were as good as any Grimwade would see overseas). 'I am afraid you will think I am imposing on you a lot of work but ... I cannot tell you the pressure I am under in this Bisulphide of Carbon matter—the trouble of getting intelligent working at Ingles St. . . . It makes one mad.' He argued, with increasing vehemence, that they should import a man especially to manufacture bisulphide of carbon; Begg had enough to do with acids, which 'our old pot' was still producing. 'I would rather go on with our present staff if it were possible, but the losses from experimenting are too great.'[24] Grimwade must have agreed: not one but two men were imported from England to improve methods of production. They did so, but in January 1886 Felton Grimwade's warned the London firm from which one was borrowed that while he had proved efficient at building a retort he was not trustworthy: as soon as he stepped off the ship in Melbourne he had offered to sell them all his English employers' secret formulae.[25]

Another, unforeseen, skirmish in the 'bisulphide of carbon war' occurred before the improved works were in production: Felton Grimwade's lost a contract to their competitor Rocke Tompsitt's, who filled it by importing the chemical from Britain in a passenger ship, labelled as 'sheepwash', Grimwade claimed: 'it yet remains to be seen how the shippers will come off in London in making such a false declaration. I would not run such a risk for any thing, but our opponents, in their desire to spoil

[23] AF to FSG, 7 August 1885 (pasted in).

[24] AF to FSG, 24 July 1885.

[25] FG&Co to Pypke and King, 8 January 1886 (Partners' letterbook).

Rabbiters' Camp, near Ararat, 1892, 'showing men, standing between tents, having just returned from the various occupations of trapping, poisoning, shooting, carboning and digging out burrows; some of the dead rabbits are skinned and hanging ready for cooking' (GH Lovewell, *Illustrated Australian News*, 1 April 1892, La Trobe Picture Collection, State Library of Victoria)

our trade are utterly reckless'. On 11 December Grimwade asked Grimwade Ridley to investigate how a big shipment of such a dangerous chemical had been sent in a passenger ship. In February 1886 Felton Grimwade's counter-attacked, proposing to Rocke Tompsitt's that the two firms submit a joint tender for the next government contract. The arrangement continued for two years, during

which Felton Grimwade's produced an increasing proportion, and eventually all, of the bisulphide required, Rocke Tompsitt's enjoying a profit without responsibility for either manufacture or import. The bait taken, Felton Grimwade's then cancelled the arrangement in 1888, and thereafter Rocke Tompsitt's were forced to apply to them for any supplies—and to pay their price.[26] Meanwhile the 'Testimonials' book, in which Felton Grimwade's laboriously copied correspondence praising their products, reported customers well satisfied with the effectiveness of the bisulphide, and soon too with new weapons developed for the war. Felton had despaired of the firm's 'Patent Phosphorised Wheat', but EC Pettch of Warra Warra wrote that he had done 'more with four bushels' of it than earlier with £2000 worth of carbon bisulphide and digging out. Phosphorised pollard was added to the armoury, and by 1901 Felton Grimwade's 'Rabbit Jam' (flavour unspecified) was said to be 'killing rabbits in all directions'.[27]

Neither rabbits nor competitors were safe from the aroused energy of Alfred Felton, though neither was eradicated. Felton gained an almost mystical pleasure from establishing a successful industry. We are now well aware of harmful consequences—the downside, as we call it—of building a noxious industry in wetlands which, with their neighbours in Port Phillip and Westernport and Bass Strait, had long been a habitat for thousands of birds migrating across the hemispheres, and a rich food source for the tribes so recently displaced; by 1885 the fish were dead, and Footscray, across the river, was already called Stinkopolis. But Felton, confident in his generation, could simply rejoice that capital and labour had created prosperity in a swamp. One Sunday in 1885, inspecting a new shed at the Acid Works, he noted also, walking with Beggs, the progress of young willows he had planted there. He was pleased, 'viewing the results of industry on that bare spot, sweet in the eyes of the Supreme Worker, a tribute greater than our system mongers would have us believe; what say you to a new faith—work no longer a curse—but a good—the best Worship?'[28]

[26] FSG to TWK, 23 December 1885, FG&Co to Rocke Tompsitt&Co, 14 May and 15 June 1888 (all Partners' letter-book). Rolls (*They All Ran Wild*, p. 179) reports that in 1878 the major shipping lines refused to transport a ton of bisulphide ordered in London by a South Australian squatter.

[27] The Testimonials Book is in the University of Melbourne Archives, DHA LS3/13. By 1905 TOXA was the popular poison.

[28] AF to FSG, 14 July 1884.

7

WHERE THE HEART IS

During the 1880s, as the financial power of Melbourne grew, building a new mansion for oneself became as fashionable as investing in the silver mines of Broken Hill, or buying a sheep station in one or other of the Australian colonies. William Buckhurst, the land agent, was one such mansion-builder, on a hill in South Yarra, as Felton reported to Grimwade in June 1884:

> It is a splendid site and from the lofty tower Buckhurst will be able to survey—not 'all the kingdoms of the world'—but a very superb view of land, sea and sky. Query—is the Buckhurst special temptation—will he become inflated and fancy himself a God? He has something to keep him earth-ward, he is lamer than I am. In his last European travel he hurt his knees, and now hobbles on two sticks.[1]

Felton could scarcely plead immunity from special temptations: in 1884–85 he himself was also house-building, though in a characteristically individual way. While living in Dalgety Street, he had bought 'Wattle House', a few yards away in Jackson Street, and was renovating and extending it.

We know a great deal about 'Wattle house', which still stands, one of St Kilda's oldest buildings and in consequence much documented to ensure its historic preservation. The street was named after Samuel Jackson, the architect of many early Melbourne buildings, including St Francis Roman Catholic Church and the Melbourne Hospital. A builder with no architectural training, he had come from Van Diemen's Land in 1836, set up his practice in 1841, and in 1845 settled in St Kilda, buying some two hundred acres between Fitzroy and Grey streets, a

[1] AF to FSG, 2 June 1884. There is an account of Buckhurst in Sutherland, *Victoria and its Metropolis*, vol. II, p. 746. His mansion 'Goodrest', 120 Toorak Road West, still stands, overlooking Fawkner Park.

source of great profit when he subdivided and sold 'Wattle Paddock' in 1853.[2] By then, probably between 1847 and 1850, he had built 'Wattle house'. Its style is neither the Georgian of Launceston nor the high-boom Victorian of 1880s Melbourne, but pure Romantic: two-storeyed, with steeply pitched gable roofs, Tudor details and timbering, fretwork barges and finials and small-paned casement widows.[3] A painting of about 1860 shows Jackson and family enjoying his domain, and a water-colour, once attributed to von Guérard, shows the house as it was about 1865, when Felton was living nearby, in Mrs O'Reilly's boarding house.

Jackson, having made a fortune, took it back to England in 1863. 'Wattle House' was leased by Miss Sophia Matilda Murphy, to house the flourishing girls school she ran with her three sisters, one of those 'private schools of a superior character', promoted (as was noted earlier) by 'the salubrity of the air' in St Kilda. (The select group of pupils included Miss Ada Armytage, of 'Como', and Lucy Hopkins of 'Winchilsea', soon to marry FD Bird, later Felton's surgeon.) The school closed when the sisters retired, and in 1878 'Wattle House' was auctioned by Samuel Jackson's daughter, the advertisement claiming that restoration to its original condition would be simple: 'A large portion is of brick, the timber throughout the whole building being equal to new. The outside would only have to be taken down, and the whole building at moderate cost could be restored in brick to its original much-admired design'.[4] Renovation proved not as easy as it looked. The new owner, a Mr Briggs, began the process, but abandoned it; and when, on 5 January 1884, 'Wattle House' was again advertised for auction, Alfred Felton proceeded to buy it. We do not know why; perhaps he thought it a bargain, and a good investment, but his letters indicate that even if he always had resale in view he certainly intended to try living in the old place first. It was with that in mind, no doubt, that he planned to add a billiard room, where he and Burstall could continue to grumble when they lost.

The process of rebuilding proved as frustrating for Felton as for any houseowner. For one thing (as he told Grimwade) he found his architect wanting:

> Roberts is in full swing at Wattle house. He is a useful man, but hardly up to the niceties of the work. As I am designer and architect I find him deficient, whilst I need

[2] On Samuel Jackson (1807–76), see the entry by PRS Jackson in *ADB*, vol. 2. His brother William, a carpenter, had joined Fawkner's party sailing to Port Phillip in the *Enterprize* in 1835; the brothers returned with sheep and plant in 1836, and became squatters before Samuel set up as an architect.

[3] Long assumed to have been prefabricated and imported, 'Wattle House' is now thought to have been built by Jackson from designs derived from an architect's pattern book, probably SH Brooks, *Designs for Cottage and Villa Architecture* (London, c. 1839). I am indebted to Professor Miles Lewis, to notes prepared by Richard Peterson, and to Ms Vida Horn for information concerning 'Wattle House'.

[4] *Argus*, 22 June 1878.

'Wattle House', St Kilda, *c.* 1865 (La Trobe Picture Collection, State Library of Victoria)

> him as adviser and architectural mentor. As I told him today—a very little on a man's nose makes a good show, and so will the exterior ornament of a house; but we must rub along.[5]

A month later, while Roberts was 'still manoeuvring at Wattle house', Felton was

> well up with pulling down and putting up . . . At present we are putting up a Tower, and have had some thought of calling the old place 'Wattle Towers' for there will be no less than 10 separate roofs, 20 gables and one Tower, but perhaps people will think it ambitious and so we adhere to the 'House'.

[5] AF to FSG, 19 May 1884. The architect was probably JW Roberts, active between 1881 and 1887, mainly with commercial building.

'Wattle House': Felton's billiard room, and tower

But 'where will it end?' Not easily: Felton soon complained that the work would cost him 'much more than I intended, but then I did not take warning at the fate of Mr Briggs—but I see it now'. Roberts was 'a little overweighted and wanting training in this kind of work'. In July Felton lamented that 'one cannot get bricks—there is so much building going on in Melbourne'; they needed 500 to finish at Wattle House, and Roberts was in despair.[6] By August 1884 Felton was fed up:

> I do not think I shall find these alterations a good thing, they mount up too much . . . I shall not try it again. A month or so back I got rather wrathful and despondent [over weekly payments] but now I am getting used to it, and do not know that I should again turn rusty if it went on till Doomsday; use is everything. Having begun I must finish—but I am not sure that the coin expended will be forthcoming again.[7]

[6] AF to FSG, 2 and 16 June and 14 July 1884.

[7] AF to FSG, 11 August 1884.

It was not until May 1885 that Felton told Grimwade he was 'just about moving into Wattle House'.

> A great number of things have to be done and I am fairly bothered out of my wits by workpeople and other difficulties, but I suppose this week will see us through if I survive it. Burstall and the old Housekeeper will like the place when they have got over the moving.[8]

Whether Burstall would like it was a question. When Felton returned from New Zealand in March 1885 he found Burstall 'in splendid form, in fact looking better than he has done for a long time'.[9] But Burstall's business was not doing well; in June the previous year Felton had assisted his friend by giving his bank a guarantee for £1000.[10] Felton spent much time (and presumably money) decorating 'Wattle House', buying many pictures; when the absconding Greig's effects were sold, he attended the sale and 'expended a few hundreds on pictures, books, [wines?] and curios'.[11] According to Alice Creswick, who told Russell Grimwade of the episode (but muddled the address and the dates), Burstall was embarrassed because he could not meet the shared expense of life in Felton's new grander style.[12] Nevertheless, when Felton at last wrote, on 18 May 1885, that 'last week we moved into Wattle House', he professed that 'Burstall I think is very well pleased with it', reporting again in June that 'we are well into Wattle House and are as jolly as our poor menage will allow. The house is much admired and the garden will be about in form when you are due in these parts'.[13]

'Wattle House', as Felton rebuilt it, contained an 'elegant hall, large drawing room, dining room, library, snuggery, billiard room, four bedrooms, kitchen, servants' hall, two servants' bedrooms, scullery, pantry and a very large cellar'. Though smaller by far than Grimwade's 'Harleston', it was nevertheless a residence fit for a gentleman, especially one who enjoyed both books and billiards. The grounds were then still extensive, with space for 'a large beautiful fernery, large greenhouse, forcing houses, lawn tennis court with kiosk etc.' Felton's limp would have limited his participation in the new game of lawn tennis, but at least one of his friends was an enthusiast, Professor Morris appearing on the Honour Board of the (Royal) South Yarra Club as its founding President.

[8] AF to FSG, 5 May 1885.

[9] AF to FSG, 25 March 1885.

[10] AF to Bank of NZ, 21 June 1884.

[11] AF to FSG, 2 June 1884.

[12] Alice Creswick told Russell of Felton buying and doing up 'Miss Murphy's old school house', described as at the corner of Alma Road and Barkly Street. 'Burstall upset because he couldn't afford to live with him but B moved there. AF bought pictures for this house.' Russell wrote 'about 87 or 88' in the margin.

[13] AF to FSG, 18 May and 2 June 1885.

Bryan Champney Burstall, 1880 (La Trobe
Picture Collection, State Library of Victoria)

FELTON AND GRIMWADE had both been slow in following other Melburnians of means into country pursuits. Neither seems to have invested in the great expansion of wheat production in the 1870s, judging from Felton's remark to Grimwade in 1884 when wheat was doing badly: 'Your friends the Hentys will be heavily hit on wheat ... You must have a cheap loaf now in England ... Do the workers get the benefit they should and put the surplus by for a rainy day, or is the balance all swept into the publican's coffers'?[14] He, and apparently

[14] AF to FSG, 22 September 1884. The Hentys had other problems also: 'The Henty firm as I have told you have made terrible losses—the result may be serious. I am told Herbert is at home gardening, taking a rest, and I am afraid all things point to an impaired intellect on his part. Do you remember Alfred Taylor, how he went off? his speculations etc.' (AF to FSG, 24 July 1885).

Grimwade, had some belated involvement in the boom in Queensland sugar which attracted much Melbourne capital from the 1870s, but by 1884 the sweetener had turned sour: 'Our Queensland sugar people will feel the low rates of sugar', Felton wrote. 'Sugar is not a good line . . . so our Oakenden [a company in which they had just invested] may be said to be nipped before it has budded. It must go on to full flower now—the plant is ordered and for better or worse we must see it through.' Seven months later he wrote that 'sugar is very bad. Our Oakenden friends are not happy. The place is hung up—the machinery ordered left with the makers in Glasgow'.[15]

> You know what a lot was thought of our Sugar Companies here and in Sydney— what precious ventures they were thought to be—and in fact were for many years. They were unlimited companies . . . I am glad I did not even think of buying: they may be a liability before long, who knows? The Companies are deep in plantations, and plantations are a very bad thing.[16]

Oakenden failed, but Felton eventually profited from a stake in the Colonial Sugar Refining Company, which he probably entered through the Port Melbourne Sugar Company, of which Campbell was a founder. In mid 1885, when a brief recession had begun, he reported: 'There are many changed fortunes here. Wheat wool, sugar, imports and exports—have all had victims'.[17]

By that time—and unlike Grimwade, who did not buy a country property until 1895, and then mainly for family use—Felton had become a pastoralist. Charles Campbell already had a large stake in the Malvern Hills Pastoral Company of Queensland (and in the Western Queensland Meat Preserving Co Ltd), and in 1884, within weeks of buying 'Wattle House', Felton joined him in a ten-year equal partnership, Campbell and Felton, for a purpose Felton described a little breathlessly to his friend Kempthorne:

> I have been very busy of late. In addition to the requisitions made of my time by the various concerns—business and manufactures—I have added to myself a sheep run on the Murray [river], the place Murray Downs, Swan Hill, 80,000 acres of freehold, 50,000 sheep, stud flock, horses, cattle and the rest of it. I am going up at Easter to see the place, and roam amongst its fine hills and grassed valleys; when you are here you shall run up with me.

[15] AF to FSG, 22 September 1884. 'It is strange that astute man Ronald [not identified] should go into sugar as it was going wrong. You are probably aware Ronald bought a plantation in Queensland when he was here last. Do you hear of him from Keep? Do you meet him even? Does he worry over his sugar venture?'

[16] AF to FSG, 20 April 1885.

[17] AF to FSG, 24 July 1885.

Charles Campbell (ANZ Trustees)

The gentle undulations of the new property, scarcely discernible in the sweeping flatness of the Riverina, scarcely qualified as hills and valleys; and Felton underestimated distances when he optimistically added that 'in a month or two' extensions to the railway would enable him 'starting in the morning' to 'dine at the fashionable hour of seven o'clock [at the] Downs'. It was 1890 before trains reached Swan Hill, which was nearly three hundred and fifty kilometres from Melbourne.[18]

Swan Hill had been named by Major Mitchell in 1836, when he camped beside a shallow lagoon where black swans 'so abounded' that 'their noise disturbed us through the night'.[19] John Hawdon took out a squatting lease on the

[18] AF to TWK, 18 March 1884. On the station, see [Croft], *History of Murray Downs Station*, Feldtmann, *Swan Hill*, and Casey, *Australian Father and Son*, p. 60.

[19] TL Mitchell, *Three Expeditions into the Interior*, vol. II, pp. 139–40.

area across the river three years later, but Murray Downs—then about the size of Middlesex—was little developed until Suetonius Officer and his brother Charles bought the lease in 1862; Suetonius paid a pound an acre for the freehold of 80 000 acres in 1866. Although close to Swan Hill, the river isolated the property, and for many years a constant lookout was kept from an armoury-tower against any approach by Aboriginal warriors through the tall reeds on the river bank two hundred yards away. (Lord Casey's father, as a young jackeroo on Murray Downs in the 1860s, took time to learn some Aboriginal words and phrases.) The tribes were still thought a threat in 1884, and later their remnants continued to traverse Murray Downs, though without disturbance; some were put on the payroll, their job—an ultimate irony—to hunt kangaroos.[20] (In 1917 Agnes Edwards, known locally as Queen Aggie, a leader of the Moolpa tribe, came to the station for the customary tobacco allowance, but also stole a fowl; next time she appeared the Manager remonstrated with her; 'Ah well Mr Laird', she replied, 'you take my country, I take your fowl'.)

The homestead, built by the Officers in 1866–68, was low, with a large squat tower at one end. Between it and the reedy fringe of the river they laid out a large garden, stocked with European fruits and flowers, date palms from Egypt and vines from Italy, with nearby an orchard of citrus from Jaffa. Their main enterprise was wool, but they irrigated some pastures, and in 1874 also began Australia's first ostrich farm, acquiring the remnants of the flock which Samuel Wilson, zealot of the Victorian Acclimatization Society, had tried to establish at Longerenong in the Wimmera. From the eggs of the two surviving females the Officers built a flock of 120; the tail plumes, harvested manually twice a year, were of excellent quality and fetched £2 each in the European market.[21] The whole station enterprise depended on the river and its paddle steamers, for supplies which could not be locally produced and to take the wool to the railhead at Echuca.

By the 1880s Murray Downs was a large community in its own right. In its heyday it supported a baker, a blacksmith, carpenters, steam engine drivers, bullock drivers, drovers, shearers, wool classers, boundary riders, kangaroo shooters, grooms for the horses and buggies, and men for ring-barking trees, cutting suckers and clearing, and for extensive irrigation works. There were also rabbit trappers, rabbits having crossed the Murray by 1877, in the swags (Eric Rolls suggests) of Mallee gamblers come to play two-up in the pub on the station side

[20] 'Hunting Kangaroos (blacks) £41 16s. 6d.' (Investment Book entry, 1891).

[21] Eric Rolls tells the story of the ostriches, in *They All Ran Wild*, pp. 318–21.

Murray Downs: additions by Felton and Campbell are on the left (photograph, John Monahan, Swan Hill)

of the river. 'Chinamen' tended the vegetable garden, and a storekeeper guarded the comprehensive storerooms. Inside the house a governess, parlour maids, and several other maids—usually the daughters of employees—were supervised by the housekeeper. A school building, the first in the district, served as a church on Sundays.[22] Murray Downs, as advertised in 1884, consisted of 77 725 acres freehold, with 20 000 acres of leased Crown Land, with 44 000 sheep, 118 horses, 214 cattle, the homestead, a woolshed for 28 shearers and, if wanted, the flock of ostriches. 'The agents', the advertisement added, 'have pleasure in drawing the attention of capitalists to this grand estate'. Charles Campbell and Alfred Felton were reported to have paid 30 shillings an acre—certainly a very large sum in total—and took possession on 13 February 1884. They did not keep the ostriches, which went eventually to another Officer station on the Darling.

[22] Presbyterian: Mrs Officer's father was the Reverend Dr Adam Cairns, originally a Free Church missionary but by the 1860s 'Victorian Presbyterianism's acknowledged spokesman' (Don Chambers, in *ADB*, vol. 3).

Felton's first reactions to the vast estate were joyful. Making the day-and-a-half journey north from Melbourne in the winter of 1884, with Campbell and Campbell's eldest daughter, he arrived at midday:

> Looking from the windows of the house we saw no end of golden fruit hanging on dark leaved trees, presenting a lovely sight when most trees are out of leaf, the richness of these trees was both novel and refreshing . . .
>
> On Thursday afternoon we planned the planting of an avenue to the house and the homestead improvements. On Friday and Saturday we took long drives over the estate, talking of sheep, stud flocks, fencing, irrigation, and on the way inspecting the country for future improvements.

The avenue of elms still stands, aided as seedlings by having a dead sheep buried under each.

On Sunday they started homeward:

> At the punt at Swan Hill the 'Downs' made a goodly show, our own vehicle, then the Swintons' trap, then the overseer and a number of employees on foot, all but ourselves bound for the Church at Swan Hill.
>
> Till today the weather has been cold, but as we crossed the Murray the sun came out and the weather was delicious, a Sunday calm seeming to rest over all things.[23]

The party arrived back in Melbourne 'laden with native turkeys, kangaroo tails and fruit' 'Campbell and myself are better satisfied with the Venture as our knowledge of the property increases . . .' A good lambing, rains and the prospect of a good price for surplus sheep added to his optimism. 'Whilst so much disaster rules in Squatting, we should be thankful for such advantages.'[24] Felton later developed the habit of distributing Murray Downs oranges among his friends as presents.

In September 1884 Felton, Campbell and a different Campbell daughter were back at Murray Downs. The partners had bought fourteen rams, including a valuable animal from 'Ercildoune'; and 'on the Monday, after Sunday's steamer had got well on its course to Echuca, the 'Trafalgar' hove in sight, bearing these gentry to their future home'.

> The Ercildoune 500 guinea Ram, and Golden Fleece—one of Cuming's—were installed each in his own house and small enclosure. The twelve Apostles, as I called them, were landed on the banks of the Murray into a nice paddock adjoining the homestead. They had a little fighting to do, but soon settled down the best of friends . . .

[23] AF to FSG, 'Kerang Sunday evening', 29 June 1884. Robert Swinton was manager of Murray Downs, 1884–88.

[24] AF to FSG, 14 July and 16 June 1884.

Over the next three days the partners 'took long drives of about 50 miles each day—camping for lunch—at times we drove through timber, when it was necessary to keep a good look out for heads and eyes—and I may say we traversed very much of the run'. They also 'went to the Woolshed and saw the shearing, to the Ostriches, and to the cultivation paddocks and garden'.[25]

Felton now passed as a squatter. 'There is an awful lot of Melbourne money in New South Wales squatting properties', he wrote to Grimwade in 1884; and late in the year the Sydney Government passed an act which improved squatters' tenure, as he explained in December:

> The new NSW Land Law comes into operation on January 1st. It is said that the Sydney Streets are paraded with Melbourne squatters each with a tin case under his arm containing of course the maps of his run. By this Law each squatter has to divide his Crown lands into 2 halves, and inform the Minister which half he desires to have.
>
> Campbell started for Sydney on Monday and yesterday no doubt joined the throng of the men with the round tin cases.[26]

The partners hoped 'to get a lease of all the land we hold from the Crown', and apparently succeeded. Unfortunately, the government of heaven was less helpful than that of New South Wales. 'The whole continent is calling out for Rain', Felton wrote in September. 'Rain is life to us out here you know, a few inches of rain all over Australia will add millions to the commonwealth and dissipate our present fears.'[27] It did not come, and in May 1885 Felton reported that on another station Campbell had lost '180,000 sheep, and all lambs. This is a terrible big loss, is it not? It makes a man look about'.[28] By June 'we Murray people are all gloom about the season', depressed further by low prices for wool in England. In July Felton lamented that 'the present results' were 'damaging to one's balance and assets. Would that one had left most of these things alone'. 'How tragic has been the history of drought in Australia! Many a man after months of watching has felt the tempting words sounding in his ears—"curse God and die!"'[29] Felton was not hard-pressed enough to do either, and Murray Downs recovered. Campbell and Felton invested in substantial 'improvements', hiring gangs of two hundred men (said to be mainly Chinese) to clear large areas, spreading much fertiliser—no

[25] AF to FSG, 22 September 1884. 'On the steamer, I met a young Church of England parson, who had shaken the dust of Wentworth off his feet and was returning to the haunts of civilization. He gave a very poor account of the liberality of the squatters in the district he had left.' One had promised £10 a year but never paid.

[26] AF to FSG, 11 August and 17 December 1884.

[27] AF to FSG, 22 September 1884.

[28] AF to FSG, 5 May 1885.

[29] AF to FSG, 15 June and 24 July 1885.

doubt from Cuming Smiths—and installing pumps and weirs to produce the largest irrigated area of the time on the entire Murray. Campbell was probably the prime mover in these developments; the *Pastoral Review* later wrote that 'though not technically acquainted with pastoral affairs his general ability was such as to make him an excellent director of [station] management'. He also helped found the Pastoralists' Association of Victoria and Southern Riverina, and became its treasurer, a role Felton would have been happy to leave to his partner.[30]

AMONG THE SURVIVING records of Felton Grimwade's is a partners' letterbook, 'F.G. & Co Private Letters', for the years between 1884 and 1895, overlapping a little with Felton's of 1875–85. Grimwade's firm hand and erratic punctuation appear in the book in December 1885, giving Kempthorne the news that Felton had sailed for England.'I have to represent him in his various private ventures ... and so you will readily understand, my hands are full', he added.

> Our friend ... will stay a few weeks en route in India, at the last he made up his mind very hurriedly and in fact even on the Monday before the Thursday on which he sailed, I was not certain he would go. I had just been back 5 weeks and had had hardly time to pick up all the details of the business. I am glad Felton has gone, it is nearly 16 years since he left for England before. I think a change of scene will do him good and also it is time he saw England and his people there.[31]

Felton was a venturesome traveller in 1885–86. In March Grimwade reported to William Felton that Alfred was enjoying himself in India, and about to leave for England.[32] His itinerary included continental Europe and the United States. Charles Campbell, sending the annual accounts of Murray Downs to Felton in Europe in 1886 (and thanking him for the photographs of ancient Thebes and the book of views of Vienna he had sent Mrs Campbell), commended his enterprise:

> Today I received your note from Vienna ... I miss from this note your graphic description of people and places ... but I look forward to many an enjoyable talk ... take your enjoyment this time mine friend for you may not have another chance—age is coming upon us all and the desire to travel grows less after a time, it was plucky on your part to move as you did.[33]

[30] *Pastoral Review*, 16 October 1905.

[31] FSG to TWK, 23 December 1885 (Partners letterbook). Grimwade's problems were compounded when Bage had a stroke in January 1886; after a partial recovery he went abroad for some time, but died in 1891. Norton Grimwade had to return from London prematurely in August 1886 and to complete his qualifications in Melbourne (*Retrospect*, pp. 14–15).

[32] FSG to William Felton, 19 March 1886.

[33] Charles Campbell to AF (loose note, Trustee company files).

Felton shared the taste of his contemporaries for photographs of impressive scenes, and included them among objects he collected. While overseas he naturally sought out museums and galleries, and also opera houses, in both Europe and the United States.

In America Felton fell ill, the doctors diagnosing 'sewer-gas poisoning'. To a true merchant every cloud had a potentially valuable lining, and in January 1887, back at Flinders Lane, Felton began a campaign, in a succession of characteristically forceful letters on 'the sewer problem', to sell suitable disinfectants to sanitary authorities in Melbourne and Sydney. He was told there was 'no opening' for permanganate of soda in Sydney, as the sewage went into the sea, and seawater was 'a perfect disinfectant' (depending, Sydney was to find, on the proportions).[34]

There is some mystery concerning Felton's domestic intentions when setting out so abruptly in December 1885. Grimwade's remark to Kempthorne that 'Felton left his house and effects in my hands for disposal' seems a simplification, as this letter to a Mr W H Greene shows:

> When you called in last evening I was not at all prepared to speak about Mr Felton's house with any definitiveness. The fact is, he left in such a hurry that I had but few instructions. He left Mr Dare more seized with his wishes.
>
> I have been with Dare this morning, and after consultation with him, beg to state as follows.
>
> I will not let the house furnished for longer than one year, at the following rent.
>
> The house furnished as it is excepting a few books to be locked away, £350 per annum with special clauses for the tenant to keep up the Garden, Conservatory, Fernery etc., or £450 per annum and I will keep up the Garden.
>
> As to purchase the lowest price I can sell for is £5500. Two estate agents valued the property at £6000. The house is in Dare's hands and was given so by Mr Felton, and there are several people enquiring about it.[35]

Apparently Felton was willing to sell 'Wattle House', after only seven months occupation; but Alice Creswick's account to Russell Grimwade that 'this house didn't last long. Burstall went to England and AF went to Esplanade Hotel' abbreviates and simplifies. Felton had earlier reported, in June, that Burstall was thinking of taking in a partner, and that 'the old gentleman will then make tracks for England', but that had not yet happened, though he seems to have left 'Wattle House'.[36] No sale was completed in Felton's absence, Jackson Street remained his

[34] AF to Anderson Bros, 28 January, 11 February and 25 March (Partners' letterbook).

[35] FSG to TWK, 23 December 1885; FSG to WH Greene, 22 December 1885 (both Partners' letterbook).

[36] AF to FSG, 15 June 1885. Burstall was listed in a new partnership, Burstall and Smith, merchants and commission agents, but not until 1889. The 1887 *Directory* lists Burstall at Dalgety Street and Felton at Jackson Street. In 1888

address in directories in 1886 and 1887, and the house was finally put to auction, in Felton's name, in January 1888.

Later in that year Felton again set out overseas, Grimwade complaining, in January 1889, that Bage was ill again and Felton in Europe. He had once again left personal chores to Grimwade, notably the sale of some pictures. On this trip, and presumably the earlier, he visited members of his family, in particular his brother William. His nephew and namesake, Alfred Leopold Felton, later told Russell Grimwade of his eccentricities as a house guest, including an inconvenient insistence on sleeping with his head to the north, along the magnetic meridian, a cause of nocturnal disruption when visiting houses where the bedrooms ran east–west. (Since Alfred Leopold was a very small boy at the time, his account of Uncle Alfred's peculiarities probably owed more to later family anecdotes than direct observation.) It was also reported (from Melbourne) that it was this brief experience of family life which dissuaded Felton from quitting Australia for England. By February 1890 he had returned to Melbourne, giving Grimwade a good report of his second son Harold, studying pharmacy in London. Felton must then have become ill, Grimwade telling Kempthorne in June that he was 'quite well again', and 'very busy in glassworks matters'.[37] For three years Felton had indeed been restless; and his residential arrangements over the next three remain obscure.

'Wattle House' survives. After Federation it was, briefly, the Melbourne residence of the Right Honourable George Reid, MHR, Leader of the Opposition; accumulating myths—it was once said to have been built by a young Englishman at the instigation of his sweetheart 'at home', who then jilted him—the house followed the fortunes of St Kilda into decline (as a brothel, a boarding house and then a special accommodation house) and thence to a local form of regeneration: it is now Jackson Manor, offering international backpackers 'superior accommodation'. Fernery, greenhouse, forcing houses and tennis court have disappeared under close-built neighbouring apartments, but in one corner a gigantic elm survives, far overshadowing the perky weather-cock on Felton's rusting tower.

and 1889 Felton has no residential address, and in 1890 and 1891 only 'Felton, Alfred (Felton Grimwade & Co) Caulfield'; EN Grimwade is listed similarly. Burstall is given a Northcote address in 1889, and from 1890 directories list 'Burstall and Smith, Merchants and Commission agents, Punt Hill, South Yarra'.

[37] FSG to ?, 25 January 1889; FSG to Charles Umney, London, 3 April 1890; FSG to TWK, 18 June 1890 (Partners' letterbook).

8

CHURCH, CHARITY AND ART

One of the friends whose company Felton missed in 1884 was Charles Strong, in retreat in Glasgow. His supporters remained in control of Scots Church, and on his departure in 1883 they sought an act of parliament enabling separation from the Presbyterian Church of Victoria, hoping to become an independent congregation of the Church of Scotland while retaining the church property.[1] The Bill won little favour, in or out of Parliament, Bishop Moorhouse speaking strongly against such separatism, though Charles Pearson supported it. Strong himself took no part in this campaign; Felton kept in touch with him, and gave Grimwade news of the fugitive.

> Our Scots Church people are proceeding with their Bill for Separation. It is an uphill fight for them. In the meantime Strong who wishes to be here is tiring in his native land, and those who found him a help and a teacher, are missing their weekly religious aliment, and who can be pleased at all but the power whose attributes must resemble a typical fiend: ay?[2]

In July Felton was shocked by a cablegram in the *Argus* announcing

> that my friend Strong had accepted an appointment in the Liverpool University. It then first dawned on me that we should not see him in Melbourne again. I regret that very much—one cannot afford to lose old chums now. His last letters did not indicate this removal to me. I wait to hear the news from him.

He tried to shrug off his disappointment: 'I will not extend my letter now, there is a sort of winter hanging not only over our skies, but [over] all the atmospheres

[1] Badger, *The Reverend Charles Strong and the Australian Church*, pp. 96–8; see also Badger's entry on Strong in *ADB*, vol. 6.

[2] AF to FSG, 14 July 1884.

which the spirit has the power of visiting ... This of course as you know is chiefly liver'.³

Felton must have been happy indeed when Strong returned to Melbourne in October 1884. Asked to give Sunday addresses in the Temperance Hall, 'the Doctor' soon gathered a large audience of former parishioners, religious liberals and others alienated from the churches of their youth. One of the first to greet him was Felton's 'friend and partner', Charles Campbell, who had introduced himself to Strong in January 1885: 'My friend Alfred Felton told me the other day that there was a probability of your settling here as principal of a Ladies College', he wrote, offering to take £200 in shares in the venture and to send three daughters to the college. 'If on the other hand you can see your way to remain in the ministry, which I and a great many of your friends would like, I will be prepared to assist in the question of a building and guarantee a certain subscription for a fixed term.'

> Many of your friends would like to see you in a free church with more or less the ritual of the English Church. I am not nor ever have been a member or adherent of Scots church but our ministers of today do not touch me ... I hold very strongly that a clergyman's work is more out of the pulpit than in it ... I would like to see a church established whose ministers or minister would teach the truths that surround us as you have done.⁴

By June 1885 Felton could write of Campbell that

> He has become a Strongite, he now goes on Sunday mornings to hear the Reverend Charles. He is I think the ablest practical head that the confraternity can claim, and perhaps he may be the guiding hand that may lead the movement into a port of security and rest ... That he can pacify the Presbytery or square the circle I fear is beyond his powers, but he may grow to it. Who can put a limit to the development of a man's powers?⁵

Felton was attending also: 'Strong is preaching some grand sermons on Sunday mornings at the Temperance Hall', he wrote in July, 'so we get some mental [sustenance?]—something to go on for the week'.⁶

Campbell and the 'confraternity' failed to square the circle, and the members of the 'Strong Preaching Committee' were formally removed from the Scots

³ AF to FSG, 28 July 1884.

⁴ Campbell to Strong, 7 January 1885 (Strong Papers, NLA 2882/1/3).

⁵ AF to FSG, 15 June 1885.

⁶ AF to FSG, 10 July 1885.

The Rev. Charles Strong, *c.* 1881 (J W Lindt, photographer, Haddon Collection, La Trobe Picture Collection, State Library of Victoria)

Church Roll.[7] In November 1885 they moved to establish a new church, 'free, progressive, unsectarian', and invited Strong to lead them. He accepted, and was soon addressing a thousand people weekly in the Temperance Hall, while the Board of Management eagerly began to collect money to build a church. Felton was abroad in 1886, but the second annual report lists him as a member of the Board in 1887, alongside Campbell, Colonel Goldstein and other worthies.[8] Felton, who never joined committees, must have been drafted in his absence; his

[7] Badger, *The Reverend Charles Strong and the Australian Church*, p. 98.

[8] Jacob Goldstein, born in Ireland of Polish, Jewish and Irish descent, had arrived in Victoria in 1858 and become a contract draftsman, a colonel in the Victorian Volunteer Artillery and was prominent in several charities. Vida, the feminist and suffragist, was one of his four daughters.

name disappeared from the list the following year. He continued to raise money: 'When I tell you that I am amongst a small number who have arranged to put up the building for the Australian Church here, you may suppose I have rather an expensive operation in hand', he wrote with formal courtesy in February 1887, refusing a request to help pay for a church in Ballarat. He had 'as much of the church building business on my hands now as suits me', and begged to be excused 'from assisting larger and wealthier religious bodies'.[9] The foundation stone of the new church was laid by Sir William Clarke (boisterous 'Big' Clarke's respectable son) in December 1887; the building, its grand high front adorned with Corinthian columns, faced Flinders Street, down the hill and around the corner from Scots Church. The Church cost £23 000, and was completed when the Board of Management had collected only a third of that sum.

For a few years the Australian Church flourished, despite its burden of debt. Charles Strong was passionately committed to social reform, and the formidable Mrs Strong—said to be a better scholar than her husband, and an excellent musician—took the lead in organising a Social Improvement Society, which soon made its mark working for the poor of Collingwood, incidentally opening Melbourne's first crèche. Cultural initiatives also blossomed: the Church formed Orchestral, Literary and Dramatic Societies, and gave a rich programme of lectures and performances. Felton regularly attended services and remained one of Strong's closest friends and supporters. Alice Creswick thought Felton 'infatuated' with Dr Strong, drawn by the preacher's 'drive'; but it could have been Strong's independence of mind which most attracted Felton, who was neither a natural churchman nor a natural sectary, but indubitably an independent.

FELTON SYMPATHISED WITH Charles Strong's passionate commitment to social reform, without quite sharing it. Strong's influence on Felton was tempered by that of Edward Morris, another close friend with a determined—and in some respects more disciplined—social conscience. It was Morris, and not Strong, whom Felton named in his will as a member of his Bequests' Committee.

Felton had grown up in East Anglia familiar with the English Poor Law, which provided relief to the destitute from the Poor's Rate, levied on property; it underwent major reform when he was a child, and he would have been aware

[9] 'Just as I was leaving London by the train at midnight, on my way to Liverpool for Australia, a clerk from our London office brought me your letter. My reply to this, I regret to say, is rather late, for your letter got mislaid and was overlooked on my return ... with kind regards and very much respect' (AF to H Brind, 2 February 1887, Partners' letterbook). Badger, *The Reverend Charles Strong and the Australian Church*, pp. 100–2, is wrong in suggesting that Felton 'soon retired from active participation' in the Australian Church, though 'he attended services and was a close personal friend of Charles Strong'. He held no official position, but remained active; in 1888 his contribution of £25 to a fund to reduce the deficit was second only to Campbell's £50. The *Annual Reports* of the Church are in the Strong papers.

The Australian Church, 1887 (William Solway, architect, *The Australasian Sketcher*, 27 January 1887, La Trobe Picture Collection, State Library of Victoria

of the fierce controversies surrounding the birth of the 'New' Poor Law, with its attempt to counter pauperism—dependence of the indigent on relief rather than their own efforts and frugality—which had been feared as a spreading social canker in England since the beginning of the century.[10] The Amendment Act of 1834, ardently defended and bitterly attacked, sought to deter labourers from sinking into pauperism by giving relief only in Union Workhouses, one of which was built opposite the school Felton attended. Victoria, without a Poor Law (or

[10] Poynter, *Society and Pauperism*, traces the growth of concern over increasing pauperism.

Professor Edward Morris, c. 1900 (Johnstone O'Shannessy & Co, photographers, La Trobe Picture Collection, State Library of Victoria)

the convict establishment which had performed some of its functions in New South Wales and Tasmania), had developed its extraordinarily elaborate network of government-subsidised private charities, which Felton supported but never, unlike his friends and others of their class, chose to manage.

In England, in the 1860s, the belief that indiscriminate private charity could be just as destructive as a Poor Law gained the status of an ideology, and Edward Morris had early come under the influence of CS Loch, moving spirit of the Charity Organisation Society, founded in London in 1869 (and originally entitled the Society for Organising Charitable Relief and Repressing Mendicity). Victoria's multitude of charities varied greatly in size and effect. Some were conspicuous, like the sprawling Immigrant Aid Society's Home for Houseless and Destitute Persons across Princes Bridge, and the massive Melbourne Benevolent Asylum then dominating North and West Melbourne; others, including the Society for Assisting Persons of Education, were extremely discreet. The

Melbourne Ladies Benevolent Society had its visitors everywhere, but nowhere an office, lest its members be importuned. 'Scientific' charity brought a new weapon against pauperisation: direct investigation of each individual supplicant to establish his or her real need, an approach which was eventually—in Britain, the United States and Australia—to contribute powerfully to the emergence of social work as a vocation.

Morris urged a COS for Victoria as early as 1877, but the established charities saw no need to be 'organised' by a potential rival. (A COS founded in Sydney in 1878 failed to make headway against the continued dominance of the Benevolent Society.)[11] But the annual reports of the Victorian Inspector of Public Charities, a post created in 1881, soon made the public aware that too much of some £200 000 given in government subsidies to public charities was frittered away by competing, inefficient agencies; and a much publicised case in 1887, when an indigent man, John Jackman, died in a hansom cab after being turned away from two hospitals, prompted Strong to write to the *Argus* advocating the formation of a Charity Organisation Society. Morris seized the opportunity to prepare a detailed proposal which occupied a whole page in the *Argus*, and called a public meeting in the Town Hall, where his eloquence won the day: a month later the COS was formed, with Morris as President and a powerful Committee, including Mannington Caffyn (who had been a Councillor with the London COS), Charles Strong, Lady Clarke, the editors of both the *Argus* and the *Age* (FW Haddon and David Syme), Colonel Goldstein and two men who were later to be members of the Felton Bequests' Committee, JA Levey and F Race Godfrey, the then Chairman of the Melbourne Hospital. The new Society's purposes included promoting co-operation in charitable work, discouraging indiscriminate giving, ensuring adequate inquiry before providing relief (which should be 'suitable and adequate'), and maintaining records of all cases. Both Chief Justice Higinbotham and Sir Henry Loch were informed that they had given assistance to a man 'utterly undeserving of sympathy or relief'; of 211 cases dealt with by the new organisation in 1887–88, 74 were found to be deserving, 76 undeserving and 61 'doubtful'.[12] 1887 was also the year of Queen Victoria's Jubilee, celebrations including a charity dinner for eleven hundred poor and a fancy-dress ball for the affluent, which Morris, founding president of the Shakespeare Society as well as of the COS, attended as Hamlet. It was also

[11] Dickey, *No Charity There*, p. 89.

[12] Anderson, *The Citizens Welfare Service of Victoria 1887–1987*. Kennedy, *Charity Warfare*, is a thorough but unsympathetic account of the COS.

marked by the founding, by Lady Loch, Higinbotham and others, of the Queen's Fund, for 'the relief of suffering womankind', a charity which later came under the control of the COS.[13]

The principles of charity organisation were welcomed by many and criticised by others, but had nevertheless achieved an unusual ascendancy in Melbourne—which they never gained in Sydney—by 1890, when Morris presided over the first Australasian Conference on Charity, and Ephraim Zox headed a Royal Commission on Charitable Institutions (to which Dr Mannington Caffyn gave evidence on alcoholism, shortly before quitting the Colony).[14] Some champions of 'scientific' charity spoke as if imposition were the only problem to be overcome but, despite Twopeny's assertion that Melbourne had little poverty compared with English cities, the reality of distress even during the boom years was difficult to deny, as the Royal Commission found. 'Scientific' charity certainly strengthened prevailing presumptions concerning the need for discipline in relief, and hence (though unintentionally) the recipients' sense of being controlled and patronised; and Charles Strong himself warned the COS—though not specifically Morris—against 'the appearance of pooh-poohing the hardship of working people, and becoming the agent of the self-righteous well-to-do, who know nothing of the poor, and care nothing'.[15] Melbourne, when prosperous, was apt to be smug about it.

Felton, always the observer and rarely a participant, did not appear in this procession of debates and meetings. He accepted the views of Morris on 'indiscriminate' charity, referring (according to Dickson Gregory) all the begging letters he received to the COS for scrutiny: 'Mr. Felton received hundreds of letters of a begging character . . . These he handed over to the Charity Organization Society for investigation; if any were proved satisfactory by the Society he would send a cheque, but if otherwise nothing further was done'.[16] The COS might be helpful in sorting unknown individual cases, but Felton did not delegate to anyone

[13] Kennedy, *Charity Warfare*, pp. 77 and 130.

[14] Ephraim Zox arrived in Melbourne from Liverpool a year before Felton, and, like him, became a merchant and a philanthropist, and remained a bachelor. He was also an MLA, a famous punster, president of the Melbourne Hebrew congregation, and 'with bell-topper, white waistcoat and mutton-chop whiskers . . . one of the best-known figures along "The Block"' (LE Fredman, in *ADB*, vol. 6).

[15] *Evening Herald*, 11 December 1891 (quoted in Kennedy, *Charity Warfare*, p. 130). Kennedy, in 'Charity and Ideology in Colonial Victoria', discusses (pp. 52–9) the 'Bourgeois myth' that Victoria had no poverty. He also asserts (pp. 59–66) that Victorian charities were so discriminatory that the claim that the colony had no deterrent Poor Law was a 'Myth for the Working Class', but there remained real legal and other differences between a poor law and private charity, though both could be deterrent. See also Shurlee Swain, 'The poor people of Melbourne'.

[16] Russell Grimwade's notes of conversations with Dickson Gregory, 1931.

decisions on which institutions or causes he would support. 'He never had time for collectors for charities', Dickson Gregory added, 'and believed in sending cheques direct to institutions, as he considered that too much money was wasted in giving commissions to the collectors'.

MOST OF FELTON's gifts were anonymous, but he was widely known as a supporter of the Old Colonists' Association, of which he became a Life Governor in 1888, before his departure overseas. Once returned, he probably attended the great 'Meadow Party' held in the grounds of the Old Colonists' village in North Fitzroy in March 1890, when the Governor inspected a guard of Honour from the Harbour Trust Battery, and 1500 guests were entertained by Punch and Judy and by a band under Signor Zelman, and 'King William' Barak and three members of the Wurundjeri tribe gave an exhibition of boomerang and spear throwing. As a boy, the grave and able William Barak had seen the chiefs place their marks on John Batman's treaty seeking 'possession and civilisation' of their lands; since 1863 Barak and remnants of the tribes, the oldest colonists of all, had been tucked away in the Coranderrk reserve at Healesville, emerging from time to time to entertain the newcomers with their skills, and he to represent his people. Felton left no recorded comment on the fate of the race the British had conquered in settling Australia. By 1890 their maintenance in the Victorian reserves had long been seen as an expense of government and not a field of private charity, and it was easy in Melbourne to regard them, with more nostalgia than guilt, as a dying race. 'They are wearing away very fast, and soon the only tribute that the white man will be able to pay will be the sculptural stone to mark the spot in which the last of an ill-fated race has been laid in the earth where once his forefathers deemed themselves the lords of the earth', wrote the polymath Alexander Sutherland, in his vast *Victoria and its Metropolis*, published in 1888. (Felton would have known Sutherland—poet, scientist, historian and author of *The Origin and Growth of the Moral Instinct*, a bold attempt to bring moral development within the theory of evolution—and an associate of his friends Morris and Strong.) The future would prove very different; certainly no one at the Meadow Party could foresee that the water-colours in which William Barak sought to preserve the traditional images of his culture would be so valued by the year 2001 that the National Gallery of Victoria would pay $75 000 for one.[17]

[17] Sutherland, *Victoria and its Metropolis*, vol. I, p. 30. 'To the ordinary people', Patricia Marcard wrote in her entry on Barak in *ADB*, vol. 3, 'he remained a romantic curiosity on picture postcards; erect and bearded, wearing sandshoes and a long coat, a Bible in one gloved hand and a boomerang in the other'. On the Meadow Party, see The Vagabond, 'The Old Folks at Home', *Age* and *Argus*, 17 March 1890. On William Barak's art, see Sayers, *Aboriginal Artists of the Nineteenth Century*. His works are also preserved in the State Library and the Museum of Victoria, and in the Ballarat and Queensland art galleries. On Sutherland, see PH Northcott's entry in *ADB*, vol. 6.

William Barak (Haddon Collection, La Trobe Picture Collection, State Library of Victoria)

The Old Colonists' Association's Annual Report for 1890–91 recorded that Felton 'had offered to build four cottages and to endow them'. Completed in the following year, they cost him £1100, and still stand, bearing his name; Felton also paid the weekly allowance for the two men and two women who first occupied them. Most residents were chosen by ballot from a large number of applicants deemed eligible and worthy after much scrutiny, in the 1890s by the Charity Organisation Society. Inmates had to be over sixty, destitute and deserving; early residents included a retired principal of Kyneton Collegiate School, a former governess, a bankrupt baker, a clerk, and a failed squatter. Once accepted, each

received a pension of 10 shillings a week (generous: the old age pension introduced in Victoria in 1901 was 8 shillings, and was expected to cover housing). Supporters, including Felton, donated food and other goods, including two cases of port wine to toast the Queen's health on Jubilee Day 1887, and Miss Louisa Henty's annual Xmas puddings, of which the Secretary reported that 'The proof of the pudding is in the eating, Yours is all gone'.

Residents were expected to be independent and well behaved, and not to be away more than twenty-four hours without permission. They mixed freely with the local community, including the occupants of the (less successful) Almshouses for 'decayed actors' which Coppin had built next door. Outings included one to Government House in 1896. When residents died, Mrs Sleight would (after 1897) bury them free in the Old Colonists' plot in the Melbourne General Cemetery. In the meantime they were, one historian has noted, expected to 'sit in the sun, water their flowers and look deserving'.[18]

Between 1892 and 1903 the Old Colonists' Association received, in addition to the four cottages, some £3062 from Felton, plus numerous gifts of wood and coal. In 1895 he increased his annual payment to £109 4s, adding, towards the endowment of his cottages, a further £69 4s per annum and transferring eight £100 debentures in the Colonial Sugar Company (paying 5 per cent, 'guaranteed by me if required'). For this contribution he asked for three nominations to cottages 'as per your arrangements with others' contributing to the endowment fund. 'I may state I think my nominations will be of such persons as the Council will most desiderate as inmates and beneficiaries.'[19]

His first nomination was Mr Clarke, 'an aged Melbourne merchant', whose indigence had been drawn to his attention by a colleague. With characteristic thoroughness, Felton told others among Clarke's friends that 'to make him comfortable he should be nicely furnished in'.

> Mr. Clarke is not likely to make his immediate wants so well known as I can, so I round up three gentlemen, Messrs R. Balderson, J. M. Bruce and Wm. Noall, and I hope they will round up half a dozen more of Clarke's friends, and then with the help of the ladies of their several families Saturday next should see Mr. Clarke domiciled in his cottage with his household gods around him.[20]

'I shall send him', Felton added (again characteristically), 'some pictures for the walls and books and reading matter'.

[18] O'Neill, *Picturesque Charity*, p. 45.

[19] AF to Secretary, Old Colonists' Association, 20 July 1895. He gave a further £1400 in debentures in 1900.

[20] AF to R Balderson, 6 August 1895.

Felton Cottages, Old Colonists' Homes: residents in the sun (Old Colonists' Association of Victoria)

THE 1880S WERE boom years for the Public Library and National Gallery, as for so much else in Victoria. A massive building programme was begun, money was spent on acquisitions—the most 'Imperial' of them Lady Butler's *Quatre-Bras 1815*, bought in 1884, and the most expensive Alma Tadema's *Vintage Festival*, a duplicate commissioned in 1888 for the highest price paid by the Gallery in the nineteenth century—and the Art School consolidated its strong but not uncriticised role in fostering native talent. There is no record of Felton's involvement in this flowering; no one seems to have considered asking him to be a Trustee of the Public Library, National Gallery and National Museums. Two of Felton's friends did become Trustees of the combined institution, Morris in 1879 and Leeper in 1887, but the Library, not the Gallery, was their prime interest (although Leeper became at the same time a member of the National Gallery Committee, which the Trustees had established in 1870).

Chief Justice George Higinbotham became Chairman of the Commission organising the very grand Centennial International Exhibition of 1888, part of the celebration of a century of British settlement in Australia; he later resigned in protest over its extravagance, but Bosisto remained a member, and LL Mount, Felton's manager at the Glass Bottle works, represented the Chamber of

The Melbourne Public Library *c.* 1888 (CB Walker, photographer, La Trobe Picture Collection, State Library of Victoria)

Manufactures. The ubiquitous Byron Moore chaired the Wine Committee and the Refreshments Committee, and Murray Smith's Fine Arts Committee included FS Grimwade (and Byron Moore and LL Smith), but not Alfred Felton. So many of Felton's acquaintance sat among the multitude on the Exhibition's committees that his own absence was itself a statement.[21]

The commercial side of the Exhibition was of course of interest to Felton and Grimwade. Hearing that an importer was about to promote imported salt against colonial at the Exhibition by having some butter preserved with the two products, Grimwade arranged for 'Mr. Wilson, in charge of the dairy at the Exhibition', to be given a bag of Lignori's superior product, already in the exhibition. 'If we do not do this, you may depend our friend Mr. Henry Berry will get Mr. Wilson to use the

[21] All the committees are listed in the *Official Record of the Centennial International Exhibition, Melbourne, 1888–89.*

very poorest sample of lake salt he can, and thus condemn colonial salt for all time.' The outcome of the battle of the salts is not recorded.[22]

In 1888 Victoria over-reached itself, signalling, indeed, the imminent end of the boom. The Centennial International Exhibition was enormous, and the public ran out of puff, and of money: 3344 art works were exhibited—in a total of 318 610 items—but only £17 990 worth sold, though Sir Joseph Edgar Boehm's large sculpture *St George and the Dragon* was bought for £1000, to stand outside the National Gallery, and Briton Riviere's *Roman Holiday* (£1575) and W Clarkson Stanfield's *Morning after Trafalgar* (£1200) to hang inside it. (Boehm's *Young Bull and Herdsman*, also purchased for £1000, was later driven off to the Royal Melbourne Showgrounds.)[23] The art displayed was impressive, and no one in Melbourne could pretend ignorance of European taste through lack of opportunity to see the latest work then generally approved. Among the 715 British exhibits, Holman Hunt's *Scapegoat* was criticised as artificial, but Vicat Cole and Leighton were admired, by some, and HN O'Neil's spectacular *Landing of Princess Alexandra at Gravesend, 1863*, now in the National Portrait Gallery in London, by many. The Queen, the Prince of Wales and Lord Rosebery all lent pictures; the Duke of Westminster went further and presented Turner's *Dunstanborough Castle* to Melbourne's National Gallery. The French sent little, but the German exhibition (of 345 works) was praised, while New Zealand sent 434 works across the Tasman. The local contribution heralded a new national flowering. Tom Roberts had returned from Europe in 1885, and his *A Summer Morning's Tiff* was shown at the 1888 Exhibition, with works by fellow Eaglemont campers McCubbin and Streeton, and by Violet Teague, Jane Price, John Mather, Julian Ashton, Louis Buvelot, Arthur Merric Boyd, Emma Minnie Boyd, and Ellis Rowan (whose flower paintings won a gold medal, which Roberts and others thought undeserved). There were two paintings by John Longstaff, who had won the Gallery's first Travelling Scholarship in 1885. One artist newly resident in Melbourne exhibited in both the British and the Australian Exhibitions: JC Waite was fifty-four when he emigrated from London in 1886 and set about painting highly finished if frequently lifeless portraits of Australian worthies.[24]

Felton might have been especially attracted to the Exhibition's massive musical programme, an orchestra under Frederic Cowen performing not only all the

[22] FSG to Alfred Shaw, 9 October 1888. Berry was a manufacturing grocer, founder of Henry Berry and Company and a prominent Free-Trader.

[23] Palmer, 'The Latest in Artistic Endeavours', pp. 209–13.

[24] See JH Holmes entry on Waite in *ADB*, vol. 6. Waite was one of the artists commissioned to paint the inauguration of Federation.

Beethoven symphonies (most more than once) but also 'contemporary' works, including a great deal of Wagner. Melbourne was scarcely a cultural backwater in the 1880s.

OPPORTUNITIES FOR VICTORIANS to collect works of art had increased dramatically between the Exhibitions of 1880–81 and 1888.[25] London dealers who sensed a new market in Melbourne's boom years, and sent out collections for sale, included Henry Wallis of the French Gallery (his offerings in 1884 including Turners from the collection of the artist's executor, Munro of Novar); and in 1885 Koekkoek of Pall Mall set up a Melbourne branch, its stock including continental art but omitting the French works they sold in London. Felton was among their customers, buying a Portielje. Sir Coutts Lindsay sent his Grosvenor Gallery Exhibition of 1887, but sold only 26 of 158 modern English works, perhaps because he claimed to be in revolt against the Royal Academy, still the arbiter of taste for many Melbourne buyers, if less obviously for the National Gallery.[26] Some buyers were suspicious; the *Australasian Critic* alleged that English dealers only sent to Australia 'works unsaleable at home', and in 1891 Tom Roberts warned the National Gallery against trusting London dealers 'who were only middle men'; but Gerard Vaughan has concluded from an examination of the catalogues that the dealers sent 'a good cross section' of their wares, other than the most costly.[27] Among local dealers the most prominent was Fletcher of Collins Street, whose good contacts in London ensured 'a steady flow of good quality works, both English and foreign', and who sold to the National Gallery as well as to private collectors (including, frequently, Felton).[28]

The collections formed in Melbourne in these years, Felton's among them, have to be judged in their own time and place. None was as great as those of Australian expatriates George McCulloch (1848–1907), an original member of the Broken Hill syndicate, who returned to England to form (in Vaughan's judgement) 'the most important collection of modern British art ever assembled', or Sydney-born George Salting (1835–1909), whose bequest of old masters to London's National Gallery remains that institution's largest single acquisi-

[25] This section relies heavily on Vaughan, Art Collectors in Colonial Victoria 1854–92; and compare his 'The Armytage Collection'.

[26] Vaughan, Art Collectors in Colonial Victoria, pp. 63-73.

[27] Ibid., p. 64. Vaughan cites the *Australasian Critic* for 1 March 1891, p. 149, and (for Roberts' warning) *Argus*, 17 September 1891.

[28] For example, Millais' *Love Birds* (Vaughan, Art Collectors in Colonial Victoria, p. 78).

tion.²⁹ Gold had made Melbourne and San Francisco twin cities in mid-century—even in the 1880s they were competing for primacy in the technology of the cable tram—and in 1870 each had established an Academy of Art. TW Stanford, a founding member in Melbourne, acquired a sound collection of minor old masters and English German and Australian landscapes, including at least twelve Buvelots, one of which he presented to the National Gallery; on Sunday mornings he opened his gallery in East Melbourne to the public. In San Francisco his brother Leland Stanford also owned some Buvelots, but as California's fortunes outstripped Victoria's, and his with them, Leland spent such large sums acquiring French art that the eponymous university he endowed eventually sent the Buvelots back for sale in Australia, thinking them not worth keeping.³⁰

On the whole, in Gerard Vaughan's opinion, Australia's richest men bought poor pictures. The 'two criteria' on which Thomas Chirnside bought old masters to decorate his Werribee mansion were 'decorative suitability and nostalgic remembrance'; the pictures looked impressive, and it is possible that several were better than 'Chirnside' deserved, considering the 'absurdly' low prices he paid. The collection which Sir William Clarke placed in his rival mansion at Sunbury was conventional. FW Armytage was the exception among the squatters, building a major collection—of continental art, moreover, as well as English—but bad pastoral investments unfortunately forced him to send the pictures to be sold in London in 1897, and Australia lost them.³¹

'In general', Vaughan has concluded, 'Melbourne collectors in the 1880s, while becoming increasingly receptive to foreign art, clung tightly to a well-entrenched, traditional taste for landscape', most resisting the lure of modern figurative art, especially 'Olympian'. They bought nineteenth-century artists rather than old masters because they preferred them, despite the extra expense—the market for old masters was very depressed in the 1870s and 1880s—and their taste was 'essentially nostalgic and nationalistic'. Although Fletcher wrote in 1886 that 'Dusseldorf pictures are as good as English and therefore acceptable to

[29] Vaughan, Art Collectors in Colonial Victoria, p. 80; on McCulloch, see Bruce Pennay's entry in *ADB*, vol. 5, and on Salting AF Pike's entry on his father Severin Salting, *ADB*, vol. 2, the *Australian Encyclopaedia*, 1958 ed., vol. 7, pp. 542–3, and Cox, *The National Gallery*, p. 61. Salting's pictures included eleven Ruysdaels, several Vermeers, two Franz Hals portraits, a Rubens, a Van Dyck, two Holbeins, a Constable, two Gainsboroughs and three Corots; he also left a Chinese collection to the Victoria and Albert Museum, and prints and drawings to the British Museum (Cox, *The National Gallery*, p. 426). His only legacy in Australia was £2000 to the Royal Prince Alfred Hospital, Sydney.

[30] Vaughan, Art Collectors in Colonial Victoria, pp. 44–5.

[31] Ibid., pp. 26–7, 47, 33 and 40.

Melbourne connoisseurs', not many bought them.[32] RH Kinnear, a merchant, did; but he had a German wife (an enormous Hoff *Golden Wedding* portrayed the couple). German influence waxed; George Folingsby, the Irish head of the National Gallery and of its art school since 1882, was German trained and had worked in Munich for twenty-five years, and the visiting German artist Carl Kahler was 'the most publicized painter in Melbourne'.[33] William Lynch, the solicitor who occasionally appeared in Felton's correspondence, amassed at his Brighton home Melbourne's largest collection, 254 oils and 139 water-colours, by 1903. His wife Caroline, widow of the English painter William Dexter (and sometime lecturer on bloomers), conducted a salon, and may have been the dominant influence on a collection which reflected a widening of Melbourne taste from a concentration on English landscape to acceptance of German art, but rarely French. (It was her death in 1884 which prompted Felton to write to Grimwade, overseas, that William Lynch had lost his 'ancient mate—perhaps this event will not be without its compensations').[34]

The 1888 Exhibition's Loan Collection—contributed by Lynch, Armytage, LL Smith, Angus Robertson, and William Drummond among others—might not have included much of the latest in fashion in England, but was far broader than that of 1880. Strutt and Glover, English artists who had worked in Australia, hung alongside the popular Peter Graham and Landseer. Dr LL Smith, always one for the grand gesture, bought spectacular pictures with the Exhibition in mind, some of them too large ever to hang in his comfortable Collins Street mansion, but his collection was curious rather than great. Alfred Felton was not among the exhibitors.[35]

Overseas in the following year, Felton certainly did not attend 'the most famous exhibition in the country's history', the 9 × 5 Impressions Exhibition mounted in August 1889 by Roberts, Streeton, Conder, McCubbin and friends, earning for themselves the label Impressionist, related to French Impressionism by a common descent from *plein-air* predecessors rather than direct influence. Fresh from their local camps, they deliberately challenged the prevailing taste for English and German pictures with work which proclaimed a distinctive Australian art. Most local collectors remained to be persuaded, though that remarkable woman, Janet, Lady Clarke, bought one to hang with her husband's conventionalities in their

[32] Ibid., pp. 70, 15-16, 47, 41 and p. 36 (citing *Once a Month*, 1 March 1886, p. 265).

[33] Cox, *The National Gallery*, p. 43; Vaughan, Art Collectors in Colonial Victoria, p. 56: 'in a broad sense cultural life in Melbourne was increasingly dominated by Germans'.

[34] AF to FSG, 25 August 1884; Vaughan, Art Collectors in Colonial Victoria, pp. 18–20. Vaughan cites articles on the Kinnear and Lynch collections in *Table Talk*, 31 January and 6 February 1890 respectively.

[35] Vaughan, Art Collectors in Colonial Victoria, pp. 38, 48–50.

mansion at Sunbury, and Mrs FS Grimwade, Lady Clarke's close associate in the educational ventures which were to become Janet Clarke Hall and Merton Hall, bought works by Roberts, Streeton and Conder. Otherwise the new style at first gained more notoriety than fame, castigated by James Smith in the *Argus* as 'a pain to the eye'. His hostility provoked, from Roberts, Streeton and Conder, a passionate manifesto proclaiming the imminent development of 'a great school of painting in Australia'. Meanwhile, in Europe, John Peter Russell, the Australian not yet returned, was befriending Vincent Van Gogh and other young painters already breaking with Impressionism, and, in Bernard Smith's term, 'laying the foundations of modern art'. Its acceptance in Australia was a very long way off.[36]

FELTON'S COLLECTION, and his taste, have been castigated by Daryl Lindsay, chronicler of Felton's Bequests. Lindsay, of the generation which despised Victorian art—which he too readily de-accessioned when Director of the National Gallery—thought that Felton acquired some of the worst of it.[37] Noting that large quantities of furniture and art works, both trash and treasure, were imported into Victoria in the late nineteenth century, Lindsay implied that Felton remained what fishermen might call a coarse feeder, buying in large lots. Leonard Cox followed Lindsay in describing Felton's taste as 'ordinary'.[38] Dr Ursula Hoff was more sympathetic, noting that Felton shared with other collectors of his generation in Victoria 'an understandably nostalgic liking for English scenery', but also that he bought an unusually large number of Australian works for his time, mainly paintings by the older generation of Australian artists.[39] Gerard Vaughan, while agreeing that Felton's 'taste was conventional and unremarkable', observed that his collection fitted neatly into the transition between purely English interests and broader tastes. 'His preference was for rustic landscape, seascape and "touristic" views'; but 'the modern foreign pictures' he acquired marked 'a new departure':

> He owned, among others, pictures by the Italians G Paglieri and Professor Simoni, several Venetian scenes by Miss A. Brandeis [A type of 'prodigy' of the mid-eighties, who was well patronised in England . . .] and assorted sea-pieces by members of the Koekkoek

[36] The passages quoted are from Bernard Smith's account *in Australian Painting 1788–2000*, pp. 76–8, 132.

[37] 'It must be remembered that Felton was a product of the late Victorian period, a period not conspicuous for its good taste . . . It was the day of the sentimental subject pictures—The *Lovers in the Lane*, and *The Stag at Bay* . . . These were the pictures that decorated the background of the world in which he lived and his taste was no better and no worse than that of his contemporaries. With this evidence the conclusion must be drawn that he had little informed aesthetic judgement on the fine arts' (Lindsay, *The Felton Bequest*, pp. 4–5).

[38] Cox, *The National Gallery*, p. 61.

[39] Hoff, *The Felton Bequest*, p. 1.

family. Pictures by these artists were brought to Melbourne from the mid-eighties (especially by Koekkoek of Pall Mall), and their inclusion in the collection suggests a positive response to the new market. On the other hand, he confined himself to 'safe' views of semi-topographical interest, and he rarely indulged in genre or figure pieces.[40]

Dr Vaughan suggests that 'Felton relied almost exclusively on what was available in Melbourne, and his taste was no doubt developed according to this experience, although one must never discount the influence of periodicals and books imported from abroad'.[41] Felton did indeed have a large collection of such periodicals and books, which the Public Library retained after his death; but he must also have been influenced by what he saw in galleries overseas.

In an art market ruled by fashion, artists go out of favour almost as abruptly as they come in, sometimes (though not always) to return with a new patina of rediscovery. Several of the British artists whose pictures Felton owned—such as Augustus Egg, HWB Davis, JC Horsley and Peter Graham—regained high repute (and high auction prices) when the Victorians returned to favour in the last decades of the twentieth century.[42] And an anonymous but apparently knowledgeable correspondent in the *Argus* at the time Felton's pictures were sold claimed that most had a sound attribution, coming from 'notable collectors' such as Arthur Tooth, Sir Coutts Lindsay, and 'the Lynch, Fisher, Kinnear, Austin and St Alban's collections'.[43]

Felton's only known patronage of a living artist arose from his friendship with the Bunny family. Judge Bunny's cultural interests were in languages and music rather than art, and he wanted his son Rupert to be an engineer, enrolling him in the University of Melbourne in 1881. After six months, seventeen-year-old Rupert dropped out, hoping to become an actor, but was foiled by his father, who arranged for him to put his interest in drawing to profitable use employed in an architect's office. According to family tradition, it was Felton who persuaded Brice Bunny to allow his talented son to enrol in the National Gallery School late in 1881. When, in 1884, a 'cure' at Karlsbad was prescribed for Brice's declining health, Rupert accompanied his father, and was allowed—again, it is said, on Felton's urging—to remain at an art school in London.[44] In 1886, after his

[40] Vaughan, Introduction to *European Masterpieces*, p. 8, and Art Collectors in Colonial Victoria, pp. 21–2 and n. 48.

[41] Vaughan, Art Collectors in Colonial Victoria, pp. 21–2.

[42] Hoff, *The Felton Bequest*, p. 5 and n. 2.

[43] 'Spretae Injuria Formae', *Argus*, 25 April 1905.

[44] Thomas, *Rupert Bunny*, pp. 12 and 16. Rupert Bunny's niece Mrs JS Reid was the source for Felton's advocacy on Rupert's behalf.

[ABOVE LEFT]
JC Waite
born Great Britain 1832, arrived in Australia 1886, died 1921
Alfred Felton
oil on canvas
130.0 × 100.0 cm
Felton Bequest, 1905

[ABOVE RIGHT]
John Longstaff 1862–1941 Australia
Alfred Felton
oil on canvas
136.5 × 92.7 cm
Felton Bequest, 1932

[LEFT]
Ada Whiting 1858–1953 Australia
Alfred Felton
miniature: water-colour on ivory
10.6 × 8.0 cm (oval)
Felton Bequest, 1934

Artist unknown
Laboratory and drug mills and *Leech aquarium*
c. 1884
water-colour and gold ink on paper
upper image (oval) 16.6 × 24.0 cm
lower image (oval) 16.3 × 24.0 cm
The University of Melbourne Art Collection,
gift of Professor John Poynter, 1994

Artist unknown
Chemical works and Bi-sulphide of carbon works, Sandridge c. 1884
water-colour and gold ink on paper
each image (oval) 16.7 × 24.1 cm
The University of Melbourne Art Collection,
purchased 1994, the Russell and Mab Grimwade
Miegunyah Fund

[ABOVE]
François Cogné France 1829–1883, worked in Australia 1856–1864
Charles Troedel born Germany 1835, arrived in Australia 1860, died 1906 (printer and publisher)
Bourke Street (East, 1863) 1863–1864
from *The Melbourne Album*, 1863–1864
lithograph printed with tint stone
26.2 × 36.9 cm (image)
40.1 × 52.0 cm (sheet)
National Gallery of Victoria,
gift of Mr AT Troedel, 1964
Hickinbotham's Emporium had recently become Bignell's New Hotel (left).

[LEFT]
Jules Joseph Lefebvre 1836–1911 French
Chloe 1875
oil on canvas
260.0 × 139.0 cm
Young and Jackson's Hotel, Melbourne

[RIGHT]
Rupert Bunny 1864–1947 Australia
St Cecilia c. 1889
oil on canvas
200.0 × 161.0 cm
Philip Bacon Collection

[BELOW]
Rupert Bunny 1864–1947 Australia
Sea idyll c.1890
oil on canvas
100.5 × 161.5 cm
Gift of Alfred Felton, 1892

[LEFT]
The National Gallery of Victoria thanks Mr Felton:
Letter from the National Gallery of Victoria thanking
Felton for his gift of *Sea idylls*, 1892

[BELOW LEFT]
Hugh Ramsay 1887–1906
James S MacDonald 1901
oil on canvas
53.2 × 65.7cm
The University of Melbourne Art Collection, gift of Mrs JO Wicking, 1947

[BELOW]
Alfred Gilbert 1854–1934 English
Perseus arming 1882
bronze
72.4 × 34.1 × 22.2 cm
Felton Bequest, 1905

[ABOVE]
Camille Pissarro 1830–1903
French
Boulevard Montmartre, morning, cloudy weather (Boulevard Montmartre, matin, temps gris)
1897
oil on canvas
73.0 × 92.0 cm
Felton Bequest, 1905

[RIGHT]
Edmond-François Aman-Jean 1860–1936 French
Woman resting (La femme couchée) c.1904
oil on canvas
38.5 × 46.3 cm
Felton Bequest, 1905

[LEFT]
Emmanuel Frémiet
1824–1910 French
*Joan of Arc on horseback
(Jeanne d'Arc équestre)* 1874,
cast 1906
bronze
212.5 × 217.5 × 302.5 cm
Felton Bequest, 1907

[BELOW]
Frederick McCubbin
1855–1917 Australia
The pioneer 1904
oil on canvas (triptych)
225.0 × 295.7 cm
Felton Bequest, 1906

[ABOVE]
Auguste Rodin 1840–1917
French
*Minerva without helmet
(Minerve sans casque)* c.1886
marble
48.2 × 26.4 × 26.7 cm
Felton Bequest, 1905

[RIGHT]
Jean-Baptiste-Camille Corot
1796–1875 French
The bent tree (morning) (Ville d'Avray, Bouleau Pond) c.1855–1860
oil on canvas
44.3 × 58.5 cm
Felton Bequest, 1907

[BELOW RIGHT]
Edward Burne-Jones 1833–1898
English
The wheel of fortune 1870s–1880s
oil on canvas
151.4 × 72.5 cm
Felton Bequest, 1909

[ABOVE]
Bertram Mackennal 1863–1931 Australia
Circe 1893
bronze
240.0 × 79.4 × 93.4 cm
Felton Bequest, 1910

father's death, he moved to work under JP Laurens in Paris; Felton probably met him there, or in London, before commissioning a painting by him in 1889. The subject, *Saint Cecilia*, was possibly Felton's choice, though only the title reflects their common interest in music. Bunny was on his way to becoming a 'European' Symbolist, but this work is more Pre-Raphaelite; a large picture, of Cecilia in a garden with two Roman men, her intended husband Valerian and his brother, who were both so overcome by the perfume of the invisible flowers left by a departing angel that they were converted to Christianity, leading to the martyrdom of all three. The painting was accepted by the Salon before reaching Felton; he treasured it, and *Saint Cecilia* proudly appeared in a Victorian Artists Society Exhibition in 1893, 'lent by A. Felton Esq'; it was certainly better received in Melbourne than Bunny's *Witches' Sabbath*, sent from Paris in 1889 and dismissed by the *Age* as French and 'decadent'.[45] *Saint Cecilia* reappeared in public in Melbourne in 2001, in an exhibition of Bunny's Symbolist art at the University of Melbourne; if the picture had remained in Felton's collection at his death, it would have stood out among the land- and seascapes, and provided a new perspective on his taste.[46]

Felton did not want to establish or run organisations, but was happy to support some. From about 1895 there had been proposals for a permanent Gallery in the Exhibition Building, and the idea was revived in 1889, when LL Smith's largest acquisitions and a number of other works were made available for the purpose. Felton's name appeared in 1889 among the guarantors of a related initiative, the Royal Anglo-Australian Society of Artists, founded by LL Smith, Murray Smith and others—Byron Moore was Treasurer—to become a kind of exhibiting branch of London's Royal Academy in Melbourne. Their organising officer was Joshua Lake, a 'schoolteacher turned curator' and an able promoter; and the Society had the Australian Governors as Patrons, and the Prince of Wales, Sir Frederick Leighton, GF Watts, Sir John Millais, and Uhde of Munich and Laurens of Paris among its Honorary Members. In 1889 it organised a British Art Gallery Exhibition, to which Whistler sent a picture, and some 17 000 people attended. A Peoples' Palace Exhibition mounted by Lake in 1891 made a profit, persuading the Exhibition Building's trustees to set up a permanent gallery, to show their own collection and occasional exhibitions. A large British Art Gallery Exhibition

[45] *Age*, 13 November 1889.

[46] Sanctity and Mystery: the Symbolist Art of Rupert Bunny, curated by Barbara Kane, Ian Potter Museum of Art, University of Melbourne, May 2001. See also Kane, 'Rupert Bunny's Symbolist Decade', p. 56. 'Mr Rupert Bunny ... has had a picture accepted and hung in the Salon. The painting—St Cecilia—is the commission of Mr. Felton, of Melbourne' (*Table Talk*, 26 July 1889, p. 4, quoted in Kane, n. 255).

of 1892, a combined effort by the Royal Anglo-Australian Society of Artists, the German Association, the Royal Scottish Academy and the art staff of London *Punch*, proved a success despite the Depression.[47] *Shearing the Rams* appeared in the Australian section, and Rupert Bunny sent his *Sea Idyll* from Paris; Felton bought the picture for the National Gallery of Victoria, in his only known transaction with that institution in his lifetime; the Gallery thanked him with a fine letter attached to a massive seal.[48] Among works from Britain, paintings by Leighton and JW Waterhouse caused a sensation. But so did the Depression, and the 1892 Exhibition was the last until 1908; but for the slump, the Melbourne and Australian art market might have blossomed with ever richer and more exotic blooms, perhaps even some germinated in Paris.

Why the National Gallery kept so few of Felton's paintings after his death will be discussed later, but it must be noted that he collected furniture and *objets d'art* as well as pictures. He liked to surround himself with things that he thought beautiful, even in his office; Russell Grimwade describes the small ivory tortoise-shaped bell, used to summon his secretary, bought in Brindisi to replace a more efficient metal one. (He also describes the 'lean and shapely, rather sallow hand' protruding from the cylindrical black sleeve and stiff white cuff as Felton reached slowly forward to ring it.)[49] In one of his little notebooks Felton recorded excerpts from the writings of James Northcote, the eighteenth-century artist. 'Painters', Northcote wrote and Felton copied, 'should never neglect that quality of beauty in their pictures: beauty is a necessity in a picture, and all the best painters have sought after it without ceasing'. A limited aesthetic, perhaps, and erroneous as historical fact, but it was a view—with its strong moral overtones—which Alfred Felton shared with many, perhaps most, of his contemporaries.

A true merchant, even as a collector, Felton enjoyed both buying and selling art. In 1885 Felton Grimwade's accepted a consignment of pictures from a London dealer for sale in Melbourne; Grimwade wrote in February 1886, in Felton's absence, that they had proved difficult to sell: so many pictures were sent

[47] Vaughan, Art Collectors in Colonial Victoria, pp. 76–8; and Palmer, 'Art in Decline', pp. 230–2. Felton, it seems, bought nothing from the 1889 exhibition, though a guarantor. 'Gifts' in Felton's Personal Ledger, which begins in July 1890, shows payments of £3 to the 'British Art Gallery' in August 1893 and £41 5s 7d to the 'Anglo-Australian Art Fund H. B. Moore Treasurer' in August 1894, but nothing else of relevance except a guinea to 'Joshua Lake Testimonial' in January 1902. On the 'permanent' gallery, which lasted until the building became a hospital during the influenza epidemic of 1918–19, see Palmer, 'The Latest in Artistic Endeavours', pp. 209–13. Some of the pictures went to the NGV, and others were burnt in the aquarium fire of 1953.

[48] Perhaps it was to pay for *Sea Idyll* that brother William, on Alfred's instructions, sent £50 to Rupert Bunny in 1893.

[49] *Flinders Lane*, p. 7.

to the colony for sale that prices were low.[50] In July 1888 Grimwade was again left with some pictures—probably culled by Felton from 'Wattle House', sold some months before—to be 'sent to Fletcher on Mr Felton's account' to sell; on E Bradford's *After the Bath* he put a reserve of £30, on John Galby's *Mount Look* and *Wasinor Valley* £20 and £15, and on *Fruit* by William Etty and two landscapes by WH Allen £5 each. £10 was a low reserve to put on a *Venetian Scene* by Guardi and on *Venus surprised by a Satyr* by le Grand, if they were genuine.

FELTON MIGHT HAVE acquired more art overseas in 1889, or had more left over from 'Wattle House'; certainly, in March 1890, soon after his return from Europe, he shipped five cases of paintings 'etc.' to Murray Downs on the paddle steamer *Clyde*.[51] They were sent to enhance the homestead, which Campbell and Felton had been enlarging for some years, adding a spacious dining room, and completing a courtyard on the eastern side with offices and storerooms punctuated by a handsome arch and a small tower. Murray Downs was an important part of both partners' lives, of Felton's after the sale of 'Wattle House', and especially of Campbell's after his daughter Mary married David Johnston, manager of the property from 1888.

One source suggests that as part of the rebuilding Felton planned to accommodate, on the main tower, the telescope of his astronomer friend, Pietro Baracchi, who had joined the Melbourne Observatory in 1877, and had taken charge of the Great Melbourne Telescope (for a time the largest in the world) in 1883. Baracchi, 'a man of particularly likeable disposition with a genius for making friends', was certainly taken to Murray Downs by Felton, but according to Russell Grimwade he took with him not a telescope but a travelling mercury column (his 'bambino'), used to test meteorological stations.[52]

The paintings Felton shipped were hung in the new dining room just in time for a great event; in May 1890, when the railway at last reached Swan Hill, it was officially opened by the new Governor, the young Earl of Hopetoun, who had arrived in Melbourne the previous November, with an entourage as glittering as his own fortune. As a later Governor observed, Hopetoun was inclined to treat Victoria as he did his own vast Scottish estate, and he liked to move around it as

[50] FSG to J Bedloe Goddard, 24 February 1886. Later he reported a possible buyer for six of them.

[51] Letter from manager, 30 March 1890. According to Mrs Croft (*Murray Downs*, p. 23), Felton sent several consignments of art works to Murray Downs; unfortunately it has not been possible to consult the letter books held at the station.

[52] [Croft], *Murray Downs*, p. 29; JL Perdrix, entry on Baracchi, *ADB*, vol. 7; *Flinders Lane*, p. 54.

much as he could, admiring and being admired. Local preparations for the visit, which was to include a night spent at Murray Downs, were elaborate: two archways were erected in Swan Hill, one saying 'Welcome', the other 'Will ye noo come back again', and a five-hour Banquet was planned 'at the skating rink', a huge space built for roller skating in 1888.[53] Feasting was 'likely to finish at 10 pm, when I presume he will start for here', wrote manager Johnston to Campbell and Felton; did the partners wish to drive him themselves? 'Some said four horses would be best, but ... if there is any band or music of any kind our horses in a crowd might get restless—so I propose the 'two bulldogs', they always look good in the wagonette'. 'The neighbours I will write and invite to stay. Mary will have plenty of beds and we will make everyone as comfortable as possible.'[54]

It seems, however, that neither Felton nor Campbell was in attendance when the Murray Downs wagonette took the Governor's party, escorted by the Kerang Rifles, into town from the railway station, nor were they reported attending the banquet. The Swan Hill *Guardian* lists among the hundreds present only the Governor, his friend EH Lascelles, holder of Tyrrell Downs Station and partner in the wool-brokers Denys Lascelles, the Swan Hill Shire President, the Mayor of Sandhurst, the Minister for Public Works, the Leader of the Opposition and some twenty-three other parliamentarians, come for the political kudos of opening a railway and the free meal of 'every imaginable viand', laid out 'artistically' on the 'elegantly decorated' tables. (There were so many gate-crashers that the service broke down, and most had to help themselves.) Manager Johnston was identified as the host at Murray Downs that night; Mary Johnston had to accommodate not only the Governor and his party but some sixteen 'Members of Parliament and other gentlemen' who could not get beds in the town. The Governor seems to have left his own State and entered New South Wales for the night without intercolonial complications.[55]

Next morning Hopetoun was back in Victoria, setting out for a very long ride. A keen horseman, he had brought his own saddle, and two 'good police horses'—required (Johnston said) to be 'swinging canterers'—had been sent from Sandhurst; the Governor rode out into the Mallee to Tyrrell Downs and Lake Corrong, where Lascelles had established a bold scheme for closer settlement on 480-acre blocks, introducing share-farming to Victoria in the process. (Felton was to invest in Lascelles' next and similar venture, the Mallee Agricultural and

[53] Feldtmann, *Swan Hill*, p. 145.

[54] David Johnston to Messrs Campbell and Felton, 26 and 23 May 1890, quoted in [Croft], *Murray Downs*, pp. 43, 45.

[55] Swan Hill *Guardian*, 28 May and 4 June 1890.

Pastoral Co Ltd, on Tyrrell Downs.) The vice-regal visitor, after predicting a great future for the region, gave the name Hopetoun to the service centre Lascelles had built for the area, and rode on to Warracknabeal. Even the *Bulletin* grudgingly admired the popular young horseman, predicting improbably that 'the young feller will go home converted to Republicanism, sell all that he hath, and sack the phlunkeys'.[56] The posse of parliamentarians, not finding a ninety-mile ride over muddy plains attractive, had gone home from Swan Hill by rail.

It was fortunate that the railway had not been further delayed in reaching Swan Hill: a few months later a plague of 'locusts' destroyed the Murray Downs garden and invaded the house; 'There are millions flying, but there are billions not, and they are the worst', Johnston complained.[57]

All or most of the pictures Felton sent up-river in 1890 remained in the dining and drawing rooms of Murray Downs for more than a century, emerging only in 1996, when nine were auctioned at Sotheby's in Melbourne. The best was Australian, an 1879 landscape by Henry Rielly; the rest, all European, included *Figures in a Rocky Wooded Landscape beside a Stream* 'in the Manner of Salvator Rosa', a popular name in the late nineteenth century among makers of copies and fakes. *La Bella*, a nineteenth-century Italian painting after Titian, had been the most popular with tourists admitted to the homestead after 1982.[58]

[56] Quoted in McCaughey, Perkins and Trumble, *Victoria's Colonial Governors,* pp. 294–5. On Lascelles, see Sheila F Wessels entry in *ADB*, vol. 5.

[57] David Johnston to Messrs Campbell and Felton, 11 November 1890, quoted in [Croft], *Murray Downs*, p. 43).

[58] The Rielly might be the painting which appeared at the 1879 and 1880 Sydney exhibitions. After Felton's death Murray Downs remained in the hands of Campbell's trustees until 1969, when it was sold on a walk-in-walk-out basis to another non-resident owner. The pictures were not included in the next sale, in 1996, and nine of the sixteen listed in the inventory were sold at Sotheby's a few months later. I am indebted to Mr John Monahan of Swan Hill for details from the inventory; and to Ms Jane Clark of Sotheby's for a copy of the sale catalogue details.

9

THE SWAGGERING THINGS ARE BUST

There was plenty of swagger in the Melbourne of 1888. The splendid *Picturesque Atlas of Australasia* produced to celebrate the centenary of British settlement in Australia boasted that Victoria was the luckiest of places: 'If we want gold and silver we have only to call them from the vasty deep and they come ... If we want money from Europe we have only to ask for it ...' Alexander Sutherland's *Victoria and its Metropolis* was almost as complacent: 'The past lies all behind us, and its story is told. We have seen the colony grow and its metropolis gather dignity'. Among the cities of the world—putting aside, of course, 'the Oriental figures of China and Japan'—Melbourne ranked twenty-fifth in population, 'certainly not lower than fifteenth' in wealth and enterprise, and second only to London in geographical extent. Victoria's future among the great nations of the world seemed assured; and the savant-cum-banker HG Turner claimed much of the credit for its banking system, which had relaxed conservative English practices to fund development from the very high savings of the Victorian population. This 'judicious and widespread liberality and wise adaptation to surroundings' had 'distinguished the banking administration of this colony'; and the end had justified the means. 'The freedom from banking disaster which Victoria has experienced since its existence as a separate colony is unsurpassed by any commercial country in the world.' The Oriental Bank had failed overseas, not in the lucky colony.[1]

Some words seem uttered to be eaten. Turner's boast could not long be maintained: the great maritime strike of 1890, though defeated by employers and the

[1] *Picturesque Atlas of Australasia,* Introduction; Alexander Sutherland, *Victoria and its Metropolis,* pp. 541 and 796–7 (ch. XXV on Banking and Finance by HG Turner). On Turner (1831–1920), who to his credit led his bank out of the Depression as well as into it, see Iain McCalman, *ADB,* vol. 6.

government, was a premonitory convulsion before the bubble of Victorian expansion burst. London began to refuse new loans, both public and private, the land boom of the 1880s and its associated institutions collapsed, and in 1893 public panic—beyond reason, as always in such cycles—'turned depression into disaster'.[2] Banks fell thick and fast, though not the Royal Bank of Australasia, which Grimwade, in one of the few major ventures he undertook without Felton as partner, had helped found in 1888.[3] Government expenditure fell by nearly 40 per cent, and unemployment rose above 25 per cent. A minority, of employers or employed, were ruined; those who retained or soon regained their jobs, and had avoided excessive debt, suffered less, though many middle-class families fell from moderate affluence to unwonted penny-pinching as income from investments fell.[4] Thousands of Victorians were prompted to emigrate to other colonies, especially to the new goldfields of Western Australia; Melbourne's population fell by 56 000 between 1892 and 1895, leaving some 20 000 houses empty in 1894. Many of those who left were no doubt young and enterprising, of the kind Twopeny had hailed as the creators of Melbourne's economic dominance after the gold rushes. That dominance continued, but for the time being the city itself was maimed. The rude vigour of the frontier town was gone for ever; Melbourne became an obviously provincial city, its parallel no longer San Francisco, but Birmingham.

Unemployment and distress in the city overwhelmed even the optimists among the philanthropic, and relief organisations proliferated. The Charity Organisation Society (COS) set up an unemployment sub-committee and attempted to assess the scale of the problem; it offended other charities, the government and the unemployed themselves by claiming that panic was prompting indiscriminate relief measures which were harmful in themselves. The Society organised pick and shovel work for the 'honest unemployed', and later a 'Labour Colony', of the kind then fashionable in North America and Europe, at Leongatha. Morris himself, alarmed by the depth and length of the depression, was moved to write a letter to the London *Times*, published in May 1894, portraying Melbourne as destitute, and requesting donations to a 'Melbourne Relief

[2] The phrase is Geoffrey Blainey's. For his argument that 'the bank crash was far from inevitable', see his *Gold and Paper: A History of The National Bank of Australasia*, pp. 162–3.

[3] Of the six founding directors, five (including Grimwade and Campbell) were manufacturers; the Bank refrained from land business, and was in consequence able to survive the depression unreconstructed (Serle, *The Rush to be Rich*, p. 255). Grimwade's involvement, as director and later chairman, continued until the eve of his death in 1910.

[4] Percival Serle's father, a manager with McEwan's and 'a gullible victim of land boomers', is an example; his grandson Geoffrey quotes agonised passages from his diary in *Percival Serle, a Memoir*, pp. 10–11.

Fund' organised by the COS. The Government, and much of the business establishment, were outraged, fearing that the flight of London capital would be accelerated by the sight of so much Antipodean dirty washing; it has even been claimed that 'Melbourne's rulers never trusted him again'.[5] Felton certainly did, naming Morris in his will as one of those responsible for managing his bequests.

Social institutions, as well as businesses and government, suffered. The fabric of industrial suburbs such as Footscray was severely strained, though locals worked hard together to shore it up. At the other end of the social spectrum insolvency caused many gentlemen to sell their mansions or at the least resign from their clubs, an untimely misfortune for the Australian Club, the Committee having rashly approved some very expensive rebuilding just as the boom was breaking. A special general meeting in 1893 began a membership drive, suspending ballots, introducing simplified election procedures and reducing the entrance fee to £10. The Club survived, but at a cost; Felton, dining there in 1895, told Grimwade that he did not think that 'the Ten-pounders' had 'improved the tone of the Club'.[6]

Felton did not name Charles Strong on his Bequests' Committee, perhaps thinking his philanthropy too often reckless. Strong's biographer remarked that he had no sociology, only an instinct for moral protest, and there was certainly little reckoning in Strong's commitment, in 1892, to the utopian and financially disastrous Village Settlement Movement.[7] The scheme's other leader, Canon Horace Finn Tucker, of Christ Church South Yarra, had a sociology of a sort, expounded on the first anniversary of the settlements:

> About 18 months ago when the bitter cry of the unemployed was beginning to make itself heard, we resolved to make an experiment in helping people to help themselves, by assisting some of the unemployed to leave the overcrowded city, and taking their families with them, to engage in reproductive work on the fair land of Victoria, too long left untilled.[8]

The myth that Australia's broad acres were suitable for subsistence farming on small holdings was as strong among philanthropists as among more radical enemies of the pastoralists' hegemony, and at a meeting called on 22 February 1892, which

[5] Kennedy, *Charity Warfare*, p. 213. For a broader view of the impact of the depression on charity, see Garton, *Out of Luck*, ch. 5.

[6] AF to FSG, n.d. On the crisis in the Club's finances caused by the depression, see de Serville, *The Australian Club*, esp. pp. 53–7. Graeme Davison's comment that 'the prized social accomplishments of the boom years were jobbed out at rock-bottom prices' is quoted there.

[7] Badger, *The Reverend Charles Strong and the Australian Church*, p. 114.

[8] Speech (by Strong or Tucker) in Strong Papers (folder on the Tucker Village Settlement, including many letters of complaint from settlers themselves. See also Badger, *The Reverend Charles Strong and the Australian Church*, ch. 8.

Morris chaired, Tucker and Strong undertook direction of an organisation committed to purchasing land for settling suitable families on ten-acre blocks, with access to common land, a too-hasty translation into a very different environment of the allotment schemes of nineteenth-century Britain. 'Permanent' settlements were set up near Benalla, near Horsham and at Red Hill, but there was never enough money to build houses or provide other support promised, and the transplanted families found sustenance short and life in tents cold, wet and intolerable. By the end of 1894 the scheme had collapsed, and although the government made a grant towards its debts—and indeed itself began to establish 'settlements' of a sort near country towns all over Victoria—Strong faced personal bankruptcy. 'Even with the Government grant of £1000 and the acceptances of a composition by the creditors', he wrote, 'I shall have <u>somehow</u> to find £4000 or £5000 besides what I have already put out'.[9] An appeal was scouted; Felton was cautiously generous:

> Will it not be well to settle definitely the sum to be paid to settle the creditors, and to secure a complete release, before a public subscription is mentioned or entered upon? For creditors may hope to get paid in full from this rather delusive method, and so delay the settlement. On the other hand . . . I am aware it would be a great satisfaction to you and others connected with the settlements to pay all the creditors in full. Now I cannot form an opinion as to what the ladies with their cards may collect, but so many of these things fail utterly. A real and feasible plan of settlement brought under the notice of business men should result in some aid from that class.
>
> Under the supposition that you will and must settle some such plan, I now offer to subscribe to a Fund that shall release you from further liability, the sum of Fifty Pounds. You can either disclose this offer or not, as it may best suit the Fund.[10]

The appeal was not effective, though some debts were paid; the Strong family was saved, family tradition has it, only because Mrs Strong produced a bag of sovereigns she had secretly hoarded.[11]

IT WAS IN these years that FS Grimwade began a larger role in public life. Elected unopposed to the Legislative Council in 1891, he did not seek office or commit himself to any party, but spoke out as he saw fit. In 1894 he told the new Turner ministry that 'he did not quite know whether members of the Government were liberals or conservatives; in fact he did not quite know what he was himself', but

[9] Strong to Emmerton, 19 February 1895 (Strong papers).

[10] AF to Dr Strong, 6 February 1895. Felton's Personal Gifts and Sundries ledger records that he had given the Village Settlements £50 'per F Sargood' in July 1893 and later received a refund of £44 4s 7d in November 1894.

[11] Badger, *The Reverend Charles Strong and the Australian Church*, p. 137.

was 'prepared to judge the new government on what they did'. His political views broadened: in his maiden speech he praised the democratic and industrious artisans of his electorate but rejected 'one man, one vote', in favour of 'a vote for manhood and a vote for thrift', and in 1895 opposed the Plural Voting Abolition and Women's Suffrage Bill, protesting his love and respect for 'the fair sex', but claiming that the majority of women did not want the vote. Nevertheless in 1898 he conceded that women had shown their fitness to exercise the franchise and argued that they were entitled to it; he systematically rebutted the usual objections, while concluding mildly that the women's vote was likely to be conservative, and that there need be no worry that they would want to enter Parliament or the Ministry. Desiring Federation 'as much as anybody', he conceded that his favoured 'dual vote' was an impediment, and attacked opposing views as 'rank toryism': the Council should not become 'a House of old fogeys, who stood where they were thirty years ago'. He even came to support compulsory voting. Speaking in favour of the Federation Enabling Act, he was 'only sorry that the capital was not to be in Sydney', and looked forward to an era of great prosperity, happily joining the delegation which took the Bill to Lord Brassey for signature.[12]

Grimwade also spoke frequently on local government, citing his experience on the Caulfield Council, and on issues to do with the professions. (A proposal in 1894 to abolish wigs and gowns in court was part of a desire 'to level down everything and everybody'.)[13] He supported the Old Age Pensions Bill, but on other social and business issues was an outspoken Free Trader. As a member of the Royal Commission on State Banking of 1894–95 he joined Murray Smith in a minority report opposing a State Bank: 'we believe that the permanent prosperity and progress of the country will be best secured by leaving to free and unchecked development the forces of individual energy and enterprise which have always distinguished British communities'.[14] He blamed Protection for the growth of 'sweating', and opposed its regulation, and other such regulatory legislation. He supported the Totalisator Bill in one of his many speeches attacking gambling—he had a habit of going to the races, but 'had never made a bet on a horse in his life'—and complained that the 'people of the colony were running mad about holidays; there were too many holidays'.[15] On matters of public health he spoke with some authority, and his pet cause was the legalisation of

[12] *VPD*, vols 75, p. 8; 68, p. 2356; 79, p. 4094; 89, pp. 1447 and 2112; 90, p. 2889; 91, p. 199.

[13] Ibid., vol. 75, p. 961.

[14] Report of Royal Commission on State Banking, *Victorian Parliamentary Papers*, 1895–96, p. 4.

[15] *VPD*, vols 79, p. 4337; 70, p. 2338.

Robert Murray Smith (Haddon Collection, La Trobe Picture Collection, State Library of Victoria)

cremation. Bringing in a private members bill in 1895 and again in 1898, he spoke vividly of the 'saturation' of cemeteries and of the noxious gases emitted. 'Was there a danger from these bodies buried in our midst?' asked a questioner; 'Yes!', he insisted. His bill passed the Council, but failed to reach the lower house, suffering the same fate in 1899, and again in 1900. Absent ill in 1902, he returned to reintroduce his Cremation bill in 1903, and to see it passed at last. Melbourne should have a crematorium named after FS Grimwade.[16]

Felton no doubt shared many or most of his partner's political views, but his attitude to politics had not softened with age. In New Zealand, Kempthorne, like

[16] Ibid., vols 88, p. 1113; 89, p. 1516; 91, p. 907; 101, p. 278; 105, p. 1006.

Grimwade, had entered parliament; when he suffered an electoral defeat in 1895, Felton's scarcely tactful letter showed no great respect for politicians as a class:

> I note you have been speaking to your constituents and the public generally on fiscal matters. I doubt not you feel you have been unkindly dealt with by providence, that the floor of the 'Ouse has been denied you. How keen is the relish of him who likes to know that he has a hand in controlling the destinies of his land and people. A fig for the harm he may do! A lust for power is the prevailing feeling—harm or no harm. But considering the class of men that often rush in, our white-waistcoated Zox observed of them, and also their types elsewhere, 'Strange with what little wisdom this world is governed'.[17]

Grimwade also became a Justice of the Peace, in which role he supported the application for naturalisation in 1907 of Helena Rubinstein, in the 1890s a young immigrant from Cracow to the small Western District town of Coleraine. In the first years of the century, after stints as governess and waitress, Helena added to Melbourne's enterprises by pioneering—indeed inventing—the modern luxury beauty industry in Elizabeth Street. Grimwade certified that she was 'known to him', and 'a person of good repute'; it seems likely that she was using Felton Grimwade's raw materials in her products, rather than the advertised 'secret ingredients from the Carpathian Mountains', but (as usual) she kept her tracks well covered. Later, when she was an international figure, Felton's Bequest was to buy Dobell's portrait of her for the National Gallery.

WE KNOW A good deal about Felton's reaction to economic depression. According to his brother William, writing in 1895 to another member of the family, 'the last few years' had been

> most trying for him—years of great mental anxiety and worry consequent on the defalcations of many whom he had helped and trusted—then the trying financial crises through which the colony has been passing and is still involved—he has also had great material losses consequent on the depreciation and shrinkage of values.[18]

William, discouraging a begging nephew, had reason to exaggerate his brother's difficulties; certainly Felton's surviving business correspondence shows no sign of discouragement or despair.[19] His letterbook of 1895–96 and his ledger of

[17] AF to TWK, 31 August 1895.

[18] William Felton Snr to William Felton Jnr, 25 September 1895, enclosed with William Felton to AF, 4 October 1895 (Felton papers, Trustee company).

[19] Felton's letters do not appear in the Felton Grimwade Partners' letter book after 1887, and in 1889 he ceased to draw a salary from the firm; FS Grimwade ceased to draw his in 1893, indicating the withdrawal of both men from the day-to-day management of the business they had founded in 1867.

1890–1903 show him deeply and continually involved in business, and despite his years—he turned sixty in 1891—his response to the depression was to work hard, and to urge others to do so.

From 1892 Felton Grimwade's letterbook is punctuated with complaints of 'a great falling off in business' and references to reductions in staff. In April 1893 Bage's widow was asked to withdraw her deposit of £3100: 'owing to the unfortunate dullness of trade, our business has contracted, our stocks are less, and we have not the use for capital that we had'. It was not the time for frivolity or celebration, as Grimwade pointed out to a chemist in North Melbourne:

> With reference to the Annual Cricket Match between the Wholesale and the Retail Chemists, we think, under the present circumstances, considering the dullness of business all through Melbourne and suburbs, and the embarrassment and trouble caused to many retail chemists by the failure of several banks, that the present time is not a very suitable one for this Annual Gathering. We would suggest that the consideration of it be postponed until a future time, when we hope a return of prosperity in the colony will have taken place.[20]

In 1894, when asking a manager to accept a smaller bonus, Felton Grimwade's complained that:

> We never believed it possible our business could decrease as it has, we do not know what limits it may go to, it is certain we shall have greater taxation, it is probable we shall have a still decreasing trade for some time to come and it is quite likely we may be compelled to ask our Employees to accept a reduction in wages all round; as it is we are about the only house in Town that has not made already a large reduction in wages . . . We venture to say, there is not a professional man, a Banker, Merchant or trader in Melbourne who has not suffered a far greater retrenchment than you are now asked to accept.[21]

The Government was indeed forced to introduce new taxes. 'The Income Tax', Felton wrote to Grimwade in 1895, 'is the trouble and the question of the hour. It is a far-reaching thing, and is stirring up as with a long pole the selector in the Wimmera Scrub and the hidden occupant of the recesses of the government offices as well as the most prominent merchant in Melbourne'.[22]

Felton Grimwade's, a business always remarkably free of debt, survived the crash, though its annual profits, above £20 000 until 1892, slumped to little more

[20] FG&Co to Charles Bage as trustee for Mrs Bage, 12 April 1893; FG&Co to GN Heyward, 13 April 1893 (Partners' letterbook).

[21] FG&Co (Grimwade, judging by the punctuation) to JK Forrest, 8 October 1894 (Partners' letterbook).

[22] AF to FSG, 22 March 1895.

The Felton Building, 7 Queen Street (National Trust of Australia, Victoria)

than half that in 1893–94. Turnover fell by at least 25 per cent, and followed Victoria's economic trajectory in not rising significantly for twenty years.

Bosisto's also survived, though its founder's personal fortune did not. In 1889 Bosisto, already in financial difficulties and indifferent health, mortgaged his third share of the business to the other partners. He continued to involve himself in the production of eucalyptus oil, Felton reporting in 1895 that Bosisto was back from Antwerp 'looking bright and better', and pleased with the estate and

its yield.[23] He died in 1898; Felton and Grimwade and other distinguished colonials bore his pall, but the value of his share (£5806) only exceeded his debt to his partners by £2477. Felton, Grimwade and Bage's widow bought the share, and reconstituted the firm as a proprietary company. Although never a large enterprise, it paid a dividend of 15 per cent in 1898–99. Bosisto was its creator, but Grimwade and (especially) Felton were active in its development, and deserved much of the credit; certainly they received most of the profit.[24]

ACROSS THE TASMAN, the New Zealand Drug Company also survived, though the Victorian partners had to advance Kempthorne £5000 when the depression struck him in 1893. Two years later Felton wrote proudly to London that the Drug Company

> is an object of envy and admiration to the bleached crowd of shrunken proprietors of all sorts of New Zealand ventures and properties, for it is amongst the very few concerns that make a profit and pay a dividend,—and so, brought on to his marrow bones, the New Zealander blesses the small things, for the big and swaggering things have bust or are busting.[25]

He was soon helping Kempthorne to raise more capital, though preaching at the same time his own creed of financial self-sufficiency: 'I shall be glad to see the time when your reserves and balance to credit of profit and loss will allow you to dispense with borrowing; why should not your reserves be equal to your capital?' The moral Felton drew from the depression was characteristically modest:

> Many a man in these colonies has to thank his stars that he kept small, and kept to small things—his own. Then the shrinkage is of his own goods and not of others to whom he is a debtor. So our little Company, although in a withered and shrunken environment, still keeps on in its quiet and unobtrusive way.[26]

Felton continued to give Kempthorne peremptory advice, urging him (for example) to seek new premises in Wellington.[27]

[23] AF to FSG, 22 March 1895. Under the Deed of Assignment in 1889 Felton and Grimwade lent Bosisto £2000 at 8 per cent interest.

[24] It was said that Bosisto felt that his partners might have helped him more. Felton remained an active director; the Company's Minutes show that as late as March 1903 he agreed 'to take steps' to deal with the matter of the lapsing of the Antwerp leasehold.

[25] AF to Grimwade Ridley & Co, 5 March 1895.

[26] Ibid.

[27] AF to TWK, 19 April 1895.

Felton and Grimwade were much more cautious in helping Kempthorne's former partner Evan Prosser, then in Sydney. When his business failed in 1895, Prosser sought the aid of all his old friends, apparently playing one off against another. 'One chemical is related to another chemical', Felton wrote to Kempthorne, 'and so the human composite thing (body, soul and spirit) called man has a relation to other men and a different one to each'.

> I have just written to George Elliott about Prosser. About trying for £5000 wherewith to buy a business for Prosser. I have shown him our £300 in hand, which we wish to make £500. In the meantime Prosser writes to you and hopes that F and G will <u>find</u> him a business. From the outset we have declined to find or to guarantee. We know the Evan Prosser of old. We will help him if we can, but we are neither going to nurse, guide, direct or coddle any Prossers, of that Prosser has due notice. If he cannot use such help, and make an effort for himself, then let him take the consequences.[28]

Felton told Elliott that he thought Prosser 'should get into something of a different nature to the three-pennyworth of cream of tartar business'. He did not live to do so; when he died, unexpectedly, in 1896, Felton sent Mrs Prosser £100 as a personal gift.[29]

FOR A FIRM in a notoriously uncertain trade, the Melbourne Glass Bottle Works weathered the depression extremely well. Felton had spent some of his time abroad studying the glass industry, and the new plant, opened at Spotswood in 1890, proved a good one, making possible not only survival but a new rate of growth. The company sent its bottles up to Melbourne by river, running a small steamer of its own.

There were losses in 1892 and 1894, but the other years of the decade were profitable. Felton's superintendence was close, and—despite Russell Grimwade's unaccountable claim that he was reluctant to visit the works, leaving inspections to the Grimwades—his enthusiasm was unabated. 'We have brought out the Foster's bottle', he reported excitedly to Grimwade, in New Zealand, in February 1895. 'It is a splendid bottle. It should work a ferment among the bottling brewers here! and I think it will.'[30] It did; and constituted another small step towards a manufacturing monopoly.

[28] AF to TWK, 19 July 1895. On 6 March Felton had told Kempthorne that he and Grimwade did not 'feel called to take him [Prosser] up. We are not altogether sure, if we did take him up, but that we should find it a trial'.

[29] AF to Elliott, 6 August 1895; Personal ledger, 'Gifts'.

[30] AF to FSG' 13 February 1895. Previously most beer bottles had been imported. Russell Grimwade's account of visiting the bottle works with his father because Felton would not go constitutes Chapter 4 of *Flinders Lane*. 'Do not let it occupy your mind', wrote Felton to Grimwade in New Zealand in 1895, 'that the acid works construction matter is any trouble to me. I have more crucial things than this almost daily in the Glass Works'.

In 1898 Mount, the first manager, gave way to former glass blower William McNeilage. Labour remained a problem. A brawl in 1899, a miniature war of the roses between workmen imported from Yorkshire and Lancashire, broke a limb or two; Felton remarked that recent immigrants from the industrial areas of northern England must find life in Victoria strange and unsettling, 'an oasis in their lives'. He was frank about the employer's interest: 'the climate (a very hot summer), alcohol, and the usual ills that flesh is heir to so often operate on our supply of labour that if there is any business going we want some surplus to come and go'. Felton wrote little about labour relations in general, but the partners' paternalistic attitude to their employees in Flinders Lane had never translated easily into their manufacturing ventures, and it may be assumed that the strikes of the 1890s alarmed him as it did all but a few among the propertied classes, concern which grew as depression increased social tension and fostered the rise of the Labor Party.

Despite managerial and labour problems, the glass works continued to prosper. The partners had generally left their profits in the business, and each had his reward as the value of his investment grew from less than £1000 in 1882 to nearly £30 000 in 1901. By 1903 the firm had outgrown its simple structure as a partnership, and the Melbourne Glass Bottle Works Proprietary Limited was registered on the last day of 1903, with Felton, FS Grimwade and McNeilage as Directors. Felton did not live to take his place on the board, but the company and its successors, Australian Glass Manufacturers and Australian Consolidated Industries, were his chief memorial in Australian industrial history.[31]

The acid works were less successful, unable to match their competitor Cuming Smith's, even after rebuilding across the river in Spotswood. In 1894 Grimwade complained to manager Begg that the year's results were 'most disappointing; we sold less acid than for twelve years past and got less for it'.[32] Felton doubted whether Begg and his son could achieve improvements, writing to Grimwade that 'in their own way I think the Beggs are doing their best. Their own way has grown on them, and I am not sure they can readily put these ways aside and drop into the Yarraville methods of devotion to work and profit-taking'.[33]

[31] The new company issued capital of £67 512; in 1903, the last year of the partnership, the capital had been £65 342 of which Felton held £29 836, Grimwade £28 124 and McNeilage £7382.

[32] FG&Co to TDM Begg, 15 August 1894 (Partners' letterbook). He had made similar complaints in 1892: 'We propose to make a thorough overhaul of this business, in its Economical and Scientific sides, and we shall not rest satisfied, until we can make Acid as advantageously as our competitors do'.

[33] AF to FSG, 22 March 1895.

In 1894 Felton and Grimwade asked Cuming Smith's to 'fairly and freely give us the benefit of your aid and assistance, in the improvement of our mode of manufacture': 'in short', to 'treat our works as if they were part of a joint concern and help us to improve them, at our own cost.'[34] The works were rebuilt; 'the interior will be noble', Felton wrote in February 1895.[35] The business remained precarious, though Felton was for a time optimistic, thinking the threat of new competition idle; 'water will find its level and so will prices'.[36] In June, however, an alarming article in the Melbourne *Argus* accused both Cuming Smith's and Felton Grimwade's of exorbitant profits from acid under protection of the tariff. Grimwade believed the article to have been 'inspired by some malevolent Soda Water Manufacturer' and proceeded to rebut it in two well-argued letters to the offending paper.[37] Felton commented on the situation in a private letter to Kempthorne in New Zealand:

> As a member of Parliament and an ex-minister said to me the other day 'The *Age* may be a liar, but it is a mere amateur compared with the *Argus*'. The *Argus* is also much of the fool too. To wit the £25,000 a year profit on Sulphuric Acid which they state we have made is simply a Baron Munchausen lie. I don't suppose we ever sold £10,000 worth in the boomiest of boom years, and as for the last two years I believe if plant is properly written down and bad debts taken off, that we have not made one shilling ... Anyhow acid with us has not been a great success for many a year. Inefficient management, falling sales and general discontent.[38]

Within a year Felton was reporting that Begg junior had left their employ to work for a new chemical company, founded by 'an unquiet German by the name of Wischer'; the *Argus* reports of high profits had 'made many mouths to water, and so has worked trouble and will work more. This lying man's print I suppose don't care a groat but the lie still works.—So Wischer has got some capitalists together with plenty of money in hand. Our profits of course will all go.' The new competitor did not at first prove dangerous, but Felton was convinced that their difficulties were deep-seated. He reported to Kempthorne that James Cuming senior had observed 'in his bluff honest way':

> 'Oh you Chemists and Druggists, you know precious little of Chemical Works and the turning out of acids and manures'. Well, as far as my observation goes of our Port

[34] FG&Co to Cuming Smith's, 29 September 1894 (Partners' letterbook).

[35] AF to FSG, 20 February 1895.

[36] AF to FSG, 22 March 1895.

[37] *Argus*, 19 and 20 June 1895.

[38] 'Well you may say, why not give the beastly paper a curt reply? Thereby hangs a tale. There are three or four people concerned—but when we meet I can give you the whole position.' AF to TWK, 17 June 1896.

Melbourne works, I admit the impeachment completely. With our dense manager, Cuming, Smith and Co. run rings around us.[39]

Felton and Grimwade finally accepted that the logical next step was amalgamation. Cuming Smith's was re-constituted as a private company in 1897, with Campbell as chairman and Felton, Grimwade and the two James Cumings as directors, each holding a fifth of the shares. The works were amalgamated, with James Cuming junior as manager. The new joint enterprise proved exceptionally profitable, paying a dividend of 22 per cent in its first year, and Cuming consolidated its position by forming the Victorian Fertilizer Association, a cartel of local manufacturers, in 1907.

Not so the Australian Salt Manufacturing Company. While overseas in 1886, Felton visited salt works in southern Europe, and perhaps also in his native Maldon; nothing he saw seems to have discouraged him from the French Island venture. After breaking with Cheetham, the Company leased from the government—with the assistance of Mr Byron Moore—a further large area of marsh. In 1887 they imported a Mr Lignori as manager; the partners lent him £300 to bring out his fiancée and gave him an electroplated tea and coffee service as a wedding gift. They received in return a very favourable report on French Island as a site for salt manufacture. The works were expanded, but at such cost that it was necessary in 1888–91 to make calls of £2000 on each partner and eventually to borrow £9500 from Felton, apparently the partner most confident of the company's future success. In 1890 it was reported that only eight of the last twenty-five tons of salt produced had been sold; Lignori was asked to accept a cut in salary 'in view of the unprofitable condition of the company', and was even instructed to sow some acres of hay to supplement earnings. The government complained that the company had held its land for eight years without establishing a successful salt industry, and the lease was renewed only on condition that success be achieved in three years.[40]

Profit remained elusive, and in 1892 Lignori leased the works with a partner, paying rent in salt, Grimwade observing that 'they are more likely to make a success of it, being always on the spot'. But Lignori's partner soon left him, and by 1896 he himself was forced to abandon the lease, which was transferred to a succession of others, the last of whom not only failed to pay any rent but required a

[39] AF to TWK, 17 June 1896.

[40] Grimwade objected strongly to a clause requiring improvements to be insured against fire: 'the improvements are of a rough description, consisting mostly of salt pits excavated from the ground and of ti-tree sheds and rough brickwork. They are themselves of very little value and so much impregnated with salt that we doubt if they would burn if set alight'.

subsidy to stay in business. Despite a flutter of hope in 1898, a pessimistic assessment a year later finally convinced even Felton that there was no alternative to liquidation. The lease was abandoned and assets sold for what they would fetch, and in 1900 the Australian Salt Manufacturing Company expired as a bad debt in the partners' ledgers. Felton's loan had been repaid, but he wrote off his remaining investment of £5233; the partners had the misfortune of becoming involved in Mr Cheetham's first venture in the salt trade, and while he learned from its mistakes they persisted in them. Cheetham did much better at Geelong, while French Island proved useful as a prison.

New opportunities occasionally emerged, despite the depression. Prosser had tried to persuade Felton and Grimwade to support a venture in Western Australia in 1894, but was told by Grimwade that neither he nor Mr Felton wished to expand: 'our idea is rather to contract our business than to extend'. Visits to Perth by both Grimwade and his son Harold found them 'disappointed with the smallness of the trade there'; but a few months later, when Kempthorne was looking for a new opening for his son Orlando, Felton Grimwade's agreed to send him to Perth as their agent, on a salary of £3 a week. He was authorised to open an office but not to establish a business, in a city in which Bickford's of Adelaide were already established. 'As you know, we are not very speculative people, and we shall abide the results of this speculation with very much interest!'[41] Young Kempthorne proved an enterprising man, the Western Australian economy was beginning to expand at last, thanks to its new goldfields, and Grimwade soon conceded that 'we are practically in business in W.A., and shall probably stay' (while warning Kempthorne against dead stock, having noticed in a business he was taking over a stock of trusses sufficient to last the ruptured of Western Australia for many years). In 1897 the partners set up an official branch of Felton, Grimwade and Company in Perth, but soon agreed with Bickford's that two wholesale druggists in Perth were one too many, and in 1901 the competitors merged to form Felton, Grimwade and Bickford Ltd.

Despite the depression, and the failure of the salt business, Felton and Grimwade had achieved by the end of the century most of what they had set out to do in three decades of business. Felton, Grimwade and Company was the largest drug house in Victoria, with profitable manufacturing and dental departments and a promising subsidiary in Western Australia. The partners were large shareholders in New Zealand's principal drug house and in the Adelaide Chemical Company, while in Victoria they controlled Bosisto's and had a large share in the prosperous enterprise of Cuming Smith's. Felton's particular respon-

[41] FG&Co to O Kempthorne, July 1895(?).

sibility among their ventures, the Melbourne Glass Bottle Works, was beginning to thrive. As the colony of Victoria became a State in the new Commonwealth in January 1901, with Melbourne its capital, and the new federal Parliament settled into the State House at the top of Collins Street for the next quarter-century, both men could be well pleased with their success. Whatever Alfred Felton had by then written in his will—a secret known only to his solicitor—he had, in these enterprises, already created an important legacy for the people of his adopted country.

CHARLES CAMPBELL REMAINED—after FS Grimwade—Felton's closest business associate. With a daughter resident at Murray Downs, it is not surprising that Campbell and his large family spent much time there. Not all of it was happy, as Felton reported in 1895:

> Mr Campbell, my partner in Murray Downs, has had much trouble on hand. He lost a daughter of 28 years rather suddenly a few months ago, and to this was added another loss, a most sad event, viz. the drowning in the floodwaters on the station of his son Alec, on his twentieth birthday. The whole family have been sadly upset by these misfortunes.[42]

Alec had been attempting to swim cattle across a flooded creek. Perhaps it was 'these misfortunes' which prompted Campbell to drink more alcohol than before, a habit which made Felton 'very irritated'; Dickson Gregory claimed that he refused to be visited by Campbell when 'under the influence'.[43] A story still current in Swan Hill—it was told to groups taking guided tours of the house—that some obvious damage to a painting was the result of one partner throwing a glass at the other during dinner is unconvincing; the partnership was renewed in 1894 for a second ten years, and the assertion, in all local accounts of the property, that the partnership of Felton and Campbell was dissolved in 1900 and Campbell became the sole owner is an error.[44]

While Campbell relished the role of pastoralist—and was thanked by the Association for his labours (unspecified) during the strike of 1891—Felton

[42] AF to Dr Phillips, 18 December 1895.

[43] WRG's notes of interview with Dickson Gregory, 12 November 1931. In 1895 Felton gave Grimwade a sharp account of their friend and partner: 'Charles Campbell don't look very well. Is it possible his stubborn strength will have to pause and give way before the advance of the years? His health and strength are important indeed to his large and not very able family . . .' Campbell did become ill; in March Felton reported him 'still a prisoner to his house—but he bears the imprisonment well. He seems to be more cheerful than he was when he had the run of the town and his gas-lit office' (AF to FSG, 13 February and 22 March 1895).

[44] e.g. 'In 1900 the partnership was dissolved, and Charles Campbell became the sole owner' (Feldtmann, *Swan Hill*, p. 16). Croft repeats the story (*Murray Downs*, p. 25).

remained primarily a merchant even as half-proprietor of Murray Downs. He had long kept a watchful eye on the wool market, writing to his London agent asking for 'estimates of the approximate all-over value per pound of the wool clip', and to Campbell suggested a better method of comparing the average of the flocks, the number of bales, gross proceeds and net proceeds over a period of years so that 'one could have these things on a page in a flat book ... and not demand the examination of sheets of calculations like at present'. Murray Downs was a big operation; in 1889 the station sent 327 bales of wool to Echuca on the *Nile*; and in 1890, taking advantage of the new railhead, 200 bales were sent direct to Melbourne by train. In 1891 some 81 000 sheep were shorn in the vast Murray Downs woolshed (which may still be seen, moved across the Riverina to house the Shearers' Hall of Fame at Hay).

The good times did not persist into the 1890s. Murray Downs wool, which sold for £18 15s a bale in 1889, fetched only £10 in 1894. 'To some this fall has been simply <u>ruin</u>', Felton wrote to Elliott in Sydney, payments to creditors leaving the grazier barely enough 'to just feed his children, his wife and himself'.[45] But to the merchant (as to the orator) timing is all: 'I suppose our wool will be in the July sales', he wrote to Campbell in June 1895. 'If so we should decide whether to sell, or hold out for a price. We have speculated in the market so far, and perhaps we can go a little further ...' And three months later: 'Were the MD wool all my own I should wire London agents to offer the 1894/5 wool in the November sales instead of September ...'[46] This bullish mood led Felton to write with some optimism to Elliott that 'things are improving in Australia and I am glad to say we now have a hope for the poor pastoralist. There is coming a rise in wool, a good one I hope at present, and I hope more to follow ... now we will hope for <u>better</u> times'.[47] He still wanted to delay sales in December, but Campbell was reluctant. Primary production was to help lead Victoria out of its depression, but the process was slower than Felton hoped.[48] 'Things continue in their slumbrous state', he complained to EW Grimwade in London. ''Tis these low prices of wool and wheat and meat and other things that are hurting us.'[49]

In 1897, three years after their partnership had been renewed, Campbell and Felton moved to purchase Langi Kal Kal, a large property (later, like French

[45] AF to G Elliott, 27 September 1895.

[46] AF to Campbell, 14 June and 10 September 1895.

[47] AF to G Elliott, 27 September 1895.

[48] AF to Campbell 5 December 1895

[49] AF to EW Grimwade, [19?] February 1895.

Island, the site of a prison) near Beaufort in Victoria. When Felton asked his partner, perhaps idly, whether he might prefer to buy it 'for or by' himself, Campbell was upset: 'I have to say, that I do not desire to purchase any property in which you do not have an equal share—with all risks and profit of the same', he wrote back the same day. If Felton would rather invest in such a property as Langi Kal Kal than be an owner, Campbell would indeed buy it himself—but only if Felton lent him half the purchase price, at 4 per cent interest, on security of the property and its income. 'Reply by Thursday morning', he added. The partners bought Langi Kal Kal together, on 1 March 1897; Felton paid £42 650 for his half share, though the property was valued on 1 April at £101 000 (£83 707 for the land and £17 253 for the stock, which included 22 280 sheep). Langi Kal Kal paid Felton £12 513 in 1898–1900; there is no record of his visiting it, though he presumably did. Campbell built a large new residence on the property.

Felton also owned a tiny property in the Dandenongs. One of his favourite jaunts involved hiring a smart jinker for a drive through the hills:

> He would say to his secretary 'Please ring up Mr Head, the livery stable man at Ringwood, and ask him to meet me at the station at 3 p.m.' . . . he would engage Mr Head, or one of his staff, to drive him around the Dandenongs where he would delight in being among the gum trees and be away from the City and noises. These trips he took almost weekly when the weather was favourable.[50]

Felton might have discovered 'Fern Park' near Ferntree Gully, on one of these excursions. He bought it in 1892, with a Mrs Ludwell as tenant, and spent some money on improvements, but it seems to have been run down and drought-stricken by early 1895, when he let it to T Dixon for £30 a year plus interest of 6 per cent on £79 worth of stock. In March, after rains had broken the drought, he urged Dixon to 'get back the cows and other missing items' and start farming, but the cows, it appeared, were scattered far and wide. Weeks later Felton wanted to know whether they had been found; no answer remains on record, but the farm continued as a small asset—he later reduced the rent to £15—in Felton's estate.[51]

Felton had no objection in principle to buying city property, provided prices were more sensible that they had been in the booming 1880s. 'What about Hosie's corner, to be offered on 11th Wednesday morning', he wrote to Campbell in September 1895, 'Is it worth looking after?' Campbell apparently

[50] Dickson Gregory to WRG, 30 April 1934.

[51] Felton to Dixon, 28 January, 16 March and 8 April 1895. Felton also bought, for £40, five acres of land at Upper Macedon in 1890, which he sold, undeveloped, in 1902 for £180. At some point Felton also acquired a villa at 143 Auburn Road, Hawthorn, and villa allotments in Barkers Road and Power Street, Kew, sold after his death.

thought not, but in 1902 Felton did buy, alone, a three-storey building at 9 Queen Street, for £27 500; it returned him £2000 in rent in 1902. The building remained in the possession of his Trustees for many years, and still stands, broad, handsome and well preserved, its florid coping surmounted by two lions, and the name 'Felton Building' boldly embossed across the second storey. Only the two smart restaurants, one Italian and one Indian, in the area below the entrance suggest that Melbourne is no longer quite as Felton knew it.

Felton's Ledgers show that the breaking of the boom hit him hard but did not ruin his fortune. Writing to an acquaintance in Fiji he expressed himself 'thankful for a fair measure of good health, and that my personal losses, though many, have been such as were under my control'. According to his ledger he wrote off some £39 320 in bad debts between 1890 and 1900, the largest items being investments of £15 692 in the failed Mercantile Finance Trustees and Agency Company, £11 332 in the Oakenden sugar venture and £5223 in the Australian Salt Company. There were thirty-four items in all, some of them sizeable private loans to friends.[52] Felton remained a rich man, valuing his assets far too conservatively at £311 000 in 1900, but his fortune had contracted by some £31 600 in the previous decade. If he had not, in the same decade, given away £20 390, the reduction in his total assets during the depression would have been negligible. After 1900, in the last three years of his life, Felton calculated his income at about £20 000 and his savings at £15 000 a year. He always knew how he was doing, and why.

[52] Other bad debts written off included the Union Finance Guarantee and Investment Co (£2263), Imperial Colonial Finance Company (written down by £625), Greenmount Sugar Company (£652), Shaw River Gold Mining Co (£640), All Nations Gold Mining Venture, WA (£532), West's Tyre Company (£500), and the Kyneton property (£606). Individual debts written off included Dr Thomas Rowan (£1519; Felton accepted some paintings in lieu), CE Moulton (£500), Ernest Dudon (£664), George Withers (£396 and Mrs FB Long (£250).

10

ON THE ESPLANADE

THE DEPRESSION RUINED the business of Felton's friend Bryan Burstall. Felton encouraged him to start again. 'Will it not be well', he wrote, 'to get everyone paid at once and the complete settlement made so you may be free to get to work at business that will repay you, and so get the burden off your mind. Strike out and try to do some paying business. I am ready when you are!' But Burstall, old, chastened and discouraged, retired to live in England; and regular payments amounting to about £100 a year began to appear as gifts in Felton's ledger, to be continued as an annuity under his will.[1]

In the middle of 1891 Felton moved into his last bachelor establishment, in rooms—later two rooms made into one on the ground floor, and a bedroom above—in the Esplanade Hotel, on the high ground above the sea, with an uninterrupted view across the Bay to Sandridge (now renamed Port Melbourne), where the young Felton had disembarked from the *California* nearly forty years before. The New Baths Hotel had opened on the site in 1857, just as the new railway reached the seaside suburb; renamed the Criterion, it was demolished in 1867. The much grander Esplanade Hotel rose on the site in 1874, designed—like the General Post Office, the Supreme Court, the Athenaeum and the Eastern Hill Fire Station—by the London-trained architects AL Smith and AE Johnson. Its sixty rooms housed many visitors (Mark Twain, it is said, among them) and several other long-term residents as well as Felton.[2] The lessee, after 1888, was

[1] AF to BC Burstall, 14 June 1895. Burstall and Smith continued as an entry in directories, and in Felton's 'Personal Gifts and Sundries' ledger until 1902 (with a small negative balance). Burstall's private address—Punt-Hill, South Yarra 1890–91, Athenaeum Club 1892—disappears from directories after 1893.

[2] According to his Personal Gifts and Sundries' ledger, from July 1891 Felton (though still listed in the directory at 'Caulfield'), made monthly payments to 'St Kilda Parade a/c Jacoby', varying between £30 and £80, until

Sigismond Jacoby, who became friendly with Felton (and once extracted £1 from him as a contribution to a 'Jews' Carnival').

St Kilda, in those days, was 'thronged on summer evenings by visitors from Melbourne in private carriages and public conveyances, on foot and on horseback', for good reason:

> there is some freshness in the breeze borne inland from the water after the hottest day ...when the moon is at her full, and she traces a broad path of radiance across the almost purple sea, and a thousand points of light glitter along the distant shore from Sandridge and from Williamstown, as well as from the vessels at anchor in the harbour or moored to the piers, and the bulky form of Mount Macedon lifts itself above the horizon in one direction and the jagged outline of the You Yangs is visible in another...[3]

From a grassy slope in the foreground a pier ran out into the sea. Half a dozen large hotels, and five 'bathing establishments' (fenced in 'to afford protection against the sharks') were popular in summer, while St Kilda remained a 'favourite residence all the year round of many thousands of prosperous citizens', including Felton and several of his friends.

'During the summer evenings', Dickson Gregory wrote, 'two persons were to be seen very frequently sitting on a seat nearly opposite the Esplanade Hotel'. They were Felton and his old bachelor friend, Sali Cleve, who had rooms next to his at the Esplanade Hotel. 'They would sit there for hours discussing topical events and the pastoral news in which each was interested.'[4] Or Felton might be seen with another close friend, Edward Keep, who lived in St Kilda until his death in 1901. And since St Kilda Pier was the place of disembarkation for new Governors and Royal visitors, the Esplanade Hotel would have given Felton a grandstand view over the crowd welcoming the Duke of York as he came ashore from the Royal yacht on his way to open the Parliament of the new Commonwealth in May 1901.

Alfred Felton's lodgings in the Esplanade Hotel were described several times by Russell Grimwade, first in an article in *The Home* of 1 January 1926:

> Before the days of telephone and motor cars—even before bicycles—the writer, as a boy, was frequently sent with a message in the morning to the old man. The two-mile

16 December 1896; he then paid usually fortnightly, about £11 weekly to 'Esplanade Hotel, McQuade', with more frequent expenditure on food and drink.

[3] [Anon.], *Our First Fifty Years*, pp. 54–5.

[4] C Dickson Gregory to WRG, 30 April 1934 (Russell Grimwade papers). Sali Cleve (1832?–1919) was a merchant, one of three partners in Cleve Bros, and representative of Baron Rothschild. He also owned a station in Queensland (de Serville, *Pounds and Pedigrees*, p. 382). Cleves' 'name is perpetuated by a handsome memorial erected on the Esplanade'.

St Kilda jetty and the Esplanade Hotel, *c.* 1883 (Nicholas Caire, photographer, La Trobe Picture Collection, State Library of Victoria)

walk was willing payment for the excuse from school, with the added charm of a few minutes in those rooms alone.

Bookshelves all round, crammed in places with orderly series of volumes; crammed elsewhere with disorderly heaps of books, papers and serials. Above, pictures, clocks, ornaments and rubbish; above that, on the walls, the earlier pictures, properly hung. In front, the later pictures, leaning against the books, or a pedestal carrying a marble statue. Perhaps an ormolu timepiece, with its glass dome, and the auction room number still on it.

The boy, having learnt his quarry's movements, would have twenty minutes to explore the large table in the centre before the old man would enter, dressed for town, in dark Beaufort coat and hard hat. Followed on his heels a frowsty waiter, with a large tin tray, commonplace china and a battered tin cover keeping the

Felton's Rooms, Esplanade Hotel, St Kilda (Nicholas Caire, photographer, National Gallery of Victoria)

whiting hot—365 whiting and 365 chickens a year. Always whiting for breakfast, always chicken for dinner. No lunch.

The always crowded table was approached, and with the tray the waiter would push aside the ivory miniatures, the heap of unopened *Spectators*, the Bristol letter weights, and the wax phonograph cylinders, and in an Adam chair and a hard hat, the day would be begun.[5]

In 1947 Russell included a similar description of the Esplanade rooms in *Flinders Lane*.

By extraordinary chance Grimwade's words have recently been confirmed by pictures. In 2000 an album of photographs of a Victorian collection of paintings appeared on the market, without its cover and with no obvious indications of its origins, other than the label of the well-known photographer NJ Caire. Fortunately, alert curators at the National Gallery of Victoria recognised paintings the Gallery

[5] *The Home*, 1 January 1926, reprinted in *Historical Record of the Felton Bequest, Supplement No 1*, pp. 99–103. The St Kilda City Council marked Felton's residence in the Hotel by placing a plaque near the entrance in 1983.

ON THE ESPLANADE 181

had received under Felton's will, and the album was acquired. The first twelve photographs show the walls of Felton's St Kilda lair—or rather glimpses of them, between and above his pictures, bronze figures, ivories, clocks and books, a collector's dream and a housemaid's nightmare. There seems little room for furniture, or for the collector himself, in such an obsessive profusion.

Felton's passions are here, or some of them, and so strongly that Grimwade's affectionate recollection of an amiable and withdrawn eccentric—'carved of ivory', while FS Grimwade was 'carved of oak'—seems partial and sentimental. Russell's youthful recollection of 'the kindly grey eyes and their twinkle that dominated the whole, for Mr Felton was essentially placid and benign' was indeed one aspect of Felton; but the image is too bland altogether for a man who could manage managers, even of bottle works, and of whom other records reveal a more crusted and astringent personality. The visitor to the Grimwade mansion, whom Russell recalled 'smilingly watching the children at play' before 'toddling off with his game leg and a single bloom that had caught his fancy—a rosebud or a carnation—generally carried between his teeth' was less indulgent than the children realised.[6]

John Longstaff's posthumous portrait of Alfred Felton, sitting on one end of a garden seat at 'Harleston', also depicts a benign, almost withdrawn figure. In fact this was Felton the relaxed and well-fed listener: on the other end of the seat, in the foreground of the original photograph, sat FS Grimwade's brother William, an ebullient raconteur in full flight, snapped by Norton Grimwade after Christmas dinner in 1902.[7] The portrait is usually on display in the National Gallery, in preference to the more accurate but artistically inferior portrait JC Waite made from a different photograph, depicting Felton as a plain and forthright man of action. More vivid than either is the miniature Amy Whiting painted on ivory, using the same photograph as Waite.

RUSSELL GRIMWADE ALSO wrote of Felton that 'Kipling might have called him an "agoraphile", for he loved the market place and its concourse of people', not least 'for the opportunity it gave of observation of his fellows'. In his last years

[6] The young Grimwades did not notice that the elderly bachelor was even capable of matchmaking. Winthrop Hackett, who was by the 1890s a powerful figure in Western Australia (and still unmarried), dined with Felton one Sunday in February 1895. 'I proposed running up with him to Harleston in the afternoon', Felton wrote to FS Grimwade, then on his way to New Zealand; 'I was considering how that Hackett and Alice would get on very well, and might spar a bit if they found pleasure in it'. But Hackett had a cold; and in any case, Felton later discovered, Alice was on the *Monowai* with her father (AF to FSG, 13 February 1895).

[7] Russell Grimwade devotes chapter 13 of *Flinders Lane* to an imaginary conversation between the two old men. They were certainly friends; Felton included William among his beneficiaries.

Felton, though no longer an active partner in Felton Grimwade's, continued as a matter of course to spend his days at Flinders Lane, causing some of the tensions usual in such circumstances. Russell recounts a brush between Felton and Norton Grimwade over Felton's habit of commandeering secretarial services for purposes unrelated to the firm, oblivious of the disruption caused; the outcome was the appointment by Felton himself of Dickson Gregory, then a young man, to be his secretary, amanuensis and messenger. In 1934 Dickson Gregory provided Russell Grimwade with his recollections of Felton, 'one of the finest men Australia or Melbourne has had the honour to have as a citizen', recalling, with obvious affection, the peculiarities of his kind if demanding employer.[8]

One of the secretary's roles was to be Cerberus, guarding the entrance to Felton's cluttered cave. His instructions were explicit: to let no one in without finding out what it was about, whether anyone else could do it, and whether it was worth taking anyone's time.[9] Felton arrived every morning with the question 'Anything fresh?'; and 'one of his first customs' was to look in the newspaper for the rainfall and the daily forecasts, with Langi Kal Kal and Murray Downs in mind. According to Dickson Gregory, Felton was 'a great reader of the daily papers and it was surprising what a great interest he took in topical affairs'.

Sometimes his reluctance to be disturbed was overcome by his own curiosity. 'Constantly', Dickson Gregory wrote, 'Mr Felton would have ladies calling at his office to interview him'. They would come to the counter at the warehouse and insist on seeing Mr Felton himself. 'That was quite sufficient for Alfred Felton when informed that a lady would not give her name. "I'll come out and see her", he would say, and then he would speak to her at his door, only to find she was an entire stranger and was begging for some bazaar or charity'. He never gave them anything, and advised them to write. 'Very rarely did a female gain access to his private office.'

The office was Felton's haven, open only to his friends. He and Signor Baracchi were found there one warm Melbourne day, both asleep, both with their hats on.

FELTON DID NOT spend all his days in Flinders Lane snoozing. He might not have involved himself much in Felton Grimwade's affairs, but he continued to pursue business interests further afield. Two chemists' businesses, in distant Broken Hill and Wilcannia, far up-river in New South Wales, had come under his direct control when their former owners defaulted on loans. 'Unfortunately there was no

[8] *Flinders Lane*, pp. 63–4; C Dickson Gregory to WRG, 30 April 1934 (Russell Grimwade papers).

[9] Notes from WH Baker, 16 February 1933. Russell Grimwade described Felton's office in *Flinders Lane*, pp. 9-13.

such thing as a buyer for a country business anywhere to be found', Felton told Armstrong, still nominal owner of Wilcannia.[10] Elliott, in Sydney, had advised simply closing up, but Felton characteristically installed managers, and from Flinders Lane, with a pen as sharp as a terrier's teeth, worried at them to succeed.

The 'Medical Hall' in Broken Hill was potentially a fine business, with large rented premises (still standing, in Argent Street) with every convenience, including electric light in the display window. Felton's instructions to CF Williams, the manager, were explicit:

> The Business has paid me no interest for two years, but has required from two to three hundred pounds extra advanced to it. Of course this is explainable, but if the business is to pay its way it can only be done by accurately taking the accounts which show what is doing, and by the exercise of great economy ... Everything must be sorted, counted, weighed, valued and duly entered in the book, balanced and a line drawn to terminate the year. These returns I want to have punctually.
>
> There can be no reason for keeping over £20 in the till—a week's takings. Whenever there is £10 in the till pay it into the bank.
>
> The Quinine wine is a grand article. Surely your Doctors should find it out and recommend it to people. Will it be well to present a bottle here and there to medical men?[11]

When Williams asked for leave of absence for a honeymoon, Felton was not sympathetic:

> Mr. Francis calling in I mentioned your proposed absence from business of a fortnight and its cause. He told me when he was married he took two days from his Business and brought his bride to his simple quarters in Bourke Street on the 3rd day.
>
> And so it is with men that are destined to make their way in the world—they have to sacrifice self a bit to attain to it. It is useless to contend that young men sit up late and gamble and so on. The man who adopts this sort of thing does not of course make any progress, neither can he ever have anything laid up on his own to back him, or for use in a time of stormy weather. I should feel much more assured of your future, if out of the first £300 due to you for services rendered you had £150 banked, or in good purchased value—say house and furniture.
>
> I will not enlarge on this, but simply quote the old and well worn sentence—*verbum sap*.[12]

[10] AF to Armstrong, in Perth, 26 March 1895. Felton had complained of Armstrong's large outstanding debt as early as 1887 (AF to Armstrong, 14 October 1887); he apparently acquired the business by tender from Armstrong's trustee (AF to RW Millington, 5 September 1895).

[11] AF to CF Williams, 1 February and 14 March 1895.

[12] AF to CF Williams, n.d. (but probably enclosed with the letter of 14 March 1895).

Later in the year Felton was more optimistic, in general and about Broken Hill in particular, writing to Elliott in Sydney that 'perhaps drug businesses can now once more find buyers. Please keep watch for the right man'.[13] But recovery was still far off. In October 1895 Felton made the long trip to Broken Hill, and reported on his return that 'a more deplorable thing I have never seen than the conjoint aspects of Shop, Books and Business'.[14] He appointed a local man as his agent—'to lick the Medical Hall business into shape'—and invested money in purchasing the premises housing the business, hoping to make it profitable. In 1899 the business was sold—cheaply—but the property remained in his estate at his death.

Wilcannia was an even greater worry. A new manager, GF Goodwin, described by Felton as 'of a liberal disposition', began by writing the wrong discount on an Elliott bill.[15] 'I trust you will be able to bring the business up to the average return, between 20 and 30 pounds a week', Felton told him, reiterating the target, with diminishing confidence, as Goodwin continued to fall below it, even in the 'busy season'.[16] In May Felton took to Elliott in Sydney the details of the Wilcannia business to demonstrate that it would pay well for an owner, though not for a locum.[17] A buyer, RW Millington, was found; he had almost bought the business the year before, and as he delayed before concluding the deal Felton's irritation with Goodwin mounted. Eventually Millington took over; he was justifiably annoyed when Goodwin remained in town and set up in opposition, but Felton showed little sympathy:

> You complain of the opposition, the dullness of trade and the state of the river. The last two are much to be regretted—but you have only yourself to thank for the first and for a large portion of the second trouble, for had you taken the place in '94 you would have saved me £100 I am now out of pocket for travelling, extra wages etc., and for yourself certainly you must have wasted more like £250. You lost your £5 a week, got the business muddled, and landed in the town an opponent against yourself at my expense—so there is the indictment in full . . .[18]

[13] AF to G Elliott, 27 September 1895.

[14] AF to JR Bowering, 4 November 1895.

[15] AF to Elliott, 29 January 1895.

[16] AF to GF Goodwin, 29 January and 14 February 1895.

[17] AF to Elliott, 18 April 1895.

[18] AF to RW Millington, 8 August 1895. Millington remained touchy, Felton blunt: 'Let me assure you', he wrote on 30 January 1896, 'no offence meant in forwarding you a statement of interest to date and asking for amount due. Had you been the House of Rothschild the same papers would be sent on to you, and what is more, the Rothschilds would expect to have them sent'.

Concerning Goodwin, Felton characteristically moved from a particular point to a general conclusion: 'When I handed Mr George Elliott Goodwin's wonderful and numerous testimonials, "Good enough for an archbishop", was his rejoinder. I have these precious pages and they are a fine comment on the humbug of "references and testimonials"'.[19] When, a year later, Goodwin failed as a competitor, Felton lent Millington money to buy his stock.[20]

The waspishness occasionally evident in this correspondence was sometimes unleashed at equals as well as subordinates. 'Why did you not give me a call of a few minutes at my office when you returned from New Zealand', he asked Burns Cuming, Manager of the Adelaide Chemical Works.

> I was surprised to learn that you had returned and passed me without sign or word. I wanted particularly to see you. Had I been a resident of Collingwood Flat or of Braybrook or some other lively outpost I could have understood it, but my office is in the centre of all that is going on in Victoria, and so I hoped and expected to have a call.[21]

Felton nevertheless learned to be patient about some at least of other people's shortcomings. Thanking Charles Campbell for a 'very kind, thoughtful and truthful letter' of advice, he went on:

> It has given me matter for thought, and there has come to my memory a passage in a book which suggests the uselessness of 'attempting to reprove a fool according to his folly'. I daresay the thing is applicable to more than one person—but as bumptiousness is a thing entrenched in ignorance, 'tis of no manner of service attempting to move that thing.[22]

'To REALLY STUDY the inner soul of Alfred Felton', Dickson Gregory told Russell Grimwade, it was necessary 'to read the extracts in his small notebooks which he always carried with him'. When reading library books, if he came across 'suitable sentences', he had Dickson Gregory write them in his notebooks; even his desk diary block produced quotations he thought worth preserving.[23] Several of the passages thus transcribed dealt with wealth and the uses to be made of it. The First

[19] AF to Millington, 5 September 1895.

[20] AF to Millington, 29 July 1896.

[21] AF to RB Cuming, 31 July 1895.

[22] AF to Campbell, n.d.

[23] 'Favourite hymns, such as "Lead Kindly Light" and "Abide with me" and Tennyson's "Crossing the Bar", also found a place ... It was only to the few who were privileged to know him intimately was his sterling character revealed' (C Dickson Gregory to WRG, 30 April 1934, Russell Grimwade papers). Dickson Gregory gave Russell two of the little books—one of which has since disappeared—but could not find others.

Epistle of Paul to the Corinthians, Chapter 13—'Though I speak with the tongues of men and of angels and have not charity, I am become as sounding brass, or a tinkling cymbal'—was copied in its entirety. Other passages were less famous; the Reverend Charles Caleb Colton, author of *Lacon, or Many Things in Few Words, Addressed to Those who Think*, warned, and Felton noted, that 'he that will not permit his wealth to do any good to others while he is alive, prevents it from doing any good to himself when he is dead'.[24] Less gloomy advice, culled from the memoirs of Mr Childs, a Philadelphia banker—'spend your money yourself for I have rarely seen an estate administered as its owner would have wished; the only money I seem to have is what I have given away'—prompted Felton to formulate his own intentions. Returned from his travels of the 1880s, and approaching the age of sixty, he devised for himself an agenda to follow in his later years.

Felton set out his priorities for spending his fortune very succinctly in one of his little books: 'Expenditures on the sick and poor; on servants and employees; on art works, travelling, and also on desirable things—personal or other'. (Only his support for his own family was omitted from the list, presumably as an obligation accepted without question.) Having given these matters much thought, Felton followed this personal programme faithfully until his death in 1904, and in 1900 included elements of the agenda in his will. His account books show in some detail how much he spent on charity, art, travelling and 'desirable things' in the years that remained to him.

FELTON WAS NO tinkling cymbal. He had always been charitable, and during his sixties he developed a pattern in his philanthropy, traceable in his meticulously kept ledger of 'Personal Gifts and Sundries'. In the 1890s he gave away £20 388, adding another £8945 in gifts in his last three and a half years. 'How many appeals, private and public, Alfred Felton helped during his lifetime will never be known', Dickson Gregory affirmed, 'for he was not a man to have his beneficence broadcast'; but the surviving records show the range of his benefactions. Small gifts to individuals among 'the sick and poor' included £7 'for poor lady in distress', rent for a widow, 'a suit of clothes for Mr . . .', £10 for 'no name', and money for the 'family of a lunatic doctor'. As befitted a responsible proprietor, he supported churches at Swan Hill and Antwerp, the Glass Works Cricket Club and the Barrier Broken Hill Boys Brigade; local patriotism prompted support for the St Kilda Cricket Club, the St Kilda and Caulfield Ladies Benevolent Society and the local Anglicans ('Canon Potter for Charities' £10, and 'Mrs Potter, Bells' £3).

[24] A copy of the 'new edition, with subjects alphabetically arranged' (1866) is in the National Library of Australia.

The *Argus*, as usual assuming the lead in the respectable virtues, solicited donations each year for a Christmas Charity Fund, for hospitals and orphanages. In December 1892 Felton gave the Fund £100, increasing the amount to 200 guineas in 1893. But in 1894 no gift to the *Argus* was recorded, replaced in January 1905 with the first of Felton's annual lists of donations directly to institutions. As will be noted later, he might have been influenced by a benefaction established in support of Victorian charities in 1878, the Estate of the late Edward Wilson, former proprietor of the *Argus*; the long lists of institutions and societies supported was published half-yearly, and according to Dickson Gregory Felton instructed him to collect all newspaper references to the trust and paste them in a book.[25] Felton's own list of January 1895 of course remained secret: £10 each to the Children's, Women's, Melbourne, Homoeopathic, Alfred and Austin hospitals, the Benevolent Asylum, the Melbourne Orphanage and the Charity Organisation Society. A year later three hospitals received £20, and the £10 list was extended to include the Educated Poor, the Immigrants Aid Society, the Blind Asylum, the District Nursing Society and the Convalescent Home for Women, and £5 each was sent to the Convalescent Home for Men, the Deaf and Dumb Institute, the Eye and Ear Hospital, the Cherbury Home for Hope, the Neglected Children's Aid Society, and the Collingwood, Melbourne, Port Melbourne and St Kilda Ladies Benevolent Societies. Felton showed an increasing interest in Try societies, charities attempting to find suitable rural employment for poor boys, local variants of the farm school schemes for translating British slum children into country life in Australia. Felton supported three such societies, their role indicated in a 1903 entry: 'Maintenance 3 lads on Farms 6 months £25'. (The more severe Society for the Prevention of Cruelty to Children, with its emphasis on prosecuting the parent and 'rescuing' the child, does not seem to have won his support.)[26] Other organisations favoured in later years included the Victorian Consumptive Sanatorium, the Servants' Training Institute, and societies aiding 'Helpless and Fallen Women'. In 1899 his physician Dr Charles Bage persuaded him to give £50 to a very different institution, Melbourne Grammar School.

As will be seen, this pattern of support for a wide range of charities, admirable in an individual benefactor, was continued all too readily by his trustees. Felton did make one very large and public gift. When, in 1900, another philanthropist gave through the *Argus* £1000 to initiate a fund to remove the debt from the Melbourne Hospital, Felton immediately instructed Dickson Gregory to 'write a

[25] It has not been found. Dickson Gregory's account is repeated in *Flinders Lane*, p. 67.

[26] On the VSPPC, see Swain, 'Confronting Cruelty'. The Bequests' Committee later supported the Society.

cheque for another thousand and take it to the *Argus* and tell them not to disclose the name of the donor'. He was, however, 'prevailed upon to allow his name to appear so as to induce others to follow suit', and the appeal was successful after 'other well known people subscribed'.[27] Felton then resumed his anonymous, broad distribution, although in December 1903, close to death, he reverted to his earlier custom, sending 200 guineas to the *Argus* Charity Fund for 'Christmas cheer' in orphanages and hospitals, to be published only as the gift of 'F'.

Felton's support for the Old Colonists continued, with an annual subscription and special gifts at Christmas and in winter, but other elderly persons also received attention. According to Dickson Gregory, Felton was 'one of a small group of warehousemen who subscribed a weekly sum for the maintenance of the widow of a traveller connected with a "Lane" warehouse. As each subscriber passed away Mr Felton made up the amount needed from his private purse'.[28] This could have been the widow of Edward Steyne Harley, whom Felton supported for some time. From 1892 he paid Harley's rent, in 1894 bought him an overcoat (a good one, costing £3 10s, from Flinders Lane merchants Paterson Laing and Bruce). In February 1895 he wrote to tell George Rolfe, son of the founder of Rolfe and Co and resident in Warrnambool, that 'in the matter of health and strength Mr Harley is very much on his last legs now'; Felton, looking into his affairs, had been given a list of those who might help; to provide 30 shillings a week would require £1 month each from Rolfe and Felton. 'The pound will be spent on the absolute necessaries of life—just food and shelter', he assured an apparently reluctant Rolfe. When Harley died, Felton demanded 5 shillings a week towards his widow; 'I expect to be in Warrnambool and I will call on you. I want to get the 5/- and I want to see your admirable place on the river'. He then quoted Childs again: 'the only money I seem to have is the money I have given away'. A special section headed 'Harley Trust' in Felton's ledger recorded his stewardship.[29]

Felton's support for 'servants and employees' included small annual pensions to both men and women. One, of £50 year, went to Mrs Bathia Court, whom he had perhaps known since his early years in the colony. Widowed, aged thirty-eight, in 1870, two of her young sons entered Felton Grimwade's employment, and Louis,

[27] Dickson Gregory to WRG, 30 April 1934 (Russell Grimwade papers), and obituary, *Argus*, 9 January 1904.

[28] 'Some time later he received an urgent letter from the beneficiary who stated that she wanted to make a Will and have him as the executor. Naturally, he declined for many reasons particularly as he was a stranger and his time was taken up with other very important matters' (Dickson Gregory to WRG, 30 April 1934, Russell Grimwade papers).

[29] AF to Rolfe, 25 February 1895 and 23 July 1896. On 1 April 1895 he had written to assure Rolfe that Harley was indeed receiving the 30 shillings weekly. Other contributors included Grimwade, Robert Harper and Charles Campbell, and the trust seems to have concluded with Mrs Harley's death in 1900.

the elder, rose to be in charge of the wholesale drug counter and one of the heroes of the great fire. But Louis fell in with 'some undesirable companions' who (in his employers' view) 'caused him to neglect his duties', and in May 1893 the axe fell:

> We received your Telegram this morning, informing us that you were too ill to come to business. We are quite aware of the cause and also of the nature of your illness, and we have decided that we cannot allow you again to enter our employment. As you know, you have more than once or twice offended in this way, we are sorry to say, we have entirely lost confidence in you and it is too great a risk to have you in our employment. We have for years past kept you on out of consideration for your wife and family, you however do not consider them yourself and you must now leave us and seek employment elsewhere.

They advised him to 'get away from Melbourne' and his 'old associates'; he should go to another colony, to 'change his habits', 'turn over a new leaf' and 'make a fresh start'. If he was 'really in earnest about this', the firm would 'advance you a few pounds to take you away', and allow his wife a pound a week for eight weeks, by which time he should have employment. The partners sent Court off with a good reference—'he is industrious, obliging and honest'—and a year later, having heard that he was 'in great straits', wrote to urge Bickford's in Adelaide to take him on: 'we believe the next position he gets he will endeavour to retain. He is sober, has a fair knowledge of drug room duties, and we think you could well engage him'. He then disappears from view, but Felton paid his mother £50 annually until she died in 1900, aged seventy-one.[30]

TO OLD FRIENDS in difficulty Felton was particularly generous, lending Henry Creswick £500 in his last years, and converting the loan into a gift when Creswick died in 1892. Felton paid for Creswick's grave, and imported an Italian memorial stone similar to the one he had erected for his brother Arthur. A number of other friends received small loans; one made in 1892 to George Bunny had to be written off in 1896. Even with friends, Felton's generosity was businesslike: did George Withers require £300 or £500 to get clearance from a debtor? 'This really must be made clear before I move a peg.' The question answered, he sent £400 and waived his request for a promissory note 'under the circumstances you describe'. The remnant of the debt was written off on Withers' death.[31]

[30] FG&Co to L Court, 3 May 1893; Reference 9 May 1893. They told Bickford's the reason for Court's dismissal, also admitting that in 1893 they had then 'more hands in our drug room than we need' (Partners' letterbook).

[31] AF to Withers, 6 and 15 (two) February 1895.

Felton's support for the Australian Church was also businesslike. The Church was in difficulties throughout the 1890s: some members were alienated by Strong's increasing radicalism, and others by his conflict with the Reverend William Addis, Assistant Minister from 1888 to 1892. Attendances remained high, but financial membership fell away, and with it church revenue—from £4040 in 1889 to £1765 in 1894.[32] The large debt on the church building could no longer be serviced, and in 1897 some of the guarantors put up a plan; the church property was made over to a group of four 'proprietors'—Charles Campbell was one—who cleared the £10 000 debt and rented the premises to the Church for £250 a year.

There remained an accumulated deficit on running expenses. According to Colin Badger, Felton offered £300 to reduce the debt if £100 could be raised, but the appeal failed, the offer lapsed and Felton 'apparently did not help to extricate the Church from its financial difficulties'.[33] But the Church's *Annual Report for 1897–8* announced that

> for the first time in the church's history, the new year is approached with no debts and no liabilities and with a small sum in hand. For this result the church is especially indebted to Mr Alfred Felton, who most generously provided the greater part of the sum required to pay off the accumulated debt in working expenses, of which the balance has been kindly donated by the members and friends of the church.

Between 1891 and 1903 Felton contributed £1806 to the Australian Church, in one year £750. He also gave Dr and Mrs Strong a Silver Wedding gift.

Felton was generous with wedding presents, in one case giving £100, in another a painting. He bought many tickets for fund-raising functions he did not attend—those he did were entered as 'personal expenditure', not 'gifts'—including a concert in aid of a hospital, by the singer Ada Crossley. Some single entries are intriguing. Who received the Bluthner Grand Piano, bought for £100, or the 'Rocking Horses', £7 19s? For which election did Felton pay £2 10s for a trap (presumably horse-drawn) for one B Mitchell? Who, in 1892, was appealing for 'Antarctic Exploration' (and received £2)? Did the entry 'F. G. Wilmott, disputed matter, £50' indicate a contested debt which Felton paid in 1891 but recorded as

[32] Badger, *The Reverend Charles Strong and the Australian Church*, ch. 7 and p. 129. The Strong Papers include much material on Addis, who made a habit of conversion. Converted to Roman Catholicism at Oxford in 1868, he became a priest in 1872 but renounced Rome in 1888, married, and was appointed to the Australian Church; returning to Oxford, he became a Unitarian and later an Anglican priest.

[33] Badger, *The Reverend Charles Strong and the Australian Church*, pp. 140–1. Badger also suggested that Charles Campbell inconveniently put up the rent in 1910; it must have been his trustees, since Campbell died in 1905.

a gift? Was the 'Euchre and Pong Pong party' of 1901 truly malodorous, or a simple book-keeper's mistake?

There was a whiff of pre-Revolution Versailles in Felton's providing the 'Collingwood Poor' with £1 15s worth of cake (on his Swallow and Ariell account), but several entries hint that the supporter of Peace rallies in 1849 still had some radical sympathies. It required a liberal conviction to give, in 1900, £10 to the redoubtable Catherine Spence's League for Effective Voting, and in 1902 £25 to the National Citizens Reform League.[34] In 1903 Felton also supported the Women's Political and Social Crusade (miswritten in the Ledger as 'Social Cruise'). But in old age he, like almost all his class and generation, was hostile towards organised labour. In 1903 he joined most of the 'respectable' classes in Melbourne in condemning the rail strike, contributing £25 to the 'Railway Strike Loyalists' Fund, and in May sent a long account of the strike to his sister-in-law in Britain. The letter has not survived, but its purport is evident in her reply: 'I quite endorse your wish that none of the men that went on "strike" and caused so much inconvenience to the whole community should ever be again employed upon your railways'.[35]

In 1897 Felton gave five guineas towards the statue for Sir William Clarke, who had died on the way to his office, and a similar amount for a Jubilee statue of the Queen. Perhaps his patriotism—he gave £5 to a 'Patriotic Working Party' in March 1900—waxed as the war news from South Africa worsened; in January 1901 he gave a much larger sum (£100) to the *Age* appeal for another statue of the Queen (having had Dickson Gregory copy into a 'little book' Milner on the Boers and an entire speech by the Liberal-Imperialist Lord Rosebery). He also supported many miscellaneous causes: urged perhaps by his Anglican partner, he contributed to the completion of St Paul's Cathedral and the restoration of Bishopscourt, and it might have been on the prompting of Morris or Leeper that he made a gift to the Melbourne Shakespeare Society. But the greater part of his giving was charitable, and discreet.

[34] On Spence, see Blainey, *A Land Half Won*, pp. 278–87; and Susan Magarey, *Unbridling the Tongues of Women*.

[35] Fanny Felton to AF, June 1903.

11

DESIRABLE THINGS

Melbourne's men of business dressed badly, according to the sharply superior Richard Twopeny. 'They look like city men whose clothes have been cut in the country', he quipped; 'they wear shiny frock coats and the worst-brushed and most odd-shaped of top-hats, and imagine they are well-dressed'.[1] Felton seems, characteristically, to have found a style he liked, simpler than most, and to have stuck to it. He was for decades a familiar figure about the city: a lean man, of moderate height, with pointed beard, grey in later years, a hard square hat and a neatly folded overcoat flung over his shoulder as he limped, using an umbrella as a stick, from cable-tram (after abandoning the pony trap) to office. In his youth he had liked to look smart, but 'no one would have taken Mr Felton to be a wealthy man by the appearances of his clothes', Dickson Gregory wrote of his later years: 'He generally wore a sac suit he had worn for a considerable time'.[2]

In his later years Felton spent a good deal of money on what he called 'desirable things—personal or other', but clothes and personal accoutrements were rarely among them. 'I am going to Mrs Brown's dinner party to-night and I have no front studs', he once told Dickson Gregory, who offered to go to Drummond's and buy a solid gold set, but was firmly directed to go to Edments for a plated set, posting on the way cheques for several hundreds of pounds 'for charities and deserving cases' which Felton had just signed.[3] If a mugger had ever

[1] Twopeny, *Town Life in Australia*, pp. 18, 79. 'The working-men are dressed much more expensively than at home, and there are no threadbare clothes to be seen' (p. 18).

[2] 'He had other good suits which his tailor, Mr Milton, had made for him, but only when he went to the races and other functions was he to be seen dressed in them' (Dickson Gregory to WRG, 30 April 1934, Russell Grimwade papers). Alice Creswick said that Felton 'took his fashions' from her father; since Henry Creswick had the habit of being outfitted in Savile Row, this seems unlikely.

[3] Dickson Gregory to WRG, 30 April 1934 (Russell Grimwade papers).

waylaid Felton, 'he would have been greatly disappointed, for he never carried much cash on his person', often borrowing a sovereign from petty cash, and keeping a cabby waiting while he did so. Given a half sovereign for change he always wrapped it in white paper for fear of mistaking it for a sixpence. He also formed the habit of collecting brown paper and pieces of string, tied into neat knots. Sooner or later they might come in useful; 'Mr Felton was not a wasteful man', Dickson Gregory unnecessarily added.[4]

Careful of expense Felton might have been, but Russell Grimwade nevertheless exaggerated his abstinence, as he had his placidity, remarking that 'in moments of exhilaration his excess amounted to a cigar'. Felton must have been often exhilarated, since the personal ledger records that he imported fine cigars in lots of a thousand.[5] His basic living at the Esplanade Hotel required less than £50 a month, but his ledgers show 'personal expenditure' in the 1890s totalling £12 488, more than £1200 per annum. In the three years that followed, 1900–3, he spent more on his personal comfort—£5412, or approximately £1800 per annum—a substantial sum for a single man in those days. He imported wine in large consignments, no doubt to wash down the chicken at dinner, if not the whiting at breakfast.[6]

Felton still enjoyed occasionally interrupting the whiting-chicken sequence to dine at the Australian Club, reporting one such evening to Grimwade in 1895:

> On Tuesday the Australian Club entertained the Earl of Hopetoun to Dinner. Dining room quite full and a very brilliant and cheerful function. The Governor made a most agreeable and suitable speech—with humour, banter and pathos in it. I was nicely placed—pleasant men—Cooke and Cain right and left ... plenty of pleasant chat, good wholesome wine and a nice dinner and good cigar after it—for all of which I had a fair appetite ... I think Mr Hay is a most agreeable, successful and patient president ... If you return by Monday's express you will be able to witness the departure of the Hopetouns on Tuesday afternoon. Great doings then.[7]

[4] 'He always used the old envelopes which he daily received, and any old paper, for scribbling his notes. In his rooms at St Kilda he kept a box wherein he collected all the odd bits of string which he tied into neat knots, rather than have a new reel of twine. Likewise he saved all the old pieces of brown papers and these had accumulated to some extent at his decease' (Dickson Gregory to WRG, 30 April 1934 (Russell Grimwade papers)).

[5] 'To 1000 cigars £9 15s 0d' in 1900, and in 1902, 'To 1000 cigars £10 19s 0d'.

[6] There are numerous entries for duty on wine: e.g. 'Wine £86 7s 10d', and later 'to sale of wine £100'; earlier he had bought local wine from de Castella and others.

[7] AF to FSG, n.d. but 1895. Henry Hay, a Riverina pastoralist, was president 1894–95. John Cooke was a successful meat exporter, prone to recite at dinners: he is recorded as declaiming the Address of Sergeant Buzfuz from *Pickwick Papers* at a dinner—presumably not this one—during Hay's presidency. W Cain was a merchant, and one-time Mayor of Melbourne.

Perhaps Felton had dined too well too often; he had long before found 'the sparkling' too much for his liver, and from 1898 'Diabetes bread', from Hutchins of Carlton, entered his expenditure, whether from choice or necessity is not known.

IN HIS LATER years Felton's faddishness about health increased. A request to his seamstress to 'order of the German lady a pair of knitted kneecaps' was more rational than his continued insistence on sleeping with his head to the north. Hot water was an excellent specific for insomnia, Felton instructed a young manager (who was in too much of it already).

> Now Insomnia often arises from some trifling stomach derangement acting on the debilitated nervous system. Well that which appeases the stomach helps you to sleep. Now nothing approaches a glass or two of hot water—perhaps sipped or taken by spoonfuls—water made hot as is agreeable to taste. I always keep a spirit lamp and kettle in my room and in my travelling bag. Often in the train (sleeper) being sleepless, I have got up, heated myself a glass of hot water, and then gone well to sleep. Now my hot water, a glass on rising. If stomach a little out, a glass, one hour before meals, a glass or two an hour before bed. However I must try and send you a Book. I cannot fully instruct by letter.[8]

Arguments against pills and potions, and for so cheap a remedy, came strangely, if persuasively, from a wholesale druggist. Russell Grimwade's assertion that Felton had given up lunch was not strictly accurate: he would send an office boy out to buy a thistle bun or a scone, which he washed down with hot water. The office boys were rewarded with a silver watch at Christmas, presumably in turn and not to each annually.

Like many other Melburnians of substance, he made much use of the services of a succession of fashionable German masseurs, Herr Krone and the appropriately named Herr Grundt. Herr Grundt did especially well out of Felton; early in 1899 he received £51 9s for ninety-eight visits for massage the year before. Felton also lent him money to set up a gymnasium up the hill in Collins Street—which Felton visited by tram—and left him a legacy.

In 1895 Felton was struck by a new opportunity for exercise, writing eagerly to London about a machine claimed to provide 'horse exercise' in the bedroom:

> I forward a copy of a machine in vogue in London. Will you kindly send me the export price, and tell me how the machine could be used by one of your experienced horsemen, and say if it resembles the action of the horse. Tell me the motive power. Does it make much noise in action? I want one if suitable and useful for my room.

[8] AF to JR Bowering, 10 February 1896.

> Kindly look at machine and afford me what information you can—if you think the machine gives a fair substitute for horse exercise, and if it is all it proclaims itself to be, and if the price is not large—say under £20, then I will thank you to send me one out by steamer.[9]

Judging from the illustration, the horse machine was the Victorian equivalent of an exercise bike, and as unexciting. If Felton did take 'horse exercise' in his rooms, he no doubt needed more frequently his usual method of cleaning himself, with wet towels. He had an aversion to baths.[10]

Felton remained continually curious about health. 'Do you know anything about Diet?', he asked JR Bowering, of Broken Hill:

> I have known some neuralgic patients cured by taking as much grilled fat bacon as they could digest. But who knows about Diet, or who cares when in health. But this is the key to the fair domain of health. When shut out we begin our search for the key.

'TRAVELLING', THE FOURTH item on Felton's agenda, remained one of the favourite pastimes of his last years. The shortest journeys he took were on the *Ozone* or the *Hygeia*, the two paddle steamers which plied from port to tiny port around Port Phillip. No one was more familiar with the excursion paddlers than Mr Felton, Dickson Gregory remarked. 'During the seasons, for many years, he travelled each Saturday afternoon for "a trip on the briny", and was to be seen talking to the same circle of old acquaintances on the promenade decks.'

This was a gossipy pastime, in the company of a few cronies, watching the general public at play. 'I had another good run down in the *Ozone* on Saturday', he once reported to Grimwade:

> There was a good joke on. It was said that [Hatson's] Scott lunching friends had played a hoax on him. That a letter had been sent that in consequence of his great services, frozen mutton, etc. Her Majesty would confer a Knighthood etc. Would he accept? Answer came. If Her Majesty deemed him worthy etc. etc. Now can't vouch for all this being gospel truth—only it looks like it, and there was much merriment over the [Hatson] vanity. Probably I shall get another chapter next Saturday.[11]

[9] AF to GR&Co., 19 April 1895.

[10] Alfred Leopold Felton was again the informant on the aversion to baths; cleaning with wet towels, claimed to enliven the skin and stimulate capillaries, was common in hospitals. There was no exercise machine among the effects sold after Felton's death.

[11] AF to FSG, 13 February 1895. A group of Melbourne men lunched regularly at Scott's Hotel, where 'public affairs were sifted with close criticism and constructive argument' (entry by Roger C Thompson on RJ Alcock, *ADB*, vol. 7, where G Swinburne, Sir William McBeath and Sir William McPherson are mentioned as regulars, with Alcock). Sutherland also refers to the group, in *Victoria and its Metropolis*.

HORSE EXERCISE AT HOME

Horse-Action Saddle.

HIGHLY APPROVED OF BY
H.I.H. THE EMPEROR OF AUSTRIA.

PERSONALLY ORDERED BY
H.R.H. the PRINCESS of WALES.

ADOPTED BY
SIR HENRY THOMPSON,
AND PRODUCED BY
DR. GEORGE FLEMING, C.B.,
Late President of the Royal College of Veterinary Surgeons, and Principal Veterinary Surgeon to the British Army,
to be a most efficient substitute for the live horse.

EXERCISE ON THIS SADDLE
QUICKENS THE **CIRCULATION,**
STIMULATES THE **LIVER,**
AIDS DIGESTION,
CURES GOUT & RHEUMATISM,
AND
SAFELY REDUCES OBESITY.

Special Side Saddles for LADIES.

THE LANCET says: "The expense and difficulty of riding on a live horse are avoided."
The *Sporting Times* says: "Ten minutes' gallop before breakfast will give the rider a Wiltshire labourer's appetite."

Horse Exercise

Although he made no further visits to Europe after 1890, 'Mr Felton was extremely fond of taking short coastal trips', Dickson Gregory wrote. 'Occasionally he was to be seen on the mail steamers bound for Sydney or Adelaide.'[12] Felton made some fifteen trips to Sydney between 1891 and 1901,

[12] The service was not always good. Dickson Gregory reported that once, when travelling on a P & O liner to Adelaide in rough weather, Felton stayed up late talking in the smoking room. 'When he entered his cabin he found one of the pipes leaking and the water had penetrated the floors and saturated the bedding.' He rang for the steward, who moved him to the adjoining cabin. In the morning he mentioned it to the purser. '"Who told you to occupy that cabin, Sir,?" said the purser. "No one has any right to change the cabin without my authority". He became rather insulting . . . When narrating the incident to some friends, [Felton] said, "Had I been on a foreign line I would have had the captain, purser, chief steward and others all expressing their regret that I had been subjected to such inconvenience"' (Dickson Gregory to WRG, 30 April 1934, Russell Grimwade papers).

The Sorrento Boat and En route to Sorrento (*The Picturesque Atlas of Australasia*, vol. 1, 1886)

either by rail or ship, staying habitually at the Australia Hotel, and regularly visiting one of his closest friends, the Scottish-trained physician and liberal politician Sir James Graham. Graham was some twenty-five years Felton's junior, and it is not known how they met, but 'whenever Mr Felton visited Sydney he was always a welcome visitor to the Grahams, and when Sir James and Lady Graham were in Melbourne a small dinner party was generally arranged at St Kilda'.[13] In the same period Felton visited Adelaide twice (once telegraphing to Burns Cuming that he was about to board the Express and wished to visit the Adelaide Hills), and made two trips, one extended, to New Zealand, where he further indulged his taste for 'scenic photos'. After a trip to the New Zealand Sounds, he ordered a considerable number of 'views' from New Zealand photographers, sending them to England to relatives and friends.[14]

Felton also went to Murray Downs once or twice in most years. In *Flinders Lane* Russell Grimwade told of accompanying him in April 1898, when 'the younger members of the party spent some days riding and camping in the more distant paddocks of the vast property', a visit also recorded in Russell's first photograph albums, where waistcoated men in shirtsleeves are depicted camped

[13] Dickson Gregory to WRG, 30 April 1934 (Russell Grimwade papers). On Sir James Graham, see Margaret Caldwell's entry in *ADB*, vol. 4.

[14] AF to Burns Cuming, 9 October 1895; Dickson Gregory to WRG, 30 April 1934 (Russell Grimwade papers).

Felton (under umbrella) picnicking at Murray Downs, with a Campbell daughter, Baracchi and others (Russell Grimwade, photographer, University of Melbourne Archives)

under box trees, the waggonette beside them. Identifiable at a lunch in the sun are a Campbell daughter, Pietro Baracchi, Edward Keep and—white beard the only feature discernible under a large black umbrella—Alfred Felton himself. In 1895 he ventured further north, to Broken Hill and to Wilcannia. At home he continued to make country excursions, to Coolart, where Russell photographed him again, once with Baracchi and once with Keep, and to the the popular Dandenongs (rather than fashionable Mount Macedon).[15] At Flemington on race days he could enjoy the transformation of the course, with new stands and a rose garden,

[15] The Murray Downs visit is described in *Flinders Lane*, ch. 7; Helen Ogilvie's wood engraving on p. 58 depicts Felton and umbrella. At Coolart, shooting was a favourite pastime, but it is unlikely that Felton took part. Or FS Grimwade: in 1868 he had accidentally shot one William Grossard, a sea-captain, while both were visiting a station on Phillip Island. The captain lived long enough to forgive him, to say that 'he did not know Grimwade was such a muff with a gun, or he would never have trusted him with it' and to ask to be buried a chain from the shore (Notes of the inquest on William Phillip Grossard, December 1868, provided by Sir Andrew Grimwade). Russell's photograph albums are in the University of Melbourne Archives.

Felton at Coolart, 1898, with Pietro Baracchi, and with Edward Keep (Russell Grimwade, photographer, University of Melbourne Archives)

achieved by none other than the ingenious Henry Byron Moore, the Victorian Racing Club's Secretary from 1882 until his death in 1925. Only in the last year of Felton's life was his fondness for being out and about frustrated by incapacity.

FELTON LIKED TO show off his collections of 'desirable things', writing to a Sydney friend in 1895 that the new pictures would ('I think') please him, when he came over. 'I have had an occupation which filled up my leisure time for some weeks, viz., fitting up a couple of large rooms at the Esplanade, but now Othello's occupation is gone! for the rooms are both full and complete.'[16] Full they were, but never complete: a special Chattels Account in Felton's private ledger recorded that in the 1890s he spent some £3396 on the third item in his agenda,

[16] AF to Dr Phillips, 18 December 1895.

'art works' (including jewellery and many pictures, ivories and other *objets d'art*), a surprising amount of furniture, and a great many books. He had advisers: WR Stevens, 'his picture buyer' and 'Keith, his book buyer', referred to in *Flinders Lane*, were paid commission, but not of course Dickson Gregory, sent around to Kozminsky's by Felton to see if any new ivories had arrived for inspection.[17]

Few items are identified in the accounts, and details are sparse: the books included 'complete edition of Balzac [still thought risqué] £1 13s 3d', but also 'Pearson's books'—unspecified—and '88 books £1 14s 5d'; picture purchases included (in 1900) 'Pictures by Cattermole', 'bought from Mrs Cushing for £50' and 'three pictures and commission £25 4s 0d', and in 1901, 'an oil painting by Peter Graham £400', 'four pictures £231 3s 0d', 'three pictures £99 10s 0d', and 'Pictures, Gemmell Tuckett, £125'. The pictures accepted from Dr Thomas Rowan in partial payment of a debt in 1901 were entered at £1500. Small items included 'carved shells £1 16s 0d'; 'carved ivories £38; ivories, ancient pieces £5 10s 0d'. In December 1903, shortly before Felton's death, Stevens bought for him, from the auction house Gemmell Tuckett & Company, 'twenty-seven pictures £636 15s 0d'. Daryl Lindsay dubbed this 'a rather strange transaction for one who in his day was regarded as a connoisseur', unaware that the purchases, from the sale of the late William Lynch's collection, included Bonington's exquisite *Low Tide at Boulogne* and other pictures of high quality.

According to Dickson Gregory, Felton especially treasured 'a large painting attributed to Peter Paul Rubens, and another large oil painting *Mountain Mists* by Peter Graham which he adored'. Both pictures loom large in the photograph album compiled by NJ Caire, as do Beavis' *Charcoal Burners*, Hayes' *Off the Mumbles Lighthouse, Swansea* and the copy of Murillo's *Flight into Egypt*, all displayed on free-standing easels. Since the Graham was not acquired until December 1901, it seems likely that the payment of £20 to Caire recorded on 15 May 1902 indicates the commission to record the collection. Not that Felton stopped buying; the purchases from the Lynch collection were still to come. We do not know where Felton thought he could put them, though he did cull the collection in 1903, sending some pictures to Steven's gallery for sale. Not all were sold, as Dickson Gregory later recounted when claiming ownership of John Faulkiner's water-colour, *Entrance to Arklan Harbour, County Wicklow*:

> Mr Felton went to Mr Stevens and picked out several pictures to be sent to the Australian Church bazaar, and told Mr Stevens to send the picture by Faulkiner to St Kilda as he was giving it away as a present. This was in September. When he had

[17] *Flinders Lane*, p. 66.

the picture back at St Kilda, Mr Felton said to me 'How do you like your picture?' I said I liked it very much, but the frame spoilt it. 'Would you like another frame on it?' I said it would be better, and Mr Felton said he would send it to Bernard's and I was to have whatever frame I liked for it.

The water-colour, reframed, was back at the hotel when Felton died; his trustees 'consented to Mr Gregory having this picture'.[18]

'There is enough time to read all the books worth reading, if you can only get the <u>mind</u> for it', Felton had copied from Benjamin Jowett. An ardent user of lending libraries, he read even more books than he bought.

> Each day when he came to the office he travelled to the city on the St Kilda tram and had a black hand bag which had the name 'Alfred Felton' stamped in gold letters This bag had been in his possession for several years, and it had carried hundreds of library books to and fro. He would get the list of new books from the dailies and mark which he wanted, some of which were in great demand, and he was very keen in obtaining them as soon as they were landed … in addition to being a subscriber to Mullen's Library and the Athenaeum Library he had books from the Public Lending Library.[19]

Felton's taste in reading was broad. He 'waited some time' for *Elizabeth in Her German Garden*, the immensely popular first novel published anonymously in 1898 by the Sydney-born Pomeranian Countess Elizabeth von Arnim, 'one of the three finest wits of her day'.[20] His copy of Dante, Sir Clive Fitts remarked, was 'festooned with bookmarks'; and the quotations which he selected to be transcribed into his neat, tiny notebooks included long excerpts from Jowett and lengthy notes on the life of Joseph Priestley—not an author then in fashion—all evidence of his continuing appetite for intellectual and moral self-improvement. He was also 'very keen on the biographies of famous men'.

Felton was also one of the first addicts of recorded music, spending large sums on gramophone records. 'When you come over I shall have much pleasure in exhibiting to you the phonograph. I am sure you will enjoy it', he wrote to a Sydney friend in December 1895.[21] He had purchased his 'Edison Phonograph, concert size' the previous February, directly from the Ohio Phonograph Company, for £42 13s 2d; it was a marvel, which Russell Grimwade twice

[18] Receipt and statement in Trustee company's papers, to which is attached one page torn from 'Sands and McDougall's time table of September', on which Felton noted 'Gregory 2 presents 3 Australian church Bazaar. (He had also given Gregory a small bronze.)

[19] Dickson Gregory to WRG, 30 April 1934 (Russell Grimwade papers).

[20] The judgement was Alice Meynell's.

[21] AF to Dr Phillips, 18 December 1895.

Felton's phonograph, wood engraving by Helen Ogilvie for Russell Grimwade's *Flinders Lane*, 1947

described. 'The audience was limited, as the instrument had no horn—a pair of rubber tubes having to pass to each pair of ears', a system of sound transmission rediscovered on modern aircraft, though in less octopus-like form; Felton thought reproduction through the more common horn sadly lacking in fidelity. The last chapter of *Flinders Lane* describes an imaginary episode when Jessie Grimwade and her daughters, visiting the old man's room one evening, sit crowded around the table in enforced propinquity, rubber listening tubes jammed in ears, attached to a sound box which wrenched from the frail wax cylinders fierce scratchings and a distant echo of *La Bohème*. Felton stood by, continually adjusting the mechanism with a screwdriver. He valued his machine so much he would not lend it, not even to Charles Strong for a function in aid of the Australian Church, promising to provide fruit for supper instead.[22]

[22] 'I regret I cannot let out of my keeping the Phonograph I have ... If you take refreshments at your feast, I shall be very happy to send you some fruit. If acceptable see me on Monday to arrange what will be suitable as to quantity' (AF to Strong, 16 August 1895). Felton bought records every year; the largest order, in 1898, was for £58 8s 7d worth. In 1900 he bought his first Columbia Phono Co records. The Sale Catalogue after his death listed among 'Electrical and Scientific Appliances' the 'Magnificent Original Edison Phonograph, concert size, with recorder, reproducer, recording tubes, ear tubes, 2 bettini's micro-reproducers, 2 trumpets, etc.' and '14 boxes containing Records for same'; what they fetched is not known.

In 1900 Felton gave to the newly established Geelong Gallery two canvases, von Guérard's *The Weatherboard Falls* and *Watt's River* by Charles Rolando, 'an immigrant artist of mediocre ability' (in Vaughan's judgement) 'who somehow convinced Melbourne patrons that he represented a sophisticated tradition of landscape painting'.[23] Felton had earlier given Bunny's *Sea Idyll* to the National Gallery, but gave it no more in his lifetime, although, like other great institutions Victoria had built since the 1850s, it suffered greatly with the end of the boom. Almost everything halted, including the building programme (fortunately substantially complete), and the expansion of the collections. The crash caught the Gallery, and its Art School, in a state of transition; in 1891 George Folingsby died, and the Trustees searched the world for a successor as Director and Head of the School. The Acting Director, Frederick McCubbin, the genial and talented Drawing Master at the School since 1886, had much local support, and the appointment of Lindsay Bernard Hall, then aged thirty-three, an original member of the New English Art Club and a man of strong artistic and administrative opinions, was not universally welcomed. Hall was to direct the Gallery for four decades, but a few months after his arrival in 1892 the crash bought drastic retrenchments, and the official recognition of the Chief Librarian as the chief executive of the whole institution, as he already was *de facto*. Hall's appointment lapsed, and his reappointment (on a lower salary) was openly opposed by some Trustees, including David Syme, James Smith and the artist John Mather. Alexander Leeper was among the majority which supported Hall, having previously warned him privately of plots against him.[24] The students of the Gallery School benefited by having McCubbin's gentle instruction in drawing followed by Hall's rigorous training in the School of Painting, but Hall continued to have enemies, all too easily aroused to fury.[25] Several of the players in these episodes were to be important in the history of Felton's Bequests, but there is no evidence that Felton involved himself in them.

There is no record either of any contact with another man later to be important to the Bequest, Walter Baldwin Spencer, who had arrived in Melbourne in 1887 to be Foundation Professor of Biology at the University, and became a trustee of the Public Library, National Gallery and National Museums in 1895. In

[23] Gerard Vaughan, *Art Collectors in Colonial Victoria*, p. 22; Shears, *A Guide to the Geelong Art Gallery and its Collections*, p. 5, and Hoff, *The Felton Bequest*, p. 5.

[24] Cox, *The National Gallery*, p. 52; Leeper Diary (Trinity College Library), 14 June, 31 May 1894: 'I spoke for Bernard Hall'.

[25] On the National Gallery School at this time, see also Fullerton, *Hugh Ramsay*, ch. 2.

the 1890s his primary involvement was with the Museums, as Leeper's was with the Library. Neither they, nor any one else, yet associated Felton with the institutions clustered at the upper end of Swanston Street.

AFTER ONE OF HIS paddle-steamer trips down the Bay, Felton's report to his partner struck a gloomy note. 'Greenlaw is dead, he wrote. A fortnight since I met him on the *Ozone*, and addressed him as the Commodore of the Fleet, and the poor old fellow enjoyed the joke, for he is proud of his steamers. He knew every bolt in them he said'. Felton's reports of the deaths of other contemporaries had become more laconic: 'Ievers, Wm, Councillor, MLA, Chairman Banking Commission, Commissioner Melbourne and Metropolitan Board of Works etc. died yesterday. You knew him. I did not. Cutting enclosed'.[26]

'Like most people Mr Felton had hobbies', Dickson Gregory noted, 'one of which was to collect the press Obituary Notices of people he had known'. They were neatly put away, like the brown paper and string.[27]

[26] AF to FSG, 20 February 1896.

[27] 'One of the last obituary notices he cut out of his morning paper was one referring to the death of Mr Bruce, father of the Right Hon Stanley M. Bruce, whom he had known for many years.'

12

TOWARDS A SOLITUDE

'Perhaps', Felton had written of the bereavements suffered by his friend Burstall, now absent in England, 'the last stages will be a solitude'.[1] To some, the life of Alfred Felton himself in his last years seemed solitary and pathetic. When Alexander Leeper, widowed in 1893, encountered Felton in the street in 1896 he recorded his fear that his own future might also be that of a lonely old man living in a hotel.[2] But Leeper, at that time struggling to overcome scruples concerning a second marriage, was an uxorious man who thought being unmarried a state of singular deprivation, while Felton never showed regret over his single state. He seems to have weathered the depredations of age—loss of friends, and of physical strength—with fair equanimity. 'The years increase', he wrote to his friend Dr Phillips, 'and if one has anything amiss whereon to brood and be disconsolate and chagrined, it is generally that kind of disorder of which the physician in Macbeth observes—"In this the patient must administer to himself"'. He repeated the aphorism to Kempthorne, after remarking that 'As to myself, I am fairly well, though not exactly satisfied. I have, I suppose, as much content as I deserve. I generally notice our worst troubles are of our own manufacture'.[3] In his little notebook he copied down Benjamin Jowett's thought on 'Depression': 'Sometimes one feels fit for anything and then again as if anyone could knock you down—as the Irishman says—with a poker'.

Felton no doubt continued to receive the 'religious aliment' provided by Charles Strong's sermons, and by the services and intellectual and musical

[1] AF to FSG, 10 July 1885. Felton kept some letters he received from his family in his last years, but there are none from Burstall among his papers.

[2] Leeper Diary, 27 October 1896.

[3] AF to Phillips, 18 December 1895; AF to TWK, n.d.

programmes of the Australian Church. In April 1898 he could (for example) have attended a Sunday afternoon recital by the Church's distinguished organist WE Nott, playing, on the large Fincham organ, a programme beginning with Bach's D Minor *Toccata and Fugue* and concluding with a Widor *Symphony*. The afternoon was not over: the Hon. Alfred Deakin then spoke on 'The Ethics of Federation', and proceedings concluded with everyone singing 'God bless our native land' to the tune of the National Anthem. (Strong was to be attacked during World War I for not permitting 'God Save the King' to be sung in the church.)[4]

How much personal comfort Felton received through his relationship with Strong is questioned in an extraordinary document written in 1898 by thirty-year-old Herbert Brookes, who had married Strong's eldest daughter 'Jennie' (baptised Jessie) the previous October. Brookes had joined the Church in 1890, and soon became intimate with the Strong family. After his marriage to Jennie—described by his biographer as 'a remarkably beautiful woman, of strong character and convictions like her father'—he began to write, in an exercise book containing two of Strong's sermons, an essay on the character of the head of his new family.[5] The opening, written at Christmas 1897, was adulatory towards the 'divine doctor, as Alfred Deakin described him to me when speaking of him one day':

> he is most truly divine when he mounts that pulpit which he has hallowed by ten years preaching... Listen to him when he prays. Is this not his peculiar genius? I like one of his prayers better even than the Lord's Prayer... What a mouthpiece he is to the highest aspirations of his congregation!

The settlement of the Church's debts in 1897 had 'lifted a great weight off the shoulders of the doctor and one can see that change'. But Brookes believed that the Church was failing; 'people thought Mrs Strong the reason so many supporters "fell away"; 'I am becoming convinced it is the Doctor himself'. 'An evil genius accompanies the Doctor and as far as I can learn has accompanied him throughout his life'. There had been too many battles.[6] 'Let it be admitted there are flaws and then dismiss this aspect. It would be hard to maintain that he was

[4] The Strong papers include a collection of programmes and orders of service. The organ is now incongruously rebuilt in—or rather outside—Melbourne University's modernist Wilson Hall.

[5] The book, labelled 'Sermons', in the Strong papers, was overlooked by Badger, who does not mention Brookes, or even Jennie. The description of Jennie is Rohan Rivett's, in *Australian Citizen*, p. 26.

[6] Though Brookes still thought that these were mere 'spots on the sun': 'the battle for his own several opinions... eg his faith in the spirit behind so-called socialism... his battle with his Assistant...' One event especially rankled: Strong had 'closed down' on a helper Brookes thought 'honest, manly upright. Imagine it! How can he act so cowardly, so unsympathetically, so unjustly, so callously?'

perfection... At present the weak spots of the Doctor are too close to me to be judged.' But should they remain concealed? 'Will it be to the service of our fellow countrymen for anyone to speak out—Oh Yes!... At present I am silent.'

The flaw in Strong's character, Brookes believed, was evident in his home, 'so miserable and gloomy to enter': 'all love seems to have vanished from the household'. 'Of course this may be a Scotch trait. If it is I loathe it. I have my doubts. To my mind it is a trait of vanished love'.

Enter Alfred Felton, as an example of Dr Strong's insensitivity:

> Charlie [Jennie's brother, Charles Strong] told me that Mr Alfred Felton walked up home with the Doctor from Windsor station last Sunday morning and that the Doctor had said (with a smile I suppose) that all that Mr Felton wanted to tell him was that the manager of the bottle works had absconded with £5000. Now Mr Felton is a well-read man and has by his munificent donations kept the Australian Church alive for several years now. Even if it be looked upon from the light of humour—I consider the remark of the Doctor's a remark that didn't fall from the mind of a religious genius anyhow—to say nothing of an open kindly and generous mind. He at least shouldn't make light before his family of the man to whom he has owed his pulpit for many years.

It seems likely that 'absconded' was an exaggeration on Charlie's part, or Strong's, or (less likely) Felton's. After LL Mount gave way to William McNeilage as manager of the Bottle Works in March 1898, an amended balance sheet in Felton's private ledger indicates that Felton and Grimwade wrote down their capital in the firm (to £20 997 each) to cover a deficit of £5218 in Mount's account, but there is no indication that dishonesty was involved. Felton made a gift of £50 to Mrs Mount, then in New Zealand, in 1899; and Russell Grimwade's recollection of Mount as 'a Canadian of great athletic prowess, possessing an optimism and charm surpassing his commercial aptitude' suggests that Felton's concern might have arisen from a discovery that the Company was not in quite such good shape as he assumed it to be.[7] And although Strong was perhaps insufficiently sympathetic to Felton's concerns, Brookes' criticism seems extreme, as does his reaction

[7] Grimwade, *Flinders Lane*, p. 32 In the 1930s Elliston told Russell that Mount was living in retirement in London, 'hale and hearty' at the age of 94, with no suggestion of wrongdoing (Russell Grimwade papers). Felton's private ledger for the Company is in the LaTrobe Library. Mount's account had a credit balance until about 1890; in 1898 the proceeds of the disposal of a house were used to reduce the deficit.

[8] Strong could by now do no right in his son-in-law's eyes—except deliver another great sermon, on 'Religion and Literature' 'great Heavens! How am I to solve the problem?' Why were family members so cold to one another? 'Can it be that the Doctor has suppressed this individual love as a sign of weakness and transformed it into a vague and generalised affection for humanity as a whole and in the abstract?' Perhaps; but also (it emerged) perhaps not; one 'Mrs Lang of Ivanhoe' gave Brookes a clue, announcing firmly that 'want of affection towards each other and the children' was part of the Scots character. 'I must go into this further. It will bear it.' There the document ends, but

Felton with (Edward) William Grimwade in the garden at 'Harleston', photographed by E Norton Grimwade, Christmas Day 1902 (ANZ Trustees)

when he then re-read his adulatory opening pages he had written at Christmas: 'what a disillusionment since then!; the ideal is shattered'.[8]

Felton did not share Brookes' disillusion with 'the Doctor'. His admiration, though perhaps too measured to justify Miss Creswick's term 'infatuation', continued, and a few months later, writing his will, he included a personal legacy of

not Brookes' agony. He took his wife to live at the mine he was managing at Creswick. There, in April 1899, 'his bride sickened suddenly, and despite desperate attempts by the doctors, she died', aged twenty-six. For three years Brookes was 'a man bereft', until Alfred Deakin became his father figure, and in 1905 his second father-in-law. The quotation is from Rivett, *Australian Citizen*, pp. 26–7. John Rickard (*A Family Romance*, p. 97) describes Brookes calling on Deakin in 1899 with 'soul paralysis'. The earnest Herbert Brookes never fitted easily in his own family.

£1000 for Strong, a timely windfall enabling the impecunious minister to buy the family a house. Its atmosphere, no doubt, remained Scottish.

IN HIS LATER years Felton's distant family was much in his mind. Russell Grimwade, drawing some questionable conclusions from Felton's will, claimed that 'he had more sympathy towards worthy friends than to what he considered unworthy relatives', but to his eldest brother William he was close and fond, and to most of the rest dutiful if not warm.[9] He wrote frequently to some, though very few of his letters have survived. While in England in 1889 he must have made himself familiar with the circumstances of various family members, and from 1891 he advanced some £600 a year for William to distribute among them, with additional sums from time to time. Felton's ledger shows remittances from Melbourne totalling £7531 between 1894 and William's death in 1900; William himself was a major recipient, receiving £30 a month (later £50) to help support his wife Fanny and two children, Freda, and 'Squire' (Alfred Leopold), living with him at Haywards Heath. William's meticulous accounting of 'Expenditure on family' included annual birthday presents for the children, and in 1897 a 'bicycle for Squire', costing £7 10s. (Bicycling was a craze in the 1890s; Felton, presumably too old and lame to learn to ride one—unlike Leeper, who did—had given a godson a 'machine' in 1896, replacing his pony.)[10]

Other members of the family receiving regular payments from Alfred through William included their brothers Edmund and Thomas Felton (each £20 a month), and three of Thomas's four daughters: Annie (Borrill) received £13 a month, with occasional extra payments for 'children's clothing' or 'winter comforts'; Ellen's husband George Edkins received £25 twice a year; and young Lucy £2 a month. Alfred selected Thomas's son William for special support, in 1892 paying £930 to buy him a pharmacy business in London.[11] In 1895 young Will reported to Felton: 'All well; mother, father, Lucy, Nell and her family, Annie and

[9] Russell Grimwade, 'Some memories of Alfred Felton'.

[10] 'I hope it will prove a trusty and useful companion on which you may pedal for many a year, to school, to college or to business.' The Bicycle Company, Singers, guaranteed against defects: 'Of course if you should try to run down a tram, Singers may object to repair it then' (Felton to Harry Hamilton (Creswick's grandson), 6 August 1896, letter courtesy of Dr NT Hamilton).

[11] In July 1891 Alfred paid an account, originally sent to brother William, of £221 for a monument with a marble cross in Exeter cemetery, and in October £1 10s for a 'photograph of Sister's grave; it was probably Eliza's. Thomas' daughter Maud had been recorded as living in Exeter in 1881, perhaps with her aunt. Alfred also sent, directly and not through William, annually from 1894, for reasons unknown, £50 each to Miss Emma Sharp and Mrs Rachel Rowe living at Brockley in 1900 and at Lewisham according to Felton's will. Rachel died in 1911 and Emma in 1919, both in London.

Mr Felton in London, 1889?
(Dr NT Hamilton)

hers, my wife and I . . . I saw Uncle Ted and Aunt Polly at Redhill'; Polly was poorly. Again nothing is heard of brother George, or of Alfred's sisters.

'What a slippery thing money is!', old William wrote to Alfred in September 1894, taking him at his word 'not to stand on ceremony about remittances', and asking for more. He was not grumbling:

> The rain is pouring down, the East wind freshening and a general state of discomfort outside; it is pleasant . . . to look at the comforts of a wind- and weather-tight habitation and if you have not your pockets full of money and your cellar full of Beer you have a sufficiency of the first to get along while the second is not needed . . .[12]

He wrote on expansively, if not cheerfully. He had read Alfred's letter about 'the poor lad drowning'—presumably Campbell's son, at Murray Downs—and capped it with accounts of other drownings, and of a tornado in America. The future was a sword of Damocles; 'we can hope the hair will prove strong and not give way for some time'.

[12] William Felton to AF, 7 September 1894 (Trustee company papers).

Alfred had sent him some Melbourne journals:

> I certainly can't think your portraiture in the paper 'High Art'. They are not the clever exaggerations of 'Punch'. Still I suppose they catch on something . . . I send you a cutting of a new play, it will come to you in due course as the *Gaiety Girls* is doing. You are a veritable Gold mine to these people. You are about the most Horse-Racing and Play-going people extant it proves you don't take life very seriously. You are getting more sunshine in Nature and in man and are losing the sour puritanism of your fore-fathers, but are you getting anything better?

The question was left hanging. 'I trust you are keeping well my dearest boy and all things going more smoothly, your affectionate brother, William'.

He wrote again in March 1895, with gratitude, a suggestion, and a report.

> I enclose statement of family expenditure (a big item) . . . you have been most prodigal . . . While on this head I would just say if I should join the majority (or rather when) Fanny is quite competent to continue to distribute your generous (more than that) remittances and would feel honoured by your confidence . . . I think Will is in fair road to a competence and success. You drove a nail in a sure place in his case.[13]

Six months later young Will himself wrote, from Balls Pond Road, London, enclosing the accounts of his business. He had made a profit of £1271 in twelve months, though not easily: 'It is slow work, competition in London being very keen, but I mean to have a good try'. Moreover it was very cramped living over the business; he thought he might buy 'a small comfortable private house near, and use these premises entirely for business', especially as 'we are expecting a little stranger in January'. But he would not act without the advice of uncles Alfred and William; 'do you think we are justified in moving? Your affectionate nephew, William'.[14]

We do not know Uncle Alfred's response, but young William did not move from Balls Pond Road; his son was born there, and later his granddaughter, who continued to manage the business until 1994.[15] Perhaps he was deterred by other family problems, soon disclosed to Alfred in a bundle of letters sent by brother William, who had just arranged for Annie Borrill's son to attend 'a good modern commercial boarding school' for two years, at great-uncle Alfred's expense. ('You will be agreeing "Happy the man who has no relatives"'.)[16] The next day he had received a plea from young Will for money towards an operation for his sister Lucy,

[13] William Felton to AF, 8 March 1895 (Trustee company papers).

[14] William Felton Jnr to AF, 13 September 1895 (Trustee company papers). The accounts were prepared by brother-in-law George Edkins, an accountant.

[15] Communication from Anne Felton Gerber, 2002.

[16] William Felton to AF, 4 October 1895 (Trustee company papers).

who had been ill and in pain for some time: Will was afraid he might have to sell his business if forced to meet the whole sum. In response William sent £20 of his own, and a stern letter warning the family not to impose on the generosity of their rich uncle Alfred. He 'could not in conscience' call on Alfred for more money, since the depression in Victoria had caused him so much anxiety and loss. Moreover

> by this constant 'pecking' at him he will think (and naturally so) his only value to us lies in the amount we can get out of him—the milch cow in fact to be drawn on at any and all times. His benefactions are so munificent and given in such an ungrudging spirit that I feel a great delicacy in further encroaching on them.[17]

A sermon on family duty followed: 'seeing the very liberal allowance your uncle makes to your father I think some provision should be made against contingencies" such as Lucy's illness and 'Annie's trouble' (unspecified, but it involved 'getting her going again'). Young Will was chastened: 'I certainly laid myself open to the charge of ingratitude'; but 'regarding my Parents, duty to them of course forbids my saying anything against them'. Uncle William hastened to reassure him: 'the bond of family love and affection . . . is a beautiful trait with you', and he was delighted that Will was 'building up a little fortune' and hoped to take over 'a larger and more profitable concern . . . I think [your uncle] will be willing to supplement your savings for you to do so'. To Alfred, William was frank in his criticism of their brother Thomas: he could sense 'as if I heard them "Get it from your Uncle Alfred, we may as well have the money as anyone else" . . . I know this Thomas Felton so well. I know I have not the charity you possess'. Alfred's reply has not survived; he tucked the correspondence away in an envelope labelled 'William Felton and the Batsford people', but his payments to brother Thomas continued.[18]

Lucy recovered, and went to convalesce with her sister Ellen Edkins, eleven years her elder, in London. A few years later Ellen herself died, leaving George Edkins with five young children; he proceeded to marry Lucy, but had to hold the ceremony in the Channel Islands (incidentally his birthplace) to evade the English laws which made marriage to a deceased wife's sister illegal. Thereafter both George and Lucy received regular payments from 'Uncle Alfred'.[19]

Meanwhile Alfred's generosity to brother William increased: in February 1898 he spent £1450 buying a home for the family, 'Ravenscroft', also in Haywards

[17] William Felton Snr to Jnr, 25 September 1895, enclosed with William Felton to AF, 4 October 1895 (Trustee company papers).

[18] William Felton Jnr to William Snr, 21 and 27 September 1895 (Trustee company papers).

[19] George Edkins received £25 six-monthly from 1891 until Alfred Felton's death. Lucy's £2 a month, regular since 1891, was increased to £13 appproximately three-monthly from early in 1900; she is identified as Lucy Edkins in Felton's will, dated August 1900.

William Felton (Alfred's brother) on his death-bed, 1900 (ANZ Trustees)

Heath. There William Felton died, aged seventy-five, early in 1900. According to Dickson Gregory, Alfred 'took the news to heart'; he kept two photographs of his eldest brother, bed-ridden and near death, prints now so faded that the broad brow and even broader bushy white beard are barely discernible.

Alfred remained on close terms with William's widow Fanny, his concern reflected in a surviving bundle of letters she wrote to him weekly between June and September 1903. Fanny, on her side, was also considerate:

> I hope all your papering and cleaning generally is over and that you are able to sit in your easy chair and thoroughly enjoy looking at all your surroundings in beautiful order . . . I know you can never exist where dust and microbes are. Your affectionate sister Fanny.[20]

Life at Haywards Heath was comfortable, thanks to Uncle Alfred. Fanny, 'Squire' and Freda took a summer holiday in Brittany, and 'Ravenscroft' had a tennis court, popular with Freda and her friends. Uncle generously bought her, and

[20] Fanny Felton to AF, 5 June 1903 (Trustee company papers).

brother Squire, expensive new bicycles, with 'all improvements'' he seems to have accepted Squire's failure in his Oxford examinations on Fanny's assurance that failure was usual and that Squire would sit again in October. Uncle Alfred wrote directly to both children, sending Freda an album; 'the photos you sent Freda this mail are most pleasing', Fanny wrote, 'you are looking so bright and happy'. 'How I wish I could sometimes have a talk with Uncle', Freda was said to have said. Felton, however, found Squire's letters too childish, and (according to Dickson Gregory) wrote to tell him 'to give up the kisses'.[21] When Felton complained of the weather, and wrote that he was 'not up to much', Fanny reminded him that that was 'one of dear Willie's expressions'. She responded sympathetically to Alfred in reflective mood: 'I quite agree with you the conflicts from within are harder to fight against than those from without, but we must get along as bravely as we can'. Had he enjoyed the Campbell girl's wedding? 'I know you do not care for great functions in general.' She had seen FS Grimwade in England the previous October: 'he was looking so white and ill, and I feared there was great grief in store for you'. 'We of Ravenscroft are a very happy and contented party', she wrote, acknowledging the 'usual' cheque for £300; 'it is more than good of you to be so kind to us'. In October she sent a 'leaf' from her housekeeper showing their detailed expenditure over six months, including 'education £139 16s 9d', presumably the lucky Squire's Oxford expenses. Felton's account book shows that he sent £3597 to Haywards Heath between William's death and his own. The sole surviving page from Felton's pocket diary includes some quick Haywards Heath calculations in September 1903, concluding 'Say 1200 a year. Is this expenditure satisfactory? Why worry about Squire?'

One of Fanny's letters shows that a Felton family rift, which had long grieved Alfred, was belatedly healed. Brother James (born in 1827), a leather merchant in Grahamstown, South Africa, had (according to *Flinders Lane*) 'married a stranger in religion'—presumably a Roman Catholic—and in consequence Felton refused to countenance a suggestion from James that he migrate to Australia.[22] (He nevertheless sent James £600 in December 1897—with another £100 for his

[21] Russell used Gregory's note as the basis for his 'imagined' letter from Felton to Squire (whom he seems to assume is Thomas' son, not William's), *Flinders Lane*, pp. 59–61.

[22] *Flinders Lane*, p. 10. Dickson Gregory told Russell Grimwade that Felton 'disliked' Roman Catholics; such an attitude was usual among Dissenters in his age and generation, but no anti-Catholic remarks survive in his correspondence, and he made donations to Roman Catholic charities, and does not seem, like many of his colleagues, to have become a Freemason. Dickson Gregory also suggested that Felton wished to keep his family at arms length, preventing 'Hannah' [Fanny?] from emigrating after William's death by threatening to cut off her allowance if she did; and by ceasing all communication with one brother in New Zealand (but none is known to have settled there, unless it be the elusive George).

'Wealth!! Get it spent' (a page from Felton's diary, 1903) (ANZ Trustees)

son, another William Felton—and payments of £39 every few months thereafter, as part of his general programme of aid to family members.) By 1903 James' wife had died, and amicable fraternal relations were apparently restored. 'I cannot tell you how pleased I am that you get such happy news from South Africa', Fanny wrote, 'James is evidently getting back to his old self'. His wife had been one of the 'silly women' who are 'priest ridden', and 'seek to think the one great virtue is to make sure of saving the soul at last. May she rest in peace, for she died according to her lights—but I am quite grateful that you should be receiving pleasant letters now'.[23]

[23] Fanny Felton to AF, 26 June 1903 (Trustee company papers).

Felton enjoyed having relatives, and generously supported worthy and unworthy alike; but he did not intend to make any of them rich.

FELTON OFTEN COMPLAINED to Fanny that he felt unwell. He had cause: in 1903, in his seventy-third year, his health had begun to fail. The year began with his usual gifts to charities, more numerous than ever, followed by payments to overseas relatives and to Burstall, and to some special cases referred to him by the Charity Organisation Society. He remained an active collector all the year, buying pictures from Gemell Tuckett's, ivories from Kozminsky's, books from Beauchamp's, photos from NJ Caire, albums to put them in from Sands and McDougall and even a Chubb's iron safe. The surviving diary page from September, recording gifts to Dickson Gregory and calculating the Hayward Heath family's income, begins 'Wealth!! Get it spent'. He had electric light installed in his picture gallery, and decided to redecorate the rooms—gallery and dining room—selecting 'a rich crimson paper' which he thought suitable for showing off the gilt frames of his pictures. The work was completed, but by then 'Mr Felton was too ill to be troubled about pictures', Dickson Gregory reported, and the task of rehanging the collection was left to him: 'Mr Felton told me to have the pictures hung as I liked, and when he was well he would alter them if he wished'. It is unlikely that Felton ever saw there the twenty-seven pictures Stevens bought for him at the sale of William Lynch's collection in December 1903.[24]

Felton's final illness was brief. His ledger shows only ten guineas spent on medical attendance in the whole of 1902; a sudden payment of £52 in 'medical expenses' in November 1903, followed by wages to two nurses, indicated a crisis. Two doctors, Charles Bage, son of his dead partner and Sheppard Grimwade, by this time a surgeon in Geelong, cared for him.[25] Sheppard later described Felton's last illness to his brother Russell. The diagnosis was prostate cancer; Fred Bird, a prominent Melbourne surgeon (and fellow member of the Australian Club), operated, but what the *Argus* reported as 'a break-up of the whole system' followed. 'He was a good patient', Sheppard reported, 'but exacting and wanting instant attention; he discussed it all and wanted to know every thing . . . inclined to be impatient early in his illness, but resigned latterly'.

According to Sheppard, there were no pictures in the simply furnished bedroom in the Esplanade where Felton spent his last days; all his treasures remained

[24] Dickson Gregory to WRG, 30 April 1934, and his note to the Trustee company, 1905.

[25] To the modest expenditure in the ledger must be added bills paid after his death: £10 8s 6d each to the nurses, £40 19s to Sheppard Grimwade, £128 2s to surgeon Bird, and an extraordinary £1521 19s to Bage, whose account must have been accumulating for some years.

> Esplanade Hotel
> St Kilda
> Jan. 4th 1904
>
> Dear Mrs Mackinnon
>
> I promised to pass this picture of your brother's on to you as soon as I considered I should have to part with it. I now send it on to you with my best regards to you and Mr Mackinnon, and hope you will long have enjoyment of such a treasure.
>
> I remain,
> Yours very sincerely
> **W. Felton**

Felton's last letter, passing on Bunny's *St Cecilia* to the artist's sister

downstairs. On 4 January 1904 Felton dictated, and shakily signed, his last letter, to Mrs Donald Mackinnon:

> I promised to pass this picture of your brother's on to you as soon as I considered I should have to part with it. I now send it to you with my best regards to you and Mr Mackinnon, and hope you will long have enjoyment of such a treasure. I remain, yours sincerely, Alfred Felton[26]

Mrs Mackinnon had been Hilda Bunny until her marriage in 1891, and the 'treasure' which moved to the Mackinnon mansion at South Yarra was brother Rupert's *St Cecilia*, parted from her patron at last.

Russell Grimwade was an enthusiastic pioneer motorist. On 8 January 1904 he was summoned from his research laboratory in Felton Grimwade's factory to drive his father and Charles Campbell to St Kilda in his new vermilion-red Panhard, capable of thirteen miles an hour. A blow-out in St Kilda Road delayed them, and they arrived at the Esplanade Hotel in more traditional fashion in a hansom cab just after midday, to find that their partner had slipped from unconsciousness into death a few minutes before. Sheppard Grimwade and the faithful Dickson Gregory were with him. The leading tenor of the show *Country Girls* was practising in the room below: 'just what he would have liked', according to Elliston, but it could be that oblivion came as a relief.

The obituaries in the *Age* and *Argus* were, by the standards of the day, respectful but not fulsome. Felton had been, they implied, an identity in Melbourne's community, rather than a leader, though he had left behind him 'a reputation for business capacity and integrity, the full reward of which he reaped in the great success of the undertaking with which he was identified in this city'. The *Age* notice was both perfunctory and inaccurate, describing Felton as 'at one time a member of the firm of Cuming Smith and Company' and 'an ex-vice patron'— whatever that might be—of the Old Colonists'. But the writer in the *Argus* clearly knew Felton, rightly observing that he 'was an unostentatious man', who took 'an intelligent and keen interest in political events' but 'never actively associated himself with public life'. He was 'of a kindly disposition, and those who enjoyed the advantage of his friendship always found in his warmly genial conversation a peculiar charm'. He was also 'exceedingly charitable, but as a rule he preferred to bestow his gifts in as unassuming a way as possible'. Both papers noted his generosity to the Melbourne Hospital, and to the Old Colonists' (at whose Council meeting the day before everyone had spoken 'in equally high

[26] The letter is in the Russell Grimwade papers.

terms of the deceased gentleman'). Both papers noted that he had 'very few near relations in this state'.[27]

Felton's funeral followed at 4 p.m. on Saturday 9 January, when some fifty carriages made the short journey from the Esplanade Hotel to the St Kilda Cemetery. The procession, led by FS Grimwade, Charles Campbell, Henry Francis, James Cuming, John Watson, James Grice (President of the Old Colonists), DR McGregor and medical advisers Bage, Bird and Grimwade, was swelled by 'large numbers' of employees of Felton Grimwade's, the Melbourne Glass Bottle Works and Cuming Smith and Company. The *Age* marred its account of the funeral by attributing to Felton the paternity of Grimwade's sons. Felton would have expected no better from a 'lying man's print'.[28]

There was no church service, but the next morning the Reverend Dr Strong, who had officiated at the grave, made 'a sympathetic reference to the deceased gentleman' during the Sunday morning service at the Australian Church. Felton had been 'one of his oldest personal friends in Australia, and one of the oldest members of the Australian Church'. At the close of the service the congregation stood while the organist played 'Dead March in Saul'; the tribute was deserved, though there remained a sense in which Felton had maintained his independence even within this most independent of congregations.

Felton had attended enough funerals to have learned a realistic attitude towards death. 'We think we are not mortal, but we are!', he had written when young Harold Grimwade was very seriously ill in 1895; and a passage he had earlier written to Grimwade about the death of a mutual friend might well have applied to his own passing:

> John Benn's death will come as a surprise to you—but 74 years is a good innings. Yet so steady was his application that there was no shadow of turning there—but death comes with its arrestment. I could not go to the cemetery ... Amid the crowd of notabilities I should not be missed. A man in his grave (if he feels anything) will feel and value a genuine regard and regret that he has gone, existing in any human mind, more than rotting wreaths, or any amount of sables by the graveside.[29]

[27] *Age* and *Argus*, 9 January 1904.

[28] *Age* and *Argus*, 11 January 1904. The *Age* claimed that 'the three sons of the deceased gentleman were the chief mourners'; it also made Charles Campbell a Colonel, and claimed that the body was interred 'in the family vault belonging to the deceased and Mr Grimwade'. There is no vault.

[29] AF to TWK, 31 August 1895; AF to FSG, 13 February 1895. John Benn (1821–95), a fellow member of the Australian Club, had arrived in Melbourne in 1849 and become senior partner in Grice Sumner and Co, merchants. Twice President of the Chamber of Commerce, he had been Chairman of the Trustees Executors and Agency Co, and had been involved in introducing gas lighting to Melbourne (J Ann Hone, entry in *ADB*, vol. 3).

PART TWO

ART AND CHARITY

*The yearly jaunt to town to see the new pictures is now regarded
in some circles as one of the most thrilling that the seasons bring.
All the way there they bless the memory of the good Felton,
and all the way back they abuse the selector.*

Blamire Young, 1906

*This Felton business is really the most exasperating work, and
were it not for the real worth of the object I would chuck it.*

Sir Frank Clarke to Alfred Bright, 1935

13

THE BEQUESTS

A FEW DAYS AFTER his death the press announced Felton's will. The unknown author of his obituary in the *Argus* had noted that 'Mr Felton had a very fine collection of pictures', and understood that it would be bequeathed to the National Gallery, but the scale of Felton's benefaction was now reported with obvious surprise. 'Mr Alfred Felton's Estate. Munificent Public Bequest. Charities and Melbourne Art Gallery endowed' the *Age* announced. 'Late Mr Felton's Will. Nearly half a million for Charity and Art', the *Argus* echoed.[1]

Felton's intentions had been kept secret, and we know nothing of the process by which he formed them. The University of Melbourne nursed a remarkably persistent belief—a Vice-Chancellor still held it in 1937—that Felton had intended to leave his money to the University, but revoked a will in its favour when the news broke that the University Accountant had embezzled an amount equal to two years' annual government grant. Felton's endowment, which distributed in its first year about £16 000, would indeed have transformed the University, whose government grant in 1900–1 was only £13 250. But the belief was wishful thinking: Felton's solicitor PD Phillips drew up the only extant will in 1900, and the embezzlement was not uncovered until 1901.[2] Perhaps the tradition is a distorted echo of the fact that Felton lent £1000 to the debt-ridden and disputatious John Simeon Elkington,

[1] *Argus*, 9 January, and *Age* and *Argus*, 13 January 1904; *Leader*, July 1904.

[2] Raymond Priestley, the University's first salaried Vice-Chancellor, after attending a 'very crowded' reception held by the Premier in the National Gallery on 27 August 1937, noted in his diary that 'there appears to my untutored mind to be a lot of poor stuff on the walls'. 'When I see some of the pictures purchased through the Felton Bequest money it makes me think of how it might have been used if Felton had stuck to his original intention and left it to the University' (Ridley (ed.), *The Diary of a Vice-Chancellor*, pp. 375–6). The origin of the University's 'tradition' has not been identified. The Will was dated 22 August 1900 and the three codicils 25 July 1901, 10 November 1903, and 5 January 1904 respectively. Felton's ledger records a payment 're Will' of £28 7s to PD Phillips and Son on 13 September 1900.

the University's Professor of History and Political Economy, and had trouble recovering it. ('Bankruptcies in 1892 and 1895', Elkington's biographer noted, 'as well as his inordinate thirst, created problems for the University'.) There may have been earlier wills; the intricate last, with its three codicils, provided Bequests for relatives and associates, and handsomely endowed two causes, charity and art.[3]

PD Phillips himself might have had something to say to Felton about his will; he was certainly quick with advice to the trustees. A remarkable man, son of a leader in the Jewish community, he had dissolved his partnership with Robert Best and Theodore Fink in 1892 because he disapproved of their land-boom activities, working thereafter with his son Morris. His daughter Marion, after an education as good as her brothers', worked with Sidney and Beatrice Webb in London and became a Labour member of the House of Commons, the first Australian woman elected to a national Parliament. The artist E Phillips Fox was PD's nephew, and PD himself was a Shakespeare scholar, like Morris and Leeper. It is not surprising that Felton found him a congenial adviser and confidant.[4]

Other possible influences and models for Felton's bequests can be identified. According to Dickson Gregory, he closely observed the operation of the Estate of the Late Edward Wilson, which since the *Argus* proprietor's death in England in 1878 had distributed large sums annually 'to or amongst any of the various religious charitable and useful institutions in the Colony of Victoria'. Felton might or might not have known Wilson—he was difficult to avoid in his early, radical days—but he knew Robert Murray Smith and others among the eight Trustees of Wilson's estate in Australia. The Estate's distribution lists, published in the *Argus*, seem certainly to have influenced the pattern of Felton's own charitable giving in the 1890s, but Felton's will included priorities which were absent from Wilson's.[5]

The art bequest perhaps emerged later in his thinking, though Ursula Hoff suggests that Felton might have been influenced by visiting in the 1880s the Metropolitan Museum of Art in New York, founded in 1870 with the avowed aim of elevating public taste.[6] He would certainly have been aware of the bequest established under the will of the sculptor and painter Sir Francis Chantrey, for the

[3] ND Harper, article on Elkington in *ADB*, vol. 8. Professor Elkington's page in Felton's ledger has many entries out and fewer in.

[4] On PD Phillips, see Fox, *E Phillips Fox and his Family*, and the entries on Marion Phillips by Beverley Kingston and on MM Phillips by Mark Duckworth and John C Gibbs in *ADB*, vol. 11. The critic Arthur Phillips was a grandson. Felton might well have discussed his testamentary intentions with Morris; unfortunately the Morris papers are now missing. The will was a surprise to Leeper, who was pleased that the Gallery could now buy some good pictures.

[5] I am indebted to the Trustees of the Estate of the Late Edward Wilson for a copy of his will.

[6] The policy of the Metropolitan was 'to provide a collection of objects' to 'bring up the taste of the people of this country to the highest standards' (Hoff, *The Felton Bequest*, p. 7).

purchase of painting and sculpture produced within Britain. Chantrey died in 1841, but the Bequest (of £105 000) did not come into operation until after the death of his widow in 1876. The Royal Academy, charged with choosing the pictures, soon came under almost continuous attack, accused of wasting the funds on inferior works by its associates. In theory, paintings produced in Britain by Monet, Sisley, Pissarro and other foreigners could have been chosen, but even with purchases restricted to native artists it seemed unreasonable that of 110 works selected by 1903, only five had been purchased outside the Academy itself. When Sir Henry Tate, inventor of cube sugar, provided the funds to build the National Gallery of British Art, opened in 1897 on the site of the old Millbank Penitentiary, and gave it his own rich collection, it was decided that all past and future Chantrey pictures were to be housed there also, to the chagrin of successive Directors of what was always known as the Tate. Parallels between the Chantrey and Felton Bequests can be found through the following century, but its history was already too troubled for it to be a likely inspiration when Felton made his decisions in 1900.[7]

There was another possible exemplar, in a neigbouring colony. Sir Thomas Elder (1818–97) was one of four sons of a Kirkcaldy merchant and shipowner, who extended his business to the infant settlement of Adelaide in 1839 by sending one son in a schooner laden with rum, whisky, brandy, tar, fish, biscuits, tinware, agricultural machinery and seed. Trading flourished, and other sons followed, Thomas arriving in Adelaide in 1854. In 1855 Robert Barr Smith, another Scot, came from Melbourne to join Elder and Co; he married the Elders' sister Joanna in 1855, and in 1863, with Thomas, renamed the firm Elder Smith & Co, soon to became one of the world's largest wool-selling brokers. Thomas also explored the interior and bought land, and, after a fortunate investment in the Wallaroo and Moonta copper mines had made him extremely rich, extended his holdings in three colonies until they were larger in area than his native Scotland. (To solve his transport problems he introduced camels, and Afghans to manage them.) His brothers returned to Scotland, but Thomas stayed on; like Felton, he was a bachelor, but lived in considerable grandeur in successive mansions, one, on Mount Lofty, suitably Scottish in style. Extremely generous to causes throughout South Australia, and especially to the University of Adelaide, he left an estate of £615 000—and probably £200 000 more outside the State—when he died in 1897.[8] Among many bequests was one 'to the Adelaide Picture Gallery £25 000 to be spent in the purchase of pictures for the said Gallery and for no other purpose'.

[7] On the Chantrey Bequest, see Spalding, *The Tate*, pp. 11, 20, 26–8 and 36.

[8] Entry by Fayette Gosse on William, Alexander, George and Thomas Elder in *ADB*, vol. 4.

Harry P Gill, the Honorary Curator of the colony's small collection (in what time he could spare as Director of Technical Art at the South Australian School of Arts and Crafts), telegraphed Bernard Hall: 'Please post Tuesday answer to this problem. How best to spend Twenty Five Thousand upon the Adelaide Art Gallery'.[9] No Gallery existed, but the South Australian Government promptly built one; and the Trustees, led by the upright, shrewd and ubiquitous Sir Samuel Way (himself a collector), adopted Gill's proposal to invest a third of the bequest to provide £250 a year to be spent on Australian contemporary works, to be selected from annual 'Federal Exhibitions' to be mounted in Adelaide. (Gill chose Roberts' *A break away!* from the 1899 Exhibition.) In 1899 Gill was sent to Britain to spend £10 000—at least $300 000 in 2002 values—on contemporary art.

There is no evidence that Felton knew Thomas Elder personally, but he would have known of his Bequest, of the Federal Exhibitions, and of Gill's extraordinary expedition. There are comparisons to be made between Felton's bequest and its only significant predecessor in Australia, but there were differences. Elder restricted his bequest to pictures—he liked looking at them, and wrote with awe of the impact on him of the 'vast galleries' of Madrid—but collecting was not a major part of his life, as it was of Felton's, and he did not make explicit any high educational purpose for the elevation of public taste. Elder's art bequest was simply a major gift to one Adelaide institution among several, and he did not devise, as Felton did in some detail, a mechanism for a continuing endowment.

Felton's general purpose, perhaps encouraged by Elder's example, was unlikely to have been affected by another windfall to the Adelaide Gallery, from Morgan Thomas, MRCS (1824–1903). In his later years Thomas spent his days in the Adelaide Circulating Library (emerging to lunch in the Hamburg Hotel in Rundle Street; 'after the meal he leaned against a hitching post until exactly 2.30 p.m., when he entered a nearby chemists shop to chat with the proprietor', who witnessed two of Thomas' wills). Thomas left £65 000 to the Public Library, Museum and Art Gallery—a conglomerate as in Melbourne—but since he had no known interest in art or natural history he probably thought—mistakenly—that the Circulating Library lay within the Board's responsibilities. Felton was on his death-bed when Thomas' benefaction was announced; the only things the two men had in common were a solitary mode of life, generous posthumous intentions and a pronounced limp.[10] If Felton had a specific model for his art bequest, he (and PD Phillips) kept it secret.

[9] Quoted in *The Story of the Elder Bequest*, p. 48. The notional Gallery had been founded in 1881, the nucleus of its collection works bought at the Melbourne Exhibition of 1880.

[10] On Morgan Thomas see EJR Morgan's entry in *ADB*, vol. 6.

FELTON NAMED AS his trustee the Trustees Executors and Agency Company Limited, founded in 1878 by William Templeton—after his dismissal as a police magistrate on Black Wednesday—on the model of companies he had observed in South Africa. Felton would have known Templeton as a fellow member of Strong's Australian Church, and was certainly acquainted with other directors, in particular John Benn and Robert Murray Smith, who had joined the Board in the 1880s after his return from serving as Victoria's Agent-General in London. Alfred Deakin thought Murray Smith 'steeped in commercialism'; but he was also highly cultivated, 'generous' (in Geoffrey Serle's words) 'to good and bad causes alike'. He too was a friend of Dr Strong, and had acted as Treasurer of the Tucker Village Settlement Association. Trustee companies of this sort, unusual elsewhere, were to play an important role in philanthropy in Victoria.[11]

The assets of 'Alfred Felton, Manufacturing chemist, deceased', were valued for probate purposes at nearly half a million pounds (perhaps $35 million in 2000 values): the net value, after meeting liabilities of £2726, was £494 522. The smallest items in his estate, some £37 in total, were inheritances from his mother, two aunts, father and sister Eliza, all of whom had died intestate.[12] The major items included his interest in Felton Grimwade & Co (£83 706, plus funds on deposit); his share of Murray Downs (about £80 000) and of Langi Kal Kal (£56 235); 9 Queen St (£30 000); and a deposit with Cuming Smith's (£25 473). The largest shareholdings in a long list—many conservatively valued—were in the New Zealand Drug Co (£24 589), Cuming Smith's (£20 000), the Melbourne Glass Bottle Works (£20 000), the Adelaide Chemical Company, the Royal Bank and Samuel Burston and Co, maltsters. Drought had made Felton's small investment in EH Lascelles' Mallee Agricultural and Pastoral Co Ltd worth very little.[13] The financial solidity of Felton, Grimwade and Company was such that the firm was able to pay £104 242 to Felton's trustees—some two-fifths of its capital—without serious harm to its structure and operations; Felton Grimwade's became thereafter a purely Grimwade concern in ownership and control.

The Trustee Company was not required to realise all the assets of the estate immediately, though as and when it did dispose of them the only new invest-

[11] On Templeton, who died in 1890, see entry by Jacqueline Templeton, in *ADB*, vol. 6. The quotation is from Serle's entry on Murray Smith in *ADB*, vol. 6.

[12] 'Breakdown of the Estate' ledger, La Trobe Library.

[13] Other shareholdings, some much reduced in value by the depression, were in J Bourke, Samuel Burston and Co, Central Queensland Meat, Kauri Timber, Kitchen and Sons, Mallee Agricultural Company, Union Trustee (1000, worth only £600) and Kemp Sheep Dip, a shaky venture. Mortgages, including £13 600 lent to Gertrude Bage, totalled £17 873. Two months after Felton died a great fire destroyed Kempthorne Prosser's drug warehouse in Wellington (*Argus*, 25 March 1904).

The Trustees' Executors and Agency Company Building, Collins Street (Albert Charles Cooke, *The Australasian Sketcher*, 1 April 1893, La Trobe Picture Collection, State Library of Victoria)

ments allowed were those then usual with such trusts—government securities or first mortgages on freehold properties—a requirement which would eventually hinder the maintenance of real income and of capital value when inflation reached unprecedented rates in the 1970s.[14] For the time being, however, Felton's bequest benefited greatly from the excellence of his own major investments,

[14] The will allowed investment in 'Debentures or other public securities of the Government or Governments whether Federal or Provincial of any or all of the Australian Colonies or in or upon first Mortgage of freehold property in the colonies of Victoria or New South Wales with power to transpose or vary any investment for another or others of an authorized nature'.

especially his shareholdings in Cuming Smith's and the Melbourne Glass Bottle Works. The Company also retained the Queen Street property, but Murray Downs and Langi Kal Kal posed some problems.[15] The partnership of Campbell and Felton was due to expire in January 1904, and the Trustees exercised an option to continue it for three years. In April, Campbell proposed that Murray Downs remain a partnership but Langi Kal Kal be sold to him; in May he offered £52 000—the book value, a little below probate value—and the offer was accepted. In July he disputed the valuation placed on Murray Downs, arguing that it had been made as if the property had recovered from the prevailing drought, not on its existing state. A new valuation was agreed, and Campbell bought Murray Downs on terms, Felton's Trustees holding a very large but diminishing mortgage over the property, paid off by 1922. When Campbell himself died in September 1905, Murray Downs and Langi Kal Kal, were held in trust—also by the Trustees Executors and Agency Company Limited—for seven of his surviving sons and daughters. Murray Downs, much diminished by subdivision, was finally sold in 1969.[16]

FELTON LEFT LEGACIES of £58 900, and annuities amounting to £5200 a year, to thirty-eight individuals. Russell Grimwade's claim that Felton's will made 'bequests to many old friends', but 'relatives did not figure in it largely' is misleading; Felton did not leave substantial wealth to any members of his family, but many were given annuities, continuing the annual payments he made in his lifetime.[17] Relatives and friends were intermingled in the lists, which Felton clearly drew up with great care. He also stipulated that legacies to females were for their sole and separate use.

In Felton's judiciously graded distribution, brother William Felton's family remained in favour. 'Squire' (Alfred Leopold Felton) received the largest legacy—£10 000, payable in 1909, when he turned twenty-five—and an annuity of £400 a year until he died in 1951; and Fanny and daughter Freda received annuities of £300 each. Felton's brother Thomas received an annuity of £250 until his death in 1911, his son Will a legacy of £5000, and his three daughters annuities (Maud Felton and Annie Borrill £100 each and Lucy Edkins £150). Felton's South African brother James received £150 a year until his death in 1910, and his son

[15] The Trustees tried to sell Queen Street in 1926, but it was passed in at £44 500; and a later auction attracted no bid at £65 000.

[16] To Kidman-Reid and Company, owned by grandchildren of Kidman the Cattle King. To the horror of some, cattle replaced sheep as the station's principal stock.

[17] Grimwade, 'Some memories of Alfred Felton'.

FS Grimwade at 'Harleston', *Melbourne Punch*, 21 April 1904

William John £100 until his in 1932. Felton's youngest brother Edmund, still of Red Hill, Surrey, received an annuity of £150.[18]

Felton's partners and their families were recognised, some generously. Legacies of £5000 each were left to Norton and Harold Grimwade, and of £3000 each to Sheppard and Russell Grimwade. Their sisters Alice and Freda Grimwade were each left annuities of £200.[19] The English Grimwades were not forgotten: an annuity of £300 went to Edward William Grimwade, Felton's companion on the Harleston garden seat, until his death in 1920, and his sons Frederick Grimwade and Edward Hall Grimwade (the house-guest in Acland Street in 1880) received legacies of £1000 each. So did the younger James Cuming, and Charles Bage and his brother Robert; each of the late Edward Bage's daughters was left £500.

Charles Campbell received a token legacy of £100, a codicil dated 25 July 1901 adding 'my picture in oils being a portrait of Emma Lyon afterwards Lady

[18] There was no mention in the will of brother George or sisters Mary Ann or Ellen; perhaps, like Eliza and long-dead Arthur, they had predeceased him. Felton's payments to Mrs Rachel Rowe and Emma Sharp, both of Lewisham, were continued as annuities of £70 each until Rachel died in 1911 and Emma in 1919.

[19] A third sister Elizabeth, also named, predeceased Felton, but her orphaned son and daughter, Cedric and Jessie Battle, were left £1000 each.

Hamilton attributed to Romney' (valued for probate at £21); a legacy to Campbell's son Charles W Campbell was also increased, from £100 to £1000. Mary Johnston (née Campbell) and her husband David (manager of Murray Downs) received £100 each, as did 'Captain Charles Dallas of the Punjab', who had married Mary's sister Catherine. No less than £5000 was left to their infant son, Alfred Stuart Dallas, born in 1895; unfortunately Alfred Dallas was drowned duckshooting, in southern India in 1921, before receiving his legacy.

Felton left £2000 to his partners in Felton Grimwade's for distribution among their employees in Flinders Lane and Jeffcott Street, giving 'fullest regard in the first place to length of faithful service'. Annuitants and legatees among them were excluded. A legacy of £500 for Felton's 'clerk' Dickson Gregory, provided in the first codicil, was increased to £1000 in the second.[20]

Felton's close friends, or their children, were generously remembered. Reginald Couche, son of the late William Couche, received £5000, and his widowed mother Henrietta an annuity of £200 a year; she died in 1905. There were legacies of £500 to each of the children of Henry Creswick's son Alexander, of New South Wales, and of Talbot Hamilton, of Hawthorn, Creswick's son-in-law. Henry Creswick's widow Jane received an annuity of £200 until her death in 1932, and their daughter Alice Creswick £100 until she died, aged eighty-five, in 1940. Dr Charles Strong was left £1000. Judge Bunny's widow, left an annuity of £100, predeceased Felton, but Rupert Bunny received his annual payment of £100 from Felton's estate until his death in 1947 (and useful it proved, in Paris and after he returned to Melbourne in 1932, out of fashion, widowed and impecunious).[21]

In 1900 Felton's will provided an annuity of £360 for his old friend Bryan Burstall, but by July 1901 he must have doubted Burstall's capacity—he was then eighty—and appointed Alexander Creswick and Talbot Hamilton as Trustees charged with spending £360 annually towards 'the maintenance, personal benefit and comfort' of the said Burstall. Felton revoked this provision in a third codicil four days before he died, leaving Burstall a reduced annuity of £100, to be paid

[20] Employees receiving annuities of £100 were AEG Griffin, TP Isaac, Thomas Cowley (reverting to his wife), A Elliston (who died in 1910; his wife in 1930) and John D Parr, 'my bookkeeper'. Bathia Court and Mrs Harley, widow of Edward Steyne Harley, recipients of allowances since the 1890s, were each left annuities of £50, but predeceased Felton.

[21] Reddin, *Rupert Bunny Himself*, p. 106. George Peacock, identified as 'artist, of Burnley' (unlikely to be the convict artist, George E Peacock, last heard of in Sydney) received an annuity of £50. Annuities of £100 were widely distributed among women in the Francis family, to Grace (Mrs Henry Francis), Clara Lavender (her sister), and her daughters Louisa, Claire and Winifred. Mrs Anne Potter, wife of Archdeacon Potter, was left an annuity of £100 until her death in 1920. Nancy Walker (daughter of HP Walker) and Mrs Louisa Perkins (widow of Ebenezer Perkins, 'lately of Kyneton') who died in London in 1916, aged eighty-five, each received annuities of £100. In 1965 Daryl Lindsay reported that three annuitants were still living.

directly to him. Bryan Burstall did not long enjoy his modest inheritance; he survived his friend and benefactor by only three months, dying in London on 22 April 1904.

The individuals receiving what Felton called 'remembrances' of £100 were nicely various, ranging from Jessie Grimwade to Herr Grundt, and including Signor Baracchi, Burns Cuming, JK Forrest and Henry Francis.[22] Perhaps Felton's political sympathies, at once independent and liberal, were indicated by a small legacy to the Honourable William Shiels, disciple of Higinbotham and Pearson, supporter of Strong, champion of women's rights, parliamentary colleague of Service and Murray Smith, briefly Premier when the banks were crashing, and Treasurer when the Railway Strike was crushed; or perhaps it was simply that Shiels was another St Kilda man. He did not have long to remember Alfred Felton; so ill that he had to make his 1903 budget speech sitting down, fortified by a flask of whisky and a bottle of champagne, Shiels died in December 1904, aged only fifty-six.[23]

The executors distributed framed photographs of Felton to Charles Campbell, EH Lascelles (the founder of Hopetoun), William McNeilage (Manager of the Bottle Works), Henry Francis and the Old Colonists' Homes. His 'personal apparel' went to various charities, and to the waiters of the Esplanade Hotel.

AFTER PAYMENT OF legacies, probate duties and other expenses, the residue of the estate remaining in the care of The Trustees, Executors and Agency Company was £378 033. For much of the following century both the capital and the income of Felton's bequest grew steadily, more rapidly than indices of the cost of living, though not of the prices of works of art. In the closing decades, in common with many other trusts, growth faltered, when governments were tardy in granting to trustees the freedom to invest as broadly as was necessary when inflation reached levels not foreseen when trusts were first regulated. After 1995 broader powers, taxation concessions and better investment policies restored substantial growth.

Responsibility for applying the income to the purposes of the will lay with a Felton Bequests' Committee of five, independent of both the Company and the National Gallery, though the Company retained sole responsibility for managing Felton's estate, informing the Bequests' Committee what funds were available to spend, and making all arrangements for payment and, in the case of works of art, for delivery to the Gallery. Members of the Bequests' Committee were to be

[22] And his son George Francis, Anthony A Smith and AC Macdonald.

[23] On Shiels, see Geoffrey Serle's entry in *ADB*, vol. 11.

rewarded for their 'care and trouble' by sharing £200 between them each year; a codicil giving the Company power to increase the allocation, which it did rarely and modestly over the next century.

The initial and in part the later membership of the Felton Bequests' Committee was specified in Felton's will: FS Grimwade, and after him Norton Grimwade, and after him Harold, a succession to last until 1949 (and then to be continued until 1955 by Russell Grimwade, not named in the will; and echoed after 1973 by Andrew Grimwade, a great-grandson of FS Grimwade). The other four were Dr Charles Bage; Professor EE Morris (who had predeceased Felton and had to be replaced); a Trustee of The Public Library, Museums, and National Gallery of Victoria, appointed by the Trustees of that body; and a Director of The Trustees, Executors and Agency Company, appointed by the Directors of the Company.[24]

Half the income of the trust was to be devoted to 'such purposes and for the aid and advancement of such objects as are charitable in a legal sense'. Without limiting the discretion of the Committee, Felton had indicated

> my hope that in the application of such income they will favourably consider first charities for Children as for example Childrens Hospitals and Orphanages secondly charities for women such as Womens Hospitals and thirdly such institutions or societies as general hospitals societies for the relief of the educated poor and other charitable institutions of a general character.

Distribution was to be made at least once in every year, and—a characteristic touch—in the week before Christmas, if convenient. The Committee soon adopted the practice of making distributions every June and December.

The other half of the income was to be applied 'to and for the purchase of works of art, ancient or modern, or antiquities, or other works or objects' which the Committee 'with the approval or upon the recommendation' of the Trustees of 'the Melbourne National Art Gallery ... shall select'.[25] Each object presented to the Gallery was to bear the words 'Felton Bequest', and the Committee could purchase only 'works and art objects' which it judged 'to have an educational value and to be calculated to raise and improve public taste'. Felton's instructions seemed clear enough. That did not mean that his Bequests' Committee would find it easy to carry them out.

[24] In the case of the Gallery Trustee or the Company Director, vacancies were to be filled by a successor similarly qualified and similarly appointed; in other cases, by successors appointed by the 'continuing or surviving' members of the Committee.

[25] The codicil of 25 July 1901 made clear that 'the Trustees for the time being of The Public Library Museums and National Gallery of Victoria' were the Trustees referred to.

Dr Charles Bage (La Trobe Picture Collection,
State Library of Victoria)

THE FIRST CHAIRMAN OF THE COMMITTEE was FS Grimwade. No one questioned Grimwade's good intentions or his probity, but a near lifetime—he was sixty-four in 1904—of judiciously adopting the right moral stance on every issue had given him a certain stiffness of mien, and perhaps of judgement. Even his youngest son no longer found him readily approachable, shielded as he was by a formal and pedantic manner, and by constantly reiterated advice that shoemakers should stick to their lasts, that crooked sticks cast crooked shadows, that bad beginnings made bad endings, and other aphorisms drawn from a remarkable repertoire of proverbial wisdom. His taste in art was conventional, despite his wife's purchases at the 9 × 5 Impressions exhibition; but he knew his late partner better than anyone, even if he had not been made privy to his testamentary intentions.

As Felton's physician, Charles Bage also knew him intimately. The brother of Edward Bage, partner in Felton Grimwade's until his premature death in 1891, Charles, born in 1859, graduated in Medicine in the University of Melbourne in 1881, and conducted a busy practice in South Yarra until 1923. He was an especially devoted member of the Felton Bequests' Committee, and its Chairman from the death of FS Grimwade in 1910 until his own death in 1930. Like a great many medicos of his time, Bage was interested in eugenics, and in the relationships between alleged racial characteristics and behaviour; in 1913 he commended to Alexander Leeper the writings of Houston Stuart Chamberlain on the debased nature of Mediterranean peoples and their baleful influence on the Roman Catholic Church.[26] How far these views influenced his judgement on either charity or art is not clear; he certainly worked hard for the Bequests' Committee—he was its first chronicler—and was described even by critics of its policies as a man of probity and dignity, though no one thought him imaginative.

The Trustees of the Public Library, Museums and National Gallery first elected as their representative their President, the Honourable Edward Langton, Chairman of their National Gallery Committee, a one-time Collingwood butcher turned accountant and outspoken conservative politician. He was also a literary man, but any influence he exerted on the Bequests' Committee ended when he died of pneumonia in October 1905. To succeed him the Trustees chose the artist John Mather, a talented painter best known for his murals in the Exhibition Building, who had emigrated to Victoria from Scotland in 1878. He had became a Trustee of the Public Library, Museums and National Gallery in 1892, after a long campaign to have an artist on the Board. He actively championed Australian art, as a Trustee and on the Bequests' Committee, but did not escape its controversies, joining others in forming the Australian Art Association as a breakaway from the Victorian Artists Society in 1912. Mather personified the belief of fellow artists that only practitioners could properly judge art; but he also gave hostages to the opposite view by being himself impulsive in judgement. Mather had intellectual interests—he too was an evolutionist, of the Herbert Spencer variety—but so over-indulged in argument that he was a less effective advocate than he might have been. Baldwin Spencer, the Trustee he defeated for the position on the Committee by one vote in 1905 (and who complained privately that the decision was 'political'), proved a much greater influence on the Bequest, though never a member of the Bequests' Committee.[27]

[26] Bage to Leeper, 22 September 1913 (Leeper papers). There were more liberal influences in the Bage family also: Charles' niece, Anna Frederika Bage, studied science and later became the first Principal of the Women's College in the University of Queensland (entry by Jacqueline Bell, in *ADB,* vol. 7). Her brother Edward, an engineer, went to Antarctica with Mawson's expedition, and was killed on Gallipoli in 1915.

[27] On Langton, see entry by Jean Cooksley in *ADB*, vol. 5, and on Mather, entry by Judy Blyth in vol. 10.

The Trustees, Executors and Agency Company Limited, charged with nominating one of their directors, chose the Chairman, Frederick Race Godfrey. Son of an Indian Army officer, Godfrey had been one of the first squatters on the Loddon, selling much meat to the miners when the Bendigo goldfield opened. A man of broad interests, he was vice-chairman of the Aborigines Protection Board, a member of the Legislative Assembly, founder of the Philatelic Society, a member of the Acclimatisation Society (and, paradoxically, of the Committee to preserve Wilsons Promontory). A founder of the Trustees, Executors and Agency Company Limited in 1878, he had been its chairman since 1895; as chairman of the Melbourne Hospital from 1887 until 1904, a founding member of the Council of the Charity Organisation Society, and as a member of Zox's Royal Commission into Charitable Institutions in 1890–91, he was well equipped to further the charitable aspects of the Bequests, but had, it seems, little involvement with the world of art, though he soon revealed some definite opinions. He retired from the Committee in 1909, and died the following year.[28]

Edward Morris, the third individual named in Felton's will, had died on 1 January 1902. Felton failed to name a replacement, which would not be easy to find: Morris, a Trustee of the Public Library, Museums and National Gallery as well as President of the Charity Organisation Society, was involved in both areas to benefit from Felton's Bequests, and had he lived longer administration of the Charity Bequest would probably have been more innovative. At its first meeting, in the Trustee company's offices at 412 Collins Street on 1 May 1904, with Grimwade in the chair and PD Phillips also present, the Committee's first business was to exercise its unencumbered power to fill the vacancy. 'After several names had been mentioned', it was decided to approach Robert Murray Smith, but he refused appointment, perhaps because he was already deeply involved in Gallery matters as a Trustee (since 1897), in Felton's estate as a director of the Trustee Company, and in the Wilson Estate as its 'perpetual' chairman. On 12 May the Committee chose instead James Alfred Levey, a foundation member of the Charity Organisation Society and Morris' successor as its President.[29] Born in England in 1846, Levey emigrated to Victoria in 1862. He became a public servant, serving in the Lands Department, as chief inspector of factories in the Chief Secretary's Department and finally as head of the Police Department, before retiring on health grounds at the age of forty-nine. Levey had elevated his social status by marrying into the Grice family, and he spent his very long retirement—nearly half a century—administering philanthropic bodies, especially the

[28] On Godfrey, see entry by Margaret Gravell in *ADB*, vol. 4.

[29] FBC Minutes, 1 and 12 May 1904.

Charity Organisation Society (which he chaired from 1902 until 1923) and the Melbourne Hospital (President 1931–35); he remained a member of their boards until his death in 1944. It is not surprising that the Felton Bequests' Committee continued to support both institutions, and that there was little fresh thought given to the charitable side of the Bequests in the first half of the century.

Levey had few developed views on art (he liked Corot's *Bent Tree* in 1907, but not the Blake drawings bought in 1917). He was eighty-four when he succeeded Bage as Chairman of the Felton Bequests' Committee in 1930; both the Committee and the Gallery faced difficulties in those years, and despite his many admirable qualities Levey was by then too old and too deeply imprinted with the memories of past conflicts to provide the leadership the times required. Institutional memory became a quality undervalued by the end of the twentieth century, but James Levey had rather too much of it.[30]

In 1909, when Godfrey resigned, Robert Murray Smith did accept nomination as the Trustee company's director on the Committee he had refused to join in 1904. He had been involved in Bequest matters from its beginning, as a Trustee of the Gallery and a director of the Company, but his new appointment was a little late; his mood in his last years (he died in 1921) was described as gloomy and pessimistic, and it was perhaps as well that he retired from the Committee in 1913.

It is difficult to escape the view that the first members of the Bequests' Committee, with the possible exception of Mather, were rather more stuffy than Felton himself had ever been. And, unlike him, they were all too accustomed to sitting on committees.

FROM THE BEGINNING, the Bequests' Committee knew that deploying the Art Bequest effectively would be difficult. The purpose—the concept of educating and elevating public taste—was familiar enough, but the scale of Felton's Bequest was unusual and challenging. There was some temerity in Melbourne's gallery, grand in its original conception and early achievements but now crippled by the economies of depression, aspiring to acquire a collection of world standing. In 1904 it was naively proclaimed that 'the Felton Bequest Collection' would soon rival London's Tate (an interesting comparison, since the Tate's collection, diluted as it was with accumulated Chantrey purchases and some cast-offs from its parent in Trafalgar Square, was commonly derided as inferior by 1903).[31] Above all, Melbourne's triumphs would have to be achieved without help from government: in Adelaide Elder's Bequest had prompted the South Australian Government to build a Gallery,

[30] On Levey, see article by Laurie O'Brien in *ADB*, vol. 10.

[31] Joshua Lake, in the Felton Collection Sale Catalogue, p. 5; Spalding, *The Tate*, p. 26.

but in Victoria, as the Chief Librarian, the senior officer in the combined institutions still straitened by depression, wrote happily, 'this magnificent bequest will practically relieve the Government of the responsibility of providing funds for the purchase of pictures and other works of art', a responsibility it had already largely relinquished and would be very slow to resume.[32] Victorian governments have always been inclined to build grand buildings and skimp the activities within them, and when funds did become available as the depression lightened, the conglomerate institution in Swanston Street received new money only to build: in 1906 a wing on Russell Street for Baldwin Spencer's National Museum, moved from the University in 1899, and the characteristically grand domed reading room for the Public Library, commenced in 1909. In Adelaide, also, Elder's example was followed by a regular stream of benefactions to the Gallery, in money or kind, but in Victoria the very scale of Felton's generosity, exaggerated as it was in a public mind ignorant of the rising cost of works of art, seems to have had the opposite effect, diverting benefactors towards other causes.

The Gallery Trustees were thus almost totally dependent on Felton funds for acquisitions, but since they had full power to nullify purchases by refusing to accept any work chosen, appropriate policies had to be agreed. The Adelaide Gallery did not have that problem, since Thomas Elder and Morgan Thomas had made their bequests to the Board itself; but in London the Chantrey Bequest caused continuing friction between the Royal Academy and the Tate, which before 1920 had no voice in the selection of the pictures it was obliged to accept. It is unlikely Felton was aware of this tension when he placed his Bequest in the hands of a committee independent of the National Gallery, but he, or his legal adviser, had nevertheless foreseen the problem, and tried to provide mechanisms to minimise dispute:

> I desire the said Committee to from time to time arrange, in consultation with the said Trustees, or such of them as the said Trustees may for that purpose appoint, such scheme or mode as may be deemed satisfactory and convenient for carrying out the foregoing trust and for securing the joint and harmonious action therein of the said Committee and Trustees.

It was easier said—even in legal English—than done. The suggestion that the Trustees might appoint a representative committee to consult had merit, though Felton, who never sat on such things, could not have experienced the capacity of committees to inhibit action. Professor Thomas Bodkin (1887–1961), a Director who exercised almost autocratic power over acquisitions for the National Gallery

[32] Quoted in Cox, *The National Gallery*, p. 61.

of Ireland and later for the Barber Institute at Birmingham, observed that 'the wise purchase of pictures for a public gallery by a committee, however enlightened, is rarely practicable. The danger of compromises and half-hearted decisions can hardly be avoided'.[33] When, as in Melbourne, each decision required agreement between two committees, the danger of open warfare between them had to be added to half-heartedness.

Unfortunately the Trustees did not at first institute the committee Felton suggested, nor did they delegate Bequest matters to the National Gallery Committee formed in 1870 when the two museums joined the conglomerate. Solely an advisory group, its decisions remained subject to the approval of the full Board, a large body whose members had interests and responsibilities spanning the Library and the Museums as well as the Gallery. The membership—specified in its Act as at least fifteen—was miscellaneous. It was all male; women, though numerous among students of the Gallery School and as artists, were excluded from management of major public institutions, though allowed to run certain charities and (more recently) their own clubs. The trustees of 1904 included Langton, Mather, Murray Smith, Leeper, Spencer, Ford Paterson and James Smith, the Board's Treasurer (all aforementioned) HG Turner (Trustee 1884–1919), banker and historian; 'Tommy' Bent (Trustee 1894–1908), too busy being Premier and responding to allegations of ill-doing to give much time to the Board; FH Bromley (Trustee 1896–1907), Parliamentary Secretary of the infant Parliamentary Labor Party, a japanner by trade and painter of impressive trade union banners; (Sir) Edward Carlile (Trustee 1902–16), Parliamentary Draftsman since 1873; the venerable RJL Ellery (Trustee 1881–1908, one-time Chairman of the Technological Museum Committee), for forty-two years the first Director of the Melbourne Observatory, begetter of the Great Melbourne Telescope and thus Baracchi's predecessor; WH Fitchett (Trustee 1893–1927), founding President of the Methodist Ladies College in 1882 and famous author of *Deeds that Won the Empire* (1897), a book placed by the Admiralty in all warships' libraries; Molesworth Greene (Trustee 1892–1915), a Dublin-born 'Old Colonist', arriving in Geelong in 1842, expert pastoralist; and Professor EJ Nanson (Trustee 1879–1913), Professor of Mathematics in the University of Melbourne since 1875, an electoral reformer whose ideas had been amended out of the first Commonwealth electoral bill.[34]

[33] Bodkin, 'On Buying Pictures for a Public Gallery', in Philipp and Stewart (ed.), *In Honour of Daryl Lindsay*, p. 22.

[34] On Bent (1838–1909), see Weston Bate, vol. 3; on Bromley (1854–1908), in CH Pearson's judgement 'a thoughtful and cultivated man', NW Safffin, vol. 7; on Carlile (1845–1917), Ross Gibbs, vol. 7; on Ellery (1827–1908), SCB Gascoigne, vol. 4; on Fitchett (1841–1928), A Thomson Zainu'ddin, vol. 8; on Greene (1827–1916), J Ann Hone, vol. 4; and on Nanson (1850–1936), GC Fendley, vol. 10.

Recently appointed members included EH Sugden (Trustee 1902–35) the first Master of Queen's College; AS Joske (Trustee 1903–39), a bookish doctor, an authority on typhoid; Lieut-Colonel WT Reay (Trustee 1903–11), one-time proprietor of the Coleraine *Albion*, now recently returned from serving in South Africa, MLA and managing editor of the Melbourne *Herald*, a protégé of Fitchett and fellow-member of the Melbourne Total Abstinence Society; HJ Wrixon (Trustee 1902–12), barrister and liberal politician, pleased, as Attorney-General, to have appointed Higinbotham Chief Justice, a committee member of the Charity Organisation Society and staunch to its principles; Sir William Zeal (Trustee 1894–1911), railway engineer and politician skilled at uncovering railway scandals, recently transferred from the Legislative Council to the new Commonwealth Senate, dapper and sandy-haired. (A bachelor like Felton, Zeal too left an art collection, to the Bendigo Gallery, and a charitable trust.)[35]

Felton would have known most of these men, though he never joined them on the committees they liked to frequent. The average age of the first Trustees, appointed in 1853, had been less than forty, but by 1905 only three were under fifty, and eight were over seventy. Victorian society as a whole was ageing; the proportion over sixty-five, negligible in the frontier society of the 1860s, had increased enough by the turn of the century to prompt the introduction of the old age pension—though not enough to make it expensive—and concern over slowing population growth was a major Australian preoccupation after 1900. (In 1912 it eased the passage of WM Hughes' 'baby bonus', £5 to every woman brought to childbirth, a measure attacked by Alfred Felton's Sydney friend, Sir James Graham, as a vote-catching evasion of the real need, for subsidies to hospitals to reduce infant mortality.)[36] The National Gallery was not the only institution whose arteries hardened, as men of influence lived longer, and kept their place in public organisations; but the effect was magnified by the Trustees' belief that their role was indeed to manage, and that of the Chief Librarian and the Director of the Gallery to advise and obey.

The Felton Bequests' Committee gained a reputation for being conservative, and certainly the policies developed in its first decades changed more slowly than the society in which it operated. The Committee Felton established to administer his Bequests began their task in the world Felton himself had known, and the

[35] On Sugden (1854–1935), see Owen Parnaby, *ADB*, vol. 12; on Reay (1858–1929), Diane Langmore, vol. 11; on Wrixon (1839–1913), Jill Eastwood, vol. 6; on Zeal (1830–1912), Geoff Browne, vol. 12. Joske (1863–1939) has no entry.

[36] Dickey, *No Charity There*, p. 127.

extraordinary longevity of some of the original members of the committee—one of the first was still Chairman in 1944—caused some rigidity in aims and assumptions by the 1930s. The institutions which Felton intended to support also remained essentially the same; the Public Library, Museums and National Gallery retained their Victorian structures until 1944, and the network of hospitals and charities rather longer, all more or less resistant to change. The years from Felton's death until approximately the 1940s can thus be treated as a period in which developments, though far from simple, retain a common context; but in the later decades of the twentieth century entirely new relationships, and new ideas, emerged to influence the role of the Bequests' Committee. For that period the accounts of the Charity Bequest and the Art Bequest, under different influences, need to be separated.

FELTON'S BEQUEST TO art was large enough to be envied by other galleries and noticed by dealers, but in an age when Joseph Duveen could distort the market by extracting sums larger than Felton's total fortune from multi-millionaires exchanging European art for American dollars, his Bequests' Committee could achieve its aims only by developing expert and consistent policies, and by putting them prudently into effect. The interlocking markets in works of art have been almost infinitely complex in their history, and the international market which burgeoned in London, Paris and elsewhere in Europe in the late nineteenth century, to meet the appetites of new buyers in Europe itself and across the Atlantic, was a sophisticated amalgam of scholarship, salesmanship and chicanery.[37] A published sale price need be no more (nor less) genuine than the work which nominally fetched it; and a new client entering the London market risked being duped. Finding in London protective guidance which was acceptable to all parties in Melbourne proved extremely difficult: suspicion of the market, and of the motives of those dealing in it, swelled in proportion to distance, and to ignorance of how dealers dealt with each other as well as with the public.

Another recurrent issue in Melbourne was the demand that Bequest funds be spent on local artists. In November 1904 the Bequests' Committee refused to promise the Victorian Artists Society that it would reserve 'a portion of the amount annually available' for 'Works by Australian Artists', as the Elder bequest had done in Adelaide; 'this would be unadvisable, but the purchase of Australian

[37] Gerald Reitlinger was one of the first to chart its intricacies, in his *The Economics of Taste. Volume 1*. Hoff gives examples of massive American purchases from the 1890s, and cites Frick's expenditure of $US3 000 000 in 1918 alone (*The Felton Bequest*, p. 15).

Works of undoubted merit would be favourably considered'.[38] The Committee's purchases of Australian works were in fact regular and frequent, expenditure on them remaining small only because they were cheap, but in the public eye—and especially in those of the local artists themselves—the categories of Australian and European were seen as competing, as in a real sense they were. 'Raising the public taste' in art had a specific meaning implied; the colonists' view of art remained London-bound. The Art Gallery of New South Wales, though more systematic in its Australian purchases, habitually took London's Royal Academy as its arbiter of taste and value overseas; Victoria's National Gallery had sometimes been more bold in its judgements, but Felton's Committee soon decided that it needed London advice of its own. In consequence, the targets in the annual Felton shoot-out were not only the works bought by the Bequest and accepted by the Gallery, but the advisers who had recommended them. Plenty of locals were convinced they could do better, and a more radical bloc deplored and attacked the often spectacular spending in Europe of money which might have given local artists a livelihood. Self-interest, with or without a varnish of cultural nationalism, complicated a debate which was never solely aesthetic.

The National Gallery, as part of an ambitious conglomerate institution—library, museums, art gallery and art school, all together and under one management—had always accepted a very broad definition of 'Works of Art', as had Felton, and his Bequests' Committee agreed that their obligation extended to acquiring glass, pottery, furniture and 'miscellaneous'—lace, woodwork etc.—for the Art Museum as well as paintings, drawings and sculpture for the Gallery. The breadth of this definition raised questions about the acquisition of material for other sections within the conglomerate, and the Bequest did buy books and some museum materials, such as coins, but drew the line—usual in Western galleries until late in the twentieth century—between art and ethnological material, relegating everything produced within Aboriginal culture to the National Museum and outside the Bequests' ken.[39]

Most of the controversies over the Bequests' purchases arose over paintings, and to a lesser extent sculpture. The Bequests' Committee entered the London art market at a time when taste, which had long been relatively stable in preferring

[38] FBC, 23 November 1904. The request emerged from a meeting of the Victorian Artists Society on 14 September 1904; McCubbin, in the chair, was not enthusiastic and Walter Withers opposed the motion, which was carried with three dissentients. The mover, W Mitchell, cited the Elder Bequest as a model (*Argus*, 15 September 1904).

[39] Morphy, 'Seeing Aboriginal Art in the Gallery', discusses recent debate on this issue.

to acquire works by the recognised living artists of the day, had broken up in factional disagreement, not least among the artists themselves. The conflict between Ruskin and Whistler, between art in the service of morality and art for its own sake, with its famous judgement of 1878 awarding the artist his farthing damages for libel, had been echoed in Australia, with the emergence from the 1880s of a group of professional artists self-consciously 'bohemian' in style and values. In time—certainly by the 1920s, when their exuberant nationalism had narrowed and hardened—they themselves became a conservative influence on acquisition policies, and were challenged in the 1930s by the miscellaneous admirers of modernism, in a long campaign of noisy battles and small but ultimately overwhelming victories.[40] In Australia, as in Britain, artists' attitudes to the 'old masters' were always divided; as a Director of London's National Gallery observed, 'they were torn between the desire for inspiration and the fear of competition'.[41] For four or five decades the Bequests' Committee had a lively time meeting a succession of private and public crises; and behind these individual controversies, and occasionally emerging into plain view, was the fundamental issue of what kind of collection Melbourne's major gallery should seek to form.

Britain, unlike Germany, had no formal university-level studies in art history in the nineteenth century, but the notion of historically representative collections had gained ground, and in Melbourne had received powerful impetus with the arrival in 1892 of Bernard Hall to be Director of the National Gallery for the next forty three years. Hall believed passionately that the gallery should be 'a museum of art reference', in which every purchase illustrated some phase of the art, not only of Europe but of other cultures, especially those of Japan and China, and of antiquity. The viewpoint, inevitably in a colony, was essentially Eurocentric: even the art of Asia was for many decades bought mainly in London, and it was only from the second third of the twentieth century that Australian experts with a Pacific perspective were involved in the process. Similarly, 'Australian' art—as distinct from work by local artists—was slow to be recognised as a separate entity; and only much later broadened to include Aboriginal work. This Eurocentricity was not imposed by imperial power but arose naturally enough (in Bernard Smith's phrase) from 'a nostalgic yearning for origins' affecting all members of the society,

[40] On the emergence of the bohemians, see ch. 6 ('Bohemians and the Bush') in Richard White's *Inventing Australia*; and on the narrowing of nationalism in some of these artists, Smith, (ed.), *Documents on Art and Taste in Australia*, ch. 8, and especially the essay by Sydney Long there printed.

[41] Hendy, *The National Gallery London*, p. 12.

even 'assimilated or partly assimilated indigenes'; it was not 'something enforced and then tolerated', but 'a fulfilment of cultural desire'.[42] Hall's assumptions concerning the historical and educational purposes of the Gallery continued almost unchallenged for many decades (despite a smoothly subversive public lecture in Melbourne in 1949, when Sir Kenneth Clark reinstated enjoyment as the primary purpose of collecting art) but it was always beset by tensions. If the Gallery in its acquisitions should not pander to mere popularity, could it altogether ignore public preferences? And how could collecting on so broad a front include the purchase of expensive individual masterpieces, which everyone craved, and still leave funds for 'filling the gaps'? With all these issues the Bequests' Committee had to grapple.

[42] Smith, *Modernism's History*, pp. 192–3.

14

BEGINNINGS

The Trustee company had a duty to sell Felton's collection before the Bequests' Committee began to buy more art. The first codicil to Felton's will allowed the National Gallery to select, within one month, anything it wished from Felton's collection, 'for the purposes of and for exhibition in the said National Gallery', before the rest was sold. The deadline was short; it was late January before Felton's solicitor attended a meeting of the Gallery Trustees to explain the Bequest, and a committee was appointed to make the selection, from the 113 oil paintings, 78 water-colours, and 15 'engravings and sundries' left in Felton's rooms at the Esplanade.[1] Advised by Hall, they chose only twenty-nine pictures (fifteen of them oils), three Japanese ivories, one bronze figure, an 'Art Cabinet', a large number of books and periodicals on art and five large albums in which Felton had pasted the black and white or sepia reproductions of paintings or statuary then sold in the major galleries of Florence and Rome.[2] All the pictures were landscapes; three—Bonington's *Low Tide at Boulogne*, James Webb's *Lock on the Thames*, and Thomas Creswick's *Stepping Stones*—Felton had owned only since the Lynch sale. Richard Beavis' *The Charcoal Burners* had been prominently displayed in the Esplanade, as had *The Garden of Love*, an unusually good Rubens copy which the Gallery accepted as 'attributed to him and with great probability'. The water-colours selected included *Heidelberg Castle*, by the distinguished David Roberts, *Near Arundel*, by E Wake Cook, who had spent some time in Melbourne (and was a native of Maldon, which might have attracted Felton to his work), and two Buvelots, *Victorian Scene* and *Yarra Flats*. The works

[1] The composition of the committee was variously reported (*Age*, 29 January 1904, *Argus*, 4 March 1904), eight names being mentioned.

[2] The books and albums are now in the State Library of Victoria.

selected were valued for probate at £1757 by Joshua Lake and W R Stevens, Felton's own adviser.[3]

Publication of the list, shorter than expected, prompted the first of the press outbursts which were to dog the Bequest for decades. Despite the efforts of Hall and others to broaden its horizons, the taste dominant in Melbourne greatly valued the sorts of pictures Felton had collected, and wanted the National Gallery to keep more. Complaining that 'there are still pictures in the Felton Collection for which room should have been found', the art critic of the *Argus* described Felton's taste as 'admirably just', and claimed there were fewer pictures of doubtful attribution in his collection than in Lynch's. The Gallery's Director, he asserted, had wished to reject all Felton's pictures, but the Trustees had thought such a course might discourage future benefactors.

Hall, tactless as usual, was stung to reply that he had not rejected everything, writing curtly that 'after half an hour's hurried visit, which was all I could get in the first instance', he had recommended one picture, 'the little Bonington' (which he had earlier sought to buy for the Gallery at the Lynch sale.) The National Gallery must maintain high standards, he argued, and doing so 'would never discourage donors'. 'Few visitors to the National Gallery', 'Your Art Critic' bit back, 'would accuse the director of upholding too high a standard'; and his complaints were supported by 'One Who Cannot Buy Pictures', incensed by the apparently perfunctory 'hurried visit'. Hall belatedly explained that 'through some misunderstanding', he had 'no intimation that a report was required until a few hours before the trustees meeting'; the pictures were locked up at St Kilda and the key had to be found. He had made other visits, but did not deny he did not want many of Felton's pictures.[4] Daryl Lindsay, Hall's successor once removed, agreed with him: of the paintings chosen, 'the only items of aesthetic value were the little masterpiece *Low Tide at Boulogne* by Richard Parkes

[3] The Gallery's official receipt for the works is in the Trustee Company files. The Bonington was valued for probate at only £31 10s, compared with the Webb at £125, Creswick (£60), Beavis (£210), 'Rubens' (£550), Roberts (£12 12s), Wake Cook (£50) and the Buvelots £2 and £30. Other pictures selected included: John Clayton Adams, *Trespassers* (£125), Gerard Portieje, *The Old Bachelor* (£35), GA Campriani, *On the Grand Canal* (£15 15s), Keeley Halswelle, *Greenrobed Senators* (i.e. trees), (£105), Pollock Nisbet, *The Edge of the Forest* (£16 16s), James Baker Pyne, *Pandy Mills Wales* (£15 15s), after van Dyck, *Cornelius van der Geest* (£12) Frederick Whitehead, *Stony Weir* (£26 5s) Richard Wilson (later relegated to 'manner of'), *Landscape* (£15), William Leighton Leitch, *Italian Scene* (£31 10s), Max Ludby, *Riverscene* (£7), Roberto Angelo Kittermaster Marshall, *A Bit of Devonshire* (£30), James Webb, *Gloucester City and Cathedral* (£35), G O'Brien *Early Melbourne* (£15) and Gustavo Simoni, *The Marble Mosque* (£25). There were also two engravings and three large photographs of Roman Scenes; the bronze figure, valued at £25, was by Carriere Belleuse. The books were valued at £106 8s, the three Japanese ivories at £25 and the 'Art Cabinet' at £10.

[4] 'Plain Truth' supported Hall, but 'S. P. T.' urged the Trustees to take more of Felton's pictures before it was too late (*Argus*, 21, 25 and 26 April 1904). The Trustees had asked that Felton's pictures be transferred to the Gallery to facilitate the process of selection, but the Trustee company refused.

Bonington, and two early works by Louis Buvelot. How came these three fine paintings amongst such a sorry company?'[5]

The sale proceeded. On 27 and 28 April 1904 Gemmell, Tuckett & Co put most of Felton's paintings and water-colours under the hammer in their 'Art Galleries' in Collins Street, the proceeds advertised as going in equal parts 'to the Hospitals and the National Gallery'. Felton's other 'Art Treasures'—'Marble Statuary, Bronzes, Carved Ivories, Sterling Silver, Art Furniture, China, Curios etc.'—were auctioned separately on 29 April; the two hundred and forty-eight lots included forty-five bronzes, ten of them Japanese, and seventy-one Japanese carved ivories, described as 'undoubtedly the finest collection ever submitted to public competition in Melbourne'. Felton's phonograph and his hot-water kettle and spirit lamp, much used to regulate his digestion, were among more personal items. Unfortunately the outcome of that sale was not reported, and neither was the sale of his books and photographs on 5–6 May, for which no catalogue survives. The sale of the pictures—which did not include those at Murray Downs, which passed to Campbell's ownership with the property—was however widely reported, the proprietors of the *Australasian* and the *Leader* publishing, in three successive issues, a page of 'photographic reproductions' of the lots.

Lindsay based his argument that Felton's collection was of poor quality largely on an annotated copy of the sale catalogue, preserved in the Trustees' files, 'a most interesting document' because (he claimed) 'it shows the price Felton paid for the pictures, the value placed on them for probate and the prices they fetched at auction'.

> The purchase prices ranged in value from ten shillings to £1000. The last, the highest priced—a work by Peter Graham—was sold for £375 ... those that sold for a few pounds were possibly the best: an 'old' Crome for £6 10s. d.; a William Shayer—a charming little picture from the illustration—for £3 10s. od., and an R. P. Bonington, possibly of doubtful attribution, for £11.[6]

Lindsay added—to be 'only fair'—that

> Alfred Felton never laid claim to any specialised knowledge of the arts. He was first and last an amateur, delighting in the odd, the bizarre, and too often in the merely commonplace, with an occasional choice of real quality ... [in] a purely personal excursion by a man of affairs into a fascinating but alien field.[7]

[5] Lindsay, *The Felton Bequest*, p. 6.

[6] Ibid., p. 5. Lindsay added that another Bonington (a sketch) sold for £15 and three Buvelots for a total of £25 10s, while three Chevaliers and an oil sketch by Rupert Bunny did not attract a bid.

[7] Ibid., p. 6.

But if Felton had read even part of the substantial collection of books on art which the Gallery acquired from his library—including files of *The Studio*, the *Fine Arts Quarterly Review*, the *Art Journal*, the *Magazine of Art* and eleven volumes of Ruskin— he would have been an informed amateur, at worst. The Trustee Company at first ruled that the bequest did not cover books, but later allowed the Gallery to take those listed by the art valuers. (Either they, or the Gallery, overlooked Felton's beautiful copy of Edward Young's *Night Thoughts*, with William Blake's hand-coloured engravings, which had once belonged to Sir William à Beckett.)[8]

As proof of the inferiority of Felton's taste, Lindsay claimed that the sale (with some 171 items offered) made only £3500, against the probate valuation of £5000. He was in error: Lake and Stevens' valuation was £4867 for the whole collection, and after deducting the Gallery's selections (£1757) the £3050 fetched in the sale was within £60 of valuation; moreover what Lindsay took to be Felton's purchase prices in the catalogue cannot now be substantiated.[9]

The Gallery Trustees' motives in not selecting more were not as simple as Lindsay implied. Joshua Lake, in the Catalogue's 'Prefatory Note', gave another reason why they kept so few:

> Nearly all the greater names in this collection are already well represented in our Melbourne Gallery by suitably large and important canvases—many of them by more than one example. In view, therefore, of the wall-space needed for the large future accessions to come from The Felton Bequest, it would not have been well to duplicate these names by smaller or even similar works; and so the Gallery wisely refrained from selecting ... any works except those it needed to supplement its present vacancies.[10]

Lake even suggested that Felton's 'generous intention' would be best effected 'by the wide distribution among the private owners in Australia of these pictures that he so carefully gathered, and that he so much loved'. No doubt there were good commercial reasons for avoiding the implication that the gallery's leftovers were inferior; but it should also be noted that part of Bernard Hall's 'scientific' policy was to hold no more than one work by any artist at a time; if a better one turned up, he hoped to dispose of the first.[11]

[8] Zdanowicz, 'The Melbourne Blakes—Their Acquisition and Critical fortunes in Australia', in Butlin and Gott, *William Blake in the Collection of the National Gallery of Victoria*, p. 18. The books listed in the Gallery's receipt included four volumes of Salon catalogues, Jameson's *Italian Painters*, Waagen's *Art Treaures of Britain* (three volumes) and *Galleries of Great Britain*, four volumes of *The Portrait Gallery*, Viardot's *History of Painters* and books on *The Wallace Gallery*, the *Dresden Gallery*, the *Gallery of Contemporary Art* and on the *Pictorial Art of Japan*.

[9] *Argus*, 28 and 29 April 1904.

[10] Joshua Lake, in the Felton Collection Sale Catalogue 1904, pp. 5–6. The *Argus* (4 March 1904) gave as a reason for the Gallery leaving Felton's two Peter Grahams that it had three already.

[11] Cox, *The National Gallery of Victoria*, p. 52.

According to the *Argus*, the Felton sale did receive 'that public attention which its importance deserved'. Bidding was 'eager' for such Royal Academicians as Benjamin Leader, Vicat Cole and Peter Graham (whose *Highland Spate* fetched £375, from TH Payne, MLC (son of the Payne seen earlier, removing his strongboxes from the Oriental Bank); Payne's clergyman brother bought James Webb's *Coast Scene*. Sir Francis Suttor came from Sydney to buy Hick's figure study *Meditation*, which the *Argus* claimed 'had received the unanimous praise of the art critics and would have been a great favourite in the National Gallery'.[12]

On the second day the water-colours sold, at moderate prices, for £1075. The tiny *Boulogne* by HWB Davis, described as 'Mr Felton's pet picture', fetched £27 10s. The Adelaide Gallery paid 40 guineas for Weedon's *South Downs, Surrey*, and Norton Grimwade £90 for E Hargitt's *Changing Pastures*. TH Payne, 'after a very spirited contest', bought JH Mole's *Rustic English Cottage*, and 'Sir Francis Suttor roused the chief interest of the sale by his eager bidding for *The Boccaccio Romance* by Charles Cattermole RI, which so many people regret was not retained by the National Gallery'. A dealer, H Solomon, bought many pictures on both days, 'chiefly for a buyer who is forming a private collection, and does not wish his name at present disclosed'.[13]

We have one eyewitness account of the sale exhibition which does support Lindsay's view that the paintings were mediocre. Percival Serle, then a young man eager to learn about art and life, attended the exhibition, and encountered there the respected landscape painter John Ford Paterson. Paterson had settled in Australia (from Scotland) in 1884; a friend of Buvelot, he had joined Roberts and others in breaking away from the Victorian Academy of Art to found the Australian Art Association, and to merge it in 1888 into the Victorian Artists Society, of which he became President in 1892. Lionel Lindsay praised Paterson, but said 'his ideas were greater than their fulfilment'; he seemed happiest singing Scots songs on smoke nights, but he was a Trustee of the National Gallery and an influential figure. He certainly influenced young Serle:

> It was [John Ford] Paterson who first taught me something about painting. When the pictures which had belonged to Alfred Felton were exhibited in 1904 I went to see them, but though many were ascribed to famous artists, I found them very disappointing. Paterson was in the room and I confided to him the trouble I was in. He was interested to find someone anxious to learn and took me in hand. 'Man', he said 'these artists never saw those pictures, they are fakes and largely pot-boilers'. Then he

[12] *Argus*, 28 April 1904.

[13] Ibid., 29 April 1904.

went round the room showing me some of the recipes certain artists had for doing their work ... For long afterwards I would find myself murmuring 'pot-boilers' to myself as I came out of shows. I would scarcely have believed that any man could have taught me so much in so short a time.[14]

Paterson was not mentioned as one of the Trustees who decided which of Felton's pictures to keep (unlike John Mather, whose *On the Yarra at Footscray* was in Felton's collection, but sold, for £4). So much of Felton's collection is now dispersed that its quality cannot be easily assessed, though the recent reappearance of photographs of his gallery will help; but whatever the level of Felton's own taste might have been, he made ample provision to elevate that of others.

AFTER FIRST MEETING in May 1904 to confirm its membership, the Felton Bequests' Committee was not called together again until September, to be told by the Trustee Company that there would be funds—some £5000 for art and £5000 for charity—to spend in December. When Cecil Rhodes died, the year before Felton, his Trustees in London had found themselves constrained in choosing young men 'for the world's fight' by the entry and other requirements of Oxford University; Felton's Bequests' Committee now had a similar but stricter requirement: the Committee had the obligation to buy works of art, but the National Gallery authorities alone could decide what they would accept. In November 1904 the Committee asked the Trustees 'to intimate what course of action' they proposed to adopt under the terms of the will; the continuing conversation on how, when and where to buy art, and what art to buy, had begun.[15]

The five worthy gentlemen on the Committee were not obliged to seek similar advice on charity, and felt no need to do so. All were well steeped in Victorian views on the matter, and at least two were active in charitable organisations; they saw few problems in distributing the income of the Trust reserved for such purposes, and no need to appoint an outside adviser. The will restricted them to making grants 'for the aid and advancement of such objects as are charitable in a legal sense', a matter of some nicety at the edges, but not in the accepted centre.

The Charitable Uses Act of 1601, 'The Statute of Elizabeth', had been repealed in England in 1888, but its spirit—literally—lived on: the repealing act

[14] A passage from Serle's unpublished Autobiography, sent to JRP by Geoffrey Serle, and quoted in part in his *Percival Serle*, p. 22. Percival Serle, 1871–1951, at this time a young accountant, was to be deeply involved with the Gallery in later years. On Paterson, see Marjorie Tipping's entry in *ADB*, vol. 5, and Percival Serle's in his *Dictionary of Australian Biography*. Paterson's *Bush Symphony* was bought by the NGV in 1900.

[15] FBC, 22 September 1904.

required that references to charities be understood 'within the meaning, purview, and interpretation of the preamble to the statute'. That preamble was itself an odd statement, at once detailed and incomplete, of 'charitable purposes':

> The relief of the aged, impotent and poor people; the maintenance of sick and maimed soldiers and mariners, schools of learning, free schools and scholars in universities; the repair of bridges, ports, havens, causeways, churches, sea-banks and highways; the education and preferment of orphans; the relief, stock or maintenance of houses of correction; the marriages of poor maids, the supportation, aid and help of young tradesmen, handicraftsmen and persons decayed; the relief or redemption of prisoners or captives; and the aid or ease of any poor inhabitants concerning payment of fifteens, setting out of soldiers and other taxes.

Few today would hold the repair of bridges or the marriages of poor maids to be charitable causes, but because the list was obviously not exhaustive—omitting, for example, the advancement of religion—its interpretation could be flexible. By the nineteenth century the courts had ruled that charitable purposes had to be for the public benefit as well as within 'the spirit and intendment of the Preamble to the Statute of Elizabeth'; and even in Australia, in 2001, the draft Report of the Inquiry into the Definition of Charities and Related Organisations proceeded not by attempting a new definition but by listing categories to be included within the test of public benefit. The Bequests' Committee had Victorian custom to guide them, and also PD Phillips; it was he who advised that they could not consider applications from individuals, or support charitable institutions outside Victoria, on his 'strong presumption' that the testator had not so intended. After rapidly gathering proposals and submissions from eligible organisations, and assessing them at two meetings in October, the Committee made the first allocations in November and December 1904. An early decision to make grants only in Melbourne was later reversed, but there were no country institutions in the first list.[16]

Felton's advice to his Committee, not binding but persuasive, urged them to favour 'first charities for children', 'secondly charities for women' and thirdly such organisations as 'General Hospitals, Societies for the relief of the educated poor and other charitable institutions of a general character'. On the face of it, the first distribution scarcely respected his priorities: more than three-fifths of the £5000 disbursed went to hospitals, and although the Women's and the Children's Hospitals each received £500 the Melbourne Hospital, low in the priorities stated in the will despite Felton's one large donation to it in his lifetime, was

[16] Ibid., 22 September, 13 and 19 October, 10 November and 7 December 1904. PD Phillips' opinion was given on 28 September 1904. In July 2003 the Australian government announced legislation re-defining charity.

given £1000. (When the Melbourne still received twice the grant to the Women's in December, the departure from Felton's priorities was noted at a meeting of the Women's Hospital, and reported in the press.)[17] The Convalescent Home for Women received £100 (appropriately twice the grant to the Convalescent Home for Men) and the Queen Victoria Hospital—an unusual institution run and staffed by women for women—also received £100, but the Alfred Hospital was given £300 and the Homeopathic Hospital (later Prince Henry's) £150.[18] The hospitals were of course major charitable institutions, and certainly eligible; it is also clear that members of the Committee were involved with them, and aware of their needs.

PD Phillips had given the Committee copies of Felton's own charitable distributions in 1900 and 1903, and the rest of the seventy-three institutions which shared the Trust's first distribution were listed in categories which reflected his own practice. The eighteen Children's Institutions were mostly orphanages or homes for neglected children: the Victorian Infant Asylum and Foundling Hospital received the largest grants—£50, and £200 for the New Wing Building Fund—the rest (including the Victorian Society for the Prevention of Cruelty to Children, which Felton had not supported) receiving £410 between them. The nine women's institutions were more varied in title and purpose, the Governesses' Institute, the Gentlewomen's Aid Society and the Pilgrim's Rest for Aged and Destitute Gentlewomen having different functions from the Carlton Refuge or the Elizabeth Fry Retreat (or the Singleton Temporary Home for Fallen and Friendless Women, first supported in 1906). The Presbyterian Sisterhood of Warrnambool was more enigmatic. Thirteen ladies benevolent societies received small sums, one in Melbourne and the rest in the suburbs ringing the city—Brunswick, Coburg, Essendon, Flemington and Kensington, Footscray, Port Melbourne, South Melbourne, St Kilda and Caulfield (a Society Felton had earlier supported), Prahran, Toorak, Richmond and East Melbourne, and Hawthorn—a formidable network of charitable endeavour. Mrs Strong's solitary crèche in Collingwood now had companions in Brunswick, North Melbourne, Richmond and Prahran-South Yarra-Toorak; each received £10.

The most varied group supported were the general philanthropic institutions, some thirteen receiving £610 between them. Felton's own favourites, the Old Colonists' Homes and the Charity Organisation Society each received £50, with

[17] *Herald*, 22 December 1905.

[18] Other grants went to St Vincent's Hospital (£50), the Eye and Ear Hospital (£100), the Victorian Sanatorium for Consumptives (£100), the Dental Hospital (£20), the Williamstown Hospital (£20) and the Melbourne District Nursing Society (£100).

a larger sum (£100) going to the Society to Assist Persons of Education. The massive Melbourne Benevolent Asylum, not yet moved from North Melbourne to Cheltenham, received £65; smaller grants went to organisations for the blind, the deaf and dumb, the St Vincent de Paul societies, the Discharged Prisoners' Aid Society and—a cause becoming mercifully redundant—the Victorian Shipwreck Aid Society.[19]

The Bequests' Committee's charitable programme was clearly eclectic, embracing virtually all the varieties of charitable organisations existing in Melbourne at the turn of the century. The Committee's decision to include country charities, made before the second distribution, of £3700 in June 1905, spread the benefits even more thinly. Nine country hospitals, two benevolent asylums and three combined hospitals and benevolent asylums, at Ararat, Hamilton and Ballarat, joined a list which was to grow even longer.

There is no record of how the Committee set its priorities—in so far as it had any—in charitable support. During 1905 individual applications, and the outcome, were occasionally reported at Committee meetings. The Barrier Boys Home of Broken Hill was thought ineligible, and the application received in June 1905 from the Women's Political and Social Crusade did not find favour, though Felton had supported both. Asked to distinguish between the Adult Deaf and Dumb Mission and the Victorian Deaf and Dumb Institution the Committee did so in its next distribution, while the St John's Ambulance Association received a special donation 'towards providing a third waggon'. In October the Social Improvement and Neglected Children's Aid Society of the Australian Church was told that their 'request for a donation towards their Picnic Expenses Fund was outside the scope of the Bequest', a reply Felton himself might not have given.

Soon individual members of the Committee began to commend particular charitable causes for support. Bage brought a request from the Board of Public Health for a grant to provide consumptive patients with such necessities as overcoats and pyjamas; it was eventually refused, on the grounds that the Sanatorium for Consumptives at Greenvale—though an institution Felton had helped during his lifetime—was a government institution and not a charity. Levey's requests for £100 for furniture for a new wing at the Austin Hospital for Incurables, and for another £100 towards Lady Talbot's Fund for a Home for Epileptics, were both granted. When Bage 'mentioned' a Refuge for Women at Berwick 'principally supported by a Mrs Watson', the Charity Organisation Society was asked to report.

[19] Others in this category (to which the convalescent homes were later transferred) included the Richmond Free Dispensary, Salvation Army Social Work, the United Service Home for Infirm Soldiers and Sailors and the Victorian Association of Braille Writers.

At its meeting in October 1905—at which Langton's unexpected death was reported; Mather took his place in December—the Bequests' Committee appointed Grimwade and Levey a sub-committee 'to draw up a scheme' for the next Charitable Distribution. They had been asked at the April meeting to send out circulars informing charities of an impending distribution, and their role became continuing; the sub-committee sought, received and considered applications for charitable grants, and prepared recommendations for the Committee to consider. (When Levey went overseas for twelve months from May 1906, Bage took his place; and when Grimwade was absent in 1908, Levey and Bage served together.) There is no record of the sub-committee's procedures (in 1907 they did insist on written applications from all recipients) or of how they reached their recommendations and which applications they rejected; the charitable activities of the Committee, although announced twice-yearly in the press, became in other respects confidential, in sharp contrast with the publicity surrounding the Art Bequest.

In December 1905, £4000 was distributed to charities, and a further £4340 in June 1906. These were large sums, but with 126 grants distributed in June the average amounts became smaller. Even a new category of special grants to building funds, introduced with donations to the Missions to Seamen, the Women's Hospital, the North Melbourne Crèche and the Ovens District Hospital, totalled only £320. The largest grant in June 1906 still went to the Melbourne Hospital: its £500 was twice the grants received by the Children's and by the Women's Hospitals, and grants of even £50 were rare among the children's and women's institutions; help to the Jewish Orphan and Neglected Children's Aid Society and to the Singleton Temporary Home for Friendless and Fallen Women fell to £5 each, twice a year. When, in 1907 the amount available for allocation each six months fell to £3500—the Trustee Company explaining that some assets had been realised, and invested perforce in trustee securities—the Committee's response was to reduce the Melbourne Hospital's grant from £500 to £450, and to deal similarly with most on the list, though a few small recipients were dropped. By 1909 the amount available had diminished further—£3185 in June and £3445 in December, spread even more thinly over 130 institutions—and in January 1910 some charities complained about the reductions. In October 1910 the Committee did authorise a large grant of £1000, to be paid in two instalments, to the Childrens' Hospital Fund, leaving only £3101 for other charities in December, but that was an exception in a pattern set and accepted. With so many organisations supported, it is possible that the Committee was occasionally misled into making grants to some which were ineffective, though the web of charities was well enough known to those working within it, and especially to

Levey and others associated with the Charity Organisation Society, to make it unlikely that the Committee was often imposed upon.

This pattern of distribution (and the totals allocated) closely resembled those of the Edward Wilson Estate—indeed the published lists could have been mistaken for each other but for the headings—and also of the TJ Sumner Estate, another trust administered by the Trustees Executors and Agency Company. But in 1907, when John Russell McPherson left a substantial sum for the benefit of charitable institutions, he admonished his trustees that 'they should not automatically distribute the income year by year amongst certain particular institutions', but should 'satisfy themselves which institutions throughout the state would be most benefited by the receipt of a substantial donation'.[20] That approach was welcomed by RJ Alcock, Treasurer of the Victoria Missions to Seamen—naturally enough, since his organisation received £500, enough to complete the first section of the Missions' building at the foot of Spencer Street—but the Felton Bequest, like the Wilson Estate, continued its broad distribution.

No doubt even small grants were useful to the recipient organisations, but it could not be said that Felton's funds affected, in these years, the general pattern of Victoria's charitable activities or greatly influenced its development. The charities, and the Committee, came to see the customary distribution as inevitable; when, in February 1915, the Committee was asked by the Reverend Dr Strong—who else?—to provide funds to relieve those made unemployed by the outbreak of war, the plea was rejected as 'prejudicially affecting' the institutions usually supported. The pattern persisted even when the funds available for distribution to charities rose to more than £15 000 by 1920.[21]

Had an opportunity been lost? Felton's own charitable activities had been flexible and idiosyncratic, and no institution bound by the laws of trusts and charities could emulate them. It was also still commonly assumed that the welfare—and health—of Victorian society depended on a very large number of voluntary charities, all of them accustomed to gathering resources in small sums from a great many sources. How far the network as a whole was effective in meeting the State's needs was not discussed by the Committee; the introduction—with remarkably little debate—of old age pensions, first by New South Wales and Victoria and then by the Commonwealth in 1908, implied that the charities, even though subsidised, were not enough, and that other forms of direct state intervention would

[20] *Argus*, 8 August 1907.

[21] FBC, 12 December 1905, 19 June and 8 December 1906, 14 June and 17 December 1907, 23 February 1915; *Argus*, 25 June and 21 December 1920.

soon reach the public agenda. The longevity of Levey perpetuated older assumptions about charity among Committee members into the 1930s and 1940s; but it remains a pity that no one on the Committee asked the question which was soon to dominate debate on the Art Bequest: should we not use Mr Felton's money to achieve a few items of real importance, rather than fritter it away on minor, if worthy works? The question was eventually asked about charity, but not yet. Nevertheless the comment of Sir Clive Fitts, the Committee member who led that later discussion, that he doubted whether earlier members 'gave much thought to the charitable bequest', was itself uncharitable.[22]

As soon as he heard of Felton's bequests, Bernard Hall, Director of the National Gallery, resubmitted to the Trustees a major document on the buying policy of the Gallery which he had prepared in 1900. A national gallery, he argued again, should be 'a museum of art reference', in which every purchase should illustrate some phase of art, in an orderly presentation of the best of its kind and period. This was the 'scientific procedure'; unfortunately Melbourne's collection was haphazard and mediocre, a chance conglomeration of items selected by laymen and by artists 'responsible and irresponsible', or received by presentation. Great movements in modern art, for example the Pre-Raphaelite, had been entirely overlooked. Successful acquisition required the services of 'a trustworthy agent of trained judgement, who presumably would have the interests of the Gallery at heart, and is fully alive to our aspirations . . . It is the *amateur* and the *irresponsible artist* that I am afraid of'.

Although reticent in conversation, Hall was outspoken on paper. In a covering letter sent with the report in March 1904, Hall told the Trustees that the Felton Bequest made it possible to emphasise 'the purely artistic side of the question, as opposed to the popular'. Felton had wished to improve public taste, and the Trustees should expect some unpopularity in following his wishes, since 'the original taste of man is always for the obvious and the common place, and . . . it is only by great labour and care that man learns to understand as beautiful that which the uneducated eye considers ugly'. Throughout his long tenure as Director Hall almost always had enemies among the Trustees, and his statement that 'art illustrates nothing but its own particular point of view' and 'had nothing to do with the ethics of the Sunday-school—bad workmanship is the only immorality known to it', infuriated eighty-four-year-old James Smith, Chairman of the Trustees' National Gallery Committee. In his long career as an art critic—probably the most distinguished (and conservative) of his generation—Smith had always

[22] Ibid., 19 August 1971.

Lindsay Bernard Hall at home, c. 1900 (La Trobe Picture Collection, State Library of Victoria)

argued (echoing Ruskin) that it was morality, not taste, which required elevation. In 1889 he had likened the famous exhibition of 9 × 5 Impressions to 'the incoherent images which float through the mind of a dyspeptic dreamer'.[23] The Gallery's function, he now argued, was to stimulate 'the moral and spiritual faculties', and subject matter should therefore be paramount; the uplifting pictures of yester-year, decried by Hall, should not be replaced by 'Mr McCubbin's lively family of ducks and ducklings', let alone by imported immoralities.[24]

The Trustees made no resolution concerning Hall's and Smith's letters, but dissension concerning them was nevertheless in the background when they

[23] The exchange is printed in Smith (ed), *Documents on Art and Taste in Australia*, pp. 202–10. White compares it with the Ruskin–Whistler exchange (*Inventing Australia*, pp. 91–2).

[24] Quoted by Cox, *The National Gallery*, pp. 59-60.

responded to the Bequests' Committee's request for advice by proposing a meeting. Late in October 1904 a small sub-committee unanimously recommended to the Trustees 'that only high class works of art be purchased under the Felton Bequest' and that £1000 be reserved each year to accumulate funds for major acquisitions, but Professor Spencer dissented from a further resolution that £3000 'be entrusted to Mr Longstaff [then in London] for the purchase of one or more high class gallery pictures which in his judgement will be a credit to the National Gallery'. When the Trustees met on 9 November Spencer successfully moved—eight supporting, but Langton, Turner, Paterson and James Smith dissenting—that the Gallery adopt 'some comprehensive and scientific scheme' of acquisitions under the Bequest, with the advice of 'acknowledged experts', and that the Director be sent to England 'to inaugurate' the process. (They also resolved that the name of the selector be printed on the label attached to each Bequest purchase, a decision never implemented.)

These resolutions were not mentioned when a committee of Trustees—Turner (Vice-President), James Smith, Spencer, and Mather—met the Bequests' Committee (including, of course, Langton, the Trustees' President) on 23 November 1904, in an exchange which produced more questions than answers. Could the Committee delegate its power to purchase to the Trustees? Could Bequest moneys be held over from one year until later, to facilitate major purchases? If so, could such amounts be invested? The Trustee company ruled that carry-over and investment were permissible, and ruled also on the 'relative functions of the Committee and the Trustees of the Gallery', confirming that the Committee could not delegate its responsibility to approve all recommendations. Told later that the Trustees had agreed that 'someone' should be sent to Europe to make arrangements for 'obtaining skilled assistance', the Committee approved the expense as a legitimate charge on Bequest funds.[25] On 19 December 1904 they at last received the resolutions passed by the Trustees six weeks before, 'for the purpose of worthily and consistently carrying out the terms of this munificent bequest'. To develop a 'comprehensive and scientific scheme', the Director should be sent to England—if the Government consented; the Director, like all Gallery staff, was a public servant—to communicate with 'such of those experts as may be willing', and 'to acquaint them personally with the aspirations and needs of the Gallery, and the desires of the Trustees'; he should also be empow-

[25] FBC, 7 December 1904. The Committee formally noted that it could not delegate its powers to the Trustees on 19 December 1904. At that meeting the Committee received letters from two Italian sculptors commending their own work; the Committee referred both to the Gallery for consideration, and was thereafter scrupulous in passing on such approaches.

ered to spend £4000 at his discretion. The Bequests' Committee agreed, with the small amendment that Hall be authorised to spend £3600, the remaining £400 being reserved for his expenses. They also adopted the Trustees' resolution 'that at least £1000 be reserved and accumulated each year', asking the Trustee Company to invest that amount in government securities.[26]

Bernard Hall was sent his instructions on 30 December 1904, the Trustees adding three that had not been seen by the Bequests' Committee. Pictures were to be preferred to other works of art; but he was nevertheless to enquire concerning 'a companion statue to *St George and the Dragon* in front of the Library', and 'also as to obtaining a bronze Lion and Lioness to replace the zinc copies now on the steps'. (Bought on Redmond Barry's advice in 1876 and now decrepit, the pair had, when new, served one unusual purpose: Marcus Clarke, journalist, novelist and idle Sub-Librarian, used on arrival to place an unfinished cigar in the mouth of one, indicating that he was 'in' and at home to his thirsty friends.) Hall seems to have ignored a third instruction, that 'as far as practicable' he was to 'seek the co-operation' of Longstaff, and also of George McCulloch, the Australian collector.[27] He set off on his mission at once, and arrived in London in February 1905.

LINDSAY BERNARD HALL was a strong figure. As an artist he had been thoroughly trained, in London, Antwerp and Munich, and he painted meticulously in the Munich style, already introduced to the Gallery's Art School by his predecessor Folingsby. No one questioned Hall's skill, though many students resented his insistence on technique, and his own highly finished paintings went out of fashion during his lifetime. 'Strait-laced and eagle-eyed', as Arnold Shore recalled him, he was a reticent man of firm opinions, too easily assumed to be narrow-minded. He was certainly principled: in 1909, when the Felton Committee proposed that one of Hall's own paintings, *Reverie,* be purchased, he thanked the committee but opposed it on the grounds that he was officially connected with the Gallery. No purchase of his work was made until 1919.[28]

[26] Ibid., 19 December 1904. A further £1300 was later made available to Hall. In March 1906 the Committee passed on to the Trustees PD Phillips' advice that it could not pledge future income 'to obtain a work of peculiar value, but if an exceptional opportunity arose the Committee would have no hesitation in agreeing to the payment of a reasonable deposit out of moneys in hand and allocating instalments out of future income as it becomes available until the purchase was completed, limiting the amount of any one purchase to two years' income say £16 000'. Phillips advised the Committee that it was obliged, however, to distribute all the income of the charity bequest each year.

[27] Langton to Hall, 30 December 1904 (Hall papers). On the zinc lions, see Burt, 'Marcus Clarke at the Public Library', p. 57; and on Hall's first mission as Felton Adviser, see Saunders, 'L Bernard Hall and the National Gallery of Victoria', ch. 5.

[28] Cox, *The National Gallery*, p. 67, n. 29.

Hall, with a broad experience of the European art world, an intimate knowledge of the Gallery's collection and firm opinions on its needs, was pleased to be sent on this 'unique' mission. He had less to spend than the £10 000 of Elder funds Gill had to dispose of in London in 1899, but there was much more to come from Felton's estate, and he had more freedom: Gill had to work with a London committee appointed by his Trustees—a powerful trio, Sir Edward Poynter, President of the Academy and Director of the National Gallery; Ernest Waterlow, President of the Royal Watercolour Society; and Edward Gregory, President of the Royal Institute of Painters in Watercolours—sitting with South Australia's Agent-General. With their approval Gill had acquired forty-two oil paintings (twenty-seven of them British), fifteen water-colours and thirty-six drawings, all by living artists whose status was accepted in the academies. Within those limits he chose extremely well, though when he returned home Robert Barr Smith insisted that his brother-in-law had intended that his Bequest be spent on old masters, not contemporary art. Gill responded that if spent on old masters the Bequest 'would melt like snow'.[29] In 1905 Hall did not look for old masters either, and was in some ways more cautious than Gill, though his own circle, the New English Art Club, was more progressive than that around Poynter, the august Olympian.

'My report on trip home', as Hall entitled his copy of the account he gave to the Chairman of the Gallery Committee in July 1905, is an engaging document, youthful in its enthusiasm. His 'original intention' had been to acquire works over the whole field of the Gallery's collections, but he had 'restricted' himself to 'Sculpture, Painting and Drawing', still a broad assignment. A hard bargainer, but very confident of his own judgement, he haggled but did not hesitate. 'I arrived in London in February just in time to see the last of the International Exhibition, held in the New gallery', he began, 'where I selected "La Femme couchée" (£40) a small, but good, example of [Edmond Francois] Aman-Jean's work, one of the most refined of modern French artists, and one whose work I was looking out for'. Prudes in Melbourne disagreed about the work's refinement, but Hall's tastes were less narrow than his later critics alleged, as his next paragraph—perhaps the most tantalising episode in the history of the Felton Bequest—shows:

> My next purchase was "Boulevard Montmartre" by Pissarro (£300), selected after 8 or 9 visits to the Impressionists Exhibition at the Grafton Gallery. I got special quotations, 25% discount for many of them, and would like to have secured a Monet, a Degas and a Sisley, but, apart from the best of them being held privately, the prices were prohibitive. It was a good opportunity for buying some example [sic] of this

[29] Trumble, 'The £10,000 London Buying Spree of 1899 and Beyond', in *The Story of the Elder Bequest*, pp. 67–78.

group, as, with so many shown side by side, one could compare them more easily. I may mention that there are six examples of Pissarro in the Luxembourg.[30]

But not, alas, in Melbourne. Hall was too thrifty: 'one cannot help wishing that he had had more funds at his disposal in that year', a later Director of the Gallery wrote in 2000.[31] Had he bought more Impressionist works in 1905 some later arguments would have been forestalled, though no doubt to be replaced by others. Nevertheless he chose well: *Boulevard Montmartre* is now considered one of Pissarro's greatest works.

Smaller acquisitions in London included three pen and ink drawings at the International Exhibition; four Charles Keene drawings (acquired at 50 per cent discount from his widow, though the British Museum had bought the fifty best on the day of his death); drawings by Hall's friend Fred Pegram and FH Townsend, two other *Punch* artists (now forgotten); a 'quaintly original' drawing by Arthur Rackham (an artist 'seen a good deal on this visit'); and three old English water colours (one by Tom Collier, an 'unfamiliar' name, but a 'classic') at an exhibition at Agnews. 'It was here I first saw Turner's "Okehampton" and coveted it from the first'; fortunately the Bequests' Committee, told by the Trustees of the opportunity to buy the great Turner water colour which Ruskin had owned and admired, provided an additional £1400, and Hall, after searching out its provenance, in May beat the price of *Okehampton Castle* down to £1100.

'Fourteen visits and innumerable letters', and a trip to Paris to see the sculptor, were needed to commission two bronzes from Alfred Gilbert. In March Hall went to Birmingham, in a vain attempt to persuade its gallery to share some of the three hundred Burne-Jones drawings they had just bought for £5000; but going on to Liverpool he found and fell for Ford Madox Brown's cartoon *The Baptism of Edwin, King of Northumbria*, again beating the price down, from £800 to £500. Later, in London, he heard that Madox Brown's *The Entombment,* which he had long admired, was for sale for £1000; and then, among 'pictures from the north', the same artist's *Haide and Juan,* a water-colour of 1869, appeared, for £130. After haggling the price of *The Entombment* down from £1000 to £750 and finally to £400, Hall broke his own rules in buying all three works, claiming he did it

> in order to make good the representation of one man, rather than to cover a wide field merely for variety's sweet sake. If the sum placed in my hands had been a casual grant I

[30] Hall to the Chairman of National Gallery Committee, 'Report on recent mission to Europe and acquisitions resulting therefrom, with recommendations with regard to the continuous spending of funds derived from the Felton Bequest', 27 July 1905 (Hall papers); and see Cox, *The National Gallery*, pp. 62–4.

[31] Vaughan, Introduction to *European Masterpieces*, p. 10.

should perhaps not have done this, but because it was an instalment only of a continuous supply, I could not resist such a beautiful bit of work ... In my opinion, any one of our three is better than the examples they have in the Luxembourg or the Tate Gallery.[32]

Hall had earlier commended Madox Brown to the Trustees; and even the critical Daryl Lindsay approved his purchase of *The Baptism of Edwin* and *The Entombment* as 'splendid examples of the Pre-Raphaelite School'.[33]

Hall was later to regret spending £350 on *The Importunate Neighbour*, bought 'after spending a morning with Mr Holman Hunt and seeing all the work he had in his house, I tried to get it for less, but could not—"even for a public gallery"'. It proved popular in Melbourne. After many visits to the Royal Academy, he bought (for £350) his friend George Clausen's *The Ploughman's Breakfast,* as the best for sale, 'a picture that will wear well'. He later bought a wood engraving by Frederick Sandys, 'old fashioned in manner but Sandys has a certain standing amongst the big outsiders'.

In April, Hall arrived in Paris in time for a sale of Daniel Vierge drawings by his widow, paying £76 at auction for 'one of the best' from the Don Pablo di Segovia series, and later acquiring four more. He spent £100 on two bronze groups of animals by Antoine-Louis Barye ('much sought after; the Louvre has a complete set'), and was pleased to get a specimen of Meissonier, the 'little panel' *L'aumone*; because it was 'incomplete in parts', he paid only £480, while others 'of the same size' were fetching from £2000 to £12 000. His major acquisitions in Paris came from a morning expedition (accompanied by Rupert Bunny) to Meudon, 'looking through M. Rodin's large studios there', and a later visit to the sculptor's town studio. There he commissioned (for £100) a casting—having seen the original in the Luxembourg—of the *Head of J. D. Laurens,* revered teacher of Bunny and other Australians, and bought for £239 the exquisite *Minerve sans Casque* (a marble head with an Australian connection, the model being Mariana Mattioco della Torre, wife of John Peter Russell; Rodin thought her the most beautiful woman in Paris). Hall also coveted a small bronze, *Le Lion qui pleure*, but decided the price (1800 francs) was too high.[34] Hall exhausted his funds buying for £180 a small oil, *Prière dans la Chappelle,* by Eugene Isabey, 'one of the famous band of the Romantic School of 1830', and although he went on to visit Munich, Vienna, Berlin and Dresden he bought no more.

[32] He also bought a volume of Brown's cartoons for £10; admitting it belonged 'more properly to the Art Library', he recommended its transfer from the Gallery.

[33] Lindsay, *The Felton Bequest*, p. 28.

[34] On Hall's dealings with Rodin, see Anderson with Paffen, 'The Sculptor Writes', pp. 125–37; and Reddin, *Rupert Bunny Himself*, p. 119.

Hall bought thirty-eight works in all, six oils, seven water-colours, sixteen drawings, three engravings, five bronzes and one marble, for £4897 12s; twenty-five were by British artists, thirteen by foreign.[35] He had turned over many dealers' stocks and been to many auctions, but having 'no sum behind me to top up the fashionable and well advertised things', had 'rather sought for the good things outside the spell of this charmed market. I have sought for neither pretty nor fashionable work, but for what were sound and even brilliant examples, by men whose work is held in the highest esteem by their brother artists'. He had bought only established artists:

> those using public funds, I hold, should no more allow themselves to speculate on the form of 'coming artists' than the State allows others to invest 'trust funds' in 'coming mines' or 'moral certainties' on the racecourse. A public collection cannot be purged like a private one . . . A little more may be paid some times, as is the case with trust investments where a similar income is looked for, but fewer mistakes will be made.

Hall foresaw criticism that 'apart from M. Brown's cartoon, the works obtained are insignificant in size, if many in number'; but claimed that he had 'struck the 'classic' note . . . over a score of times. I venture to think that in itself will at once raise the level of our aims in the eyes of collectors, dealers and artists, and make it easier for us to collect in the future'. He 'might have come back with one picture, but that would not have influenced our collection'.

In his own eyes at least, the purchasing half of Hall's mission was thus a success. He found his second task, finding experts to assist in the future purchase of works of art, much more difficult. In theory he did not want an artist, but in practice sought one. 'The difficulty is to get a man of broad views . . . as nearly every practising artist is more or less wedded to some clique, school or Association, and finds it difficult to regard judicially any outside work.' He tried: 'I discussed this question with many artists', and even 'made a point of reading through the Blue book containing a verbatim report of the Royal Commission [*sic*] of the House of Lords appointed to review the Royal Academy's administration of the Chantrey Bequest'. He spent an evening with DS MacColl discussing the problem, and 'sounded Sir Charles Holroyd, keeper of the Tate gallery, who, though very sympathetic and willing to assist if he were able, would not undertake the responsibility, as it would trench on his public and private work too much'. Eventually Hall's friend George Clausen 'came up from the country and

[35] Ann Galbally has observed that Hall's purchases in 1905–6 were divided between those artists who had impressed him in his youth and 'great contemporary or near contemporary masters, Rodin, Pissarro, Ford Madox Brown and Edward Burne Jones' (Galbally, *The Collections of the National Gallery of Victoria*, p. 172).

spent a night with me, and, after a good deal of hesitation, sent me the enclosed letter saying he would accept the position of adviser if the Trustees decided to make use of him in this capacity'. Clausen, like Hall an early member of the New English Art Club, and soon to become an RA (and later a Professor in the Academy schools and a knight) was prepared to act, for 5 per cent commission 'to cover expenses'. Another old friend, Walter McEwen, an American who had lived in Paris for twenty years, offered to advise 'in a friendly way'. 'These two men, with Mr Joseph Pennell for black and white work, are the ones I would recommend as being the safest and most reliable I can think of.'

The Art Museum was a worse problem. The craftsmen themselves 'might as well be wearing blinkers', and his hopes for help from 'the three great museums' were disappointed when the South Kensington and British Museums refused to let staff members act. Hall was 'more fortunate' in Paris, where the Louvre allowed the very distinguished Jean-Jaques Marquet de Vasselot, a specialist in oriental work and medieval enamels, to agree to search out works for Melbourne. 'I feel inclined to recommend him with every confidence', Hall wrote.

It is clear from the report that Hall expected these men to be advising him personally, and assumed that as Director of the Gallery he would be at the centre of a process he had already begun.

> All the circumstances of my mission conspired to make it, I think, an unique one. The fact that a Committee had not been appointed, and that for the first time in the history of the gallery, the sole responsibility of selection had been placed in the hands of your salaried adviser, was distinctly a new experiment. I received your charge as a high honour, and was at 'Home' very generally congratulated upon the terms of my commission.
>
> It was the opportunity of a lifetime, as it gave me an occasion for putting into practice, as far as my means and time allowed, those principles of National collecting which I have advocated for so many years.

He was to be disillusioned; and it was indeed almost a lifetime before the opportunity recurred. It is ironic that among those Hall thanked for helping him in London was 'Mr Frank Gibson, late of Melbourne', who was to become the Felton Adviser whose role in the selection of works of art Hall most bitterly resented.

Returned to Melbourne, Hall presented his report. The Bequests' Committee, at their meeting on 16 August 1905, noted the 'care and trouble' the Director had given to his mission, and Hall 'then joined the meeting and was thanked'.

IN JULY 1905, even before his purchases were seen in Melbourne, the *Argus* announced anonymously that 'the result of Mr Bernard Hall's mission to Europe does not appear to be very promising'. He 'would have done better to bring back

one or two really important pictures', a view supported in detail in a letter from 'Blighted Hopes', and answered by Hall, who must have been hurt by the criticism but never shrank from defending himself; £3600 was an 'insignificant' amount at the top end of the market, where a Whistler could bring £10 000. He had used the funds systematically, to best effect. But not to common approval: 'Why Mr Bernard Hall should have bought a Pissarro is difficult to conceive', the *Australasian* grumbled, again without seeing it.[36]

When all but two of Hall's purchases were displayed in the National Gallery in August, the *Argus* complained that 'it is to be regretted that the collection, with the exception of two works, affords neither pleasure nor enduring satisfaction'. (The exceptions were Turner's 'placid little watercolour drawing', and another by David Cox.) The Pissarro merely 'conveyed blurred movement that one often sees in a faulty biograph'. Hall again defended his purchases, quoting many authorities, but his learned essay was dismissed as a 'laboured column of excuses' by 'Your Art Critic'; and when Hall attacked the critic for abusing the mask of anonymity, the Editor defended his staff. 'Merit not Name' produced a list of local works from the current Victorian Artists Exhibition, as good as everything Hall had bought overseas—except, he conceded, the Turner—and all available at 'a tenth the price paid'. Hall must have been pleased when the *Age* published a persuasive argument that 'on the whole Mr Hall has done excellent work', especially in buying a Pissarro for £300. 'It cannot be stated too often that a public gallery should be an educational institution, for which representative examples of only the leading men and movements should be selected.' Melbourne could build 'one of the finest modern collections in the world', if a 'scientific' policy was rigorously pursued.[37]

Hall had friends as well as enemies, and it would soon emerge that the Gallery Trustees and the Bequests' Committee included both. Some were ambivalent; in November, Robert Murray Smith acknowledged Hall's abilities, but having seen his purchases wrote to fellow Trustee Henry Gyles Turner remarking on 'a figure of *Femme couchée* exhibited in the most prominent spot he could find, though it was condemned not for its nudity but its beastly realism— James Smith rightly described it as a French demimondaine four months gone in the family way'.[38]

[36] *Argus*, 29 July, 9 August 1905; *Australasian*, 9 August 1905 (a Monet or Degas might have been acceptable).

[37] *Argus*, 19, 21, 22 and 23 August, *Age*, 21 August 1905.

[38] R.M.S. [Murray Smith?] to Turner, 1905?, quoted in Saunders, 'L Bernard Hall and the National Gallery of Victoria', p. 74 (but there dated 1911).

THERE REMAINED HALL'S supplementary instructions. The Trustees had long wished to improve the Swanston Street forecourt, conducting in 1891 an unsuccessful competition to produce another equestrian statue to match the Boehm *St George,* bought from the 1888 Exhibition. In Europe Hall consulted Gilbert, who promised to send a suggestion—since 'he was in Boehm's studio when our St George was being carried out', he knew 'exactly what would be required'— but no proposal arrived. In Paris, however, Hall was 'fortunate enough to meet M. Frémiet, without doubt the greatest living master in equestrian groups', who offered a sketch of Perseus and Andromeda, and also promised to seek permission to reproduce one of his earlier successes, St George, or Jeanne d'Arc. 'The first, as a romantic treatment of the same subject as ours', Hall thought 'would make a most novel and interesting contrast'; but it was the second, a replica of Emmanuel Frémiet's *Jeanne d'Arc* standing in the Place des Pyramides, which Hall eventually ordered, for the large sum of £1800.

Frémiet's statue did not arrive in Melbourne until the beginning of 1907. Weighing two and a half tons, packed upright in a case fifteen feet high, *Jeanne* proved as difficult to transport from wharf to Gallery as a giraffe, and caused immediate controversy. A leading article in the *Argus* attacked the Trustees and Hall for betraying the new Australia by setting up the image of a dead Frenchwoman as a national Australian monument.

The French had every right to commemorate Joan, the anonymous columnist argued, even if they had waited until the nineteenth century to do so. But to the British she had brought defeat, and shame for the manner of her end. 'A statue of Joan of Arc erected in an Australian city' was 'an almost inconceivable stupidity. So far from inspiring us with national pride, it will put us to shame in the permanent acknowledgment it offers of our ancestral infamy'. 'This should make us humbler perhaps, if we took the lesson in solemn earnest' but national humility was 'a degrading vice', which bred 'self-distrust and cowardice', and poisoned 'the fountain springs of national self-dependence'. Had Britain no heroes or heroines, was Australia 'so destitute of men of mark', that we should 'celebrate an alien who perished almost four centuries before Australia was discovered?' The Trustees' action was 'an insult to the national sentiment that is slowly and laboriously maturing in our hearts and minds'.[39]

This was not the last time the Trustees and the Bequests' Committee were chastised for not making the National Gallery national enough. The objectors would

[39] 'It ironically assures us that we have done nothing ourselves worthy of keeping in remembrance, and that our British ancestors, whose blood flows in our veins, deserve only to be remembered for their misdeeds. No people can grow into a strong nation unless they are proud of themselves and proudly confident of their future' (*Argus*, 26 November 1906).

probably not have been appeased had they heard the story, later much repeated, that the model for Frémiet's *Jeanne* was not a Frenchwoman but again John Peter Russell's Italian wife; she, if not an Australian citizen—a status which did not then exist—was, by marriage at least, Australian. It is a pity the story is not true, and that Marianna was only a child when Frémiet modelled the original *Jeanne* from some other woman; cosmopolitan modern Melbourne could well have adopted an Italian-Australian woman on a French horse as a multicultural emblem. Frémiet, for his part, told Hall in 1907 that he was delighted with Melbourne's *éclectisme*, and honoured that his *Jeanne* had been given so prominent a position.[40]

Hall's lion-hunt was less successful. In London in 1905 he had two long interviews with J Swan RA (a pupil of Barye's and 'very great as a modeller of animals and a master of bronze'), who promised to send a photo of one suitable group and a sketch of another. ('The subject of the model I like best', Hall wrote, 'was *The deluge*, a lioness removing her cubs to higher ground'). But in Paris Hall had been so impressed by Rodin's small bronze lion that in 1907 he wrote to the master asking whether he would consider using it as a sketch for a much larger lion and lioness. After Rodin replied that 'the project interests me greatly', Hall again modified the plan, first to have one British lion by Swan opposite a French one of Rodin's, and ultimately—though probably not for nationalistic reasons—two British lions, placating Rodin by persuading the Bequests' Committee to buy the small *Le Lion qui pleure* for £100.[41] It arrived in 1909; the British lions never did, Swan dying before sculpting them, though as late as 1920 Hall still hoped models might be cast. No lions, zinc or bronze, now guard the front of the old building. *Jeanne* and *St George* still stand at either end of the forecourt, a symbolic *entente cordiale* mediated by a more-than-life-size *Sir Redmond Barry*, the three a proudly assertive phalanx on which Petrus Spronk's nearby *Architectural Fragment* (1995), the tip of a bluestone building apparently disappearing under the pavement, makes a post-modern comment.

[40] E Frémiet to Hall, 26 April 1907 (Hall papers). It was Basil Burdett who reported in 1939 that Rodin's model was Frémiet's also. On Marianna Matiocco and Rodin see Plant, *French Impressionists and Post-Impressionists*, p. 22, and Galbally, *The Art of John Peter Russell*, p. 28 and n. 22.

[41] Anderson with Paffen, 'The Sculptor Writes', pp. 131–5.

15

DISCORDANCE

'For the last few days the National Gallery has been thronged with visitors eagerly discussing the recent purchases', the *Age* reported in 1906 while commending Bernard Hall's selections. 'People study the canvases closely, compare notes, and discuss the subject freely ... the acquisition of these new works has given a much needed stimulus to art.'[1] Much was written, in an unusually extensive discussion of gallery acquisitions and the policies which should govern them; and although some art purchases under the Felton Bequest were praised, most received a bad press in Australia over the next decade, culminating in a supercilious remark from the Sydney *Bulletin* in 1913 that 'the Felton Bequest, so far, is a trivial, pitiable failure'.[2]

Even if Hall's European foray had been universally applauded, easy co-operation between the Bequests' Committee, the Gallery Trustees and the Gallery Director—Felton's 'joint and harmonious action'—would have been difficult to maintain. Too many individuals were involved, with conflicting interests, ambitions and opinions; and despite some initial goodwill, attempts to formulate acceptable procedures aroused impatience and distrust, which by 1908 had crumbled into rancour, exacerbated by a dispute over what should or should not be bought from a large British visiting exhibition. Much of the discussion reads like an argument between men who knew little about art but knew, emphatically, what they liked, but underneath was a genuine conflict between Hall's plans to build a representative collection and the buying preferences long evident among Victoria's private collectors. A rapprochement was made, but suspicions and resentments continued to clog the operations of the art Bequest for many years.

[1] *Age*, 31 August 1906.

[2] *Bulletin*, 10 July 1913.

WHEN LANGTON DIED in October 1905, Henry Gyles Turner, banker and littérateur, became President of the Gallery Trustees. Already seventy-four when he took the chair he was to occupy for fifteen years, he was yet another of the elderly gentlemen who dominated Felton Bequest affairs in its first decades. Turner had arrived in Victoria in 1854, befriending George Coppin during the journey, and made his name in journalism, editing the *Melbourne Review* before taking the Commercial Bank of Australia to the peak of the boom and (with more difficulty) through the bust. He had supported Strong in the Scots Church conflict, though a member of the Unitarian congregation—of which for many years his sister Martha was pastor, presenting Melbourne with the novelty of a woman preaching—and would have known Felton, though there is no evidence that they were close. Turner's two-volume *History of the Colony of Victoria* had appeared in 1904; he had been a Trustee since 1884, and his views on art, as on other cultural and political questions, were apt to be paradoxical, though always definite. Like other Trustees of his generation, he expected the staff of the Public Library, Museums and National Gallery to provide advice, but not to make decisions. The Chief Librarian was the senior officer, and the Director of the Gallery did not even attend the meetings of the Trustees at which decisions concerning his Gallery were made (nor always meetings of the Gallery Committee, abolished in 1910, or the Felton Purchase Committee, created in 1912).

In November 1905 the Gallery Trustees, assuming (despite PD Phillips' earlier advice) that they could decide expenditure under the Felton Bequest, and told that a further £7000 would be available, took it upon themselves to place £1000 in reserve and to spend £5500, £350 of it on McCubbin's *The Pioneer*, recently shown at the Victorian Artists Society. A proposal that Hall be sent overseas again in 1906 was debated, but 'after protracted discussion' Clausen was instead 'appointed' to advise. The press, reporting the decisions of the Trustees, noted that they had to be 'confirmed' by the Felton Bequests' Committee.[3]

That Committee was not to be so browbeaten. For one thing Felton's solicitor would not let them. When the Trustees elected Langton's replacement, PD Phillips insisted that they be told that Mather was not their 'representative': the Committee formed one entity, the Trustees another, and he had a separate obligation to each.[4] The Committee had already resisted popular pressure to buy 'Mr McCubbin's triptych', when the *Age* led public demand to acquire this 'poem of democracy' in September 1905, and twice deferred the Trustees' recommendation to acquire it,

[3] *Argus*, 15 and 29 November 1905.

[4] Opinion dated 8 December 1905 (Trustee company).

Henry Gyles Turner, photographed on appointment as President of the Trustees, 1906 (La Trobe Picture Collection, State Library of Victoria)

resolving to 'refrain from dealing with' such matters 'until a definite scheme had been formulated for expending funds in the purchase of local Works of Art'.[5] (In October, when they made this rule, they also broke it, acquiring, for the high price of £1000, a portrait of Alfred Felton by JC Waite. Based on a photograph, and recently painted—at whose instigation is not known—this mediocre painting of the Gallery's benefactor entered the collection with a special endorsement, the Committee recording 'that it was considered a good and faithful likeness by Hon

[5] FBC, 19 September and 30 October 1905. They also deferred (but later approved) Hall's recommendation to buy E Phillips Fox's copy of a portrait of Captain Cook by Nathaniel Dance. On the McCubbin, see the *Age,*, 16 August 1905. JB Hirst, in 'The Pioneer Legend', in Carroll (ed.) *Intruders in the Bush*, pp. 28–9, describes the painting as 'the classic embodiment in art of the pioneer legend'. For Bernard Smith's warm assessment of McCubbin's nationalism, see his *Documents on Art and Taste in Australia*, p. 237.

F. S. Grimwade and family, who through their long association with Mr Felton were in a position to judge of its merit as a portrait'.)[6]

The Committee had also deferred Hall's recommendations to appoint European advisers, and only in stages, between October 1905 and May 1906, appointed George Clausen (with authority to spend £2000 on pictures and sculpture), JJ Marquet de Vasselot (in Paris, to spend £1000 on other works) and Joseph Pennell (£200 on black and white drawings).[7] For better or worse, members of the Bequests' Committee began to exert themselves to learn about art, and to flex their own powers of judgement. In March 1906 Levey was given twelve months leave to travel to Europe, and a letter facilitating interviews with 'the artists and others who are carrying out works in connection with the Bequest'. It was also decided to subscribe to *The Expert* and *The Connoisseur* 'for the information of the Committee'.[8]

The Bequests' Committee's acceptance of a 'Works of Art Fund General Scheme', recommended (with some reluctance) by the Gallery Trustees in May 1906, was thus no mere formality. The 'Branches of Art' recognised as eligible for purchase were comprehensive: painting, sculpture, black and white drawings, glass, pottery, metal work, furniture, and miscellaneous (such as lace, woodwork etc.). Purchases outside Australia would be entrusted to experts, recommended by the Trustees and approved by Committee, each appointed for a specific period, with a definite sum to spend, and with commission agreed in advance. Within Australia the Trustees could recommend works to the Bequests Committee for approval; the Committee suggested that when necessary the two bodies should meet in conference to discuss recommendations.[9]

This understanding cleared the way for approval of McCubbin's *The Pioneer*, in June 1906, but the delay had provoked agitation in favour of Australian art and artists. The Felton Bequest should be spent only on Australian pictures, the *Argus* insisted in December, as the Chantrey Bequest was on British; why had *La femme couchée*—'in its idea hideous, in its presentation outrageous'—been acquired, and the noble *Pioneer* vetoed?[10] The Committee having earlier rejected proposals that a stated proportion of the Bequest 'be available for the purchase of works of art

[6] Ibid., 16 August and 30 October 1905. In another gesture of loyalty the Committee asked the Trustees to inscribe 'From Mr Felton's Private Collection' on the works from the Esplanade Hotel they had decided to keep.

[7] They also authorised Herbert Wilson to spend £1000 on the recommendation of authorities of the South Kensington Museum, an authority withdrawn on 11 May 1908 after only a few purchases were made.

[8] While Levey was still away, Godfrey took six months leave, also to visit England; and Grimwade spent 1908 abroad (FBC, 30 July 1907).

[9] FBC, 1 May and 1 July 1906. Procedures recommended by the Trustees for 'special purchases outside Australia' were thought likely to be outside the powers of the Committee.

[10] 'The National Gallery and the Felton Bequest', *Argus*, 1 December 1905.

produced in Australasia', their approval in March of Hall's recommendation to buy Hans Heysen's *Sunshine and Shadow* did not mollify: Heysen was 'weak', while McCubbin had 'initiated a distinctly national art on the higher plane where national feeling is bodied forth'. The critic discerned the cloven hoof of Bernard Hall, who had 'bent the Committee to his will'.[11]

Local acquisitions approved by the Bequests' Committee continued steadily over the next few years, mostly on Hall's advice.[12] He acquired some European art locally, and, as always, he sought to collect on a broad front, recommending (successfully) two Persian objects in 1907 and a Japanese bronze vase and bronze lantern in 1909. Australian works included a *Self Portrait* by the talented Hugh Ramsay, come home from Paris, aged twenty-eight, to die; and paintings by Norman Macgeorge, Will Ashton, Walter Withers, Arthur Streeton (three) and more by Hans Heysen. Hall had a blind spot towards Tom Roberts, but the frequent complaints from other local artists that the Gallery under his direction neglected their work had seldom been justified; he had acquired far more works by Australians than foreigners since his arrival in 1892.[13] Moreover the distinction was blurred, several of these 'Australian' works being neither local in subject matter nor produced here, as the development of significant colonies of Australian artists working in Europe came to complicate debate over local versus overseas purchase. Late in 1909 the Trustees at last agreed to recommend the expatriate sculptor Bertram Mackennal's great *Circe,* which they had failed to buy in 1894 (despite Hall's commending it as 'a genuine work of genius—very remarkable and impressive'—without doubt 'Young Australia's chef d'oeuvre').[14] By 1909 Mackennal was neither so young nor so Australian; in 1914 Julian Ashton told Hall he doubted whether Lambert and Streeton were 'really Australian artists . . . art is not a matter of birth, it's a matter of environment'.[15] Nevertheless in 1906 one letter-writer to the *Argus* asked why not choose, if an overseas adviser had to be appointed, Longstaff, Bunny or Streeton rather than Clausen (who belonged, another complained, to the 'faddist school', painting 'fuzzy, hazy, indistinct, flecky, spotty' pictures).

[11] *Age*, 27 March 1906.

[12] In May 1908 it was agreed between the Committee and the Trustees that either body could obtain expert advice on any local exhibition, provided they communicated it to the other.

[13] Galbally, *The Collections of the National Gallery of Victoria*, pp. 32 and 36. The Gallery bought only one work by Charles Douglas Richardson, which Lindsay unfortunately de-accessioned in 1941.

[14] Quoted in Cox, *The National Gallery*, p. 50. The original version had been a plaster cast, painted bronze; Bequests' Committee approved purchase of the bronze, cast in 1902, for £1000 on 12 September 1909, 'without official advice'.

[15] Ashton to Hall, 1 July 1914 (Hall papers).

The Bequests' Committee failed in an attempt to make one local purchase. On 23 September 1909 Mather moved, Levey seconded and the Committee agreed that Jules Lefebvre's *Chloe,* on the market after the death of Sir Thomas Fitzgerald, her purchaser in 1882, was 'a work of art complying with the conditions in Mr Felton's Will', and resolved to purchase it 'for presentation to the Melbourne National Gallery', at 'a price not exceeding £500'. The decision was 'communicated verbally to the President of the Trustees', who apparently acquiesced though other trustees did not; but the sum was not sufficient. Henry Figsby Young, an ex-digger turned publican, paid £800 for *Chloe,* and took her to his home above Young and Jackson's Hotel, where (it is said) he hid her from his wife. Discovered during spring cleaning, *Chloe* was banished, to find fame and her cultural destiny in the public bar.[16]

DURING 1906, WORKS chosen by the overseas advisers already appointed began to arrive in Melbourne. Pennell's selections of prints and drawings, though excellent, did not excite the lay mind, and neither did Marquet de Vasselot's purchases in the decorative arts, though his letters to Hall show him to have been learned, assiduous and well placed to buy excellent material which the Louvre had considered and almost bought. Hall sent him photographs of the Melbourne collection;

> after having looked at them carefully with a magnifying glass, I find out that you have a larger number of things than I had imagined. But—forgive my frankness—it seems as though what you want now is a choice of good and characteristic pieces . . . a small number of good things.

Later, when his allocation of £1000 was almost spent, he observed that

> for young museums—(allow me to call yours thus)—the best policy is to buy every year a few good things at reasonable or nearly reasonable prices, because in ten years from now these good things will have become so scarce that their prices will have risen enormously, and it will be too late.

His purchases of Italian Majolica, and a Japanese screen, were exceptionally fine. Unfortunately Hall later told him discouragingly that such work was wasted on philistine Melburnians.[17]

By July 1906 George Clausen had spent his allocation, on thirteen paintings and twenty-two drawings, costing £1951 1s. They included some small French works (Corot's *Sketch at Scheveningen,* now 'attributed to', and paintings by Fantin-Latour and Vollon), but most were contemporary British; he reported enthusiastically that

[16] FBC, 23 September 1909.

[17] Marquet de Vasselot to Hall, 19 May 1906 and 20 March 1907 (Hall papers).

drawings by Burne-Jones, Lord Leighton, Ruskin and others would be 'of the greatest possible value to students', and that he had acquired paintings of 'some general importance' to make the Gallery's collection 'more thoroughly representative of the best work of our time'. He wrote lyrically of paintings which 'deal with contemporary life' (such as William Rothenstein's *Aliens*) or enshrined 'some one quality in nature that is felt to be beautiful' (like Buxton Knight's *The Hamlet—Winter Sunshine*). 'It has been a great pleasure to me to choose these works, and I have taken very willingly a good deal of trouble over it.'[18]

Clausen thought he had done well, but few in Melbourne agreed with him (at the time: Daryl Lindsay later praised his work).[19] Hall suggested, 'with all due deference', that the quality of 'beautiful rendering of beautiful themes' had been overlooked by locals judging Clausen's purchases, but Blamire Young put the usual view bluntly:

> The yearly jaunt to town to see the new pictures is now regarded in some circles as one of the most thrilling that the seasons bring. All the way there they bless the memory of the good Felton, and all the way back they abuse the selector. Mr Clausen is the unfortunate this year, and a right royal mess he has made of it.[20]

Too many of the artists Clausen had bought were little known in Australia. They included the young Augustus John, the two drawings purchased beginning the representation of students of the Slade School, soon to dominate Melbourne's acquisition of English contemporary art but not yet acceptable to the taste of older Melburnians, expecting Felton purchases to be grand.[21] In June 1906 the Bequests' Committee reminded the Gallery Trustees of a decision 'that purchases should be of a more important character than hitherto', and in September invited them to 'a conference with the view of arranging that future purchases be of a higher standard'. Thomas Prout Webb, respected lawyer and amateur artist, bombarded Bage with demands for change: 'After two experimental selections, neither of which has produced any satisfactory result, one by an expert with a

[18] Clausen to Armstrong, 4 July 1906 (Hall papers)

[19] Lindsay, *The Felton Bequest*, p. 27, praised Clausen for the acquisition of Buxton Knight's 'splendid' *The Hamlet—Winter Sunshine* and some 'excellent' Pre-Raphaelite drawings.

[20] 'The new Felton Pictures', *Argus*, 1 December 1906. William Blamire Young (1862–1935) came to Australia from England as a schoolmaster in 1885, became a poster artist in the 1890s and a water-colourist about the time of this article. His writings for the *Argus* (1904–12) and the *Herald* (1929–34), were outspoken, but better written than those of most of his fellow critics. (See entry by E Fink, *ADB*, vol. 12).

[21] Ann Galbally, *The Collections of the National Gallery of Victoria*, p. 212. At Melbourne's request Clausen sought a work from Sargent, who replied in August 1906 that he was unwilling to sell a painting, but offered to give a drawing to the Gallery. FBC, 22 August 1906, include the list of works bought by Clausen; the dearest item (£300) was Rothenstein's *Aliens at Prayer*.

knowledge of our local requirements, the other by an expert without any such knowledge, it is very evident that something is amiss in our methods'.[22]

Clausen's failure to please Melbourne proved a catastrophe for Bernard Hall. Before the Conference met, in December, he argued desperately to persuade the Trustees to continue the 'system' he had inaugurated. It was easier, he conceded, to state 'the high standard upon which a National Collection should be made' than to reach it in practice. Having earlier warned that artists were not usually 'born collectors', he had 'thrashed out with Mr Clausen' the reasons why Hall himself had avoided buying 'experimental work', as he considered that of Steer, Rothenstein and John to be. But, 'as it turned out, in the interval of ten months, he forgot all this, and the natural man supervened'. Clausen, he insisted, could do better; 'the alternative of a mixed committee or the appointment of an "amateur" would, I hold, be worse': a committee's choices would be 'well diluted by compromise', while the amateur 'would be the sport of both artists and dealers'. With Clausen, 'although the results are not satisfactory (the work, though good of its kind, not being of the kind we look for)', 'we have struck the note of classic and serious work', exciting interest 'in the highest quarters of the artistic and critical worlds, while "commercialism" has not been so much as recognised'. Moreover 'the best people', such as Sargent, were now interested. 'To give way, even for a few months, to newspaper clamour for popular pictures which "teach lessons of real importance" would give us a set-back which would take some years to recover from.' Hall strongly urged the Trustees 'not to change the policy they had adopted, but rather to apply it firmly and continuously towards getting work of a more highly-accredited order, and of a more beautiful kind'. 'We shall have to train our man in any case, and, if Mr Clausen will continue to act for us, I would advise that he be commissioned once more upon well defined lines which will direct his aim to more "classic" results.'[23]

Hall's cause was forlorn. A majority of the Trustees were persuaded—though scarcely convinced—but not the Bequests' Committee. When the Conference met in December, Turner spoke of the Trustees' 'keen disappointment at the result of Mr Clausen's efforts'; 'that gentleman had failed to grasp the needs of the Gallery and had obtained works which were in no wise agreeable to the Committee or the Gallery Trustees'. But Clausen was 'not so blameable as might at first appear, owing to the fact that his instructions were not conveyed in writing but were merely discussed at two interviews with the Gallery director', and

[22] Prout to Bage, 6 July 1907. On Prout, see the entry by Charles Francis in *ADB*, vol. 6.

[23] Hall's memo of 10 December 1906 (Hall papers); also quoted in Cox, *National Gallery of Victoria*, pp. 64–5.

the Trustees felt he should continue with 'more explicit instructions'. After that grudging concession to Hall, not present, Turner read out a memorandum the Director had belatedly prepared for Clausen's instruction, phrases from which were to echo in later documents. The adviser should look out for 'classic' works, not the works of the 'classic' artists of which Melbourne had examples already but such artists as Gainsborough, Daubigny, Troyon and Millet. It was not 'the best of the year', that was required, but 'the best of an epoch'.[24]

Committee members were not mollified. Godfrey (soon to appear as a Leighton man) complained that Clausen 'appeared to favour a particular school', and Grimwade asked whether mere instructions could 'control Mr Clausen and prevent him making similar purchases in the future'. When Bage asked baldly 'what was the policy of the Gallery Trustees regarding the educational and artistic sides of the Gallery's requirements respectively', Baldwin Spencer, with straight face and straighter bat, 'doubted their ability to differentiate between the two classes'; it was not a question of pleasing the public, but of educating them, and Clausen's standing was high—'leading critics in England had eulogised his selection'—though Spencer conceded that stricter instructions were needed.[25] Discussion then broke down into individual suggestions for acquisitions, an ominous symptom of the absence of an agreed orderly procedure. Godfrey mentioned 'an alleged Watteau', which the President said the Gallery might take on loan. Grimwade had earlier told his Committee that he knew of some available Holman Hunts; would the Trustees consider recommending *May Morning on Magdalen Tower,* so that the Bequest could purchase it? (They did consider, but not for long, rejecting at their next meeting that spectacular sugared painting, in every sense over the top.)[26]

Murray Smith, speaking under his Trustee Company hat, inhibited further debate by questioning whether either the Trustees or the Bequests' Committee had legal power to delegate the selection of works of art, as they had to Hall, Clausen and other advisers. His warning was justified. Early in 1907 PD Phillips told the Bequests' Committee that giving an adviser an amount to spend at his discretion was of doubtful legality; and a further opinion, from Theyre à Beckett Weigall, left the power to delegate very circumscribed: the Committee could only give an agent power to purchase, for a limited price, 'any procurable work

[24] Hall to Trustees, 28 November and 10 December 1906; FBC, 17 December 1906.

[25] When Bage pursued the question of 'controlling the selectors', Turner responded that control was impracticable and never successful, since 'no artist of any standing would submit to it'.

[26] On 7 March 1907. The FBC noted that the Trustees had considered Holman Hunt's *May Morning* and *The Lady of Shallott* and 'decided not to recommend the purchase of either of them'.

of a defined character'.[27] All other works would have to be individually approved by the Committee, which (from May 1908) adopted a standard form of words, meticulously minuted: 'The Committee being of the opinion that the above works are of an artistic and educational value and calculated to raise and improve public taste, it was resolved upon the recommendation of the Gallery Trustees that their purchase at the prices stated be approved'.[28]

By March 1907, when the Committee received the Trustees' draft instructions to Clausen, and set Mather to rewriting them, Clausen had already told Hall that as a busy painter he had little time to visit dealers and salesrooms. New York's Metropolitan paid £1000 a year to Roger Fry—scholar and painter, soon to be the most influential critic since Ruskin—merely as a retainer. In April Clausen wrote that he would still be pleased to help Melbourne, but had in fact made his last recommendation.[29]

One of Hall's last requests to Clausen had borne fruit. At the December Conference Turner reported that the Trustees were in pursuit of works by Jean-Baptiste Camille Corot; would the Committee approve? Grimwade promised to call an early meeting to consider any proposal. What followed was a rare example of agreement, smoothly achieved. Hall had drawn attention to an imminent sale at Agnew's which included some fine Corots, marking seven for Clausen's consideration. Clausen chose *Souvenir de Picardie*; Hall preferred *The Bent Tree,* at £5750 three times the cost, but conceded the decision to the man on the ground. On 7 March a special meeting of the Bequests' Committee received the Trustees' recommendation to buy *Souvenir de Picardie*, and approved it, subject only to the approval of Levey, then in London. 'Proposed purchase Corot's *Souvenir de Picardie* at Agnew's for £1850. Would it be suitable for the Gallery?', he was cabled; his reply: 'Quite suitable but why not *The Bent Tree* lovely famous' prevailed. It was not known at the time that his own untutored taste had been guided by advice from Frank Gibson, a Melbourne University graduate now a London connoisseur.

News of the purchase of an 'undoubted' masterpiece was at first welcomed in Melbourne, despite qualms over paying £2000 more than for any previous acquisition (Alma Tadema's *Vintage Festival*, purchased in 1888).[30] But carping over this 'pearl of great price' began within a month, when the *Age* revealed it was but one

[27] FBC, 19 February 1907.

[28] This form of words was first used on 11 May 1908 when the Committee agreed to purchase two pieces of old Venetian lace on Hall's recommendation to the Trustees.

[29] Clausen's suggestion that Sargent or Swan might act with him was not pursued.

[30] *Age*, 4, 5 and 6 June 1907.

of two *Bent Trees* in existence; 'throughout the afternoon the picture was surrounded by large numbers of interested people', by implication smelling a con. The *Herald* assured the public that both paintings—one a morning scene the other an evening—were equally valid, but 'M. L.' of Ballarat wrote at length, seeking the Bequests' Committee's assurance it had not been deceived, and suggesting that 'we might well have permitted some American plutocrat to take the Corot', spending the £5750 on the work of 'great living artists' not yet represented in the Gallery, and eschewing 'foreign and possibly unscrupulous discoveries'. Prout Webb responded that 'the educational value' of *The Bent Tree* to the community was 'many times its market value', as the public looked to see why so small and sombre a picture could be worth so much. ED Stocks complained the picture lacked 'intention', a term he illustrated by asking how the boat was pulled so far up the bank when no haulage gear was evident; and was not the bald faced cow 'mere packing'? Fortunately Blamire Young, in a sensitive piece, urged viewers to forget how much the painting cost and to 'listen to nothing but what Corot tells us. In this way shall we obtain free entry to the temple of art . . .'[31] The picture became, and long remained, one of the public's favourites in the Gallery; a later wrangle over who could take credit for the purchase was settled only by the appearance in 1921 of a scholarly document, *How Corot's Bent Tree came to be bought*.[32]

Late in 1907 a different controversy arose, when the Sydney Secessionists' Exhibition came to the Guildhall in Melbourne, and Spencer and Hall, both admirers of the young and deliberately unrespectable Norman Lindsay, persuaded the Trustees and the Bequests' Committee to pay 150 guineas—said to be an Australian record price for a black and white work—for his *Pollice Verso*. Lindsay's Bacchanalian nudes surging around a Crucifixion shocked so many that *Pollice Verso* spent most of the exhibition with its face turned to the wall. A Latin scholar took Lindsay to task on other grounds: 'thumbs down' was the original Roman signal for mercy, while the sign for death was 'Pollice presso', thumbs up.[33] Meanwhile most Felton purchases continued to provoke inversion of the thumb, in its modern signification.

[31] Ibid, 15 July and 24 August 1907, *Argus*, 7 September 1907, *Herald*, 26 October 1907, *Argus*, 4 January 1908.

[32] In April 1907, when finally approving the purchase, the Bequests' Committee was ungracious enough to advise (despite Godfrey's formal dissent) that because Clausen's appointment as adviser had expired he was not entitled to commission on the purchase; they later conceded a fee of £75 for advice (FBC, 7 March, 5 and 30 April 1907).

[33] 'J. H. T.' in *Argus*, 7 November 1907. On the remarkable family of Lindsays, see Bernard Smith's comprehensive entry in *ADB*, vol. 10. *Pollice Verso* (1904) was one of a series of brilliant drawings which made Norman famous and infamous, and by 1914 earned him the highest income of any artist in Australia.

WHEN THE GALLERY TRUSTEES agreed to the purchase of *Pollice Verso*, they asked for further meetings to resolve 'points of difference' in the 'Scheme' of procedures for purchase, having earlier appointed Turner, James Smith and Spencer as a committee to deal with Bequest matters. In October the Committee agreed to meet, and a long period of intermittent and confusing negotiations began. On the surface the 'points of difference' seem slight, but the degree of suspicion, and frequently of hostility, was such that it took eight months to reach agreement and another six to appoint an overseas adviser. It is tempting to search for a conspirator behind the arras, making mischief—with Bernard Hall, disappointed that he had lost control, the obvious suspect—but the capacity of elderly committee members, sharing only a sense of their own self-importance, to squabble among themselves should not be under-estimated.

The Bequests' Committee's powers, restricted by the advice of PD Phillips, confirmed by counsel, formed the first issue discussed when the two groups met. In a cautious first attempt to comply with Weigall's opinion, the Trustees agreed to draft an authority for Joseph Pennell to purchase works 'of a definite character' for up to a specified amount (£50).[34] In July 1907 the Committee received a more general scheme of purchase, incorporating once again Hall's pleas for 'the best work of an epoch, rather than the best work of a year'; 'the patronage of worthy workers, or the encouragement of contemporary art', was held to be 'more the function of the private individual than that of a public body, organised to administer trust monies'. Advisers, nominated by the Trustees and approved by the Bequests' Committee, were to purchase, 'within a specified amount', works by specific artists, and to advise on the purchase of other works.[35] The scheme was referred to Bage and Mather, who proposed that the Trustees and the Committee should formulate 'guiding principles for selection' the first step being to 'classify and enumerate deficiencies'. They should invite Agnew's and other dealers to communicate regularly, on where and when 'important works of art may be procured'; the Trustees and the Committee should join in employing expert advisers, and devise a telegraphic code for rapid communication with them. Except in special circumstances, full details should be before each body before any authorisation to purchase was given.

[34] FBC, 30 April 1907. Pennell did well, and refused to take a commission; but on 11 May 1908 the Committee was reluctant to grant him a further £250, as the Trustees recommended.

[35] 'Draft Report of the Committee of Trustees appointed to confer with the Felton Bequests committee as to future purchases under the Bequest', noted 'enclosed in letter'.

For some reason the Bequests' Committee had become suspicious. They had already asked the Trustees, when recommending a local purchase, to provide a copy of the adviser's report (if any), together with 'the result of their voting, giving numbers for and against, also any dissents recorded', and 'any conditions attached to a purchase'; and this determination to pry behind decisions appeared again in Bage and Mather's draft: both bodies should agree that whenever making a recommendation to the other it would divulge all advice received and full details of voting on any motion. The Committee also insisted that while it would join the Trustees in the appointment of advisers, it remained 'free to obtain such further advice as it may deem necessary'.

The Trustees accepted most of these points—including, over Hall's strong disapproval, divulging advice received—but objected to the involvement of Agnew's or any agent, and proposed a list of the names of artists sought rather than one of 'deficiencies'. The list proposed was interesting. The twenty-eight British artists ranged from Reynolds and Gainsborough through Rossetti and Burne-Jones to Sargent and Leighton (with Alfred Hunt listed, but not Holman Hunt); twenty French artists included Chardin and Fragonard from the eighteenth century, but also Manet, Monet, Degas and Sisley; Whistler and Goya appeared among fourteen 'Various Artists'; and the list concluded with seven 'Black and White Artists' (including Herkomer and Arthur Rackham) and five sculptors, Gilbert and Rodin among them. The Committee did not immediately respond; drafts moved back and forth between the two bodies, negotiations became desultory and the appointment of advisers was unconscionably delayed.

DIFFERENCES OF TASTE, which were among the issues hampering efforts to agree on procedures, emerged brutally enough in March 1908, when Joshua Lake, Manager and Director of the British Art Gallery, presented a huge exhibition, the first such for fifteen years, in the Exhibition Building, in conjunction with the Royal British-Colonial Society of Artists. The paintings on offer were by contemporary British artists, works of the kind which been the staple purchases of Victorian collectors in the nineteenth century. The Governor opened the Exhibition and the press liked it, the *Argus* claiming that 'an atmosphere of living palpitating art' permeated the five galleries in which the 670 items were hung. The *Herald*, less moved, pointed out that the prices asked were much higher than recent sales of the artists involved, and seemed exorbitant.[36]

The exhibition was so warmly received and expertly promoted that a leaked report from Hall, recommending to the Trustees that none be purchased for the

[36] *Argus*, 24 March 1908; the *Age*, (25 March 1908) gave it 'a warm reception'; *Herald*, 29 March 1908.

[ABOVE]
Pierre Puvis de Chavannes
1824–1898 French
Winter (L'Hiver) 1896
oil on canvas
96.2 × 147.2 cm
Felton Bequest, 1910

[LEFT]
Arthur Streeton 1867–1943
Australia
Sydney Harbour 1907
oil on canvas on plywood
122.2 × 122.0 cm
Felton Bequest, 1910

[ABOVE]
E. Phillips Fox 1865–1915 Australia
The arbour 1910
oil on canvas
190.5 × 230.7 cm
Felton Bequest, 1916

[RIGHT]
George Lambert, born Russia 1873, arrived in Australia 1887, died 1930
Baldwin Spencer 1921
oil on canvas
91 × 71 cm
Reproduced courtesy of Museum Victoria

[LEFT]
William Blake 1757–1827 English
Antaeus setting down Dante and Virgil in the last circle of Hell
illustration to Dante's *Divine Comedy, Inferno XXXI*, 112–43, 1824–1827
pen and ink and water-colour
52.6 × 37.4 cm
Felton Bequest, 1920

[BELOW]
William Blake 1757–1827 English
Dante running from the Three Beasts
illustration to Dante's *Divine Comedy, Inferno I*, 1–90, 1824–1827
pen and ink and water-colour over pencil
37.0 × 52.8 cm
Felton Bequest, 1920

[RIGHT]
Maître François and workshop active
c.1460–80 French
The Wharncliffe Hours c.1475
black, blue and red inks, opaque colour, gold paint, gold leaf on parchment; 19th-century red velvet binding, gilt clasp
18.4 × 13.5 × 2.8 cm (book);
17.8 × 12.8 cm (each page)
Felton Bequest, 1920

[BELOW RIGHT]
Anthony van Dyck 1599–1641
Flemish
Rachel de Ruvigny, Countess of Southampton c.1640
oil on canvas on canvas on plywood
222.4 × 131.6 cm
Felton Bequest, 1922

[LEFT]
Flanders, Brussels
Triptych with the Miracles of Christ
(left panel obverse—*The marriage of Cana*)
oil on wood panel
113.0 × 37.2 cm (left panel)
122.4 × 184.0 cm (overall)
Felton Bequest, 1922

[BELOW]
Thomas Gainsborough 1727–1788 English
An officer of the 4th Regiment of Foot 1776–1780
oil on canvas
230.2 × 156.1 cm
Felton Bequest, 1922

[ABOVE]
Marcantonio Raimondi
c.1470–82–1527–34 Italian
Massacre of the Innocents
c.1511–1512
engraving
28.2 × 43.5 cm (plate)
32.3 × 44.7 cm (sheet)
Felton Bequest, 1958

[RIGHT]
Jan van Eyck c. 1390–1441 Flemish
(follower of)
The Madonna and the Child
oil on wood panel
26.3 × 19.4 cm
Felton Bequest, 1923

[LEFT]

Hans Memling *c.*1430–40–1494 Flemish
The Man of Sorrows in the arms of the Virgin 1475
oil and gold leaf on wood panel
27.4 × 19.9 cm
Felton Bequest, 1924

[BELOW LEFT]

John Everett Millais 1829–1896 English
The rescue 1855
oil on canvas
121.5 × 83.6 cm
Felton Bequest, 1924

[RIGHT]
Jules Bastien-Lepage
1848–1884 French
October Season 1878
oil on canvas
180.7 × 196.0 cm
Felton Bequest, 1928

[BELOW RIGHT]
Tom Roberts born Great Britain 1856, arrived in Australia 1869, died 1931
Shearing the rams 1888–1890
oil on canvas on composition board
122.4 × 183.3 cm
Felton Bequest, 1932

National Gallery, caused some astonishment. Hall, who had earlier persuaded the Trustees not to give over their galleries to house this 'private enterprise', argued that the pictures, and the catalogue, made it clear that the exhibition had been organised with 'popular prejudice' in mind rather than the needs of the Gallery.[37] The populist response was emphatic: and why not? The way to fulfil Felton's intention, one correspondent insisted—perhaps with the Elder Bequests' Federation Exhibitions in mind—was to hold a monster exhibition, broadened to include 'continental' and Australian art, every five years, and to make all Felton purchases from it.[38] A leader in the *Argus* also took Hall to task; such exhibitions brought 'the art world' to Australia, which was better than buying 'a pig in a poke' overseas.[39] Correspondents asked for a plebiscite to allow the public to choose what should be bought; when Joshua Lake promptly obliged, Leighton's *Perseus and Andromeda* scored 4156 votes to Leader's *Evening after Rain*'s 2953. Eleven works gained more than a thousand votes each, and Lake praised public perspicacity, predicting that at least four would be purchased.[40] Hall had supporters nevertheless, Archibald Strong observing pertinently that merely buying what the public wanted would not elevate public taste, as Felton had sought to do.[41]

On 24 March a special meeting of the Bequests' Committee and the Trustees was held at the Public Library to consider possible purchases from the exhibition, unfortunately in an atmosphere, this time, 'of living, palpitating distrust'. After Turner formally presented Hall's report that the pictures were 'ordinary' and his recommendation that none be purchased, Paterson, agreeing that the pictures were 'not of the quality required', moved in those terms, and Baldwin Spencer, who 'in the main agreed with Mr Paterson', seconded the motion pro forma. It soon became clear that the members of the Bequests' Committee admired the exhibition while the Trustees were divided, with Hall again the hinge on which disagreement turned; and that the underlying issue was whether the Gallery should continue to give priority to collecting fashionable contemporary British works, as in the past. Mather suggested an amendment to Paterson's motion; he wanted Alfred East's *A Savoy Pastoral*, but nothing else.

The discussion then moved from the pictures to the Director and his policy of filling gaps to form a historically representative collection. EH Sugden, the

[37] *Age* and *Argus*, 25 March 1908.

[38] *Argus*, 27 March 1908.

[39] Ibid., 26 March 1908.

[40] Ibid., 25 April 1908.

[41] Ibid., 27, 28, 30 March, *Age*, 1 April 1908.

principled and wily Master of Queen's College, a later President, was in 'almost complete agreement with Mr Hall'; he also thought that 'at present it was wise to encourage local art', and 'did not approve of filling the Gallery with merely pretty pictures. The prices in the catalogue were ridiculously extravagant'. Bromley, who complained that 'Mr Hall was endeavouring to obtain the unobtainable', 'did not consider Mr Hall's report of any value'; the Trustees had been requested to inspect the pictures, and a number were 'worthy of purchase'. Bage, too, was 'not in agreement with the essential points of Mr Hall's report'. 'Good current works of the day might increase in value'. The Trustees had proposed to send to London a list of artists wanted, omitting all of the present day: 'It was not necessary to wait until there was a scarcity of a man's pictures and then have to purchase from dealers at exorbitant figures. There was feeling shown in the criticism of every number by Mr Hall'. Spencer 'could not agree with Dr Bage's criticism of Mr Hall', but Godfrey did: 'the whole report was tinged with prejudice'. Turner again failed to defend the absent Director; he 'was sorry that Mr Hall sent out the list—he was not the best judge of landscapes'. Hall clearly did not enjoy the confidence of his Chairman.[42]

Farce ensued. Paterson withdrew his motion, the eleven Trustees present nominated twenty-three pictures, and in an exhaustive ballot voted to recommend six for purchase.[43] Their catalogue prices totalled no less than £3535, and Spencer and Bromley were asked to fix prices to be offered, with Hall's advice. Spencer, who wrote to Lionel Lindsay that he had been 'fighting hard' to keep the Trustees of the Gallery 'from buying more than one or two', now had his chance; when the Bequests' Committee met on 11 May 1908 to decide their own attitude to the pictures, they were told the Trustees had decided to buy nothing after all.[44] The Committee then considered a report from a specially appointed expert, GVF Mann, Secretary and Superintendent (and later Director) of the National Art Gallery of New South Wales, and also correspondence between the Trustees and Joshua Lake, only part of which the Trustees had sup-

[42] Turner was receiving many letters critical of Hall at this time. Sir Henry Wrixon, who had replaced Langton as a Trustee, proved a loose cannon at the meeting; he 'largely agreed with Hall and Spencer, but insisted that 'the point to him was what method was to be adopted for future purchases. He suggested obtaining some eminent man in England. It was necessary to determine whether the pictures are to be merely for the Art School or for the Public'. He was quashed by Levey—'the question of future purchases did not now arise'.

[43] The votes were recorded: only F Holl's *Home from the Front* received 9 votes for, 0 against, while Murray's *Silvery Summer* (£630) received 7 for, 1 against; but Leader's *Evening after Rain* (£630), Solomon's *Laus Deo* (£1050), and Yeend King's *In the Shade of an English Oak* (£525) each scraped in by one vote. Waterlow's *Chalk Pit on the Sussex Downs* (£175) lost on the chairman's vote.

[44] Spencer to L Lindsay, 3 June 1908, quoted in Mulvaney and Calaby, *'So Much That Is New'*, p. 342.

plied to them.[45] The Committee voted on 'several' paintings; Mather's favoured East went out on the chairman's casting vote, but there were majorities in favour of buying four works, by Holl, Leighton, Hay and Sir Ernest Waterlow. The Committee asked the Trustees to recommend all four; they refused, eventually supporting only Waterlow's *Corfe Castle Dorsetshire* and Holl's *Home from the Front*. Meanwhile private sales from the exhibition were reported to be 'increasing daily', as it prepared to move on to Brisbane and Adelaide.[46]

The Trustees' rebuff rankled. Another conference—which began on 4 June 1908 and was twice resumed, at weekly intervals—was called to discuss the draft procedures; it began amicably enough, with Bage (in Grimwade's absence overseas) and Turner (in the Chair) agreeing that the two bodies should appoint joint expert advisers, though disagreeing over the 'degree of agency' to be given them. They could be instructed jointly, Bage insisted, but they must be formally advisers to the Bequests' Committee, which had to be satisfied of the value of the works, while the Trustees needed only to recommend or approve purchase.[47] Spencer proposed that advisers be paid a salary, not commission, to buy for Melbourne only, and therefore not free to give others preference. A letter from Roger Fry—an authority whose reputation for brilliance was unassailable, but whose taste (since he had begun to champion Cézanne) was thought by some to be unsound—setting out the qualifications desirable in an adviser, was read out, and made an impression.

As so often, it was mention of Bernard Hall which shattered this fragile amiability. John Ford Paterson lit the fuse, arguing that 'they had struggled hard in the past to obtain the right man, and he saw no necessity for appointing an expert in Europe when they had a man like Mr Hall, who in addition to his other qualities was fully seized as to the requirements in the Gallery collection'. When he praised 'the purchases of Mr Hall', Godfrey exploded: 'very many of Mr Hall's purchases were very doubtful'. Moreover the Trustees themselves (he argued with increasing heat) had not shown the appropriate 'cordiality' towards the Committee. 'The Felton Bequests' Committee had never refused to sanction any recommendation by the Gallery Trustees, and yet on the Felton Bequests' Committee selecting four pictures after a great deal of trouble and consideration of expert opinion the Gallery Trustees had only approved of two'. Godfrey had

[45] *Argus*, 25 March 1908. The exhibition, and the dispute, were widely covered in the press.

[46] Ibid., 30 May, *Age*, 29 May 1908. The Gallery catalogued Holl's picture as *Home Again!*

[47] The Trustees disagreed on the legal position, Sir William Zeal wanting nothing done without a court order approving it, while Wrixon denied that one was needed.

wanted the Leighton (and had argued for it in a letter to the *Argus* on 12 June, castigating the Trustees).

> Lord Leighton had stood on a pinnacle as an eminent artist and Mr Mann of the Sydney Gallery had stated that his picture 'should occupy an honoured position in a Public gallery'. He understood the Committee's recommendation had been referred to a committee of two gentlemen both of whom supported everything laid down by Mr Bernard Hall.

Murray Smith agreed with Godfrey that 'the Committee had not been treated with the courtesy they were entitled to. Mr Hall's predilections were distinctly prejudiced and narrow'; he suggested that Hall's letter to the Gallery on the Committee's requests be read to the meeting. Turner had to disown Sir Henry Wrixon's angry retort that it was no business of the Committee what advice the Trustees received, claiming nevertheless that Hall's letter had been read after the Trustees had made their decision, and not before.

The storm passed. Bage repeated that the Committee could give an adviser power to purchase, for a limited price, 'any procurable work of a defined character (say an example of Leighton's work)'.[48] Turner proposed that the experts' recommendations should be considered by the Bequests' Committee meeting with a committee—not the whole body—of the Gallery Trustees, a committee which would be given powers to bind the Trustees. Bage agreed, and concluded that 'there was practically nothing in dispute between the Gallery Trustees and the Felton Bequests' Committee; the crux of the matter was the choosing of expert advisers and the giving of instructions'.

He was an optimist. When the Conference resumed on 11 June, the Gallery wanted an equal say in instructing the advisers, while Bage insisted that the instructions must come from the Felton Bequests' Committee, though he hoped the Trustees would approve them. Mather, reacting to increasing emphasis on old masters, asked that the expert be able to judge contemporary works as well as those of dead artists. 'He disapproved of limiting purchases to the latter; they must have been alive sometime.' Eventually Spencer agreed to draft new instructions, embodying the areas agreed. Grimwade, in England, was asked to consult with Sir Charles Holroyd on selecting an adviser; he was also to be told that Roger Fry had been mentioned as a possible adviser and expert. The Conference continued on 18 June, receiving and amending the instructions.[49]

[48] 'Say' but not do; ninety-five years later the Gallery still lacks a Leighton.

[49] They also decided, on Hall's advice, against buying Romney's *Lady Hamilton* and Reynold's *Lady Aylesbury*. It was generally easier to get agreement on a negative decision.

Four days later the Bequests' Committee pasted a copy in their Minute Book. Despite so much amendment, and so much disagreement over the purchase of contemporary works, the 'General Directions with regard to the nature of works of art to be selected' once again retained Hall's original statement of buying policy of 1906:

> The Felton Bequests' Committee and the Trustees of the National Gallery desire to obtain only examples of the best work of the best artists, and they wish studiously to avoid acquiring indifferent examples of great masters. In each case the work selected should be characteristic of the artist, and, should be one of his best and most important productions. With regard to contemporary work, as shown at current exhibitions, it is not enough that any example chosen should be the best of the year; it should bear comparison with famous work, and should be representative of the best art of the period. It is to be clearly understood that the acquisition of contemporary work is not the main object of the collection.

A list of specific duties and functions followed.[50]

Something like an agreement had at last been achieved, and in July the Trustees created, as promised, a committee of five, to be appointed annually by ballot, to confer on 'matters related to the Felton Bequest'. But the new committee had no independent power, being required 'to report to the Trustees before taking action', and suspicion and resentment continued. In August Murray Smith wrote to Turner that the Bequests' Committee were 'determined not to let the power of veto get out of their hands', and six days later warned that Hall, 'if he is allowed his own way much longer', 'will ruin the Gallery'.[51]

AGREEMENT DID NOT extend to purchases which Grimwade, in England, had meanwhile recommended, with Frank Gibson's advice. A conference in September rejected two Harpignies and a Mauve, despite Grimwade being 'delighted' with them, because Hall thought the prices excessive and the Trustees refused to assess their value 'in the absence of a report from any recognised expert'. In November Hall told the Trustees that the pictures recommended

[50] The expert was required (among other duties) 'to search for, inspect and report upon available works of art', 'to advise as to their value', and 'to negotiate for the purchase and delivery of the same when definitely instructed to do so'. In cases which did 'not permit of detailed reference to Melbourne', the expert could arrange purchase 'of works of art in regard to which he shall previously have received instructions ... specifying the particular class of work desired, the name of the artist or other distinguishing characteristics'. He was to communicate with the Felton Bequests' Committee and the Trustees of the Public Library through the London Agent of the Trustee company, who would also arrange payment for and 'the transmission of' works of art approved for purchase.

[51] RMS [Murray Smith] to Turner, 5 and 11 August 1908, quoted in Saunders, L Bernard Hall and the National Gallery of Victoria, pp. 85–6.

were 'distinctly ugly', and their prices 'enormous', convincing Turner that 'all purchases should be stopped until an Expert was appointed'.[52]

Grimwade had been asked to report on possible advisers. Returned to Melbourne, he attended a conference on 14 December and spoke 'strongly against' Roger Fry, who 'would naturally endeavour to obtain better pictures for the Gallery with the larger purse' (the Metropolitan, which already employed him). Mather 'entirely disagreed', since New York already had the artists Melbourne sought; 'in supplying our deficiencies Mr Fry would not come into conflict with New York's requirements. Under any circumstances we would have Mr Fry against us, and it would be better to reduce his opposition by employing him'. Godfrey agreed, but Turner thought the arguments against Fry 'incontestable', and strongly supported a proposal by Grimwade that Gibson, of whom Holroyd had spoken strongly, be appointed for one year, at 200 guineas. He would notify the Committee of forthcoming sales, and could 'when desired, have his opinion confirmed by a professional expert'. Paterson thought it 'rather undignified from the professional standpoint to appoint Mr Gibson; Mr Clausen had made terrific blunders and it would be much better to appoint one of our own men' (meaning Hall or an Australian artist in London). When it became clear that Fry lacked the numbers, Frank Gibson was unanimously recommended, a decision supported by the Trustees and ratified by the Bequests' Committee two days before Christmas.[53] It is interesting to speculate what might have developed had the vote gone the other way, and Fry had accepted, which was perhaps unlikely; modernism might have reached Melbourne before the War, but would scarcely have been welcomed. With Gibson's appointment as Adviser, the uneasy ménage à trois of Committee, Trustees and Director was about to become rancorously à quatre, though in the meantime Bernard Hall merely penned for the *Argus* a blandly abstract essay on 'Beauty in Art'.[54]

[52] FBC, 10 September, 10 and 17 November, 10 December 1908. Hall wrote to Bage on 29 June 1908 that he could not properly judge the Harpignies and the Mauve from photographs, but was not particularly impressed by the Harpignies and £2200 was a high price for the Mauve.

[53] Meetings 14 and 23 December. The decision was reported in the *Herald*, 18 December 1908.

[54] *Argus*, 28 November 1908.

16

MOBY DICK AND THE LONDON WHALE

FRANK GIBSON WAS born in Melbourne in 1865, son of Gavin Gibson, yet another Melbourne merchant. He had gone from Melbourne University to the Slade School, but made his name not as an artist but as critic and author (with a *Life of Charles Conder* his best known work). A man with many connections in the art world, he had guided Levey's choice among the Corots before proposing works for Grimwade to recommend. Grimwade's complaints when they were rejected reached the Bequests' Committee in October 1908, shortly before his return to Melbourne.

Grimwade's health, which had been failing for some time, now worsened, and after many months conducting business from his sick-bed, he died on 4 August 1910. Like Felton, he was attended in his last hours by Charles Bage, and the following day he was interred—despite his crematorial convictions—in the St Kilda Cemetery, in the plot next to Felton. Norton Grimwade, the eldest son, now joined the Bequests' Committee, as Felton's will had specified, and the conscientious but unimaginative Bage became its Chairman. James Smith also died in 1910, and the Trustees decided to disband the sectional National Gallery Committee which he had chaired, while cautiously giving the Felton Bequest Sub-Committee created in 1908 authority, for twelve months, to spend up to £1000 'on any one work'. In other respects the whole Board of Trustees now dealt with Gallery matters.

One of Frank Gibson's first recommendations as Felton Adviser was warmly welcomed in the Melbourne press, if little noticed by the public. He acquired at Sotheby's a collection of Japanese woodcuts, the selection made for him by the expert FE Strange, from the Victoria and Albert Museum. The acquisition—probably Gibson's finest—was praised in a long article by Blamire Young in the

Argus in May 1909, and anonymously in the *Herald* and the *Age* later in the year.[1] Hall, always interested in Asian art, had encouraged the purchase, and in May 1909 received approval to buy some Japanese bronzes he had sought out in Sydney.[2]

Hall deplored and resented the appointment of Gibson, in his view a mere 'amateur' (increasingly, his word of abuse); to him it was obvious that he himself, the man who knew the Gallery's collection best, was the best of all possible advisers. In a special report in March 1909 he suggested, confidentially to the Trustees, that Parliament be asked to 'amend the Felton Bequest' to allow the Felton Bequests' Committee to delegate its powers to its experts at home, under proper precautions, to carry out the object of the Will 'in its entirety'.[3] Meanwhile he argued against most of Gibson's proposed acquisitions, and the Trustees rejected many, including five of his recommendations at one meeting in June and some Beardsley drawings and other works in September. The Bequests' Committee received some of Hall's reports, and proposed to send them to Gibson for his information, but the Trustees objected, and after a tense exchange conceded only that Gibson could be given 'general reasons' for a refusal, but not Hall's reports.[4]

The Trustees did accept a number of proposals, and acquisitions in Gibson's first year included Burne-Jones' *Wheel of Fortune*, Constable's *West-end Fields, Hampstead*, works by Dupré, Monticelli, Pinwell, Bosboom and Maris, and another bronze by Alfred Gilbert. But Blamire Young wrote cruelly on most of eleven new pictures exhibited in December 1909, deploring (in particular and not unfairly in these cases) 'a small and dingy' Constable, 'a curious kind of alcoholic paint-splash, muddled but talented, by Monticello' and 'a grievous piece of incompetence that bears the name of Dupré'—all these, he lamented, had been bought with funds from 'the testator—a kindly genial man, who wished us well, and did the best he could for us'.[5]

Unable to change the terms of the Bequest, the Trustees recommended to the Bequests' Committee in December 1909 that a separate expert be appointed to work with the Adviser, or alternatively that no further purchases be made 'until

[1] *Argus*, 22 May 1909, *Herald*, 6 July 1909 and *Age*, 16 November 1909.

[2] FBC, 20 May 1909. On 25 June the Committee agreed to Hall's recommendation that Gibson buy more Japanese works at another sale.

[3] Hall to Trustees, 23 March 1909; Cox, *The National Gallery*, p. 428 n. 5.

[4] FBC, 2 February, 9 and 26 March, 15 April, 4 May 1909. On 3 June Murray Smith joined the Committee, on Godfrey's retirement from the Trustee Company.

[5] *Argus*, December 1909. The Burne-Jones had been greeted coolly in the *Age* and the *Argus* (8 April 1909).

the desirability of again sending the Director of the National Gallery to England had been considered'.[6] The Committee reappointed Gibson for a year, but also resolved that his recommendations should be accompanied by reports from Longstaff, then in London. Informal discussion with Turner, Spencer, Paterson and Carlile changed their minds; the Committee agreed not to appoint Longstaff or anyone else as a second adviser until a formal conference could meet, the Trustees having as yet no individual to suggest. Instead Gibson's reappointment was made conditional on his supplementing his recommendations with reports from a list of experts, to be approved by the Trustees.

The mood of the Trustees was revealed when Turner replied in March 1910 to complaints in the *Herald* (by 'Art Lover' again) that Melbourne was 'not getting the masterpieces we could afford', and that the Gallery was 'purposeless'; 'what one wants is judgement and courage'. Turner protested that the Trustees did not lack judgement, but the terms of Felton's bequest tied their hands. Some acquisitions under existing processes had 'greatly disappointed' the Trustees, and they would like 'to find a man to whom they could say with full reliance,"we want the best, and are prepared to pay for it"'. ('The best' would be a 'first class' Reynolds, Gainsborough, Romney, Constable or other artist of that stature: all British, it might be noted, but old masters, not living artists.)[7]

Despite these grumblings, in April 1910 the Trustees implicitly accepted the existing system by approving six of the nine experts suggested by the Committee.[8] This was so far from the outcome sought by Hall that he was provoked into sending a formal self-denying ordinance to his Chairman:

> I think, to avoid adding to the complicated nature of our methods of buying, it would serve the interests of the Institution better, if I offered no remarks under the recommendations made under the present system which is a new departure. I might, indeed, only confuse the issue if I should happen to disapprove of any proposal and stir up bad feeling at the other end among our numerous experts, which could not help being inimical to our best interest. It is important not to arouse any feelings of hostility, or create any friction with those who control the sources of our supply at home.[9]

[6] FBC, 16 December 1909.

[7] *Herald*, 10 and 12 March.

[8] For pictures, Claud Phillips, Roger Fry and Charles Ricketts; for French painting, M. Bénédite; for water colours, HM Cundall and AJ Finberg; for black and white work, Joseph Pennell and FE Strange; for English furniture, Percy Macquoid; and for French furniture, JJ Marquet de Vasselot. Fry would not act except 'through the medium of the *Burlington Magazine*, minimum fee 10 guineas' so Phillips was listed instead. Gibson had suggested some experts, his letter considered by the Bequests' Committee on 7 March 1910.

[9] Hall to FBC, 28 April 1910.

The sentiment seems worthy enough, but it was unreal to suggest that Hall, as Director, could remain passive, whatever his anguish, while others decided his Gallery's acquisitions. The Trustees were often made aware of Hall's opinions of suggested acquisitions from overseas, and were influenced by them, while the Bequests' Committee increasingly considered him a baleful influence, sinister because secret. 'Bad feeling at the other end' became inevitable.

WITH SO MANY eminent guides, Gibson's recommendations in 1910 had impressive names supporting them, and the paper-work received by the Committee was copious. Many bore distinguished names—Puvis de Chavannes, Bastien-Lepage, Delacroix, Bonington, Fantin-Latour and Watteau—but only the works by the first two were major, while *Les Jaloux*, allegedly by Watteau and costing £3125, was attacked in Melbourne as juvenilia, 'another illustration of the way in which the money from the Felton Bequest is being frittered away on inferior works by famous artists'.[10] Gibson's response that it was a work of his maturity and a good example fell on resistant ears, and probably rightly; by 1948 it was dismissed as an early copy of a missing Watteau, another copy of which inspired Lucien Freud's remarkable *Large Interior* of 1983.[11] Early in 1911 an article in the *Herald* reviewed the Bequest under the headline 'Forty Thousand Pounds Spent: Names without Masterpieces', criticising Gibson's recommendations and floating the idea of sending Hall to London again, or Paterson or Mather.[12] Louis Esson wrote from Carlton in vigorous support: 'Our collection is not a sanctuary of living souls, as it should be, but a cemetery of dead reputations'; and Felix Meyer demanded rescission of the clause requiring the Committee to certify artistic and educational value, so that selection could be made solely by an artist, 'one of sound judgement, alert, and decided in his views'.[13]

In December 1910 Gibson's reappointment was held over, pending a conference with the Trustees, but he had already made some important—indeed fateful—recommendations. In February 1911 the Committee learned that the Trustees had approved acquisition of Hoppner's *Mrs Robinson (Perdita)* for £2000 and *Theophila (Offy) Palmer*, believed to be by Joshua Reynolds, for £5000; Morland's *A Farmyard* had already been approved, for £440, and Raeburn's *Admiral Deans* (£500) was approved in May.[14] Gibson had chosen them in con-

[10] *Age*, 25 November 1910, *Herald*, 13 February 1911.

[11] Hoff, 'Variation, Transformation and Interpretation', pp. 26–31.

[12] *Herald*, 13 January 1911.

[13] Ibid., 14 January 1911, *Argus*, 20 May 1911.

[14] FBC, 21 February 1911.

sultation with Charles Ricketts, and the Committee was already aware of controversy in Britain, reported in Melbourne by the pseudonymous 'Silvestre Bonnard' in the *Argus,* in March, over the attribution of the Hoppner.[15] Bage was forced to defend London advice, and he and Levey took the unusual step of consulting the Victorian Governor, Sir Thomas Gibson Carmichael—an art-lover who had placed some of his own pictures on loan in the Gallery—regarding Gibson's purchases. In His Excellency's opinion, 'with the exception of the Charles and the Hunt, all the works were artistic; the prices paid were on the high side, but he recognised the difficulty of negotiating where governing bodies have to be consulted'. To answer London and local critics, the Committee asked Bage 'to furnish a report on the pictures to the Press on their arrival', but they also decided, undeterred by the fuss, 'that as this was an event in the history of the Gallery, the Gallery Trustees should be requested to make a special exhibition of [the Reynolds, Hoppner and Morland] by separating them for the time being from other pictures'. So much had been spent on Gibson's recommendations that the Committee had to dig into reserve funds for the Raeburn, which arrived later.[16]

Clearly the Bequests' Committee hoped to turn back the tide of public dissatisfaction, still rising at a threatening rate. Critics in the press disagreed among themselves over which acquisitions were good and which bad, but were united in criticism of the process, and convinced—despite frequent press reports of very high prices in London auctions—that the Bequest paid too much for too many pictures not worth the money. Unfortunately the Reynolds, and especially the Hoppner, were open to the same criticism, which erupted when they, and the Morland, were handed over in Melbourne in May 1911. Some of the first critics were artists, John Ford Paterson (a Trustee) and JS MacDonald (a future Director), both quoted in the *Herald*; in Paterson's view the Reynolds was 'far from being a good one', while MacDonald, a good judge of older pictures though prejudiced against modern, complained that 'three big names and two big prices have been put in the catalogue without adding anything significant to the national collection'. The *Argus* was more tolerant, praising the Raeburn when it arrived in September.[17]

By then Hall had gone to war. On 25 May 1911 he wrote to the Trustees, attacking in very strong terms most of the acquisitions of the previous two years.

[15] *Argus*, 2 and 4 March 1911. Compare Gerald Reitlinger's judgement that 'Hoppner surely holds the title of the most overrated old master ever known to the art market' (*The Economics of Taste*, vol. 3, p. 201).

[16] FBC, 18 May 1911.

[17] *Herald*, 27 May 1911, *Argus*, 27 May and 18 September 1911.

The public had been hypnotised by famous signatures on paintings, and the recommendations attached to them, and almost £20 000 had been wasted.

> I have brooded over this question of Gallery Standards for nearly twenty years, apart from my practice as an artist, and am as well able to give an opinion in these things as another. For this reason I could, I think, had I the opportunity, explain to the Trustees why, out of the score of works in the last batch, so few are satisfactory, and why it appears to me a poor result for so vast an expenditure.[18]

Writing to Turner the next day, Murray Smith foresaw trouble:

> Hall is an honourable high-minded gentleman, but a perfect faddist, all the more troublesome because he believes in his absurd views, and I do not think that the Felton Bequests Committee will be in the least likely to alter their carefully thought arrangements at his bidding. Hall is the only risk of irreconcilable quarrel. Our purchases were fairly good but here his prejudices come out.[19]

Murray Smith's attitude to the Committee's powers had always been firm: 'To the Committee is entrusted practically the whole business of selection, and all arrangements connected therewith, subject of course to the powers reserved to the Gallery Trustees in concurring with the Committee'.

On 15 June 1911 Hall elaborated his complaints. The Reynolds had been sold at Christie's in 1874 for £173; its last owner had bought it in 1906 for £2100, and had resold it to the Felton Committee for £5000. Although (he thought) a genuine Reynolds, it was not a masterpiece, and he drew attention to its weaknesses. The Hoppner was even worse: 'My worst fears are confirmed . . . I fail to find a masterly touch from top to bottom of this portrait . . . the £2000 spent on it [is] a mistake, and the picture itself not worthy of a place in a National collection'. Monticelli was represented by a work 'which looks for all the world like a bit of old carpet', Holman Hunt by a work surprisingly poor and thin, and the Burne-Jones was ugly, with shocking drawing of the nude, and the painting colourless and poor. 'With the exception of the Maris, Bosboom, Richard Wilson and perhaps the Reynolds, and the drawings by Swan, I find them a depressing and ugly collection.'[20] At the meeting which received this report the Trustees unanimously resolved that they were not satisfied 'with the results of the purchases of the last two years'.

Hall's public statements were less specific. In December 1911 he published in the *Argus* an hortatory general essay on Authority in Art, deploring 'popular'

[18] Quoted in Cox, *The National Gallery*, p. 68.

[19] RMS to Turner, 26 May 1911, quoted by Saunders, L Bernard Hall and the National Gallery of Victoria, p. 86.

[20] Quoted in Cox, *The National Gallery*, pp. 68–9.

taste and demanding acquisition by experts; his view was endorsed in a leading article in the same issue, with the extreme conclusion that 'not one work' in the Gallery was worthy of its artist.[21] But Hall's élitism was neatly deflated by the distinguished classicist Professor Tucker, in a letter deriding 'Superciliousness in Art': musicians did not pretend to be the only judges of music, and were not 'outsiders' capable of developing a knowledgeable taste in art? Could Hall declare that technical artists—his 'authorities'—were in agreement, or anything like agreement, with regard to the works hitherto selected, or likely to be selected?[22] Tucker implied that the 'decisive artist' proposed as a sole buyer would have no better chance than the existing advisers of pleasing the critics, in all their varieties. It is surprising that no one cited the Chantrey Bequest as an example of how badly practising artists could buy.[23]

Stirred by Hall's adverse report on the pictures, the Trustees were unusually outspoken at a Conference with the Bequests' Committee on 2 November 1911. The Trustees should initiate all acquisitions, Spencer insisted, while the Committee merely reviewed recommendations. 'Mr Bernard Hall, [unusually present] said no notice should be taken of Mr Gibson's recommendations as he had no idea of art …' ('etc.', the Secretary added, reluctant to record all Hall's diatribe). Bage, defending Gibson, coldly asked for specific reasons for dissatisfaction with his advice; when the Trustees responded by saying they would seek legal advice on their powers, Murray Smith warned them that no Felton money was available to waste on so superfluous an exercise.[24] Instead, in December 1911, the Trustees gave the Bequests' Committee part of Hall's private and disturbing report on the authenticity and method of purchase of the Hoppner. 'It was understood that the report was available for the purposes of enquiry, to cable and write Mr Gibson on the matter, and also to ask him to withhold any recommendations meanwhile'.[25] Gibson supported his purchase by again citing the reports which commended it. When Hall, on the war-path, pointed out errors in the letters of recommendation, Gibson replied with a wad of supporting documents, and by March the

[21] *Argus*, 19 December 1911.

[22] Ibid., 16 December 1911.

[23] The 'expert' John Mather, sent by the Committee in 1912 to choose three pictures from a British Exhibition in New Zealand, had his selections savaged by Blamire Young and others, though fellow artist Shirlow defended him (*Argus*, 29 June, 3, 4, 5, 6, 11, 13, 17, July 1912).

[24] Minute Book entitled 'Memoranda re works of art 1911–90' (Felton Bequest papers, La Trobe Library). This volume, a register of correspondence after 16 pages of Conference minutes 1911–15, was overlooked by Cox, who thought these proceedings not recorded.

[25] FBC, 11 December 1911.

Committee felt able to assure the Trustees that 'satisfactory testimony that the picture was a genuine Hoppner had been obtained', though they also chided Gibson: his earlier omission of a piece of evidence 'had let the Committee into a very unpleasant controversy with the Gallery Trustees', and 'he must verify statements made on behalf of vendors'. But the Committee also told him that they had informed the Trustees that in future 'they would decline to receive letters which could not be dealt with in an open manner'.[26]

The Bequests' Committee also asked the Trustees to appoint a committee 'to deal with all matters in connection with the Bequests concerning the purchase of works of art', and to meet in conference 'with the object [yet again!] of agreeing upon a scheme of purchase'.[27] In April the Trustees elected the President (Turner), the Treasurer (Carlile), Leeper, and Paterson to be a Committee to consult and act with the Felton Bequests' Committee, and the two groups met for an informal discussion of 'method of purchase' in May 1912, both sides speaking plainly. Turner told the Bequests' Committee that the Trustees simply would not accept any further recommendations from Gibson; but when he suggested that a new man should be 'coached' by Hall, Levey interjected that he would then be 'a mere dummy'. Leeper asked whether the Committee was willing to terminate Gibson's appointment 'now'; Bage replied 'No'. Norton Grimwade was also heavily committed to Gibson, but the Trustees were divided, Carlile confessing to being a Gibson supporter. The Trustees eventually announced that they would seek a man to work with Gibson.[28] Later in May they told the Committee they had decided that it was 'advisable not to furnish the Committee with the whole correspondence received by them' concerning the Hoppner, 'promising a verbal explanation at a later date'.[29]

Their decisions prompted a coldly angry letter from Hall. He had agreed that his Hoppner correspondence might be sent to the Bequests' Committee 'on the assumption that I had the support of the Trustees, and that they were taking steps to place the existing methods for acquiring works of art on a better footing'. They had, he observed, welcomed and supported his adverse reports on the system, but it now appeared that they were 'disposed to compromise' with the Felton Committee.

> I have to ask myself is it 'in the interest of the Gallery' that I am required to put myself still further into the hands of a body I have good reason to believe is hostile to me and whose policy is likely to embroil me with people at the other end.

[26] Ibid., 19 January and 7 March 1912.

[27] Ibid., 7 March 1912.

[28] Minutes of Conference of FBC, and Trustees, 9 May 1912.

[29] FBC, 18 June 1912.

The Trustees alone were responsible for works purchased for the Gallery, and he was responsible to them alone, and not to the Felton Committee.

> Frankly speaking, I am as doubtful of their methods as I think the Trustees would be, if they had, for example, to travel in a ship whose engines had been placed under the control of one who was not an Engineer, as I have constantly advised them of their peril in regard to the employment of this amateur element.[30]

Hall's campaign to oust Gibson had failed. He did not live to see the Gallery, later in the century, list *Perdita* as merely 'attributed to Hoppner' and *Miss Offy Palmer* as 'after Reynolds', vindicating his judgement. But not his tactics: he admitted he must have made enemies during the episode, as indeed he had, some London experts speaking thereafter as though the Melbourne Gallery nursed a viper in its bosom. Hall became unreasonably vehement against London advice, believing that Londoners were wilfully or negligently failing to recommend masterpieces which he was sure were abundantly available (despite the machinations of agents in the market, with whom he also became obsessed). In the years that followed, he caused the Gallery to refuse many golden opportunities offered it, some at silver prices.

The Bequests' Committee were at first reluctant to appoint an additional adviser nominated by the Trustees, foreseeing that there could be conflicting messages received from London, but they agreed in May 1912 that 'until further arrangements were made' the Trustees could nominate an expert, reporting to them, to act with Mr Gibson, the Bequest paying for the services of both.[31] When the Trustees also agreed, in May 1912, that Gibson might continue, acting with a new Adviser responsible to them, they also gave their Felton Bequest Committee—enlarged with an additional member, Sir Henry Weedon, and soon to be renamed the Felton Purchase Committee—'power to act conclusively with the Felton Bequests' Committee ... to recommend the purchase of any picture ... or to accept a recommendation of the Felton Bequests' Committee to purchase any picture at a price not exceeding 3,000 guineas'.[32] Responsibility

[30] Hall to President of Trustees, 14 May 1912 (Hall papers).

[31] On 18 June the Bequests' Committee agreed to appoint an 'expert nominated by the Trustees of the Gallery to act and report conjointly with the Committee's adviser'. The Committee had received a new opinion from counsel EJ Mitchell on the relative functions of the Trustees and the Committee under the will, suggesting that they might allow a little more delegation than in the past.

[32] Armstrong, with Boys, *The Book of the Public Library, Museums, and National Gallery of Victoria*, pp. 18–19. Sir Henry Weedon, businessman, Lord Mayor and 'a philanthropic urban liberal', was a Trustee 1912–21; another recent appointment had been Sir John (Jack) Mackey (Trustee 1909–23), a poor boy who had taught himself to read and write and became a well-liked lawyer and cabinet minister (Geoffery Serle, *ADB*, vol. 10).

for carrying out the Bequest was now formally divided between two committees of five. The structure resembled the Dual Monarchy of Austria-Hungary, though without an Emperor-King—except Hall, in self-imposed exile—and was prone to the same instability. Warfare was likely.[33]

THE TRUSTEES ASKED Sir Charles Holroyd to act as their London Adviser. He refused, as he had in 1905, and suggested the very distinguished Sir Sidney Colvin, recently retired as Keeper of the Prints at the British Museum, a man steeped in literature as well as art. Appointed Slade Professor of Fine Art at Cambridge in 1873, aged twenty-eight, he was also Director of the Fitzwilliam Museum by 1879, when his close friend Robert Louis Stevenson dedicated to him that classic backpacker's journal, *Travels with a Donkey*. Colvin accepted Melbourne's offer in December 1912, advising, from long experience, that it would be essential to be able 'to take prompt advantage of the unforeseen opportunities of the market ... Really fine things can rarely now-a-days be secured at moderate prices except in this way'. Melbourne had been warned.[34]

The recommendations of Colvin and Gibson were made separately to the Trustees and the Committee respectively, though usually in similar terms. Their first proposals were minor, but in March 1913 Colvin raised high hopes, reporting that he had examined the catalogue of the Melbourne collection and 'found deficiencies in the French school: Corot was only represented by one example; there was no Impressionist [he overlooked the Pissaro]; nor a master as celebrated as Degas'. He believed these should be secured, together with examples of the works of Rousseau, Diaz, Dupré, and Harpignies, 'and among the Impressionists, at least Monet and Renoir'. He thought that M. Durand-Ruel, a major dealer and an old friend of his, might be persuaded to sell some of the Impressionist masterpieces in his own collection; unfortunately, when visited by Colvin and Gibson in June, Durand-Ruel 'absolutely declined' to sell, but they did find, in the Durand-Ruel galleries, a Monet, a Sisley, a Renoir and a Boudin, which they recommended. All but the Renoir were bought—Gibson doubting whether Renoir would be suitably represented by a landscape—the highest price being £1250 for Monet's *Rough Weather at Étretat*.[35] Colvin also suggested a 'masterly Degas', *Foyer de la Danse* (£6000), which Hall supported, but the Trustees thought too expensive; it was indeed later sold much more cheaply (though

[33] Cox, *The National Gallery*, pp. 72–3.

[34] The Committee appointed Colvin, at a salary of £210, and reappointed Gibson for 1913, on 18 February 1913.

[35] Colvin to Trustees, 17 June 1913.

Colvin disputed whether that was truly so, the real price being masked by the operation of a dealers' 'ring').[36]

In October Colvin recommended a *Portrait of Lord Hampden* (£4000), and a *Pastoral Landscape* (£800), both by Gainsborough, and in his view two perfect examples of the painter. He also recommended a Millais, *Diana Vernon* (£750), which was accepted, but the Trustees rejected the Gainsborough portrait—it seems on Hall's advice—and the landscape. Colvin was upset, especially when he received no reply to requests for the reasons the works were declined. 'Let me beg', he wrote, 'that you will express to your Committee the keen sense of regret and disappointment' the rejection had caused him:

> In my judgement an opportunity, not at all likely to recur, has thus been lost of enriching the Melbourne Gallery with examples of Gainsborough's work both in portraiture and landscape absolutely first rate in themselves and finer than any possessed by any Colonial Gallery or any provincial Gallery at home except that at Edinburgh.[37]

He could not expect dealers and artists to hold works for six weeks if his recommendations were consistently rejected.

Refusals, now coming thick and fast, included Augustus John's *Portrait of William Nicholson,* 'by the common consent of artists one of the most masterly examples of modern portraiture' (£1200), and *Orchids,* 'a very brilliant flower piece by Nicholson himself' (£350). When Colvin was belatedly informed by the Trustees that a general committee had been constituted to consider the question of purchases under the will, he replied on 14 February 1914 that he would make no further recommendation until he had received a reply to his December letter, and until he had been informed of the decision of the committee.[38] Receiving neither, he nevertheless made further suggestions; when refused permission to bid at Christie's for a fine *Landscape with Cattle* by Troyon, to a limit of 8000 guineas, he became understandably angry when it sold for only 5500 guineas.

> The gallery is the poorer by missing an acquisition which, like the Gainsboroughs, the Augustus John, the Nicholson, and the small Lavery previously refused, would have

[36] Often the bidder had to pay off other dealers, 'generally by promising him or them an agreed share, which is often a large one, in the profit of eventual re-sale'. He also informed them that if there was little competition, or only a few dealers attend, 'their practice is to arrange a "knock out" or private auction among themselves afterwards' (Colvin, 12 December 1913, quoted in Cox, *The National Gallery,* p. 74).

[37] Colvin, 12 December 1913, quoted in Cox, *The National Gallery,* pp. 74 and 75, n. 20. On 25 November 1913 the Bequests' Committee noted that the Trustees had rejected one Gainsborough, and was willing to approve more for the other than the Trustees had. The Millais is now thought inferior, and not exhibited.

[38] He did, however, tell them of a *Dutch Landscape* by J Maris for sale (£7500), on the suggestion of Spencer, then in England.

done honour to any collection of modern pictures in the world; and your adviser has undergone yet another grave discouragement in his endeavour to fulfil the task entrusted to him.[39]

In Melbourne, the Bequests' Committee became increasingly concerned by the frequency with which the Trustees rejected recommendations, and especially by delays in informing the Advisers. In February 1914 they reminded the Trustees that 'it would be of great assistance to London advisers and bring all parties into closer touch if when recommendations were declined, the reasons for rejection were in every case recorded and communicated to the advisers as well as between the two bodies', and in May they belatedly gained permission from the Trustee Company to cable all refusals, despite the added expense.[40] When Levey set off for Europe again in February 1914, he was 'requested to investigate Mr Gibson's position in the Art World and to communicate the result', and when Norton Grimwade followed him in May he was asked to assist.[41]

With so many overseas purchases blocked, it is not surprising that the reputation of the Bequest in Melbourne declined even further, and demands for different selection procedures grew. Howard Ashton's well-argued long review of eight years of Felton acquisitions in the *Argus* in January 1913 attacked most of them, praised Hall's choices, and argued that 'an artist would make fewer mistakes than a connoisseur or a collector': only artists knew the best modern painters. (Ashton's crediting Hall with acquiring Corot's *Bent Tree* provoked a counter-claim from Levey, and an unfriendly public exchange followed between the Director and the future Chairman of the Bequests' committee.)[42] Percival Serle endorsed the praise of Hall, and proposed Longstaff as adviser. In July 'Pollice Verso' in the *Bulletin* complained that from an Australian artist's point of view the Felton Bequest was

> frostier than the cosy corner where Dr Mawson is wintering ... For many of the paltry purchases an amateur artist in London, Frank Gibson, is responsible to the trustees, who are a doctor, a chemist, a banker, an ironmonger, and an ex building contractor ... the two dealers in pills are evidently believers in buying small quanti-

[39] Colvin to Trustees, 2 July 1914.

[40] FBC, 25 February and 1 May 1914. On 3 October 1913 they had decided that they would themselves view local exhibitions. In June 1913 MacFarland replaced Murray Smith, who had been ill and absent since June 1912.

[41] FBC, 25 February 1914. On 28 July the FBC, received another report from the Trustees on the appointment of experts, and discussed their own attitude while awaiting a Conference.

[42] *Argus*, 5, 6 and 13 January 1913. Levey (*Argus*, 5 January) claimed credit for recommending the Corot, Hall (7 January) replied that he had earlier recommended it, and Levey (9 January) responded that he had not been told of the recommendation at the time, and had acted with Gibson, a point unlikely to please Hall.

ties of cheap stuff put up in attractive boxes, because most of the purchases are insignificant but well framed . . . The Felton Bequest is so far a trivial, pitiable failure.[43]

A month earlier the *Age* had listed and attacked £41 000 worth of purchases since 1905; and Arthur Woodward, head of the art school in the Bendigo School of Mines, claimed that the National Gallery in London had spent its more limited funds much better.[44] A correspondent complained of 'faddists', and of competing against American millionaires instead of buying Australian. The *Herald* attacked the Melbourne Gallery for bad hanging and lighting, and for displaying Felton 'poor stuff' instead of good old favourites like *Quatre Bras*. The Felton money, it was presciently suggested, should be used to build a good gallery in St Kilda Road.[45] The Conder acquired by Gibson in 1913—*The Blue Bird*, watercolour on silk, produced to great acclaim in 1896—was attacked despite Gibson's persuasive article on the artist in the *Argus*.[46]

In December 1913 Edward de Verdon used the appearance of Sisley's *Straw Ricks* (in his view a 'potboiler') to complain that the system had not changed, as had been promised three years before.[47] His view that the selector should not be an artist provoked Alexander Colquhoun, Secretary of the Victorian Artists Society, to assert, by direction of its Council, that in assessing art, as in surgery, skill came only from training. Arthur Wills asked for a Government enquiry to find the best method of purchase. Turner replied to de Verdon that the existing adviser was not an artist, and to Wills that meddling with Felton's will would discourage further benefactions. Wills insisted that unless the London agent could be given power to buy, the best works would be missed.[48] The *Bulletin*, noting the 'latest consignment of poor paintings', beat its populist national drum: 'The public prefers Longstaff's *Bush Fire* to Turner's *Okehampton Castle*, and Streeton's *Sydney Harbour* to Corot's *Bent Tree*'.[49]

In January 1914 Bage issued a long and measured statement on the operation of the Felton Bequest, stressing its purchases of Australian works, which were indeed continuing. He implied some criticism of the Government, for giving the Gallery nothing for acquisitions, so that Felton funds were the only source; and

[43] *Bulletin*, 10 July 1913.

[44] *Age* 28, June and 31 July 1913.

[45] *Herald*, 23 July 1913.

[46] *Argus*, 1 February and 1 April 1913. On *The Blue Bird*, see Ann Galbally, *Charles Conder*, pp. 147–9.

[47] *Argus*, 2 December 1913.

[48] Ibid., 6, 8 and 9 December 1913.

[49] *Bulletin*, 6 November 1913.

of the Trustees, for becoming in consequence less interested in the Gallery, having the Museums and Library to look after.[50] But press criticism continued, the arrival of Millais' *Diana Vernon* in April provoking a renewed attack on 'inferior' works and demands for a new adviser.[51] But in June 1914 Gibson gave an outspoken interview in London, attacking delays in making decisions and the rejection of so many of his and Colvin's recommendations: 'At the present time the Gallery Trustees have it in their power to nullify every action of my committee and to destroy the real object of the Felton Bequest'.[52]

The outbreak of war across Europe in August 1914 gave the Trustees some excuse for Melbourne's inaction over the Advisers' recommendations, but not enough; in November Colvin reported that the picture market was stagnant, but that good works were available—including again the rejected Gainsborough portrait—and he recommended several.[53] He also proposed a major coup: Turner's great *Campo Santo at Venice,* and Constable's *Dell in Helmington Park*, might be available if £20 000 could be put together. All his recommendations were rejected; he was told, belatedly, that purchases had been suspended while changes in procedures were pending, and that in any case prices might be expected to fall when the war was over, a point he disputed. The Trustees' Adviser had had enough; on 2 March 1915 Colvin wrote his resignation, in polite but damning terms:

> I desire to be distinctly understood that I must decline further to act as adviser to the Gallery Committee under such conditions as those of which I have had experience during the last two years. It is inconsistent alike with my personal self-respect, and with the credit and reputation of the gallery, that the most important recommendations of its adviser should be habitually declined as they have been, and that the confidence of the Trustees in my judgement should have been shaken, as I can only conclude to be the case, by comments ignorantly passed on such purchases as have actually been made on the joint responsibility of myself and Mr Gibson.

He had written a private letter in these terms a year before to Baldwin Spencer, authorising him to make whatever use he pleased of its contents.

> I do not know whether he has in fact made any, but its purpose was to point out that such criticisms as have appeared in the Melbourne press on purchases like those of the

[50] *Age*, 10 January 1914.

[51] *Argus*, 1 and 2 April 1914. When some Sargent landscapes were criticised in another attack on the Bequest (*Age*, 9 March), Hall courteously acknowledged (11 March) that the Trustees, not the Bequest, had bought them, through an expert; they were not what they wanted most, but all that could be got from the artist.

[52] *Herald*, 6 June 1914. A few days later the *Age* announced (13 and 15 June 1914) that Hall had put in a major report on second-rate pictures, though no details were released; the newspaper itself argued that drastic reform was necessary.

[53] Colvin to Trustees, 6 November 1914.

Lemon, the Monet, the Sisley, the Millais, and the Cameron landscape, ought to carry no weight whatever with the Trustees and would simply be laughed at by any competent judge in this country or in Europe.

It had given him 'particular pleasure' to undertake the task two years before, thinking 'that acting in conjunction with the adviser to the Felton Trust I could within a few years have done much to make the Melbourne Gallery one of the finest outside the Great European capitals'. His hopes had been 'quite frustrated by the rejection of ... works which would have done honour to any gallery in the world'.

> Finally, as a matter of parting advice to your Committee I would urge them in all seriousness and courtesy to realise that neither I nor any other recognised or competent judge of painting would consent to advise them in the absence of such confidence as they have not thought proper to extend to me and as my known position gave me, I consider, a right to expect.[54]

Colvin blamed Hall. In a final letter to Turner on 21 May he claimed that it had soon become 'evident' that

> influences in your gallery were at work to assure the condemnation beforehand in any acquisition that Mr Gibson had any share in recommending ... The evidence to which I refer was from a conversation with Professor Baldwin Spencer, then several later conversations with Mr Levey and Mr Grimwade, and lastly a series of newspaper comments obviously either inspired by ignorance or malice, or both.[55]

Hall did not give up his campaign against Gibson. In April 1915 he published in the *Argus* 'a scathing criticism', supported in a leading article, of Felton Bequest purchases, especially—yet again—the Hoppner and Reynolds, pointing out that they had cost £100 more than his entire purchases in 1905.[56] The Felton Bequests' Committee was deeply offended, formally asking the Trustees whether Hall had written on behalf of the Gallery, with their 'sanction and approval'. The response, a denial, mollified them, though the Committee reiterated that 'the general effect' of Hall's 'many inaccuracies' was 'to make more difficult the joint and harmonious action of the Gallery Trustees and the Committee in carrying out the trust conferred on them by the late Mr Felton's will'.[57] Hall was formally

[54] Ibid., 2 March 1915, quoted in Cox, *The National Gallery*, pp. 76–7.

[55] Colvin to Turner, 21 May 1915.

[56] *Argus*, 24 April 1915.

[57] FBC, 27 April and 5 May 1915. They also noted that it was 'an opportune time' for them to communicate with the press.

reprimanded—'in the opinion of the Trustees, the publication by him of the article in the *Argus* of 24th April was a discourteous and improper act'—and forbidden to make any 'public use of any information in regard to the National Gallery' without the previous sanction of the Trustees. 'Surprised and pained', he asserted that no criticism of the Trustees themselves had been intended, and that he had acted on their behalf:

> The Trustees were saddled with a system they did not approve of, but which, so they often told me, they could not put aside. I saw the Gallery retrograding. The Trustees saw it too. Resolutions had been passed to this effect, steps had been taken to alter the direction, but with no result. To push the matter further must arouse hostility and create unpleasantness. I thought it my duty to take this odium upon myself.[58]

Hall conceded that he might have 'over-magnified the responsibility attaching to my office', but, unrepentant, took his battle with Gibson overseas, repeating his arguments in an article in the *Connoisseur* in August 1915, provoking an exchange with Gibson which continued for some months.[59] In October the *Argus* reported Hall's statements in the *Connoisseur* and supported him by demanding an end to 'gross blundering'.[60] But the balance of blame was to swing over. In July 1916 a vigorous article in the *Age*—attributed by Cox to 'a group of Gibson and Colvin's supporters'—flayed the Trustees and the Director, chronicling their conflicts with Advisers and blaming them for the virtual suspension of purchases for two years: 'That the Trustees of the gallery should have flouted the recommendations of their art advisers to such an extent that four of them have successively resigned is a bad thing for the gallery'.[61] Two days later Bage agreed that the article was in the main true; and a leading article in the *Age* on 4 July attacked the 'gross blundering and ineptitude of the Trustees' and their 'scurvy and most stupid treatment of Colvin'.[62] In a memo to the Trustees, Hall made a revealing

[58] Hall to President, 27 May 1915 (Hall Papers). Hall also claimed that the Chairman of the Bequests' Committee had once 'invited' public criticism, citing a statement in 1911 when Bage had done no more than declare criticism inevitable.

[59] The exchanges (*Connoisseur*, August and December 1915, February and May 1916; *Argus*, 3 June 1916) are summarised in Cox, *The National Gallery*, pp. 78–9. Gibson fired a last shot in 1919, when 'FGS' in the *Argus* (18 January) reported a Degas sale in London, regretting that so little of that 'school' had been acquired by Melbourne (only the Pissarro and a 'very poor' Monet). Gibson replied, complaining of the Trustees' rejection of his recommendation to buy 'impressionist' works, including Degas' *Salute Rose* in 1910 and (with Colvin) his *Foyer de la Danse* in 1913.

[60] *Argus*, 16 October 1915.

[61] *Age*, 1 July 1916.

[62] Ibid., 1, 3 and 4 July 1916.

admission, that many pictures had been rejected, 'not always on their merits, but because the working of a system had been questioned and finally condemned'.

> Six times between the end of 1909 (the year of Mr Gibson's appointment) and the commencement of 1914 (at the end of Sir Sidney Colvin's first year) the Trustees passed resolutions either unfavourable to the personnel and methods employed, or expressing dissatisfaction with the results obtained ... Having taken these steps—having taken them repeatedly—to go back on their decision and to consider fresh recommendations would have been to stultify themselves and to re-establish a system which had admittedly broken down.[63]

Since Colvin was the Trustees' own adviser, appointed at the Bequest's expense on their recommendation, the Director was in fact admitting to sabotage of his own institution's policies, even if tolerated and abetted by some of his Trustees. The treatment of Colvin was shabby, and the Gallery lost for ever some important acquisitions: Turner's *Campo Santo at Venice* and Constable's *Dell in Helmington Park*, if acquired together for £20 000, would have been the bargain of the century. Reviewing the affair, Cox—who clearly admired the Director—concluded that 'at this stage in the career of a fine and honest man', Hall had become 'like Captain Ahab in pursuit of Moby Dick, the White Whale'; the destruction of the Felton Bequests' system of purchase had become an obsession.[64]

If Hall scarcely emerges well from this episode, what of Gibson, the Adviser he despised? Later scholarship was to vindicate criticism of the Watteau, and of *Perdita* and *Offy Palmer* and others. Sir Daryl Lindsay wrote that Gibson's period as adviser 'was not productive of many important additions to the Melbourne collections', other than the Raeburn, the Morland, and Puvis de Chavannes' *L'Hiver*, 'a masterpiece of mural design and one of the great works in the Melbourne Gallery'.[65] Dr Hoff added Constable's *Westend Fields, Hampstead*, to the list, and remarked that several other paintings acquired on Gibson's recommendation were 'all reliably attributed and by the sort of artists one would want to buy for a Gallery, even if they are not among the very greatest names'; she later

[63] Quoted in Cox, *The National Gallery*, p. 79, from Hall to Trustees, in the *Connoisseur* file.

[64] Cox, *The National Gallery*, p. 80. Cox's judgement has been questioned, and Hall defended, by Helen Lorraine Saunders, in L Bernard Hall and the National Gallery of Victoria. She complains (p. 2) that Cox 'ignores the validity of much of Hall's criticism of purchases by London Advisers'. 'Whilst time has vindicated many of Hall's criticisms, consideration of this has not been used to reassess Hall'; and claims further (p. 96) that Hall became 'a convenient scapegoat for much of the conflict of the period'. But his part in rejecting works he admitted should have been accepted is hard to justify.

[65] Lindsay, *The Felton Bequest*, pp. 29–30.

added praise of Gibson's acquisition of the collection of Japanese woodcuts, judged by a later Director, James Mollison, to be among the Bequests' finest purchases for the Gallery.[66]

FORTUNATELY FOR HALL'S reputation, and the Bequests', the claim in the *Age* that the Director and the Trustees had caused a suspension of purchases for two years referred only to acquisitions in Europe, and was not completely true even there.[67] Local acquisition had continued, and not only of Australian art.

In the first decade of the Bequest, Hall's recommendations for local purchases had been plentiful, though here again his concern for precise rules caused him difficulties. In October 1910 he asked his Trustees to confirm that the same standard was not required in the purchase of Australian art as in European art, so that they could encourage and stimulate local artists. In November the Trustees ruled that in the general purchase of pictures, including the work of Australian artists in England, the best available should be obtained; with locally produced art the standard should be that of the best eight to ten pictures already in that section of the Gallery. The Felton Bequests' Committee, however, had already stated that it 'felt bound by the terms of the will to put the purchase of works of art by local artists on exactly the same footing as that observed in the case of pictures bought in the open market at home', in Hall's view making local purchase with Bequest funds more difficult.[68]

It was at this time that the Bequests' Committee asked the Trustees to recommend purchase of Hall's own *The Reverie*, but Hall objected that such a purchase was improper while he was Director. The Trustees accepted his objection, and 'regretted being unable to concur in the selection'; the Bequests' Committee in turn recorded its 'regret the Gallery is not obtaining the picture in terms of the Bequest, but fully appreciate Mr Bernard Hall's attitude in the matter'.[69]

Hall, eager to maintain the pure 'science' of selection, still hoped to exchange acquisitions if an artist later produced a better work, though this had only twice been done. In July 1913 the Committee was told that the Trustees wished to buy, on Hall's recommendation, E Phillips Fox's *The Arbour* for 500 guineas, provided

[66] Dr Ursula Hoff to JRP, 7 March 1973 (author's possession). Gibson must also be given credit for purchasing the Gallery's first—and important—Conder.

[67] For example, a long list of etchings and drawings, costing £500, recommended by Gibson and Clausen was approved in September 1913.

[68] FBC, 28 November 1910. Hall asked the Trustees to place £350 on the Government estimates to stimulate local art; other Galleries were collecting Australian art, and if the Melbourne Gallery did not do so it would be 'a depressing distinction'.

[69] Ibid., 27 October and 28 November 1910.

the artist would accept the return of *A Love Story*, acquired in 1908, in part payment. Fox refused; and members of the Committee cited Mitchell's opinion that such exchanges could not be permitted by Felton's will. Fox died in 1915, and the Committee's scruples must have been overcome: *The Arbour* was acquired in August 1916 for £315, with *A Love Story* de-accessioned in part payment. It is now one of the glories of the Ballarat Gallery.

Hall was not the only source of local recommendations. Mather was sent to New Zealand in 1912; and in August 1913 it was agreed that an expert appointed by the Gallery Trustees—not necessarily Hall—should inspect local exhibitions and that his reports should be communicated to the Bequests' Committee. Two months later the Committee itself affirmed that it too would view local exhibitions; having done so, they approved two works of Thea Proctor, which Hall had also recommended. The category 'acquired without official expert advice' appeared not infrequently thereafter in the Bequests' lists of acquisitions, over purchases including GW Lambert's *Lotty and the Lady* (1910), Rupert Bunny's *Endormies* (1911), and works by Blamire Young and Edward Officer (1912).

Edward Officer, artist (of modest talents) and pastoralist—he had been born on Murray Downs in 1871, son of Suetonius Officer, and was thus aged thirteen when Felton and Campbell brought the property—was among the small group of local artists who met at the Café Francais in Little Lonsdale Street in August 1912 to form the Australian Art Association, after another dispute within the Victorian Artists Society.[70] The artist-architect William Hardy Wilson, one-time Secretary of the Chelsea Arts Club, had proposed a new national exhibiting society, based on London models, for Sydney, but Officer was convinced that Melbourne was the only place for it ('We all know there is but one place in Australia where exhibitions can be made a financial success . . . Sydney is hopeless'). Meldrum, Paterson, Withers, McClintock and Innes were also founder members, soon joined by Clewin Harcourt and others (including, later, Norman Macgeorge, who succeeded Officer as President in 1921). The Association limited its membership to practising artists of high standard, and its annual exhibitions, of Australian art drawn from across the nation, held after 1921 in the Fine Arts Society building in Exhibition Street (a handsome replica of Robert Adam's Boodle's clubhouse in London) were at first eclectic, and much praised, though sinking into conventionality before the Association's demise in 1933. The Bequest acquired some works

[70] Officer had studied at the National Gallery and under E Phillips Fox, and in Paris and London, won the Wynne Prize in 1903; he was accepted (then, if less now) as an artist as well as a connoisseur (entry by Juliet Peers in *ADB*, vol. 11). On the Association, see John Pigot's essay in his *Norman Macgeorge*, pp. 60–9.

from these shows, at which Hall himself exhibited, though complaints that the National Gallery bought too little of their work were common among the members. The high standard of painterly skill among Victorian artists in the first third of the twentieth century (perhaps best exemplified in the quiet virtuosity of WB McInnes) owed much to Hall's demanding training, and although the younger artists repudiated his values, their work—even of those who, like Macgeorge, espoused a moderate modernism—betrayed the influence of the *éminence grise* of Victoria's art world, reluctant though some might have been to admit it. Grey was an appropriate adjective; as David Marr later remarked, Melbourne tonalists of the inter-war years were 'connoisseurs of gloom'.[71]

Hall, in return, was sparing in admiration of their work. After 1913, when the Art Gallery of New South Wales was busily acquiring works by artists of or from Melbourne, Hall's recommendations of Australian art to the Bequest became narrower; Streeton, Heysen, Meldrum, Wheeler, Web Gilbert and Septimus Power giving way to cartoons by Will Dyson and a string of Norman Lindsay drawings and etchings, and to objects other than paintings and drawings. Furniture (French and English), Egyptian antiquities, Greek vases, Roman amphora, 'a Chinese Opium Pipe and accessories', antique Japanese wood-carving and fourteen Japanese tsubas (engraved sword guards) proliferated among the acquisitions. It was chiefly when turned towards London—and to a degree Melbourne—that Hall's eye had become jaundiced.

IN FEBRUARY 1915, a few weeks before Colvin's letter of resignation was written, Norton Grimwade returned from London with a glowing testimonial for Gibson. 'Mr Grimwade ... stated that he had made several inquiries, and had come to the conclusion that we could not obtain one more devoted to the interests of the Bequest, or more in touch with the art world'.[72] A month later Hall's attack on the Bequest in the *Age* and his consequent reprimand from the Trustees seem to have given the Bequests' Committee a new determination to clean the stables once and for all, especially while the Trustees were at some moral disadvantage in defending their Director. The Committee asked the Trustees for a conference, which made a bad start with Turner reading 'a statement as to the average price per lineal foot of hanging space occupied by works

[71] David Marr, 'Changing the Label', *National Times*, 3 August 1984, pp. 16–18, quoted in Gregory and Zdanowicz, *Rembrandt in the Collections of the National Gallery of Victoria*, p. 10.

[72] FBC, 23 February 1915.

purchased by Mr Bernard Hall, Mr Clausen, and recommended by Mr Gibson', and soon became heated. 'The present advisers had not had a fair run', Bage complained; 'it has been a long enough one', Mather responded.[73] The Bequests' Committee eventually conceded the point, and decided—despite Grimwade's recent encomium—to tell Gibson that in order to have a free hand in 'the proposed new arrangements for the future representation in London', he should consider [his appointment] as not extending beyond the end of the year', when he would have served for six years.[74] In August, determined to tidy away the conflicts of the recent past, they received but put aside a batch of correspondence to, from and about Colvin, and letters from Gibson (including one addressed to the Editor of the *Argus*, which they declined to forward). They then resolved that they were 'now ready to consider any nomination of a London adviser that the Trustees may make'. A few days later, on 24 September, a Conference finally agreed to six 'principles', all restating matters long debated and earlier agreed.[75]

Despite this agreement, negotiations stalled for some time, mainly it seems because the Gallery Trustees were once again attempting to formulate new acquisition policies. Communication was facilitated by the appointment as the Trustees' representative on the Bequests' Committee, after Mather died in May 1916, of Turner himself—now aged eighty-five: he was Felton's exact contemporary—but the Committee's forbearance did not extend to accepting a recommendation, made by a Felton Inquiry Committee of the Trustees, that Bernard Hall be sent to London again to obtain works of art, and to find suitable advisers. Bage responded that while his Committee agreed that the appointment of an expert adviser in London was an urgent need, 'the task of obtaining applications and judging of the merits of the applicants would not be facilitated by sending Mr Hall to London; that on the contrary it would add to the difficulties of the situation if he were sent'.[76]

[73] 'Informal' minutes, 9 March 1915 pasted into Minute Book 'Memoranda re works of art' 1911–90.

[74] FBC, 5 May 1915.

[75] Ibid., 24 August and 20 September 1915. The principles were: 'That an expert in London be nominated by the Trustees of The National Gallery; That such nomination be submitted to The Felton Bequests Committee for its approval; That the appointment be for a period of two years, and thereafter terminable by six months' notice; That the reports of such expert be sent simultaneously to The Felton Bequests Committee and The Felton Purchase Committee of the Trustees; That the reports be considered and dealt with by the two Committees in conference; That all expert advice obtained either by the Trustees of The National Gallery or by The Felton Bequests Committee be circulated at such conference'. The Felton Bequests' Committee also intimated 'that it was willing to authorise a salary for an expert up to a limit agreed upon'. At the August meeting Levey's leave was extended until February 1916.

[76] Ibid., 6 July 1916, minute communicated in letter quoted in Cox, *The National Gallery*, p. 82.

The Trustees confirmed their confidence in Hall, but—in one of their better decisions—submitted the name of Sir Baldwin Spencer as emissary. The Felton Committee agreed unanimously to send Spencer, 'for the purpose of making inquiries and recommending an Art Adviser in London', but with a number of provisos, all intended to ensure closer consultation, set out in a long letter to the Chairman. The Bequests' Committee wished to ensure that no stones capable of concealing insidious beasties remained unturned.[77]

[77] Ibid., 9 September 1916. The provisos, accepted by the Trustees on 30 September, were that Spencer's reports 'be sent simultaneously to the Felton Bequests Committee and the Trustees of The National Gallery' that the resolutions adopted at the conference between the Felton Bequests Committee and the Trustees' Felton Purchase Committee in September 1915 would 'govern the relations between The Felton Bequests Committee and the Trustees of The National Gallery and the London expert'; and that extracts (as set out) from the instructions to Gibson, agreed in June 1908, 'be communicated to any Art Adviser who may be appointed, as a part of his instructions'. The Committee offered £250, later increased to £400, for Spencer's expenses.

17

ART AND ANTHROPOLOGY

Baldwin Spencer was a man of parts. Although he came to Melbourne University's Chair of Biology as a zoologist, and became famous as an ethnologist, art was the greatest of his private passions. In his youth he had spent a year studying drawing at the Manchester School of Arts, and in Melbourne soon made friends with local artists, championing in succession Streeton and Norman Lindsay (whom he judged 'the very biggest genius' in Australian art history). He began collecting paintings and drawings for himself from about 1889, and continued so compulsively that he had to hide acquisitions—especially some Lindsays—from his wife.[1]

As an ethnologist, with an immense knowledge of the Aboriginal tribes of Central and Northern Australia, Spencer built an indubitably great collection for Melbourne's National Museum, of which he inherited the position of Director from his predecessor in the Chair (supervising also its transfer from the University of Melbourne to the Swanston Street complex in 1899, and the construction of its new building in 1906). His collection included bark paintings, grave posts and other decorated objects; 'as the largest corpus of Aboriginal art assembled before the middle of [the twentieth] century', his biographers have written, 'its cultural significance to future generations is incalculable'. They also rebuked him, politely: 'It was to the Aborigines after all, and not to a group of Melbourne

[1] Spencer's biographers note that in Australia he was 'subjected early to diverse influences of a nationalistic character', including working to develop the Australasian Association for the Advancement of Science, collaborating with the classicist Professor TG Tucker in editing *The Australasian Critic*, and making 'bush forays with enthusiastic naturalists' (Mulvaney and Calaby, *'So Much That Is New'* pp. 337, 114). Spencer proclaimed Lindsay 'the greatest artist that Australia had ever known' (p. 346).

painters, that Spencer should have turned for his school of Australian landscape'.[2] But Spencer, as the Museum's Director, was happy to keep its collections separate from the Gallery's, gathered as they were under different inherited intellectual disciplines, neither yet much questioned. Like virtually all the anthropologists of his day, Spencer was a social evolutionist, classifying cultures without hesitation into higher and lower stages of human development, and he was concerned to document Aboriginal culture as he saw it in its entirety, and to present its art in that context.[3] But he knew an artist when he saw one, whether it be among Melbourne's bohemians or in Kakadu, visited in 1912.

> Today I found a native ... evidently enjoying himself, drawing a fish on a piece of stringy bark about two feet long and a foot broad. His painting materials were white pipe clay and two shades of red ochre ... and a primitive but quite effective paint-brush ... shaped like a minute, old-fashioned, chimney-sweeper's brush. It was most effective, and he held it just like a civilised artist sometimes holds his brush or pencil ... Held in this way, he did line work, often very fine and regular, with very much the same freedom and precision as a Japanese or Chinese artist doing his more beautiful wash-work with his brush.[4]

Spencer was so impressed by the Kakadu bark painters that he 'commissioned two or three to paint me a series of canvases, or rather "barks"'. The subject matter he left to each artist, and 'as a result I was able to secure some fifty examples that illustrate the present stage of development of this aspect of art amongst the Kakadu people'.[5] Spencer was always very proud of this collection, claiming that the barks 'that now hang in the National Museum at Melbourne are regarded as first-rate examples of first-rate artists', precisely the principle of selection he always urged for Felton Bequest purchases (though the first-rate cost more in Europe than in Kakadu, where 'the highest price paid was actually fourpence halfpenny').[6]

[2] Mulvaney and Calaby, 'So Much That Is New', pp. 355-6, 358-9. 'A true history of art in this country must include forty millennia of Aboriginal creativity, and for his work in documenting some of the responses of Aboriginal artists at the moment of fatal impact, Baldwin Spencer's name will be honoured ...'

[3] Thus in the section 'Decorative Art' in his 'Aboriginals of Australia' in Knibbs, ed., *Federal Handbook* prepared for the meeting of the British Association for the Advancement of Science held in Australia August 1914 (pp. 79–85) Spencer was mainly concerned with the place of art in ritual and society and discussed qualities of design and execution in that anthropological context.

[4] Spencer, *Wanderings in Wild Australia*, pp. 792–3 (part of this passage is quoted in Morphy, 'Seeing Aboriginal Art in the Gallery', p. 42).

[5] 'It was interesting to find that the natives themselves very clearly distinguished between the ability of different artists' (Spencer, *Wanderings in Wild Australia*, pp. 793–4). Of the work of artists of the Central Australian tribes Spencer wrote that 'their geometrical designs are wonderful' (p. 792).

[6] The price was governed by size, 'varying from one stick of tobacco (a penny halfpenny) for a two-feet by one foot bark, to three sticks (fourpence-halfpenny) for "barks" measuring approximately three feet by six feet and upwards' (Spencer, *Wanderings in Wild Australia*, p. 794). The barks are described and evaluated at length on

In later years Spencer became increasingly interested in the Gallery, ultimately to the Museum's neglect.[7] In Gallery matters he was always knowledgeable: at the awkward Conference of Trustees and the Committee in June 1908, it was he who asked 'whether they were going to adopt the Chantrey and Luxembourg standard or that of the Louvre', a question which meant little to most others present. (Briefly, the best of the year, or the best of its kind.)[8] At the same time he confided to Lionel Lindsay his contempt for his colleagues' judgement: 'of course we have to compromise as the Trustees and the members of the Felton Bequest know just about as much of art as the Hyde Park loafer does'.[9]

Spencer respected Hall's role and stature without always agreeing with him, and shared his fellow Trustees' lack of confidence in the judgement of Frank Gibson, and also their disappointment with their own nominee, Sir Sidney Colvin. He had talked with Colvin at length in London in 1914, but failed to establish any rapport with him, and was not sorry to see him resign.[10] He was happy to be asked to seek out a successor to Gibson in 1916 (a decision which peeved fellow Trustee Alexander Leeper, who privately resented Spencer's star moving into the ascendant over areas other than the Museum).[11] Spencer's mission was 'to facilitate the purchase of works of art in Europe under the Felton Bequest' by making 'the fullest inquiry', and recommending 'by cable, to the Trustees', an art adviser in Britain 'whose position and reputation will command the confidence of this Board'.[12]

Baldwin Spencer arrived in Britain on 30 November 1916, his convoy surviving a submarine and air attack in the Channel. He remained in blacked-out London until the last week of January 1917, arriving back in Melbourne on 13 March.[13] He soon warned the Trustees of the London art world's unfavourable reaction to Colvin's forced resignation: 'dissatisfaction and also irritation' had been

pp. 802–13. He later commissioned more, probably at higher prices, and the collection comprised 150 barks by 1920 (Mulvaney and Calaby, *So Much That Is New*, p. 303); they raise the question whether Spencer, as patron, was 'responsible for encouraging or determining the development of bark paintings, both by creating an abnormal demand and by suggesting acceptable motifs'.

[7] A later director, RTM Pescott, wrote in *Collections of a Century* (p. 128) that 'the bold truth is that . . . Spencer had somehow lost interest . . . and the Museum was more or less left to its own resources'.

[8] Conference, 11 June 1908. The Luxembourg, in Paris, collected only the work of living artists.

[9] Spencer to L Lindsay, 3 June 1908, quoted in Mulvaney and Calaby, *So Much That Is New*, p. 342.

[10] Mulvaney and Calaby, *So Much That Is New*, p. 328.

[11] Leeper had long thought Spencer jealous of his own position, on the Gallery Committee and then the Felton Purchase Committee, and complained to himself that Spencer was 'dominating more and more' (Leeper Diary, 24 September, 28 October, 25 November 1915, 10 August 1916, quoted in Poynter, *Doubts and Certainties*, p. 359).

[12] Trustees Minutes, 28 September 1916.

[13] Mulvaney and Calaby, *So Much That Is New*, p. 329.

caused, 'both by criticism of certain works selected, and by the rejection of others that are regarded as of first class importance'. He had tried 'to point out the great difficulties under which the Trustees have laboured during recent years', when all works suggested for purchase had been recommended 'in terms of uniform glowing praise', but it had been 'difficult to reconcile the description with the actual picture' when some of them reached Australia, let alone accept it as a 'first rate example of first rate artists, such as the Trustees alone desired to secure for the Gallery'. Everyone, he told the Trustees, had the 'very decided opinion' that 'though mistakes may every now and then be made, the best results will be obtained by trusting the adviser, and giving him as free a hand as is possible under the terms of the Bequest'.[14]

Before cabling his recommendation, a week before he left London, Spencer consulted many people, including Sir Charles Holmes, Sir Edward Poynter's successor as Director of the National Gallery; Sir Cecil Harcourt Smith, Director of the Victoria and Albert Museum; Charles Aitken, Keeper of the Tate Gallery; DS MacColl, former scourge of the Chantrey Bequest, now Keeper of the Wallace Collection; and Sir Hercules Read, Keeper of British and Mediaeval Antiquities in the British Museum, most of whom were to be influential in the history of the Bequest. Perhaps to his surprise, the British artist he found most helpful and congenial was Sir George Clausen. He mixed freely with the large Australian art colony in London, and was guest of honour at their annual Chelsea Arts Club dinner—'the Eaglemonters last and least distinguished camp', in Bernard Smith's 'wry phrase'—after which the chairman, George Lambert, offered to paint his portrait 'for the mere *fun of the thing*'. He also renewed his friendships with Streeton, though 'his most serious discussions on art policy probably occurred during his two lunches with John Longstaff'. The Australian artist whose opinion he valued most was Bertram Mackennal, then working on his opulent classical sculptures for Australia House. He also, warily, consulted Roger Fry.

Spencer concluded that the adviser must have the full confidence of the Trustees, and insisted, despite some opposition, that he should visit Melbourne to be briefed. He had found four men highly recommended: Robert Ross (1863–1918), French-born son of a Canadian politician, critic, author and one-time partner in a London gallery; Frank Rinder (1863–1937), born at John-o'-Groats, art correspondent of the *Glasgow Herald* for many years, and a notable collector, especially of prints; Randall Davies (1866–1945), son of a Chelsea clergyman, for some

[14] 'Within, of course, limits imposed by the amount of money available, or which it is thought advisable to spend at any particular time, and in the case of pictures, by prescribing the period of which, or the advisability of whom, it is desired to secure examples' (Mulvaney and Calaby, *'So Much That Is New'*, p. 330).

years a secretary to Joseph Pulitzer in New York before becoming an art critic in London, an associate of Sir Charles Holmes; and Laurence Binyon (1869–1943), poet and assistant keeper of prints and drawings at the British Museum, an authority on oriental art and English water-colours. Ross, Rinder and Davies were all to be Felton Advisers, in turn. Spencer's final choice was between Ross and Rinder; he probed both men, accompanying them individually to galleries and forming a warm friendship with Rinder in particular, but the decision was made for him. 'I have practically decided to recommend [Ross]', he told his wife; 'he and Rinder are personal friends and the latter will not allow his name to be submitted if Ross is suggested. They have been delightful to deal with'.[15]

When Spencer returned to Melbourne in March 1917, he told the Trustees that British gallery directors envied the Felton Bequests' £8000 a year, more than any gallery in the Empire, and especially admired, as acquisitions, Corot's *Bent Tree*, the Puvis de Chavannes and the Ford Madox Brown pictures. The *Argus* welcomed his proposals, hoping that they would replace an 'unworkable' system which 'had broken down under its own weight'.[16] On 16 March Spencer met with Bage, Turner and MacFarland, the only Bequests' Committee members in Melbourne while Levey and Grimwade remained in London. The decision to appoint Ross was unanimous.

'ROBBIE ROSS' WAS widely respected in the London art world. A man with experience as an art critic, as Director of the Carfax Galleries, and more recently as a member of the Board of the Tate Gallery and of the Executive Committee of the National Art Collections Fund, 'he had tact, a sense of humour, excellent social gifts, and all the qualities which attract goodwill and generous help from others'. To a wider public he was known as Oscar Wilde's literary executor, having been his loyal friend, in disgrace as in triumph (and, in 1886, Wilde's first male lover).[17]

Levey and Grimwade did not think it necessary for Ross to visit Melbourne before his formal appointment, and the other Committee members were equivocal until Spencer stiffened their attitude.[18] The new adviser tried to obey, but the

[15] Mulvaney and Calaby, *'So Much That Is New'*, pp. 329–30.

[16] *Argus*, 10 and 30 March 1917; Cox, *The National Gallery of Victoria*, pp. 80, 84.

[17] Clausen to Baldwin Spencer, 2 December 1916; Cox, *The National Gallery of Victoria*, p. 83; Richard Ellman, *Oscar Wilde*, pp. 259–60. '[Ross] was a general favourite', wrote William Rothenstein: 'Although not himself a creative person, he had, in those days especially, a genius for friendship. No man had a wider circle of friends than he. He had a delightful nature, and a wit; above all he was able to get the best out of those he admired. Oscar Wilde was never wittier than when at Ross's parties, the same was true of Aubrey Beardsley and Max Beerbohm' (Rothenstein, *Men and Memories, 1872–1900*, p. 187, quoted in Cox, *The National Gallery of Victoria*, p. 83).

[18] FBC, 28 March 1917.

state of the war caused the Foreign Office to refuse him a passport; and it was not until September 1917 that the Committee agreed to postpone his visit and formally appointed him. 'Your duties', Bage wrote on 21 September, 'are set out in my letter of the 19th September 1916 addressed to the Chief Librarian', the document the Committee had prepared as a condition for Spencer's mission. Comprehensive, it included excerpts from the Will, the instructions agreed in 1908 and issued to Gibson, and the 'Duties and Functions of the Expert', revised in 1916.

The 'Duties' were softened a little. Ross was still required to communicate through the London Agents (Messrs St Barbe Sladen & Wing) for payments and business arrangements, and when cables were to be sent, but was allowed to write directly to the Felton Bequests' Committee or to the Trustees of the National Gallery, normally addressing letters on general matters to the Secretary of the Trustees of The National Gallery, who would copy them to the Bequests Committee.[19] Even more important was a gloss which allowed, 'in cases which do not permit of full preliminary report and detailed reference to Melbourne', for the Expert to arrange with the London Agents 'for the purchase of works of art, in regard to which he shall previously have received instructions, signed by the Chairman of The Felton Bequests Committee and the President of the Trustees of The National Gallery, specifying the particular class of work desired, the name of the artist or other distinguishing characteristics'. This, Bage explained, was 'to meet anticipated sales by auction or other cases in which specific recommendation and approval are impossible' but also to enable him to act 'under general instructions':

> To enable us to send you such general instructions we shall be glad if you will furnish us with any suggestions which occur to you in regard to the choice of works of art of various kinds, including not only Pictures and Sculpture but Ceramics, Furniture, Metal Work, etc. In regard to pictures, for example, you may think it advisable to be in a position to secure an example of a specified artist or artists if such come into the market and in this case you could suggest a limit in price. Or, you may wish to advise that you should be authorised to secure pictures of a particular period or school. All suggestions you make with regard to improving the collections will be welcomed and will be most carefully considered. While it may not be possible to secure many purchases till the close of the War, we should like you to be in a position to avail yourself of any odd chances which may turn up.[20]

[19] Ibid., 14 and 10 September 1917.

[20] The Trustee company wrote to their agents on 19 February 1918: 'We understand it is the intention of The Felton Bequests Committee and the Trustees of The National Gallery to furnish Mr. Ross with a list of Artists good specimens of whose work it might be advisable to purchase. So that Mr. Ross might be in a position to act promptly where time did not permit of reference to Melbourne, Ross would be furnished with instructions signed by both bodies with a limitation as to the respective prices to be paid for such works.' Bage, while warning Ross that the

Ross, in his short tenure, was never provided with such a list pre-authorising purchases, nor did he submit suggestions for one. But he soon showed his resourcefulness by joining with the Director of the Tate Gallery and others in the purchase of a great collection of Blake water-colours which had just come on the London market; the Tate's historian describes its Director's part in the acquisition as his 'greatest achievement'.[21]

The artist John Linnell, friend and patron, commissioned Blake to illustrate Dante's Divine Comedy in 1824 and the visionary artist-poet was still working on these immensely powerful drawings in 1827, when he described himself as 'an Old Man feeble and tottering, but not in Spirit and Life, not in The Real Man The Imagination which Liveth for Ever'; 'In that I am stronger and stronger as this Foolish Body decays'.[22] He died a few months later, leaving the set not quite finished; it remained in the Linnell family, and none were shown publicly until 1893. Charles Aitken, Keeper of the Tate, one of the few authorities convinced of Blake's greatness as an artist, included some of the Dante set in a major Blake exhibition in 1913, but could not persuade the Linnell family to part with them. When, in 1918, the family decided to sell their whole Blake collection at Christies, the Dantes were kept together as one lot, and Aitken (by then the Tate's first Director), expecting the set to fetch £6000 and fearing that it would be lost to America, worked to form a consortium to try to keep them in the Empire. He enlisted Laurence Binyon and Charles Ricketts, fellow members of the National Art Collections Fund Committee, and approached Ross, who had already written admiringly of Blake and had exhibited his works in his Carfax Gallery. In March 1918 the Felton Bequests' Committee approved Ross bidding up to £5000 at the sale, after receiving his cable, 'last possible public sale Blakes; keen competition and high prices expected'. Hall also approved; Blake was such an unusual artist, and so little known to the public, that he was perhaps the only man in Melbourne who knew what they were doing.

The consortium eventually comprised the Tate and Melbourne galleries (£3000 each, in twelve shares of £250) and the British Museum and Birmingham (two shares each), while single shares were held by Oxford and by Ricketts and Shannon. Its bid of £7665 for the 102 Dante drawings was successful, though only

Committee had to certify that a work met the requirements of the will before approving purchase, offered a surprisingly broad 'personal' interpretation: the Committee could approve a 'class' of work, such as 'mediaeval painting', without seeing individual pieces (Bage to Ross, 18 February 1918).

[21] Spalding, *The Tate*, p. 41.

[22] Quoted by Irena Zdanowicz, in 'The Melbourne Blakes—Their Acquisition and Critical Fortunes in Australia', in Butlin and Gott, *William Blake in the collection of the National Gallery of Victoria*.

because a telegram from America bidding 'at any price' was delayed in transmission. Ricketts devised an elaborate method for dividing the spoils, classifying the drawings into three groups according to quality and rotating selection 'to prevent small sharers getting all their picks too high up'. Melbourne had first choice, and in Ricketts' view Ross 'behaved splendidly', securing 'a sound average'; Ross himself said that the thirty-six he secured included all but six of those he would have liked to get for Melbourne. Ross also used Felton funds to buy six other lots at the sale, including the very fine *The Creation of Eve* (420 guineas), *Satan Watching the Endearments of Adam and Eve* (330 guineas) and the *Illustrations for the Book of Job* (52 guineas). The Bequests' Committee pasted the full list in its minute book, dutifully certifying that they would elevate Melbourne's taste. Levey, after seeing the new acquisitions in London, was not so sure: 'All I fear I can say about them', he told Ross, 'is that I think they are most quaint'.[23]

The Melbourne press reported without comment the acquisition of the Blakes—and later of Burne-Jones' *Garden of Pan*, and of Arthur Hughes' *La Belle Dame sans Merci*, a brilliant if unfashionable purchase—but their opportunity to see the Blakes was delayed, because all Ross' acquisitions went into storage in Britain for the duration of the war.[24] In the absence of criticism he was emboldened to recommend that £5600 be spent on the Jessop collection of Whistler lithographs, to be offered at Sotheby's; he was not himself interested in lithographs, and conceded that the public would not like them, but 'the Melbourne Gallery has been particularly well advised in the acquisition of black and white work, and if the Trustees wish to develop that side of the collection I do not think the Felton Trustees could make a better purchase in this particular line'.[25] Levey warned Ross that 'If I were out in Melbourne and a proposal to purchase came before my Committee in the ordinary way it would require much stronger reasons than I can

[23] Ross to FBC, 30 June 1918, Levey to Ross, 27 June 1918 ('most quaint'). See also Cox, *The National Gallery of Victoria*, p. 84, and Joseph Burke, 'The Eidetic and the Borrowed Image: An Interpretation of Blake's Theory and Practice in Art' in Philipp and Stewart, *In Honour of Daryl Lindsay*. The Tate paid the extra £165 and took the twelve slight and unfinished drawings left over; the drawings bought by Ricketts and Shannon ultimately went to Cambridge.

[24] *Argus*, 18 March, 13 May and 13 July 1918.

[25] 'Lithographs however fine in quality do not make any wide public appeal and Whistler's lithographs although esteemed by connoisseurs throughout the world are not easy to understand ... [but] if I was a director of any Public Museum with full powers and unlimited money to purchase, I would consider it my duty to acquire the Jessop collection of Whistler's lithographs, particularly at the price asked for.... There are several items in the collection very much desired by the British Museum, and I think by Boston, but Mrs Jessop is anxious that her husband's collection should be kept intact ...' (Ross to FBC, 2 June 1918, quoted in Cox, *The National Gallery of Victoria*, p. 85).

think of now to induce me to vote in favour of the Whistler Lithographs being purchased by the Felton Bequest', but after some delay the purchase was agreed (again, also by Hall). The same Conference which gave approval—and to two 'Canalettos', one of which turned out to be by Bellotto—refused a Gobelin tapestry Ross recommended, because in Melbourne it would be too prone 'to pests and dust storms' to justify spending 'so much' (£25 000).[26]

Ross received a cable authorising the purchase of the Whistlers when he was at last preparing to visit Melbourne, with passport approved and tickets bought; but next morning, on 5 October 1918, his landlady found him dead, of natural causes. His ashes were placed in Oscar Wilde's tomb, by then marked by an Epstein monument, in Père Lachaise Cemetery in Paris; for his epitaph, Ross adapted Keats' 'here lies one whose name was writ in water' by inserting 'hot' before the last word.[27]

As an adviser, Ross had made one great acquisition, and had been spared the obloquy heaped on it when the Blakes finally arrived in Melbourne in 1920.[28] On receiving news of his death, the Committee (meeting in Conference) asked the Trustee Company's London agents to consult Clausen and others to confirm the suitability of Rinder as his successor. St Barbe, Sladen and Wing reported that Holmes (of the National Gallery) and Aitken (of the Tate) would prefer Randall Davies, and that Wing and Levey had interviewed both men and on balance also preferred Davies, as the man with higher standing in the art world. But Baldwin Spencer emphatically did not; he had already persuaded the Trustees to recommend Rinder's appointment, and he swung the conference with a final argument that Rinder could visit Melbourne immediately to receive his instructions.[29] One week after hostilities ended in Europe, Frank Rinder was appointed Felton Adviser.

[26] FBC, 5 September 1918. By this time it was common for the Committee to meet 'on the occasion of' a Conference with the Trustees' Committee'. Those attending in July 1918 were Bage, MacFarland, Grimwade (returned) and Turner (for the Committee) and Turner, Leeper, Spencer, EC Officer, and Sir Henry Weedon (for the Trustees).

[27] Richard Ellman, *Oscar Wilde*, p. 553.

[28] Ross had also acquired Cotman's *Hay Barges* and works by Collins and Mancini. Asked to approach Streeton and Wheeler, official war artists, for pictures illustrating the War, he bought Streeton's *War Balloons*, but Wheeler had nothing available (Cox *The National Gallery of Victoria*, p. 429, n. 16). He also approached Sargent to paint a portrait of General Birdwood, but the artist refused, and Rinder later recommended a half-price Orpen portrait for £1000 (FBC, 2 July and 28 August 1919).

[29] FBC, 18 November 1918. Colvin would have preferred Lawrence Binyon. The fact that mixed advice was received from London was omitted from the account of Rinder's appointment given in the 'Confidential Report of the Sub-Committee appointed by a Conference of The Felton Bequests Committee and The Felton Purchase Committee of the Trustees of The National Gallery of Victoria to report upon the general instructions to Mr Rinder' prepared by Bage and Leeper in 1922.

THE END OF the war brought a new era to the Felton Bequest. The National Gallery still had no government funds for acquisitions, a neglect attacked by Baldwin Spencer when opening an exhibition by Will Ashton in Melbourne in 1925. 'It was deplorable that the State Ministry did practically nothing in this direction. No other government in the Empire, he lamented, 'had done so little for art as the government of Victoria', especially when compared with the Felton Bequests' contribution to Victorian cultural life.[30] Fortunately Felton's estate was prospering, and as annuitants died more income became available for art and charity. During the 1920s funds allocated for six-monthly distribution rose steadily, from £16 000 in June 1921 to £22 000 in June 1924, £24 000 in June 1926 and £30 000 in December, making a total for that year of £54 000 handed over by the Trustee company to the two funds. Income then fell a little, but the distribution was back to £55 000 by 1929. With reserves accumulated in the Art fund, the Bequests' Committee could have spent £88 366 on art works in December 1929, had it the will, the concurrence of the Trustees and appropriate advice. Even so, expectations of glittering purchases were unreasonably high among those unaware how effectively Joseph Duveen was educating American millionaires to spend fortunes on art; as Dr Cox has observed, 'the whole capital of the Felton Bequest would have been exhausted by the purchase of even one great Duveen picture'.[31] Duveen prices were, however, anomalies in the market; major purchases were still possible, and bargains could be found, at least until the general inflation in art prices after World War II. The Committee could afford to be bold.

The two decades between the wars, and especially the years of Rinder's advisership in the 1920s, saw one of the greatest sustained flows of important art acquisitions under the Felton Bequest in its history. That this was also the period when the Bequest and its proceedings were under the most sustained local attack is a paradox, requiring explanation. The issues in dispute continued throughout the period, but attention has been concentrated on the advisership of Rinder, whose role is seen as central, especially by his champions. His appointment, Daryl Lindsay wrote in 1963, 'heralded the beginning of what might be called the golden age of the Art bequest'; and in Dr Hoff's view he 'initiated the great days of the Felton Bequest; supported by funds accumulated during the war years he brought to Melbourne a wide variety of works of outstanding quality, from Gothic illuminated manuscripts, Flemish, Dutch and English old master paint-

[30] The Government should take steps 'to repay the munificence of the Felton Bequest' (*Argus*, 2 October 1925).

[31] Cox, *The National Gallery of Victoria*, p. 89.

ings, to those of the Barbizon and Impressionist groups'.[32] From this position his advisership is also seen as a time of shame, when an ungrateful Melbourne rejected some of his best recommendations and criticised his acquisitions so mercilessly that he was obliged to resign.

Puzzles remain: the gulf between the acclaim of Rinder among his London colleagues and vilification in Melbourne is almost unfathomable. He retained the support of all but one member of the Bequests' Committee, and of leading figures among the Trustees, but they were overborne by the vehemence of his critics. There were no total villains—though Trustee John Shirlow and artist-critic JS MacDonald are difficult to defend—and almost everyone involved was on the right side over some major acquisition or another; indeed Leonard Cox, and other critics of Rinder's enemies, probably understate the extent to which his acquisitions were welcomed in Melbourne.[33] But it is true that his enemies were unrelenting, and the gauntlet to be run by his recommendations was long and menacing.

Admittedly, Rinder's acquisitions were rarely seen at their best in Melbourne. The Gallery was overcrowded and drab, and the pictures poorly hung. Streeton, back in Melbourne in August 1920, published 'a breezy criticism' of the Melbourne and Sydney galleries, complaining that Melbourne's literally put the new pictures in a bad light.[34] The Sydney Gallery, marvellously sited, was airy and light, and the two galleries housing Australian works were 'a perfect delight'—partly because the inferior works had been lent off to provincial galleries. Melbourne should do likewise; but in any case 'our dear old Melbourne Gallery, clustered around the departments of a museum', was 'depressing in the extreme'. The Stawell Gallery was badly hung; and 'no sensible tradesmen would display his goods in such a dim light', seemingly reflected from the floor ('Hopeless!'). The Felton acquisitions had been much criticised, but Streeton now defended them, having 'come to the conclusion that most of the purchases had been good, but that the conditions under which the works had been shown are very bad'. Turner's *Walton Bridges*, bought on Rinder's recommendation (for £7250; Streeton wrote £10 000), which Streeton had admired looking 'splendid' in a well-lit studio in London, here looked 'almost the usual old brown landscape, and certainly not worth the money'. 'I feel that Mr Rinder would be disappointed could he view his splendid purchase under such conditions'. Melbourne's other galleries were a

[32] Lindsay, *The Felton Bequest*, p. 34; Hoff, *The Felton Bequest*, p. 8 (adding that Rinder's acquisitions 'did not receive the acclaim they deserved', receiving instead 'a great deal of hostile criticism in the Australian Press both by artists and a public ill-informed on Felton policy').

[33] Hugh Hudson, Frank Rinder and the Felton Bequest 1918–1928, pp. 19-20, 30.

[34] *Argus*, 21 August 1920.

little better lit, but the hanging was jumbled and old-fashioned, and the effect was 'commonplace, dreary'. Build a new Gallery, Streeton urged, in 'good old Melbourne bluestone', on 'the grassy mound' opposite Melbourne Grammar School. The Gallery had to wait four decades for its rehousing, and then on the swamp side of St Kilda Road; meanwhile the Felton Bequests' Committee formally recorded that the Gallery's hanging and lighting were unsatisfactory, and referred the matter to the Trustees, who began to consider it.[35]

Streeton had told Spencer in 1918 that 'what Australia needs . . . is a "Minister of Fine Arts" . . . I think that you are the man for the post. If you went for it, I think every artist here and in Australia would back you up'. But Baldwin Spencer was falling out of sympathy with some of the senior Australian artists who had been his hosts in Chelsea, and Streeton's estimate of Spencer was bruised in 1919, when Spencer auctioned most of his private collection, including some of Streeton's best works.[36] Spencer increasingly felt that Streeton's powers had declined, and that he was becoming a barrier to change. When Spencer's friend MJ MacNally, art critic for the *Age*, wrote of a Streeton exhibition in 1924—which Spencer opened standing in for Melba—that Streeton's paintings 'now echoed with the boom and bustle of arrogant commercialism', the editor would not publish such heresy. Hall also criticised the exhibition, recommending only one picture for acquisition with Felton funds.[37]

During these years, criticism of individual Felton acquisitions provided the occasion, but was not the whole cause, of local dissatisfaction. Common assumptions, not all consistent, included disbelief that the market was as it was; a conviction that famous masterpieces could be bought cheaply; resentment, deep and bitter in Hall, but shared by many, that the Gallery did not control its own destiny, but was beholden to the 'amateur' Felton Committee and its dilettante adviser; and the insistence, seldom heard in the great institutions overseas but growing in strength in Melbourne, that only artists could judge art.

In his 1920 article Streeton asked for three artists on the Board of Trustees, and his colleagues, members of a particular generation of artists, became increasingly shrill in echoing the demand. Age had overtaken, but not mellowed, the young men who had lolled about the camp in Eaglemont or swum naked at Mentone; having arrived, via London and the Chelsea Art Club, at a solemn maturity, they

[35] FBC, 15 September 1920.

[36] *Argus*, 21, 22 and 23 May 1919.

[37] Mulvaney and Calaby, *'So Much That Is New'*, p. 357. Hall criticised Streeton's exhibition in a memo of 3 March 1925 (Trustee company copy).

were all too ready to deride new youthful enthusiasms. They undervalued the work of more recent artists, especially if they were French; as early as May 1914, Streeton, back in Melbourne for an exhibition, had attacked 'the horrors of Paris', and the Post-Impressionists and Futurists in particular.[38] 'Those Chelsea Arts Club stalwarts', Mulvaney and Calaby remark, 'who folded their tents and returned to mansions in affluent postwar Australia . . . assumed that their place in the sun entitled them to become carping critics and to uphold the definition of true art'. 'The hounding of Frank Rinder', they concluded, 'typified the paranoid and parochial vision of the art world in the twenties'. 'Disgruntled artists . . . vented their spleen against what they took to be an establishment of amateurs', while seeming 'blissfully unaware what an entrenched and authoritarian establishment they themselves had become, particularly in their attitudes to newer trends in artistic expression'.[39]

Those 'newer trends' were slow to emerge in Melbourne, but were present in the 1920s and important by the 1930s. The delay might be partly attributable to the hold gained over many Melbourne artists by Max Meldrum, a charismatic radical in almost everything but his theory and practice of art, his vaunted tonalism now seeming only an extension of his teacher Hall's. But William Frater and Arnold Shore had experimented with a mild modernism during the war, and aping Cézanne became quite a vogue by 1929. George Bell, 'the revolutionary in a bowler hat', was the belated but most important convert and the decisive teacher, emerging to challenge the 'authoritarian establishment' in the 1930s. By 1938, when Meldrum was the leader of the opposition within the circles which governed the Gallery, Bell was a mildly radical leader outside them.[40]

The artists willing to experiment with modernism were not, however, an important element in the 1920s. The issue, according to the critics of Rinder's critics, was the art establishment's parochialism more than its conservatism, and its insecure assertiveness. It is not difficult to portray Melbourne, in the decade between the Armistice and the Great Depression, as a hidebound city, closed to new ideas despite the appearance of the jazz-loving flappers and their mates. In this account public parsimony, engendered by the crash of 1893, persisted; political divisions were sharpened after the Conscription crises of 1916–17 brought their strong overlay of sectarian bigotry; the Russian Revolution raised the spectre of world Communism; and a generation of young leaders had been killed in the War.

[38] *Argus*, 28 May 1914. Streeton 'cautiously criticised' many pre-war Felton purchases.

[39] Mulvaney and Calaby, *'So Much That Is New'*, pp. 330, 401. 'By 1921 the guns of some former Australian war artists were firing salvoes at Rinder's selections . . .'

[40] Felicity St John Moore's *Classical Modernism* shows the importance of this development.

It was as if Melburnians, who in these years set a height limit on their new buildings, set a similar limit on their intellectual aspirations. They also became more prudish, continuing the six-o'-clock closing of pubs, originally a wartime economy measure, and banning more books. Melbourne remained the nation's political capital until Parliament moved to Canberra in 1927, and the chief administrative centre for some decades thereafter; but the city seemed more parochial between the wars than in its glory days. Pre-war Melbourne had been notably cosmopolitan, but social and cultural sympathies narrowed when Britishness was trumpeted assertively, not only during the War but after it, when Australian governments found it expedient to stress Imperial loyalties and the cohesion of Empire, while working nevertheless to manipulate British policies to Australia's advantage, especially in matters concerning finance, immigration and trade.[41]

Melbourne's reputation changed drastically in these years, as Asa Briggs noted:

> It is scarcely an exaggeration to describe the change in Melbourne as a change of urban personality. No longer was Melbourne called the most American of Australian cities: instead, and with equal amount of inaccuracy, it was called the most British of Australian cities. Its new ruling groups were thought to be hierarchical in their attitudes, less democratic than the people with money in Sydney: by a surprising turn of judgement, less interested in the social power which money provided than in other and older forms of social power. Its professional people were thought to constitute a kind of hereditary elite. Its institutions, many of them bold ventures of an unsettled and enterprising society, were thought to be 'established', conservative' and even rigid.[42]

The case can be made, but Briggs goes on to qualify it. The contrast between the old and the new Melbourne should not be exaggerated. The city remained Australia's financial capital, and its economic growth was considerable, before and after the world-wide depression of the 1930s. The firms which Felton had helped to found became major national enterprises, among them Cuming Smith's, a leader in the chemical and fertiliser industries, and the bottle works (renamed Australian Glass Manufacturers in 1916) a national monopoly; Felton's Trustees retained large shareholdings in both, taking up new issues when offered, and in consequence his Bequests benefited substantially.[43] Felton Grimwade's

[41] Thus Prime Minister Bruce borrowed Leeper's son Allen from the Foreign Office to advise on how to make Australia's foreign policy effective; the outcome was to place R G Casey as a Liaison Officer in the British Cabinet Office to represent her interests (Poynter, 'The Yo-yo Variations', p. 248).

[42] Briggs, *Victorian Cities*, p. 305.

[43] Shares held in Cuming Smith increased from 20 000 in 1904 to 200 000 in 1927, and in AGM from an initial 20 002 to 87 883 in the same period. (The Bequest was obliged by court action to dispose of most of its shares in AGM before the company was re-formed as Australian Consolidated Industries in 1939.) Smaller holdings were

itself became part of Drug Houses of Australia, a nation-wide conglomerate, and the oxygen works, an idea not yet realised when Felton died, merged with a rival to form Commonwealth Industrial Gases. Felton's partners—James Cuming and his son, and Norton and Harold Grimwade, and their younger brother Russell— were major figures in these developments. Meanwhile Melbourne remained the centre of Australian mining enterprise, and the conduit between British capital and giant enterprises in Broken Hill, Queensland and Western Australia, epitomised by BHP and the companies linked around WL Baillieu. The remarkable Baillieu brothers, sons of a Queenscliff boatman turned hotelier, were foremost among those who went down with the land boom and bounced back up, regaining the confidence of London investors and justifying it with new enterprises. Big men, their oars had powered the Queenscliff lifeboat; their sons rowed for Oxford and Cambridge, and one became a peer. WL Baillieu's headquarters, Collins House, towards the lower end of Collins Street, did not need to break the height limit to become the main symbol of Australian capitalism. A close-knit family, the Baillieus were generous to a select list of causes, but Melbourne's National Gallery was not at that time among them.[44] One of the next generation, Sunday Baillieu, daughter of WL's brother Arthur, was to become a central figure in a modernist group usually critical of the Gallery after she married in 1932 the Tasmanian lawyer John Reed, lover of art and addict of its politics.[45]

Besides Collins House, two other new buildings, neither high but both massive, symbolised Melbourne business in the first third of the twentieth century. The Myer Emporium in Bourke Street consolidated the eminence of Sidney Myer, a poor immigrant from Eastern Europe with a genius for retailing. A generous man, whose fortune and family remain prominent in Australian philanthropy, he was more interested in music than art, and the Melbourne Symphony Orchestra and the University of Melbourne were the main beneficiaries in his lifetime. Myer (who married a Baillieu daughter, Merlyn) had a talent for advertising, which led his Emporium into a special relationship with the Melbourne *Herald*, whose offices occupied the third major building, at the eastern end of Flinders Street. There the presiding genius was (Sir) Keith Murdoch, a very significant figure in the history of Melbourne's National Gallery and of the Felton Bequest.

retained in CSR, CSR (Fiji & New Zealand), Bosisto, Samuel Burston and Co, D & W Murray and the Adelaide Chemical Company. Dividends produced a smaller proportion of the Trust's income between the wars than interest on government securities and mortgages, however.

[44] On the Baillieus, see the entry on WL in *ADB*, vol. 7, by JR Poynter. Soon after the war ended WL Baillieu risked the entire family fortune establishing a smelter in Tasmania.

[45] The voluminous literature on the Reeds includes Reid and Underhill (ed.), *Letters of John Reed*.

Born in 1885, son and grandson (on both sides) of Presbyterian ministers, Murdoch had risen from penny-ha'penny-a-line local reporter for the *Age* to be political correspondent for the Sydney *Sun* by 1912. The War transformed his career: sent to London in 1915 to manage the United Cable Service, he became a major player in the Dardanelles controversy, confidant of Prime Minister Hughes and of several British leaders, and close associate of press potentate Lord Northcliffe. He returned to Melbourne in 1921, appointed Chief Editor of the *Herald* by its Chairman, the remarkable Theodore Fink, one-time land-boomer, politician, collector of art and influential Royal Commissioner on education and the University.[46] Murdoch's modern, aggressive management transformed the venerable evening paper into a major challenge to the increasingly old-fashioned *Argus* and *Age*. (Between the wars the *Argus* also built a massive new building, which survives though the paper does not.) Fink at first supported Murdoch, though they later fell out as Murdoch's power grew; by the 1930s he had built Australia's first national media chain, including eleven broadcasting stations and newspapers in four states, in alliance with WL Baillieu (a *Herald* director), WS Robinson and others of the new generation of Melbourne entrepreneurs whose range, like his, was no longer colonial but national and international. Murdoch was to be a major liberal influence on art in Melbourne, and on its Gallery, but not yet; for the time being he respected the advice of Bernard Hall and employed as the *Herald*'s art critic the irascible and conservative JS MacDonald, 'blindly hostile to all twentieth-century painting and much before'.[47]

There was more enterprise, and more intellectual and cultural stirring, in the city in these years than appears in the annals of the conglomerate institution at the upper end of Swanston Street, or among the ageing, conscientious members of Felton's Bequests' Committee. Some Melburnians moved easily enough between old and new, and between the local and the international scene—for example LL Smith's daughter Louise, patron of the Australian poet John Shaw Neilson and founder, in Paris, of Editions de L'Oiseau-Lyre, publishing rare music, which she also had performed in Melbourne, and introducing long-

[46] On Fink, see Wilma Hannah's entry in *ADB*, vol. 8; and on the complex relationships between Fink, Murdoch and WL Baillieu, see Garden, *Theodore Fink*, especially pp. 204–31.

[47] The phrase is Geoffrey Serle's, in his entry on MacDonald in *ADB*, vol. 10. (Serle's entry on Murdoch is in the same volume.) MacDonald (1878–1952) was the son of William Lynch's solicitor partner. After study in the National Gallery Art School, he went to London and Paris, where he shared a studio with Hugh Ramsay, before teaching in America. Wounded on Gallipoli, he finished the war as a camouflage artist in France, and published studies of Frederick McCubbin, Penleigh Boyd, David Davies and George Lambert. He had given up painting by the time he joined the *Herald* in 1923.

playing records to France. Tom Roberts painted her as a child, and the surrealist Max Ernst in her maturity, a startling picture the National Gallery of 1934 would certainly have spurned.[48]

DURING THE PROSPEROUS years of the 1920s the Felton Bequests' Committee continued to distribute half its income to charity, in the pattern established in 1904 on what they took to be Felton's own example. Unlike the Art fund, there were no large reserves on which interest was earned in the Charity fund, but the expansion of the estate's earnings between 1920 and 1929 allowed the Committee to be more generous than before. Each June and December it continued to distribute grants—now openly called 'maintenance'—to a long list of institutions, in the same categories as earlier but with some charities concerned with ex-servicemen added, and another list of 'special' grants, mostly for building.

The Charity Organisation Society made some progress in its aim to co-ordinate charity after the War, persuading the Government to establish in 1922 a Hospitals and Charities Board. Only organisations registered with the Board could receive government funds, which the Board distributed on behalf of Treasury, three-quarters going to hospitals; and the same act established the Lord Mayor's Fund, to regulate public appeals and allocate the proceeds. But only about half of the state's charities were registered with the Board, limiting its power to bring order into a fragmented system, power which in any case it was reluctant to exert. The main sources of relief for those in distress in the 1920s were the Ladies Benevolent Societies and the Salvation Army, while some municipalities, and the Charity Organisation Society, provided more specialised services. Overlapping responsibilities, institutional jealousies and a chronic shortage of funds persisted, and the weaknesses of the 'system' were increasingly revealed after unemployment figures began to grow in 1927.

There were some changes in the Bequests' Committee's charitable distributions in these years, though they were not obvious to the casual reader of the twice-yearly lists. In December 1924 the distribution of £13 875 to charity included the unusually high figure of £6475 in special grants, while maintenance grants remained small: £2670 divided between eleven hospitals (£800 to the Melbourne the highest); £590 between twenty-five children's charities (including £100 to the Foundling Hospital and Infants' Home); £400 for seventeen Ladies' Benevolent Societies; £1350 between twenty-five General Philanthropic

[48] On Louise Hanson-Dyer, née Smith, see Davidson, *Lyrebird Rising*. The Gallery holds the Roberts portrait, but failed to buy the Ernst when it was available in the 1990s.

Institutions (including £150 each for the Charity Organisation Society and the Victorian Bush Nursing Association); £855 spread thinly among forty-three country hospitals, and a further £330 to ten other country institutions; and £875 between six organisations running creches. Large grants on the special list, all for building, included £1000 to the Alfred Hospital, £500 each to the Association for the Advancement of the Blind, the Horsham District Hospital, the Presbyterian Church Social Service, the Free Kindergarten Union, the Geelong Hospital and the Eye and Ear Hospital. The Victorian Convalescent Home for Women received £300 'for electric light'. Total grants to charities reached £27 990 in 1927, with the highest half-yearly distribution, £14 235, in June 1929.

The bequest was clearly an important source of capital funds for charities in these years. Hospitals continued to enjoy priority, but charities to benefit during the decade included kindergartens, the YMCA, the City Newsboys, the Melbourne District Nursing Society (after it had been given a favourable report by the Charities Board), and several initiatives towards social amelioration based on St Mark's, Fitzroy. The Committee noticed the needs of the new towns created when the Gippsland brown-coal fields were opened for electricity generation, making a modest grant to the Yallourn Church of England Association Social Hall, and later to hospitals in the area. Each year some funds were kept back for unforeseen requirements, out-of-sequence grants including £1000 to the Austin Hospital for a laundry in 1920, £1000 to the Alfred Hospital when its Appeal did not reach its target in 1921, and in 1923 a special £500 to the North Mallee Hospital Appeal. (The Committee was no doubt aware that Mallee farmers were not Victoria's most prosperous; the company comprising the Felton Estate's last holding in the area had become worthless).[49]

As medical technology progressed, Felton's Bequests began to fund X-ray and other equipment, for institutions ranging from the Dunolly Hospital to the Alfred, and the Committee passed another important milestone when it began to support Melbourne's emerging strength in medical research, giving £500 to the Walter and Eliza Hall Institute of Research in Pathology and Medicine in 1924.[50] By 1929 it was supporting the Baker Institute at the Alfred Hospital as well, and the University of Melbourne's Cancer Research Fund. But although new recipients appeared in the six-monthly lists, the general pattern continued, and Felton's bequest became stitched ever more firmly into the patchwork of Victorian charitable practice, ranging from cradle and kindergarten to benevolent home and grave.

[49] Felton's small shareholding in the Mallee Agricultural and Pastoral Estate Co Ltd was transferred in 1922 to Tyrrell Downs Agricultural and Pastoral Co Ltd, Hopetoun, which in turn failed; the debentures were valued at £78 in 1936.

[50] FBC, 15 December 1924.

18

RINDER'S LIST

Frank Rinder took life seriously, and accepted his post as Felton Adviser as a moral duty. 'Before the war', he wrote to Charles Aitken in 1919, 'I would have hesitated, probably declined, to be the Adviser, but now I feel very strongly that Australia has earned the right to a share of such art treasures as are available'. After one spectacular purchase, he added that he felt it 'an honour to have served as instrument in thus helping to repay to Australia a part, however small, of the debt which the Mother Country owes to the Commonwealth for the gallantry and resourcefulness of her troops, the energy of her manhood and womanhood during the Great War'.[1] Such sentiments were not then unusual; in 1924 Lord Crawford and others proposed that major British galleries be authorised to send important works on long loan to the lesser institutions of the Empire, to add a cultural coping to the edifice of Imperial military loyalties.[2]

Rinder was also a sensitive man, a fatal flaw in anyone buying art for the Melbourne Gallery. Forced to delay his visit to Melbourne for some months, he characteristically offered to resign if this was unacceptable. He was already at work for the Bequest; as soon as he heard of his likely appointment, he had asked Spencer what should be done about Ross' last, unconsummated, recommendation, the Whistler lithographs. Hall now had reservations about them, submitting in November 1918 a memo which 'much impressed' the Bequests' Committee; and Spencer immediately wrote warning Rinder that such purchases might have to be forgone for the present.

[1] Rinder to Charles Aitken, 5 November 1919 and 19 November 1922, quoted in Burke, 'Alfred Felton and His Bequest', p. 101.

[2] Lord Crawford et al. to the *Argus*, 30 June 1924. An Empire Art Loan Collections Society was eventually set up.

> You can imagine that, in a young country like this, where art works at once good of their kind and likely to interest the ordinary art-loving public are far to see, 'Blake' in large quantities and 5,000 guineas for Whistler's lithographs were somewhat severe tests which the Trustees stood manfully. We were hoping in view of the fact that we possess no first-class example of Raeburn or Reynolds or Lawrence or Gainsborough or Constable and very many others of the English School, that his next selection would lie along rather different lines—glad, of course, as we were to get what he secured for us, but, as you can understand, it is one thing to collect for an old established Gallery which already possesses masterpieces on its walls and can afford to put Blakes and Whistlers in portfolios where they can be enjoyed by connoisseurs, and quite another thing to collect for a young Gallery which is very anxious, naturally, to have a certain number of first-class paintings on its walls to justify its existence in the eyes of the public—that is the ordinary public which, in a young country such as this is, requires to be gradually educated in art matters, and is willing to be educated.

Spencer stressed he was not objecting to Ross's purchases, which in years to come would be 'regarded by Australians as a great acquisition', but sometimes 'one must give a "sop to Cerberus"'.[3] Rinder and Hall both recommended, and the Committee agreed, that Melbourne should try to acquire only twenty or so of the Whistler lithographs, for about £1000; the offer was refused, and the collection went elsewhere.[4]

The Committee's caution concerning public reaction seemed justified when the Blake drawings and prints finally arrived in Melbourne in August 1920, and thirty went on view. 'Glaring absurdities', the artist (and later Gallery Trustee) Alexander Colquhoun dubbed them in the *Herald*; and although the *Argus* critic conceded they were 'the most extraordinary imaginative work that has ever been seen in Melbourne', he concluded that 'one or two examples would have been welcome ... but no justification can surely be shown for the purchase of so many artistically inferior pictures, which will no doubt before long find their ways to the cellars'. £4000 was 'very much in excess of their value'; and it was a 'relief' to pass on to look at something else. The *Leader* warned parents that Blake's depiction of 'evil-doers in the next world ... should not be viewed by sensitive children'.[5]

In December 1918 the Committee, anxious to spend their accumulated funds on some major purchases, authorised Rinder to negotiate for *Christ in The Carpenter's Shop* by Millais, up to a price of 10 000 guineas, later increased to

[3] Spencer to Rinder, 11 October 1918, quoted by Cox, *The National Gallery of Victoria*, pp. 87–8.

[4] FBC, 24 February 1919.

[5] *Herald*, 10 August, *Argus*, 11 August, *Leader*, 4 September 1920; and see Zdanowicz, 'The Melbourne Blakes', p. 14.

15 000. Negotiations proved difficult, and expired in 1921 when the Tate Gallery exercised an earlier option to purchase. Before leaving London, Rinder did find a major acquisition for Melbourne, Turner's *Walton Bridges* (£7250), and also Ramsay's austere *Countess of Cavan* (£550) and some good small works.

After November 1918, when Barbe Sladen & Wing 'read out' to him the terms and duties of his office, Rinder formulated his view of what the Melbourne Gallery should and could purchase. Writing at length in June 1919, he noted that Ross had been promised a list of artists, good specimens of whose work it was desired to purchase, in effect providing authority to purchase in advance. This, Rinder argued, was essential, since it was impossible to obtain options on desirable works at reasonable prices: but what should the list include? His views were broad and moderate. Most of the money 'should be spent upon such works of art as would be appreciated by the public, provided they are of a genuinely vital artistic character', but he would include some art which reflected 'intensified and specialised perception'. 'Really meritorious pictures on a large scale' had obvious advantages, though '"gallery pictures" so-called, wherein quality is sacrificed to size, should be eschewed'. 'The wide and just claim for interest in the subject represented should on no account be disregarded'. In a later letter he warned that the available funds would secure only an occasional picture by an Old Master, though Old Master drawings could still be obtained at 'moderate' prices.[6]

IN MELBOURNE, in January 1919, the Spanish influenza epidemic—more deadly even than the Great War—closed the National Gallery for some months, but it had re-opened by August, when Rinder eventually arrived. He came by way of the United States, and spoke at length to the press about the richness and variety of the collections being formed there, and passed from private to public hands through massive benefactions.[7] In Melbourne the new Adviser was well received, and in discussions with the Committee and some Trustees devised an effective means of working. He had carefully prepared a list of artists and works, with likely prices indicated, of the kind foreshadowed to Ross, which the Conference approved, subject to being made more precise to satisfy the solicitor; and in a letter from Bage dated 22 September 1919 Rinder was authorised to purchase items listed in this 'schedule' up to a generous annual limit of £13 000. For items not listed, or costing more than 900 guineas each, he was required to

[6] The letter (Rinder to Armstrong, 2 June 1919) was summarised in Bage and Leeper's 'Confidential Report . . . upon the general instructions to Mr Rinder', adopted by the Conference on 12 July 1922 (copies in the Leeper papers and in the Trustee company files).

[7] *Argus*, 18 August 1919.

'consult the Committee either by cable or letter and obtain its sanction before completing the purchase'.[8]

Rinder gave the Felton Bequests' Committee the most comprehensive advice it could expect to receive from a London Adviser. His regular letters, sent to Armstrong at the Library and passed on to both the Trustees and the Bequests' Committee, provide an absorbing commentary on developments in the market, and are both shrewd and fair. Like most (though not all) London connoisseurs of this time, he still placed emphasis on British art. 'One of the main objects', he had written from London in June 1919, 'should be to acquire representative works of British artists of high standing, including two or three outstanding works even at great cost'. Melbourne was still keen to acquire eighteenth-century works, especially portraits (attracted, it has been suggested, to 'a patrician pastoral mythology'); Rinder agreed with the priority, advising that portraits of men could be bought at lower prices than portraits of equal quality of women and children.[9] He proposed to seek landscapes by Turner, Constable and Crome, and also—understandably, considering his origins—paintings by Scottish artists, mentioning Watson Gordon, William Dyce and Allan Ramsay. Among Continental works, he had 'a reasonable hope' of obtaining a landscape by Poussin, a peasant group by the brothers Le Nain, a still life by Chardin, a picture by Courbet, and works by the seventeenth-century Dutch School, then coming into fashion in London and much welcomed in Melbourne, with its 'strong local preference for low-toned realism' (Ann Galbally's phrase), so amply provided by its portrait painters.[10] Rinder supported the Bequests' ambitious policy of broad acquisition, and he was happy to seek out prints, ironwork, furniture, ivories, stained glass and illuminated manuscripts as well as paintings.[11]

The Schedule, which either on London advice or at Melbourne's request was often amended (a Franz Hals portrait was added in November 1920, though nothing suitable was found), was shrewdly prepared, with expert knowledge of the market.[12] It was a statement of the practicable, not of the ideal, on the assumption

[8] The schedule, amended after a Conference and made more specific to satisfy the Trustees' solicitor, was approved by the Committee on 19 September 1919. The Conference authorised Rinder to buy a Rossetti for 8500 guineas, a Raeburn for 15 000 and Romney's *Rookes* for 6000, but he later withdrew the recommendations.

[9] The phrase is Ann Galbally's, in *The Collections of the National Gallery of Victoria*, p. 140.

[10] Galbally, *The Collections of the National Gallery of Victoria*, notes (p. 112) the prominence of Dutch works among Felton purchases in the 1920s and 1930s.

[11] Rinder to Armstrong, 2 June 1919, quoted in Cox, *The National Gallery of Victoria*, p. 89, and summarised in Bage and Leeper, 'Confidential Report . . . upon the general instructions to Mr Rinder', 1922.

[12] The original Schedule, and the amendments to it in 1920–21, are conveniently presented in Bage and Leeper, 'Report on Mr Rinder's Advisership', 1922, pp. 9–22; it is discussed in Hugh Hudson, Frank Rinder and the

Frank Rinder (reprinted from Daryl Lindsay, *The Felton Bequest*)

that the Gallery sought to build a broad collection, based on what would now be called art-historical principles, ranging greatly in cost but not, at the top, attempting to compete with the Americans for the plums Sir Joseph Duveen regularly pulled from his various pies and sold for hugely inflated prices. The largest group, of sixty-nine artists, was listed as British Modern (born since 1800), and Rinder's suggestions—as often for drawings and water colours as for paintings—ranged from a Beerbohm cartoon and a drawing by Beardsley ('The Fra Angelico of Satanism') to pictures by Eric Kennington, Laura Knight, Alfred Munnings ('landscape, perhaps with animals') and Alfred Stevens, whom (like others) he much admired. Bigger game appeared in the list of forty 'British School' artists born before 1800, Constable (a portrait as well as a landscape), Gainsborough, Reynolds, Lely ('rather out of fashion but highly desirable'), Highmore, Hogarth, Holbein, Stubbs ('horse and land'), a Wilkie group, a Turner landscape and a Zoffany among them. The thirty-three 'continental artists born since 1800' were mainly French, and included Cézanne ('water colour, coloured lithograph and picture'), Degas (pastel and picture) Manet, Monet (landscape), Pissarro, Renoir (figures), Rodin (drawings), and a Rousseau landscape.

Felton Bequest 1918–1928, p. 53. A predecessor of the Schedule, the first 'list of gaps', prepared in 1908, included 63 artists—28 English, 20 French and 15 'various'—62 of them painters. Nineteen water-colourists were added in 1910 (p. 52).

Rinder listed fifty-one 'Old Masters', a catalogue of opportunities he hoped to encounter rather than an ideal collection: a Michelangelo drawing 'might soon again occur for sale', or a Rembrandt or Dürer drawing; he was (rightly) more ambitious concerning seventeenth-century Dutch and Flemish paintings, and hoped also for a Fra Angelico and works by Carpaccio and Claude Lorrain, and by Goya and El Greco. He included Tiepolo (drawing and picture) not then in high favour; and sought carte blanche on French, Italian or German 'Primitives' ('each <u>highly desirable</u>. Pictures coming under this head occur occasionally and I greatly desire authority to take advantage of such opportunities'). The Schedule concluded with a short list of sculptors and 'Miscellaneous', including Stevens again and 'one or two lights of fine old stained glass', early Gothic tapestry ('true tapestry design before the pictorialised treatment was adopted') and 'a fine illuminated manuscript'.

From a later perspective, the Schedule has obvious limitations, lacking the Post-Impressionists and later continental artists. These had their champions in Britain, but even more powerful detractors, some extremely bigoted. The National Gallery had spurned the exhibition at which Hall had bought his Pissarro; and Kenneth Clark later recalled that 'to an aesthete the lasting experience of the USA in the 1930s was provided by the marvellous collections of French paintings from Cézanne to Matisse. Our appetite for the dominating art of the last fifty years was fed only by dealers to US and Russian collectors'. The Tate, supposed repository of modern foreign art, was notorious, with two successive Directors, Charles Aitken and JB Manson, reluctant to accept Post-Impressionist works even as gifts; Manson refused the Stoop Bequest because it included an early Picasso and two Matisses, and as late as 1932 the Tate refused a Cézanne.[13] Such art was, as yet, sought mainly by individual collectors, in Scandinavia, Switzerland the United States and in Britain, who enriched dealers with the prices they paid and—later—public galleries with their benefactions. Even in Paris, the Louvre and other major galleries acquired little. The situation in London would have been worse had rayon manufacturer Sir Samuel Courtauld not given the Tate £50 000 in 1923 to be spent (by a special committee) on works by a specified list of French artists, providing the gallery with Van Gogh's *Sunflowers*, Seurat's *Bathers, Asnieres*, and outstanding works by Manet, Monet, Cézanne, Bonnard, Sisley, Renoir, Pissarro, Toulouse-Lautrec, Degas and Utrillo.[14] Only the earlier artists on this list appeared on Rinder's Schedule for Melbourne, partly, it seems, because he was cautious about adding

[13] Clark, *Another Part of the Wood*, pp. 74, 213.

[14] Spalding, *The Tate*, p. 48. Courtald was at the same time building his own collection, later bequeathed to the Courtald Institute.

very recent work to a public reference collection; he had, moreover, been warned about Melbourne's tastes.

Rinder's list was Eurocentric. The Melbourne Gallery's purchasing strategies were even broader than he perceived them, thanks to the adoption, early in the 1920s, of a policy of acquiring Asian Art. Largely at Hall's behest, and sparked partly by a bequest from 'Chinese' Morrison—which proved on receipt to be sadly inferior—and by a further gift by JT Hackett in 1924, the foundation of an important collection was laid, Hall purchasing for the Bequest (mainly in Sydney) a very long list of Chinese and Japanese ceramic ware, bronzes and other items.[15] His acquisitions ranged even more broadly in these years, to include Roman and Greek pottery, Tibetan altar vessels, Egyptian curios, English and French pewter and breast and back plates of Italian damascened steel armour. Interspersed in the Bequests' lists of such objects are Australian paintings, by Penleigh Boyd, Septimus Power, Tom Roberts, George Bell ('an excellent artist', Hall reported), Dora Meeson and GW Lambert (returned from his London successes; his *A Sergeant of the Light Horse in Palestine* was acquired in 1921, the year he painted Baldwin Spencer 'for the fun of it'), drawings by Lambert's friend Thea Proctor, etchings by John Shirlow and Sydney Ure Smith, and prints by Sydney Long and Lionel Lindsay. But in quantity they were swamped not only by the Asian acquisitions but by the extraordinary Sticht collection, acquired in Australia in 1922, only partly on Hall's recommendation. The American Robert Carl Sticht (1856–1922) General Manager of the Mt Lyell Mining and Railway Company since 1897, had amassed in Tasmania 208 original drawings by 'old masters', 177 drawings by 'English masters', 86 woodcuts by (even older) masters, 1340 other etchings, engravings, etc., 'mostly by old masters', 269 engraved title-pages, and 'specimens of typography representing about 830 English and Continental printers from Gutenberg to 1700 AD. Not included in this purchase was Edward Young's Blake-illustrated *Night Thoughts*, worth all the rest, which Sticht had bought at Felton's book sale in 1904. It took years to winnow the wheat from the substantial quantity of chaff in the collection, much of which remained with the Library rather than the Gallery. Putting Rinder's Schedule and Hall's eclectic purchasing together, it is easy to see how Australian painters practising in Melbourne in 1922 could feel that their work was unlikely to be given a high priority among the National Gallery's acquisitions.[16]

[15] Cox, *The National Gallery of Victoria*, pp. 95–7.

[16] On Sticht, see Ian McShane in *ADB*, vol. 12. Ann Galbally traces the beginnings of the Asian collections in *The Collections of the National Gallery of Victoria*, chs 9 and 10. The Felton Bequests' purchases in these years are listed (under advisers) in Charles Bage, *Historical Records of the Felton Bequests*.

Soon after returning to London from Melbourne Rinder met there Daryl Lindsay, arriving in 1921 with a letter of introduction from Baldwin Spencer. The youngest of the Lindsay brothers to enter the art world, Daryl (1879–1976) had been a bank teller and jackeroo before World War I, when he became his brother-in-law Will Dyson's batman in France. He began serious drawing in a military hospital, and Henry Tonks, surgeon and artist, enabled him to study at the Slade one day a week, as a follower of Sickert, Wilson Steer and other members of the New English Art Club. After returning to Melbourne in 1919, Lindsay went back to London in 1921, and through Rinder met Holmes, Clausen and the Scottish artist DY Cameron, Rinder's close friend. By his own account Lindsay became, intermittently over the next two decades, unofficial overseas Australian adviser to the Felton Adviser overseas. 'Knowing that I had a fairly extensive knowledge of the Melbourne collection, Rinder often asked my advice', and 'seemed to value my opinion', he wrote later; he in turn thought Rinder 'a man of refined taste, and sound judgement', with 'a wide knowledge of the European schools' and 'a strong sympathy for the best contemporary painting of his day'. There were those in Melbourne, however, who were apt to look with a jealous eye on any influence Lindsay might have had on Felton acquisitions.[17]

IN 1919 THE Felton Bequests' Committee accepted Rinder's strategy, and approved most of his recommendations as they arrived. The Gallery Trustees initially accepted the strategy, but were much more divided, factions forcing later changes of tack, which Rinder resisted, and—when they involved intemperate criticism—resented. He was also distressed by much of the press criticism. Public reactions to his selections were mixed—there were some admirers of almost everything Rinder recommended—but the hostile, especially JS MacDonald in the *Herald*, sought to wound, and succeeded. Nevertheless press criticism could have been weathered, had the Trustees supported the Adviser as staunchly as the Bequests' Committee generally did.

Membership of the Bequests' Committee was remarkably stable in the 1920s, only the nominee of the Gallery—in each case the President—twice changing. Changes among the Gallery Trustees, however, were extensive. In November 1920 Henry Gyles Turner died, aged eighty-nine, and Alexander Leeper succeeded him as President of the Gallery Trustees and as a member of the Felton Bequests' Committee. The passionate Irishman had retired as Warden of Trinity

[17] Hall was more tolerant of him than MacDonald was later, when Lindsay was close to Cockerell. Lindsay's account of Rinder is in his *The Felton Bequest*, p. 34. See also Philipp and Stewart (ed.), *In Honour of Daryl Lindsay*, and Bernard Smith's entry on the Lindsay family in *ADB*, vol. 10.

College in 1918, and the conglomerate institution in Swanston Street became his principal interest (with St Paul's Cathedral, of which he was a lay canon). According to his daughter Valentine, who acted as his secretary in those years, Leeper particularly wanted to be President: 'He was so proud of that institution—the Library, the Gallery and the Museums all under one roof—there was nothing else like it in the world'. 'God grant that I may use to thy glory the influence of this new position', he prayed. He prayed also for Divine help in the conduct of the meetings of Trustees. He needed it: they remained an argumentative lot, too many of them as old or older than their septuagenarian chairman.[18]

Leeper had been a Trustee for thirty-three years, and his leadership was so overweighed by past experience that some, especially in the Library, thought him pedantically obstructive. Armstrong reported that although the Library was a place of deposit for Victorian publications, Leeper wanted to exclude from it sensational fiction, third-rate poetry, ephemeral publications and—'especially anathema'—any book questioning the authorship of Shakespeare; but added that Leeper possessed 'a scholarly and delicate sense of humour, sometimes slightly sarcastic', and was a valuable Trustee.[19] He had been involved with the Gallery since becoming a member of the Trustees' original Gallery Committee in 1887, and there too he was apt to interfere; Percival Serle, who had retired early from his accounting post at the University to pursue cultural interests and had been hired by Hall to catalogue the Connell collection, was deeply offended when Leeper unfairly rebuked him over a Gallery lecture Serle delivered.[20]

In Felton Bequest matters Leeper got on well with Bage (who lived a few doors away in Kensington Road, South Yarra), and well enough with Sir John MacFarland, his rival and occasional enemy when both were heads of University colleges. The new President was 'entirely loyal' to Rinder, whom he greatly admired, but could not always defend effectively. Baldwin Spencer, appointed Vice-President, was also firmly committed to Rinder. Of Leeper and Hall, Valentine Leeper wrote that 'sometimes they got on and sometimes they didn't' which had been true since the 1890s, when Leeper had defended Hall against his critics. Hall's attitude to Rinder was negative; he refused to co-operate with a system which he still deplored, though he did not pursue the man with the venom he had shown towards Gibson. His influence behind the scenes remained considerable, greater

[18] 'I prayed for God's help in conduct of the meeting but I was by no means satisfied with myself and feel Hall was not fairly treated'...'I pray for help but am not a good chairman' (Leeper Diary, 6 and 14 March 1924).

[19] Armstrong, 'Fifty Years of the Public Library', p. 17, and *The Book of the Public Library*, vol. 2.

[20] Serle, *Percival Serle*, p. 36.

Dr Alexander Leeper (Leeper Library, Trinity College)

than that of John Shirlow, the etcher, Rinder's most vehement critic, a Trustee from 1922 until 1936, whose excesses came to embarrass even those who shared his dissatisfaction with the London Adviser. One such was the eminently worthy Sir George Swinburne, a Trustee from 1910 until 1928, Chairman of the Technological Museum Committee but unduly proud of his own knowledge of art (acquired, Cox suggests, from 'an early friendship in London with a Methodist minister', a 'reputed connoisseur'). Less easily swayed was Sir Leo Cussen, a Trustee 1916–33 and President 1928-33, described by RG Menzies as 'one of the great judges of the English-speaking world', shrewd and fair.[21] Older members included EH Sugden, (President 1933–35); AS Joske, now an authority on Rudyard Kipling as well as typhoid (President 1938–39); Sir John (Jack) Mackey (Trustee 1909–23); Sir Henry

[21] On Shirlow, 'the first [in Australia] to make artists' prints the basis of an artistic career', see Roger Butler in *ADB*, vol. 11; on Swinburne, engineer, politician and philanthropist, see Alison Patrick in *ADB*, vol. 12; and on Cussen see Jenny Cook and B Keon Cohen in *ADB*, vol. 8. Cussen's one-time master, the pugnacious Sir Frank Madden, was briefly a Trustee (1918–21); on him, see SM Ingham in *ADB*, vol. 10). J Moloney was also a Trustee, 1912–22.

Weedon (Trustee 1912–21); JF Mackeddie, a Scot from Ross-Shire, another medical man (Trustee 1918–44); and William Montgomery, a stained-glass designer, from London via Munich, one-time President of the Victorian Artists Society (Trustee 1916–26). Edward Officer, artist and pastoralist, joined the Trustees (and the Purchase Committee) in 1916, after decades divided between France and Australia. He served all too briefly, until his death in 1921. Not all these Trustees were particularly interested in the Gallery, though all were obliged at times to vote on issues concerning it.[22]

Two recruits joining the board in the 1920s were to be of special importance to the Bequest. Sir Frank Clarke (1879–1955), son of Sir William Clarke, was a Trustee from 1921 until 1930, when he transferred to the Felton Bequests' Committee for the next twenty-four years. Alfred Bright (1869–1938), a partner in the large Anglo-Australian firm of Gibbs, Bright and Co—successor to Bright Brothers and Co, merchants in Melbourne since 1853, the year Felton arrived— was the Eton-educated grandson of a Victorian Governor and godson of the Duke of Edinburgh; a man grand enough to be mildly unconventional and 'the worst dressed man in Melbourne', Bright became a very effective Trustee of the Gallery 1922–38, President 1935–38 and a member of the Bequests' Committee 1936–8. RD Elliott (Trustee 1924–50), son-in-law of Theodore Fink, was a figure not to be ignored; a provincial newspaper owner (modelling himself on Lord Beaverbrook) and one-term Senator, Elliott was constructive in Museum matters—he chaired the National Museum Committee 1927–31—but destructive in others, not least through his increasingly implacable enmity towards Keith Murdoch. (He also came under the sway of the dissident and charismatic—to some—Meldrum.) JH Connell, a Trustee 1922–44, was a less divisive figure; a publican, nephew of Young's and Jackson's, owner of Johnny Connell's Railway Hotel, and breeder of mastiffs, he had already served the Gallery well, his gift to the Art Museum in 1913 of his large collection of antique furniture and other objects having 'established the Decorative Arts as a vital part of the Gallery's overall collection'.[23] JT Tweddle (Trustee 1921–43), Methodist, business-man, philanthropist, and husband of the artist Isabel May Tweddle, a forceful modernist, with Cézanne, Matisse and Van Gogh as her heroes; GM Prendergast, trade unionist, Labor Premier and a modest collector of works by Penleigh Boyd and Lionel Lindsay, a Trustee 1921-37; and Maurice Blackburn, admirer of George

[22] On Officer, see Juliet Peers in *ADB*, vol. 11.

[23] Galbally, *The Collections of the National Gallery of Victoria*, p. 7. On Clarke, see RJ Southey's entry in *ADB*, vol. 8; on RD Elliott, LR Gardiner in *ADB*, vol. 8; and on Bright, Geoffrey Serle, *Sir John Medley*, pp. 10–11 (the quotation is from WS Robinson).

Higinbotham, solicitor and stubbornly independent Labor politician, a Trustee 1924–40. JT Collins, Parliamentary Draftsman and Leeper's one-time lieutenant as Principal of his Ladies Hostel (later Janet Clarke Hall) was a Trustee 1921–38. Sir John Longstaff, a Trustee 1927–41, joined the Board just in time for the climax of the Rinder affair.[24]

By the 1920s there were several—Keith Murdoch was later to emerge as the most influential—who wanted independence for the Gallery, believing that its link with the National Library and Museums hindered not only growth but also its willingness to embrace new movements in Art. Leeper defended the old conglomerate stoutly, though he did lead a delegation to ask the Premier for a new site for the Industrial and Technological Museum. They begged in vain, and the break-up did not come until 1944.

MOST OF ROSS' purchases—but not the Blakes—reached Melbourne just before Rinder's visit. They were quite well received; press criticism did not reach full pace until 1920 (despite the reappearance of Gibson as a correspondent, this time over who was to blame for not acquiring works by Degas).[25] In 19 March 1920 the *Argus* reported 'little interest' in the arrival of the Turner, but Rinder's recommendation, reported that month, to spend £10 000 on a French stained-glass 'Jesse' window, removed from Salisbury Cathedral a century before and described by Rinder as 'rich and jewel like', caused much stir.[26] The Trustees voted against it, but Spencer persuaded them to rescind the motion, seven votes to five. Nahum Barnet called it an 'astounding proposal' in the *Argus*, 'distinctly out of place as a picture gallery exhibit'; but 'Penelope' praised the acquisition as a blow for beauty against the post-war plutocracy of 'movie proprietors and confectionery manufacturers', and others welcomed it more cautiously. It would indeed have been a major acquisition, if awkward to house—St Paul's Cathedral was suggested, but ruled out by the Librarian as contrary to the will—but the Felton Bequests' Committee deferred a decision and eventually decided against it.[27] Rinder was upset, and the window went to grace the Metropolitan Museum in New York.

On 25 May 1920 the *Argus* welcomed a consignment which included a major early Romney and Stevens bronzes, but in the same paper on 1 June A McClintock

[24] On JT Tweddle see John Lack and on IM Tweddle see Juliet Peers, both in *ADB*, vol. 12; on Prendergast, Geoffrey Serle in *ADB*, vol. 11; and on Blackburn, Susan Blackburn Abeyasekere in *ADB*, vol. 7.

[25] *Argus*, 3 May 1919.

[26] For Hudson's argument that *Walton Bridges* lacked the aura of the masterpiece, because such works were no longer fully symbolic of the power of the former colony nor yet of a nation, see Frank Rinder and the Felton Bequest, pp. 33-4.

[27] Arthur Wills supported Barnet (*Argus*, 19, 20, 22 and 24 March, *Age*, 19 March 1920).

described the acquisitions as 'flotsam and jetsam' and four days later 'N. L.' expounded at length the old complaint that the Bequest continued to buy only 'minor works'; of the Advisers, he thought, Hall remained the best so far. A vigorous defence of Rinder came from Edward Officer: the Adviser had 'so far made no mistakes in his purchases, and his selections are an augury for a great collection, of which Melbourne and Australia will one day be justly proud, and the envied possessor'. 'Instant public satisfaction' would have been a greater cause for misgiving than criticism, a view which greatly annoyed McClintock.[28] A jocular *Argus* leader suggested appointing new Trustees, a team of tough men who would stand no nonsense from 'carping critics':

> The claims of John Wren [a notorious fixer] to a place on the committee are too obvious to require explanation. As for a chairman, well, Sir Elliott Johnson [Speaker of the House] and Mr Justice Higgins [President of the Arbitration Court] might toss up for the position, the one who escaped to have the privilege of paying the extra premiums on the loser's insurance policy.[29]

Officer's death in 1921 weakened the Trustees.

Rinder, responding to the press cuttings sent to him, in July provided the Trustees with a considered comment on N. L.'s 'Felton Mistakes'. He endorsed the appreciation of Hall's acquisitions, and restated his own approach:

> With £13,000 per annum plus a considerable accumulation at command, it is possible slowly to build up in Melbourne a collection of pictures, drawings, prints, sculpture and objects of art genuinely representative of the past as well as of the present. Highly important, well-authenticated works by supreme masters of the Italian, Spanish and Northern Schools ... such as profoundly impress visitors to the National Gallery in Trafalgar Square, the Louvre, the Uffizi etc. ... must always certainly remain out of reach. But patience and resourcefulness ... should serve to yield characteristic and delightful glimpses into art of the past as practised by men of acknowledged standing and capacity ... The Melbourne Gallery is the only one in Australia which can hope, thanks to the Felton Bequest, successfully to carry out any such a finely educative programme. For the sake of the development of art in Australia [it is necessary that] we of today survey horizons from the shoulders of our predecessors ... and for the sake of the amateurs who profit incalculably by intelligent study of the plastic arts as exemplified

[28] *Argus*, 26 and 30 June 1920.

[29] Ibid., 5 June 1920. Wren, discreetly described in the *ADB* as an 'entrepreneur', controlled much inner-city politics with the proceeds of his totalizator and other persuaders; Higgins (1851–1929) was about to return to the High Court from being President of the Commonwealth Court of Conciliation and Arbitration, and Johnston (1880–1942), maverick politician, was at that time Speaker of the House of Representatives. Sir James McCoy from the Fair Prices Commission was among others suggested.

in various European countries, it would be a signal mistake, I am convinced, to confine purchases to work by British artists and living or recently deceased Continental artists.

All acquisitions should have 'real aesthetic merit'. If a competent jury condemned his purchases 'from this essential standpoint', he would 'wish at once to retire'. But criticism should be realistic:

> I again emphasise that while it would be like crying for the moon to restrict purchases to the supreme achievements of the greatest artists, the standard for Melbourne must assuredly be maintained at that of important, responsibly conducted Public Galleries in Europe and America. Thus, to cite a couple of examples, it would be unwise to rule out Hogarth and Reynolds because it is highly improbable that Melbourne can ever obtain Hogarth at a level with the consummate *Marriage a la Mode* set, or *The Shrimp Girl;* or portraits by Reynolds of the calibre of *Lord Heathfield* or *Samuel Johnson*. Had such standards been enjoined, the Metropolitan Museum at New York and many other enlightened galleries would today be negligible as giving a conspectus of art developments of the past, which, be it remarked again, are of vital importance to the present.

He could only buy what came into the market; and in consequence 'from the standpoint of the onlooker without knowledge of the underlying plan, additions are apt to appear ill-ordered, even haphazard'. The Melbourne public, ignorant of the Schedule, did indeed find Felton acquisitions incomprehensibly various and too often minor, qualities probably inseparable from collection-building which was at once opportunistic and 'scientific'.[30]

A major acquisition from Rinder's 'Miscellaneous' list, the Wharncliffe *Book of Hours*—of which the Grimwades' *Golden Treasury for the Children of God* can be seen as a distant, separated, descendant—seemed to his critics too esoteric altogether. Described as 'a masterpiece for Australia' in London's *Morning Post* on 26 July 1920, and greeted as a coup for Melbourne—it would, in the view of the *Argus*, 'probably be the cause of envy amongst experts in other arts of the world'—news of the purchase nevertheless prompted a leader in the *Herald* complaining that the Trustees were making the Gallery 'a collection of curiosities'.[31] Although gratified by the acceptance of the Wharncliffe *Horae,* Rinder was disappointed when a Hogarth was declined, as he had been over the Jesse window. Nevertheless in September Alexander Colquhoun—artist, art teacher, and the

[30] Rinder to Armstrong, for Trustees, 30 July 1920 (also quoted by Cox, *The National Gallery of Victoria*, p. 91). N. L. had listed nineteen living artists, British and Continental, for priority in purchasing; Rinder observed that thirteen of the names were already in his schedule.

[31] *Argus*, 9 September 1920, *Herald*, 9 April 1920. On this key acquisition in the Gallery's small but strong medieval collection, see Galbally, *The Collections of the National Gallery of Victoria*, p. 82, and Manion, *The Wharncliffe Hours*.

Herald's art critic 1912–22—welcomed a group of five pictures (including an Augustus John) as 'one of the most rational investments yet made', though the *Argus* was more critical.[32]

Rinder was aware of the demands that the National Gallery prefer Australian art to foreign, but warned that 'in that case stay-at-home Australian artists would lack first hand knowledge of European art of the past and present, such as is proving of signal value in the United States'. In March 1921 the issue was pressed in the Melbourne newspapers. 'Why not a national Gallery?', a correspondent asked in the *Age*, a 'true one' with a small collection of copies of overseas works for the use of students and 'a separate and distinct gallery of Australian art', to which 'the income of the Felton Bequest should in future be mainly devoted'; the existing 'moribund institution' needed no more of 'the high priced modern canvases that have been bought, like pigs in a poke, from England'. A week later 'Australian Art First' claimed in the *Age* that 'it was quite an open secret that the present director of this institution is opposed to the support of Australian pictures'; the Bequest had gone from bad to worse, purchasing the Blakes. The issue even entered Parliament; from the House of Representatives Dr William Maloney—the bohemian medico-politician commonly thought to be the natural son of his uncle-by-marriage 'Big' Clarke—wrote proposing that half the Bequest should be spent on Australian art and the rest on organising an international exhibition, to be held in Melbourne every three years, from which 'foreign' works could be selected.[33]

Allegations that minor overseas works were preferred to Australian disturbed the Trustees; the breakdown, in May 1921, of attempts to acquire Millais' *Christ in The Carpenter's Shop*, and the arrival of a consignment of Rinder acquisitions—mainly water-colours, etchings and small paintings easily regarded as insignificant, though they included a drawing by Ingres and the four excellent Highmore illustrations to Richardson's *Pamela*—fed the disquiet. (Three Rodins, including an early *Penseur*, approved in May, had not yet arrived.) Leeper, under pressure to change the agreed acquisition policies, was eventually forced to bend. On 15 October 1921 he signed a letter, drafted by his deputy Spencer, which adroitly altered the emphasis in Rinder's instructions without openly amending them.

'The Trustees feel', he wrote (after thanking Rinder for the 'time and work' given to acquiring works 'which form valuable additions to the collection'), 'that in the case of collections such as that of the Melbourne Gallery, which as yet

[32] *Herald*, 27 September 1920, *Argus*, 30 September 1920. On Colquhoun, a Gallery Trustee 1936–41, see Jennifer Phipps in *ADB*, vol. 8.

[33] *Age*, 26 March, 2 and 5 April 1921.

naturally includes no masterpiece of the nature of those possessed by older galleries', it was 'eminently desirable' to seek first 'a small number of notable works of outstanding importance such as may come into the market from time to time':

> Such works would serve to form a nucleus of a great national collection, and the Trustees, without attempting to lay down any hard and fast lines in regard to the purchase of works of lesser, although at the same time of great value in a representative collection, think that, for the present, the funds of the Felton Bequest might with advantage be mainly devoted to the above purpose.
>
> The Trustees are fully aware of the difficulty of procuring such works, but are quite willing to wait until it be possible to purchase first rate and outstanding examples of artists whose work is now universally recognised as of paramount importance.[34]

A Conference of the Committees asked the two Chairmen, Leeper and Bage, to report on 'the General instructions to Mr Rinder'. They did so very thoroughly, summarising the correspondence and reprinting the Schedule, its amendments and all recommendations accepted and rejected; in effect they firmly defended Rinder's judgement. The Report, no doubt inevitably, remained confidential, and might therefore have influenced some Trustees, but not the critics or the public.[35] By June 1922, when the Report was considered and accepted, Rinder had responded to the Trustees' request for masterpieces with a coup. In February 1922 he bought van Dyck's *Rachel de Ruvigny, Countess of Southampton*, for £18 000, a picture spectacular enough for the London National Gallery to exhibit, before its departure, in the place vacated by Gainsborough's *Blue Boy*, sold to America by Duveen for $620 000. (Sir Charles Holmes was to display six of Rinder's major acquisitions in Trafalgar Square, greatly enhancing the reputation of the Bequest and of Melbourne's Gallery in Britain.)[36]

Another, even more remarkable, coup soon followed: the purchase—for £31 935, a price without precedent in Australia—of the *Madonna and Child* of Ince Hall, acclaimed as a van Eyck; 'with its acquisition', Leonard Cox wrote, 'the

[34] Leeper to Rinder, 5 October 1921, quoted in Cox, *The National Gallery*, p. 93. Spencer's handwritten draft, dated 24 September 1921, then owned by Leeper's daughter Valentine, was cited by Mulvaney in 1972 (Mulvaney and Calaby, *'So Much That Is New'*, p. 471, n. 12).

[35] Preparation of the Report coincided with a sharp reprimand from the Bequests' Committee to the Trustees for having authorised the purchase of some stained glass before gaining the Committee's concurrence. A number of procedures were again agreed, and restated on 3 October 1922, including a provision that when a conference was held in the Public Library the President should be in the chair, and when in the rooms of the Trustees, Executors Company the Chairman of the Felton Bequests' Committee (Cox, *The National Gallery of Victoria*, pp. 94–5; FBC to Trustees, 16 August 1922).

[36] The Felton Bequests' Committee ruled, however, that because Felton purchases were for the benefit of the people of Victoria, such loans should not exceed six months (Armstrong to Rinder, 11 June 1924).

Melbourne Gallery seemed to have come of age.[37] The attribution of the picture was quietly questioned when it arrived in Melbourne—as it had occasionally been since its 'discovery' near Liverpool in 1850—and was later so strongly challenged that from 1958 the Gallery listed it as 'After van Eyck', a copy of a lost original by 'the Adam of oil painting'. Nevertheless for thirty-six years this tiny *Madonna and Child* reigned as Melbourne's most famous picture (internationally; locally the palm probably went to *Chloe*).[38] Exhibited at the New York World's Fair in 1939, and in San Francisco, it was stranded in the United States by the War, and was also shown in Cleveland and Cincinnati. When Leeper spoke as President at its unveiling in Melbourne in 1923, the audience present was politely enthusiastic, but outside the Gallery walls the ignorant attacked so large a sum being spent on so small a picture (£400 per square inch, they calculated), and an article in the *Herald* headed 'Van Eyck's worst', attributed to Clewin Harcourt and sent to Rinder by Gibson, alarmed the Adviser with a reference to a 'fool and his money'.[39]

RINDER MADE SOME other excellent purchases in 1922–23, including a Flemish *Triptych*, Gainsborough's *An officer of the 4th Regiment of Foot*, Kalf's *Still life with glasses and fruit*, Ruisdael's *Watermill,* Steen's *Interior*, Courbet's *L'Hiver*, (and a little later his *La Vague*), another *Book of Hours*, and among more recent works *Durham Cathedral*, by Rinder's friend DY Cameron. In 1923 he failed to persuade the Earl of Crawford to sell a Rembrandt, but acquired, in May, for 1700 guineas, Millais' dramatic *The Rescue* ('a triumph of machine made, mediocre sentimentality', according to JS MacDonald in the *Herald*). Near misses that year included Augustus John's spectacular portrait of the cellist *Madame Suggia,* which Rinder might have bought had he won an option long enough to cable Melbourne; it went instead to America, whence Duveen bought it back for the Tate in 1925.[40] In 1923 he also began the pursuit, ultimately fruitless, of Rembrandt's *The Christ*, from the collection of Dr A Bredius, former Director of the Mauritshuis; a report that he was offered by Bredius, and refused, Vermeer's *Allegory of the New Testament*—authentic but decidedly odd, and now in the Metropolitan, New York—seems not to be substantiated.[41]

[37] Cox, *The National Gallery of Victoria*, p. 94.

[38] Ursula Hoff, *European Painting and Sculpture before 1800* (1995), pp. 103–6, summarises the assessment to that date. Hudson, Frank Rinder and the Felton Bequest (pp. 31–2) points out that Rinder acquired over 140 artworks; in *European Masterpieces* only six now have different attributions, compared with 56 of the remaining 201 works.

[39] Cox, *The National Gallery of Victoria*, p. 93 (citing Rinder to FBC, 28 June 1923).

[40] Rinder to Armstrong, 5 April 1923.

[41] Rinder to Armstrong, 5 September 1923. Cox (*The National Gallery of Victoria*, p. 99) cites Rinder to Armstrong, 30 October 1924 on the *Allegory*, but the picture is not mentioned there.

Four Trustees visited London in 1923—Sir Leo Cussen, Alfred Bright, JT Tweddle and Dr JF Mackeddie (who became a friend and admirer of Rinder)—and their presence prompted the Adviser to draft a paper on the need for further benefactions to art in Australia, sent to Melbourne in November:

> I doubt not that your art experiences in London have impressed upon you the permanent advantage that would accrue could the interest of wealthy persons in Victoria be further stimulated in the development of the National Gallery. In these days of high prices Felton funds permit us to take advantage of relatively few opportunities. The purchasing funds of the Metropolitan Museum, New York, and like institutions in the U.S.A., represent a small fraction only of the value of pictures and objects of various kinds annually acquired by gift or bequest. On the other hand, such public spirit as Mr Felton's in the art direction has as yet so far as I know been little followed in Victoria. Can anything be done to quicken such public-spirited generosity, I wonder?

Sir Leo Cussen and Dr Mackeddie had been with him to see a 'highly important picture of the 15th century' attributed to Roger van de Weyden, which could be available 'on very favourable terms'.

> The question I put to myself is: as art benefactions abound in America, and as at home the funds of our National Institutions are greatly augmented on special occasions—for instance, the National Art Collections Fund in 1906 provided £45 000 for the *Rokeby Venus* by Velasquez, and in 1909 £72 000 for Holbein's *Duchess of Milan*—is it not possible to stimulate a measure of like generosity in Melbourne?

It was unlikely: Australia had few local millionaires, and no tax deductions or exemptions from death duties to encourage them to become donors of works of art. No equivalent of the National Art Collections Fund—an organisation with wealthy subscribers and a strong and expert board, watching the market to rally public subscriptions when national treasures were on offer and at risk of export—seemed feasible there. Rinder conceded that the issue would be affected by the reputation of Felton purchases, 'which at present seem to be adversely criticised in the Melbourne Press'; he again offered to resign if 'the authorities deem such criticism to be well-founded'. 'Meanwhile Melbourne affairs are my unceasing concern'.[42]

RINDER CONTINUED TO make major purchases in 1924. Unusually fulsome, he hailed Titian's *Friar* as marking 'the birth of the modern portrait'; he did not live to see its attribution, as *Portrait of a Man*, rejected (or, as recently proposed, restored). It, and Memling's great *The man of Sorrows in the Arms of the Virgin* (then named *Pieta*) were both hung and admired in the London National Gallery

[42] Rinder to Armstrong, 15 November 1923, quoted at length in Cox, *The National Gallery of Victoria*, p. 98.

before shipment; Raeburn's *John Wardrop*, displayed in London and in the Scottish National Gallery, earned Rinder the congratulations of Lord Novar, who as Governor-General had taken his own family collection of Raeburns to Melbourne in 1914. ('I went to see your 'Wardrop' yesterday and thought it the best head in the gallery. Melbourne is indeed fortunate. This is Lady Novar's opinion also.')[43] Robert Louis Stevenson called it a picture 'which you might palm off upon most laymen as a Rembrandt'.[44] Armstrong, in his last letter before retiring as Chief Librarian, told Rinder that *Wardrop* was awaited with interest 'especially perhaps by the artists of Melbourne, several of whom have told me of their anxiety to see it at the first possible moment' (whether to praise or condemn remaining to be seen).[45] Melbourne rejected one major opportunity: when Rinder reported an imminent major sale of Blake illuminated books at Sotheby's, the Trustees cabled him to take 'no action', and the books went to the Pierpont Morgan Library, the Library of Congress, the Paul Mellon Collection and the British Museum.[46] Rinder himself decided not to recommend Vermeer's *The Astronomer*, offered to him in January 1924 for £20 000, which he thought 'not a typically fine Vermeer'; it was almost certainly a copy, since the accepted version of that picture, now in the Louvre, was then in the Rothschild collection. Rinder's observation that Vermeer was 'one of the great artists who can be represented at Melbourne only by a stroke of signal good fortune' seems likely to remain eternally true.[47]

Hall had maintained his refusal to be directly involved in the overseas acquisitions of the Felton Bequests. Asked in 1922 to comment on a painting by Sir Charles Holmes, he wrote that 'unless the Trustees desire me very particularly to do so, I would very much prefer to avoid all contentious issues with Mr Rinder's choice of pictures, as I have hitherto done. I ask the Trustees to excuse my hesitation in complying with their request'.[48] Late in 1924, when Swinburne asked if he wanted the Trustees to send him 'Home' again, he confessed that he would like to spend a couple of years as Felton Adviser, and then 'give up my present job and stay

[43] Rinder to Armstrong, 22 January and 5 February 1925.

[44] Rinder to Boys, 25 March 1926. Armstrong was succeeded by his Deputy RD Boys.

[45] Armstrong to Rinder, 22 January 1925.

[46] Rinder to Armstrong, 20 March 1924, Armstrong to Rinder, 17 June 1924; Butlin and Gott, *William Blake in the Collection of the National Gallery of Victoria*, p. 15.

[47] Rinder to Armstrong, 8 January 1924.

[48] Hall to Trustees, 25 April 1922. Note also Cox, *The National Gallery of Victoria*, p. 100: 'It is noted that on 2 October the Trustees received a report from the Director dealing with the purchasing methods of the Felton Committee and the Library Trustees. This has not yet been found, and it is noted in the file that it was removed in 1939 and not replaced.'

altogether'. Drafting a letter setting down the conversation, he complained of the 'personal prejudice' against him 'in certain quarters', adding (and crossing out)

> this is what I am up against—constant friction, irritation and shame, until I feel impelled to take some definite steps to regain my peace of mind and self-respect. I am losing my nerve to cope with it, and my strong desire is to get away from it and in so far as I can to forget it.[49]

Three weeks later Leeper told the Bequests' Committee that the Trustees had decided—at long last—to ask Hall to attend their meetings when art matters were discussed, so they could have his advice 'and criticism upon, inter alia, recommendations by Mr Rinder'. Stirred, Bage immediately wrote to the Trustees pointing to the existing agreement, 'essential to the harmonious working of the Trust', that any expert advice received by either body should be shared with the other, and could be made available to the Adviser 'at the discretion of the Felton Bequests' Committee'. Before the agreement was made, the Trustees had received Hall's opinion, but would not allow its transmission to London: 'In the opinion of my committee this procedure very seriously hampered the working of the Bequest'; to demonstrate the point he enclosed a list of the recommendations refused between 1909 and 1913—sixteen by the committee and thirty-five by the Trustees—causing Sir Sidney Colvin to take 'bitter offence' and resign, 'leading to a long vacancy in London'. Annotating his copy of Bage's letter, Hall, for ever unrepentant, claimed that Colvin's resignation was 'most advantageous to the Gallery', and that his successor (Ross) was 'of the same calibre and the farce proceeded on the same lines as before'.

> That the appointment continued till 1915, and was only finally ended by my 'very improper article' in the *Argus* (April 1915) exposing the situation, shows how little control our trustees are able to exercise over the work of collecting ... Meanwhile, though I am receiving a salary and was appointed for the purpose of advising the Trustees in all such matters relating to the Gallery I am debarred from doing so by the above agreement'.[50]

The prophet then withdrew again to his tent.

London advisers must have found Melbourne reactions difficult to predict. In July 1924, having purchased Derwent Wood's bronze *David*, Rinder had had to deal with a brief outburst of Melbourne puritanism. Told that the Trustees 'felt that, if the covering of the sex could be achieved without any loss in artistic effect it would be desirable', he advised that it could not be done; in the end the sculptor sent the

[49] Hall to Swinburne, 16 November 1924 (draft only, in Hall papers).

[50] FBC, 5 and 15 December 1924; Bage to Leeper, 16 December 1924, and Hall's annotations thereon (Hall papers).

figure 'with a separate leaf which can be applied should the authorities think it necessary'. There is no record that this optional fig leaf was ever attached, the Trustees conceding that they already had a full nude by Havard Thomas to which 'no exception has been taken'; perhaps it is kept in store in case of unforeseen ethical emergencies.[51] Melbourne was becoming less frightened of at least a moderate modernism; in June 1924 the Trustees authorised the purchase of an Epstein sculpture at up to 300 guineas. At the end of the year both committees agreed to raise Rinder's salary to £750, the Trustees cordially expressing their appreciation.[52]

Despite this apparent vote of confidence, press criticism in Melbourne of Rinder's purchases had caused his colleagues in London much disquiet. On 6 September 1924 the *Argus* printed a letter from Lord Carmichael, the former Governor and one-time private confidant of the Bequests' Committee Chairman, who had written in July commending the Bequests' acquisitions: 'thanks to the Felton Bequest, there are few cities in a happier position than Melbourne is, as far as the contents of her national Gallery go'. 'Several friends belonging to or interested in Australia' had asked him to write the letter, in which he tried, rather stiffly, to praise both the Bequest for its acquisitions and Australian artists for their achievements. Three weeks later eight heavyweights of the British art world, ranging alphabetically from Lord Crawford, Trustee of the National Gallery to Robert Witt, Chairman of the National Art Collections Fund, and including the Directors of Scotland's National Gallery and of Cambridge's Fitzwilliam Museum and the Keeper of the Royal Academy, were explicit in their praise of Rinder and in deploring 'misrepresentation' of his achievements. 'We regard, not only with admiration, but with feelings akin to envy, a gallery so fortunate as the National Gallery of Victoria, Melbourne, with its magnificent Felton Bequest', so well served by Mr Rinder, unjustly subjected to 'singularly unmeasured' attacks in the Melbourne press. Rinder, reading the press cuttings, hastened to assure Melbourne that he 'knew nothing of this letter'.[53]

The contrast between press comments on Rinder's purchases in Britain and Australia was indeed striking. Provincial as well as London papers wrote at length

[51] Armstrong to Rinder, 8 July 1924; Rinder to Armstrong, 24 July 1924 (Trustee company files). Melbourne had no monopoly in prudery; the hanging committee of the Royal Academy had agreed to display Mackennal's *Circe* only if the erotic images on the base were covered with drapes.

[52] Bage to Rinder, 7 January 1925. Swinburne, coming to England, would discuss with him the question of a term of office. Rinder told Swinburne he thought the Adviser's appointment should be for a short term (say two years) but insisted it be terminable by the Committee at any time (Rinder to Armstrong, 6 March 1925).

[53] *Argus*, 6 and 30 September 1924, reprinted *in Historical Record of the Felton Bequests Supplement No. 1* 1927 and in Burdett, *The Felton Bequests*, pp. 18–22; and Rinder to Armstrong, 16 October 1924. The other signatories of the second letter were Sydney Cockerell of Cambridge, James L Caw and James Guthrie of Edinburgh, Campbell Dodgson of the British Museum, Martin Hardie of the Victoria and Albert, and Charles Sims, Keeper, Royal Academy.

about the van Eyck ('Famous Picture for Melbourne') and the headlines announcing 'A Titian for Australia', 'A Memlinc for Australia', 'Puvis de Chavannes Cartoons for Australia' and 'Raeburn for Melbourne' were bold, and the articles they headed admiring and envious. *Country Life* printed a half-page reproduction of Daumier's *The Lawyers*, and Derwent Wood's *David* (*sans* fig leaf) was widely illustrated, as were silver and other museum pieces. The riches of the Felton Bequest were remarked on regularly; no doubt it was such a report which prompted the Town Clerk of Maldon, Essex, to write to the Bequests' Committee in March 1923, seeking a photograph of the town's hitherto forgotten illustrious son—and also a donation towards the Borough Museum (receiving in return only a copy of the recently-published *Record*). Meanwhile in Australia *Smith's Weekly*'s headline 'More money than they know what to do with; Felton Bequest now an artistic menace' headed a gossipy report attacking the acquisition of minor overseas works, an alleged clique pushing for Longstaff to replace Hall, and the pretensions of JS MacDonald as a critic (while conceding he was 'in the front rank of the profession as far as publicity is concerned').[54]

Rinder is to be envied for his opportunities, but not for his dilemmas. Masterpieces were offered him, in an abundance he knew could not last. He could not buy them all, and in each case had to weigh the importance and quality of the work, the chances that such an opportunity would recur, and the price, in a sharply rising market. He had also to assess the likelihood that the Committee and the Trustees would accept his recommendation—he was distressed that in 1925 they refused a della Robbia relief and a Burne Jones/William Morris tapestry of the Holy Grail he greatly admired—not least because dealers were less likely to grant him options if few were taken up. And, as a sensitive man, he could not but be a little inhibited in his judgement by the likely reaction of the Melbourne press, especially after the reception given the van Eyck. All this became evident when, in April 1925, he was told that £18 000 was available for purchases, with a further £10 000 to be allocated in June: in modern terms some $1.5 million in all. In May he found a 'glorious' Turner (of Venice), which also much impressed Swinburne and Elliott, then in London, but the price was an unprecedented £30 000, and Rinder hesitated to propose that such a large sum be spent on a nineteenth-century painting rather than an old master. 'Never have I been so perplexed as to whether or not to recommend purchase of a work to Melbourne', he lamented, before advising that although it would be a 'great gallery possession', and that 'two years hence' the price would seem justified, it was 'dangerous for the Melbourne Gallery to establish a precedent'

[54] *Smith's Weekly*, 5 December 1925. English press cuttings for the period 1922–33 are usefully collected in a book in the Bequest papers in the La Trobe Library. The Felton Estate Book, also there, notes the correspondence with Maldon.

with such a price for a Turner. The Bequests' Committee agreed, and declined the work, only to be summoned next day to consider an urgent message that Rinder had changed his mind, negotiated £1000 off the price and now recommended purchase. The Committee, not persuaded, still declined to buy.

Rinder was also reluctant to recommend purchase of a Rembrandt, of a man in a turban. He and Swinburne both admired the picture, but agreed also that a squint in one eye made the figure 'not immediately attractive' and unlikely to be welcomed in Melbourne. Swinburne's presence seems also to have influenced Rinder against recommending to Melbourne another painting, expensive but small, Vermeer's *Girl in a Red Hat and Blue Cloak*:

> I enclose a reproduction from today's *Times* of this characteristic and charming little picture . . . lost sight of until a few weeks ago, when Messrs. Knoedler purchased it. In company with Mr Swinburne I yesterday saw it for the second time, and we considered the practicability and desirability of purchase. Mr Carstairs, Chief partner in the Knoedler firm, generously quoted me a price substantially below that which he will doubtless obtain in America—namely £30 000 in place of £40 000—but, eminently desirable as would be the picture for Melbourne, I declined it . . . It is a gigantic sum for so tiny a work, and even Vermeer cannot quite be equated with Van Eyck.

He did, however, arrange to keep the offer open; 'should the authorities desire me to go further, please cable'. His letter went to a Felton Bequests' Conference in September, where it was endorsed 'no action taken', an outcome much to be regretted. Mellon bought this much-loved picture for US$200 000, and passed it on to Washington's National Gallery of Art; its attribution to Vermeer was rejected some years ago, when too-rigorous culling reduced the number accepted as genuine to twenty-seven, only to be restored when the canon was increased, recently, to thirty-five. The thousands who admire the painting every week did not notice any change.

The September Conference also received Rinder's report that with Sir Charles Holmes' assistance he was buying for £5500 Goya's *Portrait of a Lady*, which had been offered to the National Gallery by the Spanish Minister in Prague. Declined by them because they already had a Goya portrait of a woman, it was offered to the National Gallery of Scotland; since they were 'destitute of funds', the offer went to Melbourne. 'Having assured myself of the quality, representative character and condition of the picture', Rinder reported, 'I have arranged to buy it for Melbourne under scheduled authority' (his discretionary limit having just been raised to £10 000). The *Portrait*'s attribution was not then questioned, but unfortunately its provenance has never been satisfactorily documented, and in Melbourne its status declined, as the century proceeded, through 'attributed to', to 'in the manner of', the Spanish master. But it is a fine painting, and proof that Goya put a brush to it might yet emerge.

19

THE RENDING OF RINDER

In January 1926, when 'Goya's' *Portrait of a Lady* was hanging in London's National Gallery, the Trustees thanked the Bequests' Committee for 'the privilege, which they have so often enjoyed, of being able to exhibit to the English public the magnificent pictures acquired by your body for the Melbourne Art Gallery'.[1] When the picture arrived in Melbourne later in the year, its quality, though not its provenance, was sharply criticised.

By then the Trustees had again changed tack. Having sent Rinder in pursuit of great works of the past, they resolved in September 1925 that it was 'desirable to make a collection of works by contemporary European artists', and asked 'that Mr. Rinder be requested to pay more particular attention to modern art and not to concentrate on works by old masters'. The Bequests' Committee, when agreeing to inform Rinder of this request, was careful to assure him that no criticism of his 'excellent' work was implied.[2]

Rinder himself had already stressed, in November 1923, his own 'very keen interest in present-day art', conceding that he would like to buy more: 'undoubtedly there thus could be obtained a much better show for the money'. But great care was needed. 'Either one may be unduly attracted by novel modes of expression which in the future may be regarded as rather foundationless protests, or fail to do justice to efforts, whether arrestingly modern or vitally traditional, which have "come to stay"'; and he wanted to buy only the best of any given artist's

[1] CH Collins Baker to Bage, 25 January 1926, reprinted in *Historical Record of the Felton Bequest, Supplement No. 1*, 1927, p. 118.

[2] FBC, 11 February 1926; Trustees, 27 September 1925. On 29 October the Trustees showed their dissatisfaction with existing procedures by insisting that the Purchase Committee report to each meeting 'any action taken, or determination arrived at' concerning any work 'over the price of £50'.

work.[3] In May 1924, told of a possible change in priorities in Melbourne, he warned that 'within the next twenty years or so high quality works by the rarer Old masters will be unprocurable'.

> I am firmly convinced of the importance of endeavouring before it is too late to acquire for Melbourne a few more indisputably fine pictures by Old masters ... Only so, in my view, can the generous Felton Fund best be employed to subserve the permanent interests of art and general culture in Australia.[4]

After reviewing the Schedule—and adding some contemporary artists, including Gwen John, an unusually perceptive choice—he wrote again on 25 March 1926, advising that 'the wise policy is to expend the bulk of the money on representative works by artists who have a close knowledge of their craft, which as to character and quality has stood the test of time'[5]

The Trustees had added a rider to their resolution: that Hall be sent to London for from six to twelve months, to co-operate with Rinder in implementing the new policy. The Felton Bequests' Committee was unanimous that it was 'not desirable' to send the Director to London 'for the purpose stated', but did not formally respond to either proposal, calling instead for a 'round table' conference; it was held in February 1926, with ten Trustees present but no proceedings recorded. The Bequests' Committee bypassed the proposal to send Hall to London by suggesting that Rinder should visit Melbourne again as soon as possible; the Trustees concurred, and at a conference in April the Bequests' Committee at last agreed to vary the Adviser's instructions 'for the purpose of paying more attention to modern art' (while insisting that 'they were quite satisfied with what Mr Rinder had selected to date, and wished it to be made perfectly clear to Mr Rinder that the concurrence by the Committee in the Trustees' resolution must not in the smallest degree be taken as incorporating on their part any feeling of criticism of his past work').[6] They also insisted that the new emphasis on contemporary work not be announced until after Rinder had arrived in Melbourne.[7]

Rinder could not leave London immediately. He was unhappy with the rejection of a 'superb and characteristic' Degas *Répétition de Danse*, over which he had an

[3] Rinder to FBC, 15 November 1923, quoted in Cox, *The National Gallery of Victoria*, p. 98.

[4] Rinder to Armstrong, Felton Letter 9, 29 May 1924.

[5] Rinder to FBC, 25 March 1926.

[6] FBC, 11 February and 7 April 1926.

[7] Ibid., 3 May 1926.

option for £6000—'desire Degas but regard price too high' was the conference's response—and said he would not come at all if a further decision, reducing the sum authorised for a de Koninck landscape from £8700 to £6000, causing him to be outbid, indicated a new policy.[8] He was reassured, and belatedly authorised to purchase the Degas, only to find that the owner had ignored his option and sold it. Before leaving London, however, he was able to purchase two Manets, *The House at Rueil* and *The Ship's Deck*, which turned up almost together. News of the acquisition of the latter provoked the discontented Shirlow to seek, until dissuaded by his fellow Trustees, a resolution that the Felton Committee be informed that the Trustees regarded expenditure on Manet a misuse of Felton funds.[9]

THE DRAMA WHICH began with Rinder's visit in 1926 has been told by Leonard Cox, who recalled the episode with some distaste. In July, a month before Rinder arrived, Alfred Bright, as a relatively new Trustee alarmed by Hall's hostility to the Adviser's work, had drafted some thoughtful notes, surveying the problem:

1. The Executor's section [the Bequests' Committee] does not trust the judgement of the Trustees' Art Director.
2. That for many reasons, which apparently it would be difficult or impossible to remove, it is unlikely that the Art Director and the present official could work together.
3. The attitude of the Art Director is in short—
 Trustees could not buy pictures.
 An artist must be closely consulted in the purchase of pictures.
 Experts are no good.
4. Reviewing all purchases to date the Art Director is satisfied with only a small percentage. His reasons vary—
 Some pictures are too expensive.
 Some too slight.
 Some poor representatives.
 Some horrible.
 Some too large.
 Some too small.

[8] Ibid., 3, 9, 23 April and 3 May 1926. (A cable on 20 April—'Rinder greatly regrets Degas decision ... moderately valued 6000 but got reduction to 5800. A *Danseuses* made 19 000 in Paris 1912. Instant decision may still be effective'— did not move the Committee to act; they approved purchase at £5800 on 1 July. Rinder to Bage, 12 May 1926, complained concerning the Koninck; on 22 June the FBC informed him that 'no slight was intended, both bodies having perfect confidence in your judgement'.

[9] Dr Cox, noting that Shirlow was a good etcher whose paintings were sometimes grotesque, surmised that he was colour-blind, arguing that appreciation of Manet, like later Impressionists, requires a full range of colour perception. But Shirlow was blind to more than Manet (Cox, *The National Gallery of Victoria*, p. 104 and note 7, p. 432). FBC, 1 and 6 July, approved the Manets. Manet's *The Melon* was acquired in the same year.

Hall's chief complaints were that 'no artist is primarily concerned in the actual buying', and that the existing procedure gave the London expert free hand to spend up to £10 000 on works within the schedules. Hall and Rinder were 'gentlemen and could meet as such', but it was unlikely they could work together, and the position was 'aggravated by the Art Director not being persona grata to the Executors'. 'To meet the issue today', he concluded, one or both men would have to go', and that would not help the Gallery; better to seek a working compromise for a time, by setting a new policy.

His first thoughts were to limit the number of pictures bought, and to treat the schedules only as lists, not as authorities to buy. Having examined (and annotated) lists of all overseas acquisitions since Ross was Adviser, Bright found them 'spotty', as he reported to Leeper, with a new conclusion, that 'the alleged spottiness that they exhibit when taken as a whole may be due to the fact that the base is too broad', suggesting concentration on fewer. (It was an issue Rinder had himself foreseen when predicting that some of the works he recommended would seem minor and their acquisition haphazard when seen without reference to the grand design.)[10]

Leeper did not respond to Bright's proposal. He was too happy to report, in August, that a meeting of the two committees, in Bright's absence (interstate) and also Hall's (not invited) had unexpectedly produced sweetness and light. 'It is an immense relief to me', he wrote euphorically, 'that the two committees now fully enjoy each others confidence'; serving two masters had caused him such agony he had almost resigned. Bage had assured them that the Bequests' Committee was not hostile to Hall, though they found his judgements too 'technical'. (Leeper himself had seen Hall 'put in print his conviction that the sole purpose of a picture was to decorate a wall. That surely ignores some of the highest functions of art'.) He did not think Hall could change:

> I have very little hope that Hall will ever succeed in working with an expert like Rinder, with whose views he has no respect. My reason for saying this is that as far as I can remember his attitude [to Rinder's 'predecessors'] has always been the same. I do not blame him for this. It is a view common, I believe, among artists, and perhaps indeed among specialists of all kinds.[11]

Hall was sixty-seven, and had no pension rights, 'so we must act humanely towards him' for three or four years, Leeper charitably concluded.

He found it hard to remain charitable thereafter. Rinder arrived on 31 August and remained in Melbourne until 19 October. Only the Bequests' Committee,

[10] Memo, 27 July 1926; Bright to Leeper, 26 August 1926 (Bright papers).

[11] Leeper to Bright, 26 August 1926 (Bright papers).

the well-disposed among the Trustees and a few others made him welcome, and he could not but be aware of the hostility of others. Press criticism of his purchases continued, and he was pestered to respond. The *Herald* beat up a campaign: an article by JS MacDonald, vitriolic as was his increasing wont, was followed by letters from Napier Waller ('appreciative of what good pictures we have', but lamenting 'the poorness of the majority'), George Bell (complaining of a policy of buying old masters, producing 'second or third rate' pictures 'of very doubtful authenticity' bought at inflated prices), and by others, most supporting Hall as the adviser most likely 'to ensure a steady stream of good works'. The *Herald* asserted that the Melbourne art world was 'openly dissatisfied' with the administration of the National Gallery, with 'nearly every artist' convinced that the Felton Bequest was 'being exploited by bad buying', while the Trustees had been 'guilty of wrong administration'.[12] Rinder was 'temperamentally opposed to buying modern works', and had 'paid through the nose for bad pictures'. Shirlow, it was claimed, should be on the Purchase Committee. (He was doing his best to oblige. For some time he had been lobbying Bright, Swinburne and no doubt other Trustees asserting the need for an artist on the Committee, and also for an 'artist's view' of the quality of the works acquired.)[13]

Not all artists joined the chorus. The formidable Miss AME (Alice) Bale, who had trained with Meldrum and was Secretary of the Twenty Melbourne Painters, pointed to disagreements among artists and the uncertainty of their standards; and the next day Charles Wheeler, soon to be appointed teacher of drawing in the Gallery School, assured her that 'there are many artists here who can join with her in appreciation of some of the pictures'. But the *Herald* persisted, a leader quoting Shirlow on the weakness of the Purchase Committee ('not one of its members is a man of artistic competence') and claiming that 'neither the public nor the trustees' had faith in Rinder, while 'a special correspondent' complained of profits by middlemen, and called the latest acquisitions 'a motley lot of rubbish'. Hall should be consulted; artists, public and citizens were all behind the *Herald* in demanding that 'short work' should be made of the present trustees. The cumulative effect of the *Herald*'s headlines over the years— 'Shame and Rubbish', 'A Sorry Batch', 'Van Eyck's Worst', '£400 an Inch', 'Fool and his Money', 'Gallery in which Artists had no say', and so on—was such that a member of parliament could condemn Bequest purchases as 'freak pictures', and claim that the whole public of Victoria was opposed to the system of purchase.

[12] In a document apparently written at this time, MacDonald asked 'what is wrong with our Felton Purchases?' 'Chiefly this, I think, that too many persons of half or no art knowledge are interfering'; if it smelt of oil and varnish, it must be a work of art (MacDonald papers).

[13] Shirlow to Bright, 18 July 1926 (Bright papers).

The attacks did not abate, and it was not surprising that at a reception given for Rinder by his friend Dr Mackeddie, Leonard Cox (then a young doctor making his name as a neurologist while developing his parallel expertise in Chinese ceramics) found him 'unhappy and depressed'.[14] But not discouraged; at a meeting on 13 September with the Committee (Sir John Grice sitting in place of MacFarland, absent from Melbourne) and Trustees Clarke, Spencer, Tweddle and Collins, the Adviser was forthright. He did not want to stop purchasing Old Masters, while denying he had concentrated on them; schedules were necessary; and he favoured reserving some Felton funds for works of art other than paintings. It was for the Trustees, and not for him, to answer press criticism, which he insisted would not be supported by opinion in England. After discussion, Spencer was deputed to work with Rinder revising the schedule. At a further conference a fortnight later the Trustee members asked that the change of policy be made public, but the Bequests' Committee again demurred. Leeper, the man in the middle, abstained from voting.[15]

The revised Schedule, which was not finally approved until November, included six pages of 'British Artists (living June 1926)' including Vanessa Bell, Jacob Epstein, Roger Fry, Duncan Grant, Augustus and Gwen John, Laura Knight, Paul Nash, Stanley Spencer, Wilson Steer and Jack Yeats; three pages of 'British artists now dead but born after 1800', four pages of British artists born before 1800, and only three pages of continental artists born since 1800 and two pages of old masters. There was a long list of prints for a 'projected print room', and six pages of 'miscellaneous', including many books. The new emphasis might have been 'contemporary', but it was even more Anglocentric than before.[16]

Accompanying the Schedule was a new set of instructions, set out in a letter from Bage in October 1926. The *Policy as to Choice of Works of Art* succinctly echoed earlier statements, with a slight change of emphasis.

> The Felton Bequests Committee and the Trustees of The National Gallery desire to obtain only examples of the best work of the best artists, and they wish studiously to avoid acquiring indifferent examples of great masters. In each case the work selected should be characteristic of the artist, and should be one of his best and most important

[14] Cox, born in Prahran in 1894, son of a Methodist minister, went from Wesley College to the University of Melbourne, where he completed Medicine before joining the AIF in 1917. He was later, from 1934, to be Honorary Consulting Neurologist at the Alfred Hospital and Lecturer in Neuropathology at the University of Melbourne, and in 1948 the first President of the National Gallery Society.

[15] FBC, 27 September 1926.

[16] Ibid., 13 and 27 September, 8, 14, 19 and 26 October 1926. Ann Galbally has observed (*The Collections of the National Gallery of Victoria*, p. 210) that 'it was not until well after the Second World War that the trustees and their overseas advisers finally admitted that the important art of the twentieth century was not being created entirely, or even partly, in the United Kingdom'.

productions. With regard to contemporary work, as shown at current exhibitions, it is not enough that any example chosen should be the best of the year; it should bear comparison with famous work, and should be representative of the best art of the period.

Rinder later complained that some of the new instructions were 'restrictive', but was told 'to do his best'.[17] For a few months after his return to London he failed to find major acquisitions, and in June 1927 was outbid for an important Turner, *Dogana and Salute*, approved for £24 000, but in September he acquired not only Tintoretto's *The Doge Pietro Loredano* (£14 000), formerly owned by Prince Lichnowsky, but also Bastien Le Page's great *Season of October: The Potato Gatherers* (£4000), 'probably the best peasant picture of this celebrated nineteenth century Frenchman'.[18]

THE APPROVAL OF the Trustees to the amended schedule and instructions had been hard won. Although Bage could report after Rinder's departure the Committee's 'unanimous confidence' in him, many of the Trustees—a majority, it emerged—remained hostile, and soon broke out. Sir George Swinburne, a man much to be respected but not for his knowledge of art, had become convinced (despite his time with Rinder in London) of the inadequacy of the Adviser's selections; and on 4 October he moved, with Tweddle seconding, that 'the Trustees are of the opinion that several of the pictures that have been acquired for the Gallery are not up to what they consider Gallery Standard or the best example of the particular artists represented', a preamble later amended to read:

> That as the Trustees are of the opinion that all pictures purchased for the Gallery should be of the highest Gallery Standard and first rate examples of the work of the particular artists represented, the Trustees desire that the Felton Purchase Committee and the Felton Bequests' Committee should be requested to consider and scrutinise very specially wherever possible each purchase contemplated for the Gallery on the lines of the instructions set out in the printed *Historical Record of the Felton Bequest* . . .[19]

The motion concluded with a preemptory demand 'that the Committee should furnish to the Trustees a report with every purchase giving the opinion of the expert, on whose judgement they are acting, as to how these demands have

[17] FBC, 5 May 1927.

[18] Ibid., 6 July, 7, 15, and 27 September 1927.

[19] i.e. 'Is the work that is being considered a first rate-example of the Artist? Is it an example of sufficient importance, and merit, and beauty to be acquired for the National Gallery? Is it likely, as far as can be judged, to stand for all time as a worthy representation of the work of the particular artist?'

been met, and in what respect these standards are upheld or have been departed from or modified'. Shirlow then moved, and Prendergast seconded, that a copy of the resolution should be given to the press; an amendment by Sir Frank Clarke that the Felton Bequests' Committee be first advised of the resolution was defeated, and the motion agreed. The row was henceforth public.

Levey was enraged. At the next meeting of the Bequests' Committee he and Norton Grimwade moved that all communications from London be held by the Trustee Company and released to the Trustees only as deemed appropriate, but Bage and Leeper had the motion deferred. Leeper, now seventy-eight and unwell, tried to hold his Board of Trustees together in the best order he could, and to work with his fellow-members of the Bequests' Committee to counter the attacks. The President was again embroiled in a brush with Hall. The Director had given the Felton Purchase Committee his 'criticisms of Mr Rinder's purchases', but when Leeper asserted that 'the Trustees had a right to know all the proceedings of their committees', he insisted that he would repeat his remarks at a Trustees' meeting only if assured his comments would remain confidential.[20] Leeper was also in dispute with Shirlow, who attributed to him a remark he denied making, and the old man would have been shocked had he read a letter the etcher wrote to Hall in November 1926, alleging that 'many of the Trustees' thought the President

> a plain liar ... The fact is Dr Leeper is now so advanced in senility that he is no longer dependable. If he had any sense of dignity or proportion he would gracefully resign. I am trying to be just and charitable and for that reason am content to let the old gentleman have the matter his own way.[21]

Leeper's diary records intense lobbying and frequent private meetings over Felton affairs, and with Bage he prepared a careful rebuttal of charges against Rinder.[22] The Adviser was not, as alleged, temperamentally opposed to modern art (only fifteen of a hundred purchases had been old masters); it was not essential for him to be a practising artist (had not Baldwin Spencer, and Hall himself, so argued in the past?); and as for his competence, were not testimonials from responsible leaders in London worth more than local opinions? The Committee formulated these arguments, gained them what press coverage they could, and incorporated their substance (and London testimonials) in a *Supplement*, published early in 1927, to the *Historical Record of the Felton Bequests*. It was a quietly persuasive defence, but the

[20] Leeper to Hall, 25 September 1926, and attached draft reply (Hall papers).

[21] Shirlow to Hall, 3 November 1926 (Hall papers).

[22] Leeper Diary, September–December 1926. Leeper worked with Bage in placing material in the press to counter criticism.

balance of the public debate remained with the critics. 'No painter would question Mr Rinder's sincerity', MacDonald asserted in the *Herald* in December. 'That is not the point. The point is that he does not know bad work when he sees it.'[23]

WHILE IN MELBOURNE, Rinder had supported Hall's proposed visit to Britain. The Bequests' Committee at first did not agree, but later resolved that Hall's expenses could be defrayed from the Felton estate if he went, not to help Rinder, but 'to keep himself acquainted with recent movements in art, with a view to rendering him more efficient as an art Adviser in Melbourne', phraseology Hall found insulting. When the Trustee Company received legal advice that it could not use Trust moneys for this purpose; the Library asked the Government to pay, but it refused, and Hall stayed in Melbourne, simmering.[24]

Anger was evident almost everywhere. At a meeting of the Trustees, Montgomery, the stained-glass artist who had served for a time on the Purchase Committee, unexpectedly attacked not only the system but the benefactor himself. Mr Felton had had no right to make such a will, which interfered with the management of the institution, giving the Felton Bequests' Committee an overpowering influence on the purchase of works of art. The 'rights and jurisdiction' of the Trustees of the Gallery were infringed when the Bequests' Committee consulted an outside expert.[25] An account of his tirade in the *Age* of 23 February 1927 provoked Bage to respond, in a letter of 18 March, that works of art had never been acquired without the concurrence of the Gallery Trustees. Reminding the Trustees of the years when they had consistently declined to accept the recommendations not only of the Felton Adviser but of their own appointee, Sir Sidney Colvin, he restated the powers and duties of the Felton Bequests' Committee under the will, and pointed to the proper target of the Trustees' resentment: Government aid in purchase of works of art had been discontinued 'from the time that Mr Felton's Bequest began to operate 23 years ago', and 'the influence of the Bequest on the administration of the National Gallery to which Mr Montgomery takes exception' was a consequence.[26]

[23] *Herald*, 10 December 1926.

[24] FBC, 25 January, 8 February, 9 March 1927; Cox, *The National Gallery of Victoria*, p. 104; FBC to Trustees, 28 October and 15 December 1926. Hall's mood would not have been lightened by some questioning of the authorities under which he had acquired some Chinese art, an issue which widened to include its authenticity (FBC, 5 and 16 May 1927).

[25] *Age*, 23 February 1927. Montgomery did concede that the instructions given to the London Adviser should be taken as a model for the guidance of others in purchasing works of art in general.

[26] Bage, *Historical Record*, p.106: 'Nevertheless at a conference of the two committees on 26 May neither body thought it wise to alter the printed instructions issued to the Adviser in 1926'.

The opposition was not appeased. When a consignment of Felton purchases arrived later in 1927, the Trustees took offensive action, appointing a Special Committee to examine and report on them, and on 3 October requested the Bequests' Committee to cable Rinder 'instructing him not to purchase any other works under scheduled authority pending further instructions'. The Committee refused, but did suggest he hold off until the forthcoming report had been considered.[27] Meanwhile the Special Committee—Trustees George Swinburne and JT Collins, and the artists John Longstaff (newly appointed a Trustee) and Norman MacGeorge (a senior landscape painter of moderately progressive views)—at their third meeting co-opted eight local artists to judge the works: Streeton; WB McInnes (with Longstaff the dominant portrait painter of the time); Charles Wheeler (less conservative in his views than in his work); Napier Waller (a younger artist who had lost his right arm at the war, and found his métier in stained glass and murals); Paul Montford, (the talented English sculptor who had settled in Melbourne in 1923); Harold Herbert (prolific water-colourist and painter, and no revolutionary); Meldrum student Alice Bale (the only woman); and George Bell, then in transit towards modernism, of which he was to become a tolerant and influential teacher.[28] Hall would have been included, but was absent in Sydney. The group embraced a range of views, none extremely reactionary nor radical, but all had in common a view on the superiority of the artist as judge of art, which—the report suggests—they were determined to demonstrate.

It was scarcely fair that the ten works examined did not include Rinder's two major purchases for the year, Tintoretto's *The Doge Pietro Loredano* and Bastien Le Page's *Season of October: The Potato Gatherers,* the great pictures being still on exhibition in the National Gallery in London. The jury of hanging judges did not hesitate to condemn all but one of the other works before them—nine pictures and one sculpture—most of which Rinder himself would have conceded to be minor, though worth acquiring. The Report, dated 13 October 1927, signed by Longstaff and addressed to Leeper as President, was surprisingly perfunctory. Derwent Wood's bronze *Ambrose McEvoy* 'was much appreciated', and no more was said of it; but McEvoy's own water-colour *Iseult* 'was considered a poor example, and lacking the peculiar charm of McEvoy', and his portrait of *Mrs Claude Johnson* was found even less worthy of purchase: 'The opinion expressed was that it was obviously incomplete, and that it was unfair to the artist and to the public to purchase, as representing that artist's work, a sketch in its unfinished

[27] Trustees to FBC, 3 October 1927; FBC, 5 October 1927. He was told to seek authority by cable for especially desirable works.

[28] On Bale (1875–1955) see entry by Joyce McGrath in *ADB*, vol. 7.

Sir John Longstaff (ANZ Trustees)

state'. This was said 'with a full knowledge of McEvoy's work and technique'. (Whose knowledge is not stated; his widow later called it 'one of the finest of her husband's later works.) On HB Brabazon's *Choggia*, 'the opinion was generally expressed that the picture is not a first-rate example of the artist . . .', while 'the general opinion' of Segantini's *Vache à l'abreuvoir* 'was that this was a poor and uninteresting drawing; that it was not worthy of a place in our Gallery, nor worthy of the reputation of Segantini'. 'A minority' (actually Alice Bale and George Bell) thought Cotman's *The Shepherd* 'a good example of Cotman, but the majority said it had no distinguishing quality and was not a first class example of the artist'. 'The opinion' of Samuel Palmer's *Carting the Wheat* 'was that the composition was not interesting, that it had not good quality, and that it had not the charm of a good Palmer'; while the 'general opinion' found that Pissarro's *Borde de la Viosne, Osney* 'was that this was of secondary merit compared with the Pissarro already in the Gallery', and the price given was considered 'very high'. (Lucien Pissarro, questioned concerning its quality, later called it one of the most

beautiful pictures painted at one of the best periods of his father's work.) Concerning Professor Tonks' *A Serious Conversation* 'the opinion was expressed that there was merit in this picture. It was, however, suggested that we should possess some of Tonks drawings, which are recognised as being of high quality'. As for Sargent's *At Miami, Florida*,

> this picture was not signed, and was considered a poor example of Sargent's best work, and not in accordance with instructions to secure the best of an artist's work. It was considered that the Gallery suffers from having bad examples of a great master. It does not compare with the Sargents we have.

The Special Committee's conclusion was bald: 'The Committee is of the opinion that the pictures referred to above do not comply with the instructions very explicitly laid down to secure the best work of the best artists'. It then added, gratuitously, that although 'not asked to express any opinion on the future, or as to any modification in the present method of purchasing pictures', it suggested 'that the Trustees should consider the desirability of limiting the present wide powers given to Mr Rinder under the very comprehensive Schedule'.[29]

Longstaff had headed the document 'Strictly Private and Confidential', but on 30 September the report was leaked to the *Argus*, and Shirlow spoke out supporting it. Bage immediately protested to Leeper that the committee's findings should have remained confidential until Rinder had seen them and had time to comment; moreover, 'the wild statements published, as made by Mr Shirlow ... without any apparent realisation of his responsibility as a trustee to the Gallery, make the work of this Committee much more difficult'. Rinder, inevitably, saw the press report, and on 11 November he cabled his resignation to the Bequests' Committee, asking for early relief from his duties. Sladen Wing, by chance visiting Melbourne, was present when the Committee resolved to tell Rinder that his resignation would not be considered until the Committee had received his comments on the report.[30]

The Committee also told their Adviser that they deeply regretted 'recent unauthorised newspaper reports re resignation'; one or more Trustees had, yet again, leaked a confidential document. The Bequests' Committee immediately withdrew within the castle keep of its legal rights, as Levey had earlier threatened. Since the Trustees could no longer be trusted to share information, and the Adviser was 'appointed and employed by the Bequests' Committee, not by the Gallery Trustees', in future all communications from London would come to the Bequests'

[29] The copy quoted is in the Bright papers; Cox, *The National Gallery of Victoria*, p 107, summarises the Report.

[30] FBC, 28 November 1927.

Committee alone; and in particular any statement on the appointment or resignation of an Adviser could only be issued for publication 'on the authority of the Bequests' Committee, and in terms approved by it'.[31]

Hall, as usual, had his own agenda. On 5 December, and again a fortnight later, he fired the simmering pot with confidential memoranda, complaining again that the agreement of 1924, by requiring that all expert advice obtained by either party be shared with the other, prevented the Trustees from obtaining the views of their own appointed officer, the Gallery's Director. He was not prepared to advise his Trustees concerning overseas acquisitions if his opinions were to be made known to the hated tribe of London Advisers. The Trustees' controlling power in the direction of the Gallery, in its most important operation, was thus handed over to the Felton Bequests' Committee; the Trustees should decide absolutely what was to come into the Gallery, and where it was placed; even if the Felton Committee's reports differed from their own, the Trustees' decision must be conclusive. He even asserted that the issue was constitutional: the 'question is not whether Mr Felton had the right to make such a will [as Montgomery had said] but whether the Will should have the right to over-ride the responsibilities of the Government to the people of this state through the Trustees of the Gallery'. There was, he claimed, no thought in his mind of stirring up strife; 'it must be plain to everyone concerned that Dual control has given, and will continue to give, deplorable results as far as the Gallery is concerned'. As always, Hall exaggerated the Bequests' Committee's powers, formal and informal; and had he written his own assessments in less inflammatory terms he need hardly have feared their wider circulation.[32]

Bright, characteristically, told Swinburne that he did not find helpful Hall's legalistic 'red herring'. Commenting on Swinburne's draft response to the Bequests' Committee's *démarche*, he nevertheless agreed that 'on the other hand while give and take must exist between the two bodies to make machinery run, I share the feeling that firmness is needed'.[33] Leeper, the only member of both groups and committed to Rinder, had to speak for his Trustees as best he could. On 23 December he wrote to the Committee deploring that the sub-committee's report had been made public—while pointing out in extenuation the number of hands it had been through—and claiming that the Trustees unanimously regretted the remarks made by one of their body. But they could not accept, as consistent

[31] Bage to Trustees, 29 November 1927.

[32] Hall to Trustees, 5 and 19 December 1927 (Bright papers); and compare Cox, *The National Gallery of Victoria*, p. 109.

[33] Bright to Swinburne, 12 December 1927 (Bright papers).

with the intention and spirit of Felton's will, the Bequests' Committee's latest resolutions. 'Both committees should act together in selecting an Adviser even though formally appointed and employed by the Bequests' Committee', and it was 'essential' that reports be sent simultaneously to both Committees. The Trustees further claimed the right to communicate directly with the Adviser, and also the right to discuss, at their meetings, any statements relating to appointment or resignation of an Adviser.[34] The Trustees and the Bequests' Committee, for neither the first nor the last time, were drawn up to do battle.

THE LEADERS OF the art empire in London, faced with a colonial revolt, formed the usual defensive square around Frank Rinder, and fired volleys of increasing calibre towards Melbourne. In this they were abetted by the Trustees' own Vice-President; Baldwin Spencer, on leave in London, was greatly disturbed by his colleagues' behaviour towards Rinder, and (his biographers report) 'consoled him privately and energetically championed him publicly' during these months. He marshalled an extraordinary array of expert witnesses for the defence, including Sir James Guthrie, the Earl of Crawford and Balcarres, and Sir William Orpen (who had resented the *Argus* describing a work of his acquired by the Gallery, as 'a good average example'.[35] Six other distinguished authorities allowed Spencer to cite them in a long cable he sent to the Trustees on 12 December.

> Think Trustees may like to know feeling among London art authorities regarding selections National Gallery. Am authorised by Sir George Clausen, R.A., Sir David Cameron R.A. [a close friend of Rinder], Sir Charles Holmes, Director National Gallery, Collins Baker, Keeper, National Gallery, Charles Aitken, Director Tate Gallery, Campbell Dodgson, Keeper of Prints, British Museum, to cable as follows: Being acquainted with the soundness and honesty of his judgement and knowing many of the works selected by Rinder for Melbourne, we are astonished at nature of adverse criticism appearing in Australian press. Holmes and Baker cannot understand. Please show the Chairman Felton. You are at liberty to communicate to Press.[36]

A flood of letters followed, from overseas experts supporting Rinder and his purchases, and Bage prepared an elaborate memorandum comparing local and overseas judgements of individual Felton purchases.[37] Nevertheless the Melbourne

[34] Leeper to FBC, 23 December 1927.

[35] Mulvaney and Calaby, '*So Much That is New*', p. 402.

[36] Spencer, cable 12 December 1927. Bright told Swinburne he expected it to be 'quite likely the cause of interesting discussion' at the Trustees' meeting (Bright to Swinburne, 8 December 1927). Cox (*The National Gallery of Victoria*, p. 108) and Mulvaney and Calaby ('*So Much That is New*', p. 402 and note 18) discuss the cable.

[37] There is a copy in the MacDonald papers.

opposition, encouraged editorially by the press, could not be moved. Rinder's Tintoretto acquisition—much admired when on display in London—had been dismissed as worthless in Melbourne, because much 'restored'; when Spencer sent documentation disproving the criticism—the London expert thought its condition 'excellent', and any repairs too slight to be worthy of mention—the *Argus,* unusually strident in its criticism of the Bequest and its adviser, still found nothing 'to cause a change of view'.[38]

Spencer knew he would be making enemies. 'The "Herald" gets more and more vicious', he wrote to his wife in January 1928, 'and will be very angry with me . . . it means my being thrown out of the Vice-Presidency'. He would not mind, however, if it made the Melbourne public 'realise that home opinions do not coincide with those of a coterie of Melbourne artists who seem to be having all their own way just now'.[39]

ON 22 DECEMBER 1927, Rinder, who was not heading for a happy Christmas, sent to the Bequests' Committee his acknowledgement of the Trustees' special report, enclosing a document entitled *General Remarks by Four Artist-officers upon the Above* and supporting statements from another five, all prominent names in London.[40] On 9 February 1928 the Bequests' Committee formally resolved to advise the Trustees:

> That the Felton Bequests' Committee, having studied the report of the Special Committee of the Gallery Trustees on works recently purchased under the terms of the Felton Bequest, and having carefully considered Mr Rinder's letter of the 22 December and the comments of the various leading authorities quoted in Mr Rinder's communication, is of the opinion that, while there may be differences of tastes, and judgement, the works referred to in the report of the Special Committee comply with the terms of the late Mr Felton's will and with the instructions issued to Mr Rinder, and are worthy of being hung in the National Gallery. The Felton Bequests' Committee is satisfied that the comments of the London authorities fully justify the work done by Mr Rinder in selecting and recommending works of art, for purchase under the terms of the Felton Bequest, and confirm the high opinion held by the Felton Bequests' Committee of the efficient and satisfactory way in which the work is being carried out by Mr Rinder.

[38] Mulvaney and Calaby, *'So Much That Is New'*, p. 402 and note 20. For the generally pugnacious view adopted by the *Argus* at this time, see its leader of 3 December 1927 and comments on 10, 13, 15 March and 19 April 1928.

[39] WBS to Dorothy, 4 January 1928, quoted in Mulvaney and Calaby, *'So Much That Is New'*, p. 403.

[40] Rinder to FBC, 22 December. Sir Charles Holmes, Collins Baker, DS McColl and Martin Hardie wrote the Remarks; the others were DY Cameron, FL Griggs, Mrs McEvoy, JB Manson and Frank Brangwyn: in all, another remarkable group.

The Committee added, however, that before requesting Mr Rinder to withdraw his resignation it was willing to confer with the Trustees of the Gallery or with the Felton Purchase Committee.[41] It was, in short, prepared to compromise; indeed it could not continue to operate unless it did so.

On 7 March a large group met to identify the issues, and agreed to pursue them in separate meetings.[42] In the next weeks some differences were resolved, and the two bodies proved able to agree that the Trustees should be free to obtain and publish reports upon the London Adviser's work, provided he was given the right to reply before any publication. The schedule should be published, as an indicator of collecting policy, though without prices. In future Advisers should be appointed for limited terms, so that changes could be made without reflecting on the holder, or giving offence. The Bequests' Committee did not concede that only artists were capable of selecting works of art, but did agree that much of the opposition to Mr Rinder came from artists, a point underlined in a letter from the council of the Australian Art Association, reporting their unanimous view that 'the selection of pictures abroad under the Felton Bequest has with certain notable exceptions been unsatisfactory', and that the expressions of opinion thereon by Rinder's London defenders did not impress them. 'It is unlikely', they added gratuitously, 'that any one of these gentlemen, even if competent, has seen one quarter of the purchases they have so fulsomely praised'. In any case 'an artist or artists are the only possible experts for the purchase of works of art'.[43] Longstaff, too, writing to Leeper, advised him that 'after a long experience and having given the subject much thought, I am firmly of the opinion that the artist is the only true guide, and that only with an artist or artists on the Committee of Selection can we hope to get satisfactory results'.[44] Under so much pressure, the Felton Bequests' Committee was persuaded to seek some process whereby practising artists might be made available to the London Adviser for consultation.

The two Committees met again formally to discuss Rinder's resignation, and despite RD Elliott's forceful arguments that it be accepted, the majority was for compromise. Rinder was to be asked to withdraw his resignation, both bodies thanking him for his past work, and dissociating themselves from the press criticism,

[41] FBC to Trustees, 15 February 1928, quoted in Cox, *The National Gallery of Victoria*, p. 110.

[42] The full Bequests' Committee, plus Leeper, Cussen, Clark, Longstaff, Sugden, Mackeddie, Joske, Bright, Collins, Connell, Elliott, Swinburne and Shirlow. The FBC had caucused two days before.

[43] Australian Art Association to Trustees, 19 March 1928 (quoted in Cox, *The National Gallery of Victoria*, pp. 110–11).

[44] Cox, *The National Gallery of Victoria*, p. 111; Longstaff to Trustees, 19 March 1928.

but there were new conditions. Writing to Rinder on 3 April, Bage tried to state the requirements as mildly as possible, though he must have known they could scarcely be acceptable. 'Recognising that your resignation at this time would injure the reputation of the Felton Art Bequest', both bodies asked him to reconsider, but with two stipulations, allegedly 'to avoid causes of difference in the future'. The first, insistence that either Melbourne authority be at liberty to obtain and publish reports on his purchases, was reasonable, but the second, 'made as a concession to the view held by some of the Trustees of the National Gallery that practising artists are the only persons competent to select works of art'—'that you consent to the appointment of one or more practising artists to consult with you and report through you, on works of art recommended for purchase'—could hardly have been thought acceptable to the bruised Adviser.

Under the circumstances, Rinder's reply of 10 May was restrained, but with a barb on it. He had always consulted artists and art officials on every purchase, the most suitable authorities in each case, and to always consult the same one or two would cause 'insurmountable difficulties'. His appointment as Adviser was, he reminded Bage, 'unsought, unexpected and as I have all along felt in large measure unmerited', but he would think it 'his plain duty' to continue, 'could I credit that withdrawal of my resignation would be in the true interests of the Felton Bequests, The National Gallery of Victoria and Art in Australia'. His artist friends, however, now urged him to resign, and one, in a responsible position, insisted he do so to make clear 'that the authorities must be prepared to trust and support their Adviser'. He confirmed his resignation, with dignity intact; that of his Melbourne employers was left in shreds.[45]

'Perhaps', Leonard Cox observed, 'Frank Rinder was too sensitive'. Thomas Bodkin, the formidable Director of the National Gallery of Ireland and later of the Barber Institute at Birmingham, cited him (in an essay written for Melbourne in 1957) as an example of the 'inevitable' pain of acting as an adviser:

> I have constantly in mind the recollection of meeting the late Frank Rinder one cold wet afternoon, wandering like a stricken soul in Pall Mall. I stopped to talk to him and, frightened by his appearance, asked if he was ill. He replied that he had just

[45] Rinder to Bage, 10 May 1928 (copy in Hall papers). 'Nothing has happened during my Advisership ... which in the slightest degree alters my conviction that the basis of sole and complete responsibility is, taking the circumstances into account, the only one which can lead to a satisfactory issue'. Rinder later wrote most warmly to thank Bage for the 'many acts whereby, in most difficult circumstances, your Committee has earned my lasting gratitude ... Soon or later I am confident that the tide of adverse criticism will turn and your Committee be justified in the whole-hearted support it has given my effort to expend the Felton Fund responsibly, in the true interests of art in Australia' (Rinder to Bage, 4 October 1928). Dr Ursula Hoff told Cox (*The National Gallery of Victoria*, p. 112) that 'owing to the sad ending of his advisership Frank Rinder did not leave to this Gallery what would have been invaluable', his fine research library.

received a bundle of newspaper cuttings from Australia criticising the purchases that he had negotiated for the Felton Bequest Trustees. These were so venomous as to make him physically sick. I took him to dine with me in my club near by and it needed several hours in the company of good fellows before he was restored to his normal state of cheerfulness.[46]

The shooters, in the press and among the Trustees, had hit their mark. It seems fitting that the rejection Rinder most regretted was Melbourne's refusal to purchase Dürer's *Dead Duck*.[47]

[46] Thomas Bodkin, 'On Buying Pictures for a Public Gallery', in Philipp and Stewart (ed.), *In Honour of Daryl Lindsay*, p. 27.

[47] Rinder thought this water-colour sketch on vellum a masterpiece, and was distressed to receive successive cables on 8 and 14 February 1922 'Dürer Dead Duck hold hand' and 'Dürer Dead Duck do not purchase'.

20

FAMINE

The Felton Bequests' Committee was discomfited. In the London art world the name of Melbourne was, after Rinder's forced resignation, muddier than the marshes around Maldon. Sir Frank Clarke, calling on Lord Crawford in Britain in 1929, found him 'at first very reserved' and 'displeased at the treatment accorded to Mr Rinder', though he thawed when Clarke suggested Crawford might chair a committee in London to consider any future Adviser's recommendations. Unfortunately those whom Crawford approached to join the committee were 'reluctant to offer personal collaboration'. Clarke told Bage that 'the affairs of the Felton Bequest are much noticed in the London Art world, and that our reputation has suffered from our disagreement with Rinder, whom Lord Crawford regards as one of the leading authorities on Art in London'.[1]

Not that all the brooks in London ran crystal clear. 'I entered what was known as the London Art World', Kenneth Clark wrote of his debut (working on the 'infamous' Italian Exhibition, mounted by Mussolini in 1930).

> It was like a battlefield at nightfall. The principal combatants were exhausted or had retired to their own quarters, surrounded by their attendants; but their enmities continued unabated. Berenson and Fry had not been on speaking terms for over twenty years; both disliked and distrusted Ricketts, and all three had a low opinion of Sir Robert Witt. D. S. MacColl had, and showed, a lofty contempt for them all . . .

[1] Bage to Members of the FBC, 20 September 1929. Crawford told Clarke that 'I should say that it was only with persons connected with the National Gallery [of which he was a Trustee] that I have talked, and they seem afraid (perhaps not without reason) that if any purchases they might recommend were criticised, the authority of the National Gallery would thereby be prejudiced'. Lindsay (*The Felton Bequest*, p. 37) also reported that 'the prestige of the Felton bequests and the Melbourne Gallery suffered a distinct setback. To mention the subject in London at the time was to court a shrug of the shoulders or a caustic remark . . .'

Ricketts, once Gibson's main consultant on the despised Hoppner *Perdita*, had been offered the Directorship of the National Gallery, but wanted all the pictures re-framed, carpets on the floor, and flowers in every gallery, renewed every day; 'the post', Clark added, 'went to his nominee, C. J. Holmes' (another *Perdita* defender).[2] Holmes and Hall had been enemies since the harpooning of Gibson and Colvin in 1915; the Yorkshireman retired as Director of the National Gallery in 1928, but remained very influential in London art circles, and well trusted by the Felton Bequests' Committee.

Hall, at sixty-nine as confident as ever that he alone was competent to acquire the right works for Melbourne's Gallery, did not heed Holmes' enmity, nor anyone else's. In November 1928, when Sir Leo Cussen politely asked him to advise the Trustees on the position arising from Rinder's resignation, both 'generally' and 'so far as you think it does or may concern yourself', his prompt response was a tirade against overseas advisers. 'What has London done for us, compared with what one of our own people, steeped in our wants and aspirations, could do?' He had made precise records of what each of a long list of advisers, 'from Sir Charles Eastlake downward', had achieved, 'and surprisingly little comes up to the standard required'. 'The ideal person to fill the position would be one who had the knowledge of an artist, the leisure of an amateur and the zeal of a collector', able to deal with artists on equal terms. Nothing would please him better than to undertake again—if asked—the task he prided himself he had done so well, in two and a half months and with only £4600, twenty-three years before.[3]

Sir Leo Cussen referred the letter to the Felton Bequests' Committee, after requesting that the sentences criticising former advisers—which were detailed and explicit—be deleted before circulation. By this time he was President of the Trustees. After Rinder's resignation Leeper had fallen on his sword; in April 1928 he 'declined to allow himself to be again nominated for the office of President', vacating also his place on the Felton Bequests' Committee.[4] He took three months leave, but remained a Trustee until he died in 1934, still deeply concerned about the constant attacks on the Felton acquisitions. 'We may despair of ever getting public approval of our purchases', he wrote to his son Allen, by then very senior in the British Foreign Office, 'I suppose that is not after all a thing we should aim at or desire'.[5]

[2] Clark, *Another Part of the Wood*, pp. 158–60.

[3] Cussen to Hall, 21 November 1928; Hall to Cussen, 22 November 1928 (Hall papers).

[4] Reported at Conference, 7 May 1928. In November the FBC agreed to buy the Longstaff portrait of Leeper.

[5] Quoted in Poynter, *Doubts and Certainties*, p. 426.

Sir Leo Cussen (ANZ Trustees)

Spencer, having reluctantly accepted the resignation of Rinder as inevitable, was re-elected Vice-President in April 1928. Some weeks earlier he had recorded, in two draft pages to Leeper, his conviction that art in Australia was at a point of crisis. Had he not been abroad, he would have urged 'with all the earnestness in my power the grave danger of departing in any important manner from the present method of selection'. Every selector was 'bound sometimes to make what may be regarded by others as mistakes', but 'the unanimous opinion of all whom I have consulted is that in Mr Rinder the gallery has been peculiarly fortunate in possessing a most capable, most disinterested and wholly indefatigable Selector'. In August, in London, on the eve of his departure for South America on another scientific expedition, he resigned as a Trustee; he died unexpectedly in July 1929, on the distant and bitterly cold Hoste Island, off Cape Horn.[6]

[6] Mulvaney and Calaby, *'So Much That Is New'*, pp. 403, 418. After Spencer's death, Rinder recalled with gratitude how he had proved a 'friend and whole-hearted supporter throughout'. In a Memorial Tribute in the *Glasgow Herald* (1 August 1929) he wrote: 'Something of a Bohemian at heart, he was the best of companions. Young *au fond*, by no means credulous, innately humorous, and swift in repartee, his friendship, ever refreshed and refreshing, revealed a sunny union of learning, common sense and abundant generosity'.

Swinburne took the Presidency Leeper vacated, but enjoyed the victor's spoils only until September 1928, when he too died suddenly, in his seat in the Legislative Council Chamber. The judicious Sir Leo Cussen became President and joined the Felton Bequests' Committee, which in turn lost its Chairman of twenty years when Bage died, at the age of seventy-one, on 7 December 1930. Levey, already an octogenarian, succeeded him and chaired the Committee until his own death, aged nearly ninety-eight, in 1944. Since MacFarland was almost eighty, the Committee entered the 1930s with two very elderly members out of five, while Norton Grimwade, a member since his father's death in 1910, was sixty-four in 1930. A very able business man, stern in manner, his most noticeable cultural interest was a capacity to quote Shakespeare apparently interminably. He served the Committee staunchly, but from 1929 began to alternate his membership with his younger brother Russell.

Russell Grimwade, at fifty much the youngest of the Grimwade partners, had unusually broad intellectual interests. After graduating in chemistry from the University of Melbourne, he directed research at Felton Grimwade's, and became a partner in the firm in 1907. A scientist, and not specifically a pharmacist, his main contribution in the business was to new ventures in producing industrial gases, while, as a devoted naturalist with a special interest in forests he pioneered the protection, as well as the industrial exploitation, of the natural environment. He was involved in founding the Council for Scientific and Industrial Research, and gave long service to many organisations, including the University of Melbourne, becoming eventually one of its greatest benefactors. Beginning in his youth, Russell had amassed a major collection of Australian books and prints, and a smaller group of paintings; and several of his interests thus came together when he began to write about Alfred Felton in 1926. In 1929 Norton Grimwade, having overseen the merger of Felton Grimwade's into a new national conglomerate, Drug Houses of Australia (a move which incidentally removed the name of Felton from the front rank of Australian business) resigned from the Bequests' Committee to spend some time abroad. The will specified that he should be succeeded by the second son, Harold—and so he was when he died in 1945—but Harold, Major-General and clubman, was a manager of men rather than of art bequests, and it was sensible to ask Russell to stand in for Norton. He did so until July 1930, and again between February 1933 and July 1934, and eventually became a continuing member after Harold's death in 1949. His involvement in Felton matters between 1929 and his own death in 1955, either as a member of the Committee, or later as a Trustee of the National Museum, and as a friend of such central figures as Daryl Lindsay, Basil Burdett and Keith Murdoch, was virtually continuous.[7]

[7] On Russell Grimwade as a collector, see Aders, Kent and Lindsay, *Art, Industry and Science*.

In 1930, to take Bage's place on the Bequests' Committee, the continuing members chose one of the Gallery Trustees, already familiar with the Bequest. Francis Grenville Clarke—who promptly resigned as a Trustee—was born in 1879, the fifth child of the second marriage of Sir William Clarke, and was thus 'Big' Clarke's grandson; but there was little of that disreputable millionaire's world left in Sir Frank Clarke's Victoria. Educated in Melbourne and Oxford, a landholder and director of major companies, he was elected to the Legislative Council in 1913, and after serving as a Minister became, from 1923, President of the Council for twenty years. He built a splendid garden at Mount Macedon, and wrote a charming book on Melbourne's Botanic Gardens in 1924; Clarke had taste, and although he had no special knowledge of art or its history, he thought more deeply about the Bequest and its problems than most of those involved.[8]

The Trustees appointed John Shirlow as their representative when Sir Leo Cussen died in 1933; for three years, until his own death in 1936, the etcher was able to oppose on both bodies the acquisition of all the 'modern' works he detested.[9] His was the first of several short appointments from among the Trustees, usually terminated by death: successive Presidents Alfred Bright (1936–38) and AS Joske (1938–39), the by-then venerable Sir John Longstaff (1939–41), and the always controversial Max Meldrum (1942–45).

The Trustees, a body generally long-serving and increasingly elderly, had some important recruits after 1928, the most significant Sir Keith Murdoch (Trustee from 1933, President from 1939). Murdoch's interest in art was deep and liberal, influenced by Bernard Hall but also by others more sympathetic to modernism—Daryl Lindsay, Ure Smith, George Bell and especially Basil Burdett. In 1931, two years before becoming a Trustee, Murdoch had sponsored an exhibition which included works by Matisse and Modigliani. He was to be a leading figure in Melbourne's new art establishment, but it would take some time for even a man of Murdoch's driving vigour to disestablish the old.

Other new Trustees included FW Eggleston, biographer of George Swinburne and influential liberal internationalist, with less advanced attitudes to art than Murdoch and very critical of his politics (Trustee 1929–41), and the distinguished anatomist, naturalist and anthropologist, Professor F Wood Jones, FRS (Trustee and Chairman of the National Museum Committee 1931–36), a man of decided views who became critical of Hall, and resigned on a point of principle.[10]

[8] Bage's death was reported at FBC, 15 December 1930, Clarke elected on 9 February 1931.

[9] In May 1930 the Trustees had nominated Shirlow as a proxy when Cussen was ill; the Committee pointed out that proxies could not be appointed (FBC, 7 May 1930).

[10] On Wood Jones, see the entry by M MacCallum in *ADB*, vol. 9.

The Board as a whole was a heterogeneous collection of generally able men, with too many purposes, too seldom coinciding.

HALL'S PLEA TO serve overseas again reached the Felton Bequests' Committee in November 1928, with a supporting recommendation from the Trustees. The Committee thought him unacceptable as a London Adviser, but had difficulty finding another. At the Trustees' request, they appointed Bage and MacFarland to work with Longstaff and Bright to report generally on the best means of dealing with experts overseas, but their progress was slow. Bright's early drafts included sending Hall to London as a consultant, prompting from Bage a tart reply: 'In my opinion, with which the Felton Bequests' Committee has expressed its agreement, it is undesirable that the present Director should be sent to London in any capacity connected with the Felton Bequest'. Bage in turn proposed that Hall be required, in Melbourne, to report on each work received; because he had refused to do so, grievances had 'been allowed to accumulate for years', leaving advisers in ignorance until the next outburst.[11] Proposals, to appoint two men in London, one an artist and one a sculptor, with a primary responsibility to acquire the work of modern artists, were considered by a conference in March 1929, which deleted the emphasis on modern works. In July the requirements were loosened to accept advisers who had a 'competent" knowledge of art and 'preferably' had practised some form of it. In August more general principles were agreed: since advisers needed the 'hearty support' of all, the Trustees must agree to every appointment; the Trustees should prepare all schedules, since they were responsible for 'the general policy of collections'; advisers should be told that 'good representative work is required and that inferior examples of great periods or of famous artists are not acceptable'; all recommendations should be considered in conference; and all criticism should be kept confidential, but could be conveyed to the Adviser.[12]

A search was begun, first of all for a London Selection committee. Sir Charles Holmes refused to act. 'Recent events', he wrote, 'have shown that the views held in Melbourne as to the proper administration of the Felton Bequest differ so completely from educated opinion on this side of the water, that I could not honestly recommend anyone whose knowledge and works I respected to undertake the advisership ...'[13] Lord Lee of Fareham, the statesman who presented Chequers to the nation and joined Courtald in founding the Courtald Institute

[11] Bage to Bright, 17 January 1928 (Bright papers).

[12] FBC, 7 December, 26 March, 3 May and 7 August 1928.

[13] Holmes to FBC, 29 October 1929; FBC, 11 September, 13 November and 13 December 1929.

and bringing the Warburg Institute to London, also refused. Sir William Plender (a partner in Deloitte and Co) and Sir Francis Newbolt (patriot, Christian and author of 'Drake's Drum') were left to act alone.

While they were deliberating, a report reached Melbourne (at third hand, but unfortunately leaked to the press, to the Committee's renewed fury) that the great Sir Joseph Duveen himself was interested in the position. The vision of a procession of *Blue Boys* heading towards Melbourne, on cut-price fares, greatly excited the Trustees, but enquiries pursued at length through Sir Joseph's brother revealed that the thought of advising Melbourne, if it had ever crossed the master dealer's mind, had left no trace there. He was willing to help, if they wanted to buy a picture . . . As Wing confirmed from London, Melbourne press references to Duveen had been 'greatly exaggerated'.[14] Meanwhile the selection committee, aware of Duveen's reported interest but regarding him as unsuitable—as a Trustee of the National Gallery, 'and also because he is actively involved in the picture trade'—had recommended Holmes as Adviser; he again refused. Randall Davies, third on Spencer's list in 1915, had offered his services, and was now recommended. In April he was appointed Adviser, for three years at £750 a year, with Holmes as his consultant, for a guinea per cent.

The Trustees, at a special meeting, concurred in the appointment, by seven votes to two. Shirlow and Longstaff formed the opposition; Shirlow, rashly outspoken in public and sneaky in private, was no doubt the source which leaked the appointment to the press before the Bequests' Committee could announce it, to Bage's 'astonished' anger.[15] The need to have an adviser acceptable in London had again overborne the wishes of the Melbourne artists, at least one of whom—Norman MacGeorge—had applied for the post. In December 1929 MacGeorge had joined other Melbourne modernists Adrian Lawlor, Arnold Shore and William Frater in a plea that Melbourne buy a Cézanne, but might have recommended little had he been appointed Adviser: in 1930, making his first visit to Europe, he found Cézanne's *Card Players* 'very feeble' and Botticelli's *Primavera* 'a poor thing', and described Manet's *Olympia* as 'bad drawing and coarse, very cracked. I hope it will crack to pieces'.[16]

Randall Davies (1866–1945), a solicitor by training and an art critic (for the *New Statesman* and the *Westminster Gazette*, among others) by inclination, was a member of Sir Charles Holmes' circle. He visited Melbourne early in 1931, soon

[14] FBC, 15 January, 14 March and 9 April 1930.

[15] Sugden was in the Chair, and Leeper, Mackeddie, Tweddle, Clarke and Eggleston in favour; Bright was absent.

[16] Quoted in Pigot, *Norman Macgeorge*, p. 13.

after Levey's elevation to the Chair after the death of Bage, and after a review of policy—amicable: it took the Trustees and the Committee only five weeks to draft new instructions—agreed to complete a new schedule, drafted initially by Longstaff and Hall. The result was interesting: there were no old master paintings listed (though in a long list of drawings and water-colours Rembrandt and Tiepolo appeared, with top prices of £1000 each), and the twenty-three British artists born after 1850 outnumbered the ten listed before 1850. Delacroix appeared alone as a foreign artist born before 1850, but the seventeen born after 1850 included (with the prices scheduled) Cézanne (£2000), Courbet (£1500), Derain (£500), Gauguin (£2000), Van Gogh (£2000), Matisse (£750), Morisot (£500), Picasso (£750), Ribot (£1500), Segonzac (£900), and the Spanish artists Anglada (£750), Sorolla (£1000) and Zuloaga (£850). Seven sculptors were listed, with Epstein the most highly valued at £1000. Apparently Melbourne was willing to buy Post-Impressionist and even modern works, but expected them to be cheap. Davies brought with him photographs of works he thought available, including paintings by Hogarth, Ramsay, Gainsborough, Whistler, Hals, Raeburn and Conder, but all were later declined, after unfavourable comment by Hall.[17]

Unfortunately for Davies, his appointment coincided with deepening economic depression throughout the world. The only significant overseas purchase in 1929 had been an ancient statue of Aphrodite ('garden ornament quality', in a later Director's opinion); early in that year, even before the Wall Street crash, a major public loan had been refused in London, as low prices for wool and other exports made it harder for Australia to pay its way overseas. The Bruce–Page government fell in November, and Scullin's Labor administration could find no alternative to accepting the Bank of England's advice to balance budgets and cease borrowing, forcing cuts in wages and the devaluation of the Australian pound in 1931. In June 1930 the difficulty of remitting funds had prompted the Union Bank to ask the Committee to try to make purchases only with an appropriate deposit, the balance payable in thirty or sixty days; and as the situation worsened, Government restrictions on the transfer of funds abroad clipped the Bequests' Committee's wings. When, in August 1931, Davies recommended six pictures, including Rembrandt's great *Saskia* for £25 000, the Bequests' Committee (which had £111 290 accumulated in the Art Fund) could only reply wanly 'that it is not possible to sanction any purchases at substantial prices at present', though the Committee and the Trustees would 'be pleased to hear' from

[17] Davies attended a Conference (with Cussen, Elliott and Shirlow) 26 February 1931, and the letters and Schedule were approved on 30 March 1931. Hall's unfavourable memo on the works photographed reached the committee on 24 August 1931.

Davies 'as to current events in the Art World', and 'of works that might become available later' (not, alas, *Saskia*).[18] Davies reported that dealers were keen to sell, at cheap prices, but for a time the Committee could only buy if payment was accepted in Australia. Sir Frank Clarke, impatient, twice urged the Trustee company to make £20 000 available in London, and when they refused, asked that banks be approached to facilitate at least some purchases. A few were arranged, at adverse rates of exchange, but most were minor; and Davies was especially pleased to acquire one bargain masterwork, Zoffany's *Roman Charity*, found in a Yarmouth dealer's for £11.[19]

Local acquisitions included an unusual find. On Hall's recommendation, the Bequests' Committee bought from Miss Lucy Smith, of Brighton, for £500, *The Descent from the Cross*, a painting apparently brought to Australia in 1846 and shown at an exhibition in the Gallery in 1869. The expert Max Friedländer advised the Bequests' Committee the work was Flemish, from sixteenth-century Antwerp, and an excellent acquisition.[20] Hall also found, in Perth, *Italian Landscape, with figures, a horse and a cow* by the seventeenth-century Dutch painter Abraham Begeyn. Meanwhile a bequest, supplemented with Unemployment Relief funds, allowed the Gallery to build a new wing.

THE GREAT DEPRESSION brought levels of business failure and of unemployment which scarred Australian society for generations. Those who remained in employment did not all suffer greatly, but the impact on communities, and on human memories—even if only of images of men tramping country roads offering work for a meal, or of gangs of 'Sustenance' workers on public projects—went deep. Levey, as President of the Charity Organisation Society, must have been aware of the extent of distress, especially since the Society was charged with overseeing payments under the Unemployment Relief Act of 1930 to single women living away from home (dealing with 5003 cases in 1930 alone), and Greig Smith, the Society's Secretary, was a major figure in forming public policies. Writing in 1933, he conceded that the Depression had brought an 'unprecedented wave of unemployment, against which voluntary charity was impotent'. The voluntary effort had expanded, but increasing encroachment by government seemed, he concluded, inevitable; 'The special task that lies ahead is so to reconcile the spheres and the functions of State and non-State activities as to get

[18] FBC, 7 August 1931.

[19] Approved FBC, 16 November 1931. The problem of transferring funds abroad appeared regularly on the agenda of the FBC.

[20] FBC, 7 August 1931; Friedländer to FBC, 30 December 1931.

from them the best results for the individual citizen and for the community'. Not everyone involved was so clear-headed.[21]

The Depression affected the practice of Felton's Charity Bequest, but not its customary principles. The ominous phrase 'the relief of distress' appeared as the reason for grants of £300 to the Salvation Army in June 1929, and in December of £50 to the Church of England Men's Society and £300 to the Melbourne City Mission, while Legacy received £100 for 'relief of distress among returned soldiers', all small enough sums in total distributions of £13 085 in June and £13 490 in December. As the Trust's income fell, distributions to charities were reduced. In June 1930, when the Art Fund had £100 298 accumulated, the Charity Fund could scrape together only £10 305, giving £260 to COS's new Invalid Aid Fund, £60 to the Salvation Army for 'social work', and £650 in special grants. In December only £120 was given in special grants, all for the relief of distress, and in June 1932 no special grants at all, with total grants reduced to £8028. The lowest six-monthly distribution to charity was £7768 in December 1931, and the lowest total for a year £15 841 in 1932. Income available from the Trust recovered to £9000 in June 1933, and £11 000 in December 1934.

Everything was pruned, but hospital submissions were still favoured. Levey's influence on grants from the Charity fund was ever more evident; all submissions were referred to him, and his own request in April 1930 for an out-of-sequence grant of £1000 to his Melbourne Hospital 'to ventilate operating theatres' was immediately granted. The Presbyterian Intermediate Hospital had been told in September 1930 that when its Appeal had reached £59 000 the Bequest would provide the last £1000, and the Lord Mayor's Fund for Hospitals was given £1000 with the proviso that the Committee be consulted on its distribution. The Williamstown, Footscray and District General Hospital was not so favoured. In July 1930 its directors, pointing out that 'workers from the Australian Glass Company's works were treated at the hospital and that a considerable portion of the Bequest funds was derived from an interest in these works', suggested 'that a somewhat larger grant be made available for this hospital'; the request was referred to Levey, but the next distribution saw the hospital still at the bottom of the list, with a meagre £25.

In all this it is not surprising that when, in April 1930, Senator Lawson asked for money for an art gallery at Castlemaine, the Committee 'could not see its way, as all money available for charity distribution is applied for the relief of the poor and sick people through organised institutions'. In August 1930 the YWCA

[21] S. Greig-Smith, 'The Development of Philanthropic and Social Work in Victoria', p. 156.

was also refused assistance, and the newly created National Safety Council of Australia received an equally dusty answer in 1931, told that it was 'impossible to make a contribution to the Council for the reason that the Funds available are required for distribution amongst so many necessitous charities'.[22]

The distribution list for December 1933 differed from those a quarter of a century earlier mainly in being longer, with a larger total amount spread even more thinly among other than a favoured few. Twelve metropolitan hospitals received £2740, almost a third of the total disbursed; but from the £606 distributed to thirty-one children's institutions the last two listed received only £4 each; fourteen Women's Institutions shared £258; the grants to Ladies Benevolent Societies, Creches and Kindergartens would have been similar had the Committee not used the Central Council of Ladies Benevolent Societies to distribute £348 to member groups; and twenty-nine General Philanthropic Institutions shared £1566. Funds were especially meagre in the country, only the main hospitals in Bendigo, Ballarat and Geelong receiving more than £100 each from the £1240 distributed to forty-nine hospitals, while ten country orphanages and other institutions shared £268. Meanwhile the Melbourne Hospital, which had mounted a special appeal that year, was favoured with an additional £500.

The Bequests' Committee was clearly pleased with what it did for charity during these years of particular need. Basil Burdett, compiling a new *Record* in January 1934, wrote that 'even during the depression, with reduced income, the Committee has been able to assist many institutions which were working under more than usual difficulties and to maintain customary grants for maintenance, although on a reduced scale'.[23] The system had become so finely tuned that a briefing note for the meeting of 8 June 1934 observed that 'Maintenance grants if made on the same basis as last year' would cost £7776, but a decision already made to increase the Traveller's Aid Society's from £8 to £10 for the half year would require an additional £2. Again, from the special grants of £575 made in that half year no group received more than £100. Come boom or depression, the sailing orders of the Charitable Bequest remained 'steady as she goes'.

The same could not be said for governments. The depression had required large expenditures on relief, through the charities and directly, and predictions that the cost of old age and other benefits were to spiral upwards alarmed politicians of almost all persuasions. Many found the concept of national insurance, requiring taxpayers to contribute in advance to the cost of such social services,

[22] FBC, 18 May 1931.

[23] *The Felton Bequests*, 1934, p. 9.

very attractive. The taxpayers, and other interested parties, did not, but new state initiatives for welfare, massive enough to transform the world of charity, were closer than anyone thought.[24]

HALL'S LIFE AS Director of the National Gallery was never entirely peaceful. In 1931 he removed a popular Meldrum painting from the Gallery's walls, provoking loud protests from the Meldrumite faithful, scarcely muted when the Gallery acquired a new Meldrum work the following year. Hall continued to make frequent recommendations to the Bequests' Committee for purchases in Australia, almost all of them accepted, the Committee's objections to his appointment overseas arising more from his capacity to arouse enmity than from doubts about his artistic judgement. The lists of paintings acquired on his recommendation between 1929 and 1933—by Buckmaster, Wheeler, Napier Waller, Herbert, Ashton, Bale, Longstaff, Dora Wilson, Blamire Young, Heysen, Long, McInnes, John Rowell, William Rowell, Violet Teague, Bunny, Roberts, Streeton, Septimus Power and a few others—seems long, but not many were major works, and the list looks relatively thin beside the very large number of prints, drawings and 'Objects of Art'. In March 1930 the Trustees recommended 'that a historical and thoroughly representative collection of prints by Australian Artists be made, and for this purpose prints be obtained continuously and systematically', but the Committee replied that it was obliged to judge individual works on merit, and could in consequence give no undertaking. Later that year the Committee approved, on the recommendation of Longstaff, two works by Hall himself, one a still life of two of the Asian pots he so much admired.[25]

With paintings, if not with other objects, Hall was hard to please. In October 1930 the Sydney press noted the Gallery's absence as a purchaser at a fashionable Lambert exhibition. When Longstaff painted a portrait of Felton—from the 'garden seat' photograph—Hall did recommend its purchase as 'a fine piece of work', and the committee paid 400 guineas for it (Longstaff wanted 500); but in 1932, attending a retrospective exhibition of the work of Tom Roberts—which he had never much admired—Hall grumbled that 'Roberts seems to have no individual style. He paints in so many ways that *one cannot definitely place* him', a problem for anyone buying 'scientifically'. In 1927 he had persuaded the Bequests' Committee not to buy *Bailed Up!,* despite the Trustees' recommendation; now he reluctantly recommended one work, despite reservations which the public has

[24] Watts, 'The Origins of the Australian Welfare State', pp. 225–55.

[25] FBC, 13 August and 21 October 1930, 14 December 1931.

never shared: it was *Shearing the Rams*.[26] (As usual, Hall's prejudices were fed by Shirlow's gossip, the etcher calling Roberts 'a decent enough chap, but I don't think him big enough for a national Collection'. In the same letter he described Longstaff as 'a very weak character', for supporting a Meldrum acquisition.)[27]

In 1933 the Chief Librarian, at the request of the Committee, calculated the Bequests' expenditure on local and overseas art: of the £333 000 spent on art works by the Felton Bequest in twenty-eight years, only £31 000, less than 10 per cent, had been spent on Australian works (approximately 116 oil paintings, 52 water-colours and numerous etchings).[28] The disparity can be explained by Hall's fastidiousness on the one hand and the priority given to the pursuit of expensive old masters on the other.

In December 1931 a special sale exhibition to mark the centenary of Alfred Felton's birth was held at the Fine Art Society's rooms in Exhibition Street. The Bequest bought two water-colours and two paintings there, the most expensive Colahan's *The Little Aphrodite* for 110 guineas, but at the meeting which approved them the Chairman was asked to raise with the Trustees 'the apparent deterioration in the standard of Works purchased locally'.[29] Levey generalised the issue to cover the whole question of minor purchases with Felton funds, which MacFarland—perhaps prompted by the purchase of an 'Armenian embroidered towel' for £8—had raised in 1926.[30] Worried that such minor acquisitions were of questionable legality under Felton's will—and apparently classing most Australian work as minor—Levey wrote to Cussen asking the Trustees to consider 'whether a large percentage of the Australian pictures is calculated to raise the general standard of quality in the National Gallery'.

> While it is true that no one should judge the artistic worth of a painting by its cost or size, it is also true that, generally speaking, fine Gallery examples can seldom be obtained for £30 or £50 . . .
>
> We quite realise that it is as much your endeavour as our own to raise the standard required, and if, as we fear, the ideal has not always been kept in the forefront recently we fully accept our own share of any blame there may be. The reason for such a

[26] Hall to Trustees, quoted in Cox, *The National Gallery of Victoria*, p. 124. *Bailed Up!* had been recently re-worked, a possible though scarcely sufficient ground for rejection.

[27] Shirlow to Hall, 27 June 1932 (Hall papers). Shirlow, typically, reported that when Cussen told MacFarland, Levey and Clarke that Hall's report on works by Jorgensen and Meldrum was adverse 'these three laughed and Levey said:—"You will get no money out of us for that class of work".

[28] Cox, *The National Gallery of Victoria*, pp. 129–30.

[29] FBC, 14 December 1931.

[30] Ibid., 26 April 1926.

James Alfred Levey (photograph courtesy Drummond Street Counselling, formerly the Charity Organisation Society)

slackening, if it exists, is probably to be found in the laudable desire to encourage Australian art and artists, and to secure examples of every painter whose work is notable. With this we sympathise, but at the same time we have in mind the words of the late Mr Felton's will, 'Calculated to raise and improve public taste'.[31]

Hall was cross. 'First and last' he assured his Trustees, 'it has never been my object to foster Australian art at the expense of the Felton Bequest, or of a lower standard for the Gallery'. He heard 'a good deal, naturally, about "the encouragement of Australian art", and have to explain the terms of the Will from time to time, in self-defence, but I have consistently discouraged this idea as a policy for a permanent collection on a National Gallery scale'. He furiously compared allegedly

[31] FBC to Trustees, 24 March 1932.

'unimportant low-priced' works he had recommended with 'those supposed to be important on account of the names and the prices paid for them at home... and which apparently are not referred to in the memorandum, and are under no suspicion or censure'. He even claimed that Miss Cumbrae Stewart's *London Houses under Snow* (1928) 'gives me more pleasure, and therefore, inspiration, than *The Boulevard Montmartre* (Pissarro)', though that had been one of his own coups as Felton Adviser in 1905, and was (he conceded) 'universally admired by artists'.

> I prefer Miss Bale's and Mr McInnes' *Camellias* at 20 guineas, to Nicholson's *Tulips* (1926) at 80 guineas; and H Herbert's drawing, 40 guineas (1926) to the two De Wints (1924) at 345 guineas; and Miss Wilson's *Old Rome* 20 guineas (1930) to Corot's *Venice*, 900 guineas (1925); and any one on my list to Corot's *Model* (1920), 800 guineas. The small panel, *Inscrutability* (1932), bought at the ridiculous figure of 8 guineas, I would prefer in the same way, and so on.[32]

Levey insisted that he was not criticising Hall, but put his defence badly: 'Mr Hall does not make any purchases, and if there is any blame to be given to any one it must be upon those who authorise the purchases', a remark certain to annoy a Director who had smarted for decades under his limited power to acquire.[33]

Cussen, being a member of the Committee as well as President of the Trustees, skilfully made peace. There were no government funds for acquisition, and 'it would be a matter of regret if the collections already formed at large expense [prints, engravings etc] should remain, if no assistance is obtained from the Felton Trust, practically stagnant'. The Committee dropped the issue, and continued to fund minor purchases.

The Gallery's financial straits were indeed dire. Its Government allocation, and the salaries of the staff, had been cut, as in all Government agencies during the depression. In 1934 the Chief Librarian pointed out that of the annual vote of £450, art classes and model fees absorbed £250, 'picture frames etc.' £150, and lectures to students, £50. If the Felton Committee refused to pay for low-priced items, it would be necessary to ask for an increase in the Government vote, a notion which 'seemed to shock the Chief Librarian'.[34] In 1935 the Trustees did summon the courage to ask the Government 'for sufficient additional money to stagnate without deterioration', but to no avail. The Gallery did not suffer the physical deterioration which plagued the Library and especially the Museums

[32] Hall's 'Report on memorandum sent by the Felton Bequest Trustees to the Trustees of the National Gallery, forwarded to me by Mr. Pitt, March 24th, 1932' is reprinted in full in Cox, *The National Gallery of Victoria*, Appendix 4, pp. 407–9. The *Model* is no longer accepted as Corot's.

[33] FBC to Trustees, 24 May, Trustees to FBC, 24 June, quoted in Cox, *The National Gallery of Victoria*, pp. 121–2.

[34] Pitt Memorandum of 28 November 1934, quoted in Cox, *The National Gallery of Victoria*, p. 122.

until after the 1960s, but despite the continuing flow of acquisitions it had a neglected air.[35]

DESPITE THE DEPRESSION and the difficulty of tranferring funds, Davies was an assiduous Adviser. Early in 1932, when the financial constraints were easing, Hall, for once, supported his recommendation to buy a Landseer for £500, perhaps because it had once sold for £2000. ('Fashion is created by the dealers and I care nothing for it', Hall wrote. 'It is a chance for excellent buying—the price, even with the exchange against us, being an absurd one'.) Depression brought its own rewards.[36]

Davies purchased a string of cheap minor works from the schedule, few of which impressed. Most of his major proposals were, however, deferred or rejected, even after funds could have been made available in London (though at adverse exchange rates).[37] Paintings refused, as in the bad old days of 1913–15, included work by Del Sarto, Whistler, Steer, Turner, Rubens, three Rembrandts, a Lawrence portrait, and a painting by Teniers. A 'superb Hals' was rejected because one child had been added later to a family portrait, and a 'beautiful Gainsborough landscape' because the Trustees were still hoping for a female portrait; Davies did find them *Elizabeth Wrottesley, Duchess of Grafton* (£7000), though not until 1933. A long list of Conference deferrals—including a Hogarth portrait of Garrick and a Zoffany of Gainsborough—in August 1932, 'pending receipt of the works already purchased', suggests that Davies' judgement was not trusted, even when backed by Holmes. The few works accepted included paintings by Ruysdael and Wouvermann, a small portrait of *Melancthon* then thought to be by Cranach (now 'studio of'), and a bust by Epstein (which Montford ridiculed to Hall: 'The bust looks as if it had been in an earthquake. I knew you would be horrified').[38]

Later in 1932 Davies complained that 'not one' of his 'recommendations for important pictures has been accepted, and several have not even been acknowledged'. The Adviser's own tastes had been widened by a notable exhibition mounted in London in January 1932:

> The French Exhibition is a great source of pleasure here, and will no doubt prove a very useful guide when I come to close quarters with the modern French pictures. There are none of the ultra-modernists, like Matisse and Picasso, in the Exhibition;

[35] DJ Mulvaney recalls the shocking state of the Museum in the 1950s in his review of Rasmussen, *A Museum for the People*, in *Meanjin*, vol. 60 no. 4, 2001.

[36] Quoted in Cox, *The National Gallery of Victoria*, p. 123.

[37] The Committee told Davies more funds might be available but warned him about the exchange rate, FBC, 11 March 1932.

[38] Montford to Hall, 21 February 1933 (Hall papers).

but Gauguin and Cézanne are well represented and appear quite classical, while Manet, Degas, Renoir etc. seem positively established alongside Chardin, Boucher, Fragonard, Greuze, and the rest of the great French painters. I must confess that I cannot see Matisse and Picasso following suit, but one has to look back, and remember that Delacroix, Whistler, Manet, and the others, were all regarded as impostors in their time.[39]

But Hall had already disapproved of Davies' adding Manet to the Schedule, on the grounds that 'we have already three indifferent paintings'.

HALL LONGED TO be in London again as Adviser, and an increasing number among the Trustees wanted him there. In September 1932 Senator RD Elliott, sometime member of the Purchase Committee and a powerful figure within his own bailiwick, wrote to Levey proposing that Hall be sent, but was told that the Committee 'did not consider any change could be made in the existing arrangements' at that time. Undeterred, Elliott moved in October (with Longstaff seconding) 'that in view of Mr Hall's intimate knowledge of the Gallery and its requirements the Trustees recommend to the Felton Bequests' Committee that he be sent to London to act with Mr Davies for a period of four to six months'. Leeper moved, and the intellectual Labor lawyer Maurice Blackburn seconded, a tactful amendment asking for a conference 'for the purpose of considering the possibility of Mr Hall's being sent to London for a period of say six months to act with or assist Mr Davies in the selection of pictures'. The Bequests' Committee agreed to confer, but sought the view of its Adviser, and in November were told by cable that 'Felton Adviser would heartily welcome suggested visit but unless visitor's scope confined to works other than pictures Holmes will permanently withdraw and Adviser therefore fears friendly relations in influential quarters may be adversely affected to Melbourne's best interests'. In December Levey assured Davies that Hall would not be appointed, for fear of impairing cordial relations with the art world abroad.[40]

Meanwhile a sub-committee, consisting of Levey and Clarke from the Bequests' Committee and Cussen and Collins from the Trustees, which had been considering procedures, recommended in January that Conferences meet on a regular schedule, and that in future, 'in every case calling for prompt action', the Committee could approve purchases over £3000 without reference to the

[39] Davies to FBC, 28 January 1932 (quoted in Cox, *The National Gallery of Victoria*, p. 123).

[40] FBC, 14 November 1932. In December the Committee received from the London Agents a letter from Sir Augustus Daniel to Davies stating that 'it would not be in the best interests of the Trust for Mr Hall to be sent to London'. Levey reassured Davies on 19 December.

(left to right) Norton, Russell, Sheppard and Harold Grimwade, 1928

Trustees. The Trustees adopted both recommendations; henceforth Conferences could, in effect, make final decisions even for expensive acquisitions, provided a majority of each Committee attending concurred.

The Trustees did not approve another, curious, proposal from the Sub-Committee, to appoint a local 'Compiler', 'some person having a general knowledge of Art and of current opinions relative thereto', who would conduct what would now be called a literature search concerning any recommendation, overseas or local, and advise both Committees. They had other ideas; Randall Davies'

appointment was to conclude in April 1933, and the Bequests' Committee wished to appoint him for another year; but as soon as the matter was raised the Trustees asked again that Hall go to England to assist Davies.[41] The Committee, anxious to gain the Trustees' concurrence in the reappointment, urgently cabled their agent to ask Holmes 'to withdraw objection' to Hall's proposed visit; Holmes' services were 'highly appreciated', but his acquiescence 'would greatly ease the position for the Felton Committee and is most important for harmonious working of trust'.[42] When Holmes cabled that he had no objection to Hall's coming to 'confer' with Davies provided existing arrangements were not disturbed, the Committee, meeting around Cussen's sick-bed at his home, formally agreed to reappoint Davies and to send Hall to 'confer', approving £800 for the purpose.

Hall found the proviso contrary to his own dignity and the best interests of the Gallery. 'What I have done', he complained,

> to deserve this threat, and why my advent should disturb the happy relations of this little home group, I do not know, but, since this hostile attitude is acquiesced in and thought reasonable, I have to consider my position as Director of the National Gallery, and whether it is compatible therewith to undertake the journey not 'on active service', as I had hoped, but merely to look on and 'confer'.[43]

In April the Felton Conference was told that despite attempts to persuade him Hall had refused to go to London in a 'subordinate' capacity.

[41] FBC, 17 February 1933.

[42] Ibid., 22 February 1933.

[43] Hall to Cussen, 27 March 1933.

21

FEAST

'Rembrandts' were surprisingly common (though expensive) before the great cull of attributions later in the century, and in January 1933 Davies found another, a *Self Portrait*, from the collection of the Duke of Portland at Welbeck Abbey, offered to the Felton Committee for £25 000. Holmes, while conceding that it was not 'at first sight a thing of beauty', called it a major work of the 'most masterly and haunting power'. To him, and to other English connoisseurs of the day, Rembrandt's late works formed a pinnacle of art, like other pinnacles sometimes obscured from too searching a gaze by a romantic haze. Davies, always a follower of Holmes, was also bowled over by it:

> This Welbeck painting, ugly and rough as it is, is simply marvellous; a pathetic self-revelation of the artist in his very last years that is of supreme interest . . . The longer you look at the picture the more it holds you. It will bring visitors from all over the world to see it.

Neither the painting nor its provenance was given quite the scrutiny it deserved, but an authority as different from Holmes as Roger Fry also succumbed to its power.[1]

Eleven days after writing about the Rembrandt, Davies forwarded a copy of another letter from Holmes, written late at night: 'Just heard at dinner tonight that the N.G. have failed to buy the Hermitage Tiepolo *Feast of Cleopatra* . . . one of his masterpieces at £30 000 . . . Is this of any use to you? If so let me know *at*

[1] Cox, *The National Gallery of Victoria*, p. 126; Davies to FBC, 9 February 1933. For an account of the purchase of this and Melbourne's other Rembrandts, which is very critical of Holmes's role in 1933–35, see John Gregory's 'Prologue: the Collecting of Rembrandt for the National Gallery of Victoria' in Gregory and Zdanowicz, *Rembrandt in the Collections of the National Gallery of Victoria*, pp. 8–18. Gregory discusses the picture itself on pp. 59–76.

once'.² Holmes had reason to be in a hurry. Tiepolo's great picture, commissioned by Count Francesco Algarotti in 1743, had reached the Imperial Russian collection in 1800, via Dresden and Amsterdam, and was said to have been mounted in the ceiling of the room in which mad Czar Paul I was murdered in 1801. The story of how it came to leave the Hermitage Museum to settle in Melbourne, as rich in plot and counter-plot as a Jacobean drama, has been skilfully untangled by Professor Jaynie Anderson in her recent *Tiepolo's Cleopatra*.³

Desperately short of foreign exchange, the Soviet government had begun to sell off treasures, through Berlin, euphemistically suggesting that the de-accessioning, though furtive, was routine. (They were selling more than paintings; Leeper contributed, through his son Allen in the Foreign Office, to a fund to help the British Museum buy from the Soviet Government the *Codex Sinaiticus*, the important Biblical manuscript 'found'—actually borrowed from a monastery—by von Tischendorf in 1853.)⁴ Andrew W Mellon, then Secretary of the US Treasury, had no scruples in buying privately from a Communist government some twenty masterpieces, now glories of the National Gallery of Art in Washington, but London's National Gallery, as a public institution, had to be more cautious. Several Trustees saw the *Banquet* in Leningrad late in 1931, Duveen praising it as 'the finest Tiepolo in his knowledge'. Witt, then Chairman of the National Art Collections Fund as well as a Trustee, agreed: 'as a Gallery piece representing the blaze of Venetian Art of the 18th Century it is unsurpassed'. He proposed that the *Banquet* be bought, with payment made through Vickers, offering the Russians machinery in lieu of cash. Treasury objected, complaining that during a time of national retrenchment spending a large sum on buying a work of art from Russia would be loudly criticised. Under instructions from Witt and Lord Lee, then Chairman of the National Gallery Trustees, Colnaghi's brought the painting to London for inspection in January 1933, on the understanding the National Gallery would buy it, while Lord Lee approached the King to overcome Royal scruples over trading with the Bolsheviks (who, among other misdeeds, had killed his cousin Nicholas).

The plot thickened when Sir Augustus Daniel, Holmes' successor as Director, an archaeologist with no authority in this field, described the painting as 'incom-

[2] Holmes to Davies, Davies to FBC, 20 February 1933, quoted in part in Cox, *The National Gallery of Victoria*, p. 127.

[3] Jaynie Anderson, *Tiepolo's Cleopatra*; I am grateful to Professor Anderson for access to her material before publication. A Bequests' Conference on 9 February 1934 refused to buy, for £49, a letter of Count Algerotti's reporting the purchase, Bright writing to Sugden (7 February 1933) that 'It is distinctly interesting but not I think as far as £40 British'. There is a copy of Algerotti's letter in Hall's papers.

[4] Poynter, *Doubts and Certainties*, p. 426.

petent', while two experts on the staff of the National Gallery, Martin Davies and Ellis Waterhouse, criticised its condition and dismissed it as 'studio work' by 'an 18th century Decorator', assessments surprisingly wide of the mark. Debate raged in private, until a final decision found the majority of the Trustees against purchase; and Holmes, passionately committed to the picture and aware that Colnaghi's would be inclined to sue the National Gallery, was prompted to write his late-night letter. His embarrassment helps explain the fervour evident in his detailed report, which Davies forwarded to Melbourne with a formal recommendation to buy both pictures:

> I am aware [Holmes wrote] that the simultaneous purchase of two rare and costly masterpieces like the Rembrandt and the Tiepolo may call for a little courage on the part of the Trustees, who have to face criticism which in the past has not always shown itself to be in touch with our European experience. But that courage is essential to the making of any great collection. It is only by having the strength to make an important decision that masterpieces can ever be obtained; and it is by masterpieces, and *by masterpieces alone,* that great collections take their ultimate rank. The possession of hundreds of minor pictures counts, in comparison, for little or nothing. The moment appears to me to be a critical one for the Melbourne Gallery, so that if on raising the question of policy, I have overstepped the limits of merely technical advice, I hope the Trustees will understand and forgive me.[5]

At a Conference on 7 April 1933, with Levey in the chair, MacFarland, Russell Grimwade, Sir Leo Cussen, Longstaff, Collins and Shirlow present, the Committee approved buying the Rembrandt for £21 000 (subject to the Trustees recommending it, as they did), and agreed to offer £20 000 (£10 000 less than asked) for the Tiepolo. London cabled that £27 000 was the irreducible price for the Tiepolo, but when the Felton Bequests' Committee offered £25 000 it was accepted; a junior representative of the London Agents made the payment in bundles of small currency, carried across Trafalgar Square to a Soviet agent waiting outside the National Gallery with a suitcase. The Committee had spent a great deal of money in one day.

In August, Manchester asked to borrow the Tiepolo, and Roger Fry to have the Rembrandt copied because of its 'extraordinary interest'; the requests were at first refused, and then agreed.[6] The drama was not yet fully unfolded. The experts' criticisms of the Tiepolo appeared in the London press, no doubt to justify the National Gallery's failure to buy it. Minutes of Felton Conferences on

[5] Holmes to Davies, 20 February 1933, quoted in Cox, *The National Gallery of Victoria*, p. 127.

[6] FBC, 7 April, 5 May, 1 August 1933.

18 August and 1 September record receipt of press cuttings, 'one of which drew attention to the condition of this painting, also a letter from the London Agents commenting thereon. It was decided that no action be taken in the matter'. The Agents sent a Memorandum from Randall Davies, written from Oxford after a visit to Kenneth Clark, then Keeper of Western art in the Ashmolean Museum. Clark had told him that there had been three reasons for the British failure to buy the Tiepolo, only the first of which—'inferiority of painting and condition'—had been made public. The other two were 'Royal disapprobation on political grounds' and 'personal antagonism to Lords Duveen and Lee and Sir Robert Witt on the National Gallery Board'; and the third, Clark suggested, had counted most. Clark thought the episode absurd and discreditable, Davies reported, adding a note: 'I did not know at this date that Mr Clark was director-elect of the National Gallery—though probably <u>he</u> did'.[7] Clark did know; he had been offered the Directorship in June, when he was not yet thirty.

THE SOVIET GOVERNMENT had chosen to put the Tiepolo on the market partly because its opulence was thought too decadent for Communist values. Perhaps for similar reasons, eighteenth-century Venetian art did not then have in the west the reputation it has since attained, though the *Banquet* received a good deal of press attention in Britain, including a learned article, with full-page colour reproduction, by Roger Fry in the *Burlington Magazine*. (Fry called Sir Augustus Daniel's conclusion that it was not by Tiepolo 'one of the most remarkable examples of connoisseurship on record', since its full provenance was known.) A report of the painting, when on display in the Imperial Institute in London—the National Gallery could scarcely show a rejected picture—even appeared in the *Corriere della Sera*, Milan.[8]

In Melbourne, Tiepolo's masterpiece was not much praised. Even before it arrived there were complaints about the price, the sculptor Paul Montford writing on 19 April that he was filled with consternation when he thought 'of the wonderful collection of twenty-five examples of English or Continental, Modern or Ancient paintings that could be bought for £1000 each'. In July Hall endorsed a press release concerning the purchase with the words 'Tosh', 'Bunk' and 'Junk'; below the claim that no Tiepolo of such importance was likely to appear again he added 'Thank Heavens'. In October, when telling Lionel Lindsay of the imminent arrival of the two expensive acquisitions, Hall dismissed the Rembrandt as having been commenced but not thought worth finishing, and

[7] Davies to FBC, 11 August 1933.

[8] *Burlington Magazine*, September 1933; *Corriere della Sera*, 28 July 1933. The *Manchester Guardian* also published a large illustration.

the Tiepolo as not worth the space it would occupy, let alone the price.[9] Streeton also thought the price unjustified, and compared the picture unfavourably with the Puvis de Chavannes cartoons acquired earlier. The anonymous booklet *Alfred Felton and his Art Benefactions*, published by the Gallery in 1936, referred only to 'the excellent decorative sense and colour of this eighteenth century master', working when 'the great period of Italian art was passed'. But Sir Kenneth Clark, visiting the collection in 1949, congratulated Melbourne on its lucky purchase. 'You are fortunate in having here a stunning example of the splendid, a brilliant defiance of the austere quality—Tiepolo's *Banquet of Cleopatra* which, had it not been for a piece of fantastic obstinacy, would have been one of the glories of the London National Gallery'. When shown, cleaned, in London in 1956, the *Banquet* was described as 'the great picture from Melbourne'.[10]

The Rembrandt, far from opulent, was derided in Melbourne in 1933. Sir Charles Holmes, writing to the Trustees on 4 May, had congratulated them in terms decision-makers seldom like to hear: they had, he repeated, been courageous. It was 'a purchase for which posterity will be grateful'; 'the one consolation that the Gallery Directors have is that they will be remembered when their detractors are dead and utterly forgotten'.[11] But in 1933 the detractors were alive and kicking, and the Committee had to read, over their breakfasts, that they had bought Rembrandt's worst picture, unfinished even if genuine. The painting does indeed lack the finish of the portraits then providing a number of fashionable Melbourne painters with good incomes, but in the eyes of Roger Fry and its other admirers it did not lack genius. Its attribution did not survive the great Rembrandt cull; since 1984 it has been accepted as a portrait, remarkable enough in itself, of but not by the great artist in his last years.[12]

THE PURCHASE OF the Rembrandt and the Tiepolo prompted an unusual response from an expatriate, (Henry) Walter Barnett. A great photographer (and incidentally producer of the first moving picture seen in Australia), Barnett had been born in St Kilda in 1862, son of (yet another) London-born merchant.[13] He

[9] Hall to L Lindsay, 24 October 1933 (Hall papers).

[10] Cox, *The National Gallery of Victoria*, p. 130; Ursula Hoff, *The Felton Bequest*, p. 13. On the Tiepolo, see also Galbally, *The Collections of the National Gallery of Victoria*, pp. 163–4, and Antonio Morassi, Tiepolo's 'The Banquet of Cleopatra', in Philipp and Stewart (ed.), *In Honour of Daryl Lindsay*, pp. 100–9.

[11] Holmes to Trustees and FBC, 4 May 1933.

[12] Sturgess, 'Rembrandt by Himself' p. 48.

[13] His entry in *ADB*, vol. 7, is by Paul de Serville. An exhibition of Barnett's photographs was mounted in Sydney and elsewhere in 2000.

trained in the Bourke Street studio where Tom Roberts also worked, and they became lifelong friends. After some time in London, Barnett set up the Falk Studios in Sydney in 1885, producing brilliant portraits, for very high fees, of the famous—including Melba and Sarah Bernhardt—and the rich. He was equally successful and fashionable after moving to London in 1898. Streeton, another friend, thought Barnett had 'a good strong appreciation of the beautiful'. In 1920, retiring to the south of France, he began to collect art, especially of the region, which he thought Melbourne should also buy.

The Rembrandt and Tiepolo purchases provoked Barnett to publish, from his villa at Aix-les-Bains, a handsome small pamphlet, its title-pages set in the great tradition of pamphleteering:

> *A Protest Against the Maladministration of the Beneficent*
> *Public Trust Known as The Felton Bequest*
> 'Strength by limping sway disabled
> And Art made tongue-tied by authority
> And Folly (Doctor-like) controlling skill.'

The last line (from *Richard III*) was no doubt a barb directed against the late Dr Bage, Barnett taking pains to show that 'this courteous English Gentleman' (a two-thirds-truth; Bage was born in Colac) was 'totally unfitted for the post he occupied' as Chairman of the Bequests' Committee.

The purchases of the Rembrandt and the Tiepolo had, Barnett alleged, 'aroused a just and far reaching feeling of indignation amongst independent and competent connoisseurs as to the value of these works for the walls of the National Gallery of Victoria'. 'Competent authorities' had questioned the wisdom of acquiring a 'very disputable' Rembrandt and 'a florid and none too well preserved composition by a Venetian baroque painter at a price which seems to have been determined by the glamour of the picture's former association with the Hermitage Gallery under the Czars, rather than by intrinsic merit'. If the Felton Bequest Committee's policy was to obtain only the best examples of the best of artists and periods, then among works acquired so far only van Eyck's *Madonna and Child* complied with their instructions. 'To an unprejudiced observer who has studied the collection on the walls of the Melbourne Public Gallery', he wrote, 'there appears to have been as little Policy of definite collection as a Paris chiffonnier would attempt in searching an ash barrel for unconsidered trifles'.

In Barnett's view the greatest period of French art had been the four decades from 1860 to 1900, 'although unfortunately the great men who made that period great were not fully recognised or appreciated in their own time'. The Bequest had

acquired only three Manets, and one each of Monet, Pissarro and Sisley, but no Degas, Renoir, Cézanne, Berthe Morisot, Mary Cassat or Jongkind, 'nor representative examples of the Neo and Post-Impressionists including Gauguin, Denis, Van Rysselberghe, Seurat, Signac and especially Van Gogh'. Anyone aware of the importance of 'this great movement' knew 'the vital necessity for the representation on the walls of the Melbourne Gallery of this great Modern School'. Barnett feared that 'future benefactors of Art' might be discouraged or deterred by 'the notoriety achieved by the Felton Bequest in the first 30 years of its existence'.

He then revealed his interest. In 1927 he had held an Exhibition in Melbourne of works by French Provencal Painters, and had been encouraged by Dr William Maloney MHR 'to get together for exhibition in Melbourne a loan collection in Paris of some of the best examples that I could obtain of the French Impressionists'.[14] But when he offered 'to send out this Collection free of any charge' to the National Gallery, to show in a new gallery nearing completion, he received a cool formal reply from Chief Librarian Boys: 'I beg to inform you that, at a meeting of the Board . . . I was directed to state that while thanking you for your courteous offer, they do not think it desirable to avail themselves of it at the present time'. 'I am still at a loss', the pained photographer wrote five years later, 'to comprehend why my offer should have met with such a curt refusal and unwarranted rebuff'. He did not distinguish between the management of the Gallery and of the Bequest in concluding that he hoped that 'the circulation of this statement will awaken public interest and bring about a thorough reform in the administration of the Felton Bequest'. Barnett sent copies of his pamphlet to all gallery directors in Britain, prompting the London *Star* to report 'A Mean Attack on Felton Buyer'.[15]

Barnett's objection to the purchase of the *Banquet* led him to repeat not only London criticism of its quality, but also the Soviet's assertion that they were merely culling inferior pictures from the Hermitage. He had written to the *Times* about it, in July 1933:

> Holding no brief for the U.S.S.R., I beg to state that the recently acquired painting by the celebrated Venetian R. B. Tiepolo on behalf of the National Gallery, Melbourne . . . was disposed of by the Soviet authorities to make room for better works, and that, according to very high authority, the arrangement of the Hermitage Gallery is now vastly superior and more educational for the general public than during that long period of royal rule in Russia.[16]

[14] On Maloney see the entry by Geoffrey Serle in *ADB*, vol. 10.

[15] Barnett, *A Protest,* p. 13; *Star,* 30 September 1933.

[16] *Times,* 17 July 1933.

This assertion, that the picture was not good and the Russian motives worthy, was a neat double inversion of the Royal argument that good British money should not be paid to wicked Russians even for treasures.

THE FELTON BEQUESTS' COMMITTEE seems never to have been happy with Davies as Adviser, despite his assiduity, and the frosty reception given to the Rembrandt in Melbourne, if not the machinations concerning the Tiepolo, blunted any credit due to him and increased their dissatisfaction. In March 1933 the Committee concurred in the Trustees' request to suspend purchases from the schedule, and in June to instruct the Adviser to 'devote your time to secure important works of art rather than a number of lesser quality'.[17] (In response he recommended a 'fine Rubens portrait', accepted by the Felton Committee but refused by the Trustees.)[18] In June Sir Leo Cussen died; the Committee mourned his passing, rightly recording that 'with his extreme courtesy and wonderful tact' he had been 'a tower of strength ... in maintaining harmonious relations', a superhuman task indeed.)[19] Hall's supporters gained ground; in July Elliott, always impatient, telegraphed the Committee asking that a small committee be appointed to consider filling the Advisership after it became vacant in the following April; the Committee replied that the matter was properly handled in Conference.[20]

Some moderates were fed up with discord. In March 1933 Bright had written to Cussen that he had been 'thinking a good deal about the Felton Bequest affairs which seem to me to be getting a bit thick'. 'As a considerable portion of the semi dormant friction is but individualistic human nature', he asked, 'would it be possible to switch attention to 'principles' in the hope that team work rather than individual work would grow?' In principle, the director and the adviser should be in close touch and with confidence in each other, and if either man could not do this he was unfit for the job. The machinery should be simplified, to let them get on with it.[21] He set about the task, rewriting first the structure and powers of the Trustees' own Felton Purchase Committee. In July he discovered that on the other side of the divide Sir Frank Clarke, a former Trustee and less scarred by earlier conflicts than his Committee Chairman Levey, was preparing a number of fundamental questions concerning the role of overseas buyers, for

[17] FBC, 23 June 1933. Levey softened the rebuff by adding that gallery space was limited.

[18] Ibid., 3 February 1933. The Rubens would have cost £6600.

[19] Ibid., 9 June 1933.

[20] Ibid., 5 July 1933.

[21] Bright to Cussen, 31 March 1933 (Bright papers).

consideration at a Conference on 21 July.[22] Both committees soon agreed that Davies' appointment should not be renewed after April 1934. They also agreed—following Clarke's agenda—to seek out an expert in Australia, not a practising artist but a 'trained critic', to serve as Adviser in England on the usual terms, 'at liberty to consult Holmes or other approved consultant'. But among Australians who had stronger claims than the Gallery's own Director? Eventually, at another Conference on 1 September, the Bequests' Committee bowed to the Trustees' 'expressed wish' that Hall be appointed, stipulating that it be for not more than two years. After some awkward negotiations concerning salary, Hall, seventy-two, accepted the appointment and was given two years leave from the Gallery.[23]

Writing from Sydney to congratulate Hall, JS MacDonald, by this time Director of the Art Gallery of New South Wales, complained that Randall Davies and 'noodles' of his kind wasted money, and referred darkly to 'a lot of hanky-panky on the part of both Davies and Holmes'.[24] But Davies, although superseded, did not give up. Making as disturbing a swan-song as an Adviser could wish, he recommended a Renoir, two Cézannes, a Gauguin and a Van Gogh, five pictures ranging in price from £9500 to £5000. The Conference on 1 September, attended by Levey, Clarke, Russell Grimwade, Shirlow (as the Committee) and Sugden, Longstaff, Senator Elliott, Bright and again Shirlow (as Trustees) received a recommendation from the Trustees that their purchase not be approved, and was bound by it. Some present must have been uneasy over the Trustees' decision, for the meeting then formally resolved that Randall Davies

> be informed that it was desired he should understand the Felton Bequests' Committee and the Gallery Trustees were not rejecting the best examples of the French Modernist School, but that they did not consider the above were the best representative works of the Artists and they feel the prices asked would not be maintained.[25]

When Davies then recommended Renoir's *La Famille Henriot* for £20 000, that too was refused. The *Argus* reported that Shirlow, implacably opposed to Post-Impressionist and indeed Impressionist works, had said that the Trustees had no

[22] Bright to Sugden, 19 July 1933 (Bright papers).

[23] FBC, 1 and 25 September 1933. The salary, £600 sterling in England plus £500 Australian paid to his wife, was later amended to a salary of £A1375 to avoid double taxation.

[24] MacDonald to Hall, 26 October 1933 (Hall papers).

[25] FBC and Conference, 1 September 1933. The paintings refused, all offered by Alex. Reid and Lefevre, were Cézanne, *Portrait de l'Artiste*, *Le vase de Jardin*; Gauguin *L'Offrande*; Renoir *La Longueuse*; and (especially regrettable) Van Gogh's *Effet de Pluie*. Cox, unaware of this Conference minute, wrongly concluded that members of both committees were probably involved in a majority decision, which the Trustees had in fact pre-empted.

intention of collecting this form of art 'at present', and that 'if they had purchased the pictures, there would have been an uproar when they were exhibited'.[26] When Longstaff told a meeting of the architects' T Square Club that the pictures had been declined by the Felton Bequests' Conference, and the press reported him, Levey, embarrassed, moved the Bequests' Committee to object formally that Conference proceedings must remain confidential.[27]

The Trustees had disastrously overlooked Sir Sidney Colvin's advice two decades earlier, that even then the best pictures of the modern French school were 'scarce, expensive and almost impossible to obtain', and the Melbourne press, unpredictable and fickle, now attacked the Bequest for what it had not bought. The *Herald* led the charge: Melbourne was ready for such works, now classics, and needed them. The *Herald*'s complaint was a straw in a rising wind, coinciding as it did with the appointment as a Trustee of its proprietor, Sir Keith Murdoch. Davies, not content to have only the last laugh over Melbourne's attitude to Cézanne and his ilk, successfully recommended Reynolds' *Miss Gale* before his term of office expired in April 1934. After cleaning, she looks splendid, and so, to a degree, does her Adviser's reputation.

CONCERNED, YET AGAIN, by criticism of Bequest purchases the Committee decided, in December 1933, to publish another *Record*, this time including an account of the Charitable Bequest. For fifty guineas they commissioned as author Basil Burdett, newly returned to Melbourne to join the *Herald*. Burdett, born in Queensland in 1897, had served as a stretcher-bearer in the AIF and worked as a journalist in Brisbane before founding the influential Macquarie Gallery in Sydney, and assisting in editing *Art in Australia*.[28]

A liberal critic sympathetic to a range of artistic movements, Burdett promptly produced an excellent manuscript, though he gave only two paragraphs to the Charitable Bequest, perhaps after discovering how repetitive a detailed account would be. (Individual grants had 'not been spectacular', but had been 'made with a welcome consistency to the institutions concerned', and by the end of 1933 a total of £450 000 had been distributed.)[29] For the rest Burdett's *Record* was better written and more persuasive than Bage's earlier versions: in 'thirty brief years'

[26] *Argus* (and *Herald*), 24 October 1933.

[27] FBC, 27 October 1933.

[28] Ibid., 15 December 1933 and 9 February 1934.

[29] *The Felton Bequests*, 1934, p. 9. On Burdett, see entry by Richard Haese in *ADB*, vol. 7.

Felton's bequest had given Melbourne the nucleus of a collection which only the great galleries of Europe will rival in the future'.

> Before the foundation of his bequests no untravelled Australian had seen a landscape by Corot. No Australian student, unable to study in Europe, could see for himself the work of Van Eyck, of Puvis de Chavannes, of Rembrandt, or a hundred other masters of yesterday and today. Now through his benefaction, Melbourne is the art metropolis of a continent, if not of a whole hemisphere.

Burdett tactfully left the cupboard door closed on such skeletons as the treatment of Sir Sidney Colvin; and on Rinder he let the long letters in his support from Crawford, Carmichael and others speak for themselves. The climax of his account was the acquisition of the Tiepolo and the Welbeck Rembrandt, but Burdett loyally told also how much had been spent locally on Australian art (though a passing reference to 'a somewhat careful campaign of buying' suggests that Hall's fastidiousness did not impress him). The achievement overall had indeed been impressive; some £435 000 had been spent on art by the end of 1933, and—thanks to interest accumulated on funds held in reserve—£67 000 remained.

Burdett's *Record* gave due credit to the work of advisers recommending purchases in fields other than painting and sculpture. Hall's fascination with Asian art continued and intensified, though in this field, unlike painting, his expertise was open to question, and was indeed challenged. For Asian art the Gallery trawled widely. The Bequests' Committee paid for some Chinese pots acquired from a man in Southern Rhodesia; and in January 1933 received a letter from Professor Wood Jones, a Trustee then on leave from his Chair in Melbourne to direct Anatomy at the Peking Union Medical College. The 'present disturbed state of China' made some rare bargains available; could he help acquire some? The Committee gave him £100 to spend, and later thanked him for his good purchases (though why he needed reimbursement of 100 Mexican dollars spent buying antiques in China remains unexplained).[30]

The Bequest had always acquired furniture and 'objects of art', including fine silver, and sometimes gave individuals considerable authority to buy. In 1929 ES Makower, a Swiss-Australian silk merchant with a home in London, who had given the Gallery a collection of prints and fans, was asked to acquire silver—on which he was expert—from a schedule produced with help from LA Adamson of Wesley College. Makower, who knew Bright well and regularly corresponded with him, spent £5000 so well that in 1933 he was given an additional £2500, to

[30] FBC, 10 January, 23 June and 1 August 1933.

be spent on silver not later than 1750 (but was refused another £2500 proposed to be spent on fine miniatures, boxes and bibelots). By 1935 he had successfully spent a third allocation, of £1200. A rare parcel-gilt chalice bought in 1934 especially impressed the public when shown in Melbourne.[31]

The Trustees, lacking other funds for acquisitions, often exerted pressure to broaden the range of Felton purchases ever more widely. The Gallery had collected coins since they had been included in the first Exhibition of 1861, encouraged by von Guérard, a keen numismatist, appointed first painting master in 1870. The Bequest does not seem to have been involved in their acquisition until it bought six farthings and three halfpenny pieces of Charles II and the Commonwealth in 1927, but a major buying programme followed, supported by Hall and guided by AS Kenyon, an authority on coins as well as a historian, naturalist, ethnologist and practising engineer (organising much of the State's water supply and irrigation, especially in the Mallee). For some years after 1927, the Felton Bequest spent large sums on coins on Kenyon's recommendation, a single meeting, in June 1929, approving purchases costing £3192 14s 1d. Only at the end of 1932 did the Committee ask whether it was to buy coins indefinitely, and asked Sir Frank Clarke to report after consulting Kenyon on gaps remaining to be filled. There were many, it seemed; with Clarke's report came a recommendation to spend a further £3325 on electrolyte replicas of unavailable coins to fill the missing spaces. All were approved.[32]

The Bequest also bought books. It had the advice of a book committee, and had even asked Shirlow to design a Felton Bequest bookplate, but which books were works of art? The Wharncliffe *Horae* was more art-work than book, and some illustrated printed books also qualified. Late in 1932 an exhibition of art books purchased by the Bequest—including items from the large Sticht Collection acquired in 1922—was mounted in the Macarthur Gallery, but the following June, when the Trustees recommended purchase of a First Folio Shakespeare for £15 000, the Committee felt obliged to consult its solicitors (by now Phillips, Fox and Masel). The Folio, they said, 'fails to comply'; it might contain the work of a genius, but was not in itself a work of art.[33] After that it was easier to refuse to buy art periodicals for the Public Library, but the Bequest continued to approve a few valuable manuscripts and art books each year, including the complete Roxburghe Club publications and, in 1937, another Soviet discard, a fifteenth-century Italian manuscript

[31] Cox, *The National Gallery of Victoria*, pp. 140–1. The original Schedule was pasted in with the minutes of FBC, 15 December 1929; and see FBC 9 February 1931 and 4 August 1933, and Burdett, *The Felton Bequests*, p. 24.

[32] FBC, 14 December 1932 and 21 July 1933. Lists of the coins purchased are pasted in the FBC Minute books, and referred to in Burdett's *The Felton Bequests*, p. 25.

[33] FBC, 10 January, 9 and 23 June and 5 July 1933.

formerly in the Russian Imperial Library. These purchases were celebrated in 1938 in a special publication unashamedly 'intended to make still more evident how wide the range and how comprehensive is the scope of the wonderful gift made to the people of Victoria by Alfred Felton'.[34]

The Committee distributed Burdett's *The Felton Bequests* widely, though its impact was no doubt limited to those who read such things. Everybody read newspaper headlines.

WHEN HALL SET out on his second foray as Felton Adviser overseas, Victoria was preparing to commemorate the centenary of white settlement, in proceedings beginning in October 1934 with a Wild Australian Stampede and the Centenary Royal Agricultural Show, progressing through the Melbourne Cup and the Dedication of the Shrine of Remembrance (on 11 November) and culminating in a Pan Pacific Scout Jamboree in March 1935. By 1934 the state was emerging from the worst of the Depression—the Bequests' Committee Charity Fund was able to distribute £21 940 to charities in 1935, its income up more than a third since the low of 1932—and the celebrations were elaborate. But the Depression had greatly sharpened political opinions: the viability of existing democratic institutions was called in question from both ends of the political spectrum, and the epithets Communist and Fascist were thrown about far more widely than the small numbers of either, properly so-called, could justify. A crowd of 250 000 welcomed the Duke of Gloucester on the grey October day of his arrival to preside over celebrations, but another visitor, the radical Czech writer and agent Egon Kisch, was officially not welcomed at all; refused permission to land to attend a National All-Australian Anti-War Congress protesting at the imperialist and militarist nature of the centenary celebrations, he literally jumped ship, broke his ankle, and was taken on to Sydney. Landed, he spent three months making the most of his notoriety, increased when a court overthrew the Government's attempt to deport him for failing a dictation test in Gaelic.

The Centenary celebrations were indeed imperial in tone, though 'militaristic' only if the term can properly be applied to the dedication of Victoria's massive Shrine of Remembrance, built on the knoll above St Kilda Road which Streeton had proposed as the site for a new National Gallery. The great Centennial Air Race, from London to Melbourne, was an affirmation that the imperial relationship persisted in the age of flight, and victory by an Empire team gratified the donor of the £15 000 prize, Sir Macpherson Robertson. (In the best tradition of Victorian munificence Sir Macpherson, creator of the

[34] *Manuscripts and Books of Art Acquired under the Terms of the Felton Bequest*, 1938.

MacRobertson confectionery empire, also gave £100 000—a thousand for each year since settlement—for public works to create employment.)[35]

The Felton Bequests' Committee had itself been asked in February 1933 to mark Melbourne's centenary by presenting 'a notable piece of sculpture' to the City, but replied that it could legally buy only for the Gallery. When it was suggested that it might mark the occasion by presenting a 'definite work of art' to the Gallery between October 1934 and March 1935, the committee promised it would 'favourably consider' the idea, but the minutes record no such work recommended or designated (unless it be the proposed statue of Alfred Felton, which the Committee had to abandon on legal advice in July 1933; but that was to have been placed on some site provided by the Government. Leeper had urged 'that a bronze statue of Alfred Felton be obtained' as early as 1912, the year in which the Trustees had also considered an 'arch monument in front of the building, incorporating a medallion or statue honouring Felton, and a new and 'more artistic' Redmond Barry).[36]

The Centennial Air Race looked to the future, and the Shrine to the recent past, but for the most part the celebration commemorated the achievements of the early British settlers in Victoria. One proposal, stemming from an exhibition in 1929, was to create a Museum of Victoria's History within the Swanston Street conglomerate, an idea the Trustees favoured to the extent of establishing a separate accessions register for works relating to the early years of the State, and displaying a number of items—prints and pictures, maps and museum material—in a separate gallery in 1932.[37] The 'Historical Museum' did not eventuate, though the 'Historical Collection' remained together and was enriched by important donations, including ST Gill's goldfields works and material on Burke and Wills. But in 1934 enthusiasm for historical celebration ran high, and two men associated with the Felton Bequest, Russell Grimwade and AS Kenyon, made major contributions to the outcome.

In these months Grimwade was, as the retired Librarian Armstrong wrote to Hall in October 1934, 'much to the fore'. (And was 'not a bad fellow on the whole, though not of a type I can admire'; Armstrong had suffered much from condescending Trustees.)[38] Strong historical interests, always focused on the local past, on the European explorers of the region and the settlers who had come to create the Victoria he knew, made Grimwade the man for the hour. His work on

[35] After some argument, the money was spent on building a girls high school, a bridge, a fountain and a herbarium.

[36] FBC, 3 and 22 March 1933; Trustees, May 1912, and *Argus*, 27 June 1912.

[37] On the 'historical museum', see Galbally, *The Collections of the National Gallery of Victoria*, pp. 35–6, and Rasmussen et al., *A Museum for the People*, p. 195.

[38] Armstrong to Hall, 2 October 1934 (Hall papers).

Felton's life was largely undertaken at this time, when, as a personal Centenary gift to the people of Victoria, he bought the Yorkshire cottage of Captain Cook's parents, and had it rebuilt, stone by stone, in Melbourne. (His first proposal, that it be placed in Swanston Street in front of the Public Library, for Sir Redmond Barry to frown down on, fortunately came to nothing.) Grimwade was a member of the executive of the Centenary Celebrations Council, which met under the Chairmanship of the Lord Mayor, LL Smith's son Sir Harold Gengoult Smith, and he chaired the Historical Committee, supervising preparation of a weighty volume, *Victoria: the First Century: An Historical Survey*.[39] The work had four authors, one of them Kenyon, nominated by the Trustees of the Public Library, Museums and National Gallery.[40]

The versatile Kenyon, then President of the Historical Society of Victoria, produced a centenary work of his own, *The Story of Melbourne*, published with a Foreword by the Lord Mayor. It followed two books on settlement he had earlier co-authoured, *Pastures New* and *Pastoral Pioneers of Port Phillip*, and his 'The Art of the Australian Aboriginal' in Charles Barrett's *Australian Aboriginal Art*, issued by the Trustees in connection with an exhibition mounted in the Museum in 1929. As an ethnologist, Kenyon was an ardent collector of Aboriginal stone implements—like Spencer an 'all-day-pick-'em-up-pick-'em-up' eccentric in Aboriginal eyes—who had donated his collection to the Museum and worked with Spencer to build a massive hoard.[41]

Kenyon is the likely main author of the accounts of white settlement and its impact on Aboriginal society in *Victoria: the First Century: An Historical Survey*.[42] He had a deep interest in Aboriginal culture, as he understood it—'of course the aborigines, those much maligned individuals, were the first occupants' of Victoria—though he did not doubt that they were doomed to extinction: 'there is still a pitifully small remnant awaiting their end', he wrote, echoing Alexander Sutherland's decreasingly plausible prediction of half a century before.[43] The *Survey*

[39] The other members of the Council's Executive committee were the Premier Sir Stanley Argyle, Sidney Myer, Mrs IH Moss, Councillor AE Kane, and Norman Brookes, tennis champion (and since 1933 the Lord Mayor's father-in-law; Melbourne 'society' was still small).

[40] On Kenyon (1867–1943), see Ronald McNicoll's entry in *ADB*, vol. 9.

[41] On Kenyon and Spencer, see Mulvaney and Calaby, '*So Much That Is New*', pp. 251–3, 255, 257, 260.

[42] Centenary Celebrations Council, Melbourne, Robertson and Mullens, 1934. The other compilers were C Daley, nominated by the Historical Society of Victoria, AW Greig, nominated by the Council of The University of Melbourne, and CR Long, nominated by the Education Department. They acknowledged the help of ER Pitt, Chief Librarian.

[43] Kenyon, *The Story of Melbourne*, pp. 9, 53. 'Very soon there will be none', RH Croll wrote in similar valedictory vein in 'The Original Owners. Notes on the Aborigines of Victoria', in the *Centenary Journal 1934–1935*, p. 39, referring specifically to 'full bloods'. 'What the destiny of the Victorian aboriginal would have been had they

repeated the usual assumption of the day, that Aboriginal culture had a past but little present and no future. The future, like the present, owed most to the efforts of the white settlers. 'We are the gainers by the foresight, courage and hardihood of those who came to an empty land and stayed to foster the germ of every need, save wood and water', Grimwade wrote in the Foreword.[44] 'Empty' was an assumption still little questioned in white society; there were dissentients, but it would be decades before they had much impact on public policies. When the Lord Mayor wrote in his Foreword to *The Story of Melbourne* that 'the foundations of this wonderful city, spiritually, educationally, artistically, architecturally, and in all other respects are real, sound and dependable', he was intent to defend the achievements of Australian capitalism against the political kin of the hobbling Egon Kisch, and had in mind the unemployed 'sussos' building the Yarra Boulevard and the Great Ocean Road rather than the remnants of the tribes in the reserves. Kenyon's own conclusion was robust: 'Cradled in strife, nurtured in conflict and reared in the midst of resistance to all constituted forms of authority, Victoria has reached its centenary, still fighting . . .'[45] Not least, he might have added, over Felton's Bequests.

In the *Survey*'s brief account of art in Victoria, Mr Felton was given his due, and more:

> The story of art in Australia is inextricably bound up with the Felton Bequest . . . Since [1904] some £400 000 have been expended . . . The National Art Gallery of Victoria has consequently become one of the leading galleries of the world and the best endowed in the British Empire, and houses under its roofs a collection worth several million pounds.[46]

Kenyon praised the Bequest in similar terms in *The Story of Melbourne*, but he complained of the Bequests' Committee's 'somewhat rigid' interpretation of the words of the will, excluding 'the purchase of books, save those of a distinct art character, of ethnological specimens and of many other objects which would quite well have been of educational value in the true artistic sense'.[47] It would be some decades after Kenyon's time before art and anthropology recognised each other, and the National Gallery began to treasure the work of the likes of William Barak.

succeeded in adapting themselves to the new conditions, so suddenly and violently thrust upon them, who can say? An interesting people, of whom we know so very little, they have vanished almost in a night. It may be that such a happening is incidental to the occupation by civilised races of all lands held by savages, and that it marks the march of man's progress—"but yet the pity of it, Iago, the pity of it!"' (p. 146).

[44] *Survey*, p. 7.

[45] Kenyon, *The Story of Melbourne*, p. 142.

[46] *Survey*, pp. 383–4.

[47] Kenyon, *The Story of Melbourne*, p. 138.

22

OLD MEN DISPUTING

The Felton Bequests' Committee had been reluctant to appoint Bernard Hall as London Adviser, recording their decision in terms which were grudging indeed.[1] The ageing Director, for his part, had much satisfaction in preparing to demonstrate how wrong the Committee had been to confine his responsibilities to Australia for twenty-nine years, more than twice the common sentence of transportation for serious crime when New South Wales was a penal colony. Gradually, over his long and frequently frustrating career, he had become a pessimist. The War had made him gloomy about changes in society, and in culture; in 1918 he quoted, in a public lecture repeated in 1931, Emerson's 'Society never advances. For everything that is given, something is taken'. Convinced that even the great verities of art were under threat from modernist perversions, his new mission in Europe was to acquire for his Gallery works which affirmed true values against the uneducated forces of democracy and amateurism, and he was confident he would succeed.[2]

He was, however, dismayed by the conditions of his appointment. He wanted the terms he had enjoyed in 1905, with a bag of money to spend as he chose, but Levey warned him that the Trustees' solicitors had narrowed their discretionary powers, and he was compelled to operate under the same restrictions as more recent Advisers. To Bright, Hall wrote lamenting that the conditions were 'so entirely different to those under which I worked the last time I was in London . . . when I had a free hand, with regard to pictorial art'. He would like to have at least

[1] FBC, 28 August 1933.

[2] For a summary of Hall's lecture 'Art and Life', see McQueen, *The Black Swan of Trespass*, pp. 6–8.

a small discretionary fund to use 'where rare opportunities call for immediate decisions'. 'I look upon this business as a hunting expedition', he added frankly.

> It is sport and adventure, as well as a bag for the larder—and with your sights trained on a rare bird, it blunts all zest to have to refer all decisions as to the pull of the trigger to two committees of busy people, meeting with difficulty, 12,000 miles away.[3]

Bright (who had inherited Cussen's role as conciliator in Felton affairs) was sympathetic, urging Sugden (now President of Trustees) to ensure that Hall was allowed an 'elastic' reading of his instructions, which did not compel him always to consult his bugbear Holmes. 'My personal opinion', Bright told Sugden, 'for what it is worth is that it would be a pity that the arrival of the Adviser in London should be heralded with a row with Sir Charles Holmes'.[4] (Bright had no illusions concerning Hall's lack of tact. 'I shook with terror yesterday', he wrote to Joske, 'when our departing director started a speech, and fear I may be indirectly responsible for its brevity, which however was, judging by its opening sentences, perhaps as well'.)[5]

When Hall sailed, late in February 1934, a curious reversal of roles occurred. For decades he had harboured ever-darkening suspicions of the motives and ability of those who had held the post of Adviser since his own previous appointment in 1905; now the obsessive suspicions from which he was liberated passed immediately into the minds of the Bequests' Committee itself, and especially the Chairman. Levey could not rid himself of the belief that Hall, in Europe, was up to no good, and unfortunately the behaviour of the Adviser did little to reassure him. Meanwhile Shirlow fed mutual suspicions by secretly reporting the Bequests' Committee's confidential business to Hall, who, being an honourable man, was upset by Shirlow's behaviour, but read and kept his letters.

Despite the unwonted jocularity with which Hall set out on his hunting expedition, much frustration and a few successes characterised his second period as Adviser. In London he settled himself in a bedsitter in Tavistock Square, dining each night at a neighbouring hotel. His plans included (surprisingly) dining with Rinder, and calling on Duveen, but after these courtesies he found his task difficult. In May he wrote to Librarian Pitt that he was missing the Library very much; there was indeed some collegiality in the conglomerate Barry had built, allowing the Gallery Director to wander in and read what he chose, without

[3] Hall to Bright, 8 December 1933 (Bright papers). It was agreed he could submit revisions to the schedule after he had 'looked around' in London.

[4] Bright to Sugden, 14 December 1933 and 7 February 1934 (Bright papers).

[5] Bright to Joske, 14 February 1934 (Bright papers).

Lindsay Bernard Hall, 1934 (Jack Cato, photographer, La Trobe Picture Collection, State Library of Victoria)

ticket or delay. 'I am doing very little for the Gallery', he confessed, 'but really, out of the mass of things I come across, there is very little "tip-top". It has all been "raked over" so often, there is only the second-rate left; names only! The cream of it is tightly held in great private and public collections'.[6] He had looked at 'Chinese things', but found nothing special. The first pictures he recommended were minor, and declined; minor also were his first purchases in Paris. In June he wrote excitedly of a small Jordaens and a smaller Tiepolo, found in the collection of an Irish priest. He sought no corroboratory advice; both were bought, and neither turned out to be genuine. He was nevertheless pleased, because elsewhere (he told Pitt) 'he had seen nothing of first rank . . . There aren't any—I believe—We are too late—and Kings' ransoms would be required, if they could

[6] Hall to Pitt, 21 May 1934 (circulated to Trustees).

appear on the scene'.[7] The attribution of a portrait of the *Duchess of Newcastle* to Lely, recommended and bought for £3000 sterling, is also no longer accepted.[8]

Then, in July, in the gallery of Messrs Hoogendijk in Amsterdam, Hall found the great masterpiece he was seeking. On 4 August the London Agents cabled the Secretary of the Felton Committee: 'Hall strongly advises purchase Rembrandt, seen in Amsterdam, seventeen thousand, two feet five by one ten, two figures, most important discovery, cannot hold against competition, he accepts full responsibility'. The next day Hall himself cabled Pitt: 'Authentic find known hitherto by Italian engraving and a sketch Berlin. Fine condition. Have firm offer until you cable decision. Trust me now or never'.[9] Hall later said that he 'regarded this work, if obtained, as the most important of our Gallery possessions'.[10] Trustee Tweddle, then in Europe, cabled that he had seen a photograph of the picture, then called *Two Philosophers*, and approved its purchase; and Lionel Lindsay added 'Authenticity of Hall's find undoubted. Cannot imagine more important acquisition'.

John Shirlow, speaking at a meeting of the Felton Bequests' Committee but as a Trustee, expressed complete confidence in Hall, as a gentleman and an art expert, and reported that the Trustees unanimously supported acceptance of the painting. But Levey would never trust Hall, and the Committee was already disturbed that their Adviser had for months addressed himself only to the Trustees and not his employer (and had not corresponded personally with the Chairman of the Felton Bequests' Committee, as had become customary). They now feared (as Levey later wrote) that Hall's 'artistic impatience' was leading him to overlook 'financial precautions'.[11] Hall's letter of appointment did not make it compulsory to consult Sir Charles Holmes on major purchases, though the Committee had expected him to do so, and a major recommendation supported not by their preferred consultant but by the vendors and two of Hall's friends thoroughly alarmed them. The Committee immediately cabled the London Agents that they

[7] Hall to Pitt, 26 July 1934, quoted in Cox, *The National Gallery*, pp.133–4. Hall joked that Professor Wood Jones, one of his critics among the Trustees, must have been sticking pins into him in his absence.

[8] Some Rowlandson drawings were approved in June 1834, but an Alma Tadema was refused by the Trustees and a copy of a van Dyck equestrian portrait of Charles I by the Committee. Murdoch set out to buy the van Dyck copy for himself—'it would have been magnificent in my hall—but withdrew when the Trustees decided to buy it with other funds; it had however been sold (FBC, 22 June and 6 July 1934; Murdoch to Hall, 2 October 1934).

[9] Hall to Pitt, 5 August 1934 (Trustee company). Cox mis-transcribed this cable as concluding 'Must be now or never', as John Gregory pointed out in Gregory and Zdanowicz, *Rembrandt in the Collections of the National Gallery of Victoria*, p. 18. Gregory discusses the picture itself on pp. 21–43.

[10] Hall to FBC, and Trustees, 17 October 1934.

[11] Levey to Hall, 27 October 1934. Most of the Committee's minutes concerning the Rembrandt are conveniently extracted in a separate document in the Trustee company's papers.

'must have reasonable details and history, and Sir Charles' definite opinion before consideration'. Two days later a further radiogram arrived from Hall:

> Felton business. Price insignificant ... Have financial guarantee from seller, and eulogistic letters from Directors of Hague and Amsterdam Galleries. No better Opinion obtainable. Agreement allows me choice. Consulting unless supporting can accomplish nothing.

The long conflict between the Gallery Director and the Bequests' Committee was coming to its climax, a *High Noon* shoot-out across half the world, again with supporting roles reversed. In the past it had been the Trustees who were suspicious or contemptuous of the Committee's Adviser, but now they were his champion, and the Committee his adversary. The Trustees warned Hall that 'Action relative to Rembrandt delayed pending your reply Felton Committee cable 7th inst. asking information and Holmes' report', but the Agents reported that:

> Hall declines consult Holmes. Posting eulogistic letters from Directors Hague and Amsterdam Galleries. Picture bought in Italy about 100 years ago, after engraving by Pietro Monaco, since owned by English family who sold it to Hoogendijk, proviso name withheld.

The Dutch experts' testimonials satisfied the Trustees, but not the Felton Bequests' Committee, deeply suspicious that Hall, in all his recommendations, was relying almost entirely on his own judgement. (Which was excellent, but instinctive rather than scholarly; commending an alleged van Dyck he was even to state the great common-sense heresy: what did it matter if the picture was not by the artist claimed? ...' The painting's the thing'.)[12]

The Committee sought, for itself, further opinions from London, and resolved to make no decision until they were received.[13] Hall cabled that he had further confirmation of authenticity from Valentiner, the greatest living authority on Rembrandt, and that the Directors of three Dutch galleries had asked for its loan before transit, if bought by Melbourne. A conference was called for 31 August, and Bright, realistic as ever and alarmed that old adversarial feelings had emerged again, wrote to Sugden that while it would be possible to seek counsel's opinion to dispute Levey's claim that Hall's letter of appointment required him to consult Holmes, results were more important than emotions. 'As things stand today, setting aside all personal feeling and all questions of tact and discretion, it looks to

[12] Hall to FBC, and Trustees, 'Letter 1', 14 January 1935. 'Does this failure to identify matter, so long as the picture belongs to its period and [an important proviso] the price proper to Van Dyck is not paid for it?'

[13] FBC, 17 August 1934.

me as though something really good were before the Conference and the question is how to handle it so that the best may come of it.' The major issue was whether the picture should be accepted and when a decision had to be made? The relationship between Hall as employee and the Felton Bequests' Committee as employer was minor, and could wait. 'I hope that the Gallery Trustees will content themselves ... by telling their representatives that they hope that sufficient evidence will be forthcoming at the Conference to justify acceptance of Hall's recommendation'.[14] At the conference on 31 August the members of the Felton Purchase Committee announced that the Trustees had unanimously decided they would accept the picture if the Bequests' Committee approved it. The Committee then voted: Clarke and Shirlow approved, Sir John MacFarland (in the Chair in Levey's absence, ill) dissented; but although the motion was passed the Chairman determined that action would be deferred until the views of its two other members—Norton Grimwade was also absent—were known. Bright's attempt to resolve the issue quickly had been foiled.[15]

Writing secretly to Hall, Shirlow claimed that he, Bright, Longstaff and Sugden had 'argued your case and demolished every objection', so that 'finally it was agreed that the picture be purchased', but Macfarland, 'desiring to back up his absent friend Levey', 'had the whole affair indefinitely postponed'. 'We, who are your friends, very earnestly wish you to stick to your guns'. Levey, he added two days later, was in the country, very ill, and nothing would be done until his return. 'He is 84'—88 in fact—and 'shows all the obstinacy of extreme senility'; and his 'extreme bias was shared (he claimed) by Russell Grimwade (a gratuitous aside, since Norton had replaced his younger brother on the Bequests' Committee in July 1934).[16] Even the moderate Murdoch, who had been corresponding with Hall about acquiring pictures for his own home, told him that the Trustees were 'indignant with the Felton people'. 'Go your way steadily, my friend, undisturbed by these blunders in Melbourne.'[17]

[14] Bright to Sugden, 28 August 1934 (Bright papers).

[15] FBC, 31 August 1934.

[16] Shirlow to Hall, 1 and 3 September 1934 (Hall papers). Shirlow closed by urging Hall to 'sit tight', the 'fervent prayer' of Sir John Longstaff also. He warned Hall that he had 'supplied the enemy with valuable ammunition' by cabling successively that Hoogendijk might make a reduction and 'cannot hold against competition'; 'people here (Levey too) thought this vitiated the honesty of the whole offer'. Hall should be more cautious, 'knowing the class of people you are "up against"'. Evidence of Russell Grimwade's 'shameless bias' was his admission 'from his own lips' that he had never spoken to Hall, but was 'most emphatic' in 'expressing his views on the art side of your purchases'. 'He is a close friend of Mr Basil Burdett ... who has failed as an art dealer in Sydney and now (and for some time past) writes for "The Melbourne Herald"—ultra modern stuff that just fits the (alleged) brains of R Grimwade'.

[17] Murdoch to Hall, 2 October 1934 (Hall papers).

[ABOVE]
Giambattista Tiepolo 1696–1770 Italian
The banquet of Cleopatra 1743–1744
oil on canvas
250.3 × 357.8 cm
Felton Bequest, 1933

[LEFT]
Paul de Lamerie 1688–1751 England
Candlestick, snuffers and extinguisher
1734–1735
silver, gilt
10.7 × 16.7 × 14.4 cm (overall)
Felton Bequest, 1934

[RIGHT]
Rembrandt van Rijn 1606–1669 Dutch
Rembrandt in velvet cap and plume, with an embroidered dress: bust 1638
etching
13.5 × 10.5 cm (plate)
13.9 × 10.8 cm (sheet)
Felton Bequest, 1933

[BELOW]
The Netherlands, Rembrandt van Rijn (studio of)
Rembrandt c.1660
oil on canvas
76.5 × 61.6 cm
Felton Bequest, 1933

[LEFT]
Italy, Florence
Pharmacy jar from the Santa Maria Nuova
c.1430–1450
earthenware (maiolica)
30.9 × 30.8 × 26.0 cm
Felton Bequest, 1936

[BELOW]
Rembrandt van Rijn 1606–1669 Dutch
Two old men disputing 1628
oil on wood panel
72.4 × 59.7 cm
Felton Bequest, 1936

[ABOVE]
Claude Monet 1840–1926
French
Vétheuil 1879
oil on canvas
60.0 × 81.0 cm
Felton Bequest, 1937

[RIGHT]
Paul Cézanne 1839–1906
French
The uphill road (La route montante) c.1879–1882
oil on canvas
61.4 × 74.3 cm
Felton Bequest, 1938

[RIGHT]
Egypt, Ptolemaic period 332–30 BC
Ptah-Sokar-Osiris figure of Hor
wood, pigment, gesso, gold, silver
89.4 × 17.9 × 50.3 cm
Felton Bequest, 1939

[BELOW]
Vincent Van Gogh 1853–1890 Dutch
Head of a man (Tête d'homme) 1886
oil on canvas
33.0 × 40.0 cm
Felton Bequest, 1940

[RIGHT]
Francesco Xanto Avelli,
Urbino Italy c.1486–c.1544
Mucius Scaevola, plate 1534
earthenware (maiolica)
4.5 × 26.8 cm diameter
Felton Bequest, 1940

[BELOW]
Charles Conder born Great
Britain 1868, worked in
Australia 1884–1890,
died Great Britain 1909
Springtime 1888
oil on canvas
44.3 × 59.1 cm
Felton Bequest, 1941

[LEFT]
Italy, Florence
Profile portrait of a lady c.1475
tempera and oil on wood panel
42.9 × 29.6 cm
Felton Bequest, 1946

[BELOW]
Joseph Mallord William Turner 1775–1851
English
The Red Rigi 1842
water-colour, wash and bodycolour
30.5 × 45.8 cm
Felton Bequest, 1947

[TOP]
Chinese
Jar
Neolithic period, Yangshao
culture 2400 BC
earthenware, pigment
36.3 × 39.7 × 35.9 cm
Felton Bequest, 1947

[ABOVE]
Chinese
Mythical animal
Western Jin dynasty
AD 265–420
earthenware, pigment
25.2 × 42.4 × 13.5 cm
Felton Bequest, 1947

[RIGHT]
Walter Sickert 1860–1942
English
The raising of Lazarus
1928–1929
oil on canvas
244.2 × 91.2 cm
Felton Bequest, 1947

The Trustees had some reason to be indignant. When the full Bequests' Committee met it too sat tight, resolving to take no action until London advice was received, telling the Trustees of this decision at a Conference on 14 September. To the Committee's frustration, the London Agents reported that all experts other than dealers were either ill or absent—the usual European August holiday hazard—and suggested consulting Colnaghi's, scarcely a suitable procedure. At another Conference, on 28 September, the Committee members refused to support a resolution from the Trustees that the picture be purchased for £17 000 provided a pedigree covering ownership since the eighteenth century was provided; but after Tweddle returned to strengthen the Trustees with a positive report, the Committee had finally to yield. On 9 October a meeting attended by Levey, MacFarland and Clarke agreed to the purchase, subject to 'vendor's promised guarantee'.[18]

Eight days later Hall wrote an excited letter, this time to both the Trustees and the Committee, explaining the urgency with which he had been forced to act, unintentionally revealing how skilfully the Dutch dealer had fuelled that conviction in his bewitched customer. Hall confessed to being 'racked with anxiety' for two months lest the picture be lost to Melbourne. 'After what happened last year', he had declined to meet Holmes, because 'it would have been useless to expect impartiality from one harbouring petty resentments to my being here at all'. Ten days later, before this letter reached Melbourne, the Bequests' Committee formally moved to reprimand Hall for his refusal to consult with Holmes. Levey's letter—recorded in full in the minutes—conceded that Hall's instructions were 'so worded that in general you were free to do as you thought best', but 'quite definitely we must enforce the principle that this freedom does not extend to a specific request to obtain his or any other opinion on a specific painting', since it was 'plain that we cannot surrender our duty to satisfy ourselves by the means that seem best to us'. Hall's 'artistic impatience' had led him to subordinate the business side' and 'the financial precautions we, your employers, are bound by our legal trust to take'. Levey further complained that Hall's corresponding only with the Trustees 'appeared to indicate that you regard their approval as of greater importance than ours', a feeling sharpened by his failure to take advantage of the 'advice and goodwill' of Mr Sladen Wing. The rebuke concluded with the hope 'that it will never again be necessary to write to you in these terms'.[19]

[18] FBC, 31 August, 12 and 28 September, 9 October 1934. The committee asked that the price paid be A£17 000, but were obliged to pay the full sterling amount (FBC, 26 October 1934).

[19] FBC, 26 October 1934; Levey to Hall, 27 October 1934. Hall had upset Sladen Wing, who had asked in October whether, if the Adviser refused to carry out the Committee's instruction, the London Agents should carry it out themselves; they were told instead to cable immediately such a refusal occurred.

The Trustees, who had earlier tried to fend off suggestions that Hall was obliged to consult Holmes, were infuriated by Levey's action, complaining to the Committee that 'specific instructions' should never have been sent to Hall without their consent, and that it was 'desirable' that they be consulted before such a letter of reprimand be sent. They had (they reported) cabled Hall that it had been sent without their consent, and that they 'would be obliged' if he 'would reply in the most conciliatory way possible'. Shirlow wrote again to Hall, attacking the 'shameless behaviour' of Levey and Macfarland, with 'their sudden enthusiasm to see that the Felton money was being wisely spent! Ye gods!! . . . At Conferences Levey and co take upon themselves to dictate National gallery purchases and policy! This should never be . . . What right (if any) could prompt Levey and Co to call your judgement in question', or to get 'an amateur like Holmes to give an "opinion"'? After another swipe at Burdett as 'an interfering ass', 'in the pocket of Grimwade', Shirlow implored Hall to ignore the letter of protest. 'So far as writing to you or anyone else,—they can go to hell!'[20]

Hall confessed to Pitt that he felt he had to defend himself, but by his standards his letters to Levey were indeed conciliatory.[21] His first was delayed, but on 5 December he confessed that he had been careless in writing to the Librarian without addressing the Bequests' Committee as well, but had always assumed they would receive it. 'I am only now concerned in defending myself from the charge of discourtesy, obstinacy and even insubordination, and sincerely trust that these explanations may help to remove the bad impression I have unwittingly created . . . As it turns out, I admit that I have acted irregularly'. Wing, he added, had been surprised to be mentioned in the rebuke; 'we work together most amiably'. Levey acknowledged the letter with a brusque 'there should be no difficulty in avoiding any further misunderstandings between us'.[22]

Murdoch wrote much more warmly. 'All the trustees hope that you are not worrying unduly about the Rembrandt trouble. We were most indignant when Mr Levey wrote to you, and I hope you have forgotten it . . . You have plenty of good friends here and admirers'. But in December the Trustee company had reported to a Conference that the Agents could arrange (for 40 guineas) for Professor AP Laurie to examine 'enlarged photographs' of the Rembrandt, and the conference agreed 'that all precautions possible be taken' to verify authenticity; Hall would not have been pleased when Murdoch added that 'there seems

[20] Shirlow to Hall, 4 November 1934 (Hall papers).

[21] Quoted in Cox, *The National Gallery of Victoria*, p. 137, note 15.

[22] Hall to FBC, 5 December 1934; Levey to Hall 9 January 1935 (Hall papers).

some doubt about the picture, and if it is wrong you must not take it too much to heart—all of us make mistakes'.[23]

The Bequests' Committee, annoyed by the Trustees' action in openly siding with Hall and writing to him, had begun to consider their response on 22 November—after approving a good Raeburn, *John Guthrie of Carbeth*, located by Hall on the walls of a Glasgow club—but made no reply until January, when they adopted Levey's hard line and threatened to 'reconsider' all 'relationships'. The Adviser was appointed by the Committee, which was at liberty to give any instructions thought 'necessary in the interests of the Bequests'. Correspondence from the Adviser would in future be sent to the Agent, though 'of course' copied to the Trustees, but only as the Committee deemed appropriate.[24]

In London, that winter, Hall felt old, cold and homesick. The world was not as it had been in 1905, when he first spent the Bequests' Committee's money, with their happy concurrence. George Bell, working in Britain, found him lonely and depressed, and asked him to dinner, but he failed to arrive. Perhaps Bell exaggerated Hall's loneliness; his correspondence includes many invitations to dine in London society, and even several entreaties from the young daughter of a widowed friend to attend the many hunts to which she was addicted. On New Year's day he thanked his wife for some raisins, 'which I will enjoy last thing at night, instead of my old friend—an apple', but complained of the Bequests' Committee's slowness in responding to recommendations: 'they seem to think it is easy and that fine things fall into your lap'. In a vigorous letter to the Committee on 14 January 1935 he reported that he had revisited Antwerp for the first time in fifty-four years, and recommended several works; he also repeated (ironically enough) the complaint of all advisers since 1906, that replies from Melbourne were too long delayed.[25]

Recommendations to buy a Guardi and a Gainsborough portrait of William Pitt were received in Melbourne on 15 February, but decisions deferred 'in view of the illness of Mr Bernard Hall', the Agents having cabled that he was 'desperately ill' with double pneumonia. (The same cable gave news that Laurie's report on the Rembrandt was negative, prompting the Committee to ask for reports from 'leading artists such as President Royal Academy'.) On the day of the meeting the Agents cabled again, to say that Hall had died the day before. The

[23] FBC, 7 December 1934; Murdoch to Hall, 29 December 1934 (Hall papers). Murdoch added that Lionel Lindsay had written a good article on the Rembrandt, 'which I published', and had been asked to come to Melbourne 'as art critic for our evening paper; I think he would do a lot for Melbourne taste'.

[24] FBC, 22 November 1935, 17 January 1935.

[25] Hall to Mrs Hall, 1 January 1935 (Hall papers); Hall to FBC, and Trustees (Letter 1), 14 January 1935.

Committee arranged for the London Agents to send flowers to his funeral, but included no tribute in its minutes, and Levey's letter of condolence to Hall's widow consisted of one sentence, of fewer than forty words.[26]

HALL'S DEATH DID not end the conflict over the Rembrandt. Professor Laurie had concluded that the picture was a genuine early seventeenth-century painting, but not by Rembrandt, though painted in his studio; it was probably a copy by a pupil of a similar picture by the master. The Committee received further opinions from Sir John Lavery and Sir Charles Holmes, whose report was different but damning: the painting was a composite work by two collaborators, one Rembrandt, and the other perhaps Jan Lievens, Rembrandt's young studio companion in Leyden. The signature and the date, 1628, he thought genuine. He also thought £3500 to £5000 sterling, not £17 000, a generous estimate of the value of this early work, which he did not admire.

These reports did not greatly worry the Trustees, confident in the judgements of the Dutch authorities. But the Felton Committee believed it had been duped, and while the Trustee company reviewed the legal position it took steps to have the vendor take the painting back, or agree to a reduction in price.[27] Even a cable from the Rijksmuseum asking to borrow it for the Gallery's fiftieth anniversary was seen as a Dutch plot to enhance its value, paranoia concerning the art market having spread from Hall to the Committee, in another reversal of roles. Mr Hoogendijk offered a different picture as a substitute, but stood firm against return or revaluation, and the Committee, advised that its case at law was weak, then reversed its decision against showing the picture in Holland, 'in order to obtain press critiques on the picture which might strengthen picture's reputation or revive claims under the guarantee'.[28] Holmes did uncover, in a meeting with the dealer, the skilfully concealed ownership of the painting, by a syndicate, but that changed nothing; and the episode did little credit to his standing as a Rembrandt authority.[29] The Trustees formally agreed to accept the picture, the Committee

[26] FBC, 15 February, 1 March 1935. Levey to Mrs Hall, 16 February 1935 (Hall papers).

[27] FBC, 19 March, 12 April and 10 May 1935.

[28] Ibid., 24 May, 7 June and 3 August 1935.

[29] Cox, *The National Gallery of Victoria*, pp. 138–9. Mr Hoogendijk stated, in a letter of 24 April, 'that he had consulted all the members of the syndicate, and informed them of the substance of his interview with Sir Charles. They had ironically observed . . . "that a person who means that pears and peaches taste of turnips cannot be convinced of the lusciousness of the fruit"'.

had to amend a minute to certify that it met Felton's criteria, and, in a last fit of pique, threatened to ostracise not only Hoogendijk but all Dutch dealers.[30]

With Hall's death, Levey was determined to cancel any commitments he had not made definite, prompting a sharp exchange with Bright, who thought some worth exploring. Levey's increasingly chilly notes were written in a small abrupt hand on the notepaper of the Melbourne Club, where the old man lived for the last twenty-two years of his life.[31] A few weeks later, when Bright, who had just become President of the Gallery Trustees, wished to suggest that the Bequest make an arrangement for receiving London advice from the National Art Collections Fund—an idea which had been floated before Hall's death—he wrote in May 1935 to Norton Grimwade rather than the overbearing Chairman.[32] Levey nevertheless took up the idea with too much enthusiasm, as Sir Frank Clarke complained in a personal note. In Felton matters these two senior men were both young Turks; Clarke congratulated Bright on taking 'official charge of the Gallery, and I hope to the devil you'll find a way of taking the traditional place of the President as liaison member of the Felton Bequest'. Clarke was 'at odds with Levey' over 'your good notion of the NAC Trust'. Levey had 'jumped too far ahead', cabling Wing to proceed to negotiate with the Fund without detailed instructions; Clarke had prepared a memo of agreement, which Levey did not like, wanting to keep arrangements vague. Clarke sent his draft to Bright, because he could not expect constructive criticism from Norton Grimwade (who shared Levey's prejudices) or from Shirlow (impulsive as ever), and was fed up. 'This Felton business is really the most exasperating work, and were it not for the real worth of the object I would chuck it', the President of the Legislative Council concluded. These years were not the Bequests' Committee's finest; fortunately Clarke recovered his poise, and persisted in the good work for another twenty years.[33]

Later in 1935 London's National Gallery asked to exhibit the Rembrandt, but Hoogendijk objected—he had, he claimed, promised the (alleged) English owners it would not be shown there—and in any case the Trustees wanted it sent

[30] FBC, 13 June, 5 July 1935.

[31] Correspondence, 6–12 March 1935 (Bright papers).

[32] Bright to Norton Grimwade, 2 May 1835 (Bright papers).

[33] 'Neglected all the voyage of our days/Is bound in flats and shallows'. He expected Fordyce to take MacFarland's place, 'and while I like him he doesn't seem an accession of strength to us' (Clarke to Bright, 26 July 1935 (Bright papers)).

to Australia as soon as possible.[34] Early in 1936 the picture arrived at the Gallery, where it soon became a popular favourite. In Melbourne the Rembrandt has had several names: first catalogued as *Two Philosophers*, the two figures were later, unconvincingly, identified as *St Peter and St Paul*, while *Elias and Elisha* had also been suggested. The catalogue now follows the description in the will of the probable first owner, Jaques de Gheyn III: 'twee oude mannekens sitten ende disputeren'. The picture which Hall fought so hard to acquire and Levey opposed so determinedly is now called, appropriately, *Two Old Men Disputing*.[35]

Meanwhile, in 1935, in the absence of an adviser, the Bequests' Committee declined an offered Boucher, *La Courtesan Amoureuse,* for £10 000, and locally a version of Hall's remarkable nude *Suicide* for 300 guineas. They would have made an interesting contrast, if hung side by side at the presentation of Felton acquisitions.[36]

[34] FBC, 25 October 1935.

[35] Ursula Hoff, *European Paintings Before 1800*, 1995 ed., pp. 229–32, discusses the titles.

[36] FBC, 5 July 1935. The Hall was apparently rejected as inferior to the version 'owned by Dr Ewing' (FBC, 7 and 21 June), now—named *Despair*—in the University of Melbourne Collection. *Suicide* is now in the National Gallery of Australia in Canberra.

23

TRIBES AND DIATRIBES

WITH HALL'S DEATH the Bequest needed a new Adviser, and the Gallery (after forty-three years) a new Director. William Beckwith McInnes (1889–1939), Drawing Master in the Art School since McCubbin's death in 1918, had been appointed acting Director when Hall went to London. A virtuoso painter whose heroes were Rembrandt, Hals, Velasquez and Raeburn, McInnes emulated them well enough to win the newly-instituted Archibald prize seven times. In 1936 he was appointed Head of the Gallery School in Hall's place, a post that suited him more than the Directorship, since he had no interest in art politics; it is said that being neither dogmatic nor reactionary he was liked by conservatives and radicals alike.[1]

McInnes had made a few local recommendations, one a miniature portrait of Alfred Felton by Ada Whiting, painted from a photograph. Drawings and paintings by Arnold Shore and other members of Bell's Contemporary Group, modernists not yet flexing the muscle they were to develop, were rejected by the Conference, which bought a Shirlow aquatint and AD Colquhoun's portrait of his mother.[2] Some important overseas acquisitions were made, with Randall Davies' advice, volunteered again; in 1935 he bought for Melbourne twelve miniatures at the Pierpont Morgan sale for £2500, and spent £4942 on some splendid drawings and other items from the Oppenheimer collection in 1936.[3]

[1] On McInnes see the entry by Richard Haese in *ADB*, vol. 10. Of McInnes and his successors, Bernard Smith remarks that 'It is quite surprising at first to think of the number of Australian portrait painters who have continued decade after decade to hold Bernard Hall's old dark mirror up to nature and man in order to reduce them to so many cream and brown patches: but it is a levelling mode of portraiture which a society deeply egalitarian in its sympathies and prejudices seems to have found satisfying for the portrayal of its most distinguished sons and daughters' (*Australian Painting 1788–2000*, p. 191).

[2] FBC, 6 and 20 July 1934.

[3] FBC, 5 July and 16 August 1935, and 15 August 1936; Cox, *The National Gallery of Victoria*, pp. 141–2.

The appointment of a new Director was the Trustees' responsibility (and ultimately the Government's), that of the Adviser the Bequests' Committee's, though they were constrained by past agreements to consult the Trustees. They had scarcely begun to search when, in July 1935, Sir John MacFarland, a member of the Bequests' Committee since 1913, died, and the Trustee company nominated to replace him its chairman, Alexander Stewart (1874–1956), a businessman with links with Felton's partners. Stewart, born in Aberdeen, had been Chief Engineer on an Aberdeen White Star liner on which James Cuming senior's daughter Grace Mary was a passenger in 1900. He later took a discharge in Melbourne, married her, and became a consulting engineer, and a director of Cuming Smith's when his father-in-law died in 1911. By then, like the Grimwades, he had entered the industrial gas industry, and their interests were to merge to form Commonwealth Industrial Gases in 1935, the year Stewart joined the Bequests' Committee. A prominent member of the Collins House Group, who used even his rounds of golf as regular business meetings, Stewart had no great interest in the arts, but strong views on most matters, including, it soon emerged, the Bequests.[4] When, in October 1935, Sir Keith Murdoch also began to appear at conferences as a member of the Felton Purchase Committee, another strong figure joined those around the table; and another, in July 1936, when Shirlow died and the Trustees nominated to his place on the Bequests' Committee their President, Alfred Bright (as Clarke had hoped). For a time there were fewer academics involved in Bequest affairs, and more businessmen, though the Gallery's Felton Purchase Committee included artists among its members.

Negotiations with the National Art Collections Fund had survived Levey's impulsive intervention and continued, rather too sedately.[5] The Felton Bequests' Committee also asked whether the NACF might assist in appointing an Adviser, but in November a Conference was told that the Fund Committee feared a potential conflict of interest if it acted alone as Adviser—they were, for example, a rival bidder at the Oppenheimer sale that year—and did not think it right to act as a selection committee for a new appointment. (Sladen Wing wrote that had they done so they would have recommended Randall Davies.) Negotiations were deferred while other applicants were considered; in November 1935 Wing sent a list of fourteen, including Davies, Burdett, and Phillip Hendy (later Director of London's National Gallery, then directing the City Art Gallery, Leeds).

[4] FBC, 23 August 1935. On Stewart, see John Lack's entry in *ADB*, vol. 12. Knighted in 1937, Stewart's long service on the committee—until his death in 1956—was broken when he resigned on going overseas in 1937; John Fordyce took his place until 1942.

[5] Bright's papers include many drafts of the proposed agreement, considered by a joint sub-committee of Levey, Clarke, Bright and Collins.

Just before Christmas, newcomer Alexander Stewart made his mark by proposing that the Committee seek an Australian as Adviser, 'preferably a man about forty years of age with business knowledge, who could co-opt the best London expert advice', an idea then discussed with Tweddle, newly returned from England.[6] A conference late in January made two decisions: that Norton Grimwade and Murdoch, both due to visit Britain in June, should confer with Wing and Witt and take such other action as they thought desirable, including placing articles about the Bequest in the *Times* to attract interested parties. Meanwhile similar articles would be placed in the Australian press, by Stewart and Bright, to seek out applicants who might meet Stewart's criteria. In February the process was delayed by the death of Sladen Wing, the Committee's quietly influential agent in London for many years. Edmund Sargant, another member of the firm—now Radcliffe and Hood, St Barbe Sladen and Wing—took on his role, though lacking his experience.[7]

'Adviser to the Felton Bequest. A vacancy of national Importance', *Art in Australia* proclaimed in May 1936 over an article by Sydney Ure Smith, which was also printed as a separate pamphlet. By then some local aspirants had come forward, including James Stuart MacDonald, since 1929 Director of the National Art Gallery of New South Wales.[8] MacDonald's elaborate application, finely printed on seven stapled pages of heavy buff paper, was typically outspoken, not least in proclaiming his own achievements. His wartime training as a Camoufleur—'there is much more in it than the mere trompe-l'oeil usually implied'—had enabled him to produce a plan 'for camouflaging Australia's coastal and aerodrome defences', unfortunately not adopted, though 'it will have to be done some day'. His article on 'The need for a Ministry of Arts', written while in a repatriation hospital, had so impressed the Director of Education that he had sent a copy to every State School Principal. The Carnegie Corporation Surveyors were quoted at length on the excellence of his management of the National Art Gallery of New South Wales. *Smith's Weekly* had been right in observing in 1925 that MacDonald was 'in the front rank of the profession as far as publicity is concerned'.[9]

More than half MacDonald's application was an ardent manifesto for the artist as buyer. As an artist, he was eligible to join the great art clubs, unlike the mere 'connoisseur' or 'art writer'; 'such men cannot "live" in the discussions on Art that arise among artists', and had to rely on that 'race apart', the dealers, to

[6] These issues were pursued at conferences and FBC meetings on 30 August, 13 September, 11 October, 22 November, and 5 and 20 December 1935.

[7] FBC meetings and conferences on 29 and 31 January, 14 February and 13 March 1936.

[8] His application was reported at the conference on 8 May. Septimus Power applied a few weeks later.

[9] *Smith's Weekly*, 5 December 1925.

whom they were 'fair game'. Listing all the Directors of London's National Gallery since Eastlake, MacDonald claimed that only those who had been artists had been good buyers, while the present incumbent, Kenneth Clark, though 'an erudite and cultured gentleman' and a 'sprightly and charming writer', had bought no pictures. (He was wrong; Clark, with less to spend than the Felton Bequest's annual income, made some excellent purchases, his only spectacular mistake some spurious Giorgiones). To MacDonald, men like Clark had only 'a head knowledge and cannot relate it to Life or Art'; none but an artist, he insisted, could judge the handling of paint,

> the sign manual of an aesthetic, a spiritual standpoint, an attitude of soul not to be apprehended by the non-painter. The latter may have great love for Art, but it is not his Life, He has not been initiated. He has not done the work to warrant his being given the password.

Apparently the password never changed, and MacDonald's membership of the élite had not lapsed when he had given up painting some ten years before.[10]

Despite MacDonald's assertive advocacy, the Bequests' Committee was not persuaded that the Adviser had to be an artist. Bright's first intervention as a member of the Committee, in July 1936, was to amend, yet again, the minute of July 1933 defining the qualities sought: the Adviser 'should inter alia be a trained critic of art, but not necessarily a practising artist' (amending an amendment made in June, that the Adviser should be a 'single art expert ceteris paribus an Australian' (clearly with some understanding of Latin tags).

Overseas, Murdoch and Grimwade had some difficulty in narrowing their field to two, WG Constable, curator of the Courtauld Institute, and Sir Sydney Cockerell, a very senior figure, famous for transforming Cambridge's Fitzwilliam Museum from (in Bernard Berenson's words) 'a dismal miscellany' into 'one of the finest museum buildings existing'.[11] Cockerell, a lively man who in his youth had toured French cathedrals with Ruskin, been involved with Octavia Hill reclaiming slum housing, and worked as a printer with William Morris at Kelmscott, was interested in the job, though insistent that he did not like interference.[12] Cockerell had been among Rinder's public defenders, and Grimwade and Murdoch, worried that he might accept appointment but soon cause embarrassment by resigning,

[10] MacDonald did give one hint of his buying policy. The Americans had been 'more appreciative' of Continental art than the Australians, who 'had not scoured the Continent for works of art'. He would do so.

[11] Quoted in Cox, *The National Gallery of Victoria*, p. 142.

[12] On Cockerell, see Wilfrid Blunt, *Cockerell*. About to retire from the Fitzwilliam, Cockerell was also attracted by the stipend of £1000 a year.

JS MacDonald, self-portrait (National Gallery of Victoria)

visited him to explain an Adviser's powers and procedures. Grimwade wanted Cockerell appointed, but Murdoch remained cautious, writing to Bright:

> To my mind there is some question about the purity of his taste, and his knowledge of the really great picture; and more question about his capacity to work in with people. He is vain, aggressive, and somewhat quarrelsome. He is 69 years old. His work has been outstandingly brilliant, and we thought we would have no difficulty in saying that of all men available in Britain he is the best, although not better than the best in Australia.[13]

On 21 October Grimwade, returned, reported to the Felton Bequests' Committee, and Stewart and Bright presented a shortlist of the strongest local applicants, including critic Basil Burdett, artist Septimus Power, John G Goodchild

[13] Murdoch to Bright, 21 August 1936, quoted in Cox, *The National Gallery of Victoria*, p. 143.

(an etcher and water-colourist teaching at the South Australian School of Arts and Crafts), and JS MacDonald. Two days later Murdoch also met the Committee and, at a Conference which immediately followed, Cockerell was appointed. He sailed for Melbourne a fortnight later.[14]

THE APPOINTMENT OF a Director for the Gallery did not run so smoothly. MacDonald, was again an applicant, and had strong claims as the incumbent in the parallel position in Sydney (though he had critics there: Ure Smith, an early supporter, found him 'a great disappointment ... his outlook is narrow and biassed ... It is Melbournian'[15]). In Melbourne he had powerful supporters, including Sir John Longstaff, whom he in turn idolised as the paragon among Australian artists, after Streeton's death. But there were many other applicants; Murdoch championed in particular Basil Burdett, whom MacDonald had defeated for the Sydney Directorship; this time Burdett withdrew, probably convinced that he did not have the numbers, and support moved to a compromise candidate, William Hardy Wilson.

Hardy Wilson, earlier noted as progenitor of the Australian Art Association, met MacDonald's own criterion, having studied art under Sydney Long, been Secretary of the Chelsea Art Club and befriended by Lambert and Streeton. Born in Sydney in 1881, and by profession an architect, he had fallen in love with colonial architecture in the United States (as he was to fall for Chinese architecture later, in Peking), and returned to Sydney to write and argue powerfully for Australia to cherish its colonial heritage. In 1930 he had retired to Melbourne, mainly to write. How well suited he was to manage a major gallery must be questioned; he had wide sympathies in art, but as a writer was described as 'a mystic, with down-to-earth moments', and Sydney Ure Smith called him impressive but 'extremely impatient'.[16] At a meeting of the Trustees on 20 August 1936, all but two names were eliminated in a series of votes, and in the final round seven votes were cast for Hardy Wilson and six for MacDonald.

That did not end the matter. The appointment of the Director, a public servant, lay with the Government, which received the Trustees' advice but was not bound to act on it. The Premier was AA Dunstan, leader of the Country Party, holding office with the support of the Labor party. After the Trustees recommended Wilson, much lobbying ensued, MacDonald's champions including his good

[14] FBC, 21 and 23 October 1936. Another Conference on 20 November resolved to postpone consideration of all recommendations until after his arrival.

[15] Humphrey McQueen, 'Jimmy's Brief Lives', p. 180.

[16] On Hardy Wilson, see the entry by Richard E Apperly in *ADB*, vol. 12.

friend RG Menzies—ineffectual, since the ambitious young Commonwealth Attorney-General belonged to a hostile party—and in the outcome James MacDonald was appointed Director of the Gallery, from 1 November 1936. Several among the Trustees spoke of resigning, and Professor Wood Jones did so, on principle.[17]

For his part MacDonald despised trustees, as a tribe:

> Trusteeships are solicited, angled for, by materialists, for the same reason that dogs and cats search for grass, or whatever it is they eat; as a corrective to their usual bloody meals. They pretend, even to themselves, that trusteeship is something selfless, unconnected with gain, unremunerated, unrewarded; but they bring to it the same predatory, gainful, inhuman spirit that gave them their wealth.[18]

MacDonald had always been a controversial figure, outspoken and opinionated. He had strengths as a Director, being a gifted writer and a good judge of a picture—the Bequests' Committee had sought his advice quite frequently—provided the artist was of a school he admired; Humphrey McQueen rightly notes that although by nature combative his tastes were romantic. He was also said to be good company, at least among those whose values and racial origins he did not despise. But his tirades, when in full flight, were grotesque, beyond reason. If, in the long decades since 1904, the Bequests' Committee's relationship with Hall had been a tragi-comedy, in too many acts, MacDonald's years in office constituted an epilogue of black farce.

SIR SYDNEY COCKERELL's visit to Melbourne was a great success. He and his daughter were guests at Government House, a local paper ran a column on his doings—'Sydney day by day'—and he saw Bradman make 270 in a Test. He was less impressed by the National Gallery, as his biographer later reported:

> It was a shocking place ... Quite half the Committee (which was far too large) were totally ignorant—just people who were rich or important. The Director was a slave, and never consulted about anything. I protested: the Director must *direct*. I was disagreeable and outspoken.[19]

[17] Cox, *The National Gallery of Victoria*, pp. 143–4; on Menzies' role, stressed by McQueen in *The Black Swan of Trespass*, p. 26 and conceded as ineffective in 'Jimmy's Brief Lives', p. 180, see Martin, *Robert Menzies: A Life, vol. 1*, p. 200. Wood Jones was replaced as Trustee and as Chairman of the Technological Museum Committee by another distinguished scientist, head of the CSIR, ACD Rivett (Trustee 1937–49). Other new trustees in this period were the artists Alexander Colquhoun (1936–41) and Max Meldrum (1937–44); Labor politician, radical solicitor, and later envoy to Russia W Slater (1937–44); the prominent financier MHL Baillieu (1939–44); and Herbert Wade Kent, Honorary Curator and expert builder of the Asian collection (1938–44).

[18] Humphrey McQueen, 'Jimmy's Brief Lives', p. 180.

[19] Cox, *The National Gallery of Victoria*, p. 144, and Blunt, *Cockerell*, p. 276. Chapter 14 in Part 2 of Blunt's book deals with Cockerell's relations with Melbourne.

It would need the strength of Hitler, he told a friend, to get anything done. In fact Cockerell's greatest contribution as Felton Adviser was to the Gallery itself, rather than the Bequest. His excellent *Report on the National Gallery of Victoria, with suggestions for its rearrangement*, written in Melbourne in January, was outspoken, but surprisingly well received by the Trustees and by MacDonald, and an influence on the Gallery for decades. Cockerell was very critical of the nineteenth-century assumptions on which the existing galleries had been designed and arranged: 'The modern demand is for fewer exhibits, larger reserves, and a higher standard all round . . . the discovery having been reached that museums are made for man, not man for museums'. The collection should be totally reorganised—his recommendations were detailed though concise—but only a new Gallery would suffice. Another great benefactor was needed:

> More than thirty years ago Alfred Felton set a great example. His name shines in the hearts of all Victorian art-lovers, and is honoured in the land of his birth. James McAllan and John Connell must also be gratefully remembered. But to one conversant with the records of American museums, all of modern growth, the list of benefactors is astonishingly meagre.[20]

Why? One reason was the conglomerate organisation, treating 'four unrelated organisations as part of one whole, thus depriving each of them of the dignity of independent existence', so that the visitor 'scarcely knows where one institution ends and another begins'. A second reason might have been its 'depressing' condition: 'pride in the National Gallery has not been systematically fostered and potential gifts and bequests have been withheld'.[21]

The Report was widely discussed in the press, winning praise from Nettie Palmer and Basil Burdett (who followed his 'The problem of the Gallery' with an article criticising the recent erection in front of the building of *The Driver* and *Wipers*, replicas of the Sargeant Jagger statues on the artillery memorial in London, purchased by the Bequest for £3000).[22] The Trustees accepted the report, though Cockerell did not expect much to be done, having reached his private conclusions concerning 'the indolence and ineffectiveness of the Director, MacDonald, and the difficulty of getting decisions from an unwieldy Committee'. No immediate effect was discernible, but almost every recommendation—including the formation of a Gallery Society—was later carried out, as

[20] *Report*, printed in full in Cox, *The National Gallery of Victoria*, p. 411.

[21] Cox, *The National Gallery of Victoria*, p. 145.

[22] *Age*, 16 February 1937 (Palmer), *Herald*, 30 January, 6 and 26 February 1937. The statues are now located near the Shrine of Remembrance.

Cockerell was surprised to learn when Murdoch visited him in 1944 (and surprised also that no one had bothered to tell him.)[23]

Cockerell's meetings with the Bequests' Committee and the Purchase Committee went well. On 18 December 1936 (with Bright, Murdoch, Mackeddie, Collins and Longstaff the Trustees present) he agreed to consider the accumulated recommendations, including the notable Flemish *Le Retable de Ponthoz*, offered for £7788 sterling by Durlacher's in September, which he recommended, after pondering the price.[24] At further meetings in January his letter of appointment was agreed: there would no longer be a schedule; he could make recommendations up to £3000 alone; and for more expensive items would consult the National Art Collections Fund (a provision later amended to provide that he need do so only if Melbourne was interested in the item). Cockerell's own request that he be allowed to buy a suitable medieval manuscript—a field in which he was expert—was approved, though he was warned that 'artistic value' must be paramount in his choice. (He soon found an excellent Livy MS with an impeccable pedigree, having entered the collection of Antoine, the Bastard of Burgundy (1421–1504) through his father Philip the Good and his grandfather, John the Fearless; in March 1937 it cost £3000). Cockerell, who planned to return via Suez, was also authorised to spend £1000 on Egyptian antiquities.[25]

On his departure Levey described the new Adviser's visit as 'of great value', the general opinion. Soon batches of recommendations—each summarised on a new form which included the question 'is the price reasonable?'—began to arrive in Melbourne, the Adviser's neat small hand scarcely concealing the enthusiasm which great works could still arouse in the veteran museum director. Nevertheless Cockerell was to retire after three years in the post, believing that he 'had done no better' than his predecessors, 'all of whom have lost heart, as I have lost it'.

LATE IN 1937 George Bell organised in the National Gallery a small Loan Exhibition of Works of Modern Art by Artists Outside Australia, which included a Picasso owned by Maie Casey, and paintings by Utrillo and Van Gogh lent by Sali Herman.[26] The exhibition, and those organised elsewhere by Bell and other members of the several organisations of younger artists founded in Sydney and

[23] Blunt, *Cockerell*, p. 279: 'I feel that my visit to Melbourne has turned out to be more fruitful than I supposed'.

[24] FBC, 18 December 1936; Cox, *The National Gallery of Victoria*, p. 149. Purchase, eventually for £6500, was delayed until the NACF's approval was received in May 1937. Other works on offer but not pursued after receiving Cockerell's advice included a Whistler portrait of Mrs Sickert, an Alfred Stevens door, Holbein's *Erasmus* and a Gainsborough.

[25] FBC, 15, 28 and 29 January, 26 February and 12 March 1937.

[26] Smith, *Australian Painting 1788–2000*, p. 206; Serle, *From Deserts the Prophets Come*, p. 162.

Melbourne in the 1930s, were consistently berated by MacDonald. 'I think you would feel hamstrung if you were called upon to write on the latest development in modern art here without giving it a kick in the pants', Ure Smith wrote to him later.[27] 'I don't think we should have modern art in the gallery at all. It is not liked by the art galleries of Australia', MacDonald asserted in 1937, during the first of three of those controversial events which occasionally convulse the art world and interest the public at large—the formation of the Australian Academy of Art in 1937; the *Herald* Exhibition of French and British Contemporary Art, mounted in Adelaide, Melbourne and Sydney in 1939; and the litigation in 1944 disputing the award of the Archibald Prize to William Dobell for his *Joshua Smith*—all identified by Bernard Smith as defining points in the confrontation between conservatives in the Australian art world and the diverse movements commonly labelled modernist.[28]

Only the *Herald* Exhibition directly involved the Felton Bequest, but the controversy over the founding, by RG Menzies, then Commonwealth Attorney-General, of the Australian Academy of Art was its prologue.[29] Menzies ambition was to create a means for artists to 'speak with one voice' through a professional association with the standing—and preferably the name—of the Royal Academy. He knew that the art world was riven by difference, but hoped to recruit a broad spectrum of support. Unfortunately, he was colour-blind towards one end of the spectrum, and outspoken in condemnation of it: opening an exhibition of William Rowell's paintings in August 1936, he had berated 'the singularly ill-drawn pictures of "modern" art, described by their authors as having a symbolic value unintelligible to the un-illuminated mind'; to him, there could be 'no great art without great beauty'.[30] His words contrasted—as so often—with those of HV Evatt, opening an exhibition of Adrian Lawlor's work two months before; Evatt, admiring modern art and married to a student of George Bell, complained that Australia lagged far behind the standard of art overseas, chiefly because 'our national galleries are controlled by men who suffer from an immense abhorrence of anything that has been done since 1880'.[31] In April 1937, opening the annual exhibition of the Victorian Artists Society, Menzies caused great offence to

[27] Ure Smith's letter of 2 May 1941 is in the MacDonald papers. MacDonald distrusted both Ure Smith and Burdett as 'Murdoch men'.

[28] *Sun*, 5 June 1937; Smith, *Australian Painting 1788–2000*, p. 207.

[29] On the Academy debate, see Smith, *Australian Painting 1788–2000*, pp. 215–18; Serle, *From Deserts the Prophets Come*, pp. 159–66; Martin, *Robert Menzies: A Life, vol. 1*, pp. 196–9; and McQueen, *The Black Swan of Trespass*, pp. 26–7.

[30] *Argus*, 25 August 1936.

[31] Ibid., 3 June 1936.

members of Bell's Contemporary Group—included in the show by invitation—by claiming that the Academy would, like others overseas, 'set certain standards of art'. 'Great art speaks a language which every intelligent person can understand. The people who call themselves modernists today talk a different language'. The President of the Society rebuked him publicly, and Bell asserted that 'academies have been, throughout history, reactionary influences', setting their faces against experiment. 'Every great artist has been a rebel.'[32] In the art world, and increasingly elsewhere, 'academic' became a term of abuse.

Menzies, accused by MacGeorge of seeking to discipline those whose art he disliked, insisted in reply that 'an Academy should find room in its membership for all schools of thought provided they are based on competent craftsmanship', but added extremely provocative remarks on the 'absurdity' of modern art and 'its cross-eyed drawing'.[33] The stoush became general, and although the Academy came into existence, held inaugural exhibitions in Sydney in 1938 and Melbourne in 1939, and lingered until 1946, it then expired with scarcely a whimper.

In the view of almost all later writers, the conservatives lost the argument. 'The Old Guard', Geoffrey Serle wrote, 'suffered a terrible drubbing'.[34] (For a successful counter-attack, they had to await the Ern Malley hoax of 1944.) In May 1937 Bell was provoked to repeat the common argument that laymen could not judge art: 'just as it would be ludicrous for an artist to argue a knotty point of law, so it is ludicrous for Mr Menzies to lay down what is good drawing and good art'. Menzies' reply is much quoted and derided, even the judicious Serle describing it as 'classically mistaken'. 'I am a typical person of moderate education', Menzies wrote, 'and I hope reasonably good taste, with a lifelong interest in the fine arts . . . with all my individual defects, I represent a class of people which will, in the next 100 years, determine the permanent place which will be occupied in the world of art by those painting today'.[35] It was easy to ridicule such a stance, as simplistic and complacent, and Lawlor's pamphlet *Arquebus* did so very cleverly. Nevertheless Menzies' remark did flag a widening of the gulf between a confident avant-garde, increasingly enamoured of innovation and proud to be rebels, and a bewildered broader public which saw no reason why it should be so

[32] Quoted in Serle, *From Deserts the Prophets Come*, pp. 162–3.

[33] *Argus*, 3 May 1937. Menzies must have learned his critical vocabulary from his friend MacDonald; he had previously in London attacked a Royal Academy show as 'the efforts of untrained inebriates' (Menzies' Diary, quoted in Martin, *Robert Menzies: A Life*, vol. 1, p. 195.)

[34] Serle, *From Deserts the Prophets Come*, p. 161.

[35] *Herald*, 3 and 4 May 1937, quoted in Smith, *Australian Painting 1788–2000*, p. 217.

confronted. Despising the tastes of the common herd is the classic temptation of artistic and intellectual élites, be they of bohemia or Bloomsbury.[36]

The debate over modernism overwhelmed the notion of what constituted a 'work of art', as it had been recently understood in Europe and its diaspora by (for example) Alfred Felton, with his note approving eighteenth-century James Northcote's assertion that 'beauty is a necessity in a picture, and all the best painters have sought after it without ceasing', as if beauty had been an unchanging concept. Periodic 'stylistic disjunctions' have been for many centuries characteristic of European art; what seems to be new in the twentieth century is the frequency of the revolutions in artistic styles and values, and the public rows surrounding them. Nothing comparable had happened when Renaissance craftsmen began painting noblemen, on stretched canvas, as well as saints on walls, though that too signalled profound changes in society and in the sources of patronage for art.

The ferment was complex, and complicated by the politics of the time. The Contemporary Art Society, a broad group founded in Melbourne in July 1938 in response to the Academy row by George Bell (President), Rupert Bunny (artist Vice-President), John Reed (lay Vice-President) and Adrian Lawlor (Secretary), split in 1940 when Bell and eighty-two followers fell out with an increasingly dominant social-realist left-wing faction which was supported by smaller groups ranging from abstract artists to the disciples of Dada.[37] The politics were real enough; but the other arguments have faded. In retrospect, in most controversies over values in art, the battle lines are drawn in sand, and when a few tides have obliterated them the rallying cries cease to have meaning and the works themselves either establish their own authority or, temporarily or permanently, disappear from view. Rinder had a point in wanting to wait for a tide or two before buying for a permanent collection.

No one in the modernist debate of those years yet foresaw the dethronement of painting itself from its primacy among works of art. The existence of photography was quoted as an argument against representational painting, and 'moving' pictures were of course part of popular culture in the 1930s, but the developing technology's potential for the experimental manipulation of images, and the ensuing open slather in constructing installations and devising multi-media happenings, could scarcely be conceived. (In 1938 photography first appeared in the minutes of the Felton Bequests' Committee when HH Newton asked if four photographs

[36] Revulsion against mass culture as a motive force for modernism is the theme of John Carey's *The Intellectuals and the Masses*. 'The purpose of modernist writing ... was to exclude those newly educated (or "semi-educated") readers, and so to preserve the intellectual's seclusion from the "mass"' (Preface).

[37] Smith, *Australian Painting 1788–2000*, pp. 218–21.

could be bought from him. Since he offered to give them to the Gallery if the answer was no, the Committee predictably referred him to the Trustees.)[38] The Gallery had acquired photographs from the beginning, though it did not set up a department of photography until 1967, or appoint a curator until 1972.

Liberation is seldom unaccompanied by new forms of bondage, in twentieth-century modernism's case a new restrictive dogma—by no means limited to art—lauding newness for its own sake and despising the recent past, as if innovation itself had value. When to innovation was added the idea that new art should always shock—a concept reminiscent of an outmoded psychotherapy—Felton's nineteenth-century notion of a work of art as an elevating educative object and a simple source of pleasure was indeed eroded. That was as yet far off; and even further the erosion of modernism's own sharp distinction between progressive and academic art, and the reinstatement to value even of the despised Victorians.

THE FELTON BEQUESTS' COMMITTEE played no public part in the debates of 1938, though sometimes identified as one of the forces of conservatism. For most members of the Committee, and of the Felton Purchase Committee, their newly liberated vision had progressed no further than an urgent search for a good Cézanne, at a reasonable—that is, cheap—price. In 1936 the Bequest had bought Venturi's two-volume *Cezanne* for the Library; 'When I was in Melbourne I was asked, and indeed implored, on many occasions to recommend an example of Cézanne', reported Cockerell, who confessed he did not much like the artist but conceded his importance and conscientiously sought out available works, a task obstructed by MacDonald, who scorned Cézanne and excoriated every example suggested by the Adviser.[39]

In March 1937, reporting on Cézanne's *Nature morte à la commode,* available for £15 000, Cockerell remarked that it was the best he had seen in Paris, but the price seemed excessive, though the market was high; to MacDonald, it was simply an inferior painting excessively priced through a 'dealer's ramp'. A week later Cockerell presented three more Cézannes, offered by Wildenstein and Co. *Vase parelle et Fruits* (£10 500), 'an exceedingly good example', had belonged to Monet;

[38] FBC, 9 February 1938.

[39] Ann Galbally blames the Bequests' Committee's reliance on English advisers for their slowness in acquiring continental contemporary art (*The Collections of the National Gallery of Victoria,* p. 210). 'Self-righteous distrust and ignorance of the developments in European art' were no doubt common in London, as in Melbourne, but most of the Advisers, like Cockerell in this case, seem to have been willing to concede importance to new continental schools, but not enough to justify the prices the works commanded. They also assumed, with justification until the 1960s, that it remained the policy of Melbourne's National Gallery to build a comprehensive collection of British art, giving it priority in all periods.

MacDonald wrote that it could have been painted by any of the students of the National Gallery Painting School. Cockerell commended *Le Viaduc de l'Estague* (£5500) as 'attractive and characteristic': 'It has beautiful colour [though] I am at present rather blind to the tremendous merits of Cézanne, so my judgement is unreliable'. MacDonald, noting it came from Vollard, 'one of the adroitest of the dealers', grudgingly conceded that 'if we are to have a painting by this man, this is as good an example as we are likely to get'. Of the third painting, *La Montagne St Victoire* (£17 500), Cockerell reported that 'Wildenstein's say it is the finest Cézanne on the market . . . I am unable to see that it is worth so much, but this is undoubtedly the present market value'. But the Director wrote that 'this is not a picture acceptable to those who demand fine painting as a requisite to eligibility to a national gallery. It is demonstrably bad painting . . . If there is any attempt at drawing in these trees it is not discernible, and the mountainous background is childish and incompetent'. A Conference in April 1937 rejected the painting 'on the score of price', Murdoch present and concurring; all three were finally rejected by a Committee wary of dealers, and in particular of Wildenstein's reputation for inflating the Impressionist market. Cockerell was told that while the Committee was 'interested in obtaining a Cézanne it is not desired to pay dealers' prices but would rather wait until an example he can recommend is offered privately at a reasonable price'. The Adviser replied bluntly that he was 'unlikely to be able to obtain at a reasonable price a Cézanne which he would recommend'.[40]

Nevertheless in January 1938 Cockerell reported Cézanne's *Sous Bois*, another from Ambrose Vollard's collection, thinking it 'characteristic and beautiful'; he had been shown it by Daryl Lindsay. Burdett, in the *Herald* of 25 January, announced as a major news item that the picture had been bought for Melbourne, rejoicing that the acquisition was 'better late than never'. But 'better never than too early' applies to scoops; the Trustees had indeed recommended the purchase the day before, but the Bequests' Committee, meeting on 28 January, sought the advice of the National Art Fund Committee, which considered the price (£4000) too high, and advised that it would be better to purchase a more important work even at a higher price.[41] (*Sous Bois* did appear in Melbourne, in the *Herald* Exhibition Burdett organised in 1939.)

In May 1938 Cockerell brought forward two more Cézannes; the first, *La route montante*, painted between 1879 and 1882, offered by Wildenstein's for £8750, was 'undoubtedly a characteristic Cézanne and a very good one', though 'due proba-

[40] Conference, 9 April 1938.

[41] FBC, 9 February and 25 March 1938. The (laconic) minutes of FBC, 28 January 1938, appeared to approve a 'picture by Cézanne £4000. Needed immediate decision' but the outcome was not clear.

bly to some defect on my part, I am not so fervent an admirer of Cézanne as it is fashionable to be'. He could not regard the price as reasonable, though 'it is undoubtedly very near the present market price'; he recommended offering £7500. Samuel Courtauld and three other members of the NACF had seen and liked the picture, though the executive had not yet considered it and the secretary thought the price excessive. Cockerell had seen the other Cézanne, *Paysage en Provence* (£4000), in the private house of Captain Cazalet, parliamentarian and dealer, in the company of Daryl Lindsay, who had made a rapid water-colour sketch. (Lindsay was friendly with Cockerell; 'disgusted with his countrymen in the Melbourne art world', he had just commiserated with him on 'the jealousies and intrigues that make things so difficult in Australia'.)[42] They, and 'another artist', thought *Paysage en Provence* more pleasing than the Wildenstein painting, and very suitable for Melbourne. 'It is a beautiful and most attractive Cézanne which would tell well in a gallery'.

MacDonald thought *La route montante,* 'a wretched picture the enormous price of which is due to dealers' and dilettantes' boom'. Being temperamentally incapable of separating the messenger from the message, he lost the plot when he heard that Daryl Lindsay had gone with Cockerell to examine the other Cézanne. *Paysage en Provence* suffered by association.

> The photograph reveals it to be of the usual type of dealer-popularized paintings, and this is borne out by a not-reassuring water-colour by Mr Daryl Lindsay, who seems to have been taken into partnership by Sir Sydney Cockerell. I have written of this before, but I wish to say that I do not take seriously Mr Daryl Lindsay's pretensions to critical connoisseurship. Further, I dare say that a majority of the best artists in Australia would be enraged to learn that he is taking a hand in the selection of pictures intended for the Melbourne Gallery. That Sir Sydney has recourse to such aid will brand him, in the eyes of competent artists here, as being devoid of competency to judge pictures. My candid conviction is that Mr Lindsay has no real convictions, but is purely and simply voguish. He has not the knowledge to say what is good and what is bad. According to "Who's Who in Australia" for 1938 Mr Daryl Lindsay took up art as a profession at age 30. The quality of his painting invites and his opinions (unaided by reference to writers on art) would lead one to believe that statement to be the case.[43]

[42] Recommendations dated 2 and 6 May 1938; Blunt, *Cockerell,* p. 278.

[43] Quoted in Cox, *The National Gallery*, p. 154. After returning to Australia in the 1920s, Daryl Lindsay worked with George Bell, and was sufficiently established as an artist by 1931 for *Art in Australia* to devote a number to him. From about 1931 he was increasingly associated with Murdoch. See the entry on the Lindsay family by Bernard Smith in *ADB*, vol. 10; and Philipp and Stewart (ed.), *In Honour of Daryl Lindsay*.

Perhaps MacDonald's ill temper was catching; the committees were tetchy in response to the recommendation, cabling the Agents that they were 'anxious acquire a Cézanne but Conference agreed that regulations requiring Fund's approval not fulfilled by independent opinion of members however valuable and request that both Cézannes be submitted to Fund with question, which, if either, they recommend as a first class example'. Reporting on 1 July, the NACF Committee called *La route montante* a first-class example, and *Paysage en Provence* a good work, cheaper, and likely to prove more popular in Melbourne. The Committee went for excellence, and the Bequest at last bought its Cézanne, paying £7500 for *La route montante*, as Cockerell had recommended.[44] They do not seem to have considered buying both.

When the painting arrived in Melbourne it was put on show in the Trustee Company's sleek new almost-modernist building at 401 Collins Street, opposite its old boom-time headquarters, and was there presented to the Trustees in August 1938. The presentation programme, after a short essay on the artist, rightly reported that the Bequests' Committee and the Trustees had been 'anxious to acquire for some time an example of Cézanne's work, but the high prices asked have hitherto prevented them from being able to agree on a suitable purchase'. £7500 was a 'considerable reduction', and the picture, from the Fabbri Collection in Florence, had been exhibited in Venice and Cincinnati as well as commended by the NACF. No doubt it was the Director's duty to be present, but his opinion was not recorded.[45]

There was a row over this presentation in 1938. The Trustee company's purpose in exhibiting the latest Felton acquisitions in its new offices was—ostensibly at least—to attract a different public to view them and thus to broaden knowledge of the Bequest and its importance. Twelve hundred people attended the exhibition, but the Gallery Trustees protested that the Gallery was the only proper place to present Felton purchases.[46] In October the Bequests' Committee minuted that it agreed with the Executors

> that a brief exhibition in the heart of the city before presentation may well reach a public whose taste may be thereby cultivated and who might not so readily see the

[44] FBC, 15 July 1938. In all this discussion, no one mentioned that *La route montante* was possibly unfinished.

[45] Cockerell's report was quoted: 'It cannot be denied that [Cézanne] has been the greatest force behind recent landscape art, and he has enormously influenced the modern outlook by his originality and by something of the nature of a new appreciation of atmospheric values. For this reason every gallery of importance either owns or aims at securing at least one good example of his work (*Landscape Painting by Cézanne, acquired under the will of the late Alfred Felton*, etc., Trustee company).

[46] A large (for the time) advertisement for the public to visit appeared in the *Age*, 25 August 1938, and the dispute was reported in *Age* and *Argus*, 23 September.

works of art at the gallery, while it may bring into still greater prominence the national importance of the Felton Bequest;

but in deference to the Trustees it also advised that such an exhibition should be brief, and of selected works only, 'and the actual presentation should be at the Gallery if desired by the Trustees'. One more exhibition was mounted in Collins Street in 1939, but the practice then lapsed.[47]

The stages in the Cézanne epic punctuated proceedings of conferences at which many of the Adviser's recommendations were rejected by the Felton Purchase Committee and a few by the Bequests' Committee, sometimes because the NACF did not support the Adviser. Nevertheless many good things were bought, among them Monet's *Vétheuil*, offered in May by Tooth's for £1625. MacDonald's advice was positive: 'I know Monet's work from the time when he worked at Le Havre ... and feel sure even from the photograph that this painting of "Vétheuil" is a very good one'. Cockerill said that this period was 'now generally considered' Monet's best; 'to painters', the Director could not resist adding, this 'has long been known ... The public and the connoisseurs have just caught up. We should have it'. The Conference asked Cockerell to beat Tooth's down, and he paid £2040 for the Monet and Augustus John's *White Primula*, offered for £750, a reduction overall of £335. The Adviser was always more enthusiastic than the Director: 'I have been to Colnaghi's three times to study it', Cockerell wrote in June 1937 of van Dyck's *Portrait of Philip 4th Earl of Pembroke*, 'and have been left alone for the purpose. Each time I have been staggered by its perfection'. Kenneth Clark, whom he took to see it, 'was amazed by its beauty as well as its condition', but the NACF was less enthusiastic and thought it overpriced, and the Bequests' Committee's approval was delayed.[48] The purchase, for £2500 (£3000 had been asked for, and approved), of Augustus John's full-length portrait of *Chaloner Dowdall as Lord Mayor of Liverpool, in procession with swordbearer*, which Cockerell thought one of the half dozen best English portraits of the century, thoroughly annoyed MacDonald:

> Price need not be considered as the painting is a bad one, and the purchase should not be entertained ... If at £3000 it is a good bargain, why does not someone in England want it? Why, twenty-nine years after it was painted is it allowed to escape the 400 millionaires of Great Britain and come, as a bargain, to us?

The NACF not only thought the portrait a good purchase, but asked that it be exhibited at the Tate before shipment, as the van Dyck had been at the National

[47] FBC, 7 October 1938; Lindsay, *The Felton Bequest*, p. 74.

[48] Cockerell to FBC, 4 June 1937.

Gallery.[49] Other acquisitions included David's *Portrait of a Man* (£760), a pastel *Ballet Dancer*, then believed to be an early Degas (for 2000 guineas, after another Degas was rejected by the Trustees), a Sisley (for £2500, after others had been rejected), 'Old' Crome's *Woodland Path* (£300), Tissot's *Tracing the North West Passage*, Boudin's *Low Tide at Trouville* (£350), Constable's *Clouds* and *Hampstead Heath* (each £400), Houdon's bust of Voltaire (£300), and—perhaps in deference to his Bequest—Chantrey's of Sir Joseph Banks, for £25.

Sir Sydney Cockerell was thicker-skinned than Rinder, and MacDonald's abuse annoyed but did not shake him. Nevertheless he was not happy, distressed by the repeated rejection of Ingres' portrait of his wife, of other portraits by Hals and Renoir ('an excellent example of Renoir of his best period ... Renoir is one of the great French impressionists still unrepresented in Melbourne'), and especially of a set of seven large Burne Jones/William Morris *Quest of the Holy Grail* tapestries, created in 1898–99 for the Australian George McCulloch and now offered by a cash-strapped Lord Lee as a bargain at £2500. (The Committee was interested, but the Trustees were persuaded to reject them by MacDonald, who tactlessly scorned both the works and their creators, once close associates of Cockerell's.)[50] The Adviser asked why his recommendations were so often rejected; the Trustee Company advised the Committee not to become obliged to give specific reasons, though the Chairman could 'give some indication in certain cases', in his private correspondence (which, between Chairman and Adviser, was copious).[51]

Cockerell had deeper disappointments. He had begun by briskly recommending a wide range of acquisitions of good quality, and did not much like being told, in June 1937, to save up for 'greater masterpieces', buying lesser works only if 'for some particular reason extremely desirable'. Later he asked how much he had available to spend, and ultimately agreed that £30 000 was a reasonable sum to keep in reserve for the unpredicted masterpiece. Other differences of opinion are difficult to uncover. Cockerell's biographer suggests that a member of the Bequests' Committee annoyed him by agreeing to pay the private owner of the van Dyck the price originally asked (£12 000), after Cockerell had negotiated a lower (£10 000) with the dealer; in the end the lower price was paid, the dealer

[49] FBC, 22 April 1938. The Conference which approved the John was told of the Trustees' rejection of Degas' *Russian Dancers* (£2600); it also approved 'the late' Paul Montford's *Spirit of Anzac* for £472 10s. Degas' *Madame Malo* (£1500) was rejected by a Conference on 30 June 1939.

[50] The tapestries were considered by FBC on 26 August, 9 September and 1 December 1938. Cockerell also strongly recommended Holbein and Rubens portraits no longer thought genuine.

[51] FBC, 24 June 1937, 25 August 1938.

generously foregoing commission. The injection of yet another committee—the NACF—into an already unwieldy process of approval also added to the Adviser's frustrations, and Cockerell's discontents were such that it required a special effort in November 1938 to dissuade him from resigning.[52]

Sir Sydney Cockerell's biographer suggests that the one achievement of his Advisership of which he was 'really proud' was the 'formation', with Bernard Rackham of the South Kensington Museum, of 'a representative collection of European pottery and porcelain' for Melbourne.[53] In 1933 the knowledgeable but unassertive Percival Serle, his retirement income reduced by the Depression, had accepted appointment as part-time Curator of the Art Museum—for £1 a day, one day a week—but his sensible proposals for the enhancement of the existing collection had been ignored, to his great frustration. 'With the Felton Bequest behind us we could have a delightful miniature Victoria and Albert Museum', he lamented. (He also drafted for the Trustees *Alfred Felton and His Art Benefactions*, a guided tour of the galleries identifying Felton acquisitions, but was pleased that it was published anonymously in 1936 because other hands had added too much puff.)[54] In 1937 MacDonald discontinued Serle's appointment, but Cockerell took up his reports on the collection's strengths and weaknesses with some enthusiasm, and the Bequests' Committee was moved to authorise the Adviser to spend £4000 sterling on European ware, in consultation with Rackham.[55]

One aim was to balance the oriental collections, which were also expanding, under some important new influences, local in origin. Growing up within Britain's far-flung empire offered opportunities, for those equipped to take them, to gain employment within its non-European cultures. Not many Australians were involved in British India, and compared with the vast flow of Indian art to Britain only a trickle went to Australia. The British presence in China was primarily economic, but Melburnian 'Chinese' Morrison had made a career there, primarily as a *Times* correspondent, and some decades later HW Kent followed him, in business with the British shipping firm Butterfield and Swire. Unusually for a collector, Kent's interest in Chinese art preceded his visiting the country: he had become so fascinated by it during his Melbourne schooldays that he made his business career in China in pursuit of his passion. In 1937 he brought his excellent collection back to Australia, presented it to the Gallery, and was appointed

[52] Agents to Trustee company, 27 November 1938; Blunt, *Cockerell*, p. 278.

[53] Blunt, *Cockerell*, p. 279.

[54] Anon [Serle], *Alfred Felton and His Art Benefactions*. The Bequests' Committee approved £50 for the publication on 22 November 1935.

[55] Serle, *Percival*, pp. 40–1; *The National Gallery*, pp. 158–9; FBC, 8 October 1937, 27 January 1938.

Melbourne's first Honorary Curator of Oriental Art, and a Trustee. (He eventually to be followed in both posts by Leonard Cox, who in his history of the Gallery modestly understates his own importance in this field.) In 1938 the Bequests' Committee provided Kent with £1000 (and a further £500 a few months later) to spend abroad, where he happily acquired some of the remarkable bargains available in those years.[56]

In 1938 an Egyptian room was opened in the Museum, with Cockerell's purchases—he had bought nothing in Egypt, but later acquired Egyptian material in London—and in 1939 AS Kenyon, by then Honorary Ethnologist, helped the Bequest acquire seven mummy portraits from New York, for only £400.[57] The remarkable strength of the collections in the Art Museum soon encouraged more frequent gifts from other collectors.

In April 1939 Cockerell told the Committee that he did not wish to serve beyond his term, expiring at the end of October. The Agents suggested that he did not think he was earning his fee, and found the need to get reports from the NACF a hindrance, but his biographer quoted him as saying 'My heart was not sufficiently in this very difficult job to justify an extension'.[58] The Bequests' Committee proposed, and the Trustees agreed, that before seeking a successor they should invite H Edmund Sargant, the London Agent, to Melbourne for discussions. Sargant agreed to come in November 1939, but on the outbreak of war in September cancelled the trip.[59] The war cut short negotiations concerning two paintings by Franz Hals—offered for £50 000 and approved for £30 000, subject to NACF approval—and inhibited further purchases: told by the Trustee company that no funds could be sent overseas except to pay existing commitments, the Bequests' Committee could do little but ask the NACF to watch over Melbourne's interests until controls on the movements of funds were eased.[60] In January 1940 the NACF agreed, and also advised that some exceptional purchases might be possible during the war; the Trustee company undertook to seek permission to transfer funds if such an opportunity arose. The Conference approved these arrangements, and declined—yet again—an offer of assistance from Randall Davies.[61]

[56] FBC, 31 March 1938. On Kent, see the entry by Mae Anna Quang Pang in *ADB*, vol. 15.

[57] FBC, 15 December 1939.

[58] Blunt, *Cockerell*, p. 278.

[59] FBC, 2 and 30 June, 22 September 1939.

[60] The Hals were discussed on 11 August 1939 and £30 000 approved on 21 September 1939.

[61] Conference, 12 January and 8 March 1940. Cockerell also offered to help with specific purchases.

When Alfred Bright retired in January 1938, after much good service, Dr AS Joske became President of the Trust and member of the Felton Bequests' Committee, but died suddenly in September 1939. The Trustees elected Sir John Longstaff to succeed him on the Felton Bequests' Committee, while the Presidency of the conglomerate passed, momentously, to Sir Keith Murdoch, who also succeeded Joske in the Chair at Felton Bequests' Conferences (which had become the main occasions in these years when the Bequests' Committee discussed art, unless they were in serious dispute with the Gallery Trustees and needed to caucus).[62] Murdoch had earlier urged Daryl Lindsay to seek the vacant position of Keeper of the Prints and Curator of the Art Museum, and he was now appointed, from February 1940. Lindsay was already, he later claimed with some exaggeration, 'a sort of unofficial adviser to the Felton', and a closer one to Murdoch himself, having 'bought for him his first three pictures' and guided his increasing interest in collecting thereafter.[63]

Director and President soon clashed. In October 1939 MacDonald prepared a paper on buying policy, taking the opportunity to attack overseas purchases for their lack of quality, his opinions of the adviser system echoing Hall's. 'I am convinced', he wrote with his usual self-confidence, 'that the prime duty of the Trustees is to acquire good paintings, and let periods, schools, sequences etc. take care of themselves'. Convinced 'we must have a Titian', 'we were jockeyed into buying an indifferent Moroni' [sic]. 'We bought for an enormous price a canvas which Rembrandt was too disgusted with to finish; a Raeburn hardly worth looking at; the world's worst Watteau'. 'This has been due', he insisted, 'to the malign influence exerted by dilettanti and the partnership of Bond Street and Fleet Street'. Artists, he repeated, were the only competent judges. 'All that is required of our paintings is that they survive a painter's severe judgement'; and since 'Art has no affinity with philately ... we should have Art without epoch, country, individual fashion, provided it is good art'. The President's comments on the document were scathing, Murdoch quoting MacDonald's own statement of a year before that all his recommendations had been 'done with the object of filling gaps', and attacking his repeated creed concerning the primacy of artists as judges: 'Does Mr MacDonald's own opinion rest upon what he has done as painter? Or as a writer? Or as a dealer? Was not Mr Rinder, the writer, the most successful of our Felton buyers?' Murdoch had his own 'Notes on buying policy', identifying serious gaps, prepared by an anonymous adviser, but none of these

[62] *Herald*, 5 and 21 September 1939. Longstaff was elected until April 1940, when annual elections were to be held.

[63] Daryl Lindsay, *The Felton Bequest*, pp. 44–5.

papers seems to have been brought before a Felton Bequests' conference, or transmitted to London.[64]

If MacDonald did not welcome Murdoch's appointment, he welcomed even less the *Herald* Exhibition of French and British Contemporary Art, a major event in three cities organised on the new President's initiative. After opening in Adelaide it arrived at the Melbourne Town Hall—not the National Gallery—in October 1939. Put together for the *Herald and Weekly Times* by Basil Burdett, this exhibition has attained a status in Australia's cultural history rivalling the 9 × 5 Impressions Exhibition half a century earlier. Modern art had been seen in Melbourne before, but never so much, nor so well presented, and it attracted large crowds, and much controversy.[65]

Burdett showed very remarkable skills of selection and persuasion in bringing together more than two hundred works, from public institutions, private owners and dealers, his list of acknowledgements a who's who of the powerful in art. The French section, under the auspices of the Association Francaise d'Action Artistique and the largest by far, included works from the Louvre and the Luxembourg, from agents Wildenstein and Co and Paul Rosenberg, and from private owners, including Louise Dyer, who lent three Picassos but not her Max Ernst portrait. British owners included the Tate, the Courtauld Institute, Kenneth Clark and several dealers. From Toowoomba, much closer to home, two Sickerts and three Mathew Smiths were lent by Burdett's former partner in the Macquarie Gallery in Sydney, AeJL McDonnell, a name soon to become very important indeed in the history of Felton's Bequests. By including Surrealist and other works then thought extreme, Burdett's selection went far beyond the tastes of his sponsor; Murdoch wrote an enthusiastic foreword to the catalogue, but later complained that he thought Dali's *L'Homme Fleur* 'an obscenity of the first order', and that he had asked unsuccessfully for its removal.[66] The breadth of

[64] The documents, MacDonald's 'Report to Pitt dated 20 October 1939, prepared for a meeting of the Trustees on 15 November 1939', Murdoch's reply (with MacDonald's annotations), and the unsigned 'Notes' which are probably the anonymous adviser's, are in the MacDonald papers; they are also quoted in Cox, *The National Gallery*, pp. 165–8; and see FBC, 3 May 1941.

[65] On the Exhibition, which awaits a thorough study, see Cox, *The National Gallery*, pp. 158–9; Smith, *Australian Painting 1788–2000*, pp. 206–7; and McQueen, *The Black Swan of Trespass*, pp. 36–7). Smith observes (p. 207) that the exhibition 'exercised an influence on Australian taste in the visual arts difficult to exaggerate'; McQueen concedes that 'it was the most important visiting exhibition ever' (omitting from consideration the great nineteenth-century exhibitions), but argues that the *Herald* show arrived 'after the battle [of modernism] had been decided', and that its importance has been exaggerated. A series of public lectures accompanied the exhibition, by (for example) John Reed and Adrian Lawlor.

[66] Murdoch was speaking at the opening of the 1943 Exhibition of Melbourne's Contemporary Art Group; he is quoted in McQueen, *The Black Swan of Trespass*, p. 37.

Burdett's sympathies in art was the antithesis of MacDonald's intolerance; the art world in Melbourne would indeed have been different had Murdoch succeeded in having him appointed Director of the National Gallery in 1936. (His talents were tragically lost to Australia in 1942, when he was killed while serving with the Australian Red Cross Field Force in South-east Asia.)

The Exhibition opened in the Town Hall on 16 October 1939. On 31 October an extraordinary Conference was held there, of the Felton Bequests' Committee (Levey, Norton Grimwade, Clarke, Fordyce and Longstaff) and the Purchase Committee (Murdoch, Elliott, Eggleston, Meldrum, and Kent), with (for once) the Director also present, by invitation. The Contemporary Art Society, which had written to the *Herald* congratulating the paper on the Exhibition, had also (most unusually) recommended, from among works for sale—many of the best were not—nine for acquisition, by Braque, Pascin, Picasso, Utrillo, Van Gogh, Vlaminck (two), Frances Hodgkin and Graham Sutherland.[67] Purchased, they would indeed have made a difference to Melbourne's collection: in MacDonald's view, set out in a report, catastrophic:

> They are nine exceedingly wretched paintings. Those who have followed up the career of the movement of which they are the material, very well know that never in history has such a ramp, as that which has forced them on the world, been engineered. We have seen the advertising efforts that have been made to urge us to swallow this putrid meat. We have been sousled with one bucketful after another of jargon syphoned from Fry, Bell, Wilenski, Clutton-Brock, Freud, Jung and others—and used as if the pictures had to be boosted like a cheap line of socks . . . There is no doubt that the great majority of the work called 'modern' is the product of degenerates and perverts and that by the press the public has been forcibly fed with it. As owners of a great Van Eyck, if we take a part by refusing to pollute our gallery with this filth we shall render a service to Art.[68]

His comments on each picture, and on the mental ill health and immorality of its creator, followed.[69]

The Trustees' Purchase Committee accepted the Director's conclusions, if not necessarily his arguments, and did not recommend any of the nine works listed,

[67] The works were Braque, *La Table de Marbre*, Pascin, *Jeune Fille*, Picasso, *La Petite Cuisine*, Utrillo, *Caserne de Courbevoie*, Van Gogh, *Le Mont Gaussier*, Vlaminck, *Paysage* and *Paysage avec Pont*, Frances Hodgkin, *Pastorale*, and Graham Sutherland, *Landscape*.

[68] Memo on NGV paper dated 30 October 1939 (MacDonald papers) quoted in part in Cox, *The National Gallery*, p. 164.

[69] 'Summed up: All the work submitted conforms to the description given to his own creations by Salvador Dali in an advertisement [in which] he is alleged to have declared that his symbols are suggested by paranoic phenomenon . . . defined it means insanity marked by systematic delusions. With this one can easily and wholeheartedly agree.'

so the Conference could not consider them. In any case Levey, and perhaps others, had received the day before the meeting a much more sober document, unsigned but probably by Burdett, which assessed all the works sympathetically but did not support the Contemporary Art Society's selection. The Braque was by a leading abstract artist 'of great interest to younger people' but dear at £850 sterling; the Pascin was not a good Pascin; and the Utrillo chosen was not the best of the three on show. 'The Tate and Luxembourg have now admitted abstract pictures', Levey was reminded. 'This [the Picasso], of course, is a good one', but it was priced at £1000; and the writer 'personally' preferred other works to the rest of the nine, commending especially Vallotton, Signac and Matisse. Other possibles included Derain, Dufy, Vuillard, Tonks and Ethel Walker, and three sculptures. He offered the Bequests' Committee the services of the *Herald* in negotiating prices lower than those listed.[70]

After much discussion the Committee decided, 'on the recommendation of the Trustees', to buy Van Gogh's *Tête d'homme*, from Captain Cazalet's collection, if available for no more than £2000 sterling, and to 'endeavour to acquire' for £100 sterling *Point de jour* by Felix Vallotton (described in the catalogue as 'a traditional painter of fine attainments and a close friend and associate of Bonnard, Vuillard, and other painters of similar tendency').[71] The Purchase Committee then recommended Utrillo's *Rue à Montrouge*, (or failing that his *Route de Puteaux*), Meldrum asking that his dissent be recorded; the Bequests' Committee, apparently of his mind, rejected both. The Trustees also recommended three sculptures, *Tête* by Despiau, Wlerick's *Du Peintre Peterelle* and Marcel Gimond's *Tête de Madame Gimond* (of which the Luxemburg held a copy), but discussion of them was postponed. They were listed in the minutes of a Bequests' Committee at the end of November, with a laconic 'purchase not approved'.[72]

The two works purchased were a meagre selection from the rich fare on offer, but at least the Trustees of 1939 had done better than their predecessors of 1889, who had bought nothing from the 9 × 5 Impressions Exhibition, and would have quite outshone them had the Bequests' Committee not refused four of their six recommendations. In April 1940 the *Herald* announced that one further work, *Roses au pichet bleu*, by the Fauve André Derain, had been bought 'out of the fund then subscribed by the public for the purchase of a modern work for the Gallery'.[73]

[70] Unsigned letter to Levey, dated 30 October 1939 (MacDonald papers). Burdett had been ill when the exhibition opened, but the writer, who enclosed Levey's ticket for the show, was clearly someone in authority.

[71] In the event the Van Gogh cost only £A2196 5s and the Vallotton £A108 9s 7d.

[72] FBC, 30 November 1939.

[73] *Herald*, 18 April 1940.

The Director's crudities had been too much for one Trustee present, the liberal and proper FW Eggleston, influential as Chairman of the Commonwealth Grants Commission and soon to be Australia's first Minister to China, who thought MacDonald had deliberately set out to frighten the octogenarians on the Bequests' Committee.[74] When the Trustees met on 30 November, the *Age* reported Eggleston's disappointment that no more had been bought than the Van Gogh and the Vallotton, and added that MacDonald's report had caused 'a slight display of feeling'. The *Sun* was more explicit, claiming that Eggleston had accused MacDonald of bias and of making a report 'written in a tone of insulting extremism'; the Director, 'carried away by passion and prejudice . . . had most improperly raked up the private lives of artists who were termed perverts'. The document should be sent to the minister, Eggleston argued, 'as an example of the way in which the director drew his conclusions'. Meldrum suggested it be published instead, AD Colquhoun adding that MacDonald had 'done his duty as he sees it'. Against Eggleston's charge that an artist's private life was irrelevant, MacDonald defended himself by citing, as his source for describing Utrillo as degenerate and a pervert, the extraordinary case of Utrillo versus Manson, when the artist sued the Director of the Tate for saying that Utrillo was dead of drink and drugs, establishing on the evidence only that he was still alive despite them. Murdoch closed the debate, stating his disappointment, and concluding sternly that the 'utter contemptuousness in this report' was 'a grave reflection on the Director'. When Meldrum asked again that the report be published, Murdoch replied simply that 'there is plenty of space in the newspapers for a discussion of this subject'.[75]

The *Argus* obliged. The next day MacDonald defended himself by paraphrasing his report in detail. 'If, as Mr Eggleston said, I have no right to mix a painter's morals with his paintings why have the madnesses, diseases and bad behaviour of Amadeo Modigliani, Maurice Utrillo, Van Gogh, Paul Gauguin and the like been used to advertise their works?' The nine selected by the Contemporary Art Society were examples of work 'made into nine-day wonders, on account of their eccentricities', by an alliance between dealers and writers. 'I disagreed with this utterly, since the paintings themselves showed every sign of the degeneracy so freely cited as a proof that they were worth considering.' He defied any two people to interpret the Braque in the same way; the Picasso had 'no standing in the minds of people who interpret things through the report of their own eyes'; and the Pascin was 'vague and weak'. The Utrillo had 'no recession, no proper drawing' . . . 'its got a

[74] Humphrey McQueen, 'Jimmy's Brief Lives', note 17, p. 253 (quoting Eggleston's 'Confidential Notes').

[75] *Age* and *Sun*, 1 December 1939.

phrenetical look about it. Can't see the "brilliance and breadth" these Contemporary Art people say they see in it'. Vlaminck's two paintings were 'deliberately and theatrically spooky, as if painted by a self-constituted troll, or King of the Kobolds, and meant to scare children'. 'The Van Gogh head which was bought for the Gallery was acceptable to me as something different', he conceded, 'but £1750 sterling!—was a fashion price'. Such paintings did not meet Felton's requirements. 'I have expressed my opinion honestly and without bias or prejudice.'[76]

George Bell's response, defending the nine pictures the Contemporary Art Society recommended against MacDonald's venom, was dignified. The Director had already said in public that he did not understand modern art; 'His inability to assess it must therefore be understood. His integrity is not in doubt'. 'We have a unique opportunity in the Felton Bequest Fund', the President of the Society added. 'Its power for good, and the efforts of a section of the board of trustees, however, seem to be continually nullified by the dead weight opposition of the aesthetically insensitive.'[77] Murdoch wrote to the *Argus*, and Levey to all the papers, with brief but accurate accounts of the Conference's proceedings. Most of the other letters published were fiercely in sympathy with MacDonald's stand, and *Truth*, in an Open Letter, gloated that it had campaigned to have him appointed Director and how wise that had proved.[78] The young Albert Tucker struck a different note: Rembrandt, Steen and Hals had all been drunken brawlers; MacDonald was simply 'determined to preserve the colonial status of our art galleries at all costs.'[79]

The exhibition moved to Sydney, where the National Art Gallery of New South Wales had more will to acquire than Melbourne's but fewer means. The Trustees had refused to mount the *Herald* Exhibition if the cost to the Gallery would be more than £100, and the Exhibition opened at David Jones' store in November. The Gallery wanted to buy a Gauguin for 3000 guineas, but had only £574 to spend on acquisitions (from its Government grants of £3500). The Melbourne Gallery, its President resentfully and not entirely accurately told the press, had £35 000.[80]

BY THIS TIME even MacDonald's friends were becoming embarrassed by his excesses. His appointment was to expire on 1 November 1940, and Murdoch was

[76] *Argus*, 2 December 1939.

[77] *Herald*, 4 December 1939.

[78] *Argus*, *Age*, *Sun* and *Herald*, 7 December, *Truth*, 9 December 1939.

[79] *Argus*, 5 December 1939.

[80] *Daily Telegraph*, 22 November 1939, quoted in G Dutton, *The Innovators*, p. 3.

determined that he not be reappointed. On 28 August the Trustees recommended that the Director not continue, and also that Lindsay be promoted to the position of Director; if the Government insisted on advertising, applications should be confined to Australia. MacDonald had taken much sick leave, but stoutly resisted the President's suggestion he retire on grounds of health; instead he wrote (improperly, by Public Service protocol) directly to the Chief Secretary, exaggerating his achievements and alleging a conspiracy against him. The President, he claimed, opposed him because he had defeated Murdoch's favourite for both the Sydney and Melbourne Gallery appointments, and because he had correctly reported 'his imported show of work as a collection of rubbishy work'. Shown the letter and asked for comment, Murdoch was able to respond on the Felton Bequests' behalf as well as the Trustees', Levey providing him with a letter complaining of MacDonald's 'unmeasured and unjustifiable' comments on the Adviser, which made it difficult for the Committee to work with him. When the Trustees voted again against his further appointment he had no supporters, only Sir John Longstaff, as a friend, refraining from recording a vote.

The Chief Secretary formally sought the opinion of Librarian Pitt, whose judicious summary confirmed that MacDonald had 'alienated the support of his erstwhile advocates on the Board'. 'Outspokenness and fearlessness on the part of a Director is a great attribute, but in this case it has been marred by the personal tone of his reports, and his unjustifiable imputation of unworthy motives.' The Government nevertheless reappointed the Director until the end of the year, and insisted on advertising the post. MacDonald threatened to sue, and turned up for work on 2 January, to find his office locked against him. Among the thirteen applications received in response to the advertisement was one from JS MacDonald himself, his elaborate curriculum vitae brought up to date.

Daryl Lindsay was appointed Director, as the Trustees wished, from 26 March 1941. In London Sir Sydney Cockerell was pleased to hear that MacDonald 'had been replaced by the deaf but excellent Daryl Lindsay, a first-rate choice'.[81] With a new Director, Murdoch as President, and the nonagenarian Levey moving serenely towards his close, Felton's bequest and the gallery it served were poised to take new initiatives once the war was over, and to prepare for them even while it continued.

[81] Blunt, *Cockerell*, p. 279.

24

RECONSTRUCTION

Worl War I broke out unexpectedly, and was thought likely to be brief; as it dragged on, preparation for the peace which was to follow was tardy and fragmentary. In 1939, war had long been foreseen, and almost from its beginning much thought was given—though with varying degrees of enthusiasm—to a post-war world not merely restored but reconstructed and reformed. For Melbourne's Public Library, Museums and National Gallery the process went further than planning, and even before the war's end new legislation had dismantled the conglomerate institution and replaced it with independent Boards of Trustees for Library, Museums and Gallery, a change which radically altered the circumstances in which Felton's art Bequest operated. The charitable Bequest was also profoundly affected by the emergence after the war of what William Temple, then Archbishop of York, had been among the first to call, in 1941, the welfare state, though the effects were not immediate.

In the Gallery, the planning process did not begin at once. MacDonald remained in office until the end of 1940, though on sick leave for much of the year. During his absence Lindsay, as Acting Director, put into effect many of Cockerell's recommendations for the re-arrangement of the galleries, with the eager assistance of Serle, who found this the happiest period in his long association with the Gallery. MacDonald later complained that Lindsay had ruined some of the best ideas he claimed he had fed to Cockerell, but by November Norman MacGeorge could write with satisfaction that for the first time the Blakes were properly displayed.[1] Unfortunately, in the reorganisation, many of the Gallery's

[1] *Herald*, 12 November 1940. MacDonald's papers (NLA MS 430/4/1) include a photograph of the new Octagon Room 'urged by me'; 'when D Lindsay took charge he ruined it'. He also complained of 'Murdoch's obsession' with railings in front of the pictures. On Serle's involvement, see Geoffrey Serle, *Percival Serle*, pp. 42-3.

early acquisitions—sculpture, paintings, artists' frames and decorative art works (including Tiffany glass, later re-acquired at great cost), material little valued by MacDonald and despised by Lindsay, was disposed of, in three infamous auctions.[2] It was at this time that the proposal to convert the so-called spear gallery (which the Museum had used for weapons) into a series of 'period rooms'—each filled with the paintings, furnishings and ornaments of a particular time, a concept Hall had written about in 1933—was brought before the Bequests' Committee by the Trustees, foreshadowing requests to buy suitable furniture.[3]

Despite the war, the Bequests' Committee continued for some time to make small purchases from funds held in London, and to contemplate major acquisitions, though the works actually acquired were held in Britain after one Rembrandt etching was lost at sea through enemy action.[4] In May 1940 Chinese material from the Eumorfopolous collection was purchased on the initiative of Kent and the London dealer EE Bluett (later made an adviser for oriental art).[5] The arrangement for receiving advice from the National Art Collections Fund continued, though Sargant—who was henceforth given £200 a year for his 'valuable work'—seems to have had reservations concerning its suitability.[6] A rumour that the British Board of Trade was completing a scheme to gain foreign exchange by selling off 'Britain's redundant treasures'—echoing the Hermitage sell-off—proved unfounded.[7]

When he became Director, Lindsay clearly had an easier relationship with both committees than his predecessor, though it was not until March 1942 that the Trustees recommended that he attend Felton Conferences. (The Bequests' Committee agreed, remarking primly—and inaccurately—that it was the Felton Purchase Committee which had objected to the Director's attendance in the past.)[8] Committed, like Murdoch, to the concept of period rooms, Lindsay took a

[2] On the auctions, see Galbally and Inglis, *The First Collections*, p. 81. Some of the frames were recently discovered in the monastery at New Norcia, and restored to the paintings.

[3] FBC, 11 October 1940.

[4] *Christ Crucified between Two Thieves* was approved at FBC, 11 October 1940; the Committee was informed of the loss (identified as *The Three Crosses*) on 6 June 1941, and of the insurance payment of £742 on 14 November 1941. Another Rembrandt etching, *Christ Presented to the People* (£500) had been approved by the FBC, on 17 May 1940. A second *Christ Crucified between Two Thieves* was bought in 1948.

[5] Conference, 17 May 1940 (which also discussed and deferred a collection of Maori artefacts, ultimately rejected by the FBC, on 7 June).

[6] At the FBC meeting on 26 April 1940 Levey referred to a personal letter received from Sargant, but its contents were not recorded. The decision to pay Sargant (now of Radcliffe's and Co) was made on 22 August 1940.

[7] HW Kent raised it at a Conference on 13 December 1940, but a Conference on 23 January was told the scheme was 'indefinite'.

[8] FBC, 19 March 1942. Lindsay was, however, still required to present written reports.

strong interest in acquiring works other than paintings, and in June 1941 a Conference accepted his proposal that the NACF be given £600 to buy drawings and water colours in Britain, in accordance with guidelines laid down. In November it was agreed that selection be made by Professor Randolph Schwabe, successor to Tonks at the Slade School, and Sir Walter Russell, Keeper of the Royal Academy, if the NACF agreed.[9] In February 1942 Murdoch, about to visit Britain, offered to seek out a London adviser on furniture, returning in May with a proposal, supported by Kenneth Clark, to appoint the outstanding expert in the field, Ralph Edwards of the Victoria and Albert Museum, and to invite him to Melbourne to advise on period rooms. But the Conference had turned cautious, sobered perhaps by the calamities which followed Pearl Harbor; in February they had suspended the purchase of prints in London, and now refused Murdoch's request to resume them, also deciding that the time was not right for Edwards to visit. The Bequests' Committee suggested he be sent plans of the spear Gallery instead; but did decide to support period rooms in principle, confirming, after consideration, that it could properly spend Felton funds on furniture. Edwards, and his superior Sir Leigh Ashton, Director of the Victoria and Albert, were formally appointed Advisers for furniture, glass and works other than pictures.[10]

The suspension of print buying in February 1942 was perhaps surprising, since the Conference was at the same time stalking bigger game in London. In October 1941 it had authorised the NACF to bid for Canaletto's *Westminster Bridge* (though only if it was 'exceptional', since Melbourne already had two Canalettos—or thought it had: one was 'studio of' and the other a Bellotto—and was 'not particularly anxious to acquire more'). In April 1942 it approved bidding up to £3500 for Hogarth's *Staymaker*, to be auctioned in May, subject to the Commonwealth Bank's agreeing to transmit the funds. The Bank refused, citing wartime regulations, and the Committee consequently dropped further consideration of a Renoir *Nude* (£2500), a second Monet *Vetheuil* (£2000) and Pissarro's *Pont Neuf en Hiver* (£1000), all commended by the NACF, which drew the reasonable conclusion that its services were no longer required. The Conference begged the NACF to continue to watch out for opportunities. The Bequests' Committee had a frustrating time unable to spend its rapidly accumulating funds while bargains went by; in December 1944 reserves in the art fund reached £170 475, not a great deal less then Felton's original capital endowment.[11]

[9] Conferences, 6 June and 14 November 1941. On Bluett's appointment, see Lindsay, *The Felton Bequest*, pp. 46–7.

[10] Conferences, 20 February, 8 May and 4 June 1942, FBC, 3 and 10 June 1942. (At the meeting on 3 June Stewart returned to replace 'the late' Mr Fordyce.)

[11] Conferences, 24 October 1941, 24 April and 8 May 1942. The NACF affirmed its willingness to continue observing in August 1943.

Although overseas purchasing was interrupted, local acquisitions by the Bequests' Committee continued throughout the war. Australian works recommended to the Bequests' Committee by MacDonald before the war had always been predictably conservative but generally of good quality, ranging from Buvelot and Conrad Martens through McCubbin to the young Lloyd Rees, and his 1940 recommendations included McCubbin's *Lost*, Roberts' *The Sunny South* and paintings by Streeton, Gruner, Shore, Amalie Colquhoun and her husband AD Colquhoun.[12] Lindsay's local recommendations, after his accession as Director early in 1941, were not all Australian. Three Swabian wooden sculptures, circa 1500, from the Ullman (Ullin) collection, dispersed after Hitler came to power in Germany, were acquired from members of the family in Melbourne. A portrait of the First Duke of Wellington, thought (wrongly) to be by Sir Thomas Lawrence, was bought locally, as was a fine head of the Buddha, from Borabadur, acquired on the strong recommendation of the refugee ethnologist Dr Leonhard Adam, author of *Primitive Art*, soon to be given a haven in Melbourne University's History Department.[13]

As Director, Lindsay assiduously attended exhibitions in Melbourne and Sydney, and reported on them. In August 1940 the Trustees adopted Sir Frank Clarke's proposal for an annual prize exhibition for Australian works, an echo of Adelaide's defunct Federation Exhibitions but more closely controlled. The Bequests' Committee was asked to join in mounting the competition, but was advised by the Trustee company that such activities were outside its powers; indeed it was told neither to approve nor disapprove the idea, nor even to comment beyond stating a willingness to consider any consequent recommendation to purchase which the Trustees might bring forward.[14] The competition rules, when it was eventually mounted late in 1941, were detailed: an artist could enter no more than two recent paintings (either oil or water-colour) 'of the standard of works already in the Gallery'; up to ten pictures from each state were to be preselected, by the Gallery Trustees in Sydney and Adelaide, and in Melbourne by the Felton Purchase Committee assisted by Sir John Longstaff. For the first competition the field specified—'Australian Subject Picture'—was conservative, in a

[12] Conferences, 19 July and 16 August 1940. In July 1937 MacDonald's recommendation to buy two paintings by his hero Longstaff was opposed at the Trustees' meeting by the artist himself, who thought them too similar to works already held; the issue was referred to a Conference, which, with Longstaff present, bought one but not the other (*Argus*, 30 July 1937, Conference, 30 July 1937). The picture bought was a portrait of Mrs Reginald Bloomfield.

[13] The Bequests' Committee first considered the carvings in December 1940, but did not agree to purchase them until October 1941. The 'Lawrence' (£157 10s) was approved by the FBC on 6 May 1943 and the Borabadur Buddha (£200) on 21 July 1943.

[14] FBC, 22 August 1940; the Trustees' proposal was pasted in the Minute Book, with all references to the Committee blacked out.

conscious attempt to revive work other than landscape or portraiture: works were to portray episodes or characters of history, mythology, poetry, action and romance, and single figures were permitted only if they exemplified some emotion or story. In October 1941 the £500 prize was won by Ernest Buckmaster, already and for decades thereafter a prolific and outspoken opponent of modernism; his *Jolly Swagman* was approved for acquisition by the Bequests' Committee, together with entries by John Rowell and Septimus Power.[15] In September 1942 Lindsay, Louis McCubbin (Director of the Adelaide Gallery) and Will Ashton were appointed to judge the second 'Annual Exhibition of New Painting by Australian Artists', but they thought the field weak and awarded no prizes, though finding Harley Griffiths' *French Window* worth acquiring for eighty guineas. Disappointed, the Trustees dropped the competition.[16]

The Exhibitions of the Australian Academy of Art also disappointed, the Felton Purchase Committee declining to recommend pictures by AD Colquhoun, Dargie, Feint and two others selected by Lindsay from the 1941 Exhibition. Lindsay recommended four pictures from the 1943 Exhibition, but the Conference approved only a Percy Watson, the Trustees rejecting one picture and the Bequests' Committee another two, including Frater's *Red Hat*; fortunately the artist soon after offered it privately, for 50 guineas, and one of the Gallery's most popular pictures—once described as 'Australia's *Mona Lisa*'—entered the collection.[17] The Bequests' Committee had no part in the Gallery's acquisition of the two prizewinning works in the 1941 Contemporary Art Society Exhibition, both uncompromisingly surreal, Eric Thake's *Salvation from the Evils of Earthly Existence*, and *We inherit the Corrosive Littoral of Habit*, by the brilliant young James Gleeson. The Trustees accepted them from an anonymous donor only on condition that they need not be exhibited, and hung them in the so-called Print Room, which Cockerell had condemned as 'a combination of a workshop and a parcels office . . . subject to a plague of dust . . . a makeshift unworthy of a great institution'. Its days, unlike modernism's, were numbered.[18]

[15] FBC, 13 October 1941; Lindsay, *The Felton Bequest*, pp. 74–5; Cox, *The National Gallery of Victoria*, pp. 170–1.

[16] Conferences, 3 September and 1 October 1942. Murdoch gave a public explanation why no prize had been awarded in the *Herald*, 21 November 1942.

[17] Conferences, 6 June 1941, 21 July and 2 September 1943. 'Here is Australia's *Mona Lisa*' headed Arnold Shore's article in *Australia Post* on 3 July 1952, reporting that the picture was on loan to Longbeach, California, for an exhibition seeking the best twentieth-century portrait of a woman. 'Jock and I were the first professional painters in Melbourne to "go modern"', Shore claimed.

[18] Cockerell's Report, printed in Cox, *The National Gallery*, p. 416. See also Reid and Underhill (ed.), *Letters of John Reed*, pp. 145–6. John Reed now dominated the CAS, and his wife Sunday's cousin, (Dame) Merlyn Myer, had funded the prizes at the CAS Exhibition; she might have been the anonymous donor.

Rebuilding the Print Room and expanding its collection—selflessly looked after by Percival Serle among his other services to the Gallery—was a high priority for Lindsay. Soon after his appointment the Bequest Committee purchased, in Sydney on his recommendation, two further lots of prints (114 for £313 and 96 for £203); and in 1943 he was able to appoint as acting Assistant Keeper of Prints and Drawings a brilliant young scholar, one of the first women to make a major career in art history, Dr Ursula Hoff. Born in London in 1909, daughter of a German-Jewish businessman who spent much time in Britain, Ursula Hoff studied at the Universities of Frankfurt, Cologne and Hamburg, where she gained her doctorate. In 1933, after Hitler's accession to the Chancellorship, the family moved to London, where she undertook further studies but could not, as a young woman, find permanent employment in competition with the senior male emigré scholars who were to so greatly enrich art-historical scholarship in Britain and the United States. Working as a research assistant, Hoff published articles on seventeenth-century artists, including Rembrandt; and first heard of the Felton Bequest when Randall Davies bought Rembrandt and Andrea del Sarto drawings for it at the Oppenheimer sale in 1936. In 1939 she came to Melbourne as Secretary to the newly-established University Women's College, after the College had decided to invite a Jewish refugee to the post.[19] MacDonald had no interest in German art-historical scholarship, but the young scholar came to Medley's notice, and to Lindsay's, and in 1943 gave a notable series of lectures to large audiences at the Gallery. John Reed, who had little interest in art by anyone other than his friends, liked them no better than MacDonald, but Lindsay made a position for her, and in December 1943 persuaded the Bequests' Committee to approve an extra £500 to be spent on prints, either in Australia or London.[20] Two months later the Committee resolved that circumstances had 'sufficiently improved' for Schwabe and Russell to resume spending the rest of the £600 granted in 1941.[21] With the appointment of Hoff, the Gallery's tiny professional staff gained a scholar who rose to world standing, and whose role in the Gallery, in the affairs of the Bequest, and in art scholarship in Melbourne was to be of crucial importance for the rest of the century.

The Bequests' Committee continued to approve, normally on Lindsay's recommendation, a steady succession of Australian works, including, in 1941,

[19] Cox, *The National Gallery of Victoria*, p. 194; Anderson, 'In Homage to Ursula Hoff on her Ninetieth Birthday', pp. 250–7. Dr Hoff, British by birth, was not formally a refugee.

[20] 'She might just as well have been talking about a plumber', Reed wrote to Sunday. Tom Seward 'said wasn't she good and I said no, bad and that she failed to get any feeling through at all . . . Daryl looked aggressive and unpleasant' (Reid and Underhill (ed.), *Letters of John Reed*, pp. 203–4).

[21] FBC, 2 December and 10 February 1944.

three—*Lost*, *The North Wind* and *Self Portrait*—by 'the late Mr McCubbin'; in 1942 three Longstaffs (soon after his death) and works by Conder, Clara Southern, Phillips Fox, Will Ashton and Streeton; and in 1943 some minor works (including one by Professor Schwabe) bought at the auction of the late Basil Burdett's collection. Some acquisitions must have worried Sir Frank Clarke, prompting him in May 1943 to request, rather stuffily, a reaffirmation—necessary he thought 'owing to changes in the personnel concerned in the recommendation and acceptance of works of art'—of earlier agreed statements on the quality required in both overseas and local purchases. The Trustees ignored his call for some time before denying, in August, that the standard required of Australian purchases had been 'departed from'. Two days before, Lindsay had recommended, from the Artists' Society Exhibition in Sydney, works by Arthur Murch, Douglas Annand and Hal Missingham. A month later the Bequests' Committee seems to have refused to buy a portrait of Dr Will Maloney—the redoubtable former MHR who had encouraged Barnett to offer Melbourne an exhibition of French Impressionists—painted in Europe by his friend John Peter Russell in 1887 (a year after Russell had painted another young friend, Vincent Van Gogh). The portrait was now offered, after Maloney's death in 1940, by his former secretary, for 150 guineas; despite the Committee's refusal it entered the collection in 1943, paid for by the Trustees from other funds.[22]

In 1943 the Gallery produced a printed catalogue, belated fruit of MacDonald's intermittent labours, listing all its works with brief details of the artists. Included in the volume was a list of publications for sale, extremely modest by later standards but some indicator of public popularity. The six 'coloured reproductions' listed (6d each) were of the van Eyck *Madonna*, van Dyck's *Earl of Pembroke*, Memlinc's *Pieta*, Raeburn's *Wardrop*, Corot's *Bent Tree* and Harold Herbert's *Blue Hills*. The coloured postcards (2d each) offered Streeton's *The Valley from Kennon's*, Longstaff's *Gippsland, Sunday Night*, Phillips Fox's *The Arbour*, Augustus John's *White Primula*, Tissot's *Tracing the North West Passage*; and a photograph of the front of the building itself. The monochrome postcards (1d each) offered Boehm's *St George and the Dragon*, Frémiet's *Jeanne d'Arc*, Lambert's *Sergeant of the Light Horse*, JW Waterhouse's *Ulysses and the Sirens*, and penny-plain versions of the van Eyck and the Corot. Apart from the three acquired before 1905, all the works illustrated had been purchased by the Felton Bequest. Gleeson and his ilk were not yet even in the queue.

When Sir John Longstaff died in October 1941, the Trustees elected Meldrum to the Felton Bequests' Committee in his place. Always idiosyncratic,

[22] Conferences, 4 June 1942, 26 May and 16 August 1943; FBC, 18 August, 7 September 1943. On the Russell portrait, see Galbally and Sloggett, 'Duty points to Paris'.

at an earlier Conference he had made an unexpected proposal that the Bequests' Committee buy numerous copies of old masters to fill gaps in the collection, and to serve as examples to local artists. The suggestion would have won support in the 1860s, but was not pursued in the 1940s. The Conference did buy a Streeton and a Lambert on his recommendation in 1942.[23]

THE GENERAL PATTERN of the Bequests' charitable distribution, still closely supervised by Levey, continued after 1939, but with increasing attention to new causes related to the war. The minutes for November 1939 unusually recorded some of the requests received and Levey's reaction to them: he recommended that the Old Colonists receive the extra £50 they asked for, but responded to the Ladies Benevolent Societies' request for £345, and the Invalid Aid Fund's for £225, with only £5 each. After distributing £9178 in November, in January 1940 the Committee made a special grant of £2000 to the Royal Melbourne Hospital towards its rebuilding near the University (buildings completed just in time for the American Army to occupy them—as they occupied nearby Royal Park with a city of huts, Camp Pell—when General Macarthur established his headquarters in Melbourne in 1942; the complex continued to be the Americans' major hospital in the South West Pacific for some time, the Royal Melbourne Hospital remaining in its old buildings next to the National Gallery until 1945). In May 1940, when each fund received £12 000 from the Trustee Company, the Committee distributed £10 473 to charities, including (among £1970 in special grants) £500 to the Red Cross (Victorian Division, as required by the will) and £200 to the YMCA's National Army and Navy Committee. In August special payments were made to the RAN Patriotic Committee for Navy House, and to the RAN Relief Fund.

In December 1940, when £10 201 was distributed, the Australian Comforts Fund (Victorian Division), the AIF Women's Association and the Work to Win Campaign (for Nurses) joined the list of regular recipients of special grants, as did Navy House, Blamey House and Air Force House. In June 1941 the British War Orphan Fund (for children evacuated to Australia) shared in special grants totalling £1270; in December 1941, when each Fund received £12 500, some regular maintenance grants were pruned to increase the level of special grants to £3785 (including the RAN Relief Fund's special appeal), but £100 was still found for 'Christmas Cheer' at the Old Colonists' Homes. From June 1942 the grants to 'War Charities' were listed separately among the Special Grants, which

[23] Conferences, 5 May 1939, 13 March 1942.

rose to a peak of £5010 in December. In December 1943 the Women of the University Patriotic fund received £50, as did the Order of St John, for work at the Heidelberg Repatriation Hospital; a month later the Committee held a special meeting to vote £700 to appeals for relief after the bushfires of January 1944.[24] The Bequests' Committee's charitable grants thus continued to respond to local needs, and to reflect and support the pattern of Victorian private charitable activites as they, in turn, were organised for war.

Early in December 1944 an acquaintance saw James Levey, dapper as ever in spats, gloves and bowler hat, though a little less spry than usual, walking from the Melbourne Club down Collins Street to a meeting. On 6 December he presented to the Bequests' Committee, as he had for decades, his recommended distribution to charities, of £10 785, including £1900 in special grants (including the now customary £500 each to the Red Cross and the Comforts Fund). The next day he chaired a Conference, which received reports of drawings arrived from Schwabe in England and agreed to buy Lambert's *With the Light Horse in Egypt*. But as the meeting ended he collapsed, and four days later died, nineteen days before his ninety-eighth birthday. (He had been 'retired' for forty-eight active years; the government of 1896 had made a bad bargain in refusing him a lump sum and insisting he take a pension.)[25] At a special meeting on 20 December Norton Grimwade, 'unanimously elected Chairman', observed (inaccurately) that Levey had been born in the year Norton's father and Felton formed their first partnership (in fact Felton was only fifteen, and still in East Anglia, when Levey was born in Surrey). The question of replacing him on the Committee was postponed, but not for long; meeting on 24 January 1945 the Committee appointed a very distinguished Australian indeed to take Levey's place, the country's leading jurist, Sir Owen Dixon.[26]

Born in Hawthorn in 1886 to a barrister father forced to quit the bar through deafness, Dixon studied law and classics at Melbourne University and by the 1920s dominated the Melbourne Bar, his legal brilliance and style especially effective in cases before the High Court and the Privy Council. Having refused appointment to the Supreme Court because he thought hanging 'barbaric', he

[24] FBC, 1 December 1943 and 20 January 1944. From June 1944 the War Charities were no longer listed separately, probably a decision of a new secretary rather than the Committee.

[25] The acquaintance who saw him in the street wrote an obituary in the *Hospital Magazine*, January 1945. The obituaries in the *Argus* and *Herald* (12 December 1944) and the *Age* (13 December), and a note in the *Bulletin*, all say he was almost ninety-nine, but since he had been born on 30 December 1846 he was still ninety-seven when he died.

[26] FBC, 6, 7 and 20 December 1944, 21 January 1945. On Dixon, see the entry by Daryl Dawson and Grant Anderson in *ADB*, vol. 14, and Philip Ayres, *Owen Dixon*, MUP, 2003.

joined the High Court bench in 1929, aged forty-two. In 1942 he reluctantly accepted appointment as Australian Minister in Washington, a post made more difficult by his poor relationship with HV Evatt, once his (despised) colleague on the High Court and now Minister for External Affairs. Dixon resigned from Washington in September 1944 to return to the High Court, which he was to lead from 1952 until 1964. He brought to the Bequests' Committee intellectual stature, integrity, humanity and a sharp wit, but no special knowledge of charity nor broad tastes in art; and characteristically accepted appointment only on condition that he gain no personal monetary benefit. Before appointing him, the Committee resolved that the £250 which had been divided between the five committee members each year since 1922 be reduced to £200, divided among the other four.

The meeting in January 1945 was Norton Grimwade's second in the chair of the Bequests' Committee, but also his last; when the Committee next met, in May, it recorded his death on 29 April, and welcomed his brother Harold to the Bequests' Committee, as Felton's will required. It appointed Sir Frank Clarke as Chairman for twelve months, also resolving that 'the office should be occupied in rotation by members of the committee', a resolution abandoned a year later when Harold Grimwade was ill and declined to take the chair.[27] The Committee had lost its two senior members within four months, and no one now remained with memory of the Bequests' first decades.

THE WAR AND its demands greatly preoccupied Sir Keith Murdoch, taking him overseas for much of 1940. As the war news worsened after the fall of France, the Gallery's activities were restricted; Pearl Harbor and the Japanese advance saw the evacuation of much of the collection from Melbourne, while the conscription of manpower greatly reduced the staff. Parts of the buildings were made over for other uses, though the Gallery remained open, for reduced hours. Special exhibitions included twenty-two pictures from the *Herald* Exhibition, stranded in Australia; others were shown in Sydney.

The Trustees abolished 'for the duration' all sub-committees except the Felton Purchase Committee, a move which paradoxically gave them time to review fundamental issues.[28] Sir David Rivett was the Trustee who raised, optimistically in the dangerous days of 1942, the question of post-war development; Sir Keith Murdoch made the running thereafter, so assiduously that on one

[27] FBC, 6 June 1946. Harold was ill for much of his four years on the Committee.

[28] Cox, *The National Gallery of Victoria*, pp. 174–7.

Sir Keith Murdoch (ANZ Trustees)

occasion he left his wife and children fighting a bushfire on their country property to keep an appointment with a Minister.[29] Inside the institution, heads of Branches were asked to submit proposals for the development of their departments over the following fifty years, and the Chief Architect co-operated with outside experts in considering the future of the site, within a broad strategy formulated by the Trustees. Acquisitions through the Felton Bequest having made the expansion of the National Gallery imperative, they declared that 'during the next 50 years' it was certain that the development of these institutions would be such that 'the continuance of them all together upon the present site is impossible'. Questions immediately arose:

> It is probably necessary that the Public Library should remain on the present site. What then must be done to it in order to make it quite first rate by the most exacting modern standards? ... It is desired that the National Gallery (including the Art Museum) should remain in close association with the Library. Can plans for

[29] Dame Elisabeth's account, given in Cox, *The National Gallery*, p. 235.

reconstruction be devised which will make it quite first rate by the most exacting modern standards? . . . If, as seems possible to the Trustees, there will be no room for either [the National Museum or the Industrial and Technological Museum], what suggestions can be made for their removal to an appropriate site or sites?

By October 1943 the Special Committee on Post-War Development had come from the same assumptions to rather different conclusions:

In its opinion the four Institutions cannot be housed on the one site . . . it favoured the suggestion that the Art Gallery, including the Art Schools, should be moved to another site, preferably Wirth's Park; that another new site should be preserved for the Natural History Museum; that the Public Library should be rebuilt to suit modern requirements on the present site; [and] that the Technological Museum should be housed on the Russell Street entrance on the present site.[30]

In February 1944 the Victorian Government received a deputation to discuss the matter. (Predictably, John Reed complained to the Under Secretary of the omission of the Contemporary Art Society from discussions of the future of the Gallery: 'my Society', he wrote proprietorially, 'is the largest Art Society in Australia and draws a larger attendance to its exhibitions than the National Gallery is able to do to any of its, but is entirely unrepresented on the Board of Trustees'.)[31] The Government accepted the case put by the Trustees, and reserved for the proposed new Natural History Museum an area in the Domain, and for a new Combined Cultural Centre the Wirth's Park site, a wedge of eight acres of low land, named after the Circus which frequented it, stretching from the south bank of the Yarra along St Kilda Road, near the site of the Canvas Town Felton had seen in 1853. The Act to implement these developments was not immediately proclaimed, but at the end of the year the Public Library, National Gallery, and Art Museum Act of 1944 was passed by the State Parliament, dissolving the single body of Trustees, and creating three separate boards, one for the two museums and one each for the Library and the Gallery.[32] The press, and parliament, generally welcomed the changes, though John Cain (senior), then in opposition, questioned the need to close a small street.[33]

[30] Annual Report 1943. On these events from the Museums' perspective, see Rasmussen, *A Museum for the People*, pp. 217–18.

[31] John Reed to Under Secretary, 15 February 1944, printed in Reid and Underhill (ed.), *Letters of John Reed*, pp. 277–8.

[32] The Industrial and Technological Museum was renamed the Museum of Applied Science in 1945, and separate Trusts were established for it and the National Museum in 1950.

[33] *Argus* 20, 21 and 23 October 1944; *Herald*, 30 November 1944; *Sun*, 11 December 1944.

In all these negotiations Murdoch had been much aided by LL Chapman, the able Under Secretary in the Chief Secretary's Department, within which the institutions were located. Despite having separate Boards, sharing the same premises forced them to continue to co-operate, each represented on a fourth trust responsible for the building complex. Their new independence paradoxically involved operating within more explicit Public Service guidelines than before, and desire to be free of the Public Service Board's yoke was an ambition which grew ever stronger over the years, especially among the professional staff of the Gallery. Sir Keith Murdoch referred to the issue—recalling the appointment of MacDonald against the Trustees' wishes in 1937—after his appointment to the Chair at the first meeting of the new Board.[34] (Public Service regulations were nevertheless sometimes useful: when Robert Haines was appointed Assistant Director in 1947, it was Chapman who found the way to recognise Dr Hoff's talents by having her appointed Keeper on a permanent basis.)[35]

The new Trustees of the National Gallery of Victoria were seven in number: from the old Board, Murdoch himself, JDG Medley (the liberal-minded English schoolmaster appointed Vice-Chancellor of the University in 1938 and a Trustee in 1940, Deputy Chairman), HW Kent (Treasurer), and RD Elliott; with newcomers AT Smithers (State Director of Finance, a powerful ally), Allan Henderson (a solicitor colleague of John Reed and founder-member of the CAS, a turncoat in Reed's eyes for joining the Trustees), and Napier Waller (replacing Max Meldrum, who protested against his exclusion, provoking many letters from his supporters).[36] In February 1945 Murdoch had urged the Premier not to appoint Elliott to the new Board, arguing that he had been 'particularly difficult and destructive' on the old. 'He has nothing to bring because his support is always variable and his opinions are not worthwhile . . . I fear the blunt truth is that those who are of most value to our institutions will not work with Elliott . . .' He was nevertheless appointed, and although Meldrum was omitted, also on Murdoch's plea, he too returned to the Board when Napier Waller resigned in June 1946. Nevertheless Murdoch's power as Chairman—the new act had dropped the title of President, though Chapman ruled that Murdoch could use it if he wished—was unprecedented, cemented by his close working partnership with Lindsay. The Director now had a relationship with his Board never enjoyed by his predecessors, with no Chief Librarian interposed between them.

[34] Cox, *The National Gallery of Victoria*, pp. 178–80.

[35] Ibid., p. 194.

[36] *Argus*, 2 March 1943; supporters wrote of the injustice to 'this great artist'.

The new Gallery Board elected Murdoch to succeed Meldrum on the Felton Bequests' Committee, which thus entered the post-war era with only two members—Sir Frank Clarke and Sir Alexander Stewart—who had sat before 1939, though Murdoch had experience of its pre-war operations and Russell Grimwade was to rejoin the Committee when his brother Harold died in 1949. If Felton's bequests, like the Gallery itself, could make a new beginning, its responsibilities had also begun to narrow, a process which was to continue for the rest of the century. The Gallery was receiving more gifts (such as the Kent Collection) and benefactions (notably the Howard Spensley Bequest, transmitted through the National Art Collections Fund in 1939), and (at last) a small government grant for acquisitions (only £1200 in 1939 but increased to £5000 in 1946). With more funds under their sole control, the Trustees and the Director now had more of the autonomy that Hall had always craved; and for its part the Bequests' Committee could reasonably ask that it no longer receive trivial requests. Lindsay agreed to the proposal that in future the purchase of Australian works be made by the Gallery alone, with assistance from the Bequests Committee only in exceptional cases.[37]

The boundaries between the component institutions in the old conglomerate had not always been clearly delineated, and the separation, legal but not yet physical, did not disturb the existing distribution of holdings. The question nevertheless arose whether the Bequests' Committee remained open to receiving recommendations from the newly separated brethren as well as the Gallery; Russell Grimwade, appointed Chairman of the Museums Board, hoped so, and sought a legal opinion from RG Menzies, KC, who thought Felton funds could properly be applied to all four institutions.[38] The Trustee company, and the Bequests' Committee, faced a related, more urgent problem: at its meeting in May 1945 the Company warned the Committee that the new legislation made uncertain the body referred to in Felton's will to elect a member of the Committee as well as to recommend and receive works of art. The Company was to approach the court; in the meantime Committee decisions 'probably' remained valid, but it would be 'unwise . . . to make binding decisions respecting the art side of the Bequest'. In July 1945 a ruling by the much-respected Mr Justice Lowe (of whom Menzies quipped that no one could be as wise as

[37] Lindsay, *The Felton Bequest*, pp. 75–6.

[38] Cox, *The National Gallery of Victoria*, pp. 180–1; Poynter, *Russell Grimwade*, p. 288. In a letter accompanying his opinion Menzies wrote to Russell: 'I could not find it in my heart to charge you a fee on a matter of this kind, particularly when I recall—as I continually do—your astonishing munificence and unselfishness as a citizen'.

On 2 December 1943 the Committee had rejected the purchase of four incunabula recommended by the Trustees 'owing to doubt whether the suggested purchase is within the powers conferred by the will'.

Lowe looked) declared the Trustees of the reconstituted National Gallery of Victoria to be the body empowered to appoint a member of the Bequests' Committee and to recommend purchases, and confirmed them as the sole proper recipient of works bought with Felton's estate.[39] The other institutions suffered by becoming overnight the poor relations of a well-endowed Gallery, with more political clout than they in the important matter of rehousing. Murdoch himself, more than other Trustees, remained concerned for the group of institutions as a whole, but when the proposal for a new gallery on St Kilda Road regained momentum, the prospects of relocating the Museums and renovating the Library retreated, to be revived later in the century.[40]

[39] FBC, 29 May and 23 July 1945. Menzies' quip was well worn: Fox had used it of Thurlow in the eighteenth century, and Carlyle of Daniel Webster in the nineteenth.

[40] For decades the Old Observatory site was reserved for the Museum.

25

PEACE

In 1963 Daryl Lindsay wrote of the twelve years after 1945 as of special importance to the Gallery, 'as at no time since Rinder's day' had 'so many works of a high order' been added to the collections. He cited three reasons: in 1945, as in 1919, the Felton Bequest had large reserves (the amount accumulated unspent in its Art fund had risen from £50 316 in November 1939 to £181 419 in April 1945); the London advisers were finding and recommending first-class works (in accordance with new schedules prepared by Lindsay); and there was unusual harmony between the Trustees, the Bequests' Committee, the London advisers and the staff of the gallery. 'Everything seemed to be moving smoothly towards the desired end of obtaining the best that was available for the collections.'[1]

That the Bequests' Committee became keen, as the war news improved, to resume buying overseas had been evident from the beginning of 1944. In February, when rescinding the suspension of Schwabe's and Russell's spending in London, it asked the National Art Collections Fund to report on the condition of the market for more important works.[2] (It was even willing to buy one of the 1939 *Herald* Exhibition works still in Australia, Wilson Steer's *Hydrangeas*, but found it had to be paid for in Britain; the Committee baulked at Utrillo's *Route de Puteaux,* which Murdoch reported available for £800, and which was recommended by the Trustees.)[3] In May 1944, after receiving an optimistic report from the NACF, the Conference asked the Director for a list of works needed to fill

[1] Lindsay, *The Felton Bequest*, p. 51. The 'twelve years' no doubt referred to the period before his own retirement.

[2] FBC, 10 February 1944. Schwabe and Russell were later given an extra £500 to spend (Conference, 14 September 1945, FBC, 19 September 1945).

[3] Conferences, 4 May and 3 August 1944.

gaps in the Gallery's collection, initiating a review of the Gallery's plans which was to produce policies accepted for the following decades.[4]

Lindsay welcomed the project, which he had been urging for some time, and immediately prepared a comprehensive 'Report on the Policy for Future Buying, with a List of Works Required to Fill gaps in the Collection ... as Requested by the Felton Conference held on 4 May, 1944'.[5] The document, boldly argued though not as revolutionary as it appeared, claimed that earlier policies had been confused, leaving unanswered the fundamental question: what was 'the function and ultimate goal of our national collection?':

> Is it to be (a) a heterogeneous collection of a high aesthetic standard, lightly sprinkled with masterpieces but lacking in a maximum educational value to students and the public; or (b) a collection of works of a high aesthetic standard which has a meaning as a whole—that is, a collection which will have a definite historical and educational value to the State?[6]

The question was rhetorical; and Lindsay's answer equivocal. He conceded that fine works had been acquired, 'but on surveying the collection as a whole, one is left with a chaotic impression of a number of rooms filled with pictures ... in the main unrelated to each other and lacking a sense of unity as a collection'.

> No amount of hanging and re-hanging of our galleries can gloss over the very serious deficiencies in our collection from an historical and educational point of view. These gaps are not trifling omissions, easily filled, but yawning chasms. A case in point is the absence of any of the better-known painters of the Spanish School, with the solitary exception of a single portrait by Goya.

'It is painfully obvious', Lindsay claimed—seriously misrepresenting the work of Rinder and others—'that the buying in the past has largely been a haphazard attempt to purchase individual good pictures, without regard to their educational and cultural value as units in the building up of the collection as a whole'. Buying only on artistic excellence, as MacDonald had proposed, would produce a diminishing number of great master-works at escalating prices—perhaps twenty works over a hundred years—and the collection would still be miscellaneous. 'Filling the gaps' could only be effective 'if the buying operations are in future narrowed down to a much smaller field, in the hope of bridging over

[4] FBC, 4 May 1944.

[5] An article by Clive Turnbull in the *Herald* on 29 March 1944 on the need for a new buying policy was clearly a puff for Lindsay's ideas.

[6] Lindsay, *The Felton Bequest*, p. 83. Lindsay included his report (without the schedule) as an Appendix.

some of the most outstanding gulfs'.[7] 'A young country', Lindsay concluded, would be better advised 'to concentrate on the best works after 1840 which would be more within the range of our buying capacity', more likely to come on to the market, and 'of more use to students and the enlightened public as being more closely related to the work of our time'. He proposed buying in three groups: works prior to 1840 (to be termed Old Masters); works (other than Australian) from 1840 to the present day, to be termed Modern, 'and to include not only European but American, Canadian, South African and Asiatic works'; and Australian Works.

> On the assumption that it is practically impossible for us to build up a great collection of Old Masters I suggest as a general policy the *narrowing* down of the acquisition of works painted prior to 1840 and the *broadening* of the acquisition of those painted after 1840, and that in regard to the former we *concentrate on small groups of representative works of each period or school of painting, so that we would eventually have a collection of a series of highly representative groups covering all periods.*

To overcome the difficulty of 'gaps' and 'to show the whole historical development of painting', Lindsay recommended that 'a large collection of prints of all periods and countries in chronological order be always on view'.

Elaborating his proposals, he argued that holdings of the Italian School were inadequate in 'representation of the Italian Renaissance period, the fountain from which all modern western European painting springs'; that the Dutch School was stronger, but lacked 'representative examples of Brueghel the Elder, Rubens, Hals, Brouwer, Jan van Goyen, E. de Witte, Hobbema, and an example of either Terborch or P de Hooch (Vermeer being either unprocurable or beyond our means)'; that the French School was 'very weak' and would require works by Claud, Poussin, Chardin, Fragonard, Ingres, Daubigny, and Philippe de Champaigne, and more illuminated books; that the Spanish School needed 'a good Catalonian Primitive'; a Velasquez 'I would think unprocurable, but an El Greco a possibility, and also a Zurbaran'; that the English School was 'well represented', but 'to complete the sequence we require landscapes by Richard Wilson and Gainsborough, a sporting work by either Stubbs or Ben Marshall and a portrait or subject picture by Hogarth and a conversation piece by Zoffany'; and that for the German School 'our main requirements would be a Holbein and a Cranach'.

In Modern works 'after 1840' the gallery was 'moderately represented' with English works, but there was 'no example of Whistler, Sickert, James Pride, Duncan Grant, JD Innes, Spencer Gore and a score of more recent important

[7] Lindsay, *The Felton Bequest*, p. 85.

contemporary painters such as the brothers Nash, Stanley and Gilbert Spencer, Henry Lamb, etc.' The French section included 'a fair sprinkling of the Impressionist period works by Manet, Sisley, Claude Monet, Degas, Camille and Lucien Pissarro, Cezanne and van Gogh', but needed strengthening 'by examples of Renoir, Gauguin, Seurat, Signac and others, together with examples of the Post Impressionists, Bonnard, Vuillard, Segonzac and Utrillo'. Other Europeans to be sought included Adolf Menzel, Vlaminck, Zuloaga, Modigliani and Edvard Munch. 'It should not be forgotten that we have no representation of American and Canadian painters.' Detailed schedules were attached.

The buying of Australian works, Lindsay complained, had 'tended towards quantity rather than quality', had been 'haphazard', and lacked 'discrimination'. 'We failed to secure when offered to us the two most important pictures painted by Tom Roberts—*The Hold Up* [*Bailed Up*] and *A break away,* now in the Sydney and Adelaide Galleries respectively, also Ramsay's finest work *The Sisters*'. Needed were a Conrad Martens, a late work by Charles Conder, 'further examples of David Davies and Walter Withers', and more works by Phillips Fox, Bunny and Lambert.

While the Trustees were considering this document, Murdoch stressed the need for a future buying policy while reporting from overseas that Witt and Edwards were happy to help with the period rooms, and warning of 'the great importance of the New York art market'.[8] By September the Bequests' Committee had received Lindsay's report and was 'very interested' in discussing it.[9] Sir Frank Clarke drafted an incisive document, proposing that the Committee give 'general approval of the constructive report'. 'Convinced support' should be given to the general plan of filling gaps rather than 'buying heterogeneous works'; but Lindsay might have gone further in narrowing down the fields to be filled. In particular 'it has proved in the past rather a hopeless endeavour to find and buy great examples of the leading old masters', and rather than look for fine examples of lesser masters, as Lindsay proposed,

> we are inclined to suggest that the whole of the Old masters be relegated to a less prominent position in our buying and that later periods and schools be given distinct preference over them while being ever open-minded to the rare chance of an especial find, particularly in English Old Masters.

In the past 'too wide instructions' had caused 'confusion of mind' in the buyers. Lindsay's B class (moderns since 1840) should be in 'the forefront of preference'. The committee would be willing to spend four-fifths of its accumulated £150 000 on

[8] Conference, 3 August 1944.

[9] FBC, 13 September 1944. On 5 October Murdoch told the Conference it would discuss policy 'soon'.

such works, provided only first-class examples were bought. Lindsay's views on Australian works and sculpture were approved, and Clarke suggested that the Committee agree to provide funds for building up etchings and prints. In conclusion, he asked that period rooms be not forgotten; and suggested that the Bequest fund a visit to Europe by Lindsay, especially as the time was ripe 'for obtaining the best possible overseas buyer'.[10]

Before a meeting could be arranged to discuss the report, the Victorian Government pre-empted Clarke's last suggestion by agreeing that the Director be sent abroad, with a comprehensive brief—bearing the marks of Murdoch—to gather information directed towards stimulating cultural activities in the State. (One of his tasks was to examine 'Museum construction and lighting, and the presentation of exhibits', and the architect John Scarborough made a parallel expedition.) In November the Bequests' Committee agreed to defer discussions until after his return, to assist him to make contacts overseas, and to contribute £500 towards his expenses. While giving the Director no specific instructions, it resolved that 'if during his travels he comes across any works which he considers suitable for immediate acquisition by the Bequest' he should communicate by cable through the Trustee company.[11]

Lindsay took copies of his report overseas, and brought back statements supporting his strategy from an impressive list of nine gallery and museum heads in Britain and the United States, including the Directors of the London National Gallery, the Victoria and Albert Museum and the National Gallery of Scotland, Professor Bodkin of the Barber Institute, Birmingham, and the Directors of the Metropolitan, New York, the Art Institute, Chicago, the National Gallery, Washington, and of the Fogg Art Museum, Harvard. When summing up the conclusions he had drawn from his overseas experience in 'Our Future Policy, a Report by the Director', in September 1945, he claimed that they had also supported his most radical suggestion, that overseas advisers be dispensed with and the Gallery's director take responsibility for buying, making frequent trips abroad.

> In regard to the subject of buying outside the country, the general opinion of all experts consulted by me was that it cannot be successfully delegated to any one person or body not closely connected with the Institution in question. It is important to note that the Melbourne system of a buyer abroad has been tried out by leading American and Canadian Museums ... and in each case was discarded as unworkable and unsatisfactory.[12]

[10] 'Daryl Lindsay's Report 1944; comments by Sir Frank Clarke', dated 25 August 1944.

[11] FBC, 13 September 1944; Conferences, 5 October 1944 and 1 November 1944.

[12] 'Our Future policy', pp. 4–5.

True; but Melbourne was not yet ready to do the job itself.

> As the Melbourne gallery in regard to staffing is still hock deep in the mire, and as the Director—who should be advising on all purchases—cannot be on both sides of the world at once—I realise it is necessary to have overseas advice until such time as we can take over the whole responsibility of advising and buying. Meanwhile we have a rather unsatisfactory interim period to contend with, during which time the necessary finding and training of suitable Gallery personnel must go on.[13]

Until a properly qualified Assistant Director could be found, the employment of 'a London buyer', for at least three years, was essential. 'The two most suitable men for this purpose' were Professor Randolph Schwabe, and no less an eminence than Sir Kenneth Clark himself, recently resigned from the Directorship of the National Gallery. Lindsay thought Clark would be 'completely autocratic' as a buyer; he had told Lindsay he would not work with the National Art Collections Fund Committee. Lindsay criticised the NACF as advisers, and proposed that the arrangement with them be terminated.[14]

Someone, presumably Sir Frank Clarke, drafted a summary of the report for the Bequests' Committee's discussion, highlighting some conclusions: that overseas advisers were unsatisfactory, but that a new London buyer—Clark and/or Schwabe—would be needed for at least three or five years (while remembering that not every Director would be a good buyer: 'even if Lindsay's judgment in art is unchallenged, would that have applied to his predecessor MacDonald or to his successor?'; should the Bequests' Committee even take any part in such appointments?) Since America had sent sky high prices of the Modern French School, should not the Bequest try to 'anticipate the future fashion' rather than seek—for example—a Renoir?[15]

In November 1945 the Bequests' Committee adopted a strategy Clarke suggested: a policy of overseas buying by the Director himself would have to be postponed, the arrangement with the NACF should be terminated ('polite dropping') and that they should be willing to appoint Clark and Schwabe joint advisers, for £400 each per annum, though not quite on the terms proposed: the Advisers could spend £15 000 (not £5000) on recent British and European art, and should 'watch for opportunities to purchase outstanding old masters, French Impressionist work, or other works of art', while acknowledging 'that the acquisition of the greater old masters can only be regarded as a chance once in years and that a suffi-

[13] Ibid., pp. 5–6.

[14] Ibid., pp. 7–10. Lindsay's later claim that when he consulted Sir Robert Witt and the NACF in London they agreed that they no longer wished to act for the Felton Bequest seems an exaggeration.

[15] Notes on Daryl Lindsay's 'Report—1945'.

cient sum be reserved for such opportunities'.[16] A Conference on 21 November accepted the Committee's terms for the London Advisers (adding EE Bluett to their number, with £2000—later increased to £5000—to spend on specified oriental items). Sir Frank Clarke wrote—politely indeed—to Witt asking that his Committee 'concur with us in suspending our mutual agreement, while not forfeiting your kindly good will and connection'.[17] Meanwhile the London agents (now Radcliffe and Co) reported—after 'tactfully putting him off'—that Randall Davies had again offered his services; and the Committee invited Sargant to make the visit to Melbourne postponed in September 1939.[18] Later, in 1946, Ralph Edwards was confirmed as Adviser on furniture, and Harold Wright, of Colnaghi's, appointed Adviser for rare prints and given £500 to 'fill gaps'.[19]

The new Instructions to Overseas Advisers, prepared in January 1946 by Sir Frank Clarke after consultation with Sir Keith Murdoch, explained the background of the Bequest, admitting in refreshingly frank terms that in the past the Bequests' Committee had 'found itself in arguments with the Gallery committee as to the artistic and monetary value of works', and that since it 'was chiefly a committee of business men', had protected itself by seeking 'either locally or overseas an expert Art Adviser to inform them'. 'This position they still use on occasion, since amateurs, however they value their artistic judgment, are apt to make mistakes'. The Victorian Government had now replaced the unwieldy Trust with 'a small body of Trustees from the best lay material available ... [and] the Bequest Committee hopes for better results'. The Instructions also referred to the role of the Director with unusual candour:

> Mr Daryl Lindsay, the present Director of the Gallery, is respected by both bodies and has won for himself a privileged position, but it has not always been thus in regard to previous Directors, nor will it necessarily be so as to future Directors; they must be local men and there are few with all the necessary qualities.[20]

Largely under the influence of Sir Kenneth Clark, Lindsay had modified his collection policy to concentrate on fewer areas (as Sir Frank Clarke had wished) and loosened his proposal for 'period rooms' to allow works from different countries to be mixed in 'century rooms'. The amended Schedules now listed,

[16] FBC, 7 November 1945, 30 January and 6 June 1946.

[17] Conference, 21 November 1945; Clarke to Witt, 29 November 1945; Cox, *The National Gallery*, pp. 182–3; FBC, 7 November 1945.

[18] FBC, 5 December 1945.

[19] Ibid., 25 June 1946.

[20] Copy of Instructions in Trustee company papers.

systematically, the main artists already held in each category, and added to the list of those whose works were to be sought several not mentioned before: under Moderns, Modigliani, Roualt, Toulouse-Lautrec and Picasso were included among the French, and Piper and Pasmore among the English. In the Old Masters section it was stressed that 'the acquisition of pictures should not be the only end in view' for the fourteenth and fifteenth centuries; 'such things as first class examples of wooden sculpture, carvings, tapestries and furniture' would 'illustrate the cultural growth of the Century just as much as fine pictures', and the same would apply 'to a lesser degree' to the sixteenth, seventeenth and eighteenth centuries, though on those pages the list of artists sought was long. From the early nineteenth century only Ingres, Daubigny, Delacroix, a 'late Turner' and an 'important Constable' were sought; 'nothing required' stood against Italy, Germany and Spain. The Bequests' Committee (with its Chairman clearly the dominant mind) congratulated Lindsay on preparing 'so excellent a Schedule'.[21]

THE BEQUEST HAD £170 000 to spend. It would have had more, but for the recommendations Lindsay had sent, a little breathlessly, from overseas. Messages from America were amended, on 1 June 1945 (after victory in Europe but with war continuing in the Pacific) to a list of seven recommended acquisitions, in order of preference, found in the United States or Britain. Pride of place went, deservedly, to a Florentine *Profile Portrait of a Lady*, then believed to be by Uccello, available at Agnew's for £15 000 sterling; its purchase was supported by Sir Anthony Blunt (then of the Courtauld Institute), Lord Crawford and emphatically by Clark. Lindsay's second preference was a Terborch *Portrait of a Lady*, for £5500. His next recommendation, third only because it was cheap at £750, was an Augustus John decorative panel, found in America; equal fourth, incongruous alternatives, were Renoir's *Femme couchée*, already recommended from America, available from Durand-Ruel, New York, for US$55 000 (then about A£18 333), and a group of Burgundian and French tapestries, which Lindsay strongly desired because of 'their immense decorative value' in the Gallery in conjunction with pictures and carvings of the period (also in New York, they would cost US$62 500 if all were bought). Sixth preference was a fifteenth-century French wood carving of St Barbara, and seventh a Rubens portrait for £21 000.

A Conference in July approved the Uccello (for £13 500, if the NACF approved the price; eventually £13 700 was paid). Lindsay was rightly proud of this acquisition, which proved popular after the usual criticism—Meldrum called it 'a pig in a poke'—and despite its later re-cataloguing as 'Italian School,

[21] FBC, 6 June 1946.

Florentine, 15th Century' (though it might be from Ferrara).[22] The Terborch was also approved (and bought for £4600), but the John was deferred, and the Trustees did not recommend the Rubens portrait, the tapestries, or the oak St Barbara. The Conference also approved the purchase of a Renoir, not *Femme couchée* but either of Lindsay's earlier recommendations from New York, *Hunter and his Dog* (Wildenstern) or *La Promenade* (Paul Rosenberg), at Lindsay's discretion and at a cost not exceeding $US50 000, provided the Commonwealth Bank agreed to transmit US dollars.

Lindsay was disappointed, and on his return failed to move the Trustees on the tapestries, but persuaded them to seek in September the urgent approval of the Bequests' Committee to buy the Augustus John panel, the St Barbara and (most emphatically) the *Femme couchée*. Clarke promised a quick response, but coolly asked to see the Trustees' minute of recommendation. Meeting five days later, the Committee approved the John and St Barbara, but postponed the Renoir because only three members were present. Some six weeks later the Committee minuted simply that 'after further consideration it was decided not to approve the purchase of this painting'.[23] Lindsay later wrote of his resentment that the Renoir nude was not approved, blaming a Bequests' Committee member who had allegedly said that 'Alfred Felton would turn in his grave at the thought of such a picture being acquired from his bequest'.[24] The identity of the member has not been revealed, nor confirmation found that Lindsay responded that any man would turn in his grave at the sight of such beauty. Earlier, Murdoch had written to Lindsay wishing that 'the Renoir had been one of his clothed figures . . . there is always a certain objection to nudes in public libraries [*sic*], and Renoir's nudes contrive always to give an impression of immorality', but since he himself told the story of the Committee member's comment, at a Gallery evening in 1951, it is unlikely he was the one who made it. Harold Grimwade, as the only member of the Committee who had known Felton personally and might presume to predict his opinion— and was, moreover, no longer alive when Murdoch told the story in public—is perhaps the most likely. Murdoch later told Lindsay that he and Frank Clarke had both supported the acquisition, but purchase could not be approved because the bankers could not 'get the money cleared and across to you during the war', as Lindsay had himself foreseen, so the moralistic objection might not have been

[22] *Age*, 8 September 1945.

[23] Conference, 23 July and 14 September 1945; FBC, 19 September and 7 November 1945.

[24] Lindsay to Chairman of Trustees, 1 June 1945; Lindsay, *The Felton Bequest*, pp. 48–9; Cox, *The National Gallery*, pp. 181–2.

important. And, as Renoir himself observed to a critic, whether a half-dressed woman in a painting is dressing or undressing is in the eye of the beholder.[25]

The Director was justified in remarking that 'It would seem that there was a hoodoo on Melbourne ever acquiring a great Renoir', though hardly in ranking this incident with earlier rejections of Impressionist works, as he did in 1963:

> The mistakes of the past were not so much the fault of the advisers as the failure of the trustee bodies to properly appreciate or accept their experts' advice ... due to sheer ignorance and lack of judgement in being able to assess the aesthetic worth and the market value of the works recommended. The most outstanding instance of this was the refusal by the trustee bodies on four separate occasions to consider acquiring important examples of the French Impressionist School on the recommendations of Colvin, Cockerell, Davies and Lindsay ... on the grounds that they were not considered the best representative works of these artists by the gallery trustees who thought the prices asked would not be maintained ... their failure to grasp these opportunities must be considered a major tragedy in the history of the bequest.[26]

While abroad, Lindsay also had £2000 to spend on contemporary paintings. He chose well, buying works by Walter Sickert, Harold Gilman, Spencer Gore, Duncan Grant, Henry Lamb and the Scottish painters Samuel Peploe and George Leslie Hunter, together with a large number of drawings and prints of the English and French schools. He returned with alarming reports of the increase in prices of works of art: 'owing to the instability of the money market, both collectors and the general public' were 'rushing to buy works of art', and prices had risen between 25 and 100 per cent since 1938; but he also—like many others—expected another depression before long, during which prices for all but the finest works would fall.[27]

Lindsay had stopped in Sydney on his way back from Europe, and at the meeting in September when Sir Frank Clarke gave *Femme couchée* a cool reception he successfully recommended seven works—by Rees, Preston, Lawrence, Ure Smith (two), Cambridge and Duncan—from the Society of Artists exhibition there; Clarke courteously offered to reimburse his Sydney expenses, as the Bequest usually did.[28] In the next months Lindsay purchased several Australian works, calling on

[25] Murdoch to Lindsay, 17 May and 3 July 1945, quoted in Cox, *The National Gallery*, p. 440; Lindsay to Chairman of Trustees, 1 June 1945. The final decision on *Femme couchée* was not made, however, until after the war. Murdoch's 1951 address repeating the story was quoted in the *Bulletin*, 3 September 1951. The original remark could have been made at the FBC meeting on 19 September 1945, when Clarke, Murdoch, Stewart and Harold Grimwade were present, or on 7 November, when Dixon was also present, and the picture was finally rejected. Lindsay's riposte was recounted many years later by Sir Clive Fitts at a Farewell Dinner to Dr Hoff.

[26] Lindsay, *The Felton Bequest*, pp. 49, 58–9.

[27] 'General Report by the Director on his Visit to USA and Great Britain, Melbourne, 29 August, 1945', pp. 4–6.

[28] Conference, 14 September 1945.

Felton Bequest funds only to buy two Sali Hermans, a Conrad Martens watercolour and six Bunnys (from a retrospective exhibition, for £1125; Lindsay was executor of Bunny's estate).[29] The Gallery found money for the rest.

ALTHOUGH 1945 BEGAN one of the Felton Bequests' great periods of acquisition for the Melbourne Gallery, the Trustees were often divided. Any hopes that the group might work smoothly together were dashed by Elliott's unremitting enmity towards Murdoch, his country newspapers conducting a continuing press war against the Chairman's mighty *Herald*. Deputy-Chairman Medley, in one of the occasional verses he habitually wrote to ward off the deadening effects of life on committees, observed that:

Birds in their little nests agree,
But not the gallery Trustee,
Whose main ambition it appears
Is setting colleagues by the ears.
But when death dims our Chairman's eye,
Be the blow quick, or be it tardy,
I do not think that he will die
Like Nelson, crying kiss me R.D.

Meetings were often acrimonious, with Elliott, his pugnacity strengthened by his wartime experiences as Beaverbrook's associate (or courtier, as some averred) attacking the Chairman, the Director or any other convenient target. When the 'Uccello' arrived in Melbourne in 1946, and was ridiculed in the weekly scandal-rag *Truth*—newsboys at Flinders Street Station used to shout the ambiguous alternative '*Herald* or the *Truth*'—Elliott moved that a committee investigate the purchase, but could not find a seconder.[30] He usually had one, especially after Napier Waller resigned and Meldrum rejoined the board in July 1946 (an appointment attributed by *Smith's Weekly* to a change of government; William Slater MLA, a Meldrum admirer, who had also been dropped as a trustee the year before, was back in office as Chief Secretary).[31] Meldrum had recently offended Lindsay by describing a speech he gave as 'aesthetic larrikinism', incidentally identifying abstract art as a 'sign of decadence'.[32] HW Kent sometimes joined the

[29] Cox, *The National Gallery*, pp. 189 and 440–1.

[30] Lindsay responded with a persuasive report on the merits of the picture; *Truth*, 17 August 1946; Cox, *The National Gallery*, pp. 185–7 and 190. The Conference had prepared to cite the NACF assessment in the picture's defence (FBC, 21 November 1945).

[31] *Smith's Weekly*, 20 July 1946.

[32] *Herald*, 12 July 1946.

Sir Daryl Lindsay, Sir John Medley and Sir Alexander Stewart before Longstaff's *Alfred Felton*, 17 June 1948 (ANZ Trustees)

dissident minority, alienated by the proposal in 1945 that his beloved Chinese collection be moved from the well-lit McAllan gallery to the spear gallery—'dull and dismal', in Cox's words—in breach, he believed of his deed of gift.[33]

Nevertheless the dissidents were usually in a minority, and with the majority happy enough to support Murdoch and the Director, and the Bequests' Committee also in agreement, purchases continued on a broad front. Kent was mollified in 1946, when Bluett was given £2000 to spend on Chinese works in Britain, and the Bequests' Committee was soon persuaded to increase the amount to £5000; when that was overspent by a considerable amount, most was eventually reimbursed by a compliant Bequests' Committee.[34] A stream of recommendations from the London Advisers was received and most approved

[33] Cox, *The National Gallery of Victoria*, pp. 183–4. The move was eventually made in 1948, and the spear gallery, re-lit to Kent's satisfaction, was renamed after him (Cox, *The National Gallery*, p. 202).

[34] Cox, *The National Gallery*, pp. 193–4; Conference, 12 September 1946.

during 1946. At one meeting in June the Bequests' Committee, having approved purchases ranging from £12 000 to £200, suggested that the Trustees themselves find $1340 for Persian miniatures they had recommended, since the Committee had 'that day agreed to the expenditure of many thousands in England'; the Trustees did so, from Gallery funds, 'in the interests of mutual co-operation'.[35]

For some time Sir Frank Clarke had been disturbed that Sir Kenneth, unlike his predecessors, was corresponding directly with Lindsay rather than with the Committee, and asked him politely for a report. Clark sent one, and Clarke, in response, opened his heart concerning the Bequest, raising an issue to which he 'did not see any answer'. 'Put shortly, it is that the Felton money is devised to buy objects of art; how far are we justified in now refraining from spending it owing to an unwarrantable rise in prices ... on the length of which none of us can hazard an opinion?' While the purchasing power of money decreased, the availability of great works decreased even faster:

> We must by ordinary standards feel satisfaction that you, our overseas experts, guard us from victimization in prices; we cannot weaken on quality, and yet, I wonder if for endowment price is always a prime criterion? Say with your wealth of experience you consider £30 000 the outside value of a rare painting you approved, and which we badly needed, but some *nouveau riche* bid £35 000; is the Felton Bequest to be congratulated that it missed the painting because it would not be victimized into paying £36 000? Gilbert's words in *Iolanthe* might apply to us Trustees—'The House of Peers did nothing in particular, and did it very well'.[36]

Perhaps Sir Frank was wondering why, in 1937, when the Committee had an opportunity and the money to buy two or even three Cézannes, they had bought only one; and had more recently, yet again, refused a Renoir. Sir Kenneth's answer to his excellent question cannot (alas) be found. Clark was himself about to leave London; in 1947 he accepted appointment to the Slade Professorship of Fine Arts at Oxford, and the question of the Advisership was reopened.

Clark, and the other less famous advisers, did well for Melbourne. On 22 April 1947, only twenty months after the war ended, Stewart (on behalf of the Bequest) presented to the Gallery Trustees Turner's great water-colour *The Red Rigi* (£2000), Walter Sickert's *Raising of Lazarus* (£650), Utrillo's *La Tour Eiffel* (£1000), Veronese's *The Rewards of Philosophy* (£12 000), an (alleged) Claude

[35] FBC and Conference, 25 June 1946.

[36] 'I have, however, a more helpful question to ask you. If for a year or so you bow to the necessities involved in the scarcity of suitable paintings, and while still taking what you can get, let your interested eye concentrate primarily on sculpture, would it give a possibility of filling an admitted gap in our art collection?' Clarke to Clark, 11 June 1946, included in the minutes of FBC, 12 September 1946 and in part in Cox, *The National Gallery*, p. 187.

Lorrain, *The Flight into Egypt* (£2800; actually a copy), Rubens' *Hercules and Antaeus* (£3000), Gwen John's *The Nun* (£475), an Alfred Stevens drawing of a nude (£21) and ninety-seven pieces of oriental sculpture, ceramics and bronzes (£4986). Later in the year another shipment on the *Orion*—presented to the Trustees at a conference also attended by Sargant, responding to the invitation renewed after the war—included the Degas drawing *Femme s'essuyant* (£300), a *Baby's Head*, in bronze, by Epstein (100 guineas), a Derwent Lees self-portrait, oriental ceramics, including a pair of T'ing cauldrons (£2500 each), twenty-three early jades and drawings and prints.[37] Felton's Art Bequest was back in business, and doing remarkably well.

SIR KEITH MURDOCH made yet another major contribution to the arts in Victoria when he arranged in 1945 for the Herald and Weekly Times Ltd, 'in commemoration of the victory of the allied nations in the Pacific', to donate £30 000 (and later a further £20 000) to the University of Melbourne 'for the purpose of endowing' the *Herald* Chair of Fine Arts, the first appointment in the discipline in Australia. 'We need a Chair of Fine Arts', a leading article in the *Herald* had proclaimed in September 1944, citing as models the Slade chairs in Britain, occupied by distinguished authorities for short periods.[38] But Murdoch's consultation with his friend, Vice-Chancellor Medley, also busily reconstructing, revealed a range of ambitions. Medley planned to include in the post-war University an Institute of Fine Arts, incorporating Architecture and Music as well as Art, and he wanted a Director for it; Murdoch, man of the media, wanted a public apologist for the arts. The Institute never eventuated, but the man appointed to the Chair in 1946, the ebullient, shrewdly eccentric Joseph Burke, recently a private secretary to Clement Attlee, contrived to achieve in Melbourne both an outstanding academic department and a career of unrivalled public influence in the arts—including the Felton Bequests—while carefully preserving an air of amiable ineffectuality. Medley was happy, penning:

> *Hark! The Herald Angels sing*
> *Culture is the coming thing*
> *From the circumambient murk*
> *Call Professor Joseph Burke.*[39]

[37] Both reported at a Conference, 28 October 1947.

[38] *Herald*, 20 September 1944.

[39] 'On the Chair of Fine Arts'; on Burke, see Poynter and Rasmussen, *A Place Apart*, p. 80.

An outstanding public lecturer, Burke won for the fine arts, and indirectly for the Gallery as an institution, a new public, happy to be instructed and entertained; and his active influence extended to the Australian Council of Industrial Design and to the preservation of the national heritage through its new guardian, the National Trust. Within his University Department, soon very popular with students of all ages, Burke recruited outstanding scholars, including the European Franz Philipp and (later) Bernard Smith, whose *Place, Taste and Tradition* (1945) had set new standards in Australian art history. Dr Hoff, who lectured there, part time, from 1948 until 1973, was moved to identify Murdoch as 'the Sir Samuel Courtald of Melbourne' for his combined services to art and art scholarship.[40]

Post-war Melbourne thus gained new resources in art scholarship and a newly informed public, changing the context in which Felton's bequest operated. Other changes transformed the city, and the state, so that it no longer much resembled Felton's world; trams still ran from St Kilda past the National Gallery in Swanston Street, but were all now electrified, the last cable car finding a place within the Museum itself. The war greatly extended federal authority over the states, especially through the transfer of taxing powers, reshaping the Australian federation; and the infant Canberra, rapidly expanding especially after Menzies came to power in 1949, became a real capital and no longer merely the seat of Parliament. The influx of post-war immigrants, predominantly from Europe but also from the Middle East and eventually from Asia (as students, first, and as settlers after the White Australia policy was eased in the 1960s), changed Australian society for ever. Melbourne became cosmopolitan again, even more than it had been in the nineteenth century, and as the odour of garlic wafted out of proliferating new restaurants, even older Australians came to recognise what it was.

The cultural impact of the newcomers was perhaps greatest at first in music, and in ballet, but soon spread to the visual arts. In the long run the new cosmopolitanism completely dissolved the National Gallery's traditional assumption that the core of its acquisition policy must remain an emphasis on English art.[41] More immediately it met and mingled with the flowering, after long gestation, of local modernism, epitomised by—but extending far beyond—the group around Heide, John and Sunday Reed's house at Bulleen, not many miles from Heidelberg, but a school of a different colour. In that now much commemorated ménage, talents as disparate as Nolan, Tucker, Hester, Blackman, Perceval, Atyeo and Arthur Boyd were welcomed, though few stayed long. Although John Reed's

[40] Hoff, *The Felton Bequest*, p. 30.

[41] Galbally, *The Collections of the National Gallery of Victoria*, p. 223 (on increasing local interest in European art as migration accelerated).

dedication to modernism, and involvement with Angry Penguins and Max Harris, victim of the Ern Malley hoax, made his circle famous, Heide was but one centre among many, and by 1945 almost all the younger artists—in Sydney perhaps more than Melbourne—had learned some modernist lessons.[42] So had the public; prints of Post-Impressionist and later artists found a ready market, first among students and soon in the suburbs, expanding rapidly with the post-war housing boom. The conservatives in art became a minority; they did not melt away, but even William Dargie, heir to the traditions of Longstaff and ultimately of Hall, appointed Head of the National Gallery's Art School in 1946, recognised that his students wanted to choose between training in a variety of methods, and soon made provision for it, including separate prizes for competition in each of three schools of instruction. Modernism (seldom very distinguished) certainly triumphed in architecture; the height limit was abandoned, and much of Victorian Melbourne demolished to make way for tall buildings with glass curtain walls (real) on the outside and glass ceilings (metaphorical) within. There were no women yet among the Trustees, nor on the Bequests' Committee, and few among those submitting for and running Melbourne's Olympic Games in 1956—a triumph of improvisation—which coincided with the introduction of that most subversive of all means of visual representation, television. Melbourne in the 1950s had no new gold rushes to re-create its past dominance, but while people and goods still came by ship to Port Melbourne rather than by air to Mascot, it remained the main gateway to and from Australia, and retained much of its economic power. It was also politically and intellectually lively; the 1950s gained a reputation for being staid and dull only when seen in retrospect through the distorting prism of that decade of revolt, the 1960s.

In 1948, reviewing Russell Grimwade's *Flinders Lane* for *Meanjin*—whose translation from Brisbane to Melbourne was another Medley initiative—Burke took stock of the Bequests' achievements so far.[43] In 1946 it had been reported that since Felton's death in 1904 the value of his estate had risen to £1 000 500, and that half of the total income of £1 452 500 had been spent on works of art. The highest price for an Australian work had been £630 for a Streeton; in 1933, the purchase of the Tiepolo, a Rembrandt and a Gainsborough had swelled the

[42] Smith, *Australian Painting 1788–1988*, ch. 8.

[43] On 21 January 1948 the FBC had agreed to buy 100 copies *of Flinders Lane* for distribution; the book, beautifully printed by MUP, included woodcuts by Helen Ogilvie. Russell took a great interest in the University's Press, which he hoped might be based at his house after his death. Other notable reviews included AR Chisholm's in the *Argus*, who concluded that Felton was 'a fascinating man, whose story is well told by Mr Grimwade. If you seek his monument, follow Sir Christopher Wren's injunction: go to the Gallery, and look around you'.

year's expenditure to a record £83 500.[44] Had Melbourne received good value for Felton's money? Burke's half-term report was not uncritical; 'has done well, could do better' his conclusion:

> When I first arrived in Melbourne I experienced a sense of disappointment. Owing to the war the great collections of Europe had been closed to me, but I had travelled by way of America, and impressions of the Galleries of New York, Washington, Boston and Chicago were fresh in my mind. In particular I had revisited the Frick in New York and the Gardner Museum in Boston, both privately endowed . . . I unconsciously expected something like the Frick or the Barber Institute at Birmingham; that is to say, I expected to see, as the central treasure of the collection, twenty or thirty masterpieces of the first class—not an unreasonable number to expect for over seven hundred thousand pounds spent since 1904 . . . In Melbourne I found the Van Eyck *Madonna* on an almost solitary pinnacle.

The first disappointing impression was 'fortunately deceitful'; the Blakes had not been on exhibition, and Burke had given 'no more than a cursory glance at the English water-colour gallery, which I found on a second visit to contain a superb collection'.

> The National Gallery of Victoria undoubtedly houses a great collection, certainly the finest in the British Empire outside the United Kingdom. Unlike the Frick, the Gardner and the Barber Institute, it is a very large and rich collection; after a year averaging one or two visits a week, I do not feel I have exhausted it. It was to be expected that it should include the fullest and finest collection of Australian painting; but I doubt if many British art historians are aware that it contains an almost complete representation of the main trends and developments of English art since the early nineteenth century. In the other European schools the list of minor masterpieces and worthy examples is a long one . . . Nevertheless, it is difficult for even a friendly critic to lift up many pictures, the Blakes excepted, into the high category of the Van Eyck. The Memlinc *Pieta*, the Courbet seascape, the Rembrandt self-portrait, the Turner watercolour of the *Red Rigi*—who will add confidently to the list?[45]

'The sad truth is', Burke concluded, 'that out of thirty-three years of buying, for only nine has the Felton Trust been served as it should'. Where could another Rinder be found? In Toowoomba, of all places.

[44] Cox, *The National Gallery*, p. 189.

[45] Joseph Burke, 'Alfred Felton and his Bequest', pp. 98–9.

26

APOGEE

THE DECADES AFTER World War II brought a long period of sustained buying by the Felton Bequest, with a minimum of public criticism and private bickering. Unfortunately the same years also brought inflation in prices in the international art market, at rates which could not be matched by the earnings of any endowment fund. The Bequest had never been able to pay 'Duveen' prices, and even had the Trustees been free to gamble with Felton's money and lucky enough to win, they could have made only occasional purchases at the upper levels of the market by the mid-1950s, when the Bequests' Committee freely acknowledged that it could no longer make major purchases at earlier rates of acquisition. The Gallery received other bequests—one, from Everard Studley Miller, grandson of one of Felton's richest contemporaries—large and important, but the Bequest was still providing about three-quarters of the Gallery's acquisition funds when the Collection was transferred to its outwardly grand but inwardly awkward St Kilda Road quarters in 1968.

Felton's Bequests' Committee had long been aware of its diminishing capacity to buy in the world market, though the forced suspension of purchases by war or depression thrice gave it temporary enhancement. In 1945, with Clark and Schwabe as advisers it had a strong team; but Sir Kenneth, though he respected his colleague, had been known to remark that 'the system of two advisers is a bad one; it doubles the work and halves the pay'. He needed a man younger than Schwabe to do the leg and eye work. Lindsay recommended for the role Ae (Aeneas) John L McDonnell, born, son of a surgeon, in Toowoomba in 1904, one-time aide to the Governor of Queensland, former partner with Burdett in Sydney's Macquarie Gallery, connoisseur and soldier. McDonnell was the collector who had lent three Matthew Smiths and two Sickerts to the *Herald* Exhibition in 1939, and had then gone off to war, serving in the AIF in the

AeJL McDonnell (reprinted from Daryl Lindsay, *The Felton Bequest*)

Middle East before secondment to Supreme Headquarters of the Allied Expeditionary Force in 1944–45, with the rank of Colonel. He had worked with the Control Commission for Germany in 1945–46, with special responsibility for the recovery of works of art plundered by the Germans, and in 1947 had been decorated by the French Government. McDonnell, whom Lindsay had cited in 1945 as an ideal (if unobtainable) Assistant Director, had wide tastes and a deep knowledge of art, his own collection ranging from Europe to Asia and Australia, from ancient to contemporary, and from pictures to pottery. He wore his learning lightly, modestly concealed his great administrative skills, and had a gift for friendship. McDonnell had planned to open a new private gallery in Sydney, but finally agreed to accept appointment to work with the Advisers in London.

Before the Bequests' Committee had completed the appointment, Sir Kenneth Clark told Melbourne of his intention to resign, citing his translation from London to the Slade Chair at Oxford as the reason. He was persuaded to continue to act as a senior consultant, while McDonnell took the active role. Appointed, in March 1947, on a salary of £500, the new Adviser was obliged to consult Clark on any purchase over £500, also consulting Schwabe if he chose or if Clark was not available. The detailed terms, set out in a letter in June, reiterated the committee's emphasis 'upon the principle of "buy the best, reject the rest"'.

McDonnell warned the Committee that it would be unwise for the Adviser to bid personally at auctions, and was authorised to employ an agent. When, late in 1947, Sargant arrived on his long-postponed visit to Melbourne, he made clear to the Committee McDonnell's high standing in London.[1]

In 1947, after the year's second consignment of pictures had arrived from London, £5000 was allotted for 'furniture, glass, etc.' to be spent by Edwards and Ashton; and later in the year it was reported that the Adviser had bought, from the schedule, works by Derwent Lees, Matthew Smith, Sickert and Paul Nash, and sculptures by Henry Moore, Epstein, Maillol and Despiau. In November Clark recommended, and the Conference approved, Gainsborough's *View of the Mouth of the Thames*, for £9000, and on McDonnell's recommendation a Louis XVI escritoire, valued at £3000, and a Beauvais tapestry.[2] In a spectacular start to 1948, McDonnell recommended and the Committee approved, for £14 000, Nicholas Poussin's grand *The Crossing of the Red Sea* (companion piece to *The Golden Calf* in London's National Gallery; Anthony Blunt thought it 'not only madness, but wickedness . . . to separate the pair'). Other excellent acquisitions included Mor[o]'s *Portrait of a Lady* (£7000), Murillo's *Immaculate Conception* (£2500), *The Fountain of Love*, then attributed to Pisanello (£4500), a Signac, several modern English works and (apparently incongruously) Landseer's group, *The Earl and Countess of Sefton*. In an unusual transaction, the Trustees, on Lindsay's recommendation, authorised McDonnell to spend £1000 of the Government grant on Old Master drawings (or, if none were available, eighteenth-century sporting prints).[3]

Most of the new initiatives were McDonnell's, despite the strict limits to his autonomy. Several other Felton advisers operated—EE Bluett for Chinese works, Harold Wright for prints, Sir Leigh Ashton and Ralph Edwards for furniture, silver and glass—and some were not even aware of McDonnell's appointment. Sir Frank Clarke consulted Sargant, who wrote frankly of the ambitions of individuals involved (two were also dealers), and urged that McDonnell be given more status and autonomy. He was given some, but not yet much; in March 1948 his recommendation to buy for £3500 *Interior* by Vuillard—an artist in the Schedule—was strongly opposed by Meldrum for failing to meet Meldrumite principles and by Elliott, simply being Elliottish, and was referred to Sir Kenneth Clark. He objected to the price, so McDonnell bought it for his own collection,

[1] FBC, 12 February, 19 March, 30 April, 14 May, 28 October and 27 November 1947.

[2] Conferences, 7 and 27 November 1947.

[3] Cox, *The National Gallery*, p. 196.

reselling some years later at a substantial profit.[4] In June 1948, works presented to the Trustees by the Bequest included the Poussin, the Gainsborough and the Pasmore, Modigliani's *Portrait du Peintre Hubert* (£2200), and drawings and prints by Rodin, Tintoretto, Claude Lorrain, Sickert, Moore, Spencer, Picasso, Toulouse-Lautrec (whose *La Songeuse* had been refused by the Trustees), Munch and Roualt, and Epstein's *Tagore*. Two months later, when the Committee approved some Byzantine paintings (£1400) and a fourteenth-century crucifixion (£2500), another consignment delivered included much furniture, another Moore and a Venetian relief panel. McDonnell's legs and eyes had been busy.

SIR KENNETH CLARK visited Australia, at the Bequests' expense, early in 1949. He attended a Conference in January, and no doubt discussed policy matters with Committee members in private, but the greatest impact of his visit was on the public, and especially on the recently formed Gallery Society, recommended a decade before by Sir Sydney Cockerell and successfully launched in August 1947 by Murdoch and Lindsay, supported by Professor Burke, physicians Leonard Cox and Clive Fitts, and other prominent citizens.[5] (Elliott was said to have opposed this new link between the Trustees and the public, but apparently more from habit than principle.) By the end of 1948 the Society had more than seven hundred members, a large proportion of whom attended a public lecture on *The Idea of a Great Gallery* given by Sir Kenneth at the University of Melbourne late in January 1949.

Like Burke the year before, Clark—brilliant as always before an audience—delivered an outsider's assessment of the Melbourne Gallery (though not so specifically of the Bequest), calling in question most of the principles on which its collection had been formed. His viewpoint was patrician and metropolitan, that of a connoisseur not only of works of art but of galleries, of a man living in a city in which he could choose which of several major collections he might wish to visit each afternoon for a week or more. He did not believe that Bernard Hall's comprehensive 'scientific' collection was possible or desirable, and sought to

[4] The Trustees recommended the Vuillard by four votes to two (with Murdoch absent, ill); when it came to the FBC, on 2 June 1948 Clark's objection persuaded them against it. (McDonnell later bought a Vuillard gouache with the same title for £850 for the Gallery.) The FBC, tried to sort out the jurisdictions of the several advisers in a letter approved on 27 August 1948.

[5] Clive Fitts was President, Cox Chairman of the Executive Committee, Keith Roberts Vice-Chairman, Ian Potter Treasurer, Tristan Buesst Secretary, Burke, Len Annois and Evelyn Syme members (Cox, *The National Gallery*, pp. 203–4). The Conference Clark attended, when David Tenier's *The Skittle Players* (£2000) was accepted, was on 28 January 1949. The FBC, which was initially (21 January 1948) cautious about the cost of Clark's visit, had confirmation of the date only in December 1948. The eventual cost was £220 1s 8d (FBC, 7 June 1949).

exorcise its ghost from Melbourne's Gallery; and he had already caused Lindsay to modify his concept of an 'educational' collection.

Clark began by sketching, as deftly as any of the artists he admired, the history of the making of collections, from classical times to the nineteenth century:

> The amassing of works of art has taken four different forms. The temple with its objects of veneration; the private collector surrounding himself with things he loved; the princely collector with his crowded walls of courtier pictures; and lastly the public collection, with its half-realised educational and scientific aim. Now I believe that each of these four phases has contributed something to the idea of a great gallery and I therefore think it is worth examining them in the light of your gallery here.[6]

He was especially critical of public collections (as he could be, no longer running one). They were of course a recent invention; and although there were reasons why they should have been 'at least as good as those made by private patrons', in fact they were not. Not, as often alleged, because purchases were too often made by committees, or from fear of public opinion. ('That would indeed be a disaster, and would fill our galleries with ships in full sail and valleys full of blue bells, Highland glens full of cattle and an occasional stuffed bird suspended before a pinkish sunset.')

> No, the dangers of a State supported gallery are rather more subtle than that, and I think are ultimately due to an unconscious uncertainty of aim. Public galleries grew up together with the modern conception of education, and it was as a part of education that their support was undertaken by the public authority. This impressed on their directors the idea that such collections must look educational, and must if possible teach the history of art. So instead of buying pictures because they liked them they bought them to complete some historical sequence or to illustrate some school or period . . . And so the chief aim of works of art, which is to produce in us a peculiar kind of exalted happiness, was lost sight of.[7]

Art could indeed be educative, enlarging our capacity for life; but that had nothing to do with a collection being 'scientific'. No gallery could show 'the complete development of art'; especially as 'nine-tenths of the pictures will be shown out of their settings, and like quotations taken out of their contexts they will lose a good deal of their original meaning'. The picture gallery was 'an inherently artificial form, and must itself have the character of a work of art'.

It was the other kinds of collection, the private and the princely, which Melbourne should emulate. It should never 'neglect the sense of intimacy which

[6] Clark, *The Idea of a Great Gallery*, p. 11.

[7] Ibid., pp. 10–11.

binds a private collector to his possessions'; Melbourne's greatest picture was small, and 'the right thing to do'—though impracticable—'would be to take the van Eyck in one's hands like some precious manuscript and scrutinise it inch by inch'. Manet's *Ship's Deck* and Daumier's *Don Quixote* were 'little hard knobs of thought and experience rendered as form ... meant to be looked at often, brooded on'. Melbourne had a good collection of such things, including 'those most companionable private pictures, English water colours', 'which I hope you will continue to buy, and so display that people may feel that they are their own'. Melbourne should also buy experimental work, as private collectors used to do. Despite inevitable protests, it was 'particularly necessary in this country, where you have a young and vital and adventurous school of painting'—he had been much impressed, especially by Russell Drysdale and Sidney Nolan—because young artists needed 'a sight of the best modern work, something which still has about it the thrill of experiment'.[8]

Public opinion could too easily inhibit adventurous acquisition in public galleries:

> The most painful mistake to all European galleries was of course the modern French school. It is now almost impossible to acquire good representative examples of Renoir, Cézanne, Degas, van Gogh or Manet ... You may feel that you were prevented from acquiring them by your distance from Europe, but ... the Louvre itself failed to buy Cézanne, or the best Renoirs, and the only Seurat in a French public gallery was presented to it by an American ... the Americans got their marvellous collections of 19th century French paintings because they had private collectors with the courage to take a risk and to buy what they really liked.[9]

Clark praised in particular Melbourne's Manets, so often derided by Hall.

As a modern example of the princely collection, Clark cited the Wallace collection.

> The Marquis of Hertford and Sir Richard Wallace liked pictures and furniture of a certain kind. It was not a very elevated kind—they preferred pictures of pretty girls and people in fine clothes, and they enjoyed being surrounded by gold, gold furniture, gold clocks, gold boxes. This meant in effect that they collected French art of the 18th century. Now this happens to be one of the styles which I like least; yet I find myself going to the Wallace Collection oftener and with more pleasure than to any other London Gallery, simply because it is an harmonious whole. While you are there you live entirely in that one mood and moment. Of course to make a

[8] Ibid., pp. 13–14.

[9] Ibid., p. 16.

Collection as good as that of Sir Richard Wallace your taste in girls and gold must be of rather a special kind . . .[10]

From the princely galleries, Melbourne should learn to value splendour. The 'democratic modern world' had 'come to think of splendour as something rather wicked'; fortunately Melbourne had 'a stunning example of the splendid, a brilliant defiance of the austere equality, Tiepolo's *Banquet of Cleopatra*. At present it is rather an isolated example of splendour, and it was with a view of finding companions that I suggested the purchase of the Paul Veronese'. Neatly and surely, Clark came to the crux of his argument: that 'it is impossible to understand a single isolated work of an artist'. The galleries which left the deepest impression on visitors were those like the Wallace Collection, and especially the Prado (which had certainly impressed Adelaide's Sir Thomas Elder), 'where we see a lot of the work of a few artists, and so begin to inhabit their world'. It took time to enter (for example) the world of the great ideal painters of the sixteenth and seventeenth centuries, like Paul Veronese, represented in Melbourne by the recently acquired *The Rewards of Philosophy*. Any one coming from 'the brightly-coloured realism of the late 19th century' to see this picture in isolation would find it 'painfully artificial and not a little dull'.[11]

It was thus essential for a Gallery to avoid collecting isolated examples and to concentrate on building within selected fields; but it was not a free choice:

> It may have seemed perverse of the advisers to the Felton Trustees that when asked for a Matisse they should have produced a Landseer. The reason is that two years ago it was still possible to buy a masterpiece by Landseer . . . Whereas no Matisse worth buying has appeared on the market for fifteen years. Unfortunately it is easier to make trustees who want a Matisse accept a Landseer than to make those who want Landseer accept Matisse.

For its true enjoyment, Clark concluded, art required the 'willing suspension of every day experience'. This was necessary, above all, to enjoy 'one of the greatest treasures of your collection', Blake's illustrations to Dante's *Divine Comedy*. In Australia, with its high standard of physical life, 'the life of the spirit and of the imagination' could easily languish, unless we 'seek as our guides the great poets

[10] Ibid., p. 6.

[11] Ibid., p. 18. The Veronese represented 'the conflict between the life of duty and the life of pleasure—a very real subject to all of us. But as we no longer think in allegories—as men did for 2,000 years—we may at first consider the whole scene extremely improbable, or at least outside the range of our own experience . . . Even more difficult is the case of your Poussin, which is certainly one of the greatest pictures in the gallery, but hardly tells as such in its present isolation . . . Such a picture will never be understood until we can surround it with work in the same imaginative mood'.

and artists of the past', as Dante followed the guidance of Virgil 'in Blake's sublime drawings. This is the illumination which it is the first function of a great gallery to provide'.[12]

On the question of artists as advisers and buyers, Clark made an aside no less persuasive for being equivocal:

> Now-a-days it is often said that artists are uncertain guides in the purchase of Old Masters, and I am afraid that this has become true. The reason is that in the 17th century it was not thought necessary to be original. Contemporary art was founded directly on the art of the past. The artist had to do the same thing as his master, and, if possible, do it better. He therefore had to make a profound study of the painting which preceded him, its ideas, its pictorial science and its technique. And since painting was supposed to be closely connected with literature he had to be what is called a man of culture. All of which fitted him to advise on the formation of a great gallery; and does not apply to the majority of artists since about 1860.

Nevertheless, he added 'in parenthesis', he usually found the judgement of an intelligent artist 'a good deal more interesting than that of art experts or connoisseurs. 'If our collections were made by artists they might contain a lot of rubbish, but it would be rubbish of a more attractive kind than the archaeological documents of experts'.[13] (The concession would not have satisfied JS MacDonald, who in a speech at this time—appropriately titled *After Us the Deluge*—again attacked advisers who were not painters: 'What has Sir Kenneth Clark ever said to advance the cause of art?' MacDonald's 'acquaintance with Mr AeJ McDonnell impels me to say that he is not able to judge intrinsically of the depictive worth of any picture'; those he sent out for the Bequest were 'sufficient proof of his shortcomings'. Hall had been the only good Adviser, though MacDonald now conceded that Rinder had been the best of the amateur rest.)[14]

Clark's lecture made a deep impression; it was immediately printed, reprinted in essays presented to Lindsay on his retirement, and again some decades later. Clark had inherited bourgeois wealth and developed princely appetites, but his burden, that education and enlightenment were linked indissolubly with enjoyment, was not too far removed from Felton's simpler attitude to art and its delights.

Clark's princely values could be annoying. Lindsay particularly wanted to acquire for Melbourne a pair of Italian *cassoni*, to be displayed with pictures of their period. McDonnell found a pair, belonging to Lady Somers, widow of a Victorian

[12] Ibid., p. 22.

[13] Ibid., p. 7.

[14] Many drafts of this lecture are in the MacDonald papers.

Governor, but Sir Kenneth objected that a pair of *cassoni* would mean nothing whatever in Melbourne as they would not 'relate to anything in the Australian background'. To McDonnell they would indeed be Renaissance *cassoni*, be they 'in Florence, Paris, the Gobi desert or Melbourne'; but in any case £10 000 was too much to pay, and they went to Agnew's.[15]

Lindsay must have been pleased to receive, in 1951, a less equivocal tribute to his Gallery from a prominent English collector of prints and drawings, Sir Thomas Barlow. A Lancashire cotton spinner and weaver by inheritance, and later a banker, TB Barlow (1883–1964) had been director-general of civilian clothing during the war, refusing to buy a new suit until hostilities ended.[16] Chairman of the Council of Design and a Councillor of the Royal College of Art, 'Tommy' Barlow had been a collector since youth; and he wrote to Lindsay that he had been 'astonished' to find, on a brief visit to Melbourne, so fine a collection, citing the Tiepolo, the van Eyck and the Cotman drawings in particular: 'To have acquired the pictures you have succeeded in getting hold of seems to me a most remarkable achievement'.

> I don't know why I should write to you but cannot forbear giving myself the pleasure of telling you how much I enjoyed the visit and how intense is the delight one feels when all against one's expectations one enters a gallery which so conspicuously displays an atmosphere of scholarship, judgement and intelligent buying.[17]

Impressing Sir Thomas Barlow was a happy chance; later in the year he presented Melbourne with a charcoal landscape sketch by Gainsborough, and in 1953 with a Turner water-colour. More was to come.

DESPITE INFLATION IN the art market, the London Adviser continued to find good works at affordable prices. In 1949 alone the Bequest bought for the Gallery Stubbs' *Lion Attacking a Horse* for £528, a Sienese *St George* (£4600), Hobbema's *The Old Oak* (£8500) and an El Greco *Portrait*, unfortunately cut down (£12 000); and among the moderns Vlaminck's *Le pont sur la Seine à Chatou*, a Dufy (£250), and Bonnard's sensuous *La Sieste* (£2500). The Director caused the rejection of two of McDonnell's recommendations: a Degas bronze, of a dancer holding her foot, and a rare German drawing, Schongauer's *Head of a Monk* (£2300), which ended up in the National Gallery, Washington.[18] McDonnell was not discouraged: buying, from

[15] Cox, *The National Gallery*, p. 207. (March 1949)

[16] His patriotism was perhaps bolstered by masochism, which 'among his many remarkable qualities ... held an honoured place' (Gordon Russell, entry on Barlow in *Dictionary of National Biography 1961–70*).

[17] The letter is quoted in full in Cox, *The National Gallery*, pp. 210–11.

[18] FBC, 28 January 1949. Cox, *The National Gallery*, pp. 205–6, discusses the issues involved.

the Schedule, four Conrad Martens, he was so impressed by them that he offered to buy and present another four. The Committee thought that improper, and bought all eight instead, for £336.[19] It also began negotiations to buy Lionel Lindsay's collection of several hundred drawings and other works by the great wood-engraver for *Punch* and the *Illustrated London News*, Charles Keene, some of whose work Hall had acquired in 1905. Clark pointed to Lindsay's as the only significant private collection of Keene's works left in the world; it was eventually acquired, in April 1951, for A£4431, and McDonnell found in London a Whistler drawing of Keene himself, sketching.[20] Significant amounts were also spent on the Art Museum. In December 1948, when the Committee received a half-yearly distribution of £12 500 for the art fund, it still had another £105 000 in reserve; two years later the total was less than £90 000, as the Committee, perhaps prompted by Sir Frank Clarke's apprehension concerning rising prices and diminishing opportunities, ran down their accumulated funds as good works became available.

A visit from McDonnell at the end of 1949 urged them on. In August 1948 he had proposed visiting Australia for three months; the Committee agreed to pay his fare provided he would agree to serve for at least two more years.[21] He did not arrive until November 1949, when he was able to urge in person the purchase of Amigoni's masterly group, including the castrato singer Farinelli and the artist himself, for £2200. At a conference in December he carefully joined in a discussion of period rooms, long favoured by Murdoch. Lindsay, whose transformation of the old galleries from tedious dullness to interesting display was perhaps his greatest achievement as Director, had argued strongly for century or half-century rooms, as 'more in line with modern methods'. McDonnell spoke against period rooms of the 'cottage' variety, suitable only for regional museums. 'This museum', he assured the Conference, 'is a museum of fine arts and its policy in my opinion should be directed to acquiring only pieces of the finest quality', but an English or French eighteenth-century, or Italian seventeenth-century, room, 'where pictures, furniture and objects of art of fine quality could be arranged to show what each particular age achieved, would be a great asset to this museum'. Lindsay added that an Australian room was a possibility, without suggesting a period; (a room—of the 'cottage' variety— was to be reconstructed in the Ballarat Gallery to commemorate the Lindsays' childhood home).[22] It was eventually agreed that

[19] FBC, 21 September 1949.

[20] Ibid., 5 December 1951. It cost £65.

[21] Ibid., 27 August 1948.

[22] Ibid., 29 November, Conference, 7 December 1949.

any decision on period rooms be postponed, and that century rooms, while approved in principle, must await the new Gallery. That was still a long way off, the Government announcing—in response to Clark's urging that construction begin—that while building materials remained scarce, housing would remain its first priority for some years. The Trustees had to be content with discussions with the Melbourne City and South Melbourne Councils, and with a sign in St Kilda Road announcing—as it gradually faded—that the site had been reserved for a Cultural Centre.[23]

In February 1950 McDonnell submitted a Report, making suggestions concerning the planned new building—he proposed Medieval, Renaissance, Baroque and Rococo galleries, and also a Chinese gallery, with annexes for Muslim and Indian art—and in the meantime an effort (approved by Clark) to strengthen areas already strong, especially French, Flemish, Venetian and nineteenth-century painting. He suggested scrapping the Schedule—a proper one, Clark had remarked, would be the size of a telephone directory—and asked for a sum to buy contemporary art, at the Adviser's discretion. (The Committee's lawyers recommended against scrapping the Schedule, but the Adviser was allowed £2000 over three years for contemporary works.) McDonnell argued against keeping too much in reserve for the 'great' picture, for which Melbourne was likely to be outbid if and when it did appear, arguing (as Rinder had long before) in favour of buying the very good pictures which could more often be obtained. Furniture should be sought, but only the very fine, not simply to furnish rooms. The Committee recorded its entire satisfaction with McDonnell, and his appointment was renewed, with salary and allowance increased.[24] The press also seemed unusually pleased with the Adviser, Arnold Shore writing (too optimistically) that since the Bequest was now better run, it would 'enable us to secure almost all that could be desired if we so chose'; he concluded by quoting Burdett on Felton: 'we owe a deep gratitude to the memory of a wise and gentle man who chose charity and art as its guardians'.[25]

While McDonnell was in Australia, Dr Hoff spent four months abroad. The Committee asked her to consider which works should be submitted to Sir Kenneth, and allowed her £500 to spend, in consultation with Wright, buying drawings and prints, on which her authority was now widely recognised. She

[23] FBC, 9 March 1950; *Argus*, 12 January 1949; Cox, *The National Gallery*, p. 213.

[24] He offered to continue for three years, if desired. McDonnell, Letter 48 and Report, 14 February 1950; FBC, 19 March 1950. McDonnell left with the catalogue of Lionel Lindsay's Keene collection, to value in London.

[25] *Argus*, 13 December 1949. He was soon to claim (*Argus*, 13 July 1951) that 'Victorians are going to the National Gallery with more than an idle curiosity—they really want to know about art'.

acquired a number of sixteenth-century Renaissance prints and engravings, and recommended, with Clark's support, 'three important drawings', Rowlandson's *High Life* in Venice, Jean-Etienne Liotard's *Lady in a Turkish dress, reading*, and a Doomer. The Trustees rejected the Doomer, but after her return in May the Conference approved the others, heard her report, and received a detailed and persuasive tutorial (recorded in a full page of the minutes) on why the Liotard was a great work.[26] A few months later the Committee approved spending, over two years, £500 on contemporary ceramics and glass, and two similar sums on silver and furniture; McDonnell later made a trip to France and Sweden, and the Bequest got its money's worth.[27]

In London, McDonnell resumed his searches. When he wanted to buy Redon's *Pegasus*, strongly recommended by the Director of the Tate, the Committee obligingly added the artist to the Schedule; and he soon reported buying Salvator Rosa's *Romantic Landscape with Mercury and Argus* (£600), Pittoni's *Miracle of the Loaves and Fishes* (£1050), and in April 1951 Rouault's *Christ on the Veil of St Veronica* for £1800 sterling.[28] But he found he could not support Clark's very strong recommendation to buy Rembrandt's *Titus*, for £43 500; fortunately the conflict was resolved when McDonnell sought out and Clark agreed that the artist's *Portrait of a [Fair-Headed] Man*, once in the Beit Collection, would be an excellent acquisition at £37 000 sterling.[29] A major Constable, *Boat Passing a Lock*, another great work, turned up at the same time, for £15 000. Lindsay was keen on the Constable (considering it 'the greatest Constable "find" in recent years'), but hesitant about the Rembrandt; the English picture was approved by the Committee, the Dutch deferred. A Conference on 7 December 1950 proved dramatic: a cable suggested that the Constable had been sold elsewhere; another conveyed Clark's strong recommendation to buy both pictures; and a third, received during the meeting, announced that the London National Gallery had bought the Constable, but was faced with having to buy a work of national importance and would accept £15 000 for the landscape if offered immediately. The Conference promptly made the offer. Lindsay then advised that the Rembrandt, though imperfect, was a great picture, better than the *Self-portrait* purchased by Holmes and Davies, or Hall's *Two*

[26] FBC, 21 September 1949 (authorising her expenses also; the same meeting bought 164 prints from Wright's collection for £800); Conference, 4 May 1950. For Hoff's report, see also Anderson, 'Ursula Hoff on her Ninetieth Birthday', p. 255, and Cox, *The National Gallery*, p. 221.

[27] Conference, 2 November 1950; FBC, 2 June 1952.

[28] Ibid., 6 October 1950, 5 April 1951. *Pegasus* cost £386.

[29] Ibid., 2 and 29 November 1950. On the Rembrandts, see also John Gregory in Gregory and Zdanowicz, *Rembrandt in the Collections of the National Gallery of Victoria*, pp. 14–15 and 59–76.

Philosophers (which he called 'doubtful') and should be purchased. Always too prone to de-accession earlier acquisitions—to the devastation, in particular, of the Gallery's Victorian sculpture—he suggested that steps be taken to obtain permission to sell one of the other Rembrandts. Fortunately that proved impossible, counsel advising that Felton's will precluded sale of acquisitions funded from his estate—how, indeed, could the Committee determine that it had been mistaken in certifying that a work would elevate public taste?—but the *Portrait of a Fair-Headed Man* was purchased, for A£46 250, then the highest price ever paid for a work of art imported into Australia.[30] Press, Trustees and Committee were well pleased, Russell Grimwade congratulating McDonnell, glad that he 'had the honour to serve on the Trust at the time of this major acquisition'.[31] Lindsay's judgement was justified when the portrait (unlike the alleged self-portrait) survived the great Rembrandt cull; but meanwhile reserves in the Art fund, less than £90 000 in November 1950, were severely depleted.

The Rembrandt was Clark's last major recommendation as an Adviser. In January 1951 he resigned as Principal Consultant, claiming pressure of work. McDonnell was given new instructions: in principle, he should always consult the Committee if there was time; if not, he could buy from the Schedule up to £1000 alone, and up to £3000 with support from a recognised expert. He could recommend up to £3000 without expert support.[32] There remained some tension over Bluett's role as adviser on Oriental material; at the same meeting Murdoch asked that his disapproval of a letter Sargant had written to Bluett be recorded, and in May Murdoch was authorised to discuss Bluett's position with him in Britain. While there, he joined Kent in spending £2000 (part of an allocation of £3000 to Kent and Bluett) on works owned by Bluett himself; some members of the Committee remained uneasy that an adviser was also a dealer.[33]

Lindsay approved most of the report the principal Adviser had submitted in 1950, though wary of buying too much contemporary art and insisting that the Schedule should be revised, not abandoned, since 'the needs of the collection'—gap-filling—should not be forgotten. 'As regards McDonnell', he wrote privately to Sir Frank Clarke in 1952, 'he is, and I say it with all humility, the only Australian I know other than myself capable of buying for us in London. Like any buyer he

[30] The FBC lacked a quorum at the conference, and formally approved the Constable on 17 January 1951 and the Rembrandt at a conference on 25 January, when it also reported Counsel's opinion against sale of Felton acquisitions. See also Cox, *The National Gallery*, pp. 218–20.

[31] Poynter, *Russell Grimwade*, p. 282.

[32] FBC, 17 January 1951.

[33] Ibid., 16 May and 2 June 1951. On 2 June 1952 the Committee, having decided to conserve funds, declined Bluett's request for a new agreement; on 4 July it deferred a further request for a 'stabilized' basis, to be like other Advisers.

Sir Daryl Lindsay and Sir Russell Grimwade, 'Miegunyah', 1952 (ANZ Trustees)

has made mistakes, but on the whole he has done a remarkably sound job'.[34] Lindsay still hankered for making all decisions in house, although he did not yet have the resources to do so. Franz Philipp might write later that 'it was under Daryl Lindsay that the National Gallery of Victoria became a training ground for many gallery administrators', but the Director himself complained publicly in 1952 that many more new professional positions were being created in the Library and the National Museum than in the Gallery, though the proposals he successfully put to the minister later in the year were modest.[35] The end of Lindsay's proposed three-year period of reliance on overseas advisers had long passed, and although he was generous in his public praise of the work of McDonnell and Clark, he was sometimes grumpy when he disagreed with overseas advice.

[34] Lindsay to Clarke, 25 February 1952.

[35] Philipp and Stewart (eds), *In Honour of Daryl Lindsay*, Foreword, p. v; *Age*, 8 February 1952; Cox, *The National Gallery*, p. 231. They included another secondment from the Education Department, to enable the long-serving Gordon Thomson to be Assistant Curator of the Art Museum, funds to pay Harley Griffiths as a part-time conservator, and a new rating for Dr Hoff.

Nevertheless the discussions of these years, on policy and purchases, were generally amicable. The bad old days when Director, Trustees and the Committee were locked in triangular battle were mercifully gone. At a Conference in April 1951 Sir Frank Clarke remarked on the harmony between the two bodies, and their good relationship with the Advisers. Murdoch concurred, paying tribute to all the Bequest had done, but stressing the breadth of the Gallery's responsibilities, and its continuing needs.[36] His own Board of Trustees had become more amenable since the death, in March 1950, of RD Elliott; (Leonard Cox recalled visiting him not long before, to be shown his collection of Orpen, Brangwyn and others, destined for the Mildura gallery; 'he showed no unfriendliness to me—but then of course I did not cross him').[37] His replacement, Justice (Sir) Reginald Sholl, of the Victorian Supreme Court, was much more sedate (though in his younger days, as a Rhodes Scholar, he had inaugurated the annual Oxford–Cambridge Australian Rules football match). When Max Meldrum's term as a Trustee expired in 1951, he was replaced by John Burnell of Castlemaine (according to Cox, a man 'with a fine perception of art well beyond that of the average trustee').[38] Early in 1952 HW Kent died, after a distressing illness which made him a difficult colleague in his last months; at his request his ashes were scattered half-way between Australia and his beloved China. After some delay, Dr Cox replaced him as Honorary Curator of the Oriental Collection.

Having spent so much on the Rembrandt and the Constable, the Bequests' Committee decided, unanimously, to build up its funds again, and acquisitions slowed, though McDonnell still made some good purchases, partly from his continuing allocation for contemporary works. In December 1951 he reported buying a Paul Nash painting for £650 and a water-colour for £40, Vuillard's gouache *Interieur* for £850, and a candelabrum and a cabinet by contemporary British craftsmen.[39] In Australia, in 1951, Lindsay recommended Justin O'Brien's *Triptych* (long popular on the Gallery's Christmas cards) and—a discriminating and magnanimous choice—Meldrum's early and very fine *Picherit's Farm*, another popular favourite. Most local acquisitions, however, were now made with other funds.

In May 1952 McDonnell, able unlike his predecessors to make immediate purchases at exhibitions and galleries, reported buying Matisse's *Nu couché sur canapé rose*, writing that 'it is small, but it dates from Matisse's best period, the mid

[36] Conference, 5 April 1951.

[37] Cox, *The National Gallery*, p. 443.

[38] Ibid., p. 225.

[39] FBC, 5 December 1951.

1920s, and, to me, expresses all he has to give as a painter'.[40] Melbourne now had its Matisse as well as the Landseer, and was apparently no longer embarrassed by a *nu couché*, though some members of the Conference—Justice Sholl in particular—were shocked by Balthus' striking *Nu à la bassine*, bought for £400 sterling. In June the Committee had added Chagall and Balthus to the Schedule, at McDonnell's request; when the *Nu* arrived in July, Secretary Rigg told the Committee that the Adviser should have referred these purchases from the Schedule to Melbourne, unless time did not allow, and it was resolved that 'the instructions should be strictly observed and that this be tactfully conveyed to Mr McDonnell'.[41] The message did not prevent him reporting in December 1952, after the event, his purchase of Chagall's *Le lion et le rat* for £400 sterling.[42] He did, however, seek and gain approval for Perronneau's fine 1771 portrait of *Petrus Woortman* (£1500 sterling).

The year's purchases did not please the press. Taken all in all, they seemed 'little likely to further Alfred Felton's desire to "raise or improve public taste"', suggesting 'hesitancy, confusion of thought, false confidence or jaded inspiration, perhaps something of all. Either some drastic re-adjustment in buying policy, a reshuffle in administration, or a temporary halt for mental stock-taking, seems imperative'.[43] One picture (possibly the Balthus) prompted the Bequests' Committee itself to remind McDonnell that only the best would do; and in turn some Trustees took exception to the Committee's statement that 'the acquisition of minor contemporary works, which may have an ephemeral value, was the function of the Gallery out of its own funds'. A year later the *Argus* protested that McDonnell's purchases of 'modern art' were 'baffling'.[44]

In June 1952 Sir Frank Clarke stood down as Chairman of the Bequests' Committee, while remaining a member. Russell Grimwade, who replaced him, took the task very seriously, reminding his audience while handing over the 1952 acquisitions of the complexities of the Trust. As for criticism, it was to be expected, accepted, and indeed welcomed.

> In no field of human endeavour does the adage *Quot homines tot sententiae* apply more aptly than in the field of art. All those who have to play any part in the administration of this great Estate must realise that critics are many and it is quite impossible to

[40] McDonnell to FBC, 18 February 1952.

[41] FBC, 2 June 1952, Conference, 4 July 1952.

[42] FBC, 3 December 1952.

[43] Quoted in Poynter, *Russell Grimwade*, p. 283.

[44] *Argus*, 6 February 1953.

please everybody. The best that can be done, under these difficult circumstances, is to effect a compromise; so, over the years, you will find that the Felton Bequest buys over a very large range. Of course it is known that some purchases exhilarate some beholders whilst they anger others. That seems to be inevitable. Let us hope that each emotion has its usefulness.[45]

For some time Lindsay had wished to revisit Europe and America. His attempts to do so, in the teeth of Public Service regulations, were incidentally the cause of some tension with Sir Frank Clarke, who was apt to use the word 'holiday' rather than 'absence on business' or 'sabbatical', the term—then still used by universities—which Lindsay preferred. Clarke had hoped to entice McDonnell back as second-in command and heir apparent, but Lindsay told him it was pointless to ask; Gordon Thomson, originally a teacher seconded as Education Officer, acted as Director, the Chairman of the Public Service Board having said of Dr Hoff that he 'queried if a woman could command obedience from the staff'.[46] In the end a Carnegie grant made Lindsay's trip possible, while in July 1952 the Bequests' Committee approved £500 towards his expenses, but refused him £5000 to spend overseas; in Conference later the same day it allowed him £2000, to spend on specified items in consultation with McDonnell.[47]

On 4 October, while Lindsay was abroad, Sir Keith Murdoch died suddenly. His son Rupert returned immediately from Oxford, to build a far larger media empire than his father could ever have envisaged. Sir John Medley replaced Murdoch as Chairman of Trustees, and also took his place on the Bequests' Committee, while Allan Henderson became Deputy Chairman.[48] A remarkable era had ended; if the Trustees, and the Committee, had calmer waters to navigate than their predecessors, that was largely thanks to Murdoch's remarkable achievements over thirteen years.

JOHN DUDLEY GIBBS (Jack) Medley was a calm man, on the surface. Beneath it, uncertain health and nervous tension, regularly sublimated in the surreptitious production of occasional verse, sometimes drove him to collapse, as it had done

[45] Poynter, *Russell Grimwade*, pp. 283–4.

[46] The Clarke–Lindsay correspondence is in the Trustee company papers; see also Cox, *The National Gallery*, pp. 227–9.

[47] FBC, and Conference, 4 July 1952.

[48] Medley had briefly been Chairman before. In June 1951, when he and Sir Keith Murdoch were both absent and only four Trustees present at the meeting which elected office-bearers, Medley's was the only nomination received, and the Board adopted a minute of appreciation of Murdoch's services. Medley resigned at the August meeting and Murdoch was elected (Cox, *The National Gallery*, p. 226). On 20 October 1952 the Bequests' Committee agreed to support Cox's appointment to the vacancy on the Trust, but he was not appointed until 1956.

an hour before he was to be interviewed for the Vice-Chancellorship by the University Council in 1938. Brought in as a candidate by Russell Grimwade and others, who thought him a dark horse capable of outrunning the favourite, Commerce Professor Douglas Copland, Medley was appointed, by one vote, to his surprise as much as anyone's. As the Headmaster of a preparatory school outside Sydney he appeared to have few qualifications, although in fact Medley could have had an academic career as a classical scholar had not his appointment to a Cambridge Fellowship in 1914 been interrupted by the war and four harrowing years in France. Instead, he went into business. Connected through his mother with Gibbs, Bright and Company, he entered the firm and was soon transferred to the Australian branch, sailing, with wife and child, to Melbourne in 1920. Also on board was Alfred Bright, a partner in the firm (but not yet a Trustee of the Gallery) who became his mentor in the business and in Melbourne society, where he made friends with Russell Grimwade and others. Gibbs Bright sent Medley to Adelaide in 1922, and later to Sydney; dissatisfied with business, he quit the firm in 1930 to take over—very successfully—Tudor House School in Moss Vale. At Melbourne University he soon proved an imaginative administrator, a Vice-Chancellor who was at once a humanist, a liberal and a gentleman, even then a rare and endangered species. He retired from the University, aged sixty, in 1951, and thus had time to give to Gallery affairs when he succeeded Murdoch a year later.[49]

With Medley Chairman of the Gallery Trustees and a member of the Bequests' Committee, which his friend Russell Grimwade chaired, their mutual friend Daryl Lindsay Director of the National Gallery, and AeJL McDonnell, whom they all liked and admired, reappointed London Adviser for five years, personal animosities ceased to be so significant a hindrance to the operation of Felton's Bequest.[50] But friends can disagree, and tension between Lindsay and McDonnell was evident in 1953. When they were together in London in 1952, Lindsay concurred with the Adviser in leaving aside 'a fine Renoir', too expensive at £19 000.[51] They agreed in acquiring (for £5250) Géricault's *The Entombment* (now 'manner of'), a Burgundian Gothic tapestry (£1100) and some furniture, but

[49] On Medley, see Serle, *Sir John Medley*, and *ADB*, vol. 15; and Poynter and Rasmussen, *A Place Apart*, pp. 28–30. 'A medley of allegiances', MacDonald punned, calling Medley and Lindsay 'equal favourites for the incumbency of Bray' (Humphrey McQueen, 'Jimmy's Brief Lives', p.180).

[50] McDonnell was offered a three-year appointment, at a higher salary, after a Conference on 5 February 1953; when he asked for a five- or seven-year appointment instead, he was appointed for five (FBC, 13 August 1953).

[51] McDonnell to FBC, 21 December 1952: 'I know that he is a great painter and that a fine example of his work would be a most valuable addition to the Gallery's French 19th Century Collection, but the fact remains that Renoir's work is at present over-valued'.

after returning to Melbourne the Director complained that the Adviser had not sent forward details of some works Lindsay had admired in London, and over the next two years he quite frequently spoke against McDonnell's recommendations.[52] Perugino's *The Resurrection*—which Clark had first thought a Raphael—Lindsay thought too dear at £25 000 (it went to São Paolo); and he did not agree that Renoir's bronze bust of *Madame Renoir* was a major work. He did however support acquisition of Marmion's *Virgin and Child*, despite thinking it expensive at £15 000 and complaining that McDonnell's initial documentation had been inadequate.[53] Like every Director before him, Lindsay urged the Advisers to prize quality above all (though he was too indulgent towards less-than-outstanding sculpture and tapestries, and bought some bad furniture). Prompted by Dr Hoff, then already working towards the first edition of her *European Painting and Sculpture* (1959), he was concerned at gaps in the provenance of many of the Gallery's most famous pictures, asking the Committee to include more scholarly work in the Adviser's brief.[54]

Lindsay had returned from London reporting that old masters were increasingly rare and expensive, and arguing that works by lesser masters should be bought to fill gaps. The Committee responded by appointing the two Chairmen, Grimwade and Medley, as a committee to discuss future policy with Lindsay and Secretary Rigg and to draw up a plan; accumulating one-third of income to permit occasional major purchases was suggested as one element.[55] In October 1953 Lindsay recast the Schedule in four parts; Old Masters 'essential to complete and support' the most important existing holdings; other Old Master works the Adviser thought especially desirable acquisitions; contemporary work (since 1900) according to an approved list; and drawings and prints.[56] In November the Bequests' Committee approved the Schedule as part of a future policy: the importance of filling existing gaps was confirmed; one-third of income was to be accumulated each year; and up to £2000 was to be spent on contemporary

[52] The Géricault, the tapestry and four large Renaissance frames were approved at a Conference on 5 February 1952, which also agreed to bid up to £1000 for works auctioned from the Murdoch collection. In March the FBC, decided to bid £320 for a clock, £535 10s for Sickert's *Grand Canal, Venice*, £55 for a Bonnard lithograph *Nu à la Toilette* (both acquired), and for 13 pieces of glass.

[53] FBC, 9 February 1954 received the recommendation for the Marmion; the decision to purchase, 'cheaper if possible', was made by the FBC on 12 March. In November McDonnell had recommended an Umbrian picture for £25 000, which the Trustees recommended but at no more than £18 000; he then reported in December that he hoped to recommend a Flemish primitive instead.

[54] Cox, *The National Gallery*, p. 217.

[55] FBC, 30 April 1953.

[56] Lindsay to FBC, 14 October 1953.

works annually. A copy was sent to the Adviser, who was nevertheless free to recommend anything he chose.[57]

The *cause célèbre* of these years was the rejection of Delacroix's *Les Natchez*, very strongly recommended by McDonnell, supported by Burke, for £20 000. A Conference in July 1954 liked it, but asked for 'authoritative' reassurance on the price. McDonnell fumbled, reluctant to reveal that it had recently sold for a lesser amount at auction, and despite Sargant's advice withheld the information, which Sargant then felt obliged to convey to the Committee himself. 'McDonnell has it in his bones', he wrote, 'that disclosure of the lesser price at a recent auction sale will almost certainly mean that the Committee will not buy the picture', which the Adviser felt deeply was 'a work they ought to acquire'.[58] 'A majority of the Trustees of the National gallery', the Committee noted in November 1954, 'after having considered further information, decided not to recommend the purchase of the painting at the price asked'. But some remained uneasy, and in May 1955, having heard it might still be available, and for less, asked the Committee to enquire about it. McDonnell replied that it was indeed still for sale, London's National Gallery having reluctantly decided it was too dear and an American gallery lacking the money. He had been to see it again with Sir Russell Grimwade, who, he conceded, 'is not very taken with it'.[59] Grimwade was in London because McDonnell had found for him Strutt's *Bushrangers on the St Kilda Road*, and was in his historical mode. According to a later account by Lindsay, Grimwade objected to the picture because there were inaccuracies in Delacroix's depiction of Indian costume; since—Grimwade had established with some care—the artist had never been to America, he could not in consequence correctly portray its inhabitants. (Strutt, he knew, had seen the St Kilda road.) Lindsay was provoked to reply that Rembrandt had never been to the Holy Land, but had often depicted Jesus Christ.[60] The Delacroix went to the Metropolitan, not Melbourne, to McDonnell's disappointment. Lindsay had finally opposed it, as he opposed a Nicholas Berchem (£775) which McDonnell thought exceptional, an outstanding Liotard, a Hals (£17 000), a Picasso (£5000), and a *Portrait of an Unknown Man*, probably by Holbein (£15 000).[61]

[57] FBC, 6 November 1953.

[58] Sargent to Colin Rigg, quoted in Cox, *The National Gallery*, p. 243.

[59] McDonnell to FBC, 4 July 1955.

[60] Conversation with JRP, 1962. Lindsay was inclined to disdain his friend Grimwade's taste in art, though conceding he was expert concerning Australian prints, of which he had a fine collection.

[61] FBC, 2 June and 5 November 1954.

McDonnell was able to buy several contemporary works, including two small Max Ernsts (joining two lithographs bought the year before), a Buffet and two Barbara Hepworth sculptures, while Lindsay, in Melbourne, had to rebut the Contemporary Art Society's claim (prompted by a French Painting Today Exhibition then in Melbourne) that the Gallery neglected modern art; the accurate answer would have been 'some, but not all'.[62]

LINDSAY WAS APPROACHING statutory retiring age, and the Trustees sought an extension of his term, but could win only six months, until 1 July 1955. In March the Bequests' Committee decided to invite him, on retirement, to write 'the history of the Bequests to date', including 'the influence of the Felton Bequests on the National Gallery of Victoria'.[63] The Public Service Board's advertisement for his successor, issued in October 1954, sought a paragon, a man (it assumed without question) with 'an expert and technical knowledge of painting, sculpture, drawing, prints, ceramics (Oriental and European), and works of fine art, and their preservation and display, and a practical knowledge of market conditions and values, both Australian and Overseas, relative to such matters'. Nine men applied, three were shortlisted, and a special meeting of Trustees on 23 February 1955 interviewed Eric Westbrook, then Director of the City Art Gallery in Auckland but a Londoner by birth and an artist by training, formerly Director of the Wakefield City Art Gallery in Yorkshire and Chief Exhibitions Officer in the Fine Arts Department of the British Council. Westbrook later recounted to Serle his memory of the interview, as 'a strange, unstructured and uncontrollable occasion', with the interviewing committee 'packed with public servants from several departments'; and recalled Medley in the chair, 'with his bright sparkling eyes and sad mouth and obvious intelligence'. Westbrook was appointed, to take office at the beginning of 1956.[64]

Lindsay's last year as Director was eventful enough. In February 1955 McDonnell recommended two fine Barbizon pictures, Rousseau's *Landscape with a clump of trees* (£1400) and Daubigny's *Barge on the Oise, evening* (£1750), soon adding a third, Diaz' *Forest Clearing* (£325). In March Sir Frank Clarke died, and was replaced as a member of the Committee by Dr Clive Fitts, Russell Grimwade's physician and a friend of Burke and Lindsay, a medico with strong lit-

[62] Cox, *The National Gallery*, pp. 246–7.

[63] FBC, 4 March 1955. He was to be paid £500 a year for two years 'for completion of the work in that period'. In May Lindsay asked that the offer be left over until later in the year; the work was not completed and published until 1963.

[64] FBC, 23 July 1954; Serle, *Sir John Medley*, p. 64; Cox, *The National Gallery*, pp. 249–52.

erary and cultural interests.[65] That month a Gobelin tapestry was rejected (there was nowhere to put it), but a Japanese Noh mask and a Buddhist sculpture recommended by McDonnell were approved, prompting the Committee to seek the Adviser's (and Cox's) advice on how to build 'a small and select collection' of Japanese works.[66] The Adviser's recommendation to buy a large Picasso vase (for £350) was approved in May, and Rossetti's water-colour, *Paola and Francesca* (£800) in June. A Vuillard portrait of Mme Bonnard, which Sir Philip Hendy had wanted for London's National Gallery, was approved for £5400—much more than the *Intérieur* they had rejected, and McDonnell had bought, in 1948—after an initial deferral while three 'important matters' were explored: the reappearence of the Natchez women, the resubmission by Bluett, on Cox's recommendation, of a pair of Bodhisattva statues (£1500 each, previously rejected and now approved) and Cranach's *Judgement of Solomon*, available in Brussels, commended to Medley by Professor 'Pansy' Wright.[67] Meanwhile McDonnell used his 'contemporary' fund to buy a Roy de Maistre (in London), Piper's *Toller Parsonage* (£100), an etching, an aquatint and a lithograph by Picasso, and a Chagall lithograph; but when, in August, McDonnell recommended Braque's *Le Petit Billard* ('you may not have an opportunity of getting a better Braque', he wrote, and at £5500 'not unduly expensive') Lindsay disagreed and persuaded the Trustees to reject it.

Grimwade, back in Melbourne after acquiring Strutt's *Bushrangers* and querying Delacroix's verisimilitude, was ill. The Bequests' Committee met at his home, 'Miegunyah', on 31 October 1955 to discuss his report on the London operations of the Bequest, a document he had drafted on board ship. He had been most impressed by the quality of the Trust's advice and by the standing it enjoyed in the art world. 'I put myself into the hands of John McDonnell', he wrote 'and with him went the rounds of dealers, auctioneers, galleries and museums which are his usual hunting grounds. I soon found that he was a favoured visitor and received with interest and pleasure in all places'.[68] Grimwade found the milieu fascinating and in some respects alarming. Dealers ranged from 'a very few at the top whose

[65] FBC, 4 March 1955. Clive Hamilton Fitts, born in Melbourne in 1900, was a consulting physician in the Royal Melbourne and Royal Women's Hospitals. Some adventurous years spent abroad as a young graduate included postgraduate training in England, Switzerland and the United States, and in 1948 he had held a Carnegie Travelling Fellowship in Medicine. A book lover with broad interests (like his father-in-law Professor WA Osborne), he also involved himself in University affairs. Dixon and Menzies were also his patients. His papers are in the University of Melbourne Archives.

[66] FBC, 4 March 1955.

[67] Ibid., 25 May and 12 July, Conference, 3 June 1955.

[68] Grimwade's report, dated 5 October 1955, is pasted in the minutes of the FBC, 31 October 1955.

integrity is unquestioned, through all shades of dubiety to the many to whom any transaction is a cannibalistic adventure'. The Adviser was wise to rely on the best dealers and to avoid bargaining with them; there were more buyers than works, and dealers would not give options—necessary with the Bequest's long time-lines—to hagglers. Grimwade saw Bluett separately, intending to reprove him for overruling McDonnell on Oriental pieces, but he was confounded when the dealer produced a letter from Sir Frank Clarke granting him direct access to the Committee. Nevertheless he thought Bluett a good and useful Adviser; the Committee accepted his judgement, and decided to thank the dealer but also to ask him to communicate only through McDonnell.

The art markets of the 1950s, as Grimwade described their polite savagery, were no place for the timid or the squeamish:

> A visit to a sale at Christie's was enlightening. Several Corots were being sold and all the lots fetched prices that seemed absolutely fantastic to me and which could only be explained by the thought that many rich people in England were seizing such opportunities as some protection against possible capital levies of the future. McDonnell said it was a 'flight from currency', but that fails with me in accounting for the huge prices realised.
>
> The informal ring of buyers is a serious body to challenge and I should think that McDonnell is right in commissioning a reputable dealer to bid for anything he wants. I saw an outside lady personally bid up to £900 for a very unimportant picture she wanted. At that stage she realised that whatever she bid the 'ring' would outbid, so she withdrew, evidently prepared to pay some dealer £1500 or thereabouts for it that afternoon. A book sale at Sotheby's gave me the same feeling, that it would be most unwise to pit oneself against the accepted order and defy the laws of the jungle that prevail at such places.

Grimwade suggested that McDonnell should come to Melbourne for consultation, in 1957, after 'the Olympic upheaval' scheduled for November 1956.[69]

Russell Grimwade did not live to see the Melbourne Olympics, in spirit and execution notably amateur compared with later Games; three days after the Conference at 'Miegunyah' he died, on 2 November 1955. More knowledgeable about art than his two brothers or his father, he had been a creative member of the Committee.[70] Dixon succeeded him as Chairman, and an approach was made to Norton's son Geoffrey to join the Bequests' Committee, to maintain a

[69] Conference, 3 June, FBC, 31 October 1955.

[70] He left his house and his collection to the University of Melbourne, subject to his wife's concurrence; she lived until 1972.

Grimwade succession; with Harold's son John, Geoffrey had continued family business interests (though he was unfortunately to die too soon to save Drug Houses of Australia from falling victim to one of the first modern asset-stripping takeovers in Australia). Busy with business, Geoffrey declined to join the Committee, and suggested skipping a generation, proposing the young Andrew Grimwade, then twenty-five and recently returned from Oxford. Andrew's father, FS 'Erick' Grimwade—son of Sheppard Grimwade, the surgeon brother of Russell Grimwade who had attended the dying Felton—had died young, and Russell had taken a close interest in his great-nephew, who in 1955 was working 'on a special assignment for DHA' in Sydney. Sir Owen met him there, over lunch in the old Union Club, and decided, for whatever reason, that this very young man was not what the Committee needed. At a meeting on 14 December, Medley agreed to ask Professor Burke to join the Committee; he resigned as a Trustee when he did so, as Clarke had done in 1930. The Committee recorded that it would like to have Lindsay on the Committee also, when the time was ripe. It never was, but they consulted him frequently. Dr Leonard Cox took Burke's place as a Trustee.[71]

At the 'Miegunyah' meeting in October, Lindsay had criticised McDonnell's negative report on the Cranach—'a very dull and ugly picture on which to spend £9000'—given on the basis of photographs without visiting Brussels. Someone, perhaps Lindsay, then raised the question of 'inspecting and discussing works on arrival, in order to ascertain views generally thereon and as a guide to buying policy'; and the Committee agreed to invite the Trustees, the Director and his senior assistants to view the incoming shipment before its presentation. Some criticism of the Adviser was implied, and the decision curiously echoed the rending of Rinder by the Trustees' committee in 1926 and MacDonald's confrontation with the *Herald* Exhibition in 1939. The event proved milder than either of those dramatic precedents, but the Conference convened on 15 December 1955, to view the consignment of Felton acquisitions newly arrived in the *Oronsay*, enabled Lindsay to have his last word as Director. The twenty-four works displayed in the Childers Gallery were a varied lot: the paintings included the three Barbizon pictures (Rousseau's *Landscape with a clump of trees*, Daubigny's *Barge on the Oise, evening*, and Diaz' *Forest Clearing*), Vuillard's *Madame Bonnard with her dog at rue Drouai*, Ben Marshall's *Lord Jersey's 'Middleton'* (bought for £2800), Sir William Owen's fine Regency portrait of *Rachel, Lady Beaumont* (£4026 5s), Andre Masson's *Moonrise*

[71] FBC, 14 December 1955, 8 February 1956; Cox, *The National Gallery*, p. 265. On Geoffrey Grimwade, see the entry by Poynter in *ADB*, vol. 14; his note (17 November 1955) sending Andrew Grimwade's CV to Fitts is in the Fitts papers.

over trees in bloom (£450), Renato Guttoso's *Rocks of Anacapri* (£210), Nicolas Régnier's *Hero and Leander* (£80) and gouaches by Piper (*Toller Parsonage*, £105) and Nicholas Ghika (*Sunflowers Crete*, £35 guineas). The 'etchings, aquatints and water-colours included Rossetti's *Paolo and Francsca* (£800), Chagall's *Moonlight*, five works of Picasso (all cheap: *A faun unveiling a sleeping woman* cost £105, but three etchings only £8 8s each) and a Wilczynski. A pair of *cassoni*, bought (at last) for £1258, was the only furniture listed. A bronze of three acrobats by Emilio Stanzani, a statue in terracotta, a Chinese urn, the Picasso vase and a Renaissance frame completed the consignment, bought for £16 980 in total. Only Dixon, Fitts and Medley were there from the Committee, and Medley (again) and Burke from the Trustees, with Lindsay and Hoff both present and invited to speak. Lindsay's remarks ranged beyond the consignment; perhaps there were other recent acquisitions also in the Childers Gallery, not listed in the minutes.

His assessment was schoolmasterish: the Old Masters were '75% good'; a few of the modern works were excellent, the rest 'very disappointing'; four pieces of modern furniture (not listed) were 'excellent', but the rest could have been bought in Melbourne, while the period furniture was 'fair to good with some excellent pieces'; the porcelain and pottery were 'on the whole good', and the Chinese pieces all 'excellent'. Most of the disappointing works, he observed, had been bought without reference to Melbourne. In general discussion, Burke 'spoke strongly of the need for fullest information' on Old Masters recommended, and on important works supporting opinions; Hoff supported him, seeking in particular full details for cataloguing. The conclusion was mild: it was agreed that McDonnell be asked to look for fewer and better contemporary works, and to refer them to Melbourne when time permitted. In April 1956 he was asked to come to Melbourne for consultation in 1957.[72]

Russell Grimwade's death, and Lindsay's retirement, reduced the clubbable group of friends involved in Bequest affairs; (in 1951 Grimwade, Lindsay and Burke had been inaugurating members of the Melbourne Club's Art Committee, elevating art to a status in the Club which Colonel Standish and his ilk would scarcely have approved). Grimwade's successor as Chairman of the Bequests' Committee was the Chief Justice of the High Court, Sir Owen Dixon, a man never known to sacrifice propriety of process to friendship. If anything, Dixon erred in the opposite direction, valuing procedural clarity and the Bequests' autonomy so highly that he abandoned Conferences with the Purchase Committee in favour of formal correspondence with the Trustees, also abolishing

[72] Conference, 15 December 1955; FBC, 21 April 1956.

the cosy but often useful practice of his predecessors in the Chair of conducting private correspondence, not divulged to the Committee, with London Advisers. Sir Alexander Stewart, nominee of the Trustee Company and more interested in charity than art, also kept his distance, as did ARL Wiltshire, Chairman of the Trustee Company, his replacement when Stewart died in May 1956.[73]

1956 PROVED AN important year for the Bequest. In February McDonnell recommended Joshua Reynolds' portrait of *Lady Frances Finch*, which the new Director supported as 'one of the finest of this master I have seen'; purchase was approved, for £13 700. The Adviser had been in North America, and remarked on the high prices prevailing there; he also reported seeing 'a number of pieces, both pictures and objects, that have been considered by the Felton from time to time', notably in the Cloisters (the Metropolitan's medieval annexe) and at Hartford and Philadelphia, but left the implied rebuke unspoken.[74]

An important new source of advice for the Bequest had emerged the year before, when Professor Dale Trendall, formerly Professor of Greek and of Archaeology in the University of Sydney but since 1954 Master of University House in the Australian National University, agreed to advise on Greek vases, on which he was one the world's great authorities. In Rome, early in 1956, Trendall recommended (through McDonnell) a Chalcidian black-figure Psykter-amphora (£3500) and an Attic red-figure cup (£1600). Both were approved, the beginnings of a small—initially to be fewer than twenty pieces—but very choice collection which Trendall helped Melbourne to acquire over the following decades.[75] The Gallery appointed him Honorary Curator of Greek and Roman Antiquities in September 1958, when he was already a major influence on the Bequests' Committee.[76]

Further acquisitions approved at this time were a Glover landscape (£200) and a modern Lurcat tapestry, and (in June, for A£3096) sixty pieces of rare English porcelain from the collection of the late TH Payne, the gentleman noticed earlier as a prominent purchaser at the sale of Felton's pictures in 1904.[77]

[73] FBC, 9 June 1956. The Committee minuted Stewart's 'especial interest in charitable work'. Between May and October 1958 Stewart's son Dr J Cuming Stewart took Wiltshire's place on the Committee.

[74] Quoted in Cox, *The National Gallery*, p. 263.

[75] Galbally, *The Collections of the National Gallery of Victoria*, pp. 74–8, describes Trendall's acquisitions. Cockerell had earlier called the collection of ancient world material 'lamentably weak'.

[76] FBC, 3 December 1955; Trendall, *Greek Vases in the National Gallery of Victoria*.

[77] FBC, 21 April and 8 February 1956.

In July came another great opportunity: Sir Thomas Barlow wrote to McDonnell offering to the Melbourne Gallery, for £45 000 sterling, his entire collection of Dürer engravings and woodcuts, and of books containing woodcuts by the master. Barlow, who had begun collecting before World War I, had taken advantage of the break-up of German collections after the war to make comprehensive purchases of extraordinary quality. Assisted by Colnaghi's, he had regularly replaced the prints with finer impressions, so that 'in recent years no Dürer print superior in quality of impression to the one I already owned has come up for possible acquisition ... and I must therefore regard the collection, now, as a *fait accompli*'. Moreover, 'it is safe to say that such a Dürer collection can never again be assembled'. It would pain him to dispose of it, but he was 'most anxious that it shall not be broken up, and there is no Gallery to which I should more like it to go, than to Melbourne's, which I visited a few years ago, and where the collections very greatly impressed me by their variety and high standards ...'[78]

McDonnell, putting forward 'in many ways the most important proposal I have made to the Felton Committee, or am at any time likely to make', described Barlow's 'great' collection as rivalled only by those in the Albertina in Vienna and the British Museum, and in better condition than either.[79] Dixon was in the Chair, and Medley, Fitts and Burke present (Wiltshire an apology) when this recommendation reached the Bequests' Committee, supported strongly by AE Popham of the British Museum and by Dr Hoff (who had seen the collection, and concluded that its acquisition 'would put the Melbourne gallery among the great Dürer-owning public galleries of the world'. A fortnight later the committee met to discuss the proposal with the Director, and with Dr Hoff. Westbrook, citing Clark's support also, claimed not only that it would superbly fill a gap in the early German collection but 'could have a profound effect on Australian contemporary art and public taste', reviving standards of craftsmanship which were in decline in twentieth-century art. The future, he warned the Committee, would reprove present authorities if they allowed the collection to be broken up or sold in the United States. Dr Hoff supported him with practical advice on how the collection could be stored and displayed. The Committee again deferred the matter, to a meeting—to which Lindsay was to be invited—to be held a day after the Trustees met on 4 September. Everyone, including Lindsay, favoured acquisition; but the Trustee company advised that the cost was more than the entire sum held in reserve, A£45 000. Since it was illegal

[78] Barlow to McDonnell, 19 July 1956, quoted at length in Cox, *The National Gallery*, pp. 266–7.

[79] McDonnell to FBC, Letter 26, 1956.

Eric Westbrook (Athol Shmith, photographer, reprinted from L Cox, *The National Gallery*)

to commit future income, Conference resolved to buy the engravings (£23 220) and the woodcuts (£11 430), and to ask for an option on the books (£10 450), asking McDonnell to assure Barlow of their intention to buy the lot. Sir Thomas not only agreed, but sent the books on loan for display, with eleven additional reproductions and a book as a gift; when the collection arrived, early in 1957, it was displayed by the Australian Broadcasting Commission on television, the medium itself recently arrived in time for the Olympic Games. Rinder, who had died in 1937 still mourning the rejection of Dürer's *Dead Duck*, would have rejoiced that the Bequests' Committee had proved willing not only to empty the treasury but to mortgage the future to do justice to the German master.[80]

Yet another important development in 1956 was a major bequest to the Gallery. Everard Studley Miller (1886–1956) was the grandson of Henry ('Money') Miller (1809–88), the robust and secretive politician, financier and builder of Felton Grimwade's first warehouse, whose estate (£1 456 680 in Victoria alone in 1888) well justified his nickname; his son, the new benefactor's father, was the equally

[80] FBC, 18 August, 1 and 5 September 1956.

successful Sir Edward Miller (1848–1932), holder of the first scrip issued by BHP, and of much more.[81] Everard Studley Miller, a shy bachelor, worked in his father's Bank of Victoria, quietly (and reluctantly; he had wanted to go to Cambridge and become a don). Privately he studied classics, Egyptology and photography, and joined the Royal Historical Society of Victoria. His modest collection of prints and *objets* was also largely historical. Daryl Lindsay recalled that Miller frequently visited him at the Gallery, showing considerable interest in the workings of the Felton Bequest; and after his death in July 1956 he emerged as perhaps Alfred Felton's only imitator, leaving some £170 000 of his estate of £262 950 to the National Gallery. There were important differences. Perhaps to avoid the difficulties which had frequently beset Felton's committee, Miller's bequest was to the Gallery itself, not to Trustees, and the capital could be spent as well as income. The purpose was more limited than Felton's, and idiosyncratic: the funds were to be used solely for the purchase of 'portraits of individuals of merit in history, painted engraved or sculpted before 1800', terms which required careful interpretation by Mr Justice Sholl before the Trustees felt safe in spending the money. (Depictions of Christ were ruled not to be 'portraits'; later Madame de Pompadour was judged to have 'merit' as a patron of the arts, even if her fame rested on achievements thought less meritorious by some Trustees.) The Felton Bequest had already purchased many pictures which would have qualified, but need do so no longer (or at least not until 1977, when the Miller funds were exhausted).

The new bequest was timely. The Felton Bequest art fund received an allocation of £15 000 in November 1956, but after paying for the first two parts of the Dürer collection had only £8880 left in the kitty.

[81] On Sir Edward Miller, see EM Finlay's entry in *ADB*, vol. 10; and on Everard Studley Miller, Ursula Hoff's entry in *ADB*, vol. 10; her 'The Everard Studley Miller Bequest', in A Bradley and T Smith (eds), *Australian Art and Architecture*, Melbourne, 1980, and Paul Paffen, 'Everard Studley Miller and his Bequest to the National Gallery of Victoria', pp. 35–44.

27

VALHALLA

Eric Westbrook, forty-one when he took office in January 1956 and a generation younger than his predecessor, was a modernist. In Cox's words, his interests 'ranged beyond the fields of the visual arts, into the explosive and exciting aspects of the contemporary scene', including 'the advancing fringe of contemporary experimental visual and performing arts'; his preoccupations were 'perhaps better suited to the minds of some of the younger generation' (than to Cox's own was left unsaid).[1] After three years in the job, the new Director publicly expressed his 'uneasiness' over the representation of contemporary schools in the collections. The Department of European paintings had a 'small but worthy group of Impressionist pictures', 'but from the Post-Impressionists onwards our steps falter, and especially the one established movement of the twentieth century, Cubism, is hardly represented at all . . .'[2] Westbrook worked hard during his own long tenure of the office to ensure that neglect of the contemporary could not be levelled against him. Cox thought that 'perhaps of all directors' he had 'offered least resistance to acceptance of advice from Felton Advisers', although, as the first Director since Hall not born in Victoria, he could not have found the close relationships persisting among the Trustees and Bequests' Committee members, with their accumulated affinities and antipathies, sympathetic as a working environment. (Too many decisions, he was known to complain, seemed to have been made before the meetings, over lunch at the club.) Medley was a friendly Chairman, though as always apt to be ill when situations were tense. For much of his Directorship, Westbrook's energies were perforce devoted to the Gallery's external relationships—he was

[1] Cox, *The National Gallery*, p. 262.

[2] Introduction to *The Annual Bulletin of the National Gallery of Victoria*, vol. I, 1959.

skilled in the modern art of public relations—especially during the long and difficult gestation of the new gallery in St Kilda Road.

In November 1955 Lindsay, supported by Burke, had made a departing plea for more staff for the Gallery, and a higher status for the professionals among them, but without success. The Government listened more attentively to the new regime, and the Gallery's staff was slowly expanded, though still under the Public Service yoke. Notable appointments included Gordon Thomson as Deputy Director (confirmed in 1959) and his transformation from Education officer to Curator with special responsibility for Asian art; Leonard French as Exhibitions Officer; David Lawrance (Decorative Arts); and Brian Finemore, initially a Guide Lecturer but later the first Curator of Australian Art, whose report of 1962 gave the collection shape and direction it had previously lacked.[3] Three new Education officers were appointed in 1961, one, James Mollison, a former art student at the Royal Melbourne Institute of Technology, later becoming Director (after being the first Director of the Australian National Gallery). When McDonnell revisited Melbourne in 1962, he wrote that 'since my visit five years ago, the staff of the National Gallery has been greatly increased, indeed all the members of staff whom I have met this time have, with the exception of Dr Hoff, been appointed since I was last in Melbourne'. 'I have asked them', he added, 'to write to me—with the concurrence of the Director—whenever they think it might be advantageous'.[4]

The implications for the Bequest of an expansion of the Gallery's establishment were, in the long run, profound. Lindsay and his predecessors had very few professional staff in support, relying heavily for the care of the collection on honorary curators; some of whom—Kent and Cox, for example —had considerable influence on the Bequests' Committee, being also Trustees. As Westbrook was able to appoint more professional curators, and to organise the Gallery into formal departments, the institution's internal bureaucracy became a new element in the relationship with the Bequest, influencing priorities though remaining formally responsible to the Director. In Hall's day the Trustees had presumed to manage the Gallery directly; as that ceased to be practicable the old triangular relationship between Bequests' Committee, Trustees and Director became, for better and worse, less direct and personal. (Eventually, as the internal organisation became more complex, competing interests within it made it difficult to consider priorities at all.)

[3] Galbally, *The Collections of the National Gallery of Victoria*, pp. 37–8.

[4] Letter of 12 March 1962, pasted in the Minute Book.

[ABOVE]
Amedeo Modigliani 1884–1920 Italian
Nude resting c.1916–1919
pencil on buff paper
29.3 × 48.3 cm (sheet)
Felton Bequest, 1948

[BELOW]
Nicolas Poussin 1594–1665 French
The crossing of the Red Sea c.1634
oil on canvas
155.6 × 215.3 cm
Felton Bequest, 1948

[ABOVE]
Rembrandt van Rijn 1606–1669
Dutch
Christ Crucified between the Two Thieves (The Three Crosses) c.1660
drypoint and burin
38.6 × 45.3 cm (sheet, trimmed to platemark)
Felton Bequest, 1949

[RIGHT]
George Stubbs 1724–1806 English
A lion attacking a horse c.1765
oil on canvas
69.0 × 100.1 cm
Felton Bequest, 1949

[LEFT]
Pierre Bonnard
1867–1947 French
Siesta (La sieste) 1900
oil on canvas
109.0 × 132.0 cm
Felton Bequest, 1949

[BELOW]
Balthus 1908–2001 French
Nude with cat (Nu au chat) 1949
oil on canvas
65.1 × 80.5 cm
Felton Bequest, 1952

© Copyright ADAGP. Licensed by Viscopy, 2003

[LEFT]
Venini & Co., Murano (manufacturer)
(est. 1925) Italy
Fulvio Bianconi (designer) 1915–1996
Italy
Patchwork (Pezzato) vase c.1950
glass (pezzato technique)
36.6 × 14.6 × 10.9 cm
Felton Bequest, 1952

[RIGHT]
Pablo Picasso 1881–1973 Spain/France
Madoura, Vallauris (manufacturer)
(est. 1938) France
Vase 1950
earthenware
62.5 × 30.8 cm diameter
Felton Bequest, 1955

[BELOW]
John Glover born Great Britain 1767,
arrived in Australia 1831, died 1849
*The River Nile, Van Diemen's Land,
from Mr Glover's farm* 1837
oil on canvas
76.4 × 114.6 cm
Felton Bequest, 1956

© Copyright Succession Pablo Picasso. Licensed by Viscopy, 2003

[ABOVE]
Albrecht Dürer 1471–1528 German
Adam and Eve 1504
engraving
25.0 × 19.3 cm (image and sheet)
Felton Bequest, 1956

[LEFT]
Greece, Attica
The Group of London B 174 (attributed to)
Amphora (Attic black-figure ware) 540–530 BC
fired clay
54.8 × 36.0 × 36.2 cm
Felton Bequest, 1957

[TOP]
Antonio Pollaiuolo
1432–1498 Italian
Battle of the nudes
early 1470s
engraving
40.4 × 57.8 cm
(image and sheet)
Felton Bequest 1960

[ABOVE]
Eugène von Guérard
born Austria 1811
arrived in Australia
1852, died Great
Britain 1901
*Ferntree or Dobson's
Gully, Dandenong
Ranges* 1858
pen and ink, wash
37.9 × 54.8 cm
Felton Bequest, 1960

[RIGHT]
Indian
Tree goddess
Hoysala period,
1120–1150
chloritic schist
88.5 × 45.8 × 22.5 cm
Felton Bequest, 1963

[LEFT]
William Dobell 1899–1970
Australia
Helena Rubinstein 1957
oil on composition board
95.4 × 95.6 cm
Felton Bequest, 1964

[BELOW]
Fred Williams 1927–1982
Australia
Upwey landscape 1965
oil on canvas
147.5 × 183.3 cm
Felton Bequest, 1965

[RIGHT]
Andrea Mantegna 1431–1506 Italian
Battle of the Sea Gods: right half of a frieze early 1470s
engraving
28.9 × 39.5cm (image)
28.9 × 39.7cm (sheet)
Felton Bequest, 1966

[BELOW]
Robert Delaunay 1885–1941 French
Nude woman reading (Nue à lecture)
1915
oil on canvas
86.2 × 72.4 cm
Felton Bequest, 1966

[RIGHT]
Tibeto–Chinese
Bodhisattva, Avalokiteshvara 17th–18th century
gilt bronze, semi-precious stone, pigment
115.0 × 72.5 × 45.4 cm
Felton Bequest, 1966

The staff was increasing, but committees were teeming. Earlier in 1955 Kenneth Clinton Wheare, Gladstone Professor of Government and Public Administration in the University of Oxford, had published a slim and deceptively simple book entitled *Government by Committee*. If Wheare, son of a grocer's assistant in Warragul, had returned to Australia after holding the Victorian Rhodes Scholarship for 1929, instead of remaining in Oxford—to become eventually its first Australian Vice-Chancellor—he might have based the work not on the Oxford City Council and the innumerable government and university committees on which he sat, but on Victorian examples, including the Felton Bequests' Committee and the four boards of Trustees which now held responsibility over the Swanston Street institutions, governed, until 1944, by one. Wheare classified committees by function (negotiation, administration, legislation, scrutiny, and inquiry) and ulterior purpose (committees to pacify, committees to delay, committees to kill, and committees for form's sake); and identified—three years after Stephen Potter's *One-Upmanship* was published—the types who sat on committees and the games they played, games some knew by instinct, others learned and some never mastered, all played by rules incomprehensible to those who never sat in any of those myriad closed rooms. Wheare, a brilliant committee member himself—with, it was said, a capacity to remain unnoticed until he backed suddenly into the limelight to win a point—well knew how trivial most committee proceedings seem, and how important their eventual cumulative outcomes are.[5]

Another committee was soon to be added to Gallery affairs, shaking up the others. In May 1956 the new Government of Henry Bolte decided—partly in response to Sydney's spectacular Opera House—to proclaim the South Land Act reserving the Wirth's site, and to build there a new National Gallery as part of a Cultural Centre. Since the Building Trustees were at that time preparing to recommend that priority be given to building a new Museum in the Domain, and the Government's plan had been leaked from the Gallery Trustees to the others, warfare broke out within the Swanston street conglomerate. Cox found himself in the thick of it; appointed the Trustees' Treasurer on the sudden death of Allan Henderson, and standing in as Chairman for an again-absent Medley, he found the viewpoints of the four institutions irreconcilable. Medley had had enough; privately calling the Gallery 'an inferno of unbridled passion', he resigned as President in 1957, and from the Board in 1958. He was succeeded as President by

[5] 'Over my dead body, Mr Vice-Chancellor', he once interjected, 'if I may take a moderate position on this matter'. On Wheare, see the entry by Poynter in *ADB*, vol. 16, and Geoffrey Marshall, 'Kenneth Clinton Wheare 1907–1979', *Proceedings of the British Academy*, vol. 67, 1981.

Cox, who by the time The National Gallery and Cultural Centre Act was proclaimed, on 1 January 1958, found himself Chairman of the new Cultural Centre Committee as well, also joining the Bequests' Committee when Medley resigned in April 1958. Newcomers to the Gallery Trustees included William Ritchie, business-man and perceptive collector of Australian art, of Creswick and Ballarat, the new representative of country interests after Burnell emigrated to New Zealand, and Colonel Aubrey Gibson, company director, co-founder (with Professor Burke, among others) of the National Trust and of the Society of Collectors of Fine Arts.[6] It was thus a largely new team, with an almost new Director, which faced the task of ensuring that the new Gallery was a good one. The Felton Bequests' Committee was asked if it wished to be involved in planning the new Centre, but wisely declined.

McDONNELL RETURNED TO Melbourne for consultation in January 1957. Meeting with the Bequests' Committee, he warned of ever-increasing prices in the art market: 'it could well be that the income of the Bequest, large though it is, is becoming insufficient to add great pictures to the collection'. He suggested spending more on sculpture, while continuing to buy some contemporary paintings; and agreed to discuss with the Director the issue of gaps in the collection, and the problem of filling them at lower prices. At a Conference, on 6 February, when a new consignment was again inspected, Medley (at his last meeting) bluntly asked McDonnell for the policy which guided his purchases of contemporary work with the £2000 annual grant. The Adviser replied that his aim was to acquire a reasonably complete survey of English painting of the last fifty years, with emphasis on the recent, and a less complete collection indicating trends in contemporary European art. When new Trustee Aubrey Gibson, always a man of strong opinions, insisted that everything bought should be the artist's best, McDonnell replied that that would be very expensive: for Braque or Matisse, up to £20 000. After the Adviser had left Melbourne, he was re-appointed, for five years, the Committee also agreeing to pay premiums on a policy providing £1500 when he reached the age of sixty-five.[7]

In February 1957 the Committee received and gave general approval to 'A Suggested Acquisition Policy Prepared by the London Adviser to the Felton Bequest and the Director of the National Gallery of Victoria'. Even if the scarcity of great works and their increasing prices made it certain that 'the Felton

[6] Gibson (appointed to replace Henderson) was born in 1901; he was Managing Director of AH Gibson Industries, a Director of the Australian Elizabethan Theatre Trust and a Councillor of the Victorian Artists Society.

[7] FBC, 9 January and 27 February 1957; Conference, 6 February 1957.

Bequest can no longer often compete for such works', McDonnell and Westbrook argued, 'good pictures by minor masters' could nevertheless be found, and the Bequest's income could 'still enable it to buy textiles, woodwork, metal work, ceramics, prints and drawings of the highest quality'. A schedule of paintings by artists painting before 1900 was no longer needed. The collection of British painters after 1900 had 'some claim to completeness', but a list of the under-represented was attached. There were notable gaps in the European collection, especially the School of Paris ('Picasso, major painting of almost any period' was listed) and Central European painters; the French artists were expensive, but 'it might be worth considering first class examples of the Central European Expressionism' (Munch, Kokoschka, Marc, Feininger and Kandinsky were listed). More recent sculpture should be sought, both British and German ('it might be suggested that recent German art reaches a higher level in sculpture than in painting').

A new priority given to acquisitions for the Art Museum was spelled out in discussion of its (then) seven departments. The Report described Glass as the closest to complete, while the collection containing most pieces 'of great importance' was Oriental Art (which nevertheless should be expanded in fields peripheral to Chinese art), and the weakest were Metal Work (which might be augmented economically with silver spoons and ironwork) and Westbrook's new department of Primitive Arts (which should be built up to show their 'important connections' with modern painting and sculpture, and should include 'Australian (aboriginal)' pieces). The Furniture collection should be made more 'cohesive', and Porcelain and Pottery expanded; but Textiles and Costumes, which contained an important nucleus, should be left in abeyance until better storage and expert staff were available. Two Schedules were offered for Prints, one of fine pieces (with Lucas van Leyden, Goya and Rembrandt the first priorities) and the other, cheaper, for study purposes; while 'in the field of drawings the present collection is so small that almost any addition of first rate quality would be welcome'.[8]

The Bequests' Committee readily accepted this report, but the Trustees made heavy weather of it, spending a full year discussing and amending the document before returning it to the Bequests' Committee. The main changes concerned contemporary works (too many were of poor quality, the Trustees complained, promising further advice); and the Primitive Arts (acquisition of which should be suspended, 'with the exception that more sophisticated styles such as Benin bronzes be considered'). Westbrook was clearly displeased with the changes, insisting that the Committee see the full Report again, as 'the considered statement of

[8] Report pasted in Minutes of FBC, 27 February 1957.

the London Adviser and myself', with the changes added.[9] Behind the delay was a debate on another policy document, 'Report on purchase, conservation, display and administration', formulated in June 1957, envisaging separation into Primary and Secondary Collections, most Contemporary work remaining in the latter until its reputation matured. But as Cox later observed, it was one thing to recognise that the Collection included both first-class and second-class works, and another to agree, yesterday, today and tomorrow, which works belonged in which category.[10]

In June 1957 another consignment of art works arrived in the *Himalaya*. It included Max Ernst's tiny oil, *Guerre des deux roses*, at £475 the most expensive work in a total of only £1651, almost all bought from McDonnell's contemporary allowance. The Bequests' Committee was living hand to mouth, from one six-monthly allocation to the next, but there were still good pickings in the market. When the art fund reached £17 619, after £15 000 was received in June, the Committee promptly committed itself to buying a red-figure cup and a black-figure amphora, recommended directly to the Trustees by Trendall, for £25 000, payable over three years; in November another £16 000 received left the Committee with only £5580, after buying embroideries (£220), an overmantel, then thought to be by Adam (£600) and 107 prints, including twenty-five Rembrandt etchings, recommended by Dr Hoff from a list submitted by Colnaghis in response to the new policy.[11] There were no funds left to buy a rare Tosatsu screen which Cox had found in Japan, following a visit from McDonnell on his way to London, but before the option expired Cox advanced the £1500 himself, the Trustee company agreeing to create a private trust until the Bequest could reimburse him.[12] In February 1958 McDonnell recommended *Calvary*, then attributed to Jan Brueghel the Elder, and a van Beyeren *Still life*, each for £5000; the Committee approved *Calvary*, regretting it had insufficient funds to buy both.[13] In May (when Cox replaced Medley on the Committee), it optimistically decided it could resume active buying about September, despite having only £6430 in hand and still owing £7254 on the Greek vases, but later in the month found that after receiving a half-yearly payment of £17 250 and

[9] Westbrook to WK McDonald, 24 February 1958. McDonald had replaced Rigg as Secretary to the Committee when Rigg was made General Manager of the Trustee Company in June 1957.

[10] Cox, *The National Gallery*, pp. 274–5. It was also proposed that the Director be given assistance in his Public Relations responsibilities, to allow him to concentrate on the collections and their care.

[11] FBC, 19 October and 30 November 1957. Dr Hoff's comments are pasted in.

[12] Cox, *The National Gallery*, p. 277.

[13] FBC, 8 February 1958.

paying all bills it had only £2130 left.[14] It seemed out of the question to spend £7000 on a carpet—the Trinitarias, woven in Tabriz in the seventeenth century, and given by Philip IV of Spain to the Convent of the Trinitarias des Calzas in Madrid—even though it was recommended by the Trustees as 'a masterpiece of world importance'. But the Committee was bold; in August, after paying off the amphora, it approved not only the carpet, now reduced to £5000, but also Ricci's large *Finding of Moses* (later thought possibly an early Tiepolo) for £3000. Both the Brueghel and the Ricci were much admired in London, as in the old days, and the Committee was emboldened to approve also a fine Romney group portrait, *The Leigh Family*, for £3740 sterling.[15] When the Trinitarias carpet arrived, in March 1959, it was too large—35 feet by 11 feet—to be hung on a wall, and a dais was built from which it could be viewed on the floor before disappearing into storage; it also made a farewell appearance at the Ideal Homes Exhibition in May. The critics disdained some contemporary works which arrived with it, 'none of which', wrote McCulloch in the *Herald* (and especially not *Two Chairs on Fire*, by Jack Smith, of the Kitchen Sink School, bought for £328) 'lays any just claim to representation in the National Gallery collections'. The *Bulletin* praised the ancient carpet, but predicted, with slight exaggeration, that 'fifty years hence the Jack Smith won't fetch twopence'.[16]

EARLY IN 1959 the Bequests' Committee agreed to meet half Dr Hoff's expenses for a visit to London, partly to make purchases under the Miller Fund (for which she acquired, among other things, van Dyck's *Iconography*, a large and important collection of prints of all the portrait types invented by him). She also joined McDonnell in recommending to the Felton Committee a Tiepolo drawing and Pollaioulo's rare and remarkable engraving *Battle of the nude men* ($8500). Both were approved, as was a Florentine Processional Cross (£1000), recommended in May.[17]

Dr Hoff also had less pleasing business to pursue in London. When McDonnell was in Melbourne in January 1957, the Bequests' Committee discussed with him an alarming report concerning the attribution of Melbourne's most famous picture,

[14] Ibid., 10 and 31 May 1958. The Committee was disturbed to find that costs other than the price of works purchased were (at £5495) a larger charge on the fund than they had thought.

[15] Ibid., 30 August and 29 November 1958, 7 February 1959; *Hamilton Spectator*, 23 May 1959.

[16] *Herald*, 11 March, *Bulletin*, 1 April 1959.

[17] FBC, 7 February 1959. Apparently the Gallery never called in the grant because Dr Hoff did little Felton business in London. Interviewed in London (*Age*, 23 October 1959), Hoff spoke of how little was now in the market, and spoke enthusiastically of her first visit to Spain. The Pollaioulo was approved on 8 August 1959, when McDonnell reported adversely on a Marquet and two Kokoschkas on which the Director had sought reports in May.

ARL Wiltshire, Dr Leonard Cox and Sir Owen Dixon before Romney's *The Leigh Family*, 12 August 1959 (ANZ Trustees)

the van Eyck *The Madonna and the Child*. In June 1956 Dr Hoff, visiting Holland as the Australian representative at proceedings in celebration of Rembrandt, had taken the picture to Antwerp, for display in an exhibition at Bruges, but also for examination at the Institut Royal du Patrimoine Artistique in Brussels. By November 1956 the painting was in London, for cleaning and display at the National Gallery.[18] There Sir Philip Hendy (once an applicant for the Felton Advisership himself) showed McDonnell a letter from Dr Paul Coremans of the Brussels Institut, stating that he and his experts had concluded it was not a genuine van Eyck, news which McDonnell discussed with the Bequests' Committee in January 1957. Dr Hoff reported that Coremans had expressed no doubts to her while in Bruges; but Westbrook insisted (and everyone agreed) that 'for the reputation of the Gallery' and to set doubts at rest, a full investigation should be conducted in London, by the National Gallery. Members asked that the investigation be historical as well as scientific.[19]

[18] Reported to FBC, 24 November 1956.

[19] FBC, 16 January 1957. On 17 August the Committee insisted that all correspondence concerning the picture be kept confidential, and on 19 October agreed to pay for its continued insurance.

In 1958 Sir Owen Dixon visited London, and in July reported to the Committee his meeting there with Hendy, Martin Davies and McDonnell.[20] His tone was judicial, and it is clear that the Chief Justice was not fully convinced by the evidence put before him: 'he expressed the view', the Minutes record, 'that in the opposition between the traditional ascription of the picture and the indecisive reasons which had been given for regarding it as probably a sixteenth century copy of a hypothetical original now lost [but of which a photograph survived], the question would remain one about which opinion might be expected to fluctuate'. Davies' report was not yet complete, and 'until an exhaustive attempt to trace the whereabouts or fate of the picture the subject of the photograph was made, the conjecture that there had been an original from which the Melbourne picture had been copied must remain unsatisfying as an hypothesis'. After lengthy discussion, the Committee agreed with its Chairman that the report, when finished, should be published; but when Davies' interim report, and also a translation of the original report by Paul Coremans and his team from the Brussels Institut, were received in November 1958, the Committee decided instead to tell Cox, in his other persona as President of the Trustees, that it was willing to spend money 'to assist in the further elucidation of the problem'.[21] Further discussion in London convinced Dr Hoff of the validity of the case that the painting was 'after' rather than 'by' van Eyck, and after her return to Melbourne the news broke. On 10 November 1959, newspapers all over the country—including the *Age*, Adelaide *Advertiser*, *West Australian*, Albury *Border Morning Mail*, Bendigo *Advertiser*, Warrnambool *Standard*, and most Sydney and Brisbane papers carried the news, put vividly by the Melbourne *Sun*, 'Crowds stare at "False Van Eyck"'. Melbourne's greatest picture was great no more, though to many it looked more beautiful than ever, newly—perhaps excessively—cleaned.

Some still doubted the doubters—'There is still . . . research to be done on this work', Cox darkly remarked in *The National Gallery*.[22] Four decades later a young Melbourne postgraduate student examined the evidence—including the results of infrared reflectography, not available in the 1950s—and rejected earlier conclusions, arguing that 'the *Ince Hall Virgin and Child* can be described as an important Eyckian composition, painted in a manner consistent with the materials and technique of works attributed to Jan van Eyck . . .' The question has been reopened, but not everyone agrees how widely. The work 'is now regarded as by an artist associated with the van Eyck studio', the current Director of the

[20] Ibid., 26 July 1958.

[21] Ibid., 29 November 1958.

[22] Cox, *The National Gallery*, pp. 285–6.

Gallery wrote in 2002; and in the same year, when the Ince Hall picture was again exhibited in Bruges, it was so identified.[23]

LATE IN 1959 the first number of a new periodical, *The Annual Bulletin of the National Gallery of Victoria*, appeared. Edited by Dr Hoff (as the humbler *Quarterly Bulletin* had been before it), the journal included six scholarly articles (including Brian Finemore on Bratby self-portraits, Westbrook on Wyndham Lewis, founder of the Vorticists, and Hoff herself on the Barlow collection) and an introduction in which the Director welcomed this 'major change in the Gallery's public programme'. He also foreshadowed the development of new departments 'growing naturally out of existing groups of works' in the old Art Museum, whose centenary was approaching. (One he mentioned, a Department of Industrial Design—'a field which is now of vital importance'—did not eventuate.) But despite improvements in display, and new programmes of special exhibitions, the existing buildings remained 'entirely unsuitable for the conduct of a public Gallery in the twentieth century'.[24]

Steps towards a new Gallery were almost as slow as the building of Sydney's Opera House. The National Gallery and Cultural Centre Committee, first convened in April 1957, had Cox in the chair and Westbrook as temporary executive officer, but was responsible to the Government, not the Trustees. Kenneth Myer, soon to become managing director of the Myer Emporium, was Deputy Chairman, and membership included Kenneth Begg, Chairman of Imperial Chemical Industries, the financier Sir Ian Potter and Professor Burke; the Committee always had strong business and technical support, and was enviably free of Public Service Board control. The small professional staff of the Gallery worked hard to prepare a brief, and the Committee also received a report from Dr WM Milliken, Emeritus Director of the Cleveland Museum, who urged that the building be planned from the inside out, and that an architect be chosen—not by competition, as the Royal Victorian Institute of Architects vigorously insisted—who could work with the professional staff.[25] After inviting applications, the Committee announced in December 1959 that the architect selected was Roy Grounds, of the firm Grounds, Romberg and Boyd; he was summoned

[23] Hugh Hudson, Re-examining van Eyck, p. 93. For Dr Hoff's summary of the earlier argument, see her *European Painting and Sculpture*, under 'After' van Eyck. The quotation from Gerard Vaughan is from his 'An Eighteenth-Century Classicist's Medievalism', p. 300.

[24] *The Annual Bulletin of the National Gallery of Victoria*, vol. I, 1959, Introduction. The departments listed in 1959 were the Art Museum, Australian Art, Coins and Medals, Exhibitions and Display, Glass, Greek and Roman Antiquities, Oriental Art, Prints and Drawings, and the National Gallery Art School.

[25] Cox, *The National Gallery*, pp. 272, 286–7. Dr Cox's account (especially chs 26, 28 and 33) is of course a primary source on the building of the Gallery.

from his birthday party to be given the news. (The ensuing unseemly dissolution of the 'Gromboyd' partnership, and the rewriting of the contract with Grounds alone, cast a long shadow within the profession.) No major gallery had been built recently in Australia (and not many in the world), and Grounds and Westbrook went overseas in 1961 to seek ideas.[26]

Celebrations for the centenary of the Art Museum in 1961 included an exhibition in honour of Bernard Hall, and a grand fund-raising banquet under the eye of Cleopatra, no doubt frugal compared with some she had overlooked in St Petersburg. Funds were needed, as the estimated cost of the new gallery rose from £3.8 million to £4.75 (or £5.75 million if a 1200-seat theatre was included), figures which caused Premier Henry Bolte—later publicly described by one of his ministers as the man who did most for the arts in Victoria while knowing least about them—to be 'visibly disturbed'.[27]

The term 'Cultural Centre' in the Committee's brief and title was much criticised (more then than it might be now). In September 1961 the *Age* urged that the new complex be named after Alfred Felton, a cause given a classical twist by Medley, writing from retirement in the hills; if Oxford had its Ashmolean, why not Melbourne its Feltonian? The Sydney *Bulletin* enjoyed reporting that 'Melbourne's answer to the Sydney Opera House has as yet neither substance nor name'; nobody was happy with 'National Gallery and Cultural Centre', but there were objections—now incomprehensible, since 'Feltex' is no longer the nation's cheap substitute for carpet—to a name which would associate a great new institution with floor coverings. Three months later the *Bulletin* claimed that Westbrook lay awake every night thinking of names.[28] It is unlikely, not least because much of the Trustees' time in 1962 was taken up with a row which erupted in the Art School and made its way as far as the London press, 'traditional' artists accusing the Director and the Trustees of bias in favour of 'modern' art, and the modernists responding. The outcome was the appointment of John Brack, an artist whose stature rose above such tumults, to be Head of the Art School.[29]

AFTER DR HOFF's return from London in 1960, McDonnell continued to find important portraits for the Miller Bequest, but fewer paintings for the Felton Bequests' Committee. Australian art was worse-served: the £5000 acquisition fund provided by Government in 1946 had been reduced to £4000 in 1952 and

[26] Geoffrey Serle, in *Robin Boyd*, pp. 222–30, gives an account of the episode.

[27] Cox, *The National Gallery*, p. 293.

[28] *Age*, 28 September and 11 November 1961, *Bulletin*, 3 December 1961 and 10 March 1962.

[29] On these campaigns, see Cox, *The National Gallery*, ch. 30.

to £3500 in 1955, while in 1962 the New South Wales Gallery had £19 000 to spend on Australian art.[30] The Felton Bequest bought a collection of early drawings of Victoria by von Guerard and Edward La Trobe Bateman, and seven Chinese mirrors (£1130) for the Art Museum; they caused little comment in Melbourne, unlike the *Draped Seated Figure*, a very large bronze by Henry Moore, bought for £6000. Her arrival in June 1960 prompted a stream of letters of derision and applause in the *Herald*, and from as afar afield as Auckland; dubbed 'Heavy Hanna', *Truth* quoted her statistics as 64-84-108 (inches), and noted that 'Hanna has taken no part in the controversy . . . perhaps because she has no mouth'.[31] In November the Committee, having saved up £17 000, agreed to bid up to £11 000 sterling for the Acciaiuoli-Strozzi Hours, an important Renaissance Prayer Book, at Sotheby's; McDonnell got it for £8000, against a predicted £10 000, and bought a Byzantine manuscript in the same sale.[32] With these additions to the *Horae* Rinder had acquired, and Cockerell's Livy, the small collection of medieval and Renaissance manuscripts became choice indeed.[33]

McDonnell was very much a London-based adviser. Dr Hoff, convinced by her visit in 1959 that London dealers charged high prices and that more attention should be given to sales on the Continent, appealed (with Gordon Thomson, by then Deputy Director) to the Bequests' Committee in July 1960 to raise the allocation for contemporary work to £3000, while at the same time requiring McDonnell to use auctions more, in London and on the Continent; he should forward catalogues to Melbourne, and inspect the works chosen from them by the Gallery staff.[34] The Trustees accepted Hoff's proposals, but McDonnell responded that prices at Continental sales were high, and that verification of the works and payment for them were difficult and time-consuming. In the meantime he asked for an extra £1500 to spend on contemporary sculpture, a proposal which gave the Committee 'some difficulty', since sculpture would have to fit the new building; and Westbrook, whose tastes embraced more styles than were practised in London, was prompted to ask that Continental as well as British sculpture be sought. The Gallery sent the Adviser news of a sale in Berne, and asked for a catalogue; when he replied that prices at Berne would be too high, the Committee decided that it was time he came to Melbourne again for consulta-

[30] Cox, *The National Gallery*, p. 312. The Western Australian Gallery had £7342 and the South Australian £5500.

[31] *Truth*, 25 June 1960; and see Galbally, *The Collections of the National Gallery of Victoria*, p. 218.

[32] FBC, 12 November and 17 December 1960.

[33] Galbally, *The Collections of the National Gallery of Victoria*, pp. 82–4.

[34] FBC, 30 July 1960.

tion. In the meantime Dr Hoff was busy selecting from the late Lionel Lindsay's estate the most important items—including Tiepolo's wash drawing *A Scene of Baptism*, 'the second-finest Old master Drawing in the Print Room collections'—for A£4693.[35]

The Gallery was beginning to be interested in Indian art, and McDonnell was asked to call there on the way to Melbourne. He reported to a Committee meeting in February 1962 that London was still the centre of the market for Indian works, and that if Melbourne wished to pursue them the Victoria and Albert would help. Asked about other Asian art, he described Bluett as 'now about 80 years of age and not very co-operative', but thought he should continue; Cox agreed to send McDonnell a list of gaps he could use to check Bluett's recommendations. When Cox asked about Persian art, the Adviser replied that good examples were very expensive, but he could look out for them, and the Gallery did acquire several works in the following years.

As for European art, the Adviser urged more expenditure on contemporary works, warning that the Committee 'may have to virtually abandon the purchase of old masters'. (In 1960 Wiltshire had announced at a Felton Presentation that the Bequest had spent £1.1 million on art for the Gallery over fifty-five years; a year later the Metropolitan spent £1 million on a single reputed Rembrandt, the first picture to reach that price.)[36] When Dixon asked if too much of the modern work acquired was minor, Cox obligingly defended the Adviser's purchases: 'in time, minor things become major things'. Asked again about Continental buying, McDonnell stated that Colnaghis could bid on the Continent for the Bequest if the Committee wished, but reiterated the difficulties and claimed that in any case London was 'still without doubt the great market', with works and buyers coming from the Continent and even New York. The Committee, well pleased with him, raised McDonnell's allocation for contemporary work to £5000, subject to periodical review, and extended his appointment for another five years, at a salary of £2000.[37]

For once, McDonnell involved himself in local buying while in Australia. With the Trustees, he recommended bidding A£6000 for Dobell's *Saddle my nag* at the

[35] Ibid., 17 December 1960, 25 February, 17 June, 21 October and 20 December 1961. Other acquisitions from Lindsay's estate included a Meryon etching, 76 Keene drawings, 6 Holbein 'Dance of Death' woodcuts and 5 Rembrandt etchings.

[36] Wiltshire's speech of 3 June 1960 (Trustee company papers). The capital value of Felton's estate had by then passed £1.75 million, mostly held in trustee securities, though Cuming Smith's, the only large shareholding remaining, produced some £27 000 in dividends in 1961. Sale of the Rembrandt was reported in the *Herald*, 18 November 1961.

[37] FBC, 10 February 1962.

forthcoming, much publicised, Norman Shureck sale in Sydney, promising to 'make every effort' to keep the Bequests' interest secret. A fortnight later, when the picture was withdrawn for presentation to the New South Wales Gallery, he proposed buying a panel of smaller Dobells and was given £7000 to spend at his discretion; the sale was crowded out, with twenty-two Dobells sold for £33 558 in one frantic hour, but McDonnell managed to buy three paintings (*My Lady Waits, The Red Carnation* and *Kensington Gardens, London*) for £4672 10s.[38] Two years later, in May 1964, the Bequest paid £6300—then the highest price ever for an Australian painting—for Dobell's portrait of Helena Rubinstein, the remarkable international entrepreneur whose character FS Grimwade had vouched for in Melbourne in 1908. When the former owner, Sir Frank Packer, refused to assign copyright in the picture, the Committee considered legal action, but decided against it.[39]

Before writing his departing report to the Committee in 1962, McDonnell consulted the Director and his staff (who must have been pleased by his observation that the Gallery looked much better than it had five years before).[40] Westbrook had given him a list of painters of desirable 'art of the twentieth century', under the headings Cubism, Fauvism, Futurism, Vorticism, Surrealism, Expressionism, and Abstract. ('The list, McDonnell reported, 'should present no insuperable difficulties, though a good Cubist or Fauve picture will be expensive, indeed very expensive'.) Cox had specified 'Deficiencies in the Chinese Collection', but they were not many. Hoff had reported on the Print Room Collection, suggesting modern drawings; he thought he 'should be able to get the artists named'. Grounds had shown him plans of the new Gallery, on which he did not comment.

Returned to London, McDonnell gave the Gallery nine drawings from his own collection (seven Thea Proctors, a Lambert and a Schwabe). Bequest funds were still tight: the art fund received £18 000 in June 1962, but having approved a Regency chandelier for £2935, a Chinese bowl for £2700 and a wine cup for £1450 the Committee had only £850 uncommitted, and could not respond immediately to Cox's report that the British Museum had available four twelfth-century Indian sculptures, being sold by Lord Dalhousie for £25 000.[41] McDonnell, now keen to seek out Indian and Persian works, was enthusiastic, and

[38] Ibid., 2 and 14 March 1962. Among many press reports was an article in the *Bulletin* (14 April 1962) by Desmond O'Grady and Vic Worstead on *Investment in Art: A sound new Business*.

[39] FBC, 18 April, 2 May and 5 December 1964. The Committee had asked the Trustees to negotiate a lower price, but agreed to pay the higher when they failed.

[40] The Report was dated 12 March 1962.

[41] FBC, 9 June 1962.

the Committee agreed to buy one of the four for £6250; unfortunately Dalhousie added a £5000 surcharge for the work leaving England—though allowing Melbourne first choice—and it took the Committee until December to accumulate sufficient funds. (It was then left with only £3400 uncommitted, despite receiving an unusually high allocation of £22 500 that month.) More Chinese material was also bought that year, on Cox's recommendation, and Near Eastern items recommended by William Culican of the University of Melbourne, newly appointed Honorary Curator for the area.[42] The press liked the 1962 acquisitions, Alan McCulloch welcoming them in the *Herald* and Bill Hannan praising 'an enlightened and invaluable year's work' in the *Bulletin*.[43]

It would have been difficult for an insider to make a similar judgement on progress with the new Gallery. In 1962 details of Grounds' plans for the whole complex were made public, and while press controversy turned mostly on the proposed spire over the theatres, the staff of the National Gallery were dismayed to find that the design of the new galleries seemed to depart radically from the brief. Long negotiations followed, with the professional staff demanding changes, and the architect resisting; to Dr Hoff, very dissatisfied with provision for the European collection, Grounds responded 'Ursula I cannot do what they say I ought to do. I have to do the thing as I see it and understand it'.[44] Westbrook, after a long absence recovering from a car accident, returned to argue for leaving intact the integrity of the architect's vision. Cox, who agreed with most of the staff's criticisms, was caught in the middle—he named the relevant chapter of his book '1963: Struggle and Frustration'—and his own sense of integrity drove him to resign as Chairman of the Cultural Centre Committee, though not of the Trustees. Some compromises were hammered out, and a great deal more forced on all parties when it emerged that costs were again escalating and the Government insisted that they be capped.

The Gallery's frustration increased as the Government repeatedly delayed funding the staff increases necessary to prepare for the new institution. In February 1963 Sir Reginald Sholl tossed a bombshell while resigning as a Trustee:

> unless some quite drastic re-appraisement of the establishment and vote can be speedily undertaken, I should, as an Australian thinking of Australia's posterity, favour, and advocate, the taking over of the collection by the Federal Government as the National Gallery of Australia, for no other national collection which can be got together in the future is ever likely to equal it.

[42] Cox, *The National Gallery*, pp. 314–16.

[43] *Herald*, 3 October 1962, *Bulletin* 27 October 1962.

[44] Quoted in Anderson, 'In Homage to Ursula Hoff on her Ninetieth Birthday', pp. 250–7. Dr Hoff did achieve an excellent print room, 'one of the most functional parts of the building'.

He assumed, however, that it should remain in Melbourne.[45] NR Seddon, a German-born and English-educated director of British Petroleum and collector of contemporary Australian art, took Sholl's place as a Trustee.

The Felton Bequests' Committee, free from such troubling concerns as building and staffing, was happier. In March 1963 the members congratulated Fitts on his knighthood, and in July Dixon on his admission to the Order of Merit, but they were still counting pennies. McDonnell was annoyed to find that part of his £5000 for contemporary works had been committed elsewhere, while in September a bid from Trendall for more pots was deferred, and no action taken when the Art Gallery of New South Wales asked whether Victoria wanted to buy a Modigliani owned by Dr HV Evatt.[46] In March the Committee deferred a recommendation from the Gallery staff, anxious to have a large sculpture for a courtyard planned in the new building, to buy Rodin's *Balzac*, offered for A£16 500 (a quotation given to David Lawrance, Curator of the Art Museum, while in Europe in 1962). The statue had not been cast in Rodin's lifetime; after a succession of nude studies, in which the great novelist's prominent belly was not concealed, he was depicted in his customary working garb, a voluminous dressing gown, but objection was taken that something obscene appeared to be going on beneath it. In November, when the Art Fund had built up to £22 000, McDonnell reported that *Balzac* would cost A£18 100 and suggested a smaller work, though if the staff were determined on the larger he would not 'stand out against them'. They were, and *Balzac*, immense, brooding and defiant, eventually arrived in 1967.

THE FESTSCHRIFT IN Daryl Lindsay's honour, which appeared belatedly in 1964, was truly international in its authorship.[47] A reprint of Clark's *Idea of a Great Gallery* gave the book some grandeur, and it included articles on buying pictures for a public gallery, by Professor Bodkin of Birmingham; on gallery trustees and directors, by 'Lefty' Lewis, editor of the Yale edition of Horace Walpole and the man who persuaded Russell Grimwade to spend all of £1000 on Strutt's *Bushrangers*; on training gallery administrators, by Theodore Sizer, also of Yale; on the Tiepolo *Banquet*, by Antonio Morassi of Milan; on Constable, by his namesake WG Constable; on Degas, by Daniel Catton Rich, former Director of the Art Institute of Chicago; and on El Greco by AG Xydis, formerly of the Greek

[45] Quoted in Cox, *The National Gallery*, p. 321.

[46] FBC, 5 September, 5 October and 23 November 1963.

[47] Philipp and Stewart (eds), *In Honour of Daryl Lindsay*.

Legation in Canberra. The local contingent was strong: Ursula Hoff on Rubens; Leonard Cox on two Chinese Buddhist figures; Professor Burke on Blake; Franz Philipp on Poussin; Dale Trendall on the Felton Painter; Robin Boyd writing on building a great gallery (the Guggenheim, not his former partner's new NGV); Max Crawford on the Tom Roberts–Deakin letters; and a memoir of Lindsay by Sir Henry Newland, the Adelaide plastic surgeon who had commanded the Australian section of the Hospital in Sidcup and sent Lindsay to study with Tonks. (Philipp quotes Tonks' comment to Holmes; 'Where he gets his judgement about art from Heaven knows, as he has spent most of his life in the backblocks of Australia among sheep and cattle'.) A volume of such scholarship and range, almost all related to the National Gallery, could not have been produced in Melbourne a generation earlier.

Lindsay's own compilation, *The Felton Bequest*, commissioned by the Bequests' Committee in August 1956 for completion in two years, took seven. Lindsay must have been slow to start, the Committee paying him £5000 on completion of one year's work only in May 1959, when Fitts agreed to discuss the 'scope' of the book with the author. Later, in December, a special Saturday-morning meeting was held to review drafts; the Committee asked for added references 'to Kent and perhaps others', and agreed that the book would be published as Lindsay's work, not the Bequests' Committee's. Frank Eyre, the much-respected manager of Oxford University Press in Melbourne, was consulted on presentation, and Dr Hoff asked to check the drafts for accuracy. She thought the work 'typically Sir Daryl Lindsay' and generally satisfactory, though needing rewriting on Rembrandt's *Two Philosophers*; but the Committee also wanted references to future buying policy deleted, and asked Cox, Fitts and Burke to negotiate changes with the potentially irascible author. He submitted, but caused further delay by asking for illustrations instead of the usual list of acquisitions, and Eyre caused more by insisting, in June 1961, that an editor be appointed to provide missing 'linking paragraphs'. The editor, faced with a pile of un-numbered pages, took some eighteen months to write them, and further checking of references and illustrations delayed publication until very late in 1963.[48]

Perhaps inevitably, the book emerged as a hybrid. Less dispassionate than earlier *Records* prepared by Bage, or Burdett's elegant essay of 1934, it expounded Lindsay's opinions and defended his actions quite openly. Its production was not one of OUP's best; the absence of an index 'virtually cancels out the book as a source of reference', the *Herald* complained, and there remain many errors (not all

[48] FBC, 12 December 1959, 12 March, 30 April and 12 November 1960, 17 June and 20 December 1961, 2 March and 1 December 1962, 2 March and 8 June 1963.

attributable to Lindsay not seeing the final proofs, as he claimed when emending the copy he presented to the Melbourne Club). In *Nation*, however, young Robert Hughes' review was flattering: 'obviously not written on horseback, though some of the thinking may have been done there', the book was 'concise, elegantly written, packed with information and controversial policy suggestions', 'a fascinating tour around the inside of the greatest benefaction that Australian art has ever received from private sources'. Bernard Smith, in these years writing influential criticism in the *Age*, was more penetrating: 'The Felton story, as Lindsay unfolds it, is one of irritation and frustration, relieved by imaginative and creative acts of purchase'. The Trustees (and Hall) had been at fault, not the advisers. The purchase of works after 1840 was 'disturbing', he complained; 'the Trustees of the National Gallery have never, at any time, exhibited a marked talent for the collection of contemporary art', and should leave the field to specialised museums of modern art.[49]

Smith was later more critical of the 'adviser system': 'for one thing', he wrote, 'the gallery should not continue to be cluttered up with nondescript paintings by more-or-less anonymous and patently immature Englishmen simply because they catch some London adviser's fancy'.[50] Lindsay did not disagree, in his summing up of McDonnell's qualities as an adviser: 'in the old master field and with works of art up to the end of the nineteenth century, fields where tradition and the recognized judgement of experts over a long period have put the hall-mark on great works of art, Mr McDonnell by his sound judgement and good taste' had 'served the Bequest admirably'. He had also shown 'great discernment' in recommending works from the early twentieth century. But in the contemporary field, where an adviser was admittedly 'faced with a much more difficult problem in selecting and assessing the aesthetic and lasting qualities of the more advanced modern schools of painting and sculpture', and especially of 'semi-abstract and abstract art', though it was 'desirable to have representative examples in our collection', it was debatable whether 'some of the works acquired will stand the test of time'. Unfortunately 'a number of the pictures purchased in the last few years from the £2000 annual allowance' appeared to be 'indifferent examples of "names" rather than works of any great aesthetic merit'.[51]

It is unlikely that McDonnell saw this passage. A meeting of the Committee in November 1963 was told that Sargant had just reported him ill and in hospital. The Committee immediately wrote to wish their Adviser a quick recovery—'he must

[49] *Herald*, 11 December 1963, *Nation*, 11 January 1964, *Age*, 16 November 1963.

[50] *Age*, 25 November 1964.

[51] Lindsay, *The Felton Bequest*, p. 55.

not deal with Felton matters nor worry about works of art affairs until he has completely recovered'—but although McDonnell left hospital, he died unexpectedly at the home of a friend, on 13 January 1964, aged only fifty-nine. His last purchases from his 'contemporary allowance' were *Untitled IV*, an abstract by Charles Howard, an American living in Cambridgeshire, a drawing by Sickert, *Figures in a Pool* by Arthur Boyd and six drawings of flowers he had commissioned from Australian expert Margaret Stones: there was not an immature Englishman among them.

IN FEBRUARY 1964 the Bequests' Committee discussed at length the problem of replacing McDonnell as Adviser. They decided to move slowly, Cox undertaking to seek advice from Sir Frank Francis, Professor EK Waterhouse and Sir Trenchard Cox, and Dixon from Sir Kenneth Clark. In May, when the Committee rejected three local applicants, Cox reported that Dr Ursula Hoff might be interested, if certain difficulties could be overcome, and the Committee agreed 'it would be desirable to secure Dr Hoff for the position'. Fitts then went overseas for three months, and Burke for seven, and it was not until October that the Committee considered a short list of four, including Hoff and Mary Woodall, a scholar and administrator well known to Burke and Fitts, whose career (remarkable at that time for a woman) had culminated in a very successful appointment as Director of the Birmingham City Museum and Art Gallery, from which she had recently retired with an excellent reputation and the nickname 'Mighty Mary'.[52] The Committee confirmed their wish to appoint Hoff, and Cox was asked to negotiate with her, and with the Trustees and the Government on the terms on which she might be released; the Trustees were enthusiastic, but the Public Service Board could not approve leave for more than one year; resignation to take a short-term appointment was out of the question, and in consequence Cox had to report in December that because of difficulties 'financial and otherwise' the advisership 'could not be offered to her'.[53] Burke was asked to approach Woodall, and in March she was offered the position, on £1000 a year plus expenses, and invited to Melbourne; the Committee also agreed that she could undertake work for the Miller Bequest, for an appropriate fee. She accepted.[54]

[52] Woodall (1901–1988), was related to the Chamberlain and Nettlefold families, powerful in Birmingham's industrial oligarchy. After studying art at the Slade and History at Oxford, and completing a PhD (on Gainsborough) at the Courtauld, she gained senior administrative experience in the Ministries of Supply and Health during the war. In 1945 Sir Trenchard Cox appointed her to Birmingham, soon as his Deputy; she succeeded him as Director in 1956 (Peter Tzamouranis, A Presentation of Dr Mary Woodall (1901–1988), chs 1–2).

[53] Cox, *The National Gallery*, pp. 322-4, gives his account of proceedings.

[54] FBC, 4 February, 18 April, 2 May, 28 October and 5 December 1964, 13 February and 20 March 1965.

In November 1964, when Felton purchases from 1963 and 1964 were presented to the Trustees, Seddon, accepting them, lamented again the fall in the value of the Bequest. Since 'the whole status of the Gallery' was 'largely dependent on the bequest', it must soon acquire other 'free' sources of funds or go into decline, a message echoed the next day in a thoughtful article 'Art Bequest value falls' in the *Financial Review*.[55] The acquisitions on display, however, did not suggest immediate penury; wide in range and high in quality, they were well worth the £33 791 spent on them. 1963 purchases shown included the 'Dalhousie' torso, a Vorticist work by Percy Wyndham Lewis, the Charles Howard abstract, a modern German picture, *Sir Christopher Wren* by Meckseper, Chinese bronze and ceramic vessels, Henry Gritten's *Melbourne from the Botanic Gardens*, Mantegna's engraving *Hercules and Antaeus*, Sickert's study for *Admiral Duquesne, Dieppe*, a Chinese lacquer chair, a clay feeding cup from Persia, an English wine glass, Coptic textiles and lace from the Pollen Collection. 1964 purchases, mostly recommended by the Gallery staff in the absence of an adviser, included, as well as Dobell's *Helena Rubinstein,* Norma Redpath's sculpture *Dawn Sentinel* (£2000), a seventeenth-century French tapestry (£8000), an eighteenth-century Yan Yao landscape (£5500) a Khmer Buddha (£5000) and Michael Andrews pop-art-influenced panels *All Night Long* (£1500). When Andrews' work was illustrated in the *Sun*, Westbrook announced that 'this painting should upset everyone and I hope it does'.[56]

MARY WOODALL ARRIVED in Melbourne for a brief visit in May 1965. The *Herald*, describing her as a 'tall, assured, quietly-spoken Englishwoman', photographed her with Tiepolo's *Cleopatra*, whom she did not resemble but duly admired.[57] Attending a meeting of the Bequests' Committee, she must have thought that Felton's Art Bequest was—literally—a spent force, with only £15 400 left in the kitty. The Committee did authorise her to bid for three Chinese works at Sotheby's (up to £5500, not the £7000 requested), and asked her to consider Sir Matthew Smith's *Woman and Parrot*, recommended by Kenneth Clark for £A1500; but an offer by Dr and Mrs Evatt to sell to the Gallery Soutine's *Le*

[55] *Age*, 17 November 1964; *Financial Review*, 18 November 1964. In the absence of an official Adviser, Gallery staff were inclined to deal direct with London. On 10 May 1965 Sargant complained to the Secretary that Bluett was bidding at auction without reporting through him: 'the present regime at the Gallery likes to deal with those things direct instead of using the proper channels'.

[56] *Sun*, 17 November 1964. At their meeting on 1 December the Committee agreed to support a three-month trip by the Deputy Director to study Oriental Art, soon to become his curatorial responsibility; and on 13 February 1965 approved Culican bidding up to £3500 sterling for a Sasanian silver ewer; he got it for £3000.

[57] *Herald*, 4 May 1965.

Dr Mary Woodall (reprinted from
L Cox, *The National Gallery*)

Jeune Valet for £12 000 was refused 'in view of limited funds' and lack of evidence 'that the painting is one of Soutine's outstanding works'.[58]

Dr Woodall reported briefly on her first visit to the Gallery, views she later put on paper. She was clearly shocked by the 'lamentable' storage facilities in the old building, and by the condition of much of the collection; the 'Felton Trustees are deeply concerned', she asserted—and the Bequests' Committee proved her right by repeating her pleas to the Gallery Trustees—by the lack of a Conservation department with trained staff, especially for tapestries and other vulnerable materials, with a picture restorer in training. She did not, then or later, endear herself to all Gallery staff, but agreed with Dr Hoff that the Bequest should buy more on the continent, especially prints, and at auction, since with prices so high dealers no longer held big stocks. The Bequest, with less money to spend, should try for one or two fine acquisitions each year; she made no specific suggestions, but remarked that the Gallery needed more sculpture, that it should seek modern prints, since it would be difficult to buy pictures (of the School of Paris, for example), and should look for works from South East Asia, even if only to form a 'token collection'. These modest proposals were a far cry from Rinder's list, forty-five years earlier.

[58] FBC, 10 May 1965. Dixon, Burke, Cox and Fitts were there, ARL Wiltshire an apology. (In the event two of the Chinese works were got for £2280; the third fetched £5200.)

In July 1965 Wiltshire retired from the Trustee Company and the Bequests' Committee, and was replaced by James Cuming Stewart, whose ancestry was evident from his name. In August Sir Owen Dixon, who had been ill, retired, after twenty years on the Committee, nine of them in the Chair. Sir Clive Fitts, long an influential member with a special interest in the charitable bequest but a shrewd head concerning the arts also, succeeded Dixon as Chairman, nominated by Cox and seconded by Burke, the senior and surviving members. Dixon was not replaced on the Committee until May 1966, when Alan Hamer, an Executive Director of ICIANZ and older brother of Rupert ('Dick') Hamer (then Minister for Local Government and already a major influence on Arts policy) became a member, though unfortunately not for long; he resigned in December 1967 when appointed to head ICI in India.[59] The Gallery Trustees also gained a new Chairman, NR Seddon, when Cox did not seek re-election in June 1965, and also a new Treasurer, Andrew Grimwade, by this time a chemical engineer and grazier and since 1960 a Councillor of the National Gallery Society, who had been appointed a Trustee in December 1964 in place of Tom Mitchell. Since Russell's death in 1955, there had been no Grimwade involved in Bequest or Gallery affairs. Andrew Grimwade, who had been living in Sydney when Sir Owen Dixon had then sized him up for the Committee, had returned to Melbourne to run Carba Industries Limited, one of Russell's pet projects among the family businesses. By 1965, aged thirty-five, he was Managing Director of Carba and a director of a lengthening list of major companies, including Cuming Smith's and Commonwealth Industrial Gases, and the National Bank of Australia; well equipped to become Treasurer, he was soon seeking from governments tax concessions for the Gallery. In February 1965 another prominent Melbourne family name had appeared among the Trustees, when the architect and influential writer Robin Boyd, son of Penleigh Boyd, joined the board in place of Kenneth Begg.

Mary Woodall, when discussing with the Committee strategies for the use of the Felton resources, had hoped 'that the Gallery will eventually acquire its own funds'. Despite constant effort, that hope seemed forlorn; the Miller Bequest was not yet fully expended, and the Adviser bought some good things for it, but other funds remained scarce. In June 1965 the Trustees asked the Committee to buy paintings by Fred Williams, Roger Kemp and George Johnson, but were told brusquely that it was not the Bequests' policy to buy Australian Contemporary works 'as this should be the responsibility of the Trustees of the Gallery'. Pressed

[59] Ibid., 21 May 1966, 9 December 1967.

to reconsider, and to buy at least Williams' *Upwey Landscape* (600 guineas) the Committee confirmed its policy but promptly bent it to give the Trustees up to £A1000 a year to purchase Australian Contemporary works in Australia, and *Upwey Landscape* entered the collection.⁶⁰ The Committee scarcely narrowed its own sights: Rex Ebbott, Honorary Curator (soon to be renamed Honorary Consultant), was given £1000 to spend on glass in London, and £400 more when he asked for it, and Woodall was asked for advice on an appropriate policy towards Indian art.⁶¹ Trendall remained an active adviser, as did Thomson, who had replaced Cox as Curator of Oriental Art while remaining Deputy Director.

Woodall proved to be an Adviser with flair, finding works of quality at affordable prices. Late in 1965 she recommended (with Hoff) Mantegna's engraving *Battle of the Sea Gods*, a masterpiece fully worth £3000 sterling, and her first painting, a Northern Italian *Portrait of a Young Man* (£8000 sterling); she also reported buying from her discretionary fund *Ecriture de Londres*, a kinetic work by American JR Soto which Patrick McCaughey praised warmly in the *Age* on its arrival.⁶² (She was soon to buy also *Attika*, by the influential Hungarian-American Victor de Vasarely, for £2210.)

In February 1966 the Committee, like the rest of Australia, had to adjust their minds to a new decimal currency, the Art Bequest's allocation of £26 000 in December suddenly becoming $52 000, though it would buy no more pounds sterling than before. Woodall remained busy, recommending in February Robert Delaunay's spectacular *Jeune fille nue lisante* for £5625, a gouache by Sam Francis (£1035), a seventeenth-century mirror (£1150), a Baroque figure (£1000), and some Barry Kaye stage designs; while Trendall chipped in with a red-figure Pelikeon for 30 000 Swiss Francs (A$6224). The Art Bequest received $30 270 in May, and approved a Picasso pen and ink drawing *A Woman with a Fan* (£4500) after Hoff approved and Anthony Blunt, consulted, called it 'marvellous'; and also *The lamentation over the dead Christ* by Pieter Candid (also known as de Witte) for £2500, a Hokusai drawing (£520), Perino del Vaga's *The Holy Family* (£800) and a sheet from a famous series of Florentine drawings of famous men (£2500). Purchase of a Lion Head Rhyton (Trendall again, for $1000), and *Odyssey*, forty-four lithographs by Kokoschka (£1000), took the art fund down to $10 400, but $28 200 received in September empowered the Committee to approve (for £1200) John Peter Russell's *Field of Beetroots*—not the best choice from the great

⁶⁰ Ibid., 14 August 1965.

⁶¹ Ibid., 19 June and 14 August 1965.

⁶² Ibid., 4 December 1965, *Age*, 7 January 1967.

1966 exhibition of his works—and to have Woodall send to Melbourne, for Hoff's approval, the set of Goya prints *Les Desastros de la Guerra,* offered for £1250. Hoff was also asked to consider Zoffany's portrait of *Elizabeth Farren as Hermione in The Winters' Tale,* found by Woodall for the Miller Bequest for £4000; 'since portraits of women of merit in history are rare', she wrote, 'this seems a desirable acquisition'.[63] Woodall's earlier major recommendations for the Miller Bequest had included, in 1965, Boucher's pastel of *Mme de Pompadour*—she whose 'merit' was questioned, but confirmed—for £A9000, a 'very swagger' Ramsay portrait of Earl Greville (£12 000), and—stretching the other criterion, 'history'—a Sumerian stone head of *Gudea, Ruler of Lagash* in about 2000 BC (£11 500).

In September 1966 the Bequests' Committee refused a Hepworth sculpture, because it had decided to save up for another Woodall recommendation, *Adoration of the Magi,* then thought to be by Masaccio but now attributed to Giovanni Toscani, available for US$35 000 (A$31 530). They received Woodall's report on buying Asiatic art (Indian, Cambodian, Islamic and Chinese), and accepted her recommendation to provide Douglas Barrett of the British Museum with £2000 to spend in India, where he went buying every year. In December, when the Goya and the Masaccio were finally approved, the Trustees, liking the Indian works, asked for more (Barrett found them a red sandstone figure of Varuna for £1700); and the Committee gave Woodall £1200 to buy Islamic pottery and Japanese prints. Early in 1967 she reported buying a Giacometti lithograph, and recommended a Claude Lorrain classical landscape for £15 000, which the Committee approved after much hesitation, having earlier bought another which proved not to be genuine. After paying for it, the Art Fund was down to $1400, and had to reject a recommendation to buy three very fine prints.

TIMES WERE CHANGING, and not only in the art world. In March 1967 Radcliffe's asked whether they could send Felton purchases by cargo ship, since passenger ship sailings were now so infrequent; they were told to consider also air freight. Distance remained a tyranny for Australia, but people and ideas travelled more rapidly around the globe than before, a phenomenon especially evident among the young: student revolts in Paris or California were echoed, with little delay but much distortion, in Melbourne or Adelaide. In Australia, the governments the young despised were also changing, not least in accepting more responsibility for education and the arts. In 1968 the Gorton Government established the Australian Council for the Arts (later the Australia Council), and in Victoria the Bolte

[63] Quoted in Cox, *The National Gallery,* p. 364.

Government, though still tardy in granting the National Gallery funds for essential staff, at last provided a larger fund for acquisitions, of $18 000 ($60 000 had been asked for). A sub-committee for Australian purchases was reconstituted, and spent with a will—almost, Cox observed, a 'prodigality of spending'—determined to make up for opportunities lost in recent decades.[64]

The Government had at last changed the name of the new complex in St Kilda Road, from Cultural Centre to Arts Centre, within which the Gallery was to be a constituent unit. In consequence, the National Gallery of Victoria came under new management; the Trustees appointed under the Act of 1944 were put out of business by the National Gallery of Victoria Act 1966, which constituted a National Gallery Council of nine Trustees in their place. Present at the first meeting in October 1967 were seven of the former Trustees, Seddon (Chairman), Ritchie (Deputy), Grimwade, Boyd, Cox, Gibson and Smithers; the new members were Professor Arthur Francis of the University of Melbourne, and Father Michael Scott, Rector of Newman College. The Premier was at last persuaded to provide more staff, essential for the new building. (When the Council asked the Public Service Board to remove an anomaly in salary levels by raising those of some senior officers, who were paid less than the newly advertised junior posts—an unusual incentive to apply for demotion—the Board solved the problem by reducing the salaries of the new positions.)[65]

In Felton matters, Sir Clive Fitts, who had already brought a new order into the Charity Bequest (as will be seen), now prompted the Bequests' Committee to take stock of the Art. After spending two months abroad, he presented succinct 'Observations following a visit to England and the United States in June and July 1967'.

Fitts took a broad view. 'It needs to be emphasized', he began bluntly, 'that the great days of the Felton Bequest are over, for the corollary is that if the National Gallery continues to depend on this source for future accessions then it has a diminishing future'. The Bequest produced less than $80 000 a year for art, a sum unlikely to increase and small in competition with the great galleries of the world, and with private collectors, especially in the United States: 'The tax dispensations in the US are such as to make the purchase of great works of art for the local gallery very attractive to wealthy citizens. So far as I am aware nothing of this kind exists or is contemplated here'. And although the Bequest, the National Gallery and Dr Woodall retained a high reputation overseas, the existing dealers' market was inherently unfavourable to a small, slow buyer, as the Bequest had become. The

[64] Cox, *The National Gallery*, pp. 364–5, 378.

[65] Ibid., pp. 372–3.

real problems now emerging thus 'had little to do with the Felton Bequest or its Committee. They are essentially problems for the Citizens of Victoria, the State Government and the Trustees of the National Gallery'.

The Committee did nevertheless face two issues, in his view. One was autonomy; Sir Owen Dixon had been 'a staunch adherent to the idea that the Committee should be independent', and although the National Gallery of Victoria would eventually administer greater funds, nothing would be served by losing identity, either for the Art or the Charitable side 'which latter now equals the former in importance'. The other issue was how best to use limited funds. The Bequest, he suggested, was likely to lose touch with strong London connections if it dispersed its efforts too far into fields such as Asian and Indian art and antiquities, and it was necessary to discuss some limitation of fields with the Trustees. Dr Woodall, in his view a very good Adviser, had asked for a discretionary fund of £5000, a request he supported. Burke, supporting the Chairman's drift, asked for (and later obtained) a strong report on the art market from Dr Woodall, to reinforce the message to the Government.[66]

Discussion was resumed a month later at a special meeting held in the Melbourne Club, the Committee eventually resolving

> to conserve funds for a period with a view to concentrate on the purchase of works of art of major importance prior to 1850, and therefore, other than to provide £5000 stg for purchase by Dr Woodall of contemporary or near contemporary works in her discretion, to retain all income until the end of September 1968 and then to review the position.

Before this resolution was put, however, the Committee—on the principle that the future begins tomorrow—approved Preti's *Sophonisba receiving the poison*, another remarkable Woodall recommendation; it cost £11 500, making a hole in the $48 765 available.[67] In December the Committee declined a Ferrara sculpture under the new policy, but could not resist another Woodall recommendation three months later, when she found Cavallino's *The Virgin Annunciate* for £12 000.[68]

The Preti and the Cavallino had been 'fortuitous' purchases, the Adviser herself told the Bequests' Committee, meeting with them in August 1968. She was happy to confess herself an opportunist; in any case there was not enough

[66] FBC, 14 October 1967 and 1 August 1968.

[67] Ibid., 16 November 1967. It also extended Woodall's appointment for one year; but did not approve a Kirchner print for US$2500. In December it decided to seek a legal opinion on whether works bought by the Adviser from her discretionary fund could be sold if the Trustees rejected them.

[68] Ibid., 9 December 1967 and 24 February 1968.

money, she knew, to try to build any new collections, for example of Egyptian art. She was happy to buy contemporary art, English, European, American and indeed Australian: a Nolan was a recent purchase. The Committee promptly 'unanimously agreed that the Felton Bequest should not be used for the purchase of contemporary Australian paintings in Australia. This was considered to be the responsibility of the Council of the National Gallery'. The Gallery, when told soon after that the $2000 then enclosed was the last annual allocation, objected so strongly that the Committee relented for another year; thereafter the Gallery tried harder to raise funds, as Fitts had told them they must, not just to spend them.[69] The Government's solution was to announce that there would be a charge for entry to the new Gallery, to provide it with additional income. Fitts, and the Council, defended the charge against critics; he thought it 'essential'.

THE NEWLY-CREATED Council of the National Gallery of Victoria had a hectic year preparing for the opening of the new National Gallery, which took place on 20 August 1968, with loud fanfares and much flashing of photographers' bulbs. The press covered all stages of the proceedings—described at length by Cox, in triumphant mood—giving appropriate weight to the announcement at the celebratory banquet for 450 guests (in the new Great Hall, with its glass ceiling by Leonard French) that Dame Elisabeth Murdoch had been appointed as the first woman on the Council; there had never before been a woman Trustee.[70]

It was appropriate also that the treasures bought with Felton's money should settle in St Kilda Road, on his daily route to work; and Grounds' massive, moated bluestone building could be seen as an idealised Flinders Lane warehouse (with delivery bay around the back). Its contents were less aromatic, if sometimes inflammatory: not least one of its inaugural exhibitions, The Field. Opening the new gallery with a survey of contemporary—indeed avant-garde—Australian art rather than a historical exhibition was a radical gesture, rightly seen in retrospect as a landmark; it also confirmed, belatedly, that New York had supplanted London and Paris as the Art world's cultural capital and as the greatest influence on Australia's younger painters. The public had to learn, as they had, to comprehend developments which outmoded themselves within years rather than decades.[71]

[69] Ibid., 1 August 1968. At this meeting, after eleven years as Secretary, McDonald was replaced by JH Stevens, who was to serve the Committee for even longer.

[70] *Age* and *Sydney Morning Herald*, 21 August, *Advertiser*, 24 August, and *Womens Weekly*, 11 September 1968 (with colour photographs of the *Banquet*).

[71] For an account of the exhibition, see Bernard Smith et al., *Australian Painting 1788–2000*, pp. 443–4.

The National Gallery of Victoria, St Kilda Road, 1968 (National Gallery of Victoria)

To almost everyone's gratification, the new Gallery impressed the public, who thronged to wonder at the water wall beyond the drawbridge, and discover with difficulty the entrance—complete with ticket office—concealed beside it. (When, in January 1969, the entry fees—20c for adults and 10c for children—came into force, a correspondent claimed that Felton would be the first to protest, which was unlikely: he might not have approved, but was not by nature a protester.)[72] Architects and gallery professionals were less impressed by the new

[72] *Age*, 20 June 1968.

building than the public, finding the interior rigid, with too little flexibility and insufficient hanging and storage space. For different reasons, John Reed was predictably critical, writing sourly to a friend:

> Our new national gallery of Victoria has been opened amidst the most fantastic amount of ballyhoo you could imagine, and I suppose that is about the level of its aesthetic. It is like a prison outside and a mixture of super department store and the Chevron Hotel inside. Perhaps, with your idea of accepting society, you would find great joy in it; but it just gives me a great pain in the neck. It is about as unsuitable for showing paintings in as anything I could imagine. However the public loves it and already a million have been in.[73]

Mary Woodall, who had been invited from London for the opening, gave the Bequests' Committee her own report on the new Gallery. She was 'much impressed by many aspects', especially 'the ease of circulation and the relaxed atmosphere', but found that there was 'little more space for pictures than in the old gallery', and especially not enough for big modern works. Consequently the pictures were 'hung much too close together'; and the wall surfaces and the lighting were 'most unbecoming to pictures'; the Decorative Arts fared better, though the ceilings were too low for furniture. Some of these problems were to be overcome over the following years, though others remained to be tackled when a massive reconstruction of the building was commenced thirty-two years later. Woodall's conclusion was philosophical, advising the Committee to

> concentrate for the present on objects other than pictures, unless something very exceptional turns up ... I feel the only policy can be to get the best possible things with the money available and not be too concerned about how they be displayed. The collections matter ultimately more than the building.[74]

Alfred Felton might not have disagreed; what is certain is that there would have been precious little for the public to see in the new galleries were it not for the Bequest he had created sixty-four years before.

Not everything Felton's Bequest had presented to the old Gallery was transferred to the new. Most of the books stayed with the Library—forcing the Gallery to create a library of its own—and so did some illuminated manuscripts, a matter of later discontent. The 'Historical Collection' remained together, to become the basis of the La Trobe Library's pictorial riches, but depriving the

[73] Reed to Mike Brown, 15 November 1968 (Reid and Underhill, *Letters of John Reed*, pp. 714–15).

[74] The report is pasted in with the Minutes of FBC, 30 November 1968.

Gallery of early Australian works (which at that time it little valued).[75] Circumstances also encouraged C Elwynn Dennis, then Acting Curator of Decorative Arts, to argue that the coin collection should not be transferred to St Kilda Road, but placed elsewhere on permanent loan. The collection, he argued, contained no original objects of art and therefore had no more place in an art museum than did 'ethnic objects of only sociological significance'. Its presence was burdensome and embarrassing: members of the public interested in coins were 'incredibly enthusiastic'—'the number of letters from numasmitists is rivalled only by the number of examples they submit for identification'—and since there was no curator with specialised knowledge, the service given was not good. Moreover, through 'some oversight on the part of the architect', no provision had been made for housing or displaying the coins in the new building, and any facilities belatedly created would be awkward, costly and not secure. (The Gallery had suffered embarrassment in 1964 when thefts from the collection had been uncovered.) 'The entire situation of the National Gallery of Victoria can be made happier by removing this responsibility', Elwynn Dennis concluded, with some confidence that his cause would triumph. And so it did, though it was not until 1973 that the Science Museum formally requested the collection's transfer, completed in 1976.[76]

[75] On the 'historical museum', see Galbally, *The Collections of the National Gallery of Victoria*, pp. 35–6, and Rasmussen, *A Museum for the People*, p. 195.

[76] C Elwynn Dennis, 'Recommendation concerning the Collection of Coins and Medals', 1967 (copy in NGV Library). See also Rasmussen, *A Museum for the People*, pp. 297–8.

28

FROM CHARITY TO PHILANTHROPY

In May 1945 the Bequests' Committee made its usual half-yearly charitable distribution, the first without the guidance—not to say dominance—of James Levey, dead the previous December. No one stepped forward to devise new strategies, but as the war drew to a close the Committee began to review grants made from the Charitable Fund to wartime causes. Both the Red Cross and the Comforts Fund disappeared from the list in December 1945, though the Committee still supported the AIF Women's Association and the Nurses Work to Win. Legacy received a special grant to assist families of ex-servicemen, and small grants were made to the Victorian Blinded Soldiers Welfare Trust, the Partially Blinded Soldiers Association and the RSL Family Welfare Bureau, and later to an appeal on behalf of former Prisoners of War. A small grant made in December 1947 to the War Nurses Memorial Appeal, to build a Nurses Centre, had to be withheld later on lawyers' advice; to the law of charities, patriotism was indeed not enough. In 1953 fealty and philanthropy neatly coincided when the Bequests Committee gave £2000 to the Queen Elizabeth II Coronation Trust Fund.[1]

Appeals for causes other than patriotic, postponed during the conflict, proliferated when it was over. The Bequests' Committee gave £1000 towards rebuilding the Women's Hospital, and similar sums in 1948 to the Royal Victorian Institute for the Blind, the Victorian Society for Crippled Children, to a Royal Melbourne Hospital Appeal, and a smaller sum to the William Forster Try Boys (a cause Felton himself had supported). For a year or two a higher proportion of the total disbursements went on such special grants, with the regular maintenance grants correspondingly squeezed, though the long lists, divided into the usual categories, appeared every six months in the minutes.

[1] FBC, 3 December 1953. It was necessary to stipulate that the money was to benefit Victorian mothers and children.

The intricate structure of Victorian charity, like the society it existed to serve, was nevertheless much eroded. The Depression had, in every sense, proved too much for it, and the war opened new vistas of social change, and made the Commonwealth, and no longer the States, the arbiter of destiny. Charity was about to recast its practice as welfare, and its principles as philanthropy.

THE WORDS 'CHARITY' AND 'PHILANTHROPY' have curious parallel histories. Their primary meanings—charity: 'benevolence, especially to the poor', 'the Christian love of our fellow men'; and philanthropy: 'love towards mankind, practical benevolence towards men in general'—may seem to differ little (at least in Oxford's English), except for echoes of religion in the one and of eighteenth-century Enlightenment in the other.[2]

Charity, an ancient word reintroduced into common use in English translations of the Bible, was a simple Christian virtue, and still has a sense of tolerant forgiveness; but it also acquired legal status, in Church and State, and 'cold as charity' emerged as early as the sixteenth century to describe impersonal assistance to the unfortunate, especially in institutions. The Elizabethans rewrote the law concerning 'charitable uses' at the time they formulated the Poor Law. The nineteenth century was often happy to use both words, sometimes interchangeably, though in the 1860s CS Loch, founder of the Charity Organisation Society, preferred the word 'charity' to 'philanthropy', which he associated with the woolly-minded benevolence he wished to restrain. In the Great Victorian Enterprise to help the poor to help themselves, 'discriminating' private charity had an honoured role.

The language of Victorian charity, born with the New Poor Law, could not long survive once it became commonly assumed that the state should accept direct responsibility for the welfare of all its citizens. Several times after 1939 the influential secretary of Victoria's Charity Organisation Society, Stanley Greig Smith, reported to his executive an increasing antipathy to the word charity, not only among its recipients but in the voluntary sector itself, and in the community at large. In 1947 he persuaded the COS to follow its London and New York namesakes in a change of identity; henceforth, renamed the Citizens Welfare Service, it relinquished its original aim of co-ordinating charity and became a family welfare agency, with a special role supervising Social Work students in

[2] Compare Richard Kennedy's Introduction to *Australian Welfare History*, pp. 2–3: 'Readers might wonder what the difference is between "philanthropy", the term preferred in the two chapters on Sydney, and "charity", the term used in the chapter on Melbourne. The answer is simple: very little'. Although charity was commonly described as a Christian virtue, Jewish communities in Australia have always been noted for philanthropic activities.

training. The discrediting of charity, as a word and in practice, allowed philanthropy, carrying less social and theological baggage, to come into its own. In one of those episodes of change which punctuate the history of morals, when assumptions shift, accepted meanings are leached out of old words, and new vocabularies gain not only currency but esteem, 'charity' gave way to 'welfare', the 'poor' became the 'disadvantaged'—with a subset of euphemisms for all the perils flesh is heir to—and self-help gave way to empowerment. Some demons remained difficult to exorcise; a generation later 'welfare dependence' had to be invented to describe what the Victorians had always known (and feared) as 'pauperism'.

The welfare state had a long gestation. In the Commonwealth the old age pension had been adopted in 1908, with little debate partly because Australian governments, optimistic concerning national prosperity, did not believe many would need it. After 1918 Government expenditure on repatriation grants to returned servicemen expanded rapidly, and the long debate began on systems of national insurance, to cover ill health and unemployment as well as old age, a debate made more urgent when the Depression revealed all too clearly the inadequacies of the existing charitable systems. All attempts to introduce national insurance failed, before the war brought its own pressures for new taxation and for more general change. By clever dissimulation, taxation introduced to pay for the war was passed off as—and ultimately became—the source of funds for a range of welfare provisions. The expectation, common almost everywhere, that national affairs would be managed differently after the war, prompted the landslide in language; and welfare became indeed a major sector of government and a key issue of political debate, with its own lobby groups inside and outside the government structure.

As government action expanded, many of the old charitable institutions lost their autonomy. They had long been recipients of public funds, and agents carrying out some government policies, but the balance of authority now moved decisively against them. Old corporations—the hospitals in particular—were accustomed to exercising independence while accepting subsidies from governments, and did not enjoy becoming mere agents carrying out governments' decisions; most were eventually restructured by political fiat, the process delayed and complicated by the involvement of both State and Commonwealth governments. (In the universities, a parallel case, the process was much accelerated by the Whitlam Government's taking sole financial responsibility, and abolishing fees.) But even at its most confident, the welfare state did not try to supersede all voluntary agencies, but rather to use and direct them. Many of the charitable organisations assisted by Felton himself in the nineteenth century, and by the Felton Bequests' Committee in the twentieth, found new functions for themselves

within government programmes, though often going beyond them; thus after 1963 the Attorney-General's Department became the largest (but not sole) source of income for the Citizens' Welfare Service, the re-badged COS, in its new life as a counselling agency specialising in marriage and the family.

'A secure provision for the indigent is to the philanthropist what a pineapple is to the epicure', wrote Jeremy Bentham in 1796, when pineapples were rare and the poor short of bread. Philanthropy was always utilitarian; hence 'philanthropism' a word coined in 1835 to identify philanthropic theories or systems. And just as 'scientific charity' produced, in the late nineteenth century, a doctrine to make private benevolence efficient, and spawned the profession of social work, so in the last decades of the twentieth, when the state guaranteed basic levels of welfare, 'philanthropy' produced new doctrines, and new professionals, dedicated to making effective the role of private benevolence, as a force in the 'non-profit' sector, the space between government activity and the 'free' market. The United States, placing minimal reliance on state welfare, led the way in the theory of modern philanthropy, as in its practice; in Australia, benevolence ceased to be so much exercised in the areas which had become a state responsibility (despite one of Felton's favourite charities, the Royal Children's Hospital, continuing to benefit unusually from both). By the 1990s, in Australia as elsewhere, majority opinion questioned whether the state could or should extend its welfare functions indefinitely, and governments began to dismantle and to 'privatise' not only welfare structures but the network of government enterprises, from water supply and railways to telecommunications and airlines, which had grown as a characteristic of the Australian economy since white settlement. Private businesses, as well as private individuals, were recruited to expand the philanthropic effort, and were given incentives; Australian governments reluctant to increase taxes were willing nevertheless to forgo them, and tax deductibility joined charitable status as the criteria of a worthy cause.

In 1908 PD Phillips gave the Bequests' Committee his opinion that the word 'charitable' required that 'the object' be 'eleemosynary', 'that is the giving of something to poor or indigent persons either in money, or services, or money's worth'. A case in 1896 had determined that 'philanthropic' was not synonymous with 'charitable': an object would not come within Felton's trust 'merely because it is philanthropic—such as a lover of mankind would desire to promote—but...must also be eleemosynary to particular individuals or classes'. On this interpretation, some applicants to the Bequest were ruled ineligible, including the Lady Talbot Milk Supply Association, which educated individuals in the superiority of pure milk but gave none away, and the Ladies Work Association, which assisted a poor lady to 'supplement her means' by selling her needlework, but charged commission

for the service; both were philanthropic, but not charitable. More alarmingly, he also ruled out the Charity Organisation Society (except for its relief fund), because its aims—to regulate charity 'to prevent imposition', and to 'prevent the need of alms by promoting self help'—were not in themselves charitable. Fortunately for the COS, Theyre à Beckett Weigall gave a less strict opinion, putting the Society back within the scope of the will, though the Ladies Work Association remained 'doubtful'.[3] Over the following decades the legal restrictions on the Bequests' Committee's work were progressively loosened, though it was some time before the Committee itself sought to change them. The Bequests' charitable distributions varied little from year to year until the second half of the century, when they came to reflect more clearly changes in community values, as society first transferred to the state its dependence on a multitude of private charities, and later as state welfare was supplemented by private and corporate philanthropy, organised under new principles, mercifully not yet termed philanthropism.

CHANGES IN THE Bequests' Committee's practice emerged first in the medical area. Alfred Felton was generous to hospitals, but had never given them the priority evident from the beginning in his Bequests' twice-yearly distributions, their presence high in the lists ensured by overlapping membership between the Committee and the Boards of the Hospitals, the Royal Melbourne in particular. When, in the 1920s, the Bequests' Committee followed the major hospitals into involvement in medical research, the Walter and Eliza Hall Institute, with its close link with the Royal Melbourne, became so regular a recipient that by 1951 it was listed among 'General Philanthropic Institutions', receiving a maintenance grant as well as a special grant for research. Other recipients of Felton's own charitable distributions continued in the lists, but £50 to the Society to Assist Persons of Education, and grants of £350 to the combined Ladies Benevolent Societies, remained unchanged over several decades, suggesting habit rather than deep commitment on the Committee's part.[4] As large special grants to medical organisations became more frequent—for research, equipment and occasionally for new initiatives, such as a scheme to send nurses overseas for postgraduate training—the Committee began to make more grants outside the usual six-monthly pattern.

At a meeting in June 1952, one member of the Bequests' Committee foreshadowed, but did not achieve, a revolution in the charitable bequest. 'In respect to the teaching hospitals, Sir Russell Grimwade expressed the opinion that

[3] Phillips to Trustee company, 29 June 1908, and covering note on Weigall's opinion (Trustee company files).

[4] FBC, 16 May 1951.

greater benefit would accrue if the Committee discontinued its practice of making grants for maintenance and directed them to some specific purpose.' A pencilled note in the minute book identified the Royal Melbourne, the Alfred, Prince Henry's and St Vincent's hospitals, but the change in practice was minimal: after discussion, it was agreed only 'that the boards of the hospitals be asked to decide the purpose or purposes to which such grants shall be applied', but were not required to put forward proposals which the Committee would accept or reject.[5] Hospitals (and the Hall Institute) were still listed under maintenance grants, though the Secretary did initiate in June 1954 a useful summary of each distribution, indicating, among other things, how far the balance had swung from the older organisations. Nevertheless it was not until November 1957 that a new category appeared, 'Teaching hospitals, earmarked research or other special grants', receiving the large total of £15 985. Special grants continued to cover a wide range: in 1955 the Northcote Farm School (for British children) received £100, and the Victoria League £50 to provide books and magazines in migrant hostels; but in 1959 the list of maintenance grants was still very long, and after approving it the Bequests' Committee agreed 'to review the list of charitable institutions which have regularly shared in the past in the half-yearly distribution'.[6] At a special meeting a fortnight later it began to enunciate a new policy. Fitts was almost certainly the moving spirit, though Cox (the other medico member) and the rest seemed ready enough to accept change.

For the first time, the Committee decided to initiate a programme, and not merely support those of existing organisations. In this first modest departure from what is now called 'responsive' philanthropy—distinguished from 'strategic', where the philanthropist takes the initiative—it agreed to 'set aside a regular annual sum of income (say £5000 for the first year) for specific objects, such as the provision of teaching or visiting fellowships for teaching and research in medical or allied fields of a charitable nature'. For the rest, it confirmed that in future no grants would be made to teaching hospitals for general purposes, instructing the Secretary to tell the hospitals that the Committee would consider applications, made in the form required by the National Health and Medical Research Council, for special grants for research, including travel costs and equipment. To other hospitals, including those in the country, 'grants in future will be made only in response to appeals for funds to assist approved special purposes; but the Secretary was to notify only those who enquired, presumably to

[5] Ibid., 2 June 1952.

[6] Ibid., 30 May 1959.

prevent a deluge of applications. Organisations other than hospitals might be classified into 'approved charitable institutions' to which general purpose grants would be made, subject to report and review after three years, and others, which might receive grants for one year only. These decisions were made 'subject to legal approval'; by the next meeting Phillips Fox and Masel had confirmed that the Committee had 'complete discretion' concerning procedures in administering the charitable half of Felton's bequest, limited only by the term 'charitable in the legal sense'. Felton's own statement concerning priorities was not binding, though it could be considered advice.[7]

The decisions concerning hospitals were put into effect immediately, Fitts later reporting that 'with legal sanctions we have enlarged our definition of charity so as to enable us to assist medical research work here in various fields, and to bring workers here and send others abroad'.[8] In November all medical grants were listed as Special; Fairfield received funds to enable Dr Hattie E Alexander, Professor of Paediatrics at Columbia University, to visit Melbourne; building or research grants were made to the Royal Women's, St Vincent's and Williamstown hospitals; and other applications were deferred. For the first time in the Bequests' history the Royal Melbourne Hospital received nothing. There was, however, little change in the other categories, the Committee resolving to review the list of charitable institutions which received half-yearly grants in February (as they had reviewed hospitals in June). Professor Burke undertook to discuss the relative merits of the organisations supported with Associate Professor Ruth Hoban, Director of Social Studies in the University of Melbourne, and her historian husband Professor Max Crawford.[9]

Crawford and Hoban responded promptly, submitting a document in December setting out 'their views on sociological necessities as at present existing, and making recommendations on what the Felton Bequest could possibly do in this field', and appearing at the April meeting to discuss it. The document made no specific comments on the charities the Bequest supported, despite Ruth Hoban's deep knowledge of them, but offered instead four pages of basic principles, argued with Crawford's usual elegance. The 'most fruitful role' for trusts and foundations had changed, they believed, with the extension of government activity in social welfare. Voluntary and local government agencies might grumble at restrictions now placed on them by the Hospitals and Charities

[7] Ibid., 13 June 1959, 8 August 1959.

[8] Ibid., 19 August 1971.

[9] Ibid., 28 November 1959.

Commission and by Commonwealth departments, but had to comply with their policies, creating 'some danger' that 'the variety of fruitful ideas, experiments and policies at play in society' might be reduced. 'One of the great advantages of the charitable trusts and foundations is that they are free to back a judgement which may be completely independent of governmental and semi-governmental bodies. We are sufficiently Victorian to believe that this opportunity carries with it a responsibility to use it.'

The responsibility was two-fold: to increase 'precise and critical knowledge concerning social welfare', as an aid in assessing policies; and 'to back new and promising developments in practice, in the light of the independent judgement of the Committee'. In Britain the Nuffield Foundation (then active in Australia also) sought and supported 'promising ideas at an early stage', expecting nearly half to fail; the Felton Bequests' past policy of helping a 'vast number' of organisations had prevented it from 'exercising that type of imaginative and stimulating influence in health and social welfare'. 'Small donations to a great number of organisations' should, Crawford and Hoban proposed, 'be abandoned'.

The Committee, they noted, had members able to apply these principles to health and medicine. In other fields it should 'encourage a very small number of important enquiries or programmes of development', seeking outside advice but backing its own judgement; 'it is the essence of our argument that it is important in a society to keep up the variety of sources of such judgements'. The Committee should solicit projects, in both welfare practice and research, and give substantial support for specified periods. Concerning research, they added a 'private' warning: 'We do not think that money should be spent in large-sounding and elaborate schemes which end by telling you—at great expense—what you already know'; from 'long association with people in all these fields', they had concluded that the proportion 'of second-rate to first rate people' was unfortunately 'higher in sociological studies than in the more established disciplines such as economics, statistics and history', though that would be 'hotly disputed by all but a few sociologists and psychologists'. The Committee would get better results from experienced researchers, rather than young graduates, even if at greater cost; it must avoid 'frittering money away on raw and ill-considered work', and be ready to 'to sift the wheat from the tares'.[10]

The Bequests' Committee was not ready to be quite so bold. It made few changes in the lists of organisations supported, the pattern continuing for some

[10] RM Crawford and Ruth Hoban, 'The Alfred Felton Charitable Trust', 11 December 1959 (copy in Crawford papers, UMA). In a private letter to Fitts, Crawford confided that he and Ruth Hoban proposed to write a 'History of the Social Conscience in Australia', and that she might resign as Head of Department at the end of 1960 to work on it, if funds were available (Crawford to Fitts, 7 December 1959, Fitts papers).

years, though the special grants did receive an increasing proportion of the whole. Meanwhile visitors subsidised under the new medical programme, soon identified as Felton Visiting Lecturers or Fellows, gained much publicity for the Bequest, and for research and practice in their respective fields; the Royal Children's Hospital became an annual recipient, and the press gave much space (for example) to the visit of a Swedish paediatric surgeon, under Felton auspices, in 1959–60.

The Committee enjoyed deciding between worthy causes, rather than merely approving the old lists, Sir Clive Fitts later telling the Gallery Trustees and curators that since they had 'changed or enlarged the definition of charity', the charitable distribution offered 'an exciting experience comparable to the pleasure that comes from Felton accessions to the Gallery'.[11] After succeeding Sir Owen Dixon as Chairman of the Bequests' Committee in September 1965, Sir Clive continued his reforms; in December special grants, mostly medical, were increased to £15 438, while the routine recipients received only £9610.[12] Three days after 'decimal day'—17 February 1966, when Australia embraced decimal currency, nominally doubling the allocations in dollars made earlier in pounds—the Committee closed a chapter in the Bequests' history by formally stating, to the Prince Henry's Medical Research Centre, that 'it was not the usual policy of the committee to contribute to maintenance funds'.[13] And in April 1967, in response to a request from the Professor of Surgery at the University of Melbourne, the Committee departed further from tradition by moving its December grants forward; medical researchers, unlike Old Colonists, found forward planning more important than 'Christmas Cheer'.[14]

MANY AUSTRALIANS LATER looked back on the 1960s with some nostalgia, though for differing reasons. For many post-war immigrants, it was the time when they consolidated their new lives, and some made fortunes, while most 'Old Australians' decided that the newcomers enhanced rather than threatened their

[11] Meeting, 9 March, and FBC, 13 May 1972.

[12] In the mid-year allocations in 1965, the last before his accession to the Chair, £16 648 was distributed, with £7553 in Special Grants, mostly medical. Two months later, at Dixon's last meeting, the Committee gave the Bendigo YMCA a special grant of £1000 to reduce a bank loan on its 'stadium', and the Christian Television Association £50, but rejected an appeal by Monash University for its Great Hall (FBC, 19 June, 14 August and 4 December 1965).

[13] FBC, 19 February 1966. It also granted the University of Melbourne $2000 to bring the famous medical historian FNL Poynter from Britain to open the History of Medicine Museum in the Medical Library. In May 1967 the Committee, having $44 000 in the charitable fund, distributed $39 291, $20 071 in special grants and the rest to the usual recipients.

[14] Ibid., 8 April 1967.

Sir Clive Fitts with Sir Robert Menzies (University of Melbourne Archives)

familiar way of life, and were even willing to abandon the White Australia policy. The decade was relatively prosperous, with buoyant exports favouring the continuance of what was later termed the great Australian compromise, under which manufacturing industries were protected, primary industries subsidised, the unions given centrally regulated wages, and the poor a welfare state. Moderate interest rates, solid profits and low inflation satisfied the well off, who could also enjoy Prime Minister Menzies' political conservatism and sentimental monarchism, and the robust populism of Premier Bolte in Victoria. The young, enjoying wider access to higher education and more opportunities for employment, could revolt against the values of their elders, especially in matters sexual, in a moral revolution which proved to be permanent (unlike the publicly spectacular student political revolution, which lasted no longer than the Vietnam War). But even as prosperity and government welfare alleviated some former causes for

grievance, others emerged, not new but newly prominent, among them the situation of Aboriginal Australians, their citizenship belatedly confirmed after a referendum in 1967, and several issues clustered around the role and rights of the two groups to which Felton had given priority, women and children. Governments responded to these causes, though haphazardly, and so did charities.

In April 1967 the Bequests' Committee provided the Australian Council of Educational Research with information it had requested for publication in a new compilation, a Directory of Philanthropic Trusts—a grant seeker's primary resource—which after many editions is now produced by Philanthropy Australia.[15] In charity, unlike art, the Felton Bequest had always been but one continuing benefaction among many. Most were small; their variety was bewildering, and their number uncounted, but some giants were emerging. In 1958 the Myer Foundation was created by the family (alongside the Sidney Myer Charitable Trust, which Sidney Myer had endowed with a tenth of his estate). In 1964 William Buckland, businessman and pastoralist, left the bulk of his £4 million estate to establish a foundation for charitable and educational purposes, and in the same year the financier Sir Ian Potter set up the Potter Foundation, with an initial endowment of £1 million. Others already existing included the Helen M Schutt Trust, founded in 1951 with the former Helen Macpherson Smith's bequest of £350 000; and later foundations included—a few from a long list—the RE Ross Trust, the Hugh Williamson Foundation, the Stegley Foundation, the Lance Reichstein Charitable Foundation and the Pratt Foundation.[16] Most of these had broad missions, with some special emphases within each, either stipulated by the creator or devised by the trustees; and the number of other, more specialised trusts (like the Daffyd Lewis, founded in 1944 to give university scholarships to poor boys) was legion. Some, but not many of the largest, were administered by trustee companies, entities uncommon in Britain or North America, where philanthropic trusts were also expanding in number and influence. The creation of such philanthropic bodies still seemed to be more popular in Melbourne than in Sydney, one trust administrator with experience in both cities remarking that the initial reaction of a Sydney-sider to a deserving cause was to consider how to get it a government grant, while a Melburnian's response was to ask 'is it tax deductible?'[17]

In the later years of the 1960s Felton's charitable bequest continued to distribute a smaller proportion among its traditional recipients while making a

[15] Ibid. The latest edition appeared in 2002.

[16] The article on the founding of the Potter foundation in the *Financial Review* cited the Felton Bequest as a precedent.

[17] On the varieties of trusts, the difficulties of defining and assessing their extent, and a survey of the literature, see Leat and Lethlean, *Trusts and Foundations in Australia*.

much larger allocation of special grants. The Children's Hospital's Felton Visiting Lectureships continued, but among new organisations supported in 1968 were the Aborigines' Advancement League (Vic), given $500 towards the cost of education and welfare of children and adults, and Rossbourne House, a school in Hawthorn for handicapped children.[18] In December 1970 and April 1971, when the Bequests' Committee distributed a total of $123 000, the lists were diverse, mixing old and new. The recipients included, in December, an Occupational Therapy Farm for the Aged at Castlemaine ($200), the Alcoholism Foundation ($2000), the Australian Birthright Movement ($500), Parents Without Partners ($200), the Victorian Association for Deserted Children ($200), the Society to Assist Persons of Education ($400), the Victorian Association of Social Service ($400), the Salvation Army Appeal ($200) and (a welcome note) the Methodist Union's Christmas Fund ($200). In April Melbourne University received $7500 towards its Archives Centre, the Central Methodist Mission $2000 to set up Lifeline, and the Citizen's Welfare Service $1000 towards its Family Affair Appeal. (It was soon to be given a special grant of $5000 'towards the establishment of a research position to enable problems of the CWS to be evaluated').[19]

In March 1969 the Committee had given $4000 to the Hall Institute to mount a special conference, the Felton Bequests Symposium on *Man and his Science*. Two months later, when Alan Hamer resigned to work in India, the Institute's Director, Professor Gustav Nossal, joined the Committee.[20] Professor Nossal, born in Vienna in 1931 and educated in Sydney, had first worked in the Hall Institute in 1957, rapidly gaining an international reputation as an immunologist. He became Deputy Director of the Institute in 1961, and succeeded Sir Macfarlane Burnet as Director in 1965, when only thirty-four. A man of great energy, whose enthusiasm for good causes never tired but was guided by a sharp intellectual grasp of how they might or might not be effectively furthered, Nossal committed himself to give time to the Bequests' Committee despite his growing national and international involvements.

In November 1972, after distributing $65 554 ($4470 towards a book of documents on the history of Social Welfare), the Committee decided to consider whether the regular half-yearly grants to the old list of charities continued to be a satisfactory way of distributing about $40 000 each year. For advice it sought out

[18] FBC, 1 August and 30 November 1968, 17 June 1967.

[19] Ibid., 5 December 1970 and 17 April 1971.

[20] Ibid., 1 March and 24 May 1969.

David Scott, Executive Director of the Brotherhood of St Laurence, a man much respected for his capacity to assess social problems and devise practicable solutions.[21] His report, presented to the Committee in April 1973, was succinct and illuminating.

Identifying trends, Scott pointed to the increasing Commonwealth and State practice of subsidising established child care and family welfare agencies; to social pressures and needs to establish new kinds of welfare agencies; to new kinds of self-help groups (such as Parents Without Partners, and the Association of Civil Widows; to new community organisations (such as Community Child Care, and the Fitzroy Legal Aid Service); to the creation of agencies to meet new community problems (such as the Buoyancy Foundation, and the Autism Foundation); to existing agencies' adaptation to new circumstances (such as the Fitzroy Community Youth Centre's new programmes, and the Brotherhood of St Laurence's Family Centre Project; to the proliferation in a number of municipalities of Citizens Advice Bureaus (a cause championed by Greig Smith before his retirement from CWS); and to the increasingly important role of State and National Councils of Social Service in policy-making and planning.

How, Scott asked, should charitable trusts, like Felton's Bequests, respond to these developments? By themselves facilitating change:

> It is suggested that more effective use could be made of some or all of the money made available by Trusts if it is used to finance pilot projects for locally based community developments, relevant and well planned research, to assist self-help and client organisations and to support experimental projects of established agencies for limited periods.

Trusts could consider jointly financing larger projects. Questions to be asked of applicants included to what extent the project was preventive; whether it was pioneering or innovative; and how far it overlapped with other services. Other principles to consider included adequate reporting, ensuring that the 'needs of clients rather than self-justifying requirements of the agency' were the paramount consideration; and asking that funds be matched. Trusts, like governments, tended to spread their efforts too widely; 'better results could often be achieved if there was some concentration of funds to give a real boost to one area of service for a specified period'.[22]

[21] Ibid., 18 November 1972. It was suggested that Scott be invited to join the Committee, but the will restricted its membership to five.

[22] Fitts' papers include a copy of an earlier paper (March 1972) by Scott, 'Comments and guidelines for grants and subsidies to voluntary agencies', in which he covered much the same ground and incidentally proposed the creation of a Social Welfare Commission or Planning Council.

The Committee was impressed. At its meeting in August 1973—the first attended by Andrew Grimwade, representing the Council of Trustees in place of Cox—the Council decided to ask Scott and Professor Ronald Henderson, Director of the Institute of Applied Economic Research at the University of Melbourne, to help create a small advisory committee 'to provide members with informed details regarding special charitable areas'. Henderson was at this time busy with his massive Commission of Inquiry into Poverty, a task he had been given by the McMahon Government, with the terms enlarged by Whitlam, and no committee eventuated.[23]

The variety of causes supported by the Bequests in these years reflected some of the social initiatives David Scott had identified, though old favourites continued to be assisted. The Trust's income was increasing, like the economy at large, at a healthy rate—soon to become unhealthy as inflation, fed by the oil crisis, the Whitlam Government's unfunded spending and other causes, galloped away—and by December 1973 the Bequests' half-yearly distribution reached $81 061. It included, in special grants of $61 061, allocations of $6000 to the National Gallery for its library, $8000 to the Brotherhood of St Laurence for community-controlled child care, and a grant to CWS towards a social welfare library dedicated to Greig Smith.[24] More than $210 000 was distributed to charities in 1975, but with changes foreshadowed. In January 1975 the Boards of all the organisations receiving half-yearly grants were asked whether such grants should continue, or be replaced by allocations for specific purposes, applied for from time to time. Perhaps predictably, 70 per cent wanted their half-yearly payments continued, presumably on the principle of the bird in the hand; having rejected the chance of two in the bush, they were informed that in future they would receive only one annual grant, in June. The rest were told that the Committee would expect applications from time to time, and consider them sympathetically. By the end of the year Fitts, the chief architect of the new system of discretionary grants, was becoming 'appalled' by the deluge of applications for special grants, complaining to Nossal that the Felton Bequest should not be a mere 'substitute for the Medical Research Council' and confessing that he now found the applications dealing with non-medical social issues 'more in the spirit of Felton's wishes'.[25]

[23] FBC, 18 August 1973. Henderson had published the Institute's very influential calculation of a Poverty Line in 1966, and *People in Poverty: a Melbourne Survey* in 1970. At its meeting of 8 June 1974 the Bequests' Committee gave Henderson $4256 to assist in collecting social statistics.

[24] Ibid., 1 December 1973 and 31 May 1974. In May CWS received $5000 'to assist with the finance of continued research into the problems of the CWS and evaluation'. An unusual 'conditional' grant to Monash University to enable an individual to complete a degree at Oxford, was not, in the outcome, given. (The individual's career was scarcely hindered; he later became a Vice-Chancellor.)

[25] Fitts to Nossal, 3 December 1975 (Fitts papers).

IN DECEMBER 1975 Sir Clive Fitts, now aged seventy-five, resigned from the Bequests' Committee. Professor Nossal succeeded him as Chairman, despite strong objections from Professor Burke, who had developed in his later years an unusual vehemence in stating his opinions. He seems to have been mainly concerned that with a medical scientist in the chair art might lose its primacy in the Bequests' affairs, something Fitts himself had long seen as inevitable. With Grimwade's support, Nossal was nevertheless appointed; he was, however, committed to spending the next twelve months overseas, working on Third World health problems, a field in which his authority was already considerable and would grow much more. Burke himself became Acting Chairman throughout 1976, and as Sir Clive was not immediately replaced as a member, the Committee was depleted. Fitts complained that he was still expected to consider applications for grants, confiding to Burke that he had hoped he would be replaced by a young doctor; instead 'I seem to have been carrying on as before'.[26] The Committee thought it should cast its net widely, and took its time; Professor Nossal returned to Melbourne in time to receive a knighthood in the 1977 New Year Honours list, but it was not until October 1978 that Mrs Caroline Searby, a member of the Board of the Royal Children's Hospital and also of the Tertiary Education Commission (and in Burke's view a true 'Feltonian' in character), joined the Committee, the first woman to be chosen as a member, restoring its strength to five.

In June 1976, with Burke in the chair, the annually listed agencies were granted only $28 200 out of a total of $102 800, and in December 1976 $99 300 was all allocated to special grants (chosen, it was said, by a sub-committee of two, assisted by 'someone from the Hall Institute'). The successful again included the CWS, which received $7500 towards the purchase of a property, next door in Drummond Street.[27] Grants continued in this pattern for the rest of the 1970s, with a fair sprinkling of newcomers to the lists: special grants in December 1977 included the $5000 to the Goulburn Valley Centre for Intellectually Handicapped Children, and $600 to the Victorian Police Surgeon's Department to help support a social worker.[28] In November 1978 the Committee, having distributed $114 057 in special grants, considered appointing a prominent historian to write an article for publication in a newspaper, to have the charitable Bequest more widely

[26] Fitts to Burke, 4 July 1976 (Fitts papers). The eleven boxes of Fitts' Felton Bequest papers in the University of Melbourne Archives appear to include most of the applications to the charity bequest between 1955 and 1976. Fitts was later consulted on his replacement, but declined to make a formal recommendation. While Burke wanted someone familiar with the arts, Fitts 'would not mind if the person chosen never went near the Gallery'.

[27] FBC, 31 May and 6 December 1975, 19 June and 11 December 1976.

[28] Ibid., 5 December 1977.

Sir Joseph Burke (photograph courtesy Thomas Hazell)

known, but did not proceed.[29] In June 1979, aware that it now had much more to do concerning the charity bequest than the art bequest, the Committee held a 'general policy discussion', resolving to ask its Secretary to group applications in categories, 'to assist members' 'to ensure balanced donations'. It also 'resolved to place greater emphasis' over the next two years 'on the drug problem and rehabilitation of drug users', and at its next meeting to consider grants to nursing homes.[30] The discussion in September ranged more broadly: having decided on drugs as the immediate priority (and planned a lunch with the Director of the

[29] Ibid., 24 November 1978, 20 September 1979.

[30] Ibid., 15 June 1979.

Alcoholism Clinic at St Vincent's Hospital, a representative from Odyssey House and two specialists dealing with children with psychotic and sociopathic problems at the Children's Hospital), the Committee decided to consider also the needs of the migrant community, and the possibility of offering educational scholarships, especially in country areas, through the Girl Guides.[31] The next distribution included some grants concerned with alcohol and other drugs (and gave the CWS $2800 to microfilm its records on the history of social welfare), but most went to medical research. In May 1980 Mrs Searby and JH Stephens, the Committee's Secretary, agreed to visit three or four organisations a year, to see how funds were used and to assess if more might be needed.

The Bequests' Committee was clearly not satisfied with its knowledge of the real needs in the field of charity, and its problems increased at the end of the year when the staff member who had been helping the Secretary process grant applications retired. The Trustee Company proceeded to appoint another officer, and the Committee meeting on 15 June 1981 had in attendance, for the first time, Father Vincent Kerin Kiss, a Roman Catholic priest, formerly Director of Youth in the Diocese of Wagga Wagga, now beginning, aged forty-nine, a career in the administration of philanthropy.[32] Knowledgeable and urbane, Father Kiss developed a vast network of contacts in Australia and overseas, and rapidly became one of the best known and most persuasive advocates of philanthropic causes in Victoria. Within the Trustee company he was involved in the administration of many other bequests as well as Felton's, and he became the adviser and confidant of several of the state's major benefactors, and of some Cabinet ministers, and had a considerable influence on their public and private policies.

It was an active decade in the field of philanthropy. The Australian Association of Philanthropy, founded in 1975 largely on the initiative of Meriel Wilmot and Patricia Feilman, pioneering executives of the Myer and the Potter Foundations respectively, aimed 'to advance philanthropy in Australia' by bringing together 'grantmaking family, private corporate and community trusts and foundations'. It had forty-five members by 1989, when it published the first number of *Philanthropy*, part of its programme of disseminating information and encouraging discussion among the philanthropic. (An early issue announced the publication of *A Guide to Informed Giving*, launched by Dame Elisabeth Murdoch, herself one of Australia's most active and generous philanthropists.) Like the Charity Organisation Society, the Association sought to encourage philanthropy, but also to guide its practitioners to adopt good principles. In the scale of possible philanthropic action,

[31] Ibid., 20 September 1979.

[32] Ibid., 26 November 1979, 26 May and 24 November 1980, 15 June 1981.

direct support for individuals and families in need might be the simplest and the most immediately gratifying to the donor, but was also the least likely to have a sustained effect. Philanthropists, like the nineteenth-century charitable, should move beyond the obvious, and work to ensure permanent change in circumstances by—in the words of a later document—giving 'strategic assistance' to 'innovative solutions with sustainability plans', a sophisticated elaboration of the truth that you have to be clever to be truly kind. In another echo of the early history of the Charity Organisation Society, when Morris's first Australasian Conference on Charity of 1890 had been followed by Zox's Royal Commission on Charitable Institutions, so the first national conference on Philanthropy, organised by the Association, was followed by a major Industry Commission Inquiry into Charitable Organisations in the 1990s.

Members of the Felton Bequests' Committee, though keen to maintain a certain 'Felton cache' in its charitable activities, could not but be influenced by the new principles of philanthropy. At its meeting in November 1981, after making grants to a number of community and outreach organisations in a long list, the Committee resolved to meet in March, 'primarily to formulate a policy regarding all of the funds from the Charity Bequest'. Father Kiss was requested to prepare a 'working paper', to be circulated to members, who were in turn asked to send him draft comments. After some discussion, he was asked in March 1982 to prepare new Guidelines, for distribution later in the year. In July the Committee made a final break with the pattern it had inherited from Felton, resolving that after the distribution it had just completed no regular small grants would be made to the listed charities.[33]

The new Guidelines, confirmed in November 1982 (when the Committee had some $238 000 to distribute), conformed in style and substance to philanthropic practice current abroad and increasingly at home. The Committee's 'overall philosophy of giving' reflected 'a serious and coordinated approach to the needs and problems of our community'; Victoria was 'the programs service area', with grants directed towards 'the Women, Youth, and Children arena'. Factors influencing decisions included the efficiency of an organisation's structure and management, including planning, budget, its board of directors and staff; the program's record of achievement and potential; 'possible duplication of government or private sector efforts'; whether and in what way success or failure could be measured; the cost of fund-raising activities; the existence or level of government funding; and evidence of broad community support and impact.

[33] Ibid., 25 November 1981, 15 March and 26 July 1982.

The innovations, and the sting, came in the exclusions. In future the Bequests' Committee would not, in general, support building appeals, annual appeals, 'organisations or programs to influence legislation or elect candidates to public office'; individuals; tax-supported educational institutions; pre-school, elementary or secondary educational institutions; public or private sectarian or religious organisations whose services were 'strictly limited' to one group; grant-making foundations; endowment funds; advertising for benefit purposes; or (perforce) organisations not registered as a legal charity in Victoria. The positive principles of modern philanthropy were proclaimed in the statement that the Committee would give preference to applications ('directed to the Women, Children/youth arena') which promised 'a self-help approach of people or organisations endeavouring to help themselves'; that attacked 'root causes' and were not 'band-aid'; were preventive rather than remedial; that 'showed initiative and broke new ground' in approach or application; and 'that may not happen without the Committee's assistance'. The Committee would also favour 'research, medical or sociological, that is primarily concerned with women and young people as specified in the will'. Requests, to be submitted by 1 May and 1 October should state the purpose, give information on the organisation's board and budget, evidence of its charitable status, and list other donors and accrediting agencies.[34]

The guidelines were in place, and a new administrator in attendance eager to apply them.

HISTORY IS NEVER CYCLICAL, though business is. Or seems to be; Melbourne's boom of the 1880s might appear to have been replicated in Australia at large in the 1980s, with the consequences repeated also; but the differences were great. The Victorian economy had been small though apparently wealthy, reliant on a few major exports and a protected local industry, and on London capital; Australia's a century later was much larger and national, attempting to deregulate itself while intricately linked to a volatile global economy. The will-o'-the-wisps which led the moneyed into the marshes were, in the 1880s, suburban land and ventures such as sugar, with mining always a source of mixed fortune and misfortune. In the 1980s the chimeras were city property, services (of kinds undreamed of in Felton's philosophy), new technology, and a febrile notion of company growth and renewal. Felton and his friends were builders, and although adept at enlarging market share, Felton knew better than to acquire losses for the sake of growth. Like most of his generation, he believed in progress, even finding it, dubiously enough, in building a chemical works in a swamp. A century later, much doubt was

[34] Ibid., 18 November 1982.

expressed about progress, but almost everyone was addicted to change. Since rapid change was believed inevitable, the past became unimportant, and the skills to be learned were not those accumulated in previous generations but a non-specific adaptability to requirements as yet unknown. Neither Felton nor his partners had sought change for its own sake, and their names remained attached to the companies they created until well into the twentieth century; in the 1980s virtually every company had to be re-created, reorganised and renamed, with a new logo costing more than Felton's Bequest ever paid for a Rembrandt. Plans were made constantly, and remade almost before they had been disseminated, let alone read or acted on. It was modernism applied to business.

Nemesis comes early to some, and to others late. Towards the end of the 1980s the Australian banks—and especially the State Banks of Victoria and South Australia, originally founded to watch over the savings of the poor—met theirs, as had their Victorian predecessors a century earlier. But just as the Oriental Bank had faltered early, in 1884, so the Trustees Executors and Agency Company Limited, Templeton's innovatory structure of 1878, long thought extremely conservative in its policies, was led by a sudden rush of unwise investment into insolvency in 1983; at a Bequests' Committee meeting in May, Sir Thomas Webb was present only by invitation, being no longer a director of what had become the Trustees Executors and Agency Company Limited (Receivers and Managers Appointed). Despite the Company's optimistic Victorian motto—'I go on for ever'—its problems proved terminal, and the Company was placed in liquidation on 29 July. By November an act of parliament allowed the ANZ Executors and Trustee Company Limited, a subsidiary created by the ANZ Bank, to take over the business, the trust funds remaining intact.

The collapse caused a considerable stir, but despite the drama the Bequests' Committee distributed $187 310 from the charity fund in May, and a further $245 052 in November; among the recipients of large grants were the Italian community organisation CO.-AS.-IT. ($10 000 towards the purchase of a bus) and among the smaller, old-timers such as CWS and the Travellers' Aid Society, Felton's own priorities still lingering. Max Mainprize briefly took the place Sir Thomas Webb vacated on the Bequests' Committee, and after him, for a year, AG Kilpatrick, a Director of the ANZ Bank, before David CL Gibbs, one-time Chairman of Gibbs, Bright and Co, and now a Director of the ANZ Banking Group, began a long term of service in November 1984. Vincent Kiss became National Manager Charitable Trusts, ANZ Trustees, and manage them he did.[35]

[35] Ibid., 19 May, 19 June and 18 November 1983. In May 1984 members of the Committee had called on Sir William Vines, Chairman of the ANZ Bank, to argue for the appointment to the Committee of a non-executive rather than an executive director.

In April 1984 the Committee recorded that it had lunched with Sir James Gobbo to discuss needs in ethnic communities, especially among the aged.[36] The November meeting (David Gibbs' first) reported another lunch, with Professor Carrick Chambers, Professor of Botany at the University of Melbourne, an expert in heritage matters, and the Presidents of the Country Womens Association and of the Free Kindergarten Union, to discuss the National Trust's restoration of 'Ripponlea', issues of conservation, and the importance of voluntary work in all these activities. The Committee decided as a matter of policy to give priority to grants which supported voluntary work. It also decided to make larger grants (other than seed grants); to support projects, and to fund running costs only in exceptional circumstances; and to encourage proposals to help older people to be productive and use their knowledge (a priority much needed when businesses were busily shedding older workers, part of a process euphemistically called downsizing, paradoxically deemed essential for growth).[37]

1985 saw the Sesquicentenary of European settlement in Victoria, prompting celebrations very different from those marking the Centenary in 1935. Then it had been the art fund, not the charitable, which was asked to contribute; now the Committee agreed to make the largest charitable grant in its history to a project brought before it by Father Kiss. $132 731, of an available $155 000, was given to the Victorian Association for the Care and Resettlement of Offenders, to develop a centre, to be called Alfred Felton House, near Pentridge Gaol in Coburg, 'for the use of women and children visiting prisoners, and for the recently released'. 'The centre', the Secretary minuted, 'is a focal point for families visiting Pentridge who may require assistance with babies and young children, advice or information, or simply a place to rest and tidy up'. The only other grant made was to the Children's Hospital, $10 000 for a research project, at the discretion of the Board of Management; and the Committee agreed to two more lunches, one with representatives of Meals on Wheels (a notably voluntary organisation), and another with The Honourable Caroline Hogg, newly appointed Minister for Community Welfare Services in the Cain Labor Government. Philanthropy had become quite a convivial affair.[38]

The new broom in the charitable bequest did not sweep all the old favourites away. In November 1985, when $220 000 was distributed (making $362 731 for the year) the Old Colonists received $3000 to develop new units, CWS $3000 to

[36] Its charitable distribution of $177 000 included $10 000 'to assist in establishing a Health Issues Centre', $5000 to the Open Family Foundation and a similar sum to the Ecumenical Migration Centre (FBC, 18 April 1984).

[37] FBC, 2 November 1984.

[38] Ibid., 18 April 1985.

refurbish an area for children and women, and the Society to Assist Persons of Education was also supported. Medical Research Grants, no less than $61 500 in total, were consolidated in a separate long list. It was also decided to reconsider policy after Father Kiss returned from the study tour he was about to undertake in the United States. The meeting was the last attended by Professor Sir Joseph Burke—he had been knighted in 1980—after twenty years on the Committee and nearly forty years involvement with the Gallery; he retired at the end of 1985, and Professor Carrick Chambers was chosen to succeed him.[39]

In February 1986 Father Kiss, newly returned from North America, reported to the Committee that the 'keyword' he had learned there was 'flexibility'. The Felton Bequest, having 'uncommitted' funds, enjoyed the great advantage of freedom of decision making. After some discussion, the Committee asked him to investigate a number of potential targets for funding: the rural crisis (and especially the role of women); women in prisons; the homeless (1987 being officially their year); and (an emerging concern) child abuse. Kiss was authorised to commit $5000 immediately to help the 'Women in Agriculture' self-help group, and it was noted that he was soon to visit the Mallee with the State Minister 'to obtain first hand information'. Meanwhile the Committee decided to consult the Right Reverend Peter Hollingworth, David Scott's successor as Executive Director of the Brotherhood of St Laurence (and later Governor-General), on the plight of the homeless.[40]

Two months later, in April 1986, the Minister, Caroline Hogg, together with the General Manager of her department, and representatives of two organisations, Women in Agriculture and the Isolated Mallee Farmers Association, attended a special meeting of the Committee on the Mallee crisis. Minister Hogg, obviously moved by the areas of misfortune Father Kiss had shown her, asked the Felton Bequests' Committee to provide immediate assistance, to allow the Government time to set its policies and procedures in motion. The Committee could not but be flattered and, after the visitors withdrew, agreed to grant $30 000 to the proposed Information and Resource Centre at Sea Lake, and $5000 to Women in Agriculture, and to provide a further $5000 if no government assistance was available by 1 July. The grants were to be under the 'fiscal auspice' of Mallee Family Care, and administered by the Mallee Crisis Committee.[41]

Professor Chambers' brief membership of the Bequests' Committee concluded early in 1987, when he accepted appointment as Director of Sydney's Botanic Gardens. In a neat rearrangement, largely engineered by the retired but still active

[39] Ibid., 13 November 1985, 14 January 1986.

[40] Ibid., 20 February 1986.

[41] Ibid., 20 and 24 April 1986.

Professor Sir Joseph Burke, Sir Andrew Grimwade was elected a continuing member of the Committee in Chambers' place, resigning as the representative of the Council of Trustees, which promptly elected to the Committee Professor Margaret Manion, Burke's successor in the *Herald* Chair of Fine Arts.[42] Burke was delighted to bring Grimwade within the 'apostolic succession', no longer dependent on being the Trustees' representative, and thought Manion's appointment to succeed him on the Committee 'just perfect'; 'it has made my year'. 'Lovely, lovely', he added, as so often to students in decades of lecturing. He took a less favourable view of other aspects of the Bequests; dissatisfied with the management of the successive trustee companies, he was also one of the very few who did not applaud the role played in the administration of philanthropy by Father Vincent Kiss.[43]

As National Manager, Charitable Trusts, Kiss continued to manage very actively indeed. In May 1986 The Bequests' Committee had held $258 000 in the charity fund, but distributed only $98 700, resolving to reserve funds to mark with a major grant the Bicentenary of European settlement, which Australia was to celebrate in 1988.[44] Although the real capital value of the Bequest, constrained by the requirements to invest in Authorised Trustee Investments and to spend income, was eroded by inflation in these years—and in consequence not as large as it should have been after four-fifths of a century—the high interest rates kept the Committee's income buoyant. After distributing $160 865 in November 1986 and $158 968 in May 1987, the charity fund held $485 000 by November, making possible some grand Bicentennial gestures. The Anglican Mission to Streets and Lanes was given $120 000 to purchase and furnish a foster care facility in Brunswick, to be called Alfred Felton House, the name to be given also to another house, similarly funded by the Bequest, specially adapted for use by young people disabled by multiple sclerosis. Thirty-eight smaller grants were made to charities, and five to medical research, in the Committee's largest-ever distribution, of $578 300.[45] In May 1988, $143 950 was granted to twenty-six applicants (including St Paul's Cathedral, towards the restoration of the organ), and in November a further distribution of $244 042 went to thirty-seven applicants.

[42] Ibid., 19 February 1987. Margaret Manion, IBVM, a graduate of Melbourne University and Bryn Mawr College, had been appointed a lecturer in Fine Arts in 1972. A Trustee since 1975 (and author in 1972 of a book on one of the Bequests' great acquisitions, *The Wharncliffe Hours*) she had been appointed to the Herald Chair in 1979. She was a Pro-Vice-Chancellor when appointed to the Committee in 1987.

[43] On 23 January 1987, in a telephone conversation with Sir Andrew Grimwade, Sir Joseph Burke objected to Kiss attending a special dinner to farewell the three recently departed members of the Committee—Chambers, Webb and Burke himself—and criticised his appointment by the Company as 'not morally wise'.

[44] FBC, 12 May 1986.

[45] Ibid., 19 February and 27 November 1987.

Early in 1989 the Committee decided to review again its guidelines concerning grants, agreeing that it wanted an express statement of Felton's will, and 'a stronger expression of the creative and/or provocative agent of change that the Felton Bequests try to achieve'. A grant should act 'as a catalyst both in the Community and Government', a central tenet of the new philanthropism. The continuance of support for medical research was debated, revealing opinions 'some in favour, some with reservations'; it was agreed that such grants should continue, but only for clinical research concerning women and children. It was also agreed that, after twenty years, support might continue for the Felton Visiting Professor at the Children's Hospital, but only if the Hospital submitted a proposal of sufficiently high standard; and the proportion of funds given to medical research and the visitor each year should not exceed 10 per cent of the amount available. New kinds of projects were to be welcomed, including those involving joint funding with government or other agencies; and the Bequest should be proactive, identifying problems and finding an agency to tackle them with assistance from the Felton Bequest. All this involved more initiative, and more work for the secretariat, which was asked to list all the applications in alphabetical order and to recommend what grants should be made, a procedure welcomed by the very energetic Vincent Kiss, who handled all charity applications personally, while the experienced and utterly reliable JH Stephens looked after art matters and the general responsibilities of the Committee.[46]

The new emphases in grants were soon evident. In May 1989 the Committee included, among twenty-four grants totalling $255 998, a first payment of $50 000 in a promised $200 000 to the Royal Children's Hospital to establish a Care of Parent unit, and another $50 000 to a school-based Enterprise Organisation for students in secondary schools, a pilot programme of the Good Neighbour Council.[47] Alongside these large amounts, a great number of smaller grants proliferated, bewildering in variety. In 1990 (when the new Guidelines for grants were pasted in the Minute Book), the $287 554 allocated in May and the $385 668 distributed in December included major grants to the Children's Hospital, the Alcohol and Drug Foundation, the Arthritis Foundation (to support Victoria's first chair in Rheumatology), and to the State Library of Victoria (for a project officer developing a reading machine converting text to speech for those with impaired sight). Grants below $10 000 were approved to support a guide to Entertainment Venues for the Disabled, Junior Red Cross posters, equipment for a Hospice, renovations to

[46] Ibid., 3 March 1989.

[47] Ibid., 19 May 1989.

the Ballarat Childrens Home and Family Service, production costs of the Polyglot Puppet Theatre, the Broadmeadows Family Services camp program, a video camera for CARA (Christian Alternative Reception Remand Accommodation), a Theatre for the Deaf, the Loddon-Campaspe Leisure Buddies Program, a caravan for the Wimmera Hearing Aid Society, computers for Work Link and to assist St Luke's Family Care in Bendigo to set up a centre in Castlemaine. Other minor grants approved included assistance to the St John's Ambulance programme of inoculation against Hepatitis B, to the Smith Family, Collingwood, for 'the education of children of disadvantaged parents', to Gordon House, for furniture, and to the Christian Brothers Foundation for Charitable Works at Parkville, for fire alarms. The largest in a separate list of medical research grants was $20 000, for work on bone marrow at the Royal Melbourne Hospital.[48]

The programme was vigorous and comprehensive, but in charitable matters the Felton Bequests' Committee was achieving both more and less than its members were aware of in these years. The Minute Book of the Committee between 1985 and 1990 contains several pages stamped 'Copy: original with police', their removal arising from the arrest, on 7 December 1990, of Vincent Kiss, on twenty-three charges of theft from charitable trusts, involving initially $748 000. The Committee's meeting in March 1991 was attended by the Acting Chief Manager Operations, ANZ Executors and Trustee Co Ltd, accompanied by solicitors. 'Committee members', the minutes noted, 'had already received correspondence from ANZ Trustees regarding the criminal charges brought against Father Vincent Kiss', and were now told that ANZ Trustees would 'indemnify Committee members against any loss that might arise'. At a subsequent meeting, in August, the Committee was told 'in some detail the alleged invalid transactions totalling $148 500 made as a result of the activities of Vincent Kiss in connection with the Felton Bequest', and that the sum had already 'been placed at the credit of the Charity Bequests Income Account by way of restitution'; in October a further $49 000 was restored to Felton funds 'by way of restitution for further alleged invalid transactions'.[49] In August 1993 Vincent Kiss pleaded guilty to diverting 1.8 million dollars from various trusts to a non-existent Vanuatu Development Project account, of which he was sole signatory and beneficiary, the judge referring to 'an orgy of spending', including purchase of a villa in the Philippines, intended for his retirement. Instead he spent six years in the Ararat gaol.[50] A minor seismic disturbance in St Kilda Cemetery, when Alfred Felton turned in his grave, went unrecorded.

[48] Ibid., 19 March 14 May and 13 November 1990.

[49] Ibid., 19 March, 27 August and 30 October 1991.

[50] The *Age* reported the arrest on 8 December 1990, and guilty pleas on 8 August 1993.

29

COMING TO TERMS

The opening in 1968 of the grand new National Gallery in St Kilda Road amounted almost to a re-founding of the institution, for the first time self-contained in a building all its own. The original foundation, with the library and the museums, had been part of the great educational and moral enterprise undertaken by the intellectual and political leaders of the new colonial society, mixed though their high cultural motives might have been with baser notions of civil order and economic productivity. In the first decades of the twentieth century all four institutions were shamefully neglected by governments; they were all but forgotten, and their roles were seldom questioned, as they reached mid-century with fabric decayed and staff insufficient even to preserve the remarkable collections so rapidly acquired in their first years. Only gifts and benefactions allowed them to grow, and only the National Gallery had a resource as rich as Felton's Bequest, the benefits of which stand out even more starkly when the four institutions are compared. Promise of renewal had come after the war, but twenty-five years later only the Gallery had achieved it.

By the time the new Gallery opened, a cultural transformation was well advanced in Australia. One indication was official acceptance of the avant-garde, proclaimed in The Field exhibition and echoed in almost all the arts, both fine and popular (to use a distinction still made at that time). Less obvious, but more important, was the extraordinary proliferation of cultural activities, of all kinds, in all sorts of places, at all sorts of standards, and drawn from all sorts of backgrounds as Australia became cosmopolitan again. A little later came recognition that the arts, broadly defined, had become industries, involving large numbers of people and significant resources. In these circumstances the conscious and assumed purposes of libraries, museums and galleries were to change very substantially during

the last thirty years of the century, but while their procedures were modified, their pasts could not easily be jettisoned, and their purposes were difficult to redefine.

After 1968 the Felton Bequests' Committee needed to re-establish its relationships with the new National Gallery, its Council of Trustees and its staff. The Bequests' importance to the Gallery, once overwhelming, was beginning to diminish; with the admission charge providing new revenue, the Gallery's own acquisition funds, which had met less than a quarter of purchases in the 1960s, funded nearly half the acquisitions after 1969. Nevertheless the Bequests' contribution was still very considerable, and the Committee—and its Chairman Sir Clive Fitts in particular—felt that the gallery was not co-operating as it should. Sir Owen Dixon, by scrapping the joint conferences, had ensured the Committee's continued independence, but as the Gallery's developing internal structure, of departments and committees, became more complex (and less efficient, its critics said), independence threatened to become isolation. Fitts tried to re-establish communication with a series of discussions and negotiations during the 1970s, most turning on the role of London Adviser, whose discretionary authority was resented within the Gallery but staunchly championed by Fitts. The physician, having diagnosed the ailments, prescribed his remedies bluntly, though without shedding his bedside politeness.

Dr Woodall, while in Melbourne in 1968, had discussed with several curators the Gallery's needs as they saw them. Reporting her conclusions to the Bequests' Committee, the Adviser confessed herself out of her depth with the Japanese material sought by the staff, but would seek help; and she was hampered in other fields by Melbourne having no catalogues for collections other than paintings and prints and drawings. She had also discussed the special problem of modern art with Norman Reid, Director of the Tate, who had visited Melbourne for the opening of the new Gallery and had, inaudibly and unenthusiastically, opened The Field exhibition. In Reid's view, £30 000 would suffice to buy 'a reasonably representative collection of the art of the last few years', enough to 'make a real impact and include all the main trends'. On his claim that the only important younger artists were American or British—he offered a list of nine British and six Americans—Woodall warned the Committee of her 'impression' that 'the Melbourne staff rather discounted the British contribution and felt that American painting could be bought better in New York'.[1] She reported acquiring five Picasso prints for £4936, a Louis XVI *bureau-plat* for £8775, and two Chinese pieces, and later a Chinese bronze for £6500 and an Apulian volute-Krater for

[1] FBC, 1 March 1969.

US$5000. She had also bid £30 000 for an East Anglian Psalter, which unfortunately fetched £33 000. The Committee itself recorded bidding unsuccessfully for Conder's *Box Hill*, which fetched $32 000 at Joel's. Later in 1969 Woodall found Bernini's *Countess Matilda of Tuscany* for £9000, and she and Hoff were authorised to spend £8000 on prints while Hoff was in London. (The nine they acquired included Tiepolo's *Philosopher watching a head on a pyre* (£617), Jacopo Barbari's *Sacrifice to Priapus* (£1520) and Campagnola's *Christ and the woman of Samaria* (the dearest, at £2850). In November the first meeting of the Committee attended by Professor Nossal approved a Khmer lintel and a necklace from Roman Egypt, later found to be modern. Acquisitions were still eclectic, though paintings were few and far between.[2]

The Committee reappointed Woodall for a year, but asked her to nominate a possible successor. She had no one to suggest immediately, and her annual re-appointments continued until 1974. The old tensions between Adviser, Gallery and Committee re-emerged when the Trustees rejected glass, furniture and a Léger drawing (£1500) which Woodall had recommended, while the Committee pointedly repeated their requests for assessments of Felton purchases from the Director and staff. When Woodall asked why the furniture and the Léger were rejected, Fitts replied that the Committee (and, he said, the Curators) regretted 'this miscarriage of judgement'. The immediate cause was a Trustee—unnamed—with 'amateurish objections', but Fitts was 'very concerned over the future', recommending that the Adviser send, as a matter of course, supporting opinions and better photographs of works recommended; 'the fire may be more effective if both barrels are loaded'.[3]

Dr Woodall had little difficulty co-operating with some curators. After buying prints with Dr Hoff, she was allocated $10 000 to spend on Majolica in collaboration with the very able Kenneth Hood, Curator of Decorative Arts since 1965.[4] She touched a nerve, however, when she suggested that she be given £20 000 a year for five years to spend on contemporary art with an adviser from the Tate, although she gave an assurance that she would also 'work with' the Gallery staff.[5] The Committee deferred action until a meeting with the Gallery's Acquisition

[2] Ibid., 1 March, 24 May and 29 November 1969. The Gallery later acquired Conder's *Box Hill* with the Jack Manton Collection.

[3] Fitts to Woodall, 11 December 1969.

[4] Kenneth Hood (1928–2002) had been appointed Assistant Curator in 1961, after training as a printmaker and painter at RMIT—he won the Crouch Prize in 1963—and reorganised and expanded his department after study overseas on a Churchill Fellowship in 1967. He was appointed Senior Curator in 1971, and Deputy Director in 1976. Terence Lane published his obituary in *Gallery*, October–December 2002, pp. 21–2.

[5] FBC, 23 May 1970. The meeting approved purchase of a set of Bonnard lithographs.

Committee, on this occasion Seddon, Ritchie, Westbrook, Thomson and Hoff. After 'considerable deliberation', the proposal was not approved: £20 000 was too large a proportion of annual funds to earmark. But the group agreed to double her annual discretionary fund of £5000, provided she accepted the Gallery's list of artists preferred, for filling gaps. (The Director also asked that she be urged to attend the annual sale at Berne by Klipstein and Kornfield; Woodall replied that she would be happy to go to the continent, 'but with the very small sums available to spend I feel it is better to remain with the Dealers here than to shop around too much. I do not believe in working with too many dealers even in London'.)[6]

To avoid the rift Fitts feared, the Bequests' Committee proposed partially reviving the regular conferences Sir Owen Dixon had abandoned in the 1950s. 'A sub-committee from the Acquisitions Committee will be the body with whom the Felton Committee will in future discuss purchases involving the Felton Bequest; it is intended that the two committees should meet over important matters rather than discuss them by letter.' It was also agreed—or said to be—that staff would approach London dealers only through Woodall, and that all communication with the Adviser would be co-ordinated by Hood.[7] Woodall, meanwhile, had at last recommended a painting, Carloni's *Hercules led by Knowledge to Immortality*, for £13 500, together with some silver, furniture, a Cambodian figure (£6000) and a Khmer torso ($A11 000). But she advised against bidding at Sotheby's for Magritte's *L'éloge de la dialectique* (*In praise of dialectics*), which the Trustees recommended buying at up to £20 000; when they persisted, the Committee approved the purchase, 'despite unfavourable expert opinion received from London, which the Trustees consider to be irrelevant to the Melbourne situation'. Woodall complied, and bought it for £16 500, but her lack of enthusiasm for this major modern painting upset some staff, and Fitts, in turn, immediately defended the London Adviser.[8]

Communication remained unsatisfactory. The proposed conferences seldom happened, and the Committee still complained that it received too little information or advice from the Gallery. That argument went back to late 1968, when the Committee had agreed to give one more annual grant of $2000 to the Gallery to buy Australian works, but in return had asked (following 'remarks' made by the Director, not recorded but apparently criticising Dr Woodall's acquisitions) for special reports from curators on works already purchased by the

[6] Ibid., 17 April 1971.

[7] Ibid.

[8] Ibid., 5 December 1970. Fitts drafted, but apparently did not send, a long letter to Seddon complaining that Gallery staff were ignoring proper lines of communication.

Adviser, and for indications of future requirements.[9] The Gallery failed to provide the information, though when Fitts asked again in May 1969 for periodic assessments of Felton purchases, he did receive four reports and submissions.[10] There the flow stopped, and throughout 1970 Fitts kept asking, and not receiving. In August 1971, 'to clear the air', he invited representatives of the Gallery (Trustees Gibson, Downing and Murdoch, with Westbrook Thomson and Hoff) to meet with the Bequests' Committee at the Melbourne Club; although the meeting was 'informal', full minutes were recorded.[11]

Fitts began with an apology. Having read Cox, Lindsay and Grimwade on the history of the Bequest, he conceded that in earlier days 'Felton Committeemen were uncertain of their responsibilities on the Art side; some perhaps overrated their knowledge of art and their artistic judgement and in their pride exercised authority for which they lacked the foundation'. But the Trustees were not blameless: he had recently spoken to one who had never met the Felton Committee and knew little about it. 'I left him wishing that nature had bequeathed him a charitable as well as an artistic side. I also wondered whether these two important bodies having a common interest should be so remote from each other'.[12]

In the affairs of a great gallery, he continued, everyone must be accountable. The Bequests' Committee's primary commitment was to Felton's will, and to meet it they needed independent advice. He defended the London Adviser, responsible to the Committee though available also to the staff; she should always be open to criticism, but it must be documented, not covert. Dr Woodall had been right to give her opinion on the Magritte; 'the Gallery must at times fight to make its point'. The Bequests' Committee also needed advice from the Gallery: where were the reports on the Adviser's acquisitions, last received in 1969? 'In this changing world the Felton Fund has a diminishing future', he concluded. 'What is to take its place?' What was happening to the entrance fee income? 'It would be helpful to my Committee to know the plans and policy of the Gallery Trustees in so far as they affect the Felton Bequest Committee.' And, incidentally, what had happened to the Caro sculpture, bought with Felton funds and no longer in the Gallery?

Discussion followed, opened robustly by Colonel Gibson asking bluntly what the Felton Bequests' Committee considered they were doing to carry out the

[9] Ibid., 30 November 1968.

[10] From Hoff, Hood, C Elwynn Dennis (Sculpture) and John Stringer (Exhibitions and Display).

[11] FBC, 19 August 1971.

[12] He added, surprisingly, that 'when Bernard Hall, a Director, had authority abroad on behalf of the Felton Bequests' committee his performance did not measure up to that of his predecessor Randall Davies'.

wishes and intentions of Alfred Felton? Fitts refused to be provoked: 'the answer is that they apply half of the income from the estate for the purchase of works of art, very much in keeping with the terms of the will'. They acted, he added, on information from the Trustees, the staff of the Gallery, the Adviser, and experts such as Trendall, thus neatly turning attention to the two contentious issues: Gallery resentments over the role of the London Adviser, and the Committee's complaints that the Gallery did not keep it properly informed. In defence of advisers, Burke stressed their role in seeking expert advice, urging curators to consult Woodall whenever overseas. Hoff, who always did, remarked that experts existed at different levels; while one might know what works would fit the Melbourne collection, concerning a particular work there might be only 'one man in the whole world' who knows its story, and 'the Adviser's job has frequently been to nose out such experts'.

Westbrook clearly disliked the Adviser's discretionary fund, alleging the 'complete unsuitability' for the Gallery of Larry Poons' *Cobone*, which Woodall was acquiring from Kasmin Ltd for £2107, and describing its faults in some detail. He was reminded that the discretionary fund had been allocated to her with the full agreement of the Trustees.[13] Thomson urged that the Adviser buy only the well-established among contemporary artists, paying more, and not try to pick future winners when they were still cheap. Nevertheless he thought an overseas adviser necessary, citing the chance purchases of two Bernini works (one by Felton, one Miller); 'it would have been sheer luck if both of them had turned up at a time when someone from Melbourne was paying a visit to London'. Cox said that in his experience, now long, a London Adviser was essential, but Westbrook, returning to the attack, argued that curators expert in their fields should have a greater say 'if not complete authority' in advising what was needed in their departments. Figures he gave of how few acquisitions were initiated by staff compared with the Adviser's recommendations startled Professor Downing, a new Trustee, into asking why the balance lay so heavily against the locals. Shortage of funds was 'the sole reason', Stephens interjected.[14]

[13] Later, when reviewing Hoff's *The Felton Bequest*, Westbrook took pains to stress important acquisitions which had been initiated within the Gallery, not by Advisers (*Age*, 25 June 1983).

[14] Professor Richard Downing, Ritchie Research Professor of Economics in the University of Melbourne since 1954 and the founder of its Institute of Applied Economic and Social Research, had been a Trustee since 1970. Active in cultural matters, he was also Chairman of the Australian Ballet School and a director of the Melbourne Theatre Company. Appointed Chairman of the ABC by the Whitlam Government, he died suddenly, aged 60, in 1975. Downing had great charm; when he was on leave in England in 1972, Woodall wrote to Fitts (9 May), 'I much enjoyed meeting Professor Downing, who took a furnished house near here for a few months. I was very indiscreet, he seemed so understanding'.

Although Dame Elisabeth Murdoch supported Fitts' plea for fuller information concerning staff reactions to Felton acquisitions, no one from the Gallery offered to supply it. Fitts was clearly unsatisfied, observing as he closed proceedings that nothing said had convinced him they did not need a London Adviser. He asked again for annual reports, and finally and pointedly for information on 'the fate of the Caro sculpture bought through Felton funds and subsequently removed from the Gallery and seemingly destroyed'. 'Perhaps the Gallery Trustees would advise the Felton Committee of their views.'

The meeting had little effect. In December Fitts still had no reply concerning the Caro, about which Woodall, 'very concerned', had alerted him in June 1971. The original sculpture, recommended by her in 1967, was no longer in the Gallery; she had heard that Caro had exchanged it, while Westbrook was away. 'I do not think Felton can tolerate this kind of thing', Woodall insisted.[15] Late in 1972 the Director at last explained: during a visit to Melbourne the sculptor had suggested exchanging the piece 'for one of his more important works'. The Curator had agreed, and 'the exchange was made', Westbrook admitted, 'without higher authority'. (On its return to the dealer, British customs ignominiously described it as 'a piece of iron, value £1'.) The Director accepted 'responsibility for the action taken by one of his staff', assuring the Committee that he had 'taken all possible steps to prevent a recurrence'.[16]

The requested reports did not arrive from the curators. In December 1971 the Committee resolved to write to the President of the Council of Trustees, proposing an exchange of information: in return for a list of all acquisitions other than Australian art, it would provide details of the funds it had available (though after approving Annibale Carracci's *The Holy Family* for £13 000, a terracotta sculpture for £8000, and a mirror for £6000, the Committee had little money left, which was perhaps the main reason why the Gallery and its staff were not as interested in the Bequest as in the past). Fitts' perception that all was not well within the Gallery's systems was strengthened by a strong letter from Trustee William Ritchie, reporting that the Acquisitions Committee was not working because curators knocked out each other's recommendations; to Burke, Fitts complained that the staff's failure to provide reports 'really amounts to neglect and it is so blatant as to give rise to the thought that it may be intentional'.[17]

Persisting, Fitts arranged another meeting in March 1972, with all the Committee present and, from the Gallery, the President (Seddon), Deputy-

[15] Woodall to FBC, letter 153, 4 June 1971.

[16] FBC, 18 November 1972.

[17] Ritchie to Fitts, 6 September 1971; Fitts to Burke, 21 February 1972 (Fitts papers).

President (Ritchie), Director Westbrook, Hoff (then Assistant Director) and thirteen members of the curatorial staff. 'If ever there was a time when Felton Trustees took it upon themselves to make artistic judgements they were ill-fitted to express then I believe it belongs to vanished time', Fitts told them.

> I plead with you to let us have not only reports but comments informed with the warmth of human feeling so that in years to come the historian will find that the records of the Felton Archive spring to life informed by the opinions of those who have the care of the accessions that come to the various departments of the Gallery.

After a brief reference to the reform of the charitable side of the Bequests—then much in his mind—Fitts called on Professor Burke, who gave an excellent but general address on the tendering and taking of advice before the meeting dispersed, without recorded discussion.

There were still no reports from the curators by the Committee's meeting in May 1972 (to which Woodall recommended a Titus clock for £7700, which had later to be sold to the Iveagh Bequest at Kenwood because an export permit was refused).[18] It was not until April 1973 that Hood reported that he was making a 'determined effort' to get reports from the curators, not least because they were also required by the Council of Trustees. Meanwhile, after consultation with Hoff, Woodall was given authority to spend at Sotheby's up to £20 000 on Rembrandt etchings and £6000 for a Barocci drawing (which fetched the full price; two Rembrandt etchings—*The Shell*, and *A Nude Man Seated before a Curtain*—cost £15 400); and in April her adverse comments caused the Committee to reject the Trustees' recommendation to buy Fontana's *Concetto Spaziale*. In August, at the first meeting attended by Andrew Grimwade as a member, they did approve Thomas Clark's *Wannon Falls*, for $10 000, having earlier (in 1969) hesitated before acquiring his *Coast near St Kilda*.[19]

IN THE LAST THIRD of the twentieth century the political climate in which public art galleries and comparable organisations operated in Australia changed as radically as the cultural context, governments at last recognising 'the arts' as a field in which it was expedient to have policies and to spend some money. Victoria, though traditionally parsimonious towards its public institutions, led the way among the states, mainly through the leadership of (Sir) Rupert ('Dick') Hamer, a Minister since 1962, who succeeded Sir Henry Bolte as Premier in 1972. Hamer was also

[18] Meeting, 9 March, and FBC, 13 May 1972. On the sale of the clock, see FBC, 18 August 1973; a fluctuating rate of exchange caused some problems. In 1972 Woodall had also bought a Picasso drawing, *Homme à la Guitare*.

[19] FBC, 18 November 1972, 28 April 1973 (which also heard that Woodall had bought David Bomberg's *Tor and Tay* for £2750) and 18 August 1973.

Treasurer, and after passing legislation establishing the first Ministry of the Arts in Australia he took the new portfolio as well. The Ministry's responsibilities were broadly stated: assessing the state of the arts, developing appreciation of them, increasing their availability and providing facilities for their practice. The Victorian Arts Centre (completed by 1982 with the opening of the State Theatre complex and of the Concert Hall), the State Library, the National Gallery and the Museums all came under the new Ministry, as did the Royal Exhibition Building, regional galleries and arts centres (increasing in number) and specialised institutions such as the Victorian Tapestry Workshop. The National Gallery thus gained direct access to a specialised Ministry, and was able to make submissions to it concerning both policy and funding, but although additional funds were allocated to the arts they had to be shared among an increasing number of recipient institutions.

In the arts, as in education and so much else, the Government of the Commonwealth began to rival and in some cases to eclipse the States, in influence and expenditure. The Australian National Gallery, approved for the national capital under Liberal governments in the 1960s—and not to open until 1982—was symbolically launched by a Labor government in 1973 with a purchase as controversial as it was sensational, Jackson Pollock's *Blue Poles*, for $1.1 million. (In 1960 McDonnell had remarked, in one of those over-optimistic predictions which punctuate the history of the Felton Bequest, that he 'would hesitate to spend £18 000 [a recent sale price] on a Jackson Pollock, however much I admired it. I think they will be cheaper later ...')[20] Even the Australian National Gallery, though publicly funded on a scale unmatched by any State, needed partnerships between government and private money to make major acquisitions, as the prices of works of art continued to increase. Not even the richest gallery in the world could now re-create the collection which Felton's Bequest had bought for Melbourne's National Gallery, since money could no longer buy the multitude of the world's art treasures which have gone out of the market into public collections, again as Rinder had foreseen. In 1981 the Paul Getty Museum joined with the Norton Simon Foundation to purchase Poussin's *Virgin and Child with St John and Angels* for £1 650 000; in 1948 the Felton Bequest had paid £14 000 for the same artist's *The Crossing of the Red Sea*.

If major contributions from government were now seen as essential to the arts, as they had long been to welfare (and were to become to sport), the Commonwealth initiatives establishing new 'flagship' institutions with 'national' status—developments usually attributed to the fertile mind of the great public

[20] 'and I think so realizing how important he has been to this generation of painters'. He did not recommend a water-colour then offered for £3500 (McDonnell to FBC, 30 November 1960).

servant 'Nugget' Coombs—were not necessarily helpful to the levels of cultural activity in those parts of the continent where flagships do not sail. The problem proved greater in the performing arts than the visual: travelling exhibitions had long been practicable and successful, but it rarely makes sense to move a major opera company around. Fortunately, other Commonwealth initiatives spread the benefits more broadly, forming part of an extraordinary proliferation of sources of funding for arts throughout Australia. Some trusts and foundations had long supported them, and the Australia Council, the state ministries, and from time to time other government and semi-government bodies all joined in the distribution of funds, under various programmes and policies, apparently generous in total though often meagre in particular. Arts organisations and individuals had to become as adept at grant-seeking as charities and researchers had always been, as grant-giving committees, and their satellite advisory committees, became almost innumerable. Applicants also multiplied, on the old Australian principle that the chooks gather where the scraps are thrown; some once-wild practitioners of the arts became thoroughly domesticated, and a number of individuals and organisations found themselves as grant-dependent as any pauper under the Old Poor Law. For arts bodies, as for charities, private business also became an important source of funding, though the arts found it difficult to compete for commercial sponsorship with sport, which in Australia had replaced religion as the opiate of the people, proving as profitable to its distributors as any other. Numbers attending, and what governments called 'access', became important criteria of worth in the arts, inevitably tempting museums and like institutions to emphasise entertainment above education, while debate concerning the remnant of their educative purposes often became political and shrill. For better or worse, 'culture' changed its meaning—or rather, lost one of its meanings, at the 'high' end—and since all tastes were now thought worthy, a latter-day Alfred Felton wishing to 'raise and improve public taste' would scarcely know how to begin.

ERIC WESTBROOK RESIGNED from the National Gallery in 1973 to become the first Director of the Victorian Ministry of the Arts. In that year also the Premier facilitated the creation of the Victorian College of the Arts, housed in the recently-vacated Police College in St Kilda Road, next to the National Gallery. The Gallery's Art School became one of the four foundation schools in the new College, which offered tertiary training in the visual arts, drama, dance and music. Although the Council of Trustees thus lost a responsibility it had exercised for more than a century, the new school remained until 1991 in the quarters which Grounds had designed for the old Art School behind the National Gallery.

Westbrook was succeeded as Director of the National Gallery in 1973 by Gordon Thomson, Deputy Director for twenty-one years and due to retire in 1975. When he was on leave Kenneth Hood stepped in as Acting Director in 1974–75, efficient and reliable, as he continued to be, as Deputy Director or Deputy Director Collections, from 1976 until 1992. The cultural changes sweeping around the Gallery could not leave the Bequests' Committee untouched, though both remained in the rearguard of the accelerating advance; and in September 1973 Sir Clive Fittts organised another general discussion with the Trustees and staff of the Gallery concerning the future role of the Bequest. Should Felton's money continue to be used to buy 'classic' works, or concentrate on the modern? William Ritchie favoured the classics, as did Hood. Dr Hoff—unusually loquacious: Fitts once chided her on her capacity to stay silent in five languages—did not like the distinction, wanting something of everything, and took the opportunity to propose that the Committee allocate a substantial sum to be spent in Europe by Woodall and Sonia Dean, the very able Curator of Prints and Drawings (and later Deputy Director), specifically at the annual auction of Kornfeld and Klipstein at Berne, 'a rich source of modern prints and old masters'. 'It is not frequent', Hoff added, that such a qualified officer [as Dean] is in Europe'; Thomson supported her, arguing that Switzerland and America were the best markets for contemporary art, which 'you can buy in England, but it is aimed at British taste'. He supported, however, continuing to seek classics: 'there is something about things traditional, regular and unbending'. The company was assured by Fitts that 'The Felton Committee leans to the classical tradition, but is not committed solely to it'. He praised the London Adviser, as was his custom, stressing her high standing in Europe. 'The Committee desires to place emphasis on scholarship', he announced, and would consider giving Ms Dean support in Europe, and might also bring out a scholar from there; Melbourne might not have lost the Titus clock, he claimed, if a scholarly report had been submitted. In December the Committee at last received reports from six curators and the Acting Director, and allocated $50 000 for Dean and Woodall to spend in Berne, where they spent only $11 323, buying the great Heckel *Brücke-Mappe* at a bargain price. (Visiting London dealers' rooms, with the formidable Woodall gesturing decisively with her shooting-stick, proved an unforgettable experience for the younger scholar, capped only by lunch with Agatha Christie.)[21]

Fitts, restless and discontented with existing relationships, arranged another policy discussion in February 1974, when it was decided (the Trustees having

[21] Meeting, 4 September 1973, FBC, 1 December 1973. Woodall did not tell Dean they had so much to spend.

agreed) to increase the Adviser's discretionary fund to £10 000, no longer restricted to contemporary art but to be spent within guidelines. Some members of the Bequests' Committee shared the Gallery staff's reservations concerning Woodall's capacity to assess contemporary art, but Fitts again defended her and did not care for a suggestion to appoint the young Patrick McCaughey as a second Adviser based in Australia; but that, and other general issues, including directing funds to the purchase of Australian art, were deferred because the Director had only two years to run.[22] In April 1974 the Committee held an amicable discussion with the Council of Trustees, and another in August with the staff. Thomson, present at both, sought no changes in policy; asked by Fitts whether the Committee should accumulate funds for a major purchase, the Director said he preferred the staff to be on a constant look-out for opportunities for lesser purchases. 'This of course, appears in the overall to be a rather fragmental approach, but in his opinion it is the best one.' Asked whether the Bequest should return to the field of Australian art, making a small annual allocation, he replied that funds in that field were no longer so great a problem, since the Commonwealth's Visual Arts Board subsidised some purchases dollar for dollar, and there were more private donors.[23]

Members of staff were more forthcoming in August, when the Committee met six Trustees, the Director (again), David Lawrance (Chief Conservator), and six curators.[24] Asked to state priorities, the curators suggested Chinese paintings and American art (which was mostly too dear, but should be given emphasis, a view Dame Elisabeth Murdoch supported). Professor Burke spoke commending buying at auction, now possible and most desirable, while Fitts, enthusiastically supported by Professor Nossal, urged emphasis on the Gallery's educational role. A new note was raised when Ms Jennifer Phipps, Curator of General and Ethnic Art, proposed 'a special area in the Gallery devoted entirely to Aboriginal Art'; the Gallery had not 'specialised in this area', but should do so.[25]

[22] Fitts, stressing the importance of close relations with the Gallery, cited the Minute of 1971 on the desirability of reviving 'conferences'. Grimwade reported that the new Director had agreed to give the general assessment of Felton purchases which the Committee had first asked for in 1968, but when nothing had been received by June the Committee gave up and decided to seek only comments on works as they arrived (FBC, 1 December 1973 and 12 February 1974, 30 November and 8 June 1974).

[23] FBC, 15 April 1974. Present were the Committee, plus Seddon, Murdoch, Hoff, Hood, Brian Stonier, Austin, Baillieu Myer, and the Director and Acting Deputy Director.

[24] Brian Finemore (Australian Art), Annette Dixon (European and American Art after 1800), Terence Lane and Irene Zdanowicz (Decorative Arts), Mae Anna Pang (Asian Art) and Jennifer Phipps (General and Ethnic Art). The Conservator stressed the need for careful reports on the condition of works recommended.

[25] Meeting, 14 August 1974.

Woodall, soon to retire, was still busy. Approvals in June 1974 included a Degas monotype (£7000) and a Toulouse-Lautrec lithograph (*Le Jockey*) for £20 000, a Reni *Head* (£12 000) and—a major find—Annibale Carracci's octagonal *Pan* for £35 000. The Trustees rejected a Munch woodcut (US$88 000) and a Delacroix drawing (US$9400), while recommending a silver gilt cup ($12 000) which the Committee approved. In August the London Adviser arrived in Melbourne, where her tenure of office was celebrated with an exhibition of her acquisitions, while the Committee considered her successor.[26] Woodall told a meeting that the Bequest faced no serious problems, and at a dinner in her honour heard Fitts' punning observation that they were 'not damned by being poles apart from Jackson Pollock', but her 'thoughts', pasted in to the Minute Book in lieu of a final report, were much less complacent.[27] After reviewing the collections, she made a confession:

> I am not satisfied with my efforts in connection with Modern Art ... I have recommended that I should treat Modern Art like other subjects and buy what comes along as it seems important. Felton cannot afford to buy the established Masters of the American School, and I feel that I have not chosen very well amongst the second-line, buying, in the Gallery's opinion, bad examples. I would like in a cowardly way to leave my successor to work out a better "modus operandi" unless I come across something I consider very important.

'I was not impressed', she added, 'by the Gallery's own buying in this field'.

Woodall claimed that her relations with staff were good, but that most were too busy to do the scientific side of their work—'the girl in charge of the silver has to clean it herself'—and 'University graduates in Art History can of course get better paid posts in Universities than Museums'. She complained that she had not been given lists for Asian Art, only last-minute requests to bid for items. 'It is difficult that I am badly informed about Asian Art. There have been marvellous sales this summer.' The Adviser was sometimes simply a post office for staff requests,

> but I feel very strongly that he or she must also initiate acquisitions according to some plan, however fluid ... Until the Gallery has adequate funds of its own, Felton has an impossible task with its limited funds. In my view the Gallery should only apply to Felton for special things, not just for anything for which they cannot find the money themselves. The name Felton on a label should convey real quality, and historical importance,

so she had tried 'to concentrate on rather special and precious objects, which should acquire what one might call the Felton 'cachet'. She had not tried to fill

[26] FBC, 23 August 1974.

[27] Fitts' speech, on 15 September 1974, was included in full in the Minute Book. Woodall met the Committee on 23 August 1974, and her 'thoughts', dated 29 October 1974, were pasted in the Minutes for 30 November 1974.

gaps, but to strengthen strong points in the collection, and to set up parallels between paintings and prints, and (for example) shapes in china and glass. Acquisitions, she reiterated, depended on what was available and were therefore subject to guidelines, not specific policies.

Woodall thought the standard of display throughout the Gallery low, and the exhibition mounted in her honour 'very poorly presented'. She regretted that too many Felton purchases, especially in the excellent print collection, were not on show. 'It seems to me that those magnificent modern prints that Felton has just bought should have been shown at once quite as conspicuously as "Blue Poles"; they really are splendid and a milestone in the growth of the collection'. The physical condition of the collections was endangered by thick dust, which the air conditioning apparently could not remove, while the Conservation Department had not enough staff, and its techniques were 'not up to date'. Finally, it was good to see so many people in the Gallery, 'but are they being helped to use it to the best advantage? I do not know'. The Committee decided to send her report to the Trustees and to a new Director, when appointed.

Back in London, the Adviser made some last recommendations, the Committee approving a very rare Munch coloured woodcut *To the Forest* from Colnaghis for £34 000, a Renoir lithograph for £6500, six water-colours by Danila Vassilieff and a Chinese cup (£15 000), to be labelled 'to honour the work of Dr Leonard B Cox for the Felton Bequest and the National Gallery of Victoria'. As the year ended the Committee appointed Dr Hoff as Adviser, for five years, on a salary (£3500) 'in line with a Keeper of a London Gallery'. In April 1975, when Hoff was briefed and told that the Bequest had about A$180 000 to spend annually on art, the Committee approved Henry Gritten's *View of Hobart* (£12 500) and Trendall's recommendation to bid up to £10 000 for vases at Christie's, in the event buying only one for £1575. It also discussed in detail the funds available to the Gallery for acquisitions; Felton's bequest was still the largest regular source, though all agreed that additional benefactions should be sought. But when, in November, the Committee received Baillieu Myer's 'proposals for fund-raising to purchase masterpieces during Arts Victoria 1975', they gave it moral support but told him that on legal advice they could not merge the Art Bequest funds with others, even in so good a cause.[28]

THE DIRECTORSHIP WAS advertised in 1975, at a salary which Woodall observed was less than the top rate for a Curator at the Victoria and Albert. 'We really need someone exceptional to pull the place together', Fitts told her ruefully in

[28] FBC, 30 November 1974.

September, when an almost-consummated appointment unexpectedly fell through. In December the Trustees at last appointed Eric Rowlison, born in Connecticut in 1939 and a Graduate of New York University, who had been Registrar of Collections at the Art Gallery of New South Wales 1971–73, and Registrar at the Museum of Modern Art, New York, 1973–75; since he gave his recreation as the study of Oceanic primitive art, his tastes were clearly wide-ranging. A fortnight earlier, on 6 December, Sir Clive Fitts had resigned from the Bequests' Committee; and with the departure for a year in Geneva of Professor Nossal, his successor as Chairman, the Committee's membership was reduced to three. The rump remaining let rest the matter of communication with the Trustees, but the Committee's links with the Gallery were strengthened when Andrew Grimwade became President of the Council of Trustees in May 1976, beginning the longest tenure of the office in the twentieth century.[29]

Arrived in London, Hoff found the art market sadly lacking in outstanding works, and prices unreasonably high.[30] She acquired many good prints and etchings, including in December 1975 a first edition of Goya's *Los Caprichos*, for some £24 000, and she also began to explore the field of Indian miniatures.[31] After the Committee approved some expensive recommendations from the Trustees ($50 000 for the Fitzgerald Collection of Chinese material, and a bronze Goddess Kali for £15 096), its funds were reduced to only $10 100. When Sir John Pope-Hennessey drew Dr Hoff's attention to a major work at Agnew's, Sassetta's predella panel depicting *The Burning of a Heretic*, the Gallery had to seek funds from the Government and from private donors rather than the Bequest to acquire this remarkable work. The process was complex, convincing the President and others of the need for a mechanism for the purpose.

The idea of the Art Foundation of Victoria—described by one of its founders as 'the Felton Bequest for the twenty-first century'—was first mooted among the Trustees in 1975. Amendments to Australia's taxation rules were creating more attractive terms for art benefactions, and an opportunity at last emerged to marshal private funds in support of the Gallery on the scale Rinder had called for in the 1920s. In September 1976 Andrew Grimwade, Hugh Morgan (a Trustee of

[29] Grimwade had been Deputy President since February 1975. Discussing purchasing policy in June, the Committee decided to offer no advice to the Council, after noting that the new Director had asked Kenneth Hood to co-ordinate communication with the Adviser. The Minute added that the Bequests' Committee considered the Gallery staff competent in the Australian field, and that two Trustees, Richard Austin and Hugh Morgan, had 'frequent contact with the Asian market'. On important issues, 'the Felton Committee should make the approach when the occasion warrants it'. The matter was to be reconsidered in twelve months (FBC, 19 June 1976).

[30] She later delivered a lecture in Melbourne on the London Art Scene, which was published with a grant from the Committee (FBC, 5 December 1977).

[31] FBC, 6 December 1975.

the Gallery 1975–83) and Eric Westbrook approached Premier Hamer, who, characteristically sympathetic, pledged dollar for dollar up to $2.5 million over five years, and became the Foundation's Patron, launching a limited appeal in December 1976. The Gallery's first acquisition through the Foundation, Renoir's *The Guitar Player* (1896), nevertheless required some last-minute underwriting before its unveiling by the Queen in March 1977, but Melbourne had its Renoir at last. By June 1977 some $2.8 million had been committed to the Foundation, and the scheme was launched to a wider public, with Sir Lindesey Clark as President, Hugh Morgan Chairman and Andrew Grimwade Deputy Chairman, netting another million by June 1978. Over the following decades the Foundation provided the Gallery with an impressive range of major works, funded by corporations or individual benefactors, including (in 1984) Picasso's *Weeping Woman,* and later a whole collection in a new field, Pre-Colombian art. The Foundation also commissioned Australian works and funded publications, and its creation reduced the burden of acquisition funding falling on the Bequest to between a quarter and a third of the Gallery's purchases.[32]

IN JUNE 1976 the Bequests' Committee, comprising only Burke, Webb and Grimwade, increased Hoff's discretionary allowance to A$20 000, but asked her to buy 'fewer items of greater importance rather than attempting to spread the buying over a wider field'. Her next list of purchases was again long, but included modern prints and was accompanied by a recommendation to buy a Boecklin oil, *In the Springtime,* for £25 650.[33] In 1977 the Bequests' Committee did not meet until June, when it approved a Picasso etching and an oil, *A Mediterranean Port Scene*, painted in 1652 by Jan Baptist Weenix. Dr Hoff was herself present at a special meeting in August, when the Committee supported her pursuit of Indian paintings; she was discussing a major collection with Robert Skelton. Grimwade reported that because of commitments the new Foundation was unlikely to be a source of funds for two to three years.[34] The Committee itself kept making commitments—a Fragonard illustration for *Orlando Furioso* (US$22 000), a Hans Arp marble sculpture *Crown of Buds II* (accompanied by a gift of the original work in

[32] *Foundation, The First Decade of Collecting. The Art Foundation of Victoria*, NGV, 1988, describes and illustrates the establishment of the Foundation.

[33] FBC, 19 June and 11 December 1976. The Committee also decided in June to draft a questionnaire for curators to assess Felton acquisitions, but suspended the decision in December when the Adviser, predictably, objected. From May 1978 the Committee received the same reports from the curators which the Director received.

[34] FBC, 16 August 1977. Dr Hoff remarked that the Director had never mentioned to her any feelings that she was acquiring items of insufficient worth; and repeated her predecessor's complaint that curators were negotiating with dealers without telling her, and asking her to bid for items at short notice.

plaster) a Bell Krater (SF40 000) and more Indian miniatures—delaying the accumulation of a major sum, and was not in a position to respond immediately when Dr Hoff produced the most expensive recommendation of her time as Adviser, the purchase of a major collection of 274 paintings from Rajasthan on offer from the Boril Establishment in Geneva. Curator Emma Devapriam showed slides of the collection at a special meeting of the Committee in October 1978, with all six Trustees present and the Director and his Deputy. All shared her enthusiasm for this unique collection, one of the most important of its kind outside India, though Burke asked for another expert opinion on them. The price asked was US$300 000, and at another Committee meeting the same day (the first attended by Mrs Caroline Searby) the purchase was approved in principle, subject to another report. When received, it 'strongly' recommended purchase, observing that US$300 000 was 'by no means excessive' for such a rare collection, and the Committee formally agreed to buy it, over 'about' two years. In fact payment of US$200 000 (A$175 982) was made in January 1979, and the transaction completed by July; the Collection went to London, for restoration at the Victoria and Albert Museum, while a special text was commissioned for a publication issued when the paintings were exhibited in Melbourne, in September 1980.[35]

Dr Hoff had meanwhile acquired in London a Rauschenberg *Assemblage* and Hockney etchings. The Committee considered suspending her discretionary allowance until the Indian paintings had been paid for; when she expressed reluctance, they merely asked her to be very selective when purchasing.[36] In February 1980, when Sir Gustav called a special meeting to enhance communication with Gallery staff—this time at the Hall Institute in Parkville, not the Melbourne Club—the Adviser's work was praised. Rowlison declared that 'in general terms' 'the purchases made by the London Adviser from her discretionary funds had been excellent and fitted the requirements of the various Curators', but made the proviso usual in all staff discussions of London Advisers, that not everyone was satisfied with purchases 'in the area of Contemporary Painting and Sculpture'. Curators were asked to bring up to date their lists for the Adviser; as the meeting closed, the Minutes noted, 'it was apparent that those attending appreciated the opportunity for discussion'.[37]

There were, as usual, many demands on Felton funds. The Committee put aside $300 000 because Trendall wanted all or part of the Northampton Collection of

[35] Meeting with Trustees and FBC, 12 October 1978; FBC, 24 November 1978, 15 June 1979; Topsfield, *Paintings From Rajasthan in the National Gallery of Victoria: a Collection acquired through the Felton Bequests' Committee*.

[36] FBC, 24 November 1978. At this meeting the Committee received reports from curators, and details of a proposed reorganisation.

[37] Meeting, 13 February 1980, attended by Rowlison, Hood, Dean, Mae Pang, Lane, Zdanowicz; Nossal, Webb, Burke, Grimwade and Stephens.

vases from Castle Ashby, up for auction at Christies in July 1980, though in the event the Adviser was successful with only three bids, costing £35 200 in total. In May she had herself recommended a Jasper Johns lithograph *Periscope II* for £2250. In discussion with the Adviser, in Melbourne in September 1980 for the exhibition of the Rajasthan paintings, the Committee agreed that emphasis in acquisitions should shift from the decorative arts to American water-colours and prints, while the Committee kept a floating fund of $200 000 to acquire more Indian works, though only if excellent.[38] As so often in Felton affairs, opportunity soon subverted intention; the Indian floating fund was suspended when Claude Lorrain's remarkable drawing *A Wooded Landscape* became available for US$200 000 ($173 300). After Professor Burke questioned whether it was worth the money, and another member whether the public would often see it, the Committee asked Sonia Dean to attend a meeting in April 1981 to confirm the judgement of the Trustees and of the London Adviser that it was indeed a masterpiece, which she did decisively. Purchase was finally approved in June, when Dr Hoff also reported that she had bought Picasso etchings, and recommended Goya's *Los Proverbios*, eighteen earthy plates in a folio, for US$43 500. Her appointment was extended until April 1983; and she agreed to write, for the Gallery to publish, a short account of the Felton Bequest, a task for which she was uniquely equipped.[39]

Late in 1979 Young and Jackson's Hotel was sold, and the possibility that its most famous resident might also be on the market excited interest at the National Gallery. Andrew Grimwade told a representative of the vendors that the National Gallery 'would be enthusiastic' to get the picture, depending on price and timing, but before *Chloe* could be valued—a price above $100 000 was rumoured—and the matter put to the Felton Committee, the hotel's purchasers insisted on her inclusion in the sale, apparently thinking that without her Young and Jackson's was just another pub. Had *Chloe* been acquired, it is unlikely that she would have replaced Bunny's *Dame Nellie Melba*—acquired by the Foundation with the support of the generous Henry Krongold—as the picture the Queen unveiled during the Royal visit to the Gallery in May 1980.

SINCE HIS APPOINTMENT in 1976, the President had been very busy mustering support for the National Gallery from government and private sources, through the Foundation and in other ways; and he was also keen to strengthen its organisation. The existing structure pleased neither those who worked within it nor those, like the Bequests' Committee, who had to deal with it, and the Premier concurred in

[38] FBC, 11 September 1980. Dr Hoff also reported that the curators were giving her better information, though still too often communicating directly with dealers.

[39] FBC, 30 April, 15 June and 25 November 1981.

the appointment of an external consultant to carry out a Management Review, while discussion with the Public Service Board and other authorities began. By mid-1980, when the long process was almost complete, changes were looming at the Ministry of Arts also, where Eric Westbrook, concluding a distinguished career in both Gallery and the Ministry, retired in September. In the outcome, Eric Rowlison moved sideways, retiring at the end of September to become Assistant Director, Special Projects, in the Ministry. Ronald Nolan then acted as Director of the Gallery, while Sir Andrew Grimwade—he was knighted that year—and his Council searched for Rowlison's successor. The Premier agreed that the salary could be raised, to a level above that of a professor.

In April 1981 the Bequests' Committee learned formally what it already knew, that Patrick McCaughey, Professor of Visual Arts at Monash University since 1974, was to become Director of the National Gallery from December 1981. The first of Sir Joseph Burke's former students at the University of Melbourne to hold the post, McCaughey was still only thirty-eight. His postgraduate studies in the United States had brought him under North American influences, and as art critic and teacher he had championed their cause, and that of Australian artists similarly influenced. Some academic colleagues thought him more publicist than scholar, and as a critic he had occasionally trodden on important toes, but no one denied his brilliance.[40] In November the Bequests' Committee invited him to attend its next meeting, in March 1982, for which Professor Burke prepared 'Notes for Discussion with the Director' (and, by coincidence, Vincent Kiss his policy paper on the charitable bequest).

As expected, Professor McCaughey came to his post with definite views, clearly articulated. Given a copy of Professor Burke's 'Notes', he promised to respond to them, and told the Committee that the Felton Bequest should continue to strive for excellence: 'in his opinion, Felton purchases should be 'of a style which are able to be upon display at all times'. After discussion, the Committee, which had $82 000 in the Art Fund, decided to accumulate $500 000 for a European Old Master, by saving all its income except the Adviser's $20 000 discretionary fund.[41]

Before its next meeting the Committee received a persuasive document from the Director. 'I trust I am addressing only the Felton Bequests' Committee',

[40] Born in 1943, son of the Revd Professor JD McCaughey, later Master of Ormond College (and later still Governor of Victoria), Patrick McCaughey became, after graduating from the University of Melbourne, art critic for the *Age* (1966–74) and a Teaching Fellow at Monash (1967–69.) He then held a Harkness Fellowship at the Museum of Modern Art, New York, returning to become University Fellow in Fine Arts at the University of Melbourne before appointment to the Monash Chair in 1974. He was a member of the Visual Arts Board of the Australia Council 1973–74 and of the Council of the Australian National Gallery from 1976.

[41] FBC, 15 March 1982.

McCaughey began, 'and can, therefore, speak in confidence to them alone'. It was 'indisputable' that 'the Felton Bequest had made the NGV what it is today', but its role had changed in ten years from providing 45 to 50 per cent of acquisitions to about 25 to 30 per cent after the creation of the Foundation, 'the Felton bequest for the twenty-first century'. But if the Felton Bequest had 'diminished responsibilities', it 'should regard that as a liberating situation' the burden of buying across the entire collection now being shared. Since it could in any case no longer buy 'across the board' even over a five-year period, how should it now 'raise or improve public taste'?[42]

McCaughey was concerned that the Gallery was not buying enough 'museum-wide' works, as the Australian National Gallery was: 'The sense that the action has somehow moved to the Australian National Gallery in Canberra and left the National Gallery of Victoria behind might be unfair but it is pervasive'. The Melbourne gallery had dissipated its funds over all its many departments; in future regular allocations would only be made to departments which 'collected actively in the contemporary area': Contemporary Australian Art, Decorative Arts, Costumes and Textiles, Prints and Drawings, Photography, European and American Art Post-1800, who would share $127 000 a year between them. (He was later to include Aboriginal Art among his priorities.) The rest of the Gallery's funds would be kept for 'Museum-wide Acquisitions', works of such importance that they would always be on display. All departments could submit requests for such funds, which in 1982 had so far been used to acquire works by Rothko and Tucker, and a Jalisco grave group. The Felton Bequest should likewise buy only 'star pieces'. Purchases would be fewer, but each must count, since 'the great challenge to the Gallery and the Felton Bequest in the 1980s is to match what earlier generations achieved'.

The Director then made specific suggestions. The Bequest should not buy Australian works, since the NGV was one of only three Australian galleries actively buying abroad. In recent times it had bought Greek vases, European Old Masters paintings and drawings, and the Indian (Rajasthan) collection. it should now specialise, he believed, in European prints and drawings. 'The Prints and Drawings Department of the National Gallery of Victoria is a Wundwerkammer, our lode of endless surprise and marvel', with many strong groups to be supplemented, which the younger Australian National Gallery lacked. The Decorative Arts could also be strengthened, but Classical Antiquities had become too expensive. (Trendall had showed him a work which fetched $300 000; 'why go on when one cannot match the finest quality obtaining in the collection?') And

[42] McCaughey to FBC, 13 July 1982.

although the Gallery had entered the field of Indian Art late, it could develop its collection further. 'It would surely meet with Alfred Felton's profoundest wishes', he claimed (with no supporting evidence), 'that one aspect of the arts of Asia was regarded as important in raising and improving public taste'.

McCaughey then raised the issue of the Felton Adviser. It was anomalous to pay someone a salary to buy two or three works a year, unless he or she could also work as 'a general ambassador for the NGV', with (as Burke had suggested) a special relationship with the Director. 'I should like to see', he added with the intolerance of youth, 'a Felton Adviser who is on the way up rather than their way out'. Any adviser on Modern Art should be in New York, and the allowance of $20 000 to buy contemporary works in London should be stopped at once, since recent purchases (other than prints and drawings) had in his view not been of gallery standard. The Gallery had bought its Rothko at auction in New York: 'all it requires is speed, decisiveness, a reliable view and check on the work in the sale room and the use of a telephone'. The Director was in every sense a modern man.

The Committee found McCaughey's arguments convincing, and at a meeting in July, in his presence, affirmed its commitment to 'museum-wide acquisitions'. The Director narrowed his proposed fields for acquisition to Old Master drawings, the Decorative Arts (but 'only the finest, most representative examples'), and Indian Art, but relented on Classical Art, agreeing to use Trendall's expertise to build the Felton Vase collection. Dr Hoff had resigned, from the end of April 1983, having bought more Indian material, four Goya etchings to add to *Los Proverbios* and a Scottish water-colour by Eileen Lawrence ('presented by Ursula Hoff to the National Gallery through the Felton Bequest'). Her discretionary allowance was cancelled from December, and on McCaughey's advice the Committee deferred a replacement to consider instead the appointment of a number of experts or consultants on moderate retainers.[43]

One 'museum-wide acquisition' was in sight. In November 1982 the Committee, which had accumulated $415 000, approved the expenditure of $427 017 (US$438 750) on Boucher's *The Enjoyable Lesson*. In what Dr Hoff was to describe as 'a remarkable coup', the Gallery acquired simultaneously not only this exquisite painting but its companion, *The Mysterious Basket*, with funds from the Art Foundation of Victoria, the new benefaction co-operating with the old.[44]

Hoff returned to Melbourne in April 1983, to give an account of her stewardship, and to be thanked and praised, notably at a dinner in her honour. (The Bequest also purchased in 1985 a second portrait of her by John Brack, as strik-

[43] FBC, 26 July 1982.

[44] Ibid., 18 November 1982; Hoff, *The Felton Bequest*, p. 17.

Yes (please) Minister: Director Patrick McCaughey and Minister Race Mathews before the Bouchers, 1982 (National Gallery of Victoria)

ing as his first, drawn in 1954.)[45] At a meeting of the Committee in April 1983 Dr Hoff agreed that a full-time adviser was no longer necessary. She had already, in comments on Professor Burke's paper of 1982, remarked that 'the Felton Adviser tends now to be deprived of what hitherto had been his/her main function, namely to inaugurate purchases'; she herself had been mainly concerned with the 'second function', 'to seek out experts to provide second opinions on works under consideration', and she concluded that 'the Felton Committee might consider changing the nature of the Adviser from a Lord Clark 'man of taste' to a scholarly 'man behind the scenes'.[46] With easier communication, and major purchases only every two or three years, the Gallery staff could act without one, but the Committee itself needed outside advice, as Felton had foreseen,

[45] Ibid., 19 May 1983, 20 February 1986.

[46] 'Observations on Functions of the Felton Bequests' Committee', enclosed with Hoff to Stephens, 25 May 1982.

and could appoint (say) three on small retainers.[47] The Committee agreed that the Bequest must remain independent of the Gallery, and at a further meeting in May—the agenda overshadowed by the news that the Trustees and Executors Company was in receivership—three new advisers were chosen: John Ingamells, Director of the Wallace Collection; Gerard Vaughan, another of Burke's former students, then working under Francis Haskell in Oxford; and John Elderfield, a curator of the department of drawings at New York's Museum of Modern Art, 'a brilliant scholar of twentieth-century art'. Each was appointed for three years, on a retainer of £1500 (or US$2000), plus expenses. The three new advisers agreed that Radcliffe's should continue as the Bequests' agents.[48]

The Director soon had another 'museum-wide acquisition' in mind for the Bequests' Committee. At its meeting in November 1983, when the Art Fund stood at $270 000, McCaughey and Dr Hoff jointly recommended a Canaletto—genuine this time, and a great painting—*The Bacino of San Marco,* available at Agnew's, for US$700 000. The Committee could do no more than express interest, while the Director tried to persuade Agnews to reserve the picture; in December he reported not only that he had done so, but that it was on its way to Melbourne, without, he assured the Committee, any commitment falling on the Bequest.[49] By the beginning of 1985 the Bequests' Committee had accumulated $641 500, and on the motion of Grimwade, seconded by Burke, resolved to purchase the Canaletto when it had sufficient funds (and the Trustees had formally recommended the picture). The commitment was no sooner made than the Australian dollar was floated, and promptly sank, raising the local cost of the painting from A$720 000 to A$930 000. The resulting crisis required an unusual remedy: the Trustee company, unable to spend Felton capital, agreed to deposit $750 000 with the Government as a trustee investment, at 14 per cent interest, the Government lent the Gallery $1million to pay for the picture and pay the interest, and the Bequests' Committee was eventually able to pay the A$1 064 638 the picture cost in January 1986.[50] The Committee, inevitably, warned the Director that 'no more forward acquisitions by Felton will be considered', and did not resume purchases until November 1985, when on McCaughey's recommendation

[47] FBC, 6 April 1983. Asked whether under those circumstances the Bequest might lose dealers' first offers, Dr Hoff said not, since they were now made to Directors. Dr Hoff denied reports that art prices had fallen with the recession; since the supply was drying up, they had increased 'in most cases'. At a further meeting on 11 April Dr Hoff, and members of the Committee, produced many names (Burke proposing the editors of *Apollo* and *The Connoisseur,* and Hoff an officer of London's National Gallery and a director of Christie's).

[48] Ibid., 19 May 1983.

[49] Ibid., 8 November and 6 December 1983. Vaughan was present at the later meeting.

[50] Ibid., 27 January and 18 April 1985.

(supported by Ingamells and Vaughan) it approved *Ring Gymnast I*, a major work by the Swedish expressionist Eugene Jansson, for £65 000. In May 1987, when the Art Fund held $590 000, the Trustees recommended that £52 000 be spent on a Picasso drypoint on paper *Still Life with a Bottle of Marc,* and in November a fine Meissen plate, from the famous Swan series, was bought in Melbourne for £18 000 sterling.[51]

Patrick McCaughey's skills in public presentation had been tested in May 1984 when the evidence became so powerful that it was no longer possible to assert that the picture lauded by Davies, Holmes and Fry in 1933 as a Rembrandt *Self Portrait* had been painted by the master himself. In 1969 the Gallery had rebutted reports that it was a fake by producing X-ray evidence of its structure, provided by CSIRO, but the Amsterdam Rembrandt Research Project's conclusion, that it was a portrait of Rembrandt but not by him, was accepted by the Director as conclusive. He handled the subsequent press conference with so much panache ('great flair', in Grimwade's words) that the Gallery gained renewed prestige for possessing two genuine Rembrandts—also displayed—and much credit for its honesty in admitting a mistake about the third.[52]

John Ingamells had visited Melbourne in August 1984, when the Director of the Wallace Collection offered the Committee some frank advice. In a written report, he noted that the NGV collected over a wide field, comparable with the Victoria and Albert rather than London's National Gallery; although it would never be able to build up any field to be ideal—nor, in particular, acquire a major historical collection of European painting such as existed in the older European galleries—it should not miss opportunities to strengthen any field. Buying had to be pragmatic; the collection, weak before the seventeenth-century, also needed a major Baroque painting (preferably a Rubens) and a Hogarth painting. Buying within a modest historical scope, illustrated by the best examples, might mean that in the long run the display area need not increase, but that several of the pictures then hanging would be replaced. Ingamells also saw urgent needs in conservation, recommending that staff be sent to seminars at the Getty. He also suggested rearrangements: the Bratby triple self-portrait, the 'so-called' Rembrandt self portrait, and the head attributed to Barocci 'might be removed', and the Boccherini (a Miller acquisition of 1961) placed in a secondary gallery. 'The NGV gives the impression', he concluded, 'of a well-ordered and cherished collection, and it contains a considerable number of works of international quality. It is quite apparent

[51] Ibid., 13 November 1985, 14 January and 24 November 1986, 15 May and 27 November 1987.

[52] *Herald*, 15 September 1969. The picture remains remarkable; and there is now evidence that the canvas was a remnant from a roll in Rembrandt's workshop.

that it is being very well administered, and that it has a first-class Director. In these circumstances my comments are deferentially submitted'. In the meeting, he spoke more warmly: a 'picture man' himself, he had been 'staggered' at the breadth of the collection, ranging from Greek pots to the Indian paintings; at least twenty European works of the period 1500–1850 would have been 'taken by' London's National Gallery, and his recommendation to buy a major work only once in three to four years was really a compliment to the present collection (though it did need a Rubens and a Hogarth to 'raise the surrounding pictures').[53]

In 1985 Patrick McCaughey was appointed for a second five-year term as Director, but was also given leave to be a Visiting Professor at Harvard for the 1986–87 northern academic year. Before he left in September, the Gallery suffered a major embarrassment when self-proclaimed 'Australian Cultural Terrorists' stole ('kidnapped') the Picasso *Weeping Woman*; she was found unharmed in a railway-station locker fifteen days later, but the ensuing stocktake and improvements to security and record-keeping cost time and money, necessary though they were.

[53] FBC, 24 August 1984. The report is pasted in the Minute Book.

30

TOWARDS A CENTENARY

THE NEW WORLD of philanthropy was, fortunately, resilient enough to enable the Felton Bequests' Committee to surmount the crisis which befell it at the end of 1990. The ANZ Trustees appointed a new Manager, Charitable Trusts—Marion Webster, formerly Executive Director of the Australian Association of Philanthropy—who promptly reorganised grant-giving for medical research by developing, after consultation with the Chairman and with the Williamson and Buckland Foundations, a Medical Advisory Committee of representatives of all three Trusts to consider applications, each Trust having nominated an amount available for allocation.[1]

In August 1991 the new manager also produced a major report on the effects on rural society of the serious recession which ended the 1980s. She identified four areas of particular concern: rural youth unemployment; the consequences of deinstitutionalisation—as serious as the word is ugly—particularly in the area of mental health; the need for intensive family-based therapy, especially where families were very vulnerable; and problems consequent on ageing, especially among women. She committed the Charitable Trusts Department of the Company to pursuing these issues, including 'actively seeking some projects for funding'. Sir Andrew Grimwade hoped that they would bring forward two or three 'very innovative and new projects for funding' at every meeting of the Committee. The Committee itself had clearly moved from the merely responsive to the strategic mode of philanthropic thinking.[2]

[1] FBC, 27 August and 30 October 1991. It was also agreed to encourage public debate on medical research and technology, and on the social implications of ageing. After 1991 the preparation of policy papers and of recommendations for the Charitable Bequest was carried out by (in turn) Marion Webster, Elizabeth Cham, Sylvia Geddes, Sylvia Admans and Teresa Zolnierkiewicz.

[2] Ibid., 27 August 1991.

Restitution of the funds from the 'alleged invalid transactions' of the 1980s had given the Committee a larger amount than usual to distribute, some $403 420 in October 1991. They allocated $344 487 to thirty-four organisations, the largest amounts ($25 000 each) to the Chair of Rheumatology and to Travellers Aid, 'to revitalise the Society'. Unusual items in the list were a grant to the Gum-San Lead Museum Trust towards a museum on the Chinese and Gold, another to restore the oldest building in Cann River, and $15 000 to the Footscray Football Club 'to enable senior footballers to act as teacher aids in Primary Schools and act as role models and be a stimulus to education'. The Committee also decided that in principle it would not fund bursaries or scholarships, since they amounted 'to funding individuals', a decision it was later to amend.[3]

In March 1992 JH Stephens retired after twenty-four years of remarkable service to the Bequests' Committee, but was persuaded to continue part time to compile a list—invaluable for this book—of all the acquisitions the Bequest had presented to the National Gallery since 1904.[4] At the same meeting Committee member David Gibbs was congratulated on a speech which, it was noted, 'raised the broader issue of publishing a scholarly work on Felton and a more general work on the history of philanthropy'. The Committee liked the idea, as did several other trusts, and a special Publications Committee pursued it; but a major project proposed by the University of Melbourne and the Australian National University did not eventuate.[5] The Committee's present practice of philanthropy was meanwhile assisted by the appointment of Elizabeth Cham as a research officer (later Manager Research), seeking out and assessing suitable projects. In May 1992 she gave a paper 'on the modern interpretation of the Felton will', reminding the Committee of its freedom to apply Felton's own priorities in changed circumstances, and after discussion the Committee agreed to include 'older women' as a new priority. She also developed a number of headings under which applications and grants would be listed, initially comprising Communication and Information, Cultural Development and the Arts, Education and Training, Furniture and Equipment, Housing and Accommodation, and Personal Services, but later much extended. The list differed from the old categories of charitable institutions, which the Bequests' Committee had adapted from the Edward Wilson Trust in 1905, in being primarily a tool to analyse past performance as a

[3] Ibid., 30 October 1991.

[4] It does not include an uncountable number of items, such as coins and books, passed to the Museums or the Library when the Gallery moved to St Kilda Road in 1968.

[5] FBC, 19 March and 5 November 1992, 26 May and 27 August 1993.

basis for future philanthropic strategies. Most of the purposes now supported were modern, even if some of the organisations were old.[6]

The Bequests' Committee had a number of major projects under consideration, one of which, on 'the structure of Australian schooling', proposed by the Principal of the Methodist Ladies College, was given $150 000 over two years in November 1991. A year later the Committee gave the Medical Advisory Committee $50 000 to distribute, and $36 750 to the Queen Elizabeth Centre for mothers and babies for a study of post-natal depression, a project assessed by the Company's Charitable Trusts' Department a year later as a 'huge success'; 'savings to the public purse have already outstripped the original Felton Grant'.[7] In May 1993 the Committee committed $148 000 over three years to the Child Protection Society for a Child Sex Abuse Treatment programme, described as 'innovative and filling a gap', and supported another project on ageing. At a meeting of the Committee in August 1993, Frank McClelland, an Officer of the Department of Rural Affairs, spoke of the 'rural crisis in Victoria and the sense of disempowerment among the rural community', and the need to 'restore the rural sector's sense of vision and hope for the future, particularly by the provision of counselling and information services'. Having heard him, the Committee agreed to give priority for two or three years to measures to relieve rural communities throughout the State, with special emphasis on the long-term unemployed.[8] The Committee confirmed its earlier decision to reserve 10 per cent of income for the Medical Advisory Committee, but in November 1993 decided to fund a visiting Professor at the Children's Hospital only every second year. It also affirmed another tenet of modern philanthropism when it 'agreed in principle to work in partnership funding with other trusts, foundations, governments and local governments, on the proviso that the integrity of the Felton Bequest as a leader/innovator is not diminished'.[9]

The repercussions of the economically tumultuous 1980s were not yet over for the Felton Bequest. In May 1994 the Committee was told that the ANZ Trustees had become part of another entity, ANZ Funds Management, while remaining, as the Trustees Company Act of 1984 required, a separate company. Marion Webster moved to another post, Lorne Greville succeeding her as National Manager, Charitable Services. For some time the Committee had been

[6] Ibid., 7 March 1992. At this meeting Lorne Greville succeeded Stephens as Secretary.

[7] Ibid., 5 November 1992, 26 May and 4 November 1993.

[8] Given the urgent needs arising from the recession, they deferred Cham's longer-term proposals concerning the Centenary of the Felton Bequest.

[9] FBC, 27 August and 4 November 1993.

alarmed to find its income declining, as interest rates fell from the very high levels earned in the 1980s. In 1991 the Committee had distributed $523 600 in thirty-one charitable grants, $363 505 in 1992 and $373 525 in 1993, but in 1994 only twelve grants were made, totalling $112 000.[10] The fall in income also brought to notice the extent to which the capital base of trusts constrained to be held in Authorised Trustee Investments had been eroded by two decades of inflation, especially since the Trustees were obliged to spend all the income (of the Charity Bequest, at least) and precluded from reinvesting part to replenish real capital value. Restrictions were to be eased in 1995, when the so-called 'Prudent Person' legislation broadened Trustees' options—while at the same time increasing their responsibilities—but by then damage had been done. In May 1994 the Company's National Manager, Investments, spoke to the Bequests' Committee on the Company's investment philosophy, and the Minutes noted—rather too mildly—that 'some concern was expressed regarding the income earned, and the Committee queried whether the Trustee might vary the nature of the investments to provide a greater income return'. The issue rankled; in November, when the Committee asked for and received an investment report, it was accompanied by a firm reminder that under Felton's will the Trustee company had sole responsibility for investment policy. The Committee conceded the point, but remained concerned about both income and capital appreciation, especially as some trusts and foundations, especially those with wider powers of investment, had made spectacular growth. The Helen M Schutt Trust, founded in 1951 with a bequest of £350 000—with broad powers of investment and an unusual obligation on the Trustees to accumulate a large part of the income in its first decades—grew in fifty years to be worth $50 million. Felton's bequest reached half that sum in twice the time.[11]

The Bequests' support was certainly in demand. In 1992–93 some 155 applications were received, and forty funded, three receiving more than $40 000 and nineteen $10–25 000. Nearly half were for children, a quarter for women, and slightly more for disadvantaged families and individuals, while less than a fifth were rural and the rest urban. But in May 1994 existing commitments and reduced income allowed only one application to be approved, $7000 to employ an administrator for the Mallee Support and Development Group at Sea Lake; among the sixty-five

[10] Figures listed in a paper by Cham, reported to FBC, 20 February 1995.

[11] Sandilands, *Helen Macpherson Schutt*, p. 34. By 1972 the book value of the bequest had risen from £350 000 to $3 165 000. The Felton Bequests' growth over the century, from the equivalent of $800 000 to $25 million, was nevertheless substantially more than the increase of 16.4 times given by one Australian Bureau of Statistics index of increase in the cost of living. While the ANZ Trustee Company is the sole trustee for the Felton Bequest, it is a co-trustee with others for the Buckland, Viertel, Williamson and a number of other Trusts.

applicants disappointed were the Alfred Hospital, the Victorian Aboriginal Child Care Agency, and the Prostitutes Collective of Victoria Inc, while the application from the Society to Assist Persons of Education, seeking $5000 to 'supply small grants to disadvantaged students', was deferred. Nine grants, including the Society's, could be approved in November, when the largest allocated was $16 000 to the Emerald Club for Hope and Outreach Inc, 'helping young people in crisis to reshape their lives'.[12]

After receiving a further policy paper from Elizabeth Cham, the Committee decided in February 1995 that in future up to half its funds would be reserved for two or three projects of long duration focusing on rural children and women, projects likely to 'actually make a difference in the community'.[13] It asked that four rural target areas, medium-sized country towns, be identified as 'areas of need'; projects should involve volunteers, and be possible to replicate elsewhere. On another issue the Committee, concerned for the Bequests' reputation and standing, discussed granting naming rights, agreeing that it 'would not be seduced', but that something might prove appropriate towards the centenary. At its next meeting it did agree to lend its prestige as an old foundation to lobby government to ensure funding of worthy initiatives—another tenet of the new philanthropy—in this case the Queen Elizabeth Centre's Nurse Outreach programme. The Committee also selected two rural projects, giving $39 000 to the Anglican Church for child-care services in country Victoria, in a three-stage project, supervised by a broadly-based committee, and $22 000 to Catholic Social Services for its People Together Project, Community Audits in Moe and Mortlake, aimed at focusing attention on the future rather than on complaints of loss of rural infrastructure.[14]

In November 1995 the Committee was pleased to note that its income was increasing. Five applications were approved, amounting to $133 256, one deferred and seventeen declined; and the Committee was impressed by a report received from the Children's Protection Society, which indicated that large grants over three years could make a major impact.[15] But although the charitable fund held some $252 432 in November, the Committee was chastened when told at a meeting in February 1996 that, following amendments to the Trustee Companies Act, ANZ Trustees were to charge larger management fees, which had fallen

[12] FBC, 26 May and 16 November 1994. During the May meeting the Executive Officer and another member of the Child Protection Society spoke to the Committee on counselling victims of sexual abuse.

[13] Ibid., 20 February 1995.

[14] Ibid., 9 May 1995.

[15] Ibid., 13 November 1995.

with the decline in income. The new charges prompted some tense discussions between companies and commitees; although assured that the Company would improve services, including research capability, Felton Bequests' Committee members became increasingly concerned by rapid staff turnover, another characteristic of large businesses (and especially banks) in the last years of the century.

In 1996 the Bequests' Committee approved a major grant of $100 000 spread over two years to the excellent Jean Hailes Foundation, 'to improve the health of rural women'. Melbourne Grammar School (the school attended by so many of Felton's partners' descendants, which Bage had persuaded the old man to give £50 to in 1899) applied for $500 000 towards a new Hall for the Junior School; after some debate, it was given $250 000, to be paid over five years.[16] Lorne Greville, as Manager, Charitable Services, distributed another policy paper in August, but left the position before any changes were adopted (other than a decision to cease funding the Children's Hospital Lecturer altogether). By April 1997 a new team was in place, with Peter Bearsley the new General Manager, Charitable Trusts, and Sylvia Geddes Manager, Charitable Services.[17]

The Committee had lost the services of Elizabeth Cham, appointed in 1995 to be the first full-time Executive Director of the Australian Association of Philanthropy Australia. The Association, and philanthropy, were thriving. Foundations were proliferating, set up by companies, or initiated and funded in whole or part by governments (usually seeking to influence some public activity, such as the earlier Victorian Health Promotion Foundation, funded from taxes on unhealthy indulgences), while community foundations, each established in a particular area to facilitate private philanthropy—a modern-day adaptation of the Victorian trustee company—developed momentum.[18] Discussion of the principles which could or should govern philanthropy accelerated after October 1994, when the Industry Commission issued the draft report of the major Inquiry into Charitable Organisations, requested by the federal government in December 1993. The four hundred submissions received by the Inquiry included one from the Australian Council of Social Service, significantly entitled *Beyond Charity— The community services sector in Australia*, in which ACOSS stressed the extraordinary diversity of the groups which had in the past initiated community

[16] Ibid., 15 May, 19 August and 14 November 1996. The Committee also heard good reports of the beginnings of the National Parenting Project, managed by the National Association for the Prevention of Child Abuse and Neglect, for which it was providing $220 000 over two years.

[17] Ibid., 21 April and 6 November 1997, and 6 August 1998. In November Geddes suggested new procedures for dealing with grants, with two members of the Committee examining all applications; after a trial period, it was abandoned as impracticable.

[18] On these developments, see Leat and Lethlean, *Trusts and Foundations in Australia*.

organisations (including 'charities') in Australia, and argued to continue the 'mixed economy' of welfare provision, with governments supporting agencies which nevertheless retained their essential independence: 'the relationship by and large should be one of partnership'.

'Partnership' became a popular word in the field, the Industry Commission affirming its intention to 'to strengthen the contribution which the charitable sector makes to Australian society' by 'establishing a better partnership between the sector and governments'. ACOSS complained that it placed too much emphasis on making community organisations more efficient and accountable as agents of government, and too little on enhancing their capacity to work creatively outside government programmes, the problem the Crawfords had foreseen forty years before.[19] Certainly the major charities did become much more efficient businesses, increasing returns on their investments, reducing the costs of fund-raising, and in some cases receiving significant income from commercial ventures and fees for services. A study of the financial statements of 453 charitable organisations in 2002 nevertheless found that of their total income of $4.5 billion, governments contributed $2.05 billion.[20]

Discussion in these years also embraced the principles and practice of 'corporate philanthropy', again with emphasis on partnerships (of which the Youth Trainee Scheme conducted by the Brotherhood of St Laurence jointly with The Body Shop was a local example.)[21] Underlying these discussions were two increasingly common assumptions: that communities themselves needed to take responsibility for their own social amelioration, and that partnerships between governments and private and corporate philanthropy were the appropriate strategy to make action by community agencies effective.

The new doctrines found favour with latter-day governments. Philanthropy Australia, the new name the Association adopted in 1997, helped to persuade Prime Minister Howard to convene a Round Table to further co-operation between government, business, philanthropic organisations and community groups, and to include the encouragement of philanthropy among the policies of his government. Although Alfred Felton spent most of his life in partnerships, the man who never joined committees would have been puzzled to hear described

[19] Agencies needed freedom, and participation in the processes in policy making; in short, genuine partnerships. ACOSS also thought the Commission's recommendations to extend tax deductibility for donations too limited, though welcome, 'ACOSS Response to Industry Commission Inquiry into Charitable Organisations Draft Report', ACOSS Paper no. 69, 1995. *Beyond Charity* is summarised in an appendix.

[20] Survey by Givewell, reported in the *Age*, 7 November 2002.

[21] Elder and Meadows, *Getting Commercial About Being Charitable*, surveys such developments.

as a partnership the 'new social coalition' bringing together 'the unique skills of individuals, business, government and the community' which the Prime Minister welcomed in 1999. The Government was also persuaded to amend the Taxation Act to the benefit of charities, and of other organisations with 'Deductible Gift Recipient' status. One amendment allowed donors of property (including works of art) to gain full tax deductibility of the market value of the work, free of liability for tax on capital gain since its purchase, while another provision—very valuable to the Felton Bequest and others like it—allowed charities to benefit from the imputation credits from Australian share dividends, which as not-for-profit entities they could not otherwise utilise. In 2002, after an Inquiry into the Definition of Charities and Related Organisations had reviewed existing meanings of 'charitable in the legal sense', the Government extended the range of recognised charities to include self-help bodies with open and non-discriminatory membership and—a neat pairing—closed religious orders which prayed for the public good. Philanthropy, like charity before it, was never to be simple.

The amendment concerning imputation credits increased the charities' returns from shares by about 40 per cent, helping the Felton Bequest's income to grow from about $800 000 a year in 1998 to $1.3 million in 2002. This sum is significant, but the Bequest is not, in terms of modern philanthropy, a giant; by the beginning of the twenty-first century the Pratt, Myer and Ian Potter Foundations were each distributing more than $7 million annually, and the Felton Bequest ranked twenty-fourth among the twenty-five trusts known to be distributing more than a million dollars a year.[22]

As always with change, the new philanthropy brought forth doubters as well as enthusiasts. Some criticised, on the grounds of accountability and transparency in decision making, the Government's willingness to forgo revenue to allow others to spend on good causes what would otherwise have been public money; while many of those accustomed to exercising patronage in the older charities and trusts were reluctant to recognise that the funds they disbursed were no longer wholly private. A contrary complaint has already been noted, that newly detailed contracts and performance specifications restricted the independence, and could influence the attitudes, of the voluntary sector.[23] Others have thought that 'Venture Philanthropy' seemed to have borrowed more than the adjective from venture capitalism, as

[22] *Philanthropy Australia Factsheet*, 2002.

[23] Leat and Lethlean, *Trusts and Foundations in Australia*, pp. 12–13. David Scott asked rhetorically, 'will NGOs provide leadership for a social justice movement or have they become franchisees of government?' ('Where have all the activists gone?', *Eureka Street,* November 2002, pp. 36–7). In July 2003 it was objected that the Government's proposed redefinition of charity would disqualify agencies 'attempting to change the law or government policy'.

bright and ambitious young executives moved easily between jobs in the profit and not-for-profit sectors; and that philanthropy had become so strategic that it was no longer sufficiently responsive, especially when organisations refused to consider proposals or applications they had not themselves invited. The introduction of private business into the earlier partnerships of charities with government aroused even darker fears in others, foreseeing for trusts and foundations the fate of Laocoon and his sons, squeezed to death by two large serpents. (Redmond Barry had included a cast of the famous ancient sculpture of their fate in the Gallery's first collection, but Daryl Lindsay had thrown it out.) A more optimistic animal metaphor might be the partnership of human and horse, productive, over the ages, of so much wealth, power and—as Polly and Alfred Felton found, ambling around the leafy lanes of Studley Park before returning to St Kilda for Sunday lunch—companionship; though that too prompts a question: which partner holds the reins, and which needs to be broken in?

There is no denying the importance of philanthropy to the public and to governments in the new century. By 2002 there were approximately 20 000 organisations with Deductible Gift Recipient status in Australia, and a larger number of Tax Exempt Charities; and in Victoria Steve Bracks, unexpectedly Premier in 1999 and emphatically confirmed in the role in 2002, remarked that the importance of philanthropy was one of his discoveries in office: 'I think all Victorians, including myself, underestimated the amount of support given by donors and philanthropists, organisations that do make a difference, that do improve peoples lives'.[24]

EARLY IN 1998 the Felton Bequests' Committee received an important report, the Trustee Company's Charitable Trust Distribution Board's Strategic Impact Program, quintessential new philanthropy. After consultation with various parties in the community concerning areas of unmet need, Sylvia Geddes, as Manager, Charitable Services, brought a selection before the ANZ Charitable Trusts Distribution Board, which chose one and co-opted a panel of experts to advise and to recommend from among applicants after the project had been advertised. Funding was arranged from trusts for which the Company was sole Trustee. Ms Geddes explained the process as an example of what targeted philanthropy could achieve; in earlier decades Committee members might have felt—charity potentate James Levey certainly would have—that by thus devising 'templates' of

[24] Interview in *Melbourne*, November 2002, p. 040 [*sic*]. 'Is there a particular group whose work you never previously rated highly but now give big tick to?' 'Philanthropy Australia . . .'

appropriate giving the proponents of philanthropism were unduly constraining their independent judgement, but in 1998 the Bequests' Committee found her arguments persuasive and agreed to reserve half its funds for Strategic Projects within the Program and half for 'traditional funding areas'. In May 1998, having accumulated $96 000 for a Strategic Project, it considered several, and asked for a scheme to be prepared in detail for scholarships, aimed at improving retention rates in secondary education, for Aboriginal and Torres Strait Islander students in Victoria. In August it formally approved a radical new departure for the Bequest, the Alfred Felton Koorie Secondary School Scholarships Program, offering fifty scholarships, in each of five years. The Program was publicly launched in November.[25]

The Annual Report issued by the ANZ Charitable Trusts for 1998/99 was an elegant document, surveying the whole range of the Company's trusteeships, of which some fifty were listed in recent editions of the *Australian Directory of Philanthropy*. An apologia for the current principles of philanthropy in action, it covered an impressive range, from the Company's own consolidation into 'Programs' of small funds for which it is sole trustee, through the ANZ Charitable Trust Australia (offering donors facilities for setting up individual foundations, with the company again sole trustee) and Community Foundations active in Victorian and three other states, to long established 'discretionary' trusts such as the Buckland and the Felton, of which the Company was not necessarily sole trustee. In his foreword as General Manager, Charitable Trusts, Peter Bearsley chose for special mention the Felton Bequests, welcoming its participation in the strategic project 'to identify and promote the well-being of children'. 'Most Victorians know how important the Alfred Felton Bequest has been for the National Gallery of Victoria but there are many who are not aware of its equal importance in contributing to the welfare of the community, particularly women and children . . .'[26]

A special section in the Report described the Felton Bequest, giving pride of place among its Strategic Projects to the Alfred Felton Bequest Koorie Secondary School Scholarships. In 1998 candidates had been shortlisted by the eight Regional Koorie Education Committees, and final selection of forty-eight winners made by an independent panel chosen by the Bequests' Committee and the Education Foundation. The scholarships, held for three years, were worth $500 in Year 9 and $750 in Years 11 and 12, and were untied; all scholars attended either a Victorian Government school or Worowa Aboriginal College. The

[25] FBC, 3 March, 26 May and 6 August 1998.

[26] ANZ Charitable Trusts Report 1998/99, p. 3.

Sir Gustav Nossal and Sir Andrew Grimwade, 1998
(ANZ Trustees)

scheme was 'a brilliant idea and a significant gesture for reconciliation', in the words of Sir Gustav Nossal, joint chair of the Commonwealth Government's Council for Aboriginal Reconciliation as well as Chairman of the Bequests' Committee (and, in 2000, Australian of the Year). Also listed among the Bequests' major grants were $220 000 over two years to establish the Doncare Good Beginnings Volunteer Home Visiting Program, a plan of NAPCAN (the National Association for the Prevention of Child Abuse and Neglect), and support for the Child and Family Care network, $30 000 to fund a research co-ordinator to support the 'Who's Minding the Children?' Task Force.

General Grants, $339 873 in total, were also listed. Some old-timers were there: the Royal Melbourne, Royal Children's and Williamstown hospitals, the University of Melbourne (for research equipment), the Cottage by the Sea at

Queenscliff, the Queen's Fund (set up in 1888 by the Charity Organisation Society, which itself no longer appeared, under any name), the Brotherhood of St Laurence, the Melbourne City Mission, and the Travellers' Aid Society among them. But the Ladies Benevolent Societies had vanished, and all the city and country asylums, their inmates 'deinstitutionalised' into the community, and also the orphanages, made redundant by falling birth rates and the single-parent benefit. Almost all the new organisations and programmes were directed to newly recognised community needs, from the Koorie Heritage Trust and Knox Community Care Inc to the TADvic Co-operative Ltd, providing equipment to assist people with disabilities. Children were appropriately favoured, and not only their health: the Pinocchio Community Toy Library provided educational toys for disadvantaged children, and the Museum Board of Victoria, successor to part of the old conglomerate, received $10 000 towards the Children's Playground at the new Museum in Carlton Gardens.

Felton or his contemporaries could have recognised, in all this list, no more than the names of a few institutions, and understood little of the social pressures these grants were intended to ease. Some of their favourite causes, such as 'the relief of the educated poor', appear no more: governesses having become extinct, it is now a matter of definition whether there continue to be any educated poor, or too many to count, and the Victorian society dedicated to the purpose dissolved itself in 2002. Nevertheless, it is chastening to think how shocked Felton, and other Victorians, would be by some of modern society's problems. In 1890 FS Grimwade could assure Premier Munro that the small amount of opium grown or imported into Victoria was, he believed, used almost entirely for medicinal purposes.[27] In 2001 the Felton Bequests' Committee was moved beyond words by accounts from the Mirabel Foundation of the plight of children neglected, abandoned or orphaned by their parents' addiction, and the difficulties of relatives in caring for them. The Committee made the Mirabel Youth Support program a new major project, approving grants of $160 000 over two years; it also successfully commended the program for some Government support.

Early in 2001 the Bequests' Committee recast its guidelines for applicants in a more affirmative mode, emphasising priority for projects which could 'bear the Felton stamp' rather than the categories which were excluded from support. The Chairman urged Sylvia Admans, Manager, Charitable Services, 'to be proactive in

[27] Munro's intended increase in the duty on opium, he warned, would not reduce the trade: Felton Grimwade's had imported 250 pounds of the drug in the previous ten years (he thought about half the total imported), and in the last three years had bought 360 pounds produced locally (at Bacchus Marsh and Sunbury, and in Gippsland). A higher duty would increase local production, not reduce consumption, which was in any case almost entirely for medicinal purposes, in his happy opinion (FSG to Munro, n.d. but 1890).

bringing forward projects' which might be 'innovative' and 'catalytic', citing VACRO (The Victorian Association for the Care and Resettlement of Offenders) and Mirabel as examples. A year later Ms Admans' successor, Teresa Zolnierkiewicz, reviewed the 2001 grants in a new classification: 'Flagship Projects', receiving half the funds, had emphasised parenting skills and early intervention for disadvantaged children, and the improvement of educational outcomes for Koorie youth. 'Special Projects' (innovations, and the evaluation of projects, mostly rural) had received about a third, followed by grants to 'Direct Support Projects' (such as loans schemes), and for capital works, with smaller grants made to meet deficit funding or core costs in organisations. The Committee noted an increasing emphasis on 'community building' in both government and philanthropic policies, a theme it pursued in March 2002 in discussion with Ms Rhonda Galbally, CEO of Our Community.com.[28]

At that meeting the Committee determined to seek out and support new Flagship Projects, each to last two to three years, to help particular disadvantaged groups (such as Koories) and areas (especially rural). Although this emphasis would reduce the number of small projects supported, the Committee decided to continue inviting applications from all comers, while retaining the right to approach organisations directly. Mrs Searby and Ms Zolnierkiewicz reported favourably on a visit to Berry Street Victoria Inc, and in November 2002 the Committee agreed to allocate $100 000 for each of two years to its proposed development of a school for high-risk young people. At the same meeting it also resolved to extend the Koorie Scholarship and Mentoring Projects; and had sufficient funds left to make sixteen further grants, ranging from $45 000 to the Lighthouse Foundation (for 'Youth for Youth') to $3438 to Bethany Family Support (for its Post Natal Depression Project).[29]

There remains plenty for the Felton Bequests' Committee to do to meet the words which Phillips drafted for the will, 'the aid and advancement of such objects as are charitable in a legal sense', with preference for 'charities for Children' and 'charities for Women'. Berry Street Inc is the successor to the Victorian Infant Asylum, founded in 1877 to combat infanticide and to assist unmarried pregnant girls; over the decades, as social conditions and values changed, the organisation renamed and continually transformed itself, from a home for foundlings and an organiser of foster care to an adoption agency, a

[28] FBC, 22 February and 17 May 2001, 5 March 2002. The 'sectoral' approach, addressing specific social problems each in isolation, was now characterised as part of a 'silo mentality'. In 2001 Bruce Bonyhady replaced David Gibbs as the Trustee company's nominee on the Committee.

[29] FBC, 16 May and 17 November 2002.

Mrs Caroline Searby

training school for mothercraft nurses, and eventually to an agency with a broad programme caring for children and adolescents at risk and in need of foster care. Felton subscibed to the original charity, and his Bequests' Committee continued its support, culminating in the latest major project.[30] Much is altered, but children in need are always with us; and the line of descent from Morris' Charity Organisation Society to the ingenious plans devised by modern philanthropic administrators is clear enough. The patronage inherent in nineteenth-century charity, and the remote interventionism of the welfare state, have given way to recognition of the importance of initiatives arising within communities themselves, and of the need for philanthropy to identify, nurture and champion this new charity, charity between equals, democratic charity.

[30] Beryl Penwill, *Looking Back, Looking Forward: The Story of 'Berry Street' Child and Family Care.*

PATRICK MCCAUGHEY RETURNED to the National Gallery from Harvard in June 1987 with the news that he had been offered the directorship of the Wadsworth Atheneum at Hartford, Connecticut. His resignation was accepted from 31 December 1987, and a search for a successor led to the appointment of Dr TL Rodney Wilson, of New Zealand, from March 1988. Cuts in Government funding, and a Cabinet reshuffle, made 1988 a difficult year for the Gallery; the Cain Labor Government, in office since 1982, and especially Race Mathews as Minister for the Arts, had supported the Gallery, but when times became difficult the new Minister could do little to help.

1988 brought also the Bicentenary of European settlement in Australia, and in McCaughey's last months as Director he was involved in two major acquisitions chosen to mark the national celebrations. Sir Rupert Clarke, 'Big' Clarke's great-grandson, third baronet of Rupertswood and Chairman of the National Australia Bank, proposed that it present to the Arts Centre Trust the greatest modern sculpture in the world; and after a further decision that the gift should be made through the National Gallery, McCaughey was despatched, at the Bank's expense, to find it. He chose the very large Willem de Kooning now in the forecourt of the Arts Centre, overcoming a last-minute feminist objection to the work, from a Trustee of the Arts Centre Trust, by rapidly ascertaining that it had been misnamed *Seated Woman* and was properly called *Standing Figure*. To the Felton Bequests' Committee, which wished to mark the Bicentenary in art as well as in charity, McCaughey proposed buying the best available example of Australian indigenous art, and with the Committee's concurrence approached the Carnegie family in a bid to acquire a remarkable, very large painting, *Napperby Death Spirit Dreaming*, by Tim Leura Tjapaltjarri (brother of Clifford Possum Tjapaltjarri, who had also worked on the painting). Specially commissioned in 1980—four years before the artist's untimely death—by Geoffrey Bardon, the Papunya teacher who encouraged local artists to work on canvas and wrote *Aboriginal Art of the Western Desert,* it was about to be shown in New York, in the Dreamings exhibition which helped create an international market for Aboriginal art. In a new departure for the Bequest, this 'unique masterpiece' (as one authority described it) was bought, after certification by two independent valuers, for $250 000, incalculably more than the few pence Baldwin Spencer had paid for the barks he had commissioned in Kakadu in 1913. They, to the Gallery's increasing regret, remained in the Museum.[31]

[31] FBC, 10 May and 10 August 1988. The picture was then entitled *Anmatjera Aranda Territorial Possum Spirit Dreaming*. Its purchase was strongly supported by the Curator of Aboriginal and Pre-Columbian Art, who predicted that in the future it could rank in importance with Strutt's *Black Thursday*, Roberts' *Shearing the Rams* and McCubbin's *The Pioneer*.

Wilson attended the Bequests' Committee meeting in August 1988, when as Director he formally recommended three remarkably various major acquisitions: the Tim Leura Tjapaltjarri work; *Night*, an important American oil painting by Philip Guston, Jackson Pollock's friend and with him once expelled from art school, commended by Elderfield as 'one of the most luscious late Guston's I have seen' (US$350 000: A$446 030); and fourteen Blake engravings from his *Songs of Innocence,* on the market in London (for £67 500, after discount). The recommendation was complicated by reference to a possibly available Klimt, but the purchases proceeded. In November 1988 the Committee was pleased to hear that the Trustees were to have a medallion of Alfred Felton placed, with others, in the footpath outside the Gallery.[32]

After such heavy expenditure in the Bicentennial year, funds were diminished, though there was enough to buy, in May 1989, a rare photograph of Conrad Martens, for $9900.[33] But if the Bequests' Committee's resources were now relatively limited, it could on occasion move with a speed unimaginable in earlier decades, when Advisers struggled to keep dealers' options open while awaiting the ship bearing the Committee's decision to London. On 1 June 1989, at 9.10 a.m., Kenneth Hood rang Jack Stephens with a request, supported by a recommendation from Gerard Vaughan, that the Bequest purchase forty-three hand-coloured plates by William Blake (with the name Alfred Felton on one of them) to be auctioned at Sotheby's, London, at 11.00 a.m. that very day. The time difference gave Stephens some eleven hours to approach his committee; Chairman Nossal, flying between San Francisco and New York, was not available, but by the end of the morning approval was gained by telephone from Searby (in Hong Kong) and Gibbs (in Greece), and written support received from the two members in Melbourne, Grimwade and Manion. Vaughan was able to bid, successfully, for the copy of Young's *Night Thoughts*, hand-coloured by Blake himself, which it had twice before failed to acquire—from Felton's own collection in 1904, for nothing, or cheaply from Sticht's, in 1922. In 1989 it cost the Bequest £30 000 sterling. No one now thinks Blake merely 'quaint'.[34]

Hood had made the recommendation because he was again Acting Director, after Rodney Wilson, who had never found life in Melbourne congenial, resigned to return to New Zealand in December 1988. After a short search, and

[32] FBC, 10 August and 18 November 1988.

[33] Ibid., 19 May 1989.

[34] Stephens' Diary Note is in the Trustee company's papers. Vaughan had an anxious moment waiting to see if his last bid—£30 000 was his approved limit—would be topped. The acquisition was not formally approved by the Trustees until 13 June. On *Night Thoughts*, see Butlin and Gott (with Zdanowicz), *William Blake in the Collection of the National Gallery of Victoria*, pp. 17–18, 157–72.

a long delay before the Government confirmed the appointment in June 1989, James Mollison was appointed Director for three years. Since his first appointment to the Gallery as an Education Officer in 1960–61, his career had included the Directorship of the Ballarat Fine Art Gallery, a period with the Commonwealth Art Advisory Board in the Prime Minister's Department, and eighteen years as the first Director of the Australian National Gallery (Acting 1971–77, Director 1977–89).[35] Before Mollison's appointment was announced, Sir Andrew Grimwade made known his retirement from the Presidency after fourteen years and as a Trustee after twenty-five, though not from the Felton Bequest. On 9 October, at a Trustees' lunch in his honour, it was announced that the Trustees' meeting room would henceforth be known as the 'Andrew Grimwade Board Room'. The Bequests' Committee had already decided that it would be pleased to have recommended to it a suitable portrait of Sir Andrew, 'especially in view of his family's long association with Felton and the Bequest', and a portrait by Clifton Pugh was painted, recommended and purchased in 1990.

THE NEW DIRECTOR arrived in October 1989 and met with the Felton Bequests' Committee the following February, to discuss policy. Mollison wished to maintain excellence in acquisitions, not least to enhance the reputation of the Bequest, and 'to include recommendations from all areas including prints, decorative arts and photography. He was especially interested in 'linking works', like the 1765 porcelain figure group he was about to recommend, *The Music Lesson*, by Joseph Willems (US$45 000), modelled from the Boucher painting. He also recommended an Odilon Redon Lithograph, *Tête d'enfant avec fleurs* (US$75 000) and two Aboriginal works, Rover Thomas Joolama's *Dreamtime Story of the Willy Willy* ($6500) and Jack Britten's *Purnululu Country* ($6000).[36]

By May 1990 the Bequests' Committee had accumulated an estimated $1 200 000 (before reducing it by US$235 000 by buying a Chinese scroll by Lu Ji). In June they held a special meeting to present the Bequests' latest purchases to Will Bailey, Grimwade's successor as President of the Council of Trustees (and also, incidentally, custodian of Felton's bequest as Group Chief Executive of the Australia and New Zealand Banking Group), using the occasion to explain the Bequests' procedures and to stress its independence.[37] At the November meeting—when Professor Manion announced that she was not seeking reappointment to the

[35] FBC, 4 May and 18 June 1990.

[36] Ibid., 16 February, 13 November 1990.

[37] Ibid., 4 May, 18 June, 1990.

Council of Trustees, and would in consequence cease to be a member of the Committee—the Art Fund stood at $1.225 million. It was agreed to spend no less than US$380 000 on a piece of early porcelain by Gricci, recommended by Ingamells as 'a fine and rare example of a substantial figure composition' and also commended by Vaughan. The Committee also approved two paintings by Emily Kam Kngwarray, *After rain* and *Untitled*, for $7000 each. After recommending four works by Aboriginal artists in one year, Mollison hesitated to propose more.[38]

The Bequest's purchases were varied, if no longer numerous. At its meeting in March 1991—the first attended by Professor Jenny Zimmer, of Monash University, in place of Professor Manion, and the first without Vincent Kiss—the Committee approved, on the Director's recommendation, spending £5000 sterling on a preliminary drawing for Jansson's *Ring Gymnast I*, and US$110 000 on a Chinese hanging scroll by Chen Hong Shou, and also approved purchase (at the 'special price' of US$500 000) of Lee Krasner's oil *Combat*, commended by William S Liebermann of the New York Metropolitan: 'of all Krasner's Gestural paintings this is the best'.[39] At its August meeting the Committee, with only $306 558 to spend, approved five Japanese items, Professor Zimmer remarking that the Gallery should take advantage of the abilities of its Curator of Asian art, Dr Mae Anna Pang, to acquire more excellent works before prices rose out of reach. (Mollison, aware of her talents, gave high priority—alongside Aboriginal art—to Chinese and Japanese calligraphy and painting.) But the Committee was in a mood to consider buying policy more generally, noting that 'in recent times the Committee and its consultants have adopted a rather passive attitude in not putting forward suggestions for acquisition. This has of course resulted from the greater professionalism of the recent directors and the Curators, also the much easier lines of communication' with overseas experts. But 'as in the past', the Committee had 'a right at any time to suggest a preference for the future direction of possible acquisitions', and in March 1992 it did so, asserting that it should henceforth purchase only major works, saving up for them if necessary.[40]

The Director had a different view. Present when the Committee made its point, Mollison made it clear that while welcoming major works he also wished to put forward artists 'not yet recognised by the buying public', recommending

[38] Ibid., 13 November 1990. The three consultant/advisers were all offered reappointment; Elderfield and Vaughan accepted, but Ingamells, retiring from the Wallace Collection, declined. In May 1991 he was replaced, on Mollison's recommendation, by David Jaffe.

[39] Ibid., 19 March 1991. Professor Zimmer, whose membership of the Committee continued until 1999, had taken a degree at the University of Melbourne after study at RMIT, and had been Dean of Art and Design at the Chisholm Institute of Technology before appointment to a Chair at Monash in 1990.

[40] Ibid., 27 August and 30 October 1991.

[TOP LEFT]
René Magritte 1898–1967 Belgian
In praise of dialectics (L'éloge de la dialectique) 1937
oil on canvas
65.5 × 54.0 cm
Felton Bequest, 1971

[ABOVE]
Greece, Attica
The Achilles painter (attributed to)
Lekythos (Attic white-ground ware) 460–450 BC
fired clay
35.2 × 11.3 × 11.3 cm
Felton Bequest, 1971

[LEFT]
Erich Heckel 1883–1970 German
Standing child (Stehendes Kind) 1910
published in the sixth *Die Brücke* portfolio 1911
colour woodcut
37.5 × 27.7 cm irreg. (image), 54.2 × 40.0 cm (sheet)
Felton Bequest, 1974

EW Godwin (designer)
1833–1686 England
William Watt, London
(manufacturer) active
1860s–1880s England
Sideboard 1867 designed,
*c.*1885–1888 manufactured
ebonised wood, brass, gold paint
184.4 × 256.3 × 52.0 cm
Felton Bequest, 1977

Francisco Goya y Lucientes 1746–1828 Spanish
What a golden beak! (*¡Qué pico de oro!*)
plate 53 from *Los Caprichos*, first edition 1799
etching, burnished aquatint and burin
19.3 × 13.7 cm (image); 21.5 × 15.6 cm (plate);
25.0 × 18.1 cm (sheet)
Felton Bequest, 1976

Rembrandt van Rijn 1606–1669 Dutch
St Jerome reading in an Italian landscape c.1653
etching, burin and drypoint
26.1 × 21.0 cm (plate); 26.8 × 21.6 cm (sheet)
Felton Bequest, 1977

[TOP LEFT]
Nathu active 1830s Indian
Maharana Jawan Singh riding
1835
opaque water-colour and gold paint on paper
43.3 × 25.8 cm
Felton Bequest, 1980

[ABOVE]
John Brack 1920–1999 Australia
Portrait of Dr Ursula Hoff 1985
oil on canvas
152.2 × 122.0 cm
Felton Bequest, 1985

[LEFT]
Canaletto 1697–1768 Italian
Bacino di S. Marco: From the Piazetta c.1735–1745
oil on canvas
131.4 × 163.2 cm
Felton Bequest, 1986

[TOP]
Tim Leura Tjapaltjarri, Anmatyerre
c.1939–1984
Clifford Possum Tjapaltjarri,
Anmatyerre c.1932–2002
Napperby death spirit Dreaming 1980
synthetic polymer paint on canvas
207.7 × 670.8 cm
Felton Bequest, 1988
© The artists' Estates courtesy
Aboriginal Artists Agency

[ABOVE LEFT]
Philip Guston 1913–80 American
Night 1972
oil on canvas
168.5 × 200.7 cm
Felton Bequest, 1988

[ABOVE RIGHT]
Rover Thomas (Joolama)
c.1926–1998 Warmun
Dreamtime story of the willy willy
1989
earth pigments and natural binder
on canvas
160.0 × 200.0 cm
Felton Bequest, 1990

[LEFT]
Japanese
***Three-tiered food box,
Jubako*** 17th–18th century
stoneware, gold paint,
enamel, bronze
(*Ko-kiyomizu* ware)
17.8 × 15.0 × 13.0 cm
Felton Bequest, 1991

[ABOVE]
Capodimonte Porcelain Factory, Naples (manufacturer) 1743–1759
Italy
Giuseppe Gricci (sculptor) *c.*1700–1770 Italy
Goffredo at the tomb of Dudone *c.*1745–1750
porcelain (soft-paste)
32.1 × 29.1 × 20.6 cm
Felton Bequest, 1991

[LEFT]
Chen Hongshou 1599–1652 Chinese
Plum-blossom study late 1640s
ink on paper
129.0 × 55.5 cm
Felton Bequest, 1991

[ABOVE]
Sèvres Porcelain Factory, Sèvres
(manufacturer) (est. 1756) France
Jacques–François Micaud
c.1732–1735–1811 France
Tureen and stand 1760
porcelain (soft–paste)
27.0 × 50.6 × 40.7 cm
Felton Bequest, 1992

[RIGHT]
Egypt, Roman period,
AD 1st–2nd century
Head covering of Padihorpasheraset
cartonnage, gilt, glass paste, pigment
53.7 × 35.9 × 30.1 cm
Felton Bequest, 1995

[LEFT]
Howard Hodgkin 1932– English
Night and day 1997–1999
oil on plywood and wood
163.0 × 196.2 cm
Felton Bequest, 2001

[BELOW LEFT]
Nathaniel Dance 1735–1811 English
Portrait of the Pybus family 1769
oil on canvas
144.0 × 142.6 cm
Felton Bequest, 2003

[BELOW]
Master of the E–series Tarocchi
active *c.*1465 Italian
Prime mover (Primo mobile)
plate 49 from the *E–series Tarocchi*
c. 1465
engraving
18.2 × 10.1 cm
(image and sheet)
Felton Bequest, 2002

[RIGHT]
Six Directors of the NGV:
Gordon Thomson, James Mollison,
Dr Gerard Vaughan, Dr Timothy Potts,
Dr Eric Westbrook and Patrick
McCaughey 2002

[BELOW]
Aerial view of The Ian Potter Centre:
NGV: Australia at Federation Square and
NGV: International at St Kilda Road
© 3D Rendering – Gollings + Pigdeon

that Jake Berthot's *For Chris* be bought for US$30 000. 'The gallery has no option but to collect contemporary international art ahead of the market', he argued, and 'Berthot is known to be the artist to watch'. Someone suggested as a compromise that the Committee might save a proportion of its funds for major purchases, a view confirmed as policy at the next meeting: reiterating its 'wish to only purchase the best work of any artist', the Committee resolved that a third of the income would be saved over the following two or three years, to 'enable the purchase of a really significant work of art should one emerge'. But in November 1992, having reduced its available funds from $230 209 to $153 993 by holding back a third, it nevertheless agreed to buy Anselm Kiefer's *Bose Blumen* for A$344 333, when sufficient funds had accumulated.[41] By November 1993 the Art Fund had risen (slowly, in the years of low returns) to $319 326, plus $159 663 'accumulated', and the Kiefer was bought, though Professor Zimmer was asked to tell the Gallery 'that, given the lean times, the Bequest would not be in a position to purchase further works for some time'. The new acquisition was formally presented a year later—or rather the ceremonial party was held, the Committee finding to its surprise that the picture itself was not there.[42] The acquisition was indeed unusual: the work, made between 1985 and 1991, consisted of oil, gesso, emulsion, soil, and foxglove (*Digitalis purpurea*) on canvas, and was potentially a conservator's nightmare had the artist not instructed that the sealed frame never be opened, so that over the centuries the digitalis, reduced to vertical stems and dried leaves, would resemble remains archaeologists excavated. Kiefer was a famous modern artist, but not everyone was convinced, one unbeliever asking why so much had been paid for a work he thought not only rotten, but rotting.

Mollison concluded his term as Director in 1995. In November 1994, when the Committee held $354 235 in the Art Fund, Professor Zimmer said it was the Gallery's intention to delay any recommendation until a new Director was appointed; but in February 1995 had to explain the 'events surrounding' the purchase of an Egyptian Mummy mask for £53 167 (A$111 696); it had been approved by the Trustees, and recommended by the Director and by Vaughan as Adviser, but had been purchased without consulting the Bequests' Committee. Having approved the expenditure retrospectively, the Committee also resolved that when urgent decisions had to be reached, 'reasonable attempts' to contact all members would be made; that the consent of three of the five members was necessary before funds could be committed; and that all members were to be told, by telephone or fax if necessary, if one of their number opposed any purchase. It also informed the

[41] Ibid., 7 May and 5 November 1992.

[42] Ibid., 16 November 1994.

Gallery that it would not view sympathetically any requests made before a new Director was appointed.[43]

In 1995 the Council of Trustees chose as Director thirty-six-year-old Dr Timothy Potts, a graduate of Sydney and Oxford, a specialist in Near Eastern Archaeology and Art, who had joined the Gallery the year before as Director of International Art after five years as an investment banker of New York and London. In May the Committee approved purchase of a Goya etching of Margarita de Austria, bought in Paris for $7632 plus $778 in fees; calculating it would have some $500 000 in the Art Fund by the end of June, the Committee also asked Dr Potts for a further recommendation. None was immediately forthcoming, and although in September a 'very successful' Committee lunch was held with Potts and a new Chairman of the Council of Trustees, John Gough (formerly Chairman of the ANZ Bank), the Art Fund reached $663 349 by the end of October with no immediate goal in sight.[44] It was not until May 1996 that Professor Zimmer reported 'ongoing investigations' into the marble torso of a Greek athlete (possibly the Diskophoros, *Discus Holder*), an acquisition proposed partly as a tribute to the memory of Professor Trendall, recently deceased. The investigation was protracted; it was not until November 1997—a meeting, incidentally, when the Committee resolved to support the City of Port Phillip's nomination of the Esplanade Hotel for the Victorian Heritage Register—that news was received that the statue had arrived.[45]

At the same meeting in November, Professor Zimmer reported that the Gallery had in mind three major works, one of which it might recommend to the Bequests' Committee: an Egyptian sculpture of the God Osiris, a Chinese lacquer dish, or a painting, *La Toilette de Venus*, by Jean-Baptiste (Baron) Regnault (1754–1829), a major example of the highly-finished style associated with the French Salon, though it had never hung there. The Gallery had no similar work; Regnault had painted it in 1815, some sixty years before Lefevbre's *Chloe*, a nude of the same ilk.[46] The Committee 'indicated a preference towards the painting', which was in Melbourne a year later, when the Gallery confirmed its wish to acquire it. A fall in the value of the Australian dollar raised the price to about A$1.4 million, but the Gallery paid 'a certain sum' to secure it, assuring the Committee (which could well remember the Canaletto's inflation) that the

[43] Ibid., 20 February 1995.

[44] Ibid., 9 May and 13 November 1995.

[45] The investigation, begun after Jeffrey Spiers wrote to Dr Potts on 24 April 1996, was referred to in FBC, 15 May, 19 August and 14 November 1996 and 21 April and 6 November 1997.

[46] FBC, 6 November 1997.

Bequest would be asked for a fixed amount when the deal was concluded. The cost was US$850 000 (A$1 375 404), which the Committee had accumulated by early 2000, when the picture was formally presented, after being on show with a notice 'pending purchase by the Felton Bequest'.[47]

By then Dr Potts had left the National Gallery of Victoria to take a post in America, and in June 1999 Dr Gerard Vaughan had returned to Melbourne to replace him. A specialist in the visual arts and the history of collecting, his experience with the Campaign for Oxford and five years as Director of the Development Trust at the British Museum gave him skills he would need in Melbourne, where he was called on to lead the National Gallery through its greatest transformation. The vast new Museum Victoria was about to open, behind the old but splendidly refurbished Exhibition Building (incidentally concealing its elegant dome from the dismayed literati of North Fitzroy), and the long, slow rebuilding of the Library, now occupying the whole of the Swanston Street site, was invisibly progressing. Renovation of Sir Roy Grounds' St Kilda Road National Gallery had been planned for some time by the NGV Trustees, but remained towards the rear of the cultural queue until the State Government decided, in one of the few major projects devoted to aspects of Australian culture other than sport, to build a great Square over the railway yards between St Paul's Cathedral, Swanston Street and the river, to celebrate the Centenary of Australian Federation in 2001. Post-modern in concept as well as architectural design, the complex was to include a museum of the moving image but, since it was also to commemorate nationhood, the Council of the NGV was asked whether it would accept a separate new gallery for Australian art if one were built there. The Trustees agreed, provided they could at the same time rebuild the St Kilda Road Gallery, to house the International collection. The Government agreed, though the NGV had to find a large part of the funds.

Planning and building both projects took several years. For the Gallery it began with the intricate task of packing and storing the main collections in the new Victorian Archives facility in North Melbourne, while some works went on loan to provincial galleries. To maintain a presence in Melbourne itself, space at the rear of the old Swanston Street complex, vacated by the Museum and destined for the Library, was 'borrowed' to house a new gallery, dubbed NGV on Russell. The Gallery, taking the opportunity to display some of its riches abroad, also sent a major exhibition, European Masterpieces, Six Centuries of Paintings from the National Gallery of Victoria, to tour the United States. From October 2000 until

[47] Ibid., 3 March, 26 May and 6 August 1998.

early 2002 eighty-eight works, packed in sixty-four crates, crossed and re-crossed the United States in three climate-controlled vehicles (with armed escorts), from Cincinnati to Fort Worth, Denver, Portland in Oregon and Birmingham, Alabama (an add-on, by request). The tour was a triumph, attracting half a million visitors; of the masterpieces exhibited, ranging from medieval to (post) modern, and from Amiconi to Zoffany, sixty-one were Felton acquisitions.

The massive process of relocating the collections was well advanced when, in March 2000, the Bequests' Committee discussed with Dr Vaughan a number of possibilities for its next purchase. (It was about to decide that with congenial advice at home and rapid communication abroad its long practice of having overseas advisers was outmoded; Elderfield, the last of the tribe, was so informed in May.)[48] Vaughan made clear his preference for Sir Howard Hodgkin's *Night and Day*, a recent work which he had seen and admired in London; and his praise for the English painter was supported by Jeremy Lewison, Director of Collections at the Tate, who thought the painting would come to be seen as 'a key work from the last decade'; *Night and Day*—the title an echo of Cole Porter's song—was 'clearly a major Hodgkin and deserves to be in a major public collection'. Dr Alison Inglis, of the University of Melbourne, attending her first meeting after taking Professor Zimmer's place on the Bequests' Committee, also praised it. In November 2000 the Committee viewed the picture; as Robert Hughes has written, Hodgkin's paintings 'look abstract but are full of echoes of echoes of figures, rooms, sociable encounters', and the artist himself wrote that he 'would like to paint pictures where people didn't care what anything was, because they were so enveloped by them'; *Night and Day*, dramatic in its intensity, proved as enigmatic as the Regnault had been explicit. It cost US$350 000, in Australian dollars about $675 000.[49] By 2000 the Bequest had to save up for such things; fortunately for the Gallery, the NGV Foundation was by then attracting donations on the scale which Rinder had long before argued the community should provide to supplement Alfred Felton's generosity.[50]

Dr Vaughan thought Hodgkin's masterpiece an especially appropriate acquisition because of the Gallery's remarkably strong holdings of British art. When the

[48] Ibid., 8 May 2000.

[49] Ibid., 21 March, 9 November 2000. Quotations from *Howard Hodgkin Night and Day, Felton Bequest Acquisition, 2001*, NGV, 2001.

[50] In the financial year 2000/2001 the value of works of art purchased by or donated through the Foundation was $3.8 million—an increase from $1.2 million the year before—and the total value of works of art acquired through the Foundation rose above $35 million (*NGV Foundation Annual Report 2001*).

painting arrived, it appeared in the Murdoch Gallery in NGV on Russell, surrounded by a small exhibition also entitled Night and Day, intended to illustrate the tension between abstract and figurative art in the twentieth century. Twenty-three of the thirty-five pictures hung were Felton acquisitions, ranging from Orpen's *Night* (hanging juxtaposed with Guston's *Night*) and Sir Charles Holmes' *Black Hill Moss*, through Augustus and Gwen John, Stanley Spencer, Paul Nash, Wyndham Lewis and Bridget Riley down to Hodgkin himself. Two Americans (Rothko and Guston) and one Swede (Jansson) were added, but the show incidentally did much to justify the frequently-criticised acquisition over the years of then-contemporary English art by Felton Advisers.

NGV ON RUSSELL, which closed in June 2002 in preparation for the opening of the spectacular Ian Potter Centre NGV: Australian Art on Federation Square, and the remarkably rebuilt National Gallery of Victoria: NGV International Art in St Kilda Road, was a charming gallery in its brief existence. Much of the area occupied had originally been part of the old National Museum, built for Baldwin Spencer in 1905, the year after Felton died, and the year also of Bernard Hall's foray to Europe as the first of the Bequests' Advisers, when he happily acquired *Jeanne d'Arc*—still guarding the front of the old buildings—the Pissarro *Boulevard Montmartre*, and much else.

When NGV on Russell opened, Longstaff's posthumous portrait of Alfred Felton faced one of the entrances to the grand, balconied McCoy Hall, and the Bequests' first major purchase of Australian art, McCubbin's *The Pioneer*, faced the other. (Just inside stood a Museum piece, the race-horse Phar Lap, until transported to his vast new stable behind the great Exhibition Building of 1880.) For the NGV, McCoy Hall housed mainly visiting exhibitions, though Art Museum treasures—silver, china, glass, Trendall's Greek pots (the Felton Painter's among them), and the Picasso vase—stood around its outer walls. The majority were Felton Bequest purchases, as were most of the works hung in the Murdoch Gallery, used mainly for exhibitions drawn from the NGV's own collections. Between Murdoch and McCoy, the long, elegant old McArthur Gallery displayed Old Masters, chosen from those deemed physically unfit or otherwise unsuitable for selection to tour the United States.

Almost all the pictures hung in the McArthur Gallery were Felton Bequest acquisitions; and collectively they represented the tastes and skills of successive Felton Advisers, so few of whom had received, in Melbourne, much gratitude for their efforts. Prints and drawings were not included, so Ross's Blakes were not there, nor Hoff's main acquisitions, though her advice had guided decisions on

many of the paintings hung. Outside the main gallery—perhaps appropriately—though visible through its doors were the early Bastien Lepage which Gibson acquired in 1910, and Wilson Steer's *The Japanese Gown*, bought by Clausen in 1906. Inside the long, high room, Hall's final triumph, Rembrandt's *Old Men Disputing*, hung in one corner, its title commemorating also the circumstances of its purchase. The *St Sebastian*, which Hall had recommended in 1934 as a Ribera but proved to be after Giordano, hung nearby; so too did the fine Flemish *Descent from the Cross*, which he had found in suburban Melbourne in 1931. Nothing recommended by Colvin was on show—Hall had vetoed too many—but Rinder's choices, scattered around the room, included Palmezzano's *Baptism of Christ* (1920), Willem Kalf's *Still Life with glasses and fruit* and the great Flemish *Triptych with the Miracles of Christ* (both 1922). Davies, never much regarded in Melbourne, is perpetually justified by the Tiepolo *Banquet*, though much of the credit was due to Holmes, the adviser behind the Adviser. Cockerell's first recommendation, the Flemish *Carved Retable of the Passion* (1937), dominated a corner of the gallery, not far from *The Garden of Love*, now attributed to the Studio of Vivarini, not the School of Pisanello as Kenneth Clark had believed in 1947–48, and Ter Borch's *Lady with a Fan*, fruit of Lindsay's 1945 expedition. Lindsay had also been associated with McDonnell in buying Turchi's *Charity* in 1953; other McDonnell recommendations on the walls included Ricci's grand *The Finding of Moses* (apparently by some Italian river, not the Nile) (1958), and Pittoni's *Miracle of the Loaves and Fishes* (1950–51). Woodall had recommended Annibale Carracci's *The Holy Family* (1971), Candid's *Lamentation over the Dead Christ* (1966) and Preti's alarming *Sophinisba receiving the Poison* (1967).

In the middle of the Gallery's north wall hung Poussin's great *Crossing of the Red Sea* (Clark and McDonnell, 1948), the black cloud lowering over the drowning Egyptians; opposite, presiding over all, the Egyptian herself, pearl poised for ever over the bitter chalice, while the lap-dog, Mark Antony, and the tall, dark figure Tiepolo so often interpolated in his pictures wait expectantly (Davies, 1932). By the entrance door, beyond Mytens' imposing *Sir John Ashburnham* (which Westbrook joined Woodall in recommending in 1971, but for the Miller Bequest, not the Felton), and the Highmore *Pamela* series (which Rinder had shared with the Fitzwilliam Museum and Trafalgar Square in 1921), hung the newly arrived Regnault, *La Toilette de Venus*, the goddess and her attendants brightly polished and brazen. For a few months, opposite, hung the picture the Bequest had twice tried to buy but failed: Lefebvre's *Chloe*, returning, while her Swanston Street hotel was rebuilding, to precisely the same spot on the same wall she had first graced (disgraced, some had said) in 1883, when the McArthur

Gallery was almost new. The Sylphs of the Salon were revealed as sisters, not only under but all over their very visible skin.[51]

THE WORKS OF ART assembled in the NGV on Russell were later reunited with the rest of the collections in two great galleries, the spectacular Ian Potter Centre NGV: Australian Art on Federation Square, opened in November 2002, and the renamed NGV: International Art in St Kilda Road—with Mario Bellini's imaginative new structures built within Roy Grounds' strong bluestone walls—opened a year later. Each of the more-than-fifteen-thousand Felton acquisitions in the renewed National Gallery of Victoria has been duly certified by his committee 'to have an educational value and to be calculated to raise and improve public taste', as his will required. The words now seem archaic, but the million and a half people who visited the intricate new building on Federation Square in its first seven months could not fail to learn as well as enjoy, as they made their way from the Indigenous art boldly unfolded in extraordinary variety on the ground floor to Fieldwork, the twenty-first century reincarnation of the Field Exhibition of 1968 on the third. Most of the key Australian works acquired with Felton funds are on the middle floor, where Roberts' shearers bend over their rams and Mackennal's *Circe* beckons to the riches around her. Over the century the Bequest had bought even more international art than Australian, and the range of its acquisitions which can now be shown in St Kilda Road astonishes. Without Felton's bequest these works would not be here, hazardous and occasionally contentious though their rites of passage to Melbourne may have been, past committees, advisers, trustees and gallery officers, not all well disposed to the works, or to each other. Sir Frank Clarke was right: 'the real worth of the object' made 'the most exasperating work' worth while.

The work continues, fortunately with less exasperation. After acquiring a major painting by a living Englishman in 2000, the Felton Bequests' Committee approved, in November 2001, the purchase (for US$38 000) of the oldest print now held in Australia, *Primo Mobile,* engraved by the Master of the E Series Tarocchi, active in Ferrara *circa* 1465. In 2002, in a small act of recognition of its benefactor, the Director insisted that the Gallery, and not the Bequest, pay for the miraculously-reappeared album of Caire's photographs of Felton's rooms in the Esplanade Hotel. It remains a pity that Dr Vaughan's predecessor Bernard Hall

[51] Sonia Dean, after hanging *Chloe*, noticed that she was in the same spot and had returned there on the same date as in 1883. This time she was not dismissed, but remained until summoned back to new quarters in Young and Jackson's Princes Bridge Hotel.

did not keep more of the pictures and *objets d'art* which cluttered those rooms in 1904, though it is true that—Melburnians' tastes being perceptibly elevated—only a few of Felton's favourites could easily find a place among the treasures now gathered in what he knew as the Art Museum in the Public Library.

In 2003, as the centenary approached, the Director recommended, the Committee approved and the Trustee company began negotiations for three major acquistions. One is a work by a modern American photographer. The second, Alexander Archipenko's *Silhouette (Second Version)*, small, slim and shining, is one of the finest of early cubist sculptures, conceived in Paris in 1910, the year the National Gallery acquired *Circe*. The third was a discovery, close to home. Nathaniel Dance, one of the galaxy of great English eighteenth-century portrait painters, so far represented in Melbourne's Gallery only by Phillips Fox's copy of his *Captain Cook* (Felton Bequest 1906), painted in 1768-70 a group of six members of the Pybus family, properous and contented in a peaceful English landscape. In 1839 a descendant, Cecil Pybus Cooke, fired by Major Mitchell's account of Australia Felix, arrived in Portland, via Hobart, where he had married shipboard companion Arbella Winter. Arbella's brother Samuel Pratt Winter was already squatting, at Murndal on the Wannon; the Cookes settled nearby, at Condah. Arbella's son Samuel Winter Cooke inherited both properties, and Nathaniel Dance's great painting eventually came to rest with other Winter Cooke family heirlooms at Murndal. Unknown to scholars, and mercifully to re-touchers and restorers, *Portrait of the Pybus Family* has emerged from behind the grime of two centuries as a bright new relic of the Enlightenment, further enhancing the National Gallery of Victoria's rich holdings of eighteenth-century painting.

In 2003 the Bequests' Committee also decided—at long last and after false starts in 1912 and 1933—to commission a sculpture to commemorate Alfred Felton, on the centenary of his death. The plan was bold. Distinguished sculptors were invited to submit designs, not necessarily for a representational bust, but for 'a monument celebrating genius and philanthropy', wording which might well have surprised the modest Mr Felton, as might the outcome. A great bequest always achieves far more than its benefactor could have envisaged. Mark Antony—Shakespeare's, not Tiepolo's—was wrong: the good that men do lives after them, as well as the evil; who, indeed, can set a limit to a man's powers?

MEMBERS OF THE FELTON BEQUESTS' COMMITTEE

Frederick Sheppard Grimwade, Chairman 1904–10
Charles Bage, 1904–30, Chairman 1910–30
Edward Langton, 1904–5
Frederic Race Godfrey, 1904–9
James Alfred Levey, 1904–44, Chairman 1930–44
John Mather, 1905–16
Robert Murray Smith, 1909–13
Edward Norton Grimwade, 1910–29, 1930–33, 1934–45, Chairman 1944–45
Sir John Henry MacFarland, 1913–35
Henry Gyles Turner, 1916–20
Alexander Leeper, 1920–28
George Swinburne, 1928
Sir Leo Finn Bernard Cussen, 1928–33
Sir Wilfrid Russell Grimwade, 1929–30, 1933–34, 1949–55, Chairman 1952–55
Sir Frank Grenville Clarke, 1931–55, Chairman, 1945–52
John Shirlow, 1933–36
Sir Alexander Anderson Stewart, 1935–37, 1942–56
Alfred Bright, 1936–38
John Fordyce, 1937–42
Alexander Sydney Joske, 1938–39
Sir John Campbell Longstaff, 1939–41
Duncan Max Meldrum, 1942–45
Sir Owen Dixon, 1945–65, Chairman 1956–65
Harold William Grimwade, 1945–49
Sir Keith Arthur Murdoch, 1945–52
Sir John Gibbs Medley, 1952–58
Sir Clive Hamilton Fitts, 1955–75, Chairman 1965–75

Sir Joseph Terence Burke, 1956–85
Aubrey Roy Lytton Wiltshire, 1956–58, 1958–65
Leonard Bell Cox, 1958–73
James Cuming Stewart, 1958, 1965–70
Allan William Hamer, 1966-68
Sir Gustav Joseph Victor Nossal, 1969–, Chairman 1975–
Sir Thomas Langley Webb, 1970–83
Sir Andrew Sheppard Grimwade, 1973–
Caroline Mary Searby, 1978–
Maxwell Stanley Mainprize, 1983
Alwynne George Kilpatrick 1983–84
David Charles Leslie Gibbs, 1984–2001
Thomas Carrick Chambers, 1985–86
Margaret Mary Manion, 1987–90
Jennifer Kay Zimmer, 1990–99
Alison Scott Inglis, 2000–
Bruce Phillip Bonyhady, 2001–

ILLUSTRATIONS

COLOUR

between pages 152 and 153

JC Waite, *Alfred Felton*
John Longstaff, *Alfred Felton*
Ada Whiting, *Alfred Felton*
Laboratory and drug mills and *Leech aquarium*, c.1884
Chemical works and *Bi-sulphide of carbon works, Sandridge*, c.1884
Francois Cogné, *Bourke Street East*, 1863
Jules Joseph Lefebvre, *Chloe*, 1875
Rupert Bunny, *St Cecilia*, c.1889
Rupert Bunny, *Sea idyll*, c.1890
The National Gallery of Victoria thanks Mr Felton, 1892
Hugh Ramsay, *James S MacDonald*, 1901
Alfred Gilbert, *Perseus arming*, 1882
Camille Pissarro, *Boulevard Montmartre, matin, temps gris*, 1897
Edmond-François Aman-Jean, *La femme couchée*, c.1904
Emmanuel Frémiet, *Jeanne d'Arc équestre*, 1874, cast 1906
Auguste Rodin, *Minerve sans casque*, c.1886
Frederick McCubbin, *The pioneer*, 1904
Jean-Baptiste-Camille Corot, *The bent tree (morning)*, c.1855–1860
Bertram Mackennal, *Circe*, 1893
Edward Burne-Jones, *The wheel of fortune*, 1870s–1880s

between pages 280 and 281

Pierre Puvis de Chavannes, *L'Hiver*, 1896
Arthur Streeton, *Sydney Harbour*, 1907
E. Phillips Fox, *The arbour*, 1910

George Lambert, *Baldwin Spencer*, 1921

William Blake, *Antaeus setting down Dante and Virgil in the last circle of Hell* (Illustration to Dante's *Divine Comedy, Inferno* XXXI) 1824–1827

William Blake, *Dante running from the three beasts* (Illustration to Dante's *Divine Comedy, Inferno* I) 1824–1827

Maître François and workshop, *The Wharncliffe Hours*, c.1475

Anthony van Dyck, *Rachel de Ruvigny, Countess of Southampton*, c.1640

Triptych with the Miracles of Christ: Left panel obverse—*The marriage of Cana* [Flanders]

Thomas Gainsborough, *An officer of the 4th Regiment of Foot*, 1776–1780

Marcantonio Raimondi, *Massacre of the Innocents*, c.1511–1512

The Madonna and the Child, [Flanders], late 15th century

Hans Memling, *The Man of Sorrows in the arms of the Virgin*, 1475

John Everett Millais, *The rescue*, 1855

Jules Bastien-Lepage, *October Season*, 1878

Tom Roberts, *Shearing the rams*, 1888–1890

between pages 408 and 409

Giambattista Tiepolo, *The banquet of Cleopatra*, 1743–1744

Paul de Lamerie, *Candlestick, snuffers and extinguisher*, 1734–1735

Rembrandt van Rijn, *Rembrandt in velvet cap and plume, with an embroidered dress: bust*, 1638

Rembrandt van Rijn (studio of), *Rembrandt*, c.1660

Pharmacy jar from the Santa Maria Nuova, Florence, c.1430–1450

Rembrandt van Rijn, *Two old men disputing*, 1628

Claude Monet, *Vétheuil*, 1879

Paul Cézanne, *La route montante*, c.1879–1882

Ptah-Sokar-Osiris figure of Hor, Egypt, Ptolemaic Period 332–330 BC

Vincent van Gogh, *Tête d'homme*, 1886

Francesco Xanto Avelli, *Mucius Scaevola*, plate, 1534

Charles Conder, *Springtime*, 1888

Profile portrait of a lady, [Florence] c.1475

Joseph Mallord William Turner, *The Red Rigi*, 1842

Jar, Neolithic period, Yangshao culture, 2400 BC

Mythical animal, Western Jin dynasty, AD 265–420

Walter Sickert, *The raising of Lazarus*, 1928–1929

between pages 504 and 505

Amedeo Modigliani, *Nude resting*, 1916–1919

Nicolas Poussin *The crossing of the Red Sea*, c.1634

Rembrandt van Rijn, *Christ Crucified between the Two Thieves (The Three Crosses)*, c.1660

George Stubbs, *A lion attacking a horse*, c.1765

Pierre Bonnard, *La sieste*, 1900

Balthus, *Nu au chat*, 1949

Fulvio Bianconi (designer), *Patchwork (Pezzato) vase*, Venini & Co., Murano, c.1950

Pablo Picasso, *Vase*, 1950

John Glover, *The River Nile, Van Diemen's Land, from Mr Glover's farm*, 1837

Albrecht Dürer, *Adam and Eve*, 1504

Amphora (Attic black-figure ware), 540–530 BC

Antonio Pollaiuolo, *Battle of the nudes*, early 1470s

Eugène von Guérard, *Ferntree or Dobson's Gully, Dandenong Ranges*, 1858

Indian *Tree goddess*, Hoysala period, 1120–1150

William Dobell, *Helena Rubinstein*, 1957

Fred Williams, *Upwey landscape*, 1965

Andrea Mantegna, *Battle of the Sea Gods: right half of a frieze*, early 1470s

Robert Delaunay, *Nue à lecture*, 1915

Bodhisattva, Avalokiteshvara, Tibeto-Chinese 17th–18th century

between pages 600 and 601

René Magritte, *L'éloge de la dialectique*, 1937

The Achilles painter (attributed to), *Lekythos* (Attic white-ground ware), 460–450 BC

Erich Heckel, *Standing child*, 1910 (from sixth *Die Brücke* portfolio, 1911)

Sideboard designed E Godwin, 1867, manufactured William Watt c.1885–1888

Francisco Goya y Lucientes, *¡Qué pico de Oro!*, Plate 53 from *Los Caprichos*, 1799

Rembrandt van Rijn, *St Jerome reading in an Italian landscape*, c.1653

Nathu, *Maharana Jawan Singh riding*, 1835

John Brack, *Portrait of Dr Ursula Hoff*, 1985

Canaletto, *Bacino di S. Marco: From the Piazzetta*, c.1735–1745

Tim Leura Tjapaltjarri, Anmatyerre and Clifford Possum Tjapaltjarri, Anmatyerre, *Napperby death spirit Dreaming*, 1980

Philip Guston, *Night*, 1972

Rover Thomas (Joolama), *Dreamtime story of the willy willy*, 1989

Three-tiered food box, *Jubako*, 17th–18th century

Giuseppe Gricci (sculptor), *Goffredo at the tomb of Dudone*, c.1745–1750, Capodimonte Porcelain Factory, Naples

Chen Hongshou, *Plum-blossom study*, late 1640s

Jacques-François Micaud, *Tureen and stand*, 1760, Sèvres Porcelain Factory, France

Head covering of Padihorpasheraset, Egypt, Roman period, AD 1st–2nd century

Howard Hodgkin, *Night and day*, 1997–1999

Master of the E-series Tarocchi, *Primo mobile*, c.1465

Nathaniel Dance, *Portrait of the Pybus Family*, 1769

Six Directors of the NGV: Dr Eric Westbrook, Gordon Thomson, Patrick McCaughey, James Mollison, Dr Timothy Potts and Dr Gerard Vaughan, 2002

Aerial view of The Ian Potter Centre: NGV: Australia at Federation Square and NGV: International at St Kilda Road

BLACK AND WHITE

Alfred Felton, photograph and signature	*Frontispiece*
Princes Bridge, 1886	12
Victoria's 'Declaration of Independence', 11 November 1850	14
Canvas Town, South Melbourne	16
Arthur Felton's grave, Melbourne General Cemetery	26
Felton Grimwade and Co's Stores, Flinders Lane and Bond Street, 1868	36
The New Premises of Messrs Felton Grimwade and Co, 1878	38
Soda water bottles in production, The Melbourne Glass Bottle Works Company, The Beach, Emerald Hill, 1876	41
Alfred Felton, 1867	46
FS Grimwade, 1867	46
St Kilda Pier, Sunday Afternoon, 1879	49
Almshouses of the Old Colonists' Association, 1870	52
The Melbourne Exchange Hall, 1879	55
Sir Redmond Barry	58
The Sculpture Gallery at the Public Library, 1866	61
Opening of the New Fine Arts Gallery, Public Library, 1875	65
International Exhibition of 1880 Building	68
Chloe—A Question of Propriety, 1883	69
Opening of Parliament—Interior of Legislative Council Chamber, 1864	72
H Byron Moore, 1881	76
The Telephone Room, Melbourne Exchange, 1881	80
Flinders Lane, c.1883	82
Messrs Felton and Grimwade Factories, 1884	84
Sunday Morning—Collins Street	96
The Australian Club	101

The Race between Beach and Hanlan for the Sculling Championship of the World	*105*
Cup Day, a Sketch on the Road, 1876	*108*
Rabbiters' Camp, near Ararat, 1892	*117*
'Wattle House', St Kilda, c. 1865	*121*
'Wattle House': Felton's billiard room, and tower	*122*
Bryan Champney Burstall, 1880	*124*
Charles Campbell	*126*
Murray Downs	*128*
The Rev. Charles Strong, c. 1881	*136*
The Australian Church, 1887	*138*
Professor Edward Morris, c. 1900	*139*
William Barak	*143*
Felton Cottages, Old Colonists' Homes: residents in the sun	*145*
The Melbourne Public Library, c. 1888	*146*
Robert Murray Smith	*163*
The Felton Building, 7 Queen Street	*166*
St Kilda jetty and the Esplanade Hotel, c. 1883	*179*
Felton's Rooms, Esplanade Hotel, 1902	*180–1*
Horse Exercise at home	*197*
The Sorrento Boat, and En route to Sorrento	*198*
Felton picnicking at Murray Downs	*199*
Felton at Coolart, 1898, with Pietro Baracchi, and with Edward Keep	*200*
Felton's phonograph, wood engraving by Helen Ogilvie	*203*
Felton with (Edward) William Grimwade in the garden at 'Harleston'	*209*
Mr Felton in London, 1889?	*211*
William Felton on his death-bed, 1900	*214*
'Wealth!! Get it spent'	*216*
Felton's last letter	*218*
The Trustees' Executors and Agency Company Building, Collins Street	*228*
FS Grimwade at 'Harleston', 1904	*230*
Dr Charles Bage	*234*
Lindsay Bernard Hall at home, c. 1900	*257*
Henry Gyles Turner, 1906	*270*
Frank Rinder	*331*
Dr Alexander Leeper	*336*
Sir John Longstaff	*360*
Sir Leo Cussen	*370*

James Alfred Levey	*381*
Norton, Harold, Sheppard and Russell Grimwade, 1928	*385*
Lindsay Bernard Hall, 1934	*405*
JS MacDonald, self-portrait	*419*
Sir Keith Murdoch	*452*
Sir Daryl Lindsay, Sir John Medley and Sir Alexander Stewart before Longstaff's *Alfred Felton*	*468*
AeJL McDonnell	*475*
Sir Daryl Lindsay and Sir Russell Grimwade, 'Miegunyah', 1952	*487*
Eric Westbrook	*501*
ARL Wiltshire, Dr Leonard Cox and Sir Owen Dixon	*510*
Dr Mary Woodall	*523*
The National Gallery of Victoria, St Kilda Road, 1968	*530*
Sir Clive Fitts, with Sir Robert Menzies	*542*
Sir Joseph Burke	*548*
Patrick McCaughey and Race Mathews before the Bouchers, 1982	*579*
Sir Gustav Nossal and Sir Andrew Grimwade, 1998	*593*
Mrs Caroline Searby	*596*

BIBLIOGRAPHY

ARCHIVAL SOURCES

Until 1996 the few surviving papers of Alfred Felton were either in the files of the Trustee Company or among Russell Grimwade's papers in the University of Melbourne Archives, which also holds the surviving records of Felton Grimwade and Company and related businesses. Part of the Trustee Company's Felton files were transferred to the State Library of Victoria in 1996, together with the Minute Books (from May 1904 to March 1991) and other records of the Felton Bequests' Committee. Later Minute Books and seven boxes of Felton Bequests' Committee papers remain with the Company. Many of the Felton Bequests' Committee papers are duplicated in the files of the National Gallery of Victoria, and in private papers. The following collections have been consulted:

The ANZ Executors and Trustee Company Limited, Collins Street, Melbourne

The files include Felton's 'AF Personal Gifts and Sundries' ledger 1890–1904; letters from his family and from Charles Campbell; photographs; the catalogue of sale of Felton's pictures; estate accounts; legal opinions concerning the Bequests; reports and correspondence from Advisers; 'Works of Art General Correspondence'; and a book of newspaper cuttings 1904–18.

La Trobe Library, State Library of Victoria, Australian Manuscripts Collection

Records of the Felton Bequests (PA 96/83, Range 42), comprising:

Bound volumes of Minutes of the Felton Bequests' Committee from 5 May 1904 to 13 November 1990; a volume of Minutes of Conferences, 1933–55; Minute Book of the Australian Salt Manufacturing Company; and a ledger 'Breakdown of the Estate'.

Seven boxes of records, containing: a 'Catalogue of Works proposed for Purchase 1947–1962' (Box 1); Press cuttings, English 1922–33, Australian 1936–53, 1952–69 (Box 2); miscellaneous publications, including reports of charities (Box 3); Account book 'Alfred Felton, Melbourne Glass Bottle Works 1882–1903', the 'AF No1 General' letterbook 1895–96, and the 1875–85 letterbook (Box 4); legal and financial documents including

annual balance sheets of Felton Grimwade and Co. 1883–89 (Box 5) and Trustees Executors and Agency Co papers concerning Felton's estate (Boxes 6 and 7).
Henry Gyles Turner Papers (MS12989)
Leonard B Cox Papers (PA 98/58)

University of Melbourne Archives

Sir Russell Grimwade papers. Acc No 94/2, U31/5–9 includes material on Felton collected by Grimwade, and notes added later by Poynter. Acc Nos 81/72 and 75/89 contain Russell Grimwade's photographs.

Drug Houses of Australia Ltd. Acc 75/72 includes 'FG&Co Private Letters' (the Partners letterbook) (1884–95) and Bosisto material.

Bright Family papers. Acc 80/75 includes AE Bright's National Gallery and Felton Bequests' papers, 1925–36.

Sir Clive Fitts papers. Acc 84/63 (LS 4/8/13) includes 10 boxes of Felton Bequests' material.

Sir Joseph Burke papers, Acc 86/37.

Sir Andrew Grimwade has recently deposited papers in the University Archives. I am grateful for access to some of this material.

National Gallery of Victoria Library

Felton Bequest papers (mostly copies, though some are original).

Copies of the papers of L Bernard Hall held by the Australian National Gallery, Canberra.

National Library of Australia

Charles Strong papers (MS2282).
James S MacDonald papers (MS 430, especially Series 4).
Sir Keith Murdoch papers (MS 2823).

Leeper Library, Trinity College, University of Melbourne

Alexander Leeper papers.

BOOKS, CHAPTERS IN BOOKS, ARTICLES, PAMPHLETS AND THESES

[Anon] *Felton Grimwade & Co. Forty Years' Retrospect, July 1 1867 to July 1 1907*, reprinted from *The Chemist and Druggist of Australasia*, 1 July 1907.

[Anon] *Our First Fifty Years*, Victorian Souvenir Edition, Film and Book Publishing for the Herald and Weekly Times, Melbourne, 1986. (Chapters reprinted from *The Picturesque Atlas of Australasia*, Melbourne, 1886-8.)

[Anon] [Russell Grimwade?] *The Story of J. Bosisto & Co. Pty. Ltd. 1852 to 1952: A Century of Gum Leaves*, published by J. Bosisto & Co. Pty Ltd, Melbourne [1952?].

Aders, Elizabeth, Kent, Rachel, and Lindsay, Frances, *Art, Industry and Science: The Grimwade Legacy*, The University of Melbourne Museum of Art [1997].

Adamson, Graeme, *A century of change: the first hundred years of the Stock Exchange of Melbourne*, Currey O'Neil, South Yarra, 1984.

Anderson, Jaynie, 'In Homage to Ursula Hoff on her Ninetieth Birthday', *Art and Australia*, 2000, no. 2, pp. 250–7.

——, *Tiepolo's Cleopatra*, Macmillan, Melbourne, 2003.

——, with Paffen, Paul, 'The Sculptor Writes: Rodin in Correspondence with Melbourne', in *Rodin: Sculpture and Drawings*, National Gallery of Australia, Canberra, 2001.

Anderson, Paul, *The Citizens Welfare Service of Victoria 1887–1987: A Short History*, privately printed by the Citizens Welfare Service, Melbourne, 1987.

Armstrong, Edmund La Touche, *The Book of the Public Library, Museums, and National Gallery of Victoria, 1856–1906*, Melbourne, 1906.

——, with Boys, Robert Douglas, *The Book of the Public Library, Museums, and National Gallery of Victoria, 1907–1931*, Melbourne, 1932.

Badger, CR, *The Reverend Charles Strong and the Australian Church*. Abacada Press, Melbourne, 1971.

Bage, C (compiler), *Historical Record of the Felton Bequests, from their inception to 31st December 1922*, Felton Bequests' Committee, Melbourne, 1923.

——, *Historical Record of the Felton Bequests, Supplement No. 1, from January 1st 1923 to December 31st, 1926*. Felton Bequests' Committee, Melbourne, 1927.

Bate, Weston, 'Gold: Social Energiser and Definer', *Victorian Historical Journal*, vol. 72, nos 1–2, September 2000, pp. 7–27.

——, *A History of Brighton*, 2nd ed., Melbourne University Press, 1983.

——, *Victorian Gold Rushes*, 2nd ed., Sovereign Hill Museums Association, Ballarat, 1999.

Blainey, Geoffrey, *Gold and Paper: A History of The National Bank of Australasia*, Georgian House, Melbourne, 1958.

——, *A Land Half Won*, Macmillan, Melbourne, 1980.

——, *The Rush that Never Ended: A History of Australian Mining*, 4th ed., Melbourne University Press, 1993.

Blunt, Wilfrid, *Cockerell: Sydney Carlyle Cockerell, Friend of Ruskin and William Morris and Director of the Fitzwilliam Museum*, Hamish Hamilton, London, 1964.

Briggs, Asa, *Victorian Cities*, Penguin ed., London, 1968.

Broome, Richard, *The Victorians: Arriving*, Fairfax Syme and Weldon Associates, Sydney, 1984. (Volume 1 of the *150th Anniversary History of Victoria*)

Burdett, Basil, *The Felton Bequests: an Historical Record. 190–1933*, Felton Bequests' Committee, Melbourne, 1934.

Burke, Joseph, 'Alfred Felton and his Bequest', *Meanjin*, vol. 7, no. 2, 1948, pp. 95–104.

Burt, Sandra, 'Marcus Clarke at the Public Library', *The La Trobe Journal*, no. 67, Autumn 2001, pp. 55–60.

Butlin, M and Gott, T, *William Blake in the Collection of the National Gallery of Victoria*, with an Introduction by Irena Zdanowicz, National Gallery of Victoria, Melbourne, 1989.

Cannon, Michael, *The Land Boomers*, Melbourne University Press (corrected edition), 1967.

—— *Melbourne after the Gold Rush*, Loch Haven Press, Main Ridge, 1993.

—— *Old Melbourne Town before the Gold Rush*, Loch Haven Press, Main Ridge, 1991.

Carey, John, *The Intellectuals and the Masses: Pride and Prejudice among the Literary Intelligentsia, 1880–1939*, Faber and Faber, London, 1992.

Carroll, John (ed.), *Intruders in the Bush: The Australian Quest for an Identity*, 2nd ed., Oxford University Press, Melbourne, 1992.

Casey, Lord, *Australian Father and Son*, Collins, London, 1966.

Clark, Jane, and Whitelaw, Bridget (eds), *Golden Summers: Heidelberg and Beyond*, International Cultural Corporation of Australia, Melbourne, 1985.

Clark, Sir Kenneth, *Another Part of the Wood: A Self-Portrait*, Coronet Books, Hodder and Stoughton, 1976 ed.

——, *The Idea of a Great Gallery*, A Lecture Delivered at the University of Melbourne under the auspices of the Trustees of the National Gallery and the National Gallery Society, January 27, 1949, The Specialty Press Pty Ltd, Melbourne, 1949.

Clarke, FG, *The Land of Contrarities: British Attitudes to the Australian Colonies, 1828–1855*, Melbourne University Press, 1977.

Coman, Brian, *Tooth and Nail: The Story of the Rabbit in Australia*, Text Publishing, Melbourne, 1999.

Conley, Margaret, 'The "Undeserving" Poor: Welfare and Labour Policy', in Richard Kennedy, (ed.), *Australian Welfare History: Critical Essays*, Melbourne, Macmillan, 1982, pp. 281–303.

Cooper, John Butler, *The History of St Kilda: from its First Settlement to a City—and after, 1840 to 1930*, Printers Pty Ltd, Melbourne, 1931.

Cox, Leonard B, *The National Gallery of Victoria 1861 to 1968: A search for a Collection*, National Gallery of Victoria, Melbourne, [1970].

[Croft, Alice], *History of Murray Downs Station*, privately printed, Swan Hill, *c.* 1965.

Croll, RH, 'The Original Owners. Notes on the Aborigines of Victoria', in *Centenary Journal 1934–1935*, ed. LL Politzer, Collinson's Publishing Service, Collins St, 1934.

Cuming, James (ed. John Lack and MA Cuming), *An Autobiography*, City of Footscray Historical Society, Footscray, 1987.

Davidson, Jim, *Lyrebird Rising: Louise Hanson-Dyer 1884–1962*, Melbourne University Press at the Miegunyah Press, 1994.

Davison, Graeme, *The Rise and Fall of Marvellous Melbourne*, Melbourne University Press, 1978.

Davison, Graeme, Hirst, John, and Macintyre, Stuart (eds), *The Oxford Companion to Australian History*, Oxford University Press, Melbourne, 1998.

Dean, Sonia, *European Paintings of the 19th and Early 20th Centuries in the National Gallery of Victoria*, National Gallery of Victoria, Melbourne, 1995.

De Courcy, Catherine, *The Foundation of the National Gallery of Ireland*, The National Gallery of Ireland, Dublin, 1985.

de Serville, Paul, *The Australian Club, Melbourne 1878–1998*, The Australian Club, Melbourne, 1998.

——, *Port Phillip Gentlemen: Gentlemen and Good Society in Melbourne before the Gold Rushes*, Oxford University Press, Melbourne, 1980.

——, *Pounds and Pedigrees: The Upper Classes in Victoria 1850–80*, Oxford University Press, Melbourne, 1991.

Denis, Rafael Cardoso, and Trodd, Colin (eds), *Art and the Academy in the Nineteenth Century*, Manchester University Press, 2000.

Dickey, Brian, *No Charity There: A Short History of Social Welfare in Australia*, Nelson, Melbourne, 1980.

Dingle, Tony, *The Victorians: Settling,* Fairfax Syme and Weldon Associates, Sydney, 1984. (Volume 2 of the *150th Anniversary History of Victoria*)

Dowling, Peter, 'Gold in Australia: Image and Text in the *Illustrated London News*', *The La Trobe Journal*, no. 67, 2001, pp. 24–38.

Dugan, D, 'Victoria's Largest Exhibition', *Victorian Historical Journal*, vol. 54, no. 3, 1983, pp. 1–11.

Duncan, Carol, *Civilizing Rituals: Inside Public Art Museums*, Routledge, London and New York, 1995.

Dunstan, David, *Victorian Icon: The Royal Exhibition Building, Melbourne*, The Exhibition Trustees, Melbourne, 1996.

Dutton, Geoffrey, *The Innovators: the Sydney alternatives in the rise of modern art, literature and ideas,* Macmillan, Melbourne, 1986.

Eagle, Mary, *The Art of Rupert Bunny in the Australian National Gallery*, Australian National Gallery, Canberra, 1991.

Earnshaw, MGL, *The Church on Market Hill*, Essex Electronic Interface, n.d.

Elder, Jean, and Meadows, Kay, *Getting Commercial About Being Charitable: Business and Community Partnerships*, Philanthropy Monograph #1, Melbourne, 2000.

Ellman, Richard, *Oscar Wilde*, Random House, New York and London, 1987.

Feehan, H Victor, 'Joseph Bosisto: A re-appraisal', *Victorian Historical Journal*, vol. 50, no. 4, 1979, pp. 221–36.

Feldtmann, Arthur, *Swan Hill*, Rigby, Adelaide, 1973.

Fox, Len, *E Phillips Fox and his Family*, Sydney, 1985.

Fullerton, Patricia, *Hugh Ramsay: His Life and Work*, Hudson, Hawthorn, 1988.

Galbally, Ann, *The Art of John Peter Russell*, Sun Books, South Melbourne, 1977.

——, *Charles Conder, the last bohemian*, Melbourne University Publishing at the Miegunyah Press, 2002.

——, *The Collections of the National Gallery of Victoria*, Oxford University Press, Melbourne, 1987.

——, *Redmond Barry: An Anglo-Irish Australian*, Melbourne University Press, 1995.

——, and Inglis, Alison (with Christine Downer and Terence Lane), *The First Collections: The Public Library and National Gallery of Victoria in the 1850s and 1860s*, University of Melbourne Museum of Art, Melbourne, 1992.

——, and Sloggett, Robyn, '"Duty points to Paris": John Peter Russell's *Dr Will Maloney* as talisman', *Art Bulletin of Victoria*, vol. 37, 1997.

Garden, Don, *Theodore Fink*, Melbourne University Press, Melbourne, 1998.

Garran, Andrew (ed.), *The Picturesque Atlas of Australasia*, The Picturesque Atlas Publishing Co, Sydney, 1886–88.

Garton, Stephen, *Out of Luck; Poor Australians and Social Welfare*, Allen and Unwin, Sydney, 1990.

Glass, Margaret, *Tommy Bent: 'Bent by name, bent by nature'*, Melbourne University Press, 1993.

Goodman, David, *Gold Seeking: Victoria and California in the 1850s*, Allen and Unwin, Sydney, 1994.

Gow, Ian, and Clifford, Timothy, *The National Gallery of Scotland: an Architectural and Decorative History*, The National Galleries of Scotland, Edinburgh, n.d. [1988?].

Grant, James, and Serle, Geoffrey, *The Melbourne Scene 1803–1956*, Melbourne University Press, 1957.

Gregory, John, and Zdanowicz, Irena, *Rembrandt in the Collections of the National Gallery of Victoria*, National Gallery of Victoria, Melbourne, 1988.

Greig-Smith, S, 'The Development of Philanthropic and Social Work in Victoria', in *Centenary Journal 1934–1935*, ed. LL Politzer, Collinson's Publishing Service Collins St, 1934.

Grimwade, Sir Andrew, The Story of Edward French 1786–1835, unpublished typescript, 2001.

Grimwade, John FT, *A Short History of Drug Houses of Australia Ltd to 1968*. privately published, Melbourne, 1974.

Grimwade, Sir Russell, *Flinders Lane: Recollections of Alfred Felton,* Melbourne University Press, 1947.

——, 'Some memories of Alfred Felton', Speech given at the opening of Murdoch Gallery, Melbourne, 1954.

Hall, Bernard, *Art and Life*, Hassell, Adelaide, 1918.

Hendy, Philip, *The National Gallery London*, Thames and Hudson, London, 1963 ed.

Hoff, Ursula, *European Painting and Sculpture Before 1800*, National Gallery of Victoria, Melbourne, 1973 and 1995 eds.

——, 'The Everard Studley Miller Bequest', in A Bradley and T Smith (eds), *Australian Art and Architecture*, Melbourne, 1980.

——, *The Felton Bequest*, National Gallery of Victoria, Melbourne, 1983.

——, 'Variation, Transformation and Interpretation: Watteau and Lucien Freud', *Art Bulletin of Victoria*, no. 31, National Gallery of Victoria, 1990, pp. 26–31.

Hudson, Hugh, Frank Rinder and the Felton Bequest 1918–1928: International Acquisition Policy, Art Curatorship and Museum Management Postgraduate Diploma, University of Melbourne, 1998.

——, Re-examining Van Eyck: a new analysis of the *Ince Hall Virgin and Child*, MA, University of Melbourne, 2001.

Kane, Barbara B, Rupert Bunny's Symbolist Decade: A Study of The Religious and Occult Images 1887–1898. MA, University of Melbourne, 1998.

Kehoe, Mary, *The Melbourne Benevolent Asylum, Hotham's Premier Building*, The Hotham History Project, North Melbourne, 1998.

Kennedy, R, 'Charity and Ideology in Colonial Victoria', in R. Kennedy (ed.), *Australian Welfare History: Critical Essays*, Macmillan, Melbourne, 1982.

——, *Charity Warfare: The Charity Organisation Society in Colonial Melbourne*, Hyland House, Melbourne, 1985.

Kenyon, Alfred S, *The Story of Melbourne*, Lothian Book Publishing Company, Melbourne, [1934].

Knibbs, GH (ed.), *Federal Handbook prepared in connection with the 84th meeting of the British Association for the Advancement of Science held in Australia August 1914*.

Lack, John, *A History of Footscray*, Hargreen Publishing in conjunction with the City of Footscray, North Melbourne, 1991.

Leat, Diana, and Lethlean, Esther, *Trusts and Foundations in Australia*, Melbourne, Philanthropy Australia, Melbourne, 2000.

Lindsay, Daryl (ed.), *The Felton Bequest: An Historical Record*, Oxford University Press, Melbourne, 1963.

McCaughey, Davis, Perkins, Naomi, and Trumble, Angus, *Victoria's Colonial Governors, 1839–1900*, Melbourne University Press at the Miegunyah Press, 1993.

McNicoll, Ronald, *Number 36 Collins Street: Melbourne Club 1838–1988*, Allen & Unwin/Haynes, Melbourne, 1988.

McQueen, Humphrey, *The Black Swan of Trespass: The Emergence of Modern Painting in Australia to 1944*, Alternative Publishing Cooperative Limited, Sydney, 1979.

——'Jimmy's Brief Lives', in A Bradley and T Smith (eds), *Australian Art and Architecture*, Melbourne, 1980.

McQueen, Rob, 'Limited Liability Company Legislation: The Australian Experience 1864–1920', *Law and History in Australia*, vol. 5, 1989 Conference, ed. Suzanne Corcoran for the Adelaide Law Reform Association, 1991, pp. 57–75.

Magarey, Susan, *Unbridling the Tongues of Women: a Biography of Catherine Helen Spence*, Hale and Iremonger, Sydney, 1985.

Manion, Margaret, *The Wharncliffe Hours: a study of a fifteenth-century prayerbook*, Sydney University Press, 1972.

Manuscripts and Books of Art acquired under the terms of the Felton Bequest, Melbourne, Public Library, Museums and National Gallery of Victoria, 1938.

Marr, David, 'Changing the Label', *National Times*, 3 August 1984, pp. 16–18.

Martin, AW, *Robert Menzies: A Life, vol. 1, 1894–1943*, Melbourne University Press, 1993.

Moore, Felicity St John, *Classical Modernism: The George Bell Circle*, National Gallery of Victoria, Melbourne, 1992.

Morphy, Howard, 'Seeing Aboriginal Art in the Gallery', in 'Museums of the Future: The Future of Museums', *Humanities Research*, vol. VIII, no. 1, 2001, pp. 37–50.

Mulvaney, DJ, and Calaby, JH, *'So Much That Is New': Baldwin Spencer 1860–1929*, Melbourne University Press, 1985.

Mulvaney, John, and Kamminga, Johan, *Prehistory of Australia*, Allen and Unwin, Sydney, 1999.

Official Record of the Intercolonial Exhibition of Australasia, Melbourne 1866–67, Melbourne, 1867.

Official Record of the Melbourne International Exhibition 1880–81, Melbourne, 1882.

Official Record of the Centennial International Exhibition, Melbourne, 1888–89, Melbourne 1890.

Oldham, John, and Stirling, Alfred, *Victorian: A Visitors Book*, 2nd ed., The Hawthorn Press, Melbourne, 1969.

O'Neill, Frances, *Picturesque Charity: The Old Colonists' Homes, North Fitzroy*, Monash Publications in History: no. 9, 1991.

Pacini, John, *Windows on Collins Street: A History of the Athenaeum Club, Melbourne*, The Athenaeum Club, Melbourne, 1991.

Paffen, Paul, 'Everard Studley Miller and his Bequest to the National Gallery of Victoria', *Art Bulletin of Victoria*, 35, 1994, pp. 33–44.

Palmer, Sheridan, 'The Latest in Artistic Endeavours', and 'Art in Decline', in David Dunstan, *Victorian Icon: The Royal Exhibition Building, Melbourne*, The Exhibition Trustees, Melbourne, 1986.

Penwill, Beryl, *Looking Back, Looking Forward: The Story of 'Berry Street' Child and Family Care*, Berry Street Child and Family Care, Melbourne, 1953.

Pescott, RTM, *Collections of a Century*, National Museum of Victoria, Melbourne, 1954.

Philipp, F, and Stewart, J (eds), *In Honour of Daryl Lindsay: Essays and Studies*, Oxford University Press, Melbourne, 1964.

Physick, John (ed.), *The History of the Victoria and Albert Museum*, HMSO, London, 1976.

Pigot, John (curator), *Norman Macgeorge, Man of Art*, Ian Potter Museum of Art, University of Melbourne, Melbourne, 2001.

Plant, Margaret, *French Impressionists and Post-Impressionists* (rev. ed.), National Gallery of Victoria, Melbourne, 1977.

Poynter, John, *Alfred Felton*, Oxford University Press, Melbourne, 1974.

——, *Doubts and Certainties: A Life of Alexander Leeper*, Melbourne University Press, 1999.

——, *Russell Grimwade*, Melbourne University Press at the Miegunyah Press, 1967.

——, *Society and Pauperism: English Ideas on Poor Relief, 1795–1834*, Routledge and Kegan Paul and Melbourne University Press, London, Toronto and Melbourne, 1969.

——, 'The Yo-yo Variations: Initiative and Dependence in Australia's External relations, 1918–23', *Historical Studies*, vol. 14, no. 54, 1970, pp. 231–49.

———, and Rasmussen, Carolyn, *A Place Apart: The University of Melbourne: Decades of Challenge*, Melbourne University Press, 1996.

Priestley, Susan, *The Victorians: Making Their Mark,* Fairfax Syme and Weldon Associates, 1984, Sydney. (Volume 3 of the *150th Anniversary History of Victoria*)

Radford, Ron, et al., *The Story of the Elder Bequest,* The Art Gallery of South Australia, Adelaide, 2000.

Rae, Ian D, and Lack, John, 'Development of the Acid and Fertiliser Industry in Nineteenth Century New Zealand: Business Networks and Government rewards', 2001.

Rasmussen, Carolyn, et al., *A Museum for the People: a History of Museum Victoria and its Predecessors 1854-2000*, Scribe Publications in association with Museum Victoria, Melbourne, 2001.

Reddin, Collette, *Rupert Bunny by Himself: His Final Years in Melbourne*, privately published, Melbourne, 1987.

Reid, Barrett, and Underhill, Nancy (eds), *Letters of John Reed: Defining Australian Cultural life 1920–1981*, Viking, Melbourne, 2001.

Reitlinger, Gerald, *The Economics of Taste*. Volume 1: *The Rise and Fall of Picture Prices 1760–1960*, Barrie and Rockliffe, London, 1961.

Rickard, John, *A Family Romance: The Deakins at Home,* Melbourne University Press, 1996.

Ridley, Ronald (ed.), *The Diary of a Vice-Chancellor; University of Melbourne 1935–1938, Raymond Priestley*, Melbourne University Press, 2002.

Rivett, Rohan, *Australian Citizen: Herbert Brookes 1867–1963*, Melbourne University Press, 1965.

Rolls, Eric C, *They All Ran Wild*: *Animals and Plants that Plague Australia,* Angus and Robertson, Sydney, 1969.

Ryan, Peter, *Redmond Barry: A Colonial Life 1813–1880*, Oxford University Press, Melbourne, 1972, Melbourne University Press, 1980.

Sandilands, Jane, *Helen Macpherson Schutt, Philabnthropist*, Melbourne, Helen M Schutt Trust, Melbourne, 2001.

Saunders, Helen Lorraine, L Bernard Hall and the National Gallery of Victoria: Conflict and Change, MA, University of Melbourne, 1984.

Sayers, Andrew, *Aboriginal Artists of the Nineteenth Century*, Oxford University Press in association with the National Gallery of Australia, Melbourne, 1994.

Serle, Geoffrey, *From the Deserts the Prophets Come*, Heineman, Melbourne, 1973.

———, *The Golden Age, A History of the Colony of Victoria 1851–1861*, Melbourne University Press, 1963.

———, *Percival Serle, 1871-1951: Biographer, Bibliographer, Anthologist and Art Curator. A Memoir*, Officina Brindabella, Canberra, 1988.

———, *Robin Boyd: A Life*, Melbourne University Press, 1995.

———, *The Rush to be Rich, A History of the Colony of Victoria 1883–1889*, Melbourne University Press, 1971.

——, *Sir John Medley: A Memoir*, Melbourne University Press, 1993.

[Serle, Percival, et al.], *Alfred Felton and His Art Benefactions*, Printed for the Trustees of the Public Library, Museums and National Gallery, Melbourne, 1936.

Shaw, AGL, *A History of the Port Phillip District: Victoria Before Separation*, Melbourne University Press at the Miegunyah Press, 1996.

Shears, Susie, *A Guide to the Geelong Art Gallery and its Collections*, Geelong Art Gallery, Geelong, 1989.

Smith, Bernard, *Australian Painting 1788–2000*, 2nd ed., Oxford University Press, Melbourne, 2001.

——, *Modernism's History: A study in twentieth-century art and ideas*, UNSW Press, Sydney, 1998.

——, (ed.), *Documents on Art and Taste in Australia: The Colonial Period 1770–1914*, Oxford University Press, Melbourne, 1975.

Spalding, Frances, *The Tate: a History*, Tate Gallery Publishing, London, 1998.

Spencer, Sir Baldwin, *Wanderings in Wild Australia*, Macmillan, London, 1928.

Stirling, Alfred, *Joseph Bosisto*, The Hawthorn Press, Melbourne, 1970.

Struve, Walter, 'Nineteenth Century German Melbourne on Display', in Ellen I Mitchell (ed.), *Baron von Mueller's Melbourne*, Plenty Valley Papers, vol. 3, La Trobe University, Melbourne, 2000.

Sturgess, Nancy, 'Rembrandt by Himself: A Brief History of the Melbourne Portrait of Rembrandt by an Unknown Artist', *Art Bulletin of Victoria*, no. 33, National Gallery of Victoria, 1993, p. 48.

Sutherland, Alexander, *Victoria and its Metropolis*, Melbourne, McCarron Bird and Co, 1888.

Swain, Shurlee, 'The poor people of Melbourne', in G Davison, D Dunstan, & C McConville, *The outcasts of Melbourne: Essays in Social History*, Allen and Unwin, Sydney, 1985.

——, 'Confronting Cruelty: Writing a History of the Detection and Treatment of Child Abuse', *Victorian Historical Journal*, vol. 71, no. 1, March 2000, pp. 7–18.

——, The Victorian Charity Network in the 1890s, PhD, University of Melbourne, 1977.

Thomas, David, *Rupert Bunny 1864–1947*, Melbourne, Lansdowne Press, 1970.

Tolley, Michael J, 'William à Beckett's Copy of Young's *Night Thoughts*', *Art Bulletin of Victoria*, no. 30, 1989, pp. 24–35.

Topsfield, Andrew, *Paintings from Rajasthan in the National Gallery of Victoria: A Collection acquired through the Felton Bequests' Committee*, National Gallery of Victoria, Melbourne, 1980.

Trendall, AD, *Greek Vases in the Felton Collection*. National Gallery of Victoria with Oxford University Press, Melbourne, 1968.

——, *Greek Vases in the National Gallery of Victoria*, National Gallery of Victoria, Melbourne, 1978.

Trumble, Angus, 'Harry P Gill', and 'The £10,000 London Buying Spree of 1899 and Beyond', in *The Story of the Elder Bequest*, The Art Gallery of South Australia, Adelaide, 2000.

Twopeny, REN, *Town Life in Australia*. London, 1883 (Penguin Colonial Facsimile Reprint, Melbourne, 1973).

Tzamouranis, Peter, A Presentation of Dr Mary Woodall (1901-1988): First Woman to be Appointed London-based Adviser to the Felton Bequest at the National Gallery of Victoria, BA Hons, 2002

Vaughan, Gerard, 'An Eighteenth-Century Classicist's Medievalism: The Case of Charles Townley', in BJ Muir (ed.), *Reading Texts and Images: Essays on Medieval and Renaissance Art and Patronage in Honour of Margaret M Manion*, University of Exeter Press, 2002.

——, 'The Armytage Collection, Taste in Melbourne in the late 19th Century', *Studies in Australian Art*, 1978, p. 35.

——, Art Collectors in Colonial Victoria 1854–1892: An Analysis of Taste and Patronage, BA Honours, University of Melbourne, 1976.

——, et al., *European Masterpieces: Six Centuries of Paintings from the National Gallery of Victoria, Australia*, National Gallery of Victoria, Melbourne, 2000.

Victoria: the First Century: An Historical Survey, Centenary Celebrations Council, Robertson and Mullen, Melbourne, 1934.

Watts, Rob, 'The Origins of the Australian Welfare State', in R Kennedy (ed.), *Australian Welfare History: Critical Essays*, 1982.

Wheare, KC, *Government by Committee: an Essay on the British Constitution*, Oxford, Clarendon Press, 1955.

White, Richard, *Inventing Australia: Images and Identity 1688–1980*, George Allen and Unwin, Sydney, 1981.

Williams, AJ, *A Concise History of Maldon and the Tarrangower Diggings*, Maldon Times, Maldon, 1953.

Wright, Ray, *A Blended House: The Legislative Council of Victoria 1851–56*, Legislative Council, Parliament of Victoria, Melbourne, 2001.

Zacharin, RF, *Emigrant Eucalypts: Gum Trees as Exotics*, Melbourne University Press, 1978.

Zdanowicz, Irena, 'Introduction: The Melbourne Blakes—Their Acquisition and Critical fortunes in Australia', in M Butlin and T Gott, *William Blake in the collection of the National Gallery of Victoria*, Melbourne, National Gallery of Victoria, 1989, pp. 10–19.

INDEX

Italic numerals refer to illustrations

Adam, Dr Leonhard, 445
Adamson, LA, 397–8
Addis, Rev William, 191
Adelaide Chemical Works Company, 38, 172, 186, 227
Adelaide Public Library, Museum and Art Gallery, 225–6, 238, 249, 446
Admans, Sylvia, 594–5
Agnew's, 279, 580
Aitken, Charles, 312, 315, 317, 332, 363
Alcock, RJ, 255
Alexander, Dr Hattie E, 539
Alfred Felton Koorie Secondary School Scholarships Program, 592, 595; *see also* Indigenous Australians, assistance from Felton Charitable Bequest
Allen, WH, 155
Alma-Tadema, Sir Lawrence, 145, 277
Aman-Jean, Edmond François, 260, 265, 271
Amigoni, Jacopo, 483
Andrews, Michael, 522
Angry Penguins, 472
Annand, Douglas, 448
ANZ Executors and Trustee Company Limited, 552, 557, 583, 585, 587–8, 591–2
Archipenko, Alexander, 606
Armstrong, HC, 87–8, 184, 345, 399
Armytage, Ada, 120
Armytage, FW, 149, 150
Arp, Hans, 573–4

Art Foundation of Victoria, 572–3, 575, 577–8
Art Gallery of NSW (formerly National), 242, 282, 417
art market, 241, 300, 368–9, 474, 496, 506, 528
Ashfold (AF's butler), 97, 98
Ashton, Howard, 298
Ashton, Julian, 147, 272
Ashton, Sir Leigh, 444, 476
Ashton, Will, 272, 318, 446, 448
Asian art, 333, 397, 470, 495–6, 507, 522, 526, 560–1, 570
Australia Council (formerly Australian Council for the Arts), 526, 567
Australian Aborigines, *see* Indigenous Australians
Australian Academy of Art, 424–6, 446
Australian Art Association, 235, 249, 305, 365, 420
Australian Association of Philanthropy, 549–50, 583, 588; *see also* Philanthropy Australia
Australian Church, 137, 138, 191, 203, 207, 219–20, 227, 253; *see also* Strong, Rev Charles
Australian Club, 54, 71, 100, 101, 103–4, 107, 160, 194

Australian Council of Social Service (ACOSS), 588–9
Australian Glass Manufacturers (later Australian Consolidated Industries), 322, 377; *see also* Melbourne Glass Bottle Works
Australian National Gallery, 566, 577
Australian Salt Manufacturing Company, 42, 85–6, 171–2, 176

Bage, Dr Charles, 78, 188, 230, *234*, 235, 588; physician, 217, 220, 287; FBC, 233, 253–4, 335, 366, 368, 392, (Chairman), 235, 274, 276, 279–80, 282–4, 287, 299–300, 313–14, 329, 355–6, 371, 373–4, (defends Gibson), 291, 293–4, 302, 307, (defends Rinder), 342, 346, 353, 356–8, 361, 363, (*Record*), 396–7, 519
Bage, Edward, 31, 75, 78–9, 81, 100, 133, 165, 235
Bage, Robert, 230
Bailey, Willoughby James, 599
Baillieu, William Laurence, 323–4
Baker, Collins, 363
Balderson, R, 144
Bale, AME (Alice), 354, 359–60, 379, 382

Balthus (Balthazar Klossowski de Rola), 489
Baracchi, Pietro, 155, 183, 199, *199*, 200, 232
Barak, William, 142, *143*, 402
Barbari, Jacopo, 560
Bardon, Geoffrey, 597
Barlow, Sir Thomas, 482, 500–1
Barnet, Nahum, 339
Barnett, Walter, 391–4, 448
Barocci, Federico, 565, 581
Barr Smith, Robert, 225, 260
Barrett, Douglas, 526
Barrow, Louisa, 59
Barry, Sir Redmond, *58*, 58–9, 62–7, 259, 404–5, 591; statue, 267
Barye, Antoine-Louis: bronzes, 262
Bastien-Lepage, Jules, 290, 356, 359
Bateman, Edward La Trobe, 514
Beardsley, Aubrey, 288, 331
Bearsley, Peter, 588, 592
Beavis, Richard, 201, 245
Beerbohm, Max, 331
Begeyn, Abraham, 376
Begg, Kenneth, 512, 524
Begg, TDM, 112–13, 116, 169
Bell, George, 321, 333, 354, 359–60, 373, 411, 423–6, 440
Bell, Vanessa, 355
Bellini, Mario, 607
Bellotto, Bernardo, 444
Benn, John, 220, 227

628

Bent, Thomas, 107, 239
Bentham, Jeremy, 4, 536
Berchem, Nicholas, 493
Bernini, Gian Lorenzo, 563, 560
Berry, Graham, 55–6, 67–8, 70–3
Berry, Henry, 146–7
Berthot, Jake, 601
Best, Robert, 224
Bickford and Sons, 32, 190
Binyon, Laurence, 313, 315
Bird, F Dougan, 120, 217, 220
Blackburn, Maurice, 337, 384
Blake, William, 237, 248, 345, 442, 473, 480–1, 519, 598;
water-colours, 315–17, 327–9, 341
Bluett, EE, 443; FBC Adviser, 463, 468, 476, 486, 495, 496, 515
Blunt, Sir Anthony, 464, 476, 525
Bodkin, Thomas, 238–9, 366–7, 518
Boecklin, Arnold, 573
Boehm, Sir Joseph Edgar: *St George and the Dragon*, 147, 266–7, 448
Bohemian Club, 106
Bolte, Sir Henry, 505, 513, 527, 542, 565
Bonington, RP, 290; *Low Tide at Boulogne*, 201, 245–7
Bonnard, Pierre, 332, 460, 482
Books of Hours: *The Wharncliffe Horae*, 340, 343, 398, 514; the Acciaiuoli-Strozzi *Book of Hours*, 514
books, 398–9, 423, 531–2, 560
Borrill, Annie, 210, 212–13, 229
Bosboom, Johannes, 288, 292
Bosisto, Joseph, 33–4, 67, 82–3, 145, 166–7; *see also* J. Bosisto and Company
Boucher, François, 384, 414, 526, 578, 579, 599
Boudin, Eugène Louis, 296, 432
Boyd, Arthur Merric, 147, 471, 521
Boyd, Emma Minnie, 147
Boyd, Robin, 519, 524, 527

Boyd, Theodore Penleigh, 333, 337
Boys, RD, 393
Brabazon, Hercules B, 360
Brack, John, 513; portraits of Dr Ursula Hoff, 578–9
Bracks, Steve, 591
Bradford, E, 155
Brandeis, A, 151–2
Brangwyn, Frank, 488
Braque, Georges, 437–9, 495, 506
Bredius, Dr A, 343
Breughel, Jan, Breughel the Elder, 459, 508–9
Bright, Alfred, 337, 344, 435, 491; FBC, 372, 394–5, 407–8, 416–417, 419, 435; Gallery Trustee, 352–4, 362, 373, 403–4, (President), 372, 413, 423
British Art Gallery Exhibition 1892, 154
British Museum, 315
Britten, Jack, 599
Bromley, FH, 239, 282
Brookes, Herbert, 207–9
Brotherhood of St Laurence, 545, 547, 554, 589, 594
Bruce, JM, 144
Buckhurst, William 119
Buckland, William, 543; Foundation, 583, 592
Buckmaster, Ernest, 379, 446
Buffet, Bernard, 494
Bunny, Brice, 45, 98, 152
Bunny, George, 190
Bunny, Rupert, 45, 98, 152–3, 231, 262, 272, 305, 379, 426, 460, 466, 575; *Saint Cecilia*, 153, 218, 219; *Sea Idyll*, 154, 204
Burdett, Basil, 371, 373, 378, 410, 422, 436–8, 448, 484; FBC Adviser, 416, 419–20; *Herald* exhibition, 436–41, 457; *Record of the Felton Bequests*, 396–9, 519
Burke, Sir Joseph, 470–3, 477, 493, 494, 506, 512, 548, 555, 576; FBC, 497, 500, 519, 521, 524, 528, 539, 547, 554, 563, 569, 573, 574–5, 578–80; Gallery Trustee, 497–8, 504, 564–5
Burls, Rev Robert, 4–6

Burne-Jones, Edward Coley, 261, 274, 280, 288, 292, 316, 348, 432
Burnell, John, 488, 506
Burnet, Sir Macfarlane, 544
Burstall, Bryan Champney, 46–7, 97, 99, 120, 123, *124*, 132, 177, 206, 217, 231–2
Butler, Lady (Elizabeth Thompson), 145, 299
Buvelot, Louis, 67, 147, 149, 245–7, 249, 445
Byzantine art, 477, 514

Caffyn, Dr S Mannington, 88, 140–1
Caire, NJ, 180, 201, 217
Cameron, Sir David Young, 334, 343, 363
Campagnola, 560
Campbell, Alec, 173, 211
Campbell, Charles, 37, 39, 100, *126*, 219–20; Australian Church, 135–6, 191; business partnerships with AF, FS Grimwade, 36, 38, 171; friendship with AF, 94, 106, 114, 186, 230–2; pastoral partnerships, 125, 128, 130–1, 173–5, 229, 247
Campbell, Charles W, 231
Canaletto (Giovanni Antonio Canal), 317, 444, 580
Candid (de Witte), Pieter, 525
Carlile, Sir Edward, 239, 289, 294
Carloni, Carlo Innocenzo, 561
Carmichael, Sir Thomas Gibson, 291, 347, 397
Caro, Sir Anthony, 562–4
Carracci, Annibale, 564, 570
Casey, Maie, 423
Cassat, Mary, 393
cassoni, 481–2, 498
Cattermole, Charles, 201, 249
Cavallino, Bernardo, 528
Cazalet, Captain, 429, 438
Cézanne, Paul, 321, 331–2, 374, 383, 393, 395–6, 427–31, 460, 479; *La Route montante*, 428–30
Chagall, Marc, 495, 489, 498
Cham, Elizabeth, 584, 587–8

Chambers, Prof Carrick, 553; FBC, 554–6
Chantrey, Sir Francis, 423; bequest, 224–5, 238, 263, 271, 293, 311
Chapman, LL, 454
Chardin, Jean-Baptiste Siméon, 280, 330, 384, 459
Charity Organisation Society (later Citizens Welfare Service), 139–41, 143, 159–60, 236–7, 252, 253, 255, 325–6, 376–7, 534–5, 536, 537, 544, 546–8, 549–50, 553–4, 596, 594; AF's personal support, 188, 217
charities considered for support by AF and/or the FBC: hospitals, 325, 537–8; Alfred, 188, 252, 325, 587; Austin, 188, 253, 326; Ballarat, 378; Bendigo, 378; (Royal) Children's, 188, 251, 254, 536, 548, 553, 585, 588, 593, (Felton Visiting Lecturers), 541, 544, 556; country, 253, 378; Dunolly, 325; Eye and Ear, 325; Fairfield, 539; Foundling, 252, 325; Geelong, 325, 378; Heidelberg Repatriation, 449; Homeopathic (Prince Henry's), 188, 252, 538, 541; Horsham District, 325; (Royal) Melbourne, 59, 188–9, 219, 235, 237, 251–2, 254, 325, 377–8, 449, 533, 537–9, 557, 593; North Mallee, 325; Ovens District, 254; Presbyterian Intermediate, 377; Queen Victoria, 252; St Vincent's, 538–9, (Alcoholism Clinic), 548; Williamstown, Footscray and District, 377, 539, 593; (Royal) Women's, 188, 251–2, 254, 533, 539; Ladies Benevolent Societies, 252, 325, 378, 449, 537, 594; Collingwood, 188; Melbourne, 140, 188; Port Melbourne, 188; St Kilda and Caulfield, 187, 188; other: Aborigines'

INDEX

Advancement League, 544; Adult Deaf and Dumb Mission, 253; AIF Women's Association, 449, 533; Air Force House, 449; Alcohol and Drug Foundation, 556; Alcoholism Foundation, 544; Arthritis Foundation Chair of Rheumatology, 556, 584; Association for the Advancement of the Blind, 326; Association of Civil Widows, 545; Australian Birthright Movement, 544; Australian Comforts Fund, 449, 533; Autism Foundation, 545; Ballarat Children's Homes and Family Service, 557; Barrier Broken Hill Boys Brigade, 187, 253; Benevolent Asylums: country, 253; Melbourne, 139, 188, 253; Berry Street Victoria Inc, 595; Bethany Family Support, 595; Blamey House, 449; Blind Asylum, 188; blind, deaf and dumb, organisations for, 253; Blinded Soldiers Association (Victoria), 533; Bouyancy Foundation, 545; British War Orphan Fund, 449; Broadmeadows Family Services, 557; Brotherhood of St Laurence, 545, 547, 554, 594; Cann River building restoration, 584, 589; Carlton Refuge, 252; Catholic Social Services People Together Project, 587; Central Methodist Mission (Lifeline), 544; Child and Family Care network, 593; Child Protection Society, 585, 587; Christian Alternative Reception Remand Accommodation, 557; Christian Brothers Foundation for Charitable Works, 557; Church of England Men's Society, 377; Citizens Advice Bureaux, 545; City Newsboys, 326; Comforts Fund, 450; Community Child Care, 545; Cottage by the Sea, 593–4; Country Women's Association, 553; crèches and kindergartens, 252, 254, 378; Deaf and Dumb Institute, 188; Discharged Prisoners' Aid Society, 253; District Nursing Society, 188; Elizabeth Fry Retreat, 252; Emerald Club for Hope and Outreach Inc., 587; Enterprise Organisation, 556; Footscray Football Club, 584; Free Kindergarten Union, 326, 553; Gentlewomen's Aid Society, 252; Girl Guides, 548; Good Neighbour Council, 556; Gordon House, 557; Goulburn Valley Centre for Intellectually Handicapped Children, 547; Governesses' Institute, 252; Invalid Aid Fund, 449; Isolated Mallee Farmers Association, 554; Jean Hailes Foundation, 588; Jewish Orphan and Neglected Children's Aid Society, 25; Knox Community Care Inc, 594 Legacy, 377, 533; Lighthouse Foundation, 595; Loddon–Campaspe Leisure Buddies Program, 557; Lord Mayor's Fund for Hospitals, 377; Mallee Agricultural and Pastoral Co Ltd, 227; Mallee Crisis Committee, 554; Mallee Family Care, 554; Mallee Support and Development Group, 586; Meals on Wheels, 553; Melbourne City Mission, 377, 594; Melbourne District Nursing Society, 326; Melbourne Orphanage, 188; Methodist Union's Christmas Fund, 544; Mirabel Foundation Youth Support program, 594–5; Missions to Seamen, 254, 255; National Association for the Prevention of Child Abuse and Neglect: Doncare Good Beginnings Volunteer Home Visiting Program, 593; National Citizens Reform League, 192; National Safety Council of Australia, 378; Navy House, 449; Neglected Children's Aid Society; Northcote Farm School, 538; Norton Simon Foundation, 566; Occupational Therapy Farm for the Aged (Castlemaine), 544; Odyssey House, 548; Parents Without Partners, 544, 545; Partially Blinded Soldiers Association, 533; Pilgrim's Rest for Aged and Destitute Gentlewomen, 252; Pinocchio Community Toy Library, 594; Polyglot Puppet Theatre, 557; Presbyterian Church Social Service, 326; Presbyterian Sisterhood of Warrnambool, 252; Prostitutes Collective of Victoria, Inc., 587; Queen Elizabeth Centre, 585 (Nurse Outreach programme, 587); Queen Elizabeth II Coronation Trust Fund, 533; RAN Patriotic Committee and RAN Relief Fund, 449; Red Cross, 449, 450, 533, 556; Refuge for Women (Berwick), 253; Rossbourne House, 544; Royal Victorian Institute for the Blind, 533; RSL Family Welfare Bureau, 533; Salvation Army, 325, 377, 544; Sanitorium for Consumptives, 253; Sea Lake Information and Resource Centre, 554; Servants' Training Institute, 188; Singleton Temporary Home for Fallen and Friendless Women, 252, 254; Society to Assist Persons of Education, 139, 253, 537, 544, 587; St John's Ambulance Association, 253, 557; St Luke's Family Care, 557; St Vincent de Paul societies, 253; TADvic Co-operative Ltd, 594; Theatre for the Deaf, 557; Traveller's Aid Society, 378, 552, 584, 594; Try Societies, 188; Victorian Aboriginal Child Care Agency, 587; Victorian Association for Deserted Children, 544; Victorian Association for the Care and Resettlement of Offenders (VACRO), 595 (Alfred Felton House, 553); Victorian Bush Nursing Association, 326; Victorian Consumptive Sanitorium, 188; Victorian Convalescent Homes for Men, 252; Victorian Convalescent Homes for Women, 326, 188; Victorian Deaf and Dumb Institution, 253; Victorian Infant Asylum, 252, 595; Victorian Police Surgeon's Department, 547; Victorian Shipwreck Aid Society, 253; Victorian Society for Crippled Children, 533; Victorian Society for the Prevention of Cruelty to Children, 188, 252; War Nurses Memorial Appeal, 533; William Forster Try Boys, 533; Wimmera Hearing Aid Society, 557; Women in Agriculture, 554; Women of the

University Patriotic
 Fund, 449; Work Link,
 557; Work to Win
 Campaign, 449, 533;
 Yallourn Church of
 England, 326; YMCA,
 236, 449; YWCA,
 377–8
Cheetham, Richard, 42,
 85–6, 171–2
Chen Hong Shou:
 hanging scroll, 600
Cherbury Home for
 Hope, 188
Childers, Hugh, 12–13,
 18, 63
Chinese art, 306, 433–4,
 443, 468, 476, 514,
 516–17, 522, 559, 569,
 571–2, 599–600, 602
Chirnside, Thomas, 149
Clark, Sir Kenneth, 332,
 368–9, 390–1, 418, 431,
 436, 444, 521–2, 579;
 FBC Adviser, 462–4,
 469, 474–6, 483–6, 492,
 500; in Melbourne,
 477–83; *The Idea of a
 Great Gallery*, 244,
 477–81, 518
Clark, Sir Lindesey, 573
Clark, Thomas, 66, 565,
 565
Clarke, Sir Frank, 368,
 494, 605, FBC, 337,
 371, 376, 384, 394–5,
 398, 408, 410, 413, 416,
 437, 455, (Chairman),
 451, 460–3, 465, 469,
 476, 483, 488–90, 496;
 Gallery Trustee, 337,
 355, 357, 371, 445
Clarke, Marcus, 52–3, 259
Clarke, Sir Rupert, 597
Clarke, Sir William and
 Lady, 112, 137, 140, 149,
 150–1, 192, 337, 372
Clarke, WJ ('Big'), 48,
 341, 372, 597
Claude Lorrain (Claude
 Gellée), 70, 332, 459,
 469–70, 477, 526, 575
Clausen, Sir George, 262,
 312, 317, 334, 363; FBC
 Adviser, 263–4, 269,
 271–2, 273–7, 286, 307
Cleve, Sali, 178
Cockerell, Sir Sidney:
 FBC Adviser, 418–23,
 427–30, 432–4, 441,
 466; in Melbourne,
 421; *Report on the
 National Gallery of
 Victoria*, 422, 442–3,
 477
coins, 398, 532

Colahan, Colin, 380
Cole, Vicat, 147, 249
Collier, Tom, 261
Collins, JT, 338, 355, 359,
 384, 389, 423
Colnaghi's, 409, 431, 463,
 508, 515
Colonial Sugar Refining
 Company, 125, 144
Colquhoun, Alexander,
 299, 328, 340–1, 445–6;
 artist, 415; Gallery
 Trustee, 328, 439
Colquhoun, Amalie, 445
Colvin, Sir Sidney:
 Trustees' Adviser,
 296–303, 311, 346, 358,
 396–7, 466
Commonwealth
 Industrial Gases, 323,
 416, 524
Conder, Charles, 88,
 150–1, 299, 375, 448,
 460, 560
Connell, John H, 337, 422
Constable, John, 300, 303,
 330–1, 432, 464, 518;
 Boat Passing a Lock,
 485, 488; *West-end
 Fields, Hampstead*, 288,
 303
Constable, WG, 418, 518
Contemporary Art
 Society, 426, 437, 439,
 494
Cook, E Wake, 245
Cooke, Samuel Winter,
 606
Coombs, HC ('Nugget'),
 566–7
Coppin, George, 48, 51,
 144, 269
Coremans, Dr Paul,
 510–11
Corot, Jean-Baptiste
 Camille, 273, 277, 287,
 296, 338, 382, 397, 496;
 Bent Tree, 237, 277–8,
 298–9, 313, 448
Cotman, John Sell, 360,
 482
Couche, Reginald, 231
Couche, William and
 Henrietta, 46, 89, 106,
 231
Courbet, Gustave, 330,
 343, 375, 473
Court, Bathia, 189–90
Court, Louis, 77, 190
Courtauld, Sir Samuel,
 332, 429, 471
Courtauld Institute, 436
Cowen, Frederic, 147–8
Cox, David, 265, 303
Cox, Dr Leonard, 151,
 488, 510, 519, 525, 562,

571; defends Rinder,
 319, 352, 354, 366; FBC,
 495, 506, 508, 515–17,
 521, 524, 538, 546, 563;
 Gallery Trustee, 434,
 477, 497, 503–4;
 (President), 505–6
 511–12, 527, 529
Cox, Sir Trenchard, 521
Cranach, Lucas (the
 Elder), 383, 459, 495,
 497
Crawford, Lord, 347, 368,
 397, 464
Crawford, Prof RM, 519,
 539–40, 589
Creswick, Alexander, 231
Creswick, Alice, 47, 123,
 132, 137, 209, 231
Creswick, Henry and
 Jane, 47–8, 190, 231
Creswick, Thomas, 245
Crome, John ('Old'), 247,
 330, 432
Culican, William, 517
Cumbrae Stewart, Janet
 Agnes, 382
Cuming, Grace Mary, 416
Cuming, James, 35–6,
 38–9, 129, 170–1, 220,
 323
Cuming, James, Jr, 171,
 230, 323
Cuming, Robert Burns,
 38, 186, 232
Cuming, Smith and
 Company, 36–8, 114,
 116, 131, 169, 171, 172,
 220, 227, 229, 322, 416,
 524
Cussen, Sir Leo, 344, 370,
 394; FBC, 371–2, 382,
 386, 389; Gallery
 Trustee, 336, 369;
 (President), 371, 380–2,
 384

Daffyd Lewis Trust, 543
Dalhousie, Lord, 516;
 'Dalhousie' torso, 522
Dali, Salvador, 436
Dallas, Alfred, 231
Dallas, Captain Charles,
 231
Dance, Nathaniel: *Portrait
 of the Pybus Family*, 606
Daniel, Sir Augustus,
 388–90
Dargie, William, 446, 472
Daubigny, Charles
 François, 276, 459, 464,
 494, 497
Daumier, Honoré, 348,
 479
David, Jaques Louis, 432
Davies, David, 460

Davies, Martin, 389, 511
Davies, Randall, 312–13,
 317, 375, 383–4,
 387–94, 395–6, 415,
 416, 434, 463, 581; FBC
 Adviser, 374–6, 384–7,
 394–6, 447, 466, 485
Davis, HWB, 152, 249
De Wint, Peter, 382
Deakin, Alfred, 207, 227
Dean, Sonia, 568, 575
Degas, Edgar, 260, 280,
 296–7, 331–2, 338,
 351–2, 383, 393, 432,
 460, 470, 479, 482,
 519, 570
Delacroix, Ferdinand-
 Victor-Eugène, 290,
 375, 384, 464, 570; *Les
 Natchez*, 493–5
Delaunay, Robert, 525
Dennis, C Elwynn, 532
Derain, André, 438
Despiau, Charles, 476,
 438
Devapriam, Emma, 574
Diaz de la Peña, Narcisse-
 Virgilio, 296, 494, 497
Dixon, Sir Owen, 450–1,
 510, 511, 518; FBC,
 450–1, 515,
 (Chairman), 496–500,
 521, 524, 528, 541, 559,
 561
Dobell, William, 164,
 515–16; *Helena
 Rubinstein*, 516, 522
Dodgson, Campbell, 363
Dods, Mr, 95, 97
Dowling, R, 103
Downing, Prof Richard,
 562–3
Drug Houses of Australia,
 322–3, 371, 497; *see also*
 Felton Grimwade &
 Co.
Drummond, William, 150
Drysdale, Russell, 479
Dufy, Raoul, 438, 482
Dunstan, AA, 420
Dupré, Jules, 288, 296
Durand-Ruel, M, 296
Dürer, Albrecht, 332,
 500–2; *Dead Duck*, 367,
 501
Dutch School, popularity
 of, 330
Duveen, Sir Joseph, 241,
 318, 331, 374, 388, 390,
 404, 474
Dyce, William, 330
Dyck, Anthony van, 342,
 431–3, 448, 509
Dyer, Louise, *see* Hanson-
 Dyer
Dyson, Will, 306, 334

East, Alfred, 281, 283
Eastlake, Sir Charles, 65, 369
Ebbott, Rex, 525
Edkins, Ellen and George, 210, 213
Edkins, Lucy, 212–13, 229
Edridge (AF's amenuensis), 113
Edwards, Ralph, 444, 460, 463, 476
Egg, Augustus, 152
Eggleston, Frederic William, 373, 437, 439
Egyptian art, 306, 423, 434, 529, 560, 601–2
El Greco, 332, 459, 482, 519
Elder, Sir Thomas, bequest, 225–6, 237–8, 480
Elderfield, John, 580, 598, 604
Elkington, John Simeon, 223–4
Ellery, RJL, 239
Elliot, Fred, 102, 113–14
Elliot, George, 168, 184–6
Elliott, RD, 488; Gallery Trustee, 337, 348, 365, 384, 394–5, 437, 454, 467, 476–7
Elliot Bros, 32, 114
Epstein, Jacob, 347, 355, 375, 383, 470, 477, 476
Ernst, Max, 325, 436, 493, 508
Esson, Louis, 290
Etty, William, 155
Eucalyptus Mallee Company, 34, 83; *see also* J. Bosisto and Company
eucalyptus oil, 33–4
Evatt, Dr HV and Mrs, 424, 451, 518, 522–3
exhibitions, international, 66–70, 145–50
Eyck, Jan van, follower of, *Madonna and Child*, 342–3, 348–9, 392, 397, 437, 448, 473, 479, 482, 509–12
Eyre, Frank, 519

Fantin-Latour, Ignace-Henri-Jean-Théodore, 273, 290
Faulkiner, John, 201–2
Feilman, Patricia, 549
Feininger, Lyonel, 507
Feint, Adrian, 446
Felton, Alfred (AF), 46, 199, 200, 209, 211, 216, 221, 422, 450, 513, 530–1, 594; alcohol, 102; apprenticeship, 8–9; art collection, 57, 103, 109, 148, 150–3, 154, 200–2, 216, (sale), 247–50, (selection by NGV), 154, 245–8; birth, 3–6; books and reading, 57, 152, 201–2, 216, 248; charitable activity, 108–9, 142–5, 187–92, 215–16; clubs, 54–6, (Athenaeum Club), 54, 103, (Australian Club), 54, 71, 102, (Melbourne Athenaeum), 54–5, (Melbourne Cricket Club), 56, (Mercantile Exchange), 55, 55, (Victoria Racing Club), 56; death, 217, 219–20; dress style, 193; during economic depression, 164–5; emigration, 9–10, 14–16; excursions, 95–7, 106, 196–8, 198; friends, 23, 45–8; during gold rush, 19–20; health, 99–102, 195–6, 197; horses, 95–7; involvement in NGV and Public Library, 145, 204; legacies and annuities, 229–32; merchant, 19, 21, 76; music, 202, 203; other businesses, 183–6, ('Medical Hall' Broken Hill), 184–5, 199, (Wilcannia), 184–5, 199; other property investments, (Fern Park), 175, (Felton Building), 166, 175–6, 227, 229; pastoral investments, 124–5, *see also* Campbell and Felton (partnership), Langi Kal Kal station, Murray Downs station; politics, 70–1, 73, 163; portrait, 270–1; private life, 21, 44–5, 193–5; religion, 51–4, 134–5, 191; residences, 22, 45, (Dalgety Street, St Kilda), 97–100, 119, (Esplanade Hotel), 45, 132, 177–82, 180–1, 194, 200, 219, 246, (Gertrude Street, Collingwood), 21, (Mrs O'Reilly's boarding house, St Kilda), 22–3, 120, ('Wattle House'), 119–23, 121, 122, 132–3, 155; schooling. 6–7; share investment, 89–90; statue, 606; travel, 136, 171, 196–200, 210, (England), 56–7, 92, 131, (Europe), 93, 133, (New Zealand), 56–7, 90, 123, (US), 131–2; wholesale druggist, 21; will and estate, 187, 223–4, 227–9, 236, 472, (legacies and annuities), 229–32, (trustees), *see* Trustees, Executors and Agency Co. Ltd
Felton, Alfred, family, 210–15; Felton, Alfred Leopold ('Squire'), 133, 210, 214–15, 229; Felton, Arthur, 7; death, 24–5, 26; Felton, Edmund, 7, 93, 211, 230; Felton, Eliza, 7, 93, 227; Felton, Ellen (AF's niece), 93; Felton, Ellen (AF's sister), 7; Felton, Fanny, 210, 214–15, 217, 229; Felton, Freda, 210, 214–15, 229; Felton, George, 7, 211; Felton, Hannah, AF's mother), 5–7, 9, 93, 227; Felton, James, 7, 215–16, 229; Felton, Mary Ann, 7; Felton, Maude, 229; Felton, Thomas (AF's brother), 7, 93, 210, 213, 229; Felton, Thomas, 5–6; Felton, William (AF's brother), 7, 9, 57, 93, 164, 210, 211–14, 214, 229; Felton, William (AF's father), 5–7, 9, 57, 93, 227; Felton, William (AF's nephew), 93, 210–13, 229; Felton, William John (AF's nephew), 216, 229
Felton Art Bequest, 233, 237–9, 243–4, 250, 256–9, 377, 472–3, 506–8, 559–65, 597–606; and Australian art, 241–2, 271–2, 341, 380–2, 397, 447–8, 466–7, 513–14, 524–5, 569, 597; local acquisitions, 272–3, 304–6, 376, 415, 445–6, 515–16; press reaction, 290, 298–9, 354; 'scheme of purchase', 269–71, 275–6, 279–80, 283–5, 288–9, 294–6, 314, 329–30, 341–2, 352–4; *see also* Felton Bequest
Felton Art Bequest Advisers, 242, 263–4, 271, 283–6, 311–13, 334, 371–3, 416–20, 444, 476, 578–80, 604; *see also* Bluett, EE; Burdett, Basil; Clark, Sir Kenneth; Clausen, Sir George; Cockerell, Sir Sidney; Davies, Randall; de Vasselot, Jean-Jacques Marquet; Edwards, Ralph; Elderfield, John; Gibson, Frank; Hoff, Dr Ursula; Ingamells, John; Kent, HW; MacDonald, James Stuart; McDonnell, Ae John L; Pennell, Joseph; Rinder, Frank; Ross, Robert; Schwabe, Prof Randolph; Trendall, Prof Dale; Vaughan, Dr Gerard; Woodall, Dr Mary
Felton Bequest, 228–9, 318, 402; Committee (FBC), 137, 234–7, 240–1, 250, 279–80, 334, 371–2, 416, 427, 454–6, 506, 518, 524, 527–9, (initial membership), 233, 236, (responsibilities), 232; precursors, 224–6; *see also* Felton Art Bequest; Felton Charitable Bequest
Felton Charitable Bequest, 188, 233, 252–6, 376–9, 442, 449–51, 533–57, 543–51, 552–7, 583–96; concepts of charity and philanthropy, 49–51, 137–42, 250–1, 534–7, 584–5, 588–91, 596; guidelines, 550–1, 556, 584, 594–5; investment income, 325–6, 585–7; *see also* Felton Bequest
Felton, Grimwade and Bickford Ltd., 172
Felton Grimwade & Co., 27–36, 79–83, 84, 104, 172–3, 220, 227, 322–3; acid production, 35–7, 112–14, 116, 118, 169–71; Depression

1890s, 164–6; employees legacies from AF, 231; Flinders Lane factory and warehouse, 28–9, 36, 38, 42–3, 75, 79, 82, 82, 182–3, 501, (fire), 77–9; Jeffcott Street factory, 29, 79; leech trade, 30; New Zealand, 32–3; partnership, 31; sale of art, 154–5; salt making, 171–2; in US, 94–5; WA office, 172; *see also* Drug Houses of Australia; Commonwealth Industrial Gases
fig leaf, optional, 346–8
Finemore, Brian, 504, 512
Fink, Theodore, 224, 324
Fitchett, WH, 240, 239
Fitts, Sir Clive, 256, 477, 519, 542; FBC, 494–5, 498, 500, 518, 521, (Chairman), 524, 527–9, 538–9, 541, 546–7, 559–65, 568–9, 571–2
Fitzgerald, Edward, 8
Fitzgerald, Sir Thomas, 67, 273
Fitzroy Community Youth Centre, 545
Fitzroy Legal Aid Service, 545
Folingsby, George, 150, 204, 259
Fontana, Prospero, 565
Ford Paterson, John, 249–50, 305; Gallery Trustee, 239, 258, 281–3, 289–91, 294
Fordyce, John, 437
Forrest, JK, 232
Fox, E Phillips, 224, 305, 448, 460, 608; *The Arbour*, 304–5, 448
Fragonard, Jean Honoré, 280, 384, 459, 573
Francis, Prof Arthur, 527
Francis, Sir Frank, 521
Francis, Henry, 87, 220, 232
Francis, Sam, 525
Franklyn, H Mortimer, 52–3
Fraser, Simon, 109
Frater, William, 321, 374, 446
Frémiet, Emmanuel: *Jeanne d'Arc*, 266–7, 448
French, Edward, 25–6
French, Grace, 25–6
French, Leonard, 504, 529

Freud, Lucien, 290
Friedländer, Max, 376
Fry, Roger, 277, 283–4, 286, 312, 355, 368, 387, 389–91, 581
furniture, 306, 397–8, 476–7, 488, 491, 507, 522, 525, 560, 564–5

Gainsborough, Thomas, 276, 280, 289, 297, 300, 328, 331, 342, 375, 383, 411, 459, 472, 476, 477, 482
Galbally, Rhonda, 595
Galby, John, 155
galleries, public, 59–60
Gallery Society, 477
Gant, Robert Drake, 8–10
Gauguin, Paul, 375, 384, 393, 395, 439–40, 460
Geddes, Sylvia, 588, 591–2
Geelong Art Gallery, 204
Gemmell Tuckett & Co., 201, 217, 247
Géricault, Théodore, 491
Ghika, Nicholas, 498
Giacometti, Alberto, 526
Gibbs, David CL, 552–3, 584, 598
Gibson, Colonel Aubrey, 506, 527, 562–3
Gibson, Frank, 264, 277, 287–8, 343; Adviser to FBC, 285–6, 289–91, 296–304, 306–7, 311, 369
Gibson, Gavin, 287
Gilbert, Alfred, 261, 266, 280, 288
Gilbert, C Web, 306
Gill, Harry P, 226, 260
Gill, ST, 400
Gilman, Harold, 466
Girl Guides, 548
glass, 507, 516, 522, 525, 560; stained, 332, 338, 340
Gleeson, James, 446
Gloucester, Henry, Duke of, 399
Glover, John, 150, 499
Gobbo, Sir James, 553
Godfrey, Frederick Race, 140; FBC, 236, 237, 276, 282–4, 286
Goldstein, Colonel, 136, 140
Goodchild, John G, 419–20
Goodwin, GF, 185–6
Gore, Spencer, 459, 466, 477
Gough, John, 602

Goya, Lucientes, 153, 280, 332, 349–50, 458, 507, 526, 575, 578, 602
Graham, Sir James, 198, 240
Graham, Peter, 150, 152, 201; 247, 249
Grant, Duncan, 355, 459, 466
Greek and Roman art, 306, 499, 508, 525, 559, 574, 577, 582, 602
Greene, Molesworth, 239
Gregory, Dickson, 178, 183, 186, 192, 193–4, 201–2, 214, 217, 219, 231
Gregory, Edward, 260
Greig, William John, 86–7, 123
Greig-Smith, Stanley, 50, 376, 534, 545–6
Greuze, Jean-Baptiste, 384
Greville, Lorne, 585, 588
Gricci, Giuseppe, 600
Grice, James, 220
Grice, Sir John, 355
Griffiths, Harley, 446
Grimwade, Dr Alfred Sheppard, 94, 217, 220, 230, 385, 497
Grimwade, Alice, 230
Grimwade, Sir Andrew Sheppard, 593; FBC, 233, 497, 546–7, 555, 580–1, 583, 598; Gallery Trustee, 524, 527, 565; (President), 572–3, 575–6, 599
Grimwade, Edward Hall, 97, 230
Grimwade, Edward William, 22–3, 209, 230
Grimwade, Freda, 230
Grimwade, Frederick, 230
Grimwade, Frederick Sheppard, 22, 30, 46, 57, 74, 86, 103, 146, 171, 182, 220, 230, 594; arrival in Melbourne, 22–3; banking, 159; death, 287; in Europe, 75, 92–4, 215, 283–6; FBC, 233–4, 236, 254, 276–7, 284–7; health, 99–100, 214–15; marriage, 25–6; merchant, 81; MLC, 32, 70, 161–3; in Perth, 172; pastoral investments, 124–5; public life, 70, 164; religion, 51; residences, (Coolart), 33, 200, ('Harleston'), 44, 87, 123, 209, 230; Royal

Commission on the Tariff, 35; in US, 94–5
Grimwade, FS ('Erick'), 497
Grimwade, Geoffrey, 496–7
Grimwade, Harold, 133, 172, 220, 230, 323, 385, 455; FBC, 233, 371, 451, 465
Grimwade, Jessie, 25–7, 87, 151, 203, 232
Grimwade, John, 497
Grimwade, Norton, 31, 94, 182–3, 200, 230, 249, 313, 323, 371, 385; FBC, 233, 287, 294, 298, 306–7, 357, 371, 408, 413, 417–19, 437; Chairman, 450–1
Grimwade, Sir Russell, 31, 43, 94, 97, 154, 168, 178–83, 194, 198, 202–3, 219, 229, 230, 323, 371, 385, 399, 408, 410, 487, 494, 496, 498, 524, 562; FBC, 233, 371, 389, 395, 455, 486, (Chairman), 489–90, 491–3, 537–8; *Flinders Lane*, 5, 371, 400–1, 472; in London, 493, 495
Grimwade, William 182, 209
Gritten, Henry, 522, 571
Grounds, Sir Roy, 512–13, 516–17, 529, 603
Grundt, Herr, 195, 232
Gruner, Elioth, 445
Guardi, Francesco, 155, 411
Guérard, Eugène von, 66, 205, 398, 514
Gum-San Lead Museum Trust, 584
Guston, Philip, 598, 605
Guthrie, Sir James, 363
Guttoso, Renato, 498

Hackett, JT, 98, 333
Haddon, FW, 47, 140
Haines, Robert, 454
Hall, Lindsay Bernard, 257, 278, 280–1, 369, 372–3, 375, 405, 481, 485–6, 503–4, 513; Adviser in London and Europe 1904–05, 258–64; Adviser in London 1934, 351, 358–9, 395, 399, 403–12; artist, 259, 304, 320, 321, 376, 379–80, 398, 414; death, 411–14; Director of Gallery,

204, 226, 243–4, 379–83, 605–6; and FBC, 282–6, 335, 339, 345–7, 354, 362, 379–82, 384–6, 390–1, 407–12, 519; opposes Gibson, 288–96, 301–4; opposes Rinder, 353–5; purchases 1905, 264–6, 265–7, 268–9, 271–2, 283, 307; 'scientific' collection policy, 248, 256–8, 281–2, 477–8; selection from AF's collection, 245–6
Hals, Franz, 330, 375, 383, 432, 434, 440, 459, 493
Hamer, AW, 524, 544
Hamer, Sir Rupert ('Dick'), 524, 565–6, 573, 575–6
Hamilton, Talbot, 231
Hanlan (rower), 104, 105
Hanson-Dyer, Louise (nee Smith), 324–5, 436
Harcourt, Clewin, 305, 343
Harcourt Smith, Sir Cecil, 312
Hargitt, E, 249
Harley, Edward Steyne, 189
Harpignies, Henry-Joseph, 285–6, 296
Harris, Max, 472
Hawdon, John, 126–7
Hayes, Frederick William, 201
Heckel, Erich, 568
Helen M Schutt (later Helen Macpherson Smith) Trust, 543, 586
Henderson, Allan, 505; Gallery Trustee, 454, 490
Henderson, Prof Ronald, 546
Hendy, Sir Phillip, 416, 495, 510–11
Henty, Louisa, 144
Hepburn, Charles James, 89
Hepworth, Barbara, 494, 526
Herald, 324, 396; Exhibition of French and British Contemporary Art, 424, 428, 436–40, 474
Herbert, Harold, 359, 379, 382, 448
Herkomer, Sir Hubert von, 280
Herman, Sali, 423, 467
Heysen, Hans, 272, 306, 379, 272

Hickinbotham, William, 21
Hicks, GE, 249
Higgins, Henry Bournes, 339
Highmore, Joseph, 331, 341
Higinbotham, George, 47, 51, 53, 73, 140–1, 145, 240, 338
Hoban, Ruth, 539–40
Hobbema, Meindert, 459, 482
Hockney, David, 574
Hodgkin, Frances, 437
Hodgkin, Sir Howard: *Night and Day*, 604–5
Hoff, Dr Ursula, 151, 224, 303, 318, 447, 454, 471, 490, 504, 512, 519, 560, 561–3, 565, 568, 578–80; FBC Adviser, 484–5, 492, 498, 500, 508–11, 513–16, 521, 523, 525, 526, 571–5, 578
Hogarth, William, 331, 340, 375, 383, 444, 459, 581–2
Hogg, Caroline, 553–4
Hokusai, 525
Holbein, Hans, 331, 344, 459, 493
Holl, Frank, 283
Hollingworth, Rt Revd Peter, 554
Holmes, Sir Charles, 312, 334, 342, 349, 363, 369, 373–4, 383–9; artist, 345, 605; FBC Adviser 391, 395, 404, 406–7, 409–10, 412, 485, 581
Holroyd, Sir Charles, 263, 284, 286, 296
Hooch, P de, 459
Hood, Kenneth, 560–1, 565, 568, 598
Hoogendijk gallery, 406, 412–14
Hopetoun, Earl of, 155–7, 194
Hopkins, Lucy, 120
Hoppner, John: *Mrs Robinson (Perdita)*, 290–5, 301, 303, 369
Horsley, JC, 152
Hospitals and Charities Board, 325
Houdon, Jean Antoine, 432
Howard, Charles, 521–2
Howard, John, 589–90
Howard Spensley Bequest, 455
Hugh Williamson Foundation, 543, 583

Hughes, Arthur, 316
Hughes, Robert, 520, 604
Hughes, William Morris, 324
Hunt, Alfred, 280
Hunt, William Holman, 147, 262, 276, 280, 291–2
Hunter, George Leslie, 466
Hygeia (paddle steamer), 196

Ievers, W, 205
Immigrant Aid Society, 50, 139, 188
Ind, Mrs, 105–6
Indian art, 433, 515–17, 525–6, 572–5, 578, 582; Rajasthan paintings, 574–6
Indigenous Australians, 142, 401–2, 543; art, 309–10, 507, 597; assistance from Felton Charitable Bequest, 592, 595
Ingamells, John, 581–2, 600
Inglis, Dr Alison, 604
Ingres, Jean Auguste-Dominique, 341, 432, 459, 463
Innes, JD, 305, 459
Isabey, Eugene, 262

J. Bosisto and Company, 82–3, 166–7, 172; *see also* Bosisto, Joseph; Eucalyptus Mallee Company
Jackman, John, 140
Jackson, Samuel, 119–20
Jacoby, Sigismund, 177–8
Jagger, Charles Sargeant, 422, 422
Jansson, Eugene, 580–1, 600, 605
Japanese art, 273, 287, 304, 306, 495, 508, 526, 600
John, Augustus, 274, 275, 341, 297, 343, 355, 431, 448, 605
John, Gwen, 351, 355, 470, 605
Johns, Jasper, 575
Johnson, Sir Elliott, 339
Johnson, George, 524
Johnston, David and Mary, 155–7, 231
Jones, Prof F Wood, 373, 397, 421
Joolama, Rover Thomas: *Dreamtime Story of the Willy Willy*, 599

Jordaens, Jacob, 405
Joske, AS: FBC, 372, 435; Gallery Trustee, 240, 336, 435

Kahler, Carl, 150
Kalf, Wilhelm, 343
Kandinsky, Wassily, 507
Kaye, Barry, 525
Keene, Charles, 261, 483
Keep, Edward, 46, 178, 199, *199*, 200
Keith, Felton's book buyer, 201
Kelly, Ned, 59
Kemp, Roger, 524
Kempthorne, Orlando, 172
Kempthorne, TW, 32–3, 100, 112–14, 163–4, 167, 172, 206
Kempthorne Prosser, 38
Kennington, Eric, 331
Kent, HW, 433, 504; collection, 455; FBC Adviser, 434, 443, 486; Gallery Trustee, 434, 437, 454, 467–8, 488
Kenyon, AS, 398, 400–2, 434
Keogh, DP, 100–1
Kiefer, Anselm, 601
Kilpatrick, AG, 552
Kinnear, RH, 150
Kisch, Egon, 399, 402
Kiss, Fr Vincent, 549–57, 576, 600
Klimt, Gustav, 598
Kngwarray, Kam: *After rain*, 600; *Untitled*, 600
Knight, Buxton, 274
Knight, Laura, 331, 355
Koekkok family, 151
Koekkok of Pall Mall, 148
Kokoschka, Oscar, 507, 525
Koninck, Philips de, 352
Kooning, Willem de: *Standing Figure*, 597
Koorie Heritage Trust, 594
Koories, *see* Indigenous Australians
Krasner, Lee, 600
Krone, Herr, 195
Kruse, John, 29

Ladies Work Association, 536–7
Lady Talbot Milk Supply Association, 536
Lake, Joshua, 153–4, 246, 248, 280–3
Lalor, Peter, 19, 71
Lamb, Henry, 460, 466

INDEX

Lambert, George W, 272, 305, 312, 333, 420, 448, 450, 460, 516; *Baldwin Spencer*, 333
Lance Reichstein Charitable Foundation, 543
Landseer, Sir Edwin Henry, 150, 383, 476, 489
Langdon, HJ, 115
Langi Kal Kal station, 174–5, 183, 227, 229; *see also* Felton, Alfred, pastoral investments; Campbell and Felton (partnership)
Langton, Edward, 269; FBC, 235, 254; Gallery Trustee, 239, 258
Lascelles, EH, 156–7, 232
Laurens, Jean Paul, 153
Laurie, Prof AP, 410–12
Lavery, Sir John, 297, 412
Lawlor, Adrian, 374, 424, 425, 426
Lawrance, David, 504, 518, 569
Lawrence, Eileen, 578
Lawrence, Sir Thomas, 328, 383, 445, 466
Lawson, Sir Harry Sutherland Wightman, 377
Le Nain, Louis, 330
Leader, Benjamin, 249, 281
League for Effective Voting, 192
Lee, Arthur Hamilton, Viscount Lee of Fareham, 373–4, 388, 390, 432
Leeper, Alexander, 25, 46–7, 98, 206, 210, 224, 235, 336, 388; FBC, 334–5, 341–3, 353, 357, 362, 369; Gallery Trustee, 145, 204, 239, 294, 311; President, 334–5, 338, 346, 357, 359, 361–2, 365, 369–70, 384
Lees, Derwent, 476, 470
Lefebvre, Jules: *Chloe*, 67, 69, 273, 343, 575, 602
Léger, Fernand, 560
Leighton, Sir Frederick, 147, 153–4, 274, 280, 284, 281–2
Lely, Sir Peter, 331, 406
Levey, James Alfred, 140, *381*, 450, 591; FBC, 236–7, 254–6, 271–2, 287, 291, 294, 298, 313, 316–17, 357, 361, 437,

(Chairman), 371, 375–7, 380–2, 384, 389, 394–6, 403–4, 406–14, 416, 423, 438, 440–1, 449–50, 533
Lewis, Wilmarth S ('Lefty'), 518
Lewison, Jeremy, 604
Liebermann, William S, 600
Lievens, Jan, 412
Lignori, Mr, 171–2
Lindsay, Sir Coutts, 148, 152
Lindsay, Sir Daryl, 151, 201, 262, 274, 303, 318, 334, 371, 428–9, 435, *468*, *487*, 494, 497, 502, 562, 591; on AF's collection, 151, 246–8; festschrift, 518–19; *The Felton Bequest*, 519–21; Gallery Director, 441–2, 445, 447, 455–9, 461–7, 468–9, 474–5, 477–8, 481–3, 486, 488, 490, 491, 492, 493–500, 504; report on NGV collection, 457–64
Lindsay, Lionel, 249, 311, 333, 337, 390, 406, 515
Lindsay, Norman, 306, 309; *Pollice Verso*, 278–9
Linnell, John, 315
Liotard, Jean-Etienne, 485, 493
Loch, CS, 139, 534
Loch, Sir Henry and Lady, 52, 104, 140–1
Long, Sydney, 333, 379, 420
Longstaff, Sir John, 147, 258–9, 272, 289, 298, 299, 312, 348, *360*, 379–80, 420, 448; *Alfred Felton*, 182, 379, *468*; FBC, 372, 389, 435, 437; Gallery Trustee, 338, 359–61, 365, 373–5, 384, 395–6, 408, 423, 440, 445
Lowe, Sir Charles, 455–6
Lu Ji: scroll, 599
Lynch, William and Caroline, 88, 150; Collection, 201, 217

McAllan, James, 422
McCaughey, Patrick, 525, 569, 576, *579*; and FBC, 576–8; Gallery Director, 576–8, 580–2, 597
McClelland, Frank, 585
McClintock A, 305, 338–9

MacColl, DS, 263, 312, 368
McCubbin, Frederick, 147, 150, 204, 257, 272, 445, 448, 460; *The Pioneers*, 269–71
McCubbin, Louis, 446
McCulloch, Alan, 509, 517
McCulloch, George, 148, 259, 432
MacDonald, James Stuart, 291, 319, 334, 395, *419*, 420, 424, 448, 458, 481, 497; and FBC, 417–18, 421, 432, 435–6, 445; Gallery Director, 420–3, 427–31, 437–44, 447, 454, 462; *Herald* art critic, 324, 343, 348, 354, 357
McDonnell, Ae John L, 475, 481, 520–1, 566; collection, 516; FBC Adviser, 474–7, 481–501, 504, 506, 507–11, 513–16, 518
MacDowell, Swanson and Katherine, 107
McEvoy, Ambrose, 359–60
McEwan, Mr, 102
McEwen, Walter, 264
MacFarland, Sir John Henry, 416; FBC, 313, 335, 355, 371, 373, 389, 408–10
Macgeorge, Norman, 272, 305–6, 359, 374, 425, 442
McGregor, DR, 220
McInnes, WB, 306, 359, 379, 382; recommendations, 415
Mackeddie, JF, 344, 355; Gallery Trustee, 337, 423
Mackennal, Bertram, 312; *Circe*, 272, 605
Mackey, Sir John, 336
MacKinnon, Hilda, 219
MacNally, MJ, 320
McNeilage, William, 169, 208, 232
McPherson, John Russell, 255
Madox Brown, Ford, 261–3, 313
Magritte, René, 561–2
Maillol, Aristide, 476
Mainprize, Max, 552
Maistre, Roy de, 495
Makower, ES, 397
Manet, Eduard, 280, 331–2, 352, 374, 383–4, 393, 460, 479

Manion, Prof Margaret, FBC and Gallery Trustee, 555, 598–600
Mann, GVF, 282, 284
Manson, JB, 332, 439
Mantegna, Andrea, 522, 525
Marc, Franz, 507
Maris, Jacob, 288, 292
Marmion, Simon, 492
Marshall, Ben, 459, 497
Martens, Conrad, 445, 460, 467, 483, 598
Masaccio, 526
Masson, André, 497–8
Mather, John, 147, 204, 250, 307; FBC, 235, 237, 254, 258, 272, 277, 279–80, 284, 290; Gallery Trustee, 239, 281, 305, 307
Mathews, Charles Race Thorson, 579, 597
Matisse, Henri, 332, 373, 375, 383–4, 438, 480, 488–9, 506
Mauve, Anton, 285–6
Meckseper, Friedrich, 522
Medley, Sir John, 447, *468*, 470, 472, 512; FBC, 490–1, 495, 498, 500, 508; Gallery Trustee; (Chairman), 490–2, 494, 503, 506
Meeson, Dora, 333
Meissonier, Jean Louis Ernest, 262
Melbourne Chamber of Commerce, 70, 74–5
Melbourne Glass Bottle Works, 39–42, *41*, 83–5, 168–9, 173, 208, 220, 227, 229; *see also* Australian Glass Manufacturers
Melbourne Grammar School, 87, 188, 588
Melbourne Telephone Company, 79, *80*
Meldrum, Max, 305–6, 320, 354, 379–80, 464; FBC, 372, 448–9; Gallery Trustee, 337, 437–9, 454–5, 467, 476, 488
Mellon, Andrew W, 388
Memling (or Memlinc), Hans, 344–5, 348, 448, 471
Menzel, Adolf, 460
Menzies, Sir Robert Gordon, 421, 424–5, 455, 471, *542*
metal work, 507, 559, 561, 570

636 INDEX

Methodist Ladies College, 585
Metropolitan Museum of Art (New York), 224, 276, 286, 339–40, 343, 600
Meyer, Felix, 290
Michelangelo, 332
Michie, Alexander, 20
Millais, Sir John Everett, 153, 297, 300, 328–9, 341, 343
Miller, Sir Edward, 502
Miller, Everard Studley, 474; Bequest, 501–2, 509, 513, 521, 524, 526, 581
Miller, Henry ('Money'), 28, 501
Millet, Jean François, 276
Milliken, Dr WM, 512
Millington, RW, 185–6
Missingham, Hal, 448
Mitchell, Major Thomas, 126
Modigliani, Amedeo, 373, 439, 460, 464, 477, 518
Mole, JH, 249
Mollison, James, 304, 504; Gallery Director, 599–601
Monet, Claude, 225, 260, 280, 296, 331–2, 393, 431, 444, 460
Montford, Paul, 359, 383, 396
Montgomery, William, 337, 358
Monticelli, Adolphe, 288, 292
Moor, Henry, 18
Moore, Henry, 514
Moore, Henry Byron, 55–6, 75, 76, 79, 88, 146, 153, 171, 200, 476, 477
Moorhouse, Rt Revd James, 134
Mor (Moro), Antonis, 476
Morassi, Antonio, 518
Morgan, Hugh Matheson, 572–3
Morisot, Berthe, 375, 393
Morland, George, 69, 290–1, 303
Moroni, Giovann Battista, 435
Morris, Prof Edward, 47–8, 57, 123, 137, *139*, 140–2, 145, 159–60, 224, 550; FBC, 233, 236; Gallery Trustee, 236
Morris, William, 348, 418, 432

Morrison, George Ernest ('Chinese'), 333, 433
Mount, LL, 145–6, 169, 208
Mueller, Ferdinand von, 34
Munch, Edvard, 460, 477, 507, 570, 571
Munnings, Alfred, 331
Munro, James, 594
Murch, Arthur, 448
Murdoch, Dame Elisabeth, 549; Gallery Trustee, 529, 562, 564, 569; philanthropist, 549
Murdoch, Sir Keith, 323–4, 371, 436, 451–2, 452, 461, 470–1, 490; FBC, 454–5, 457, 463, 465, 486; Gallery Trustee, 337–8, 372, 396, 408, 410–11, 416–20, 423; President, 435, 437, 443, 454–5, 468, 477, 483, 488–91; and Lindsay, 454; and MacDonald, 435–6, 439–41
Murdoch, Rupert, 490
Murillo, Bartolomé Esteban, 201, 476
Murphy, Sophia Matilda, 120
Murray Downs station, 126–31, *128*, 155–7, 173–4, 183, 198–200, *199*, 227, 229; art, 247
Museum Victoria, 594, 603
museums, 62–3, 566,
Myer, Baillieu, 571
Myer, Kenneth, 512
Myer, Sidney, 323
Myer Emporium, 323
Myer Foundation, 543, 549

Nanson, Prof EJ, 239
Nash, Paul, 355, 460, 476, 488, 605
National Art Collections Fund (NACF), 315, 388, 413, 416, 431–2, 434, 443, 444, 455, 457, 462, 464
National Gallery (London), 60, 329, 342, 344–5, 413–14, 431–2, 462, 495
National Gallery of Victoria: to 1944 (as part of Public Library, Museums and National Gallery of Victoria): 57, 59, 60, *61*, 62, 63, 64, 65, 66, 145, *146*, 152,

154, 204, 232, 233, 242, 318–20, 359–61, 364–6, 372, 382–3, 401, 416, 420–1, 422, 430–1, 435, 447, 451–3; from 1944: 453, 473, 484, 504–6, 512, 516, 527, 546, 603–6; Purchase Committee, 269, 294–5, 357, 394, 416, 427, 437; redevelopment, 1997–2003, 603–7; Trustees: 145, 235–7, 239–40, 250, 269, 279, 282, 334–9, 372–3, 384, 454–6, 467–70, 488, 505–6, 512, 520, 524, 527, 546, 555, 599
Near Eastern art, 517
New Zealand Drug Company, 167
Newbolt, Sir Francis, 374
Newland, Sir Henry, 519
Newton, HH, 426–7
Nicholson, William, 297, 382
9 × 5 Impressions Exhibition, 150
Noall, W, 144
Nolan, Ronald, 576
Nolan, Sir Sidney, 471, 479, 529
Northcliffe, Lord, 324
Northcote, James, 154
Nossal, Prof Sir Gustav, 593; FBC, 544, 546, 560, (Chairman), 547, 569, 572, 574, 595, 598
Nott, WE, 207
Novar, Lord, 345
Nuffield Foundation, 540

O'Brien, Justin: *Triptych*, 488
O'Neil, HN, 147
Officer, Edward, 305; Gallery Trustee, 337, 339
Officer, Suetonius and Charles, 127–8
Old Colonists' Association, 48–9, 51, 52, 189, 219, 232, 449, 553; Felton Cottages, 142–4, *145;* support from Felton Bequest, 252, 449, 541
Oriental Bank Corporation, 89, 158
Orpen, Sir William, 363, 488, 605
Owen, Sir William, 497
Ozone (paddle steamer), 196

Packer, Sir Frank, 516
Paglieri, G, 151
Palmer, Nettie, 422
Palmer, Samuel, 360
Pang, Dr Mae Anna, 600
Parfitt, PJ, 98
Parkes, ES, 103
Pascin, Jules, 437–9
Pasmore, Victor, 464, 477
Paul Getty Museum, 566, 581
Payne, TB, 89
Payne, TH, 249, 499
Pearson, Charles, 134
Pegram, Fred, 261
Pennell, Joseph, 264; FBC Adviser, 271, 273, 279
Peploe, Samuel, 466
Perceval, John, 471
Perronneau, Jean-Baptiste, 489
Persian art, 469, 515–16, 522
Perugino, Pietro, 492
Pharmacy College, 83
Philanthropy Australia, 589–90; *see also* Australian Association of Philanthropy
Philipp, Franz, 471, 487, 519
Phillips, Dr, 206
Phillips, Fox and Masel, 398, 539
Phillips, Marion, 224
Phillips, Morris, 224
Phillips, PD, 223–4, 226, 236, 251–2, 269, 276, 279, 536, 595
Phipps, Jennifer, 569
Picasso, 332, 375, 383–4, 423, 437–9, 464, 477, 493, 495, 498, 507, 525, 559, 573, 581, 582
Piper, John, 464, 495, 498
Pisanello (Antonio Pisano), *see* Vivarini, Antonio
Pissarro, Camille, 225, 260–1, 265, 296, 331–2, 360–1, 382, 444, 460
Pissarro, Lucien, 360–1, 460
Pitt, ER, 404–6, 410, 441
Pittoni, Giovanni Battista, 485
Plender, Sir William, 374
Pollaiuolo, Antonio, 509
Pollock, Jackson, 566, 570, 598
Poon, Larry, 563
Pope-Hennessey, Sir John, 572
Popham, AE, 500
Port Melbourne Sugar Company, 125

INDEX

Portielje, Gerard, 148
Portland, Duke of, 387
Portrait of a Young Man, 525
Potter, Sir Ian, 512, 543
Potter Foundation, 543, 549, 590
pottery and porcelain, 433, 499, 507, 518, 526, 564, 571, 574–5, 600
Potts, Dr Timothy, 602–3
Poussin, Nicolas, 330, 459, 476, 477, 519, 566
Power, Septimus, 306, 333, 379, 419, 446
Poynter, Sir Edward, 260, 312
Poynter, Robert, 21
Pratt Foundation, 543, 590
Pre-Columbian art, 573
Prendergast, GM, 337, 357
Preti, Mattia, 528
Price, Jane, 147
Pride, James, 459
primitive art, 507
prints, 484–5, 492, 507–8, 523, 560
Proctor, Thea, 305, 333, 516
Prosser, Evan, 32–3, 114, 168, 172
Pugh, Clifton: portrait of Sir Andrew Grimwade, 599
Puvis de Chavannes, Pierre Cécile, 290, 303, 313, 391, 397

Queen Elizabeth II, 575
Queen Victoria, 147, 192
Queen's Fund, 594

rabbits, poison for, 110–18, *117*, 127–8
Rackham, Arthur, 261, 280
Rackham, Bernard, 433
Radcliffe and Co., 463, 526, 580; *see also* St Barbe Sladen & Wing
Raeburn, Sir Henry, 290–1, 303, 328, 375, 411, 435, 448
Railway Strike Loyalists' Fund, 192
Ramsay, Allan, 329, 330, 375, 526
Ramsay, Hugh, 272
Rankin, Dr, 99–100
Rauschenberg, Robert, 574
RE Ross Trust, 543
Read, Sir Hercules, 312

Reay, Lieut-Colonel WT, 240
Redon, Odilon, 485, 599
Redpath, Norma, 522
Reed, John, 426, 447, 453–4, 471–2, 531
Reed (Baillieu), Sunday, 323, 471
Rees, Lloyd, 466
Regnault, Jean-Baptiste, 602–4
Régnier, Nicolas, 498
Reid, George M, 109, 133
Rembrandt, 70, 332, 343, 349, 375–6, 383, 397, 435, 440, 443, 472, 485, 493, 507–9, 565; drawings, 375; etchings, 565; *Portrait of a [Fair-Headed] Man*, 485–6, 488; *Two Philosophers (Two Old Men Disputing)*, 406–14, 485; (studio of), *Rembrandt*, 387, 389–92, 473, 485, 581
Reni, Guido, 570
Renoir, Pierre-Auguste, 296, 331–2, 383, 393, 395, 432, 444, 460, 462, 465, 469, 479, 491, 492, 571, 573; *Femme couchée*, 464–6
Reynolds, Sir Joshua, 280, 289, 328, 331, 340, 396, 499, (studio of), *Theophilia (Offy) Palmer*, 290–2, 295, 301, 303
Ricci, Sebastiano, 509
Richardson, Charles Douglas, 67
Ricketts, Charles, 315–16, 368–9
Riddoch, John, 87
Rielly, Henry, 157
Rigg, Colin, 489, 492
Riley, Bridget, 605
Rinder, Frank, *331*, 404, 435, 473, 497, 501, 566, 572; FBC Adviser, 312–13, 317–21, 327–30, 339–42, 347, 350–1, 397, 418, 458, 481, 484; purchases, 343–9, (public reaction), 334, 343, 347, 354; resignation, 361–70; schedule, 330–4, 340–2, 351, 353–6, 361; in Melbourne, (1919), 327, 329–30, 334, (1926), 352–6
Ritchie, William, 506, 527, 561, 564–5, 568

Rivett, Sir David, 451
Rivière, Briton, 147
Robbia, Luca della 348
Roberts, David, 245
Roberts, JW, 120–2
Roberts, Tom, 67, 147, 148, 150–1, 226, 272, 325, 333, 379, 392, 460; *Shearing the Rams*, 154, 379–80, 605
Robertson, Angus, 107, 150
Robertson, Sir Macpherson, 399–400
Robinson, WS, 324
Rocke Tompsitt's, 32, 116–18
Rodin, Auguste, 262, 267, 280, 331, 341, 477, 518
Rolando, Charles, 204
Rolfe, Mr and Mrs George, 203
Romney, George, 289, 338, 509, 510
Rosa, Salvator, 70, 157, 485
Rosebery, Lord, 147, 192
Rosenberg, Paul, 465
Ross, Robert: FBC Adviser, 312–17, 346; recommendations and purchases, 315–17, 327–8, 338–9, 353
Rossetti, Dante Gabriel, 280, 495, 498
Rothenstein, William, 275, 274
Rothko, Mark, 577–8, 605
Rouault, George, 464, 477, 485
Rousseau, Théodore, 296, 331, 494, 497
Rowan, Ellis, 147
Rowan, Dr Thomas, 201
Rowell, John, 379, 446
Rowell, William, 379, 424
Rowlandson, Thomas, 485
Rowlison, Eric, 572, 574, 576
Royal Academy, 225, 238, 242
Royal Anglo-Australian Society of Artists, 153
Royal Bank of Australasia, 159, 227
Royal British-Colonial Society of Artists Exhibition 1908, 280–3
Royal Exhibition Building, 566
Royal Victorian Institute for the Blind, 533
RSL Family Welfare Bureau, 533

Rubens, Peter Paul, 201, 383, 394, 464–5, 459, 470, 581–2; *Garden of Love* (copy), 245
Rubinstein, Helena, 164, 516
Ruisdael, Jacob van, 343, 383
Ruskin, John, 274
Russell, John Peter, 151, 262, 448, 525
Russell, Sir Walter, 444, 447, 457

St Barbe Sladen & Wing, 314, 317, 329; *see also* Radcliffe and Co
St Kilda, 21–2, *49*, 178, *179*
St Kilda Cricket Club, 187
St Paul's Cathedral, 192, 555–6
Salting, George, 148
Samuel Burston and Co., 227
Sandys, Frederick: wood engraving, 262
Sargant, H Edmund, 417, 434, 443, 463, 470, 475, 486, 493, 520
Sargent, John Singer, 275, 280, 361
Sargood, Sir Frederick Thomas, 103
Sarto, Andrea del, 383, 447
Sassetta, 572
Scarborough, John, 461
Schongauer, Martin, 482
Schwabe, Prof Randolph, 444, 447–8, 450, 457, 516; FBC Adviser, 462–3, 474–5
Scots Church, 95, 97, 103, 134–6
Scott, David, 545–6, 554
Scott, Fr Michael, 527
Searby, Mrs Caroline, FBC, 547, 549, 574, 595, *596*, 598
Seddon, NR: Gallery Trustee, 518, 522, 561, (Chairman/President), 524, 527, 575
Segantini, 360
Segonzac, Andre Dunoyer de, 375, 460
Serle, Percival, 249–50, 298, 335, 433, 442, 447
Service, James, 70–3, 109
Seurat, Georges, 332, 393, 460, 479
Shayer, William, 247
Shiels, William, 232

INDEX

Shirlow, John, 333, 335, 380, 398, 416; artist, 415; FBC, 372, 389, 395, 404, 408; Gallery Trustee, 319, 352, 354, 357, 361, 374, 395–6, 406, 408, 410, 413
Sholl, Sir Reginald, Gallery Trustee, 488–9, 502, 517–18
Shore, Arnold, 321, 374, 415, 445, 484
Sickert, Walter, 436, 459, 466, 469, 474, 476, 477, 522
Sievwright, Mr, 95
Signac, Paul, 393, 438, 460, 476
Simoni, Professor, 151
Sisley, Alfred, 225, 260, 280, 296, 299, 332, 393, 432, 460
Sizer, Theodore, 519
Skelton, Robert, 573
Slater, William, 467
Smith, Bernard, 471, 519
Smith, George, 35–6
Smith, Sir Harold Gengoult, 401
Smith, Helen Macpherson, 543
Smith, Jack, 509
Smith, James, 63–4, 66, 151; Gallery Trustee, 204, 239, 256–8, 265, 279, 287
Smith, Dr LL, 146, 150, 153, 324
Smith, Louise, *see* Hanson-Dyer
Smith, Lucy, 376
Smith, Sir Matthew, 436, 474, 476, 522
Smith, Robert, 35
Smith, Robert Murray, 146, 153, 163, 224, 227; FBC, 236, 237, 276, 284–5, 292–3; Gallery Trustee, 239, 265
Smith, Sydney Ure, 333, 372, 417, 420, 466
Smithers, AT, 454, 527
Solomon, H, 249
Soto, JR, 428, 525
Southern, Clara, 448
Soutine, Chaïm, 522–3
Spencer, Gilbert, 460
Spencer, Stanley, 355, 460, 605
Spencer, Sir Walter Baldwin, 204–5, 308–11, 320, 401, 597; FBC, 235, 276, 327, 341–2; Gallery Trustee, 239, 258, 279, 281,
282–4, 289, 293, 300–1, 335, 339, 355, 357, 363–4, 370; Museum Director, 309–10; in London, 311–14, 317, 334, 363
Spronk, Petrus, 267
Sprunt, John, 25–6
Stanfield, W Clarkson, 147
Stanford, Leland, 149
Stanford, TW, 149
Stanzoni, Emilio, 498
State Library of Victoria, 531–2, 556, 566
Stawell, Sir William, 70–1
Steen, Jan, 343, 440
Steer, Philip Wilson, 275, 355, 383, 457
Stegley Foundation, 543
Stephens, JH, 549, 556, 563, 584, 598
Stevens, Alfred, 331, 470
Stevens, WR, 201, 246
Stevenson, Robert Louis, 345
Stewart, Sir Alexander, 468; FBC, 416–17, 419, 455, 469, 499
Stewart, James Cuming, 524
Sticht, Robert Carl: collection, 333, 398, 598
Stocks, ED, 278
Stones, Margaret, 521
Strange, FE, 287
Streeton, Arthur, 147, 150–1, 272, 299, 306, 309, 312, 319–21, 359, 379, 391–2, 420, 445, 448–9, 472
Strong, Rev Dr Charles, 51–4, 57, 95, 136, 190, 203, 206–9, 220, 231, 255, 281; Scots Church conflict, 269, 134–7, 140–2; Village Settlement Movement, 160–1; *see also* Australian Church
Strong, Mrs Charles, 137, 207, 252
Strong, Prof Herbert Augustus, 45
Strong, 'Jennie', 207
Strutt, William, 150, 493, 495, 518
Stubbs, George, 331, 459, 482
Sugden, EH, 240, 281–2, 336, 395, 404, 407–8
Summers, Charles, 64
Sumner, TJ, Estate, 255

Sutherland, Alexander, 142, 158, 401
Sutherland, Graham, 437
Suttor, Sir Francis, 249
Swan, J, 292, 267
Swinburne, Sir George: Gallery Trustee, 336, 348–9, 354, 356, 359, 362; President, 371
Syme, David, 19–20, 140, 204

tapestries and textiles, 332, 464–5, 476, 491, 495, 499, 507–8, 522
Tate Gallery, 225, 238, 315, 329, 332, 436, 438, 559
Taylor, Joe and Mrs A, 109
Teague, Violet, 147, 379
Teale, Goodman, 99
Templeton, William, 227
Teniers, David (called The Younger), 383
Terborch, Gerard, 459, 464–5
Thake, Eric, 446
The Body Shop: Youth Trainee Scheme, 589
The Field exhibition, 529, 558–9, 605
Thomas, J Havard, 347
Thomas, Morgan, 226, 238
Thomson, Gordon, 490, 504, 514, 525, 561–3; Gallery Director, 568–9
Tiepolo, Giovanni Battista, 332, 375, 405, 509, 515, 560; *Banquet of Cleopatra*, 387–94, 397, 472, 480, 482, 518, 522
Tintoretto, Jacopo, 477; *The Doge Pietro Loredano*, 356, 359, 363
Tissot, James Jaques Joseph, 432, 448
Titian (Tiziano Vecelli), 435; attr, *Friar (Portrait of a Man)*, 344–5, 348
Tim Leura Tjapaltjarri Anmatyerre and Clifford Possum Tjapaltjarri Anmatyerre: *Napperby Death Spirit Dreaming*, 597–8
Tonks, Henry, 334, 438, 444, 519, 361
Tooth, Arthur, 152

Torrance, George, 106
Torre, Mariana Mattioco della, 262, 267
Toscani, Giovanni, 526
Toulouse-Lautrec, Henri de, 332, 464, 477; *Le Jockey*, 570
Townsend, FH, 261
Trendall, Prof Dale, 519, 602; FBC Adviser, 499, 508, 518, 525, 563, 571, 574–5, 577–8
Trinitarias carpet, 509
Triptych with the Miracles of Christ (Flemish), 343
Troyon, 276, 297
Trustees, Executors and Agency Co. Ltd., 227–8, 228, 232, 248, 250, 357, 410, 430–1, 449, 455, 580; FBC appointee, 236, 237, 416, 499, 524; insolvency, 552, 580
Tryon, Rear-Admiral (Sir) George, 107
Tucker, Albert, 440, 471, 577
Tucker, Canon Horace Finn, 160–1
Tucker, Professor Thomas George, 293
Tulks, Augustus, 64
Turner, Henry Gyles, 158–9, 270, 334; FBC, 307, 313; Gallery Trustee, 239, 258, 265; President, 269, 276–7, 279, 281–6, 289, 292, 294, 299, 306–7
Turner, Joseph Mallard William, 69, 147, 148, 261, 265, 299, 300, 303, 330–1, 348–9, 383, 464, 482; *Dogana and Salute*, 356; *The Red Rigi*, 469, 473; *Walton Bridges*, 319, 329, 338
Tweddle, Isabel May, 337
Tweddle, JT: Gallery Trustee, 337, 355–7, 344, 406, 409, 416

Uccello, Paolo, attr to: *Profile Portrait of a Lady*, 464, 467
United Manufacturers Association, 67
University of Melbourne, 57, 59, 62, 223–4, 323, 371, 584, 593; Archives Centre, 544; Cancer Research Fund, 326; *Herald* Chair of Fine Arts, 470–1, 555

Utrillo, Maurice, 332, 423, 437–9, 457, 460, 469

Vaga, Perino del, 525
Vallotton, Felix, 438–9
Van Beyeren, 508
Van Gogh, Vincent, 151, 332, 375, 393, 395, 423, 437, 448, 460, 479; *Tête d'homme*, 438–40
Vasarely, Victor de, 525
Vasselot, Jean-Jacques Marquet de, 264; FBC Adviser, 271, 273
Vassilieff, Danila, 571
Vaughan, Dr Gerard, 151–2; FBC Adviser, 580–1, 598, 600, 601; Gallery Director, 603–6
Velasquez, Diego, 344, 459
Verdon, Edward de, 299
Vermeer, Jan, 459, 343, 345, 349
Veronese, Paolo, 469, 480
Victoria and Albert Museum, 574
Victoria League, 538
Victorian Academy of Art, 69, 249
Victorian Artists Society, 235, 249, 305, 424–5
Victorian Arts Centre (formerly Cultural Centre), 505–6, 512–13, 517–18, 529–32, *530*, 558–95, 566
Victorian Association of Social Service, 544
Victorian Tapestry Workshop, 566
Vierge, Daniel, 262
Village Settlement Movement, 160–1
Vivarini, Antonio, school of: *The Fountain of Love*, (formerly attr. Pisanello, school of), 476, 606
Vlaminck, Maurice, 437, 440, 460, 482
Vollard, Ambrose, 428
Vollon, Antoine, 273
Vuillard, Edouard, 438, 460, 476, 488, 495

Waite, JC, 147; portrait of AF, 182, 270–1
Wales, Prince of, 147, 153
Walker, Ethel, 438
Wallace, Sir Richard: Wallace Collection, 59, 479–80
Waller, Napier, 354, 359, 379; Gallery Trustee, 454, 467
Wallis, Henry, 148
Walter and Eliza Hall Institute of Research in Pathology and Medicine, 326, 537–8, 544
Waterhouse, Prof EK, 521
Waterhouse, Ellis, 389
Waterhouse, JW, 154, 448
Waterlow, Sir Ernest, 260, 283
Watson, John, 220
Watson, Percy, 446
Watteau, Jean Antoine, 276, 290, 303, 435
Watts, GF, 153
Way, Sir Thomas, 226
Webb, James, 249, 245
Webb, Sir Thomas, 552; FBC, 552, 573
Webb, Thomas Prout, 274–5, 278
Webster, Marion, 583, 585
Weedon, Sir Henry, 295; Gallery Trustee, 336–7
Weenix, Jan Baptist, 573
Weigall, Theyre à Beckett, 276–7, 279, 537
West, Sir Benjamin, 70
Westbrook, Eric, *501*, 573; Gallery Director, 494, 500, 503–4, 507–8, 510, 512–14, 516–17, 522, 561–5, 567–8, 576
Weyden, Rogier van de, 344
Wheare, Kenneth Clinton, 505
Wheeler, Charles, 306, 354, 359, 379
Whistler, James Abbott Mcneill, 153, 280, 316–17, 327–8, 375, 383–4, 459, 483
Whiting, Amy: portrait of AF, 182, 415
Wilkie, Sir David, 331
Willems, Joseph, 599
Williams, CF, 184
Williams, Fred, 524; *Upwey Landscape*, 525
Wills, Arthur, 299
Wilmot, Meriel, 549
Wilson, Dora L, 379, 382
Wilson, Edward, 19, 47; Estate, 188, 224, 236, 255, 584
Wilson, Richard, 292, 459
Wilson, Samuel, 127
Wilson, Dr TL Rodney, Director, 597–8
Wilson, William Hardy, 305, 420
Wiltshire, ARL, *510*; FBC, 499–500, 524
Wing, Sladen, 369, 374, 409–10, 413, 416–17
Winter, Samuel Pratt, 606
Wischer, —, 170
Withers, George, 190, 305
Withers, Walter, 460
Witt, Sir Robert, 347, 388, 390, 417, 460, 463
Witte, E de, 459
Women's Political and Social Crusade, 192, 253

Wood, Francis Derwent, 346–8, 359
Woodall, Dr Mary, *523*; FBC Adviser, 521–8, 531, 559–65, 568–71
Woodbridge (Suffolk), 7–8, 10, 92–3
Woodward, Arthur, 299
Wouwermann, Philips, 383
Wren, John, 339
Wright, Prof Sir Douglas ('Pansy'), 495
Wright, Harold: FBC Adviser, 463, 476, 484
Wrixon, Sir Henry J, 240, 284
Wyndham Lewis, Percy, 522, 605

Yeats, Jack, 355
York, Duke of, 178
Young, Blamire, 274, 278, 287–8, 305, 379
Young, Edward: *Night Thoughts*, 248, 333
Young, Henry Figsby, 273
Young, Mrs, 104
Young and Jackson's Hotel, 273, 575
Youngman, Edward, 22, 27
Youngman, Henry, 22, 27
Youngman & Co, 22–3, 270

Zeal, Sir William: Gallery Trustee, 240
Zimmer, Prof Jenny, 600–4
Zoffany, Johann, 331, 383, 376, 459, 526
Zolnierkiewicz, Teresa, 595
Zox, Ephraim, 141, 550
Zuloaga, 375, 460
Zurbarán, Francisco de, 459

THE MIEGUNYAH PRESS

This book was designed and typeset by Lauren Statham
in 11.5 point Bembo with 14.5 points of leading.

The text is printed on 100 gsm Alpine

2300 copies of this edition were printed in Australia by Ligare